"No matter what things
you study, you will find
that those which are
good and useful are also
graced with beauty."

Baldassare Castiglione, *The Book of the Courtier*, 1528

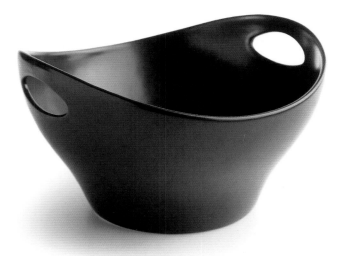

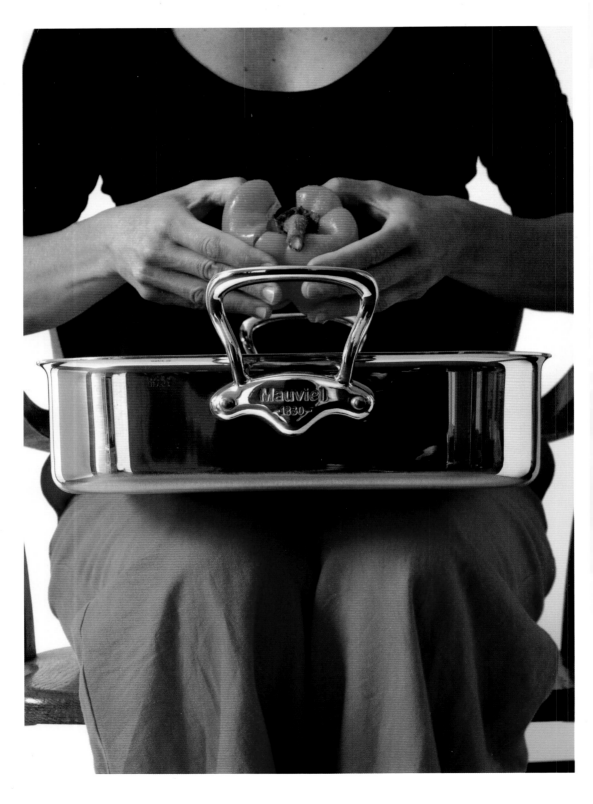

Tools for Living:

A Sourcebook of Iconic Designs for the Home

Charlotte & Peter Fiell

FIELL

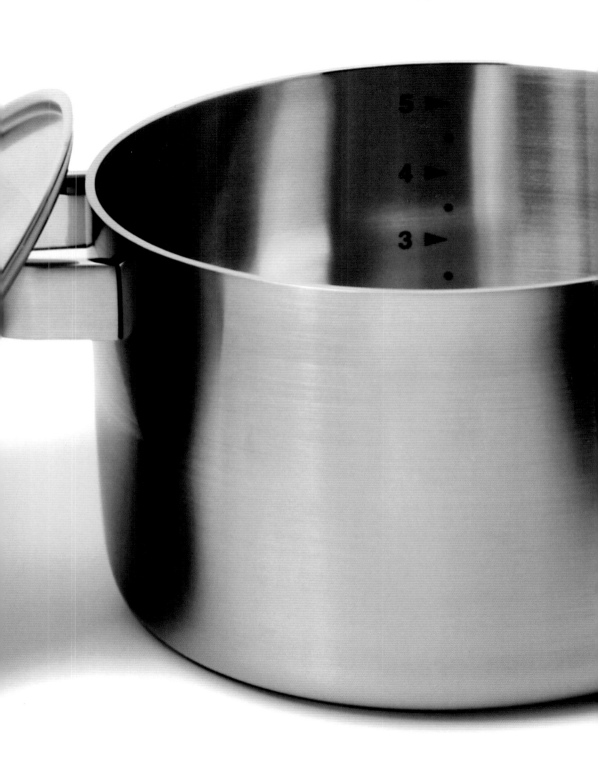

Published by Fiell Publishing
www.fiell.com

A catalogue record for this book is available
from the British Library

ISBN 978-1-906863-01-2

Project Concept: Charlotte & Peter Fiell
Editorial: Charlotte & Peter Fiell
Texts: Charlotte & Peter Fiell
Picture Sourcing: Jennifer Tilston & Charlotte Fiell
Design: Mark Thomson Design
(Mark Thomson & Rob Payne)
Initial cover design concept: Farrow Design
Proofing and Copy Editing: Quintin Colville
& Rosanna Negrotti
Translation co-ordination and proofing:
Yvonne Havertz
German translations: Birgit Herbst,
Cara Kanter, KuK Übersetzungen (Jessika Komina
& Sandra Knuffinke), Annette Wiethüchter
French translations: Philippe Safavi,
Stéphanie Jaunet
Indexing: Louisa Green

Printed in China

<<< Lovisa Wattman, *Model No. 4505* Collection
serving bowl for Höganäs Keramik, 1996

<< Mauviel Design Team, *M'cook* roasting pan
for Mauviel, 2003

< Dahlström, Björn, *Tools* cookware
for Iittala, 1998

Contents

Introduction

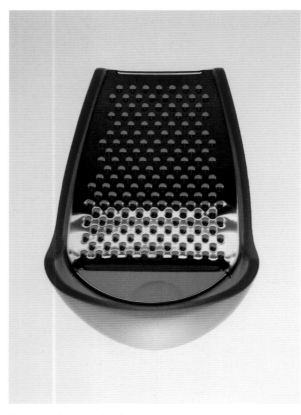

Alejandro Ruiz, *Parmenide* cheese grater for Alessi, 1994

Since prehistoric times, tools have shaped human existence. In fact the design, making and use of tools are distinguishing features of what it is to be human. Although other members of the animal kingdom fashion implements to assist them with certain limited tasks, no other species uses them to the same extraordinary extent. Indeed, it is no exaggeration to suggest that tools maketh man, because they allow us to shape the environments and cultures that make us who we are. Today our homes are literally crammed with tools, from kitchen knives to task lights, yet much of the stuff with which we surround ourselves is neither particularly well-designed nor especially well-made, because the market is frequently and predictably tethered to the commercial bottom line.

This book is based on the simple premise that well-designed objects can enhance our daily lives. We all need 'tools for living' – from cutlery and cooking utensils to furniture and lighting – so this book focuses on the ultimate designs for the home. After all, when you get right down to it, objects that fulfill the criteria for 'good design' are not only functionally and aesthetically superior, but they usually last longer too. Moreover, this enhanced durability is ultimately better for the environment. If a product lasts twice as long as its competitors then its net environmental impact is halved, so buying 'better' makes sound eco-sense as well as economic sense.

Well-designed objects are also more pleasurable to use; they give us joy by helping us to accomplish a specific task more rapidly and efficiently. They are also more likely to possess functional and structural integrity, which makes them less susceptible to the vagaries of fashion. The old saying 'buy cheap, buy twice' remains true, and we believe that it is preferable in the long run to buy an object that functions well because it has been carefully and painstakingly designed, even if it is a little more expensive. Cheaper, poor-quality versions are more likely to fail or to become stylistically obsolete – either way they will have to be replaced. By contrast, many of the designs selected for this survey could, with careful use, be passed down through generations of users because they have been designed to last.

Some of the items in this book are truly democratic and cost just a few pounds or dollars, others are more exclusive and cost several hundred or in a few cases several thousand. Regardless of price, though, they

are all the best of their kind. Many are innovative products recently designed by today's leading talents, while others are acknowledged 'design classics' that have stood the test of time, such as Max Bill's *Model 367/6047* wall clock or David Mellor's *Pride* cutlery. We have also included historic designs that have been honed to functional perfection over decades, and in some cases over centuries, such as the traditional *Brown Betty* teapot or Bulldog's hand-forged gardening tools.

Over the years, friends and family have repeatedly asked us, 'Where can I get really well-designed cutlery?', 'What is the best shelving system?', 'Which door handles can you recommend?'. So we have decided to go room by room, object type by object type, looking for the best-designed products available, with the one proviso that any selected design has to be in current production so that it can be purchased. Each selection is accompanied with a short description of its attributes from a design perspective. We have also provided the manufacturers' web addresses, so that items can be sourced with relative ease. It has been an all-consuming search that has spanned the world of domestic tools, from Japanese knives and Finnish cooking pots to Italian lighting and English teapots.

As Michael Landy's *Break Down* art installation in London (2001) emphatically revealed, the average home contains literally thousands of objects, many that are not particularly needed or even really wanted. Instead of endlessly accumulating domestic dross – from useless gadgets and kitsch gimmicks to knock-off 'designer' pastiches and furnishings so poorly made that they are only intended to last a few years – we should perhaps subscribe to the entreaty formulated by William Morris: 'Have nothing in your house that you do not know to be useful or believe to be beautiful'. Wouldn't it be better not to clutter our lives with a sea of questionable bric-a-brac, but rather to share our homes with a smaller number of functionally and aesthetically refined possessions?

Ernesto Rogers, the famous Milanese architect, believed that by studying a spoon it should be possible to understand the culture that had created it and to extrapolate the type of city that such a society would build. Surveying the plethora of shoddy household goods found in our stores today can hardly fill us with confidence about our present trajectory. Given the finite nature of the world's resources the time has

surely come for responsible quality over mindless quantity. With dizzying speed the bling-tastic must-haves of the last decade have already become the tarnished junk of a past era marked by its celebrity obsessions and cultural emptiness. Instead there is a growing awareness and an increasing appreciation of 'ideal' objects that are functional, durable and timelessly beautiful. These are purposeful objects that inspire the mind, gladden the eye, warm the heart, and comfort the hand... objects that are cherished tools in the workshops of our daily lives.

One of the main ways we accumulate objects is through gifting, so another aim of this publication is to function as an essential guide and source of inspiration for people looking for that special present. An object for the home that works well and looks beautiful can give years of pleasure to the recipient, which is a lot more than can be said for all those unwanted gifts of last resort. We equally hope that those setting out to furnish their own homes will use this book to make informed choices. An inferior design often costs as much as a good one, and careful purchasing decisions will pay dividends in the present and in the future. Naturally, this book will also appeal to people who just want to buy the best, which, of course, doesn't necessarily mean the most expensive.

In Scandinavian countries it has long been believed that good design is the life-enhancing birthright of all. We hope that this guide to the world's best household designs will bring pleasure and enjoyment into our daily lives through better 'tools for living'.

Einleitung

Seit grauer Vorzeit haben Werkzeuge die Entwicklungsgeschichte der Menschheit geprägt und begleitet. Die Herstellung und der Gebrauch von Arbeitsgeräten ist in der Tat eines der wichtigsten Merkmale des Menschseins überhaupt. Zwar nutzen auch eine Reihe von Spezies aus der Tierwelt rudimentäre Werkzeuge für einige wenige Zwecke, aber kein anderes Lebewesen auf dem Planeten Erde nutzt sie so ausgiebig und in solcher Vielfalt wie der Mensch. Es ist nicht übertrieben zu behaupten, dass Werkzeuge den Menschen schufen, denn erst sie haben es uns im Laufe von Jahrtausenden ermöglicht, die Kulturlandschaften und Kulturen zu schaffen, die uns zu dem gemacht haben, was wir sind. Heute sind unsere Wohnungen und Häuser buchstäblich vollgestopft mit Werkzeugen, Geräten, Arbeitsutensilien – von Küchenmessern zu Schreibtischlampen –, aber viele Gebrauchsgegenstände, mit denen wir uns umgeben, sind nicht besonders schön gestaltet oder gut gemacht, weil der Markt häufig (und das ist vorhersagbar) nur daran interessiert ist, für so wenig Kosten wie absolut nötig so viel Gewinn wie möglich zu machen.

Dieses Buch geht von dem Gedanken aus, dass gut gestaltete Gebrauchsgegenstände und Arbeitsmittel unseren Alltag nicht nur erleichtern, sondern auch verschönern. Wir alle brauchen „Werkzeuge zum Leben" – von Besteck und Kochtöpfen bis hin zu Möbeln und Lampen – und deshalb stellt dieses Buch „letztgültige" Beispiele von Alltagswerkzeugen und Einrichtungsgegenständen vor. Schließlich sind Objekte, die den Kriterien des „guten Designs" und der „guten Form" gerecht werden, den schnell und billig hergestellten Dingen nicht nur in funktionaler Hinsicht überlegen, sondern sie halten meistens auch viel länger. Und wenn ein Produkt doppelt und dreifach so lange hält wie seine Konkurrenzprodukte, ist das auch besser für die Umwelt. Mit dem Kauf eines „besseren" und in der Anschaffung teureren Produkts handelt man also nicht nur in ökonomischer, sondern sogar in ökologischer Hinsicht klug.

Der Gebrauch gut gestalteter Gegenstände bereitet außerdem ein größeres sinnliches Vergnügen als billige Massenartikel. Wir freuen uns, wenn wir mit ihnen eine bestimmte Aufgabe schneller und effizienter erledigen können. Ihre Funktion ist optimal in ihre Form und Konstruktion integriert, so dass sie nicht so schnell Gefahr laufen, aus der Mode zu kommen.

Die Redensart „billig kaufen heißt doppelt kaufen" gilt auch heute noch, und auf Dauer ist es billiger, ein gut funktionierendes (weil sorgfältig gestaltetes und gebautes) Produkt zu kaufen, selbst wenn es ein bisschen mehr kostet. Billigere Gegenstände von schlechter Qualität versagen meist früher oder werden schneller „altmodisch" und müssen ersetzt werden. Im Gegensatz dazu können viele der in diesem Buch präsentierten Produkte bei sorgsamer, schonender Behandlung von Generation zu Generation weiter vererbt werden, weil sie auf Langlebigkeit hin gestaltet und gefertigt wurden.

Etliche der im vorliegenden Buch beschriebenen Gebrauchsgegenstände kosten nur wenige Dollar oder Euro und sind insofern „echt demokratisch". Andere sind exklusiver und kosten mehrere hundert (in einigen Fällen sogar mehrere tausend) Dollar oder Euro. Abgesehen vom Kaufpreis sind sie aber alle die besten ihrer Art. Bei einer ganzen Reihe handelt es sich um Innovationen, die von begabten jungen Designern geschaffen wurden, bei anderen um anerkannte, bewährte „Designklassiker" wie zum Beispiel Max Bills *Wanduhr Modell 367/6047* oder David Mellors Essbesteck *Pride*. Zusätzlich fanden etliche historische Objekte Eingang in dieses Buch, die über Jahrzehnte – in wenigen Fällen sogar über Jahrhunderte – immer wieder verbessert wurden, zum Beispiel die traditionelle englische Teekanne *Brown Betty* oder die handgeschmiedeten Gartengeräte der Firma Bulldog.

Im Laufe von Jahren haben uns Freunde und Verwandte immer wieder Fragen wie diese gestellt: „Wo finde ich wirklich formschönes Besteck?" – „Welches Regalsystem ist eurer Meinung nach das beste?" – „Welche Türgriffe könnt Ihr uns empfehlen?" Deshalb entschlossen wir uns, von Raum zu Raum und Produktart zu Produktart nach den funktional wie formal besten und schönsten Gebrauchsgegenständen zu suchen, die allesamt noch produziert werden, damit interessierte Leser sie auch kaufen können. In Kurztexten werden die ausgewählten und abgebildeten Produkte aus der Perspektive des Designs erläutert. Die angeführten Homepage-Adressen der verschiedenen Firmen erleichtern die Suche nach Bezugsquellen. Auf unserer eigenen Suchexpedition haben wir die globale Welt der Werkzeuge und Gebrauchsgegenstände erforscht und unsere Funde in diesem Buch versammelt – von japanischen Messern

und finnischen Kochtöpfen bis hin zu italienischen Lampen und englischen Teekannen.

Wie Michael Landys Kunstinstallation *Break Down* 2001 in London eindrücklich gezeigt hat, enthält eine Wohnung (oder ein Haus) im Durchschnitt Tausende von Gebrauchsgegenständen, die im Grunde nicht wirklich gebraucht oder gewünscht werden. Statt endlos unnütze Eierspalter und allerlei technischen Haushalts-Schickschnack bis hin zu preiswerten Imitaten von Designermöbeln (mit eingebautem Verfallsdatum billig gemacht) sowie andere Gerätschaften und „Wohnmüll" anzuhäufen, sollten wir uns vielleicht lieber dem folgenden, von William Morris formulierten Diktum verschreiben: „Sie sollten nichts in Ihrem Haus haben, von dem sie nicht wissen, dass es nützlich ist, oder von dem Sie nicht glauben, dass es schön ist." Wäre es nicht besser, unser Leben nicht mit einem Haufen Siebensachen von fragwürdigem Nutzen zu belasten und uns stattdessen mit einer begrenzten Anzahl funktional und ästhetisch ausgeklügelter Dinge zu umgeben?

Der berühmte Mailänder Architekt Ernesto Rogers war davon überzeugt, dass es bei der Betrachtung und Untersuchung eines Löffels möglich sein müsse, das Kulturvolk zu verstehen, dem er entstammt, und daraus die Art von Stadt abzuleiten, die von diesem Volk gebaut worden wäre. Beim Anblick der Fülle hässlicher und minderwertiger Haushaltswaren in den Geschäften können uns heute Zweifel für den Weg in die Zukunft der Werkzeuge und Gebrauchsgegenstände beschleichen. Und angesichts der Tatsache, dass die weltweiten Rohstoffvorkommen nicht unerschöpflich sind, ist doch wohl die Zeit für die verantwortungsvolle Produktion von Qualität statt unüberlegtem Ausstoß von Massenware gekommen. Mit atemberaubender Geschwindigkeit ist Vieles, was noch vor Kurzem als „absolutes Muss" glänzte, inzwischen zum glanzlosen Wegwerfprodukt einer von Promiversessenheit und kultureller Armut geprägten Vergangenheit mutiert. Stattdessen wächst die Wertschätzung „idealer" – weil funktional effizienter und haltbarer – Dinge von zeitloser Formschönheit, die den Geist inspirieren, das Auge erfreuen, das Herz erwärmen und der Hand schmeicheln – Gebrauchsgegenstände, die wir jeden Tag als „Werkzeuge zum Leben" schätzen.

Nicht nur, aber zum Teil bestehen unsere „Sammelsurien" aus Geschenken. Deshalb soll dieses Buch auch

Kaj Franck, *Teema* teapot for Iittala, 1977–1980

denen als Suchhilfe und Inspirationsquelle dienen, die für einen besonderen Menschen ein ganz spezielles Geschenk suchen. Ein Gegenstand für die Küche oder Wohnung, der gut aussieht und funktioniert, kann dem Beschenkten jahrelang Freude machen – was man von den meisten in letzter Minute gekauften Verlegenheitsgeschenken nicht behaupten kann. Wir hoffen, dass auch diejenigen, die ihre Wohnung oder ihr Haus (neu) einrichten möchten, unser Buch als Entscheidungshilfe nutzen werden. Minderwertiges Design kostet oft ebenso viel wie hochwertiges, und kluge Kaufentscheidungen zahlen sich früher oder später aus. Natürlich wird dieses Buch auch diejenigen ansprechen, die einfach das Beste kaufen möchten – und das ist nicht zwangsläufig immer das Teuerste!

In Skandinavien herrscht seit langem die Überzeugung, dass gutes Design zum Geburts- und Lebensrecht aller Menschen gehört. Wir hoffen, dass die vorliegende Publikation als Wegweiser zu den besten Haushaltsutensilien und Wohnaccessoires dienen wird, die als „Werkzeuge zum Leben" unseren Alltag erleichtern und verschönern.

Introduction

Seul l'être humain est capable de fabriquer des outils sophistiqués et de les faire évoluer dans le temps. Depuis la préhistoire, les outils ont façonné l'existence humaine. On parle parfois d'*Homo faber* pour souligner cette caractéristique essentielle de l'homme. Depuis qu'ils vivent en groupe, puis en société, les humains se sont partagé les tâches et se sont donc spécialisés en fonction de leurs aptitudes naturelles ou des besoins du moment. Cette organisation a permis à l'humanité de conserver, de multiplier et de faire évoluer les techniques de fabrication des outils. De nos jours, nos maisons sont littéralement envahies par toutes sortes d'appareils ou d'objets inutiles achetés pour répondre à notre besoin de consommation.

Cet ouvrage souhaite simplement démontrer que les objets bien conçus améliorent notre quotidien, qu'il s'agisse d'ustensiles de cuisine, de mobilier ou bien d'éclairages en tout genre. Qui pourrait vivre sans ? Il nous a paru judicieux de proposer une sélection de produits relatifs au design domestique. L'idéal reste une création élégante et fonctionnelle, parfaitement résistante à l'écoulement du temps. Un produit qui dure deux fois plus longtemps que ses concurrents est aussi un produit au profil plus écologique. Le consommateur d'aujourd'hui est plus exigeant et souhaite un « design durable » afin d'amortir son investissement tout en préservant l'environnement. Ainsi, un achat « intelligent » répond à des critères à la fois écologique et économique.

Outre l'aspect environnemental, les créations design allient l'utile à l'agréable. La configuration « fonctionnelle » de l'objet ne peut être négligée ou traitée en deçà de l'aspect esthétique, car le principe même du design est de répondre aux besoins d'utilisation. Le vieil adage « le bon marché est toujours trop cher » reste d'actualité dans une société basée essentiellement sur une consommation de masse. Nous sommes convaincus qu'il est préférable d'acquérir un objet bien pensé et durable, même s'il est un peu plus cher. Souvent de mauvaise qualité ou d'une obsolescence trop rapide, les produits bon marché ne sont pas une valeur en soi. La plupart des objets présentés dans cet ouvrage sont conçus par des designers soucieux de coordonner et d'harmoniser les aspects fonctionnels et esthétiques, créant ainsi de véritables objets d'art.

Les produits proposés dans cet ouvrage sont indiscutablement les meilleurs dans leur catégorie : les prix varient des plus raisonnables aux plus exorbitants, de quelques dizaines à plusieurs milliers d'euros. Tous sont le fruit du travail exigeant de nouveaux designers dans l'air du temps, innovant inexorablement la matière et la forme pour un résultat optimal. Certains appartiennent aux « classiques du design », véritables icônes qui ont résisté à l'épreuve du temps comme par exemple l'horloge murale *367/6047* de Max Bill, ou encore les couverts *Pride* de David Mellor. Certaines créations « classiques » ont été affinées au cours des décennies, voire au travers des siècles à l'instar de la théière traditionnelle *Brown Betty* ou des outils de jardin forgés à la main, Bulldog.

Il n'est pas rare d'entendre quelqu'un se demander « Où puis-je trouver de bons couverts ? », « Quelles étagères vais-je choisir pour cette pièce ? », « Quelles poignées de porte me recommanderiez-vous ? ». Nous nous sommes donc lancés dans une vaste entreprise qui consiste à revisiter chaque pièce de la maison et à étudier chaque objet afin de trouver les meilleurs produits design actuellement disponibles sur le marché. Tous les articles recensés sont accompagnés d'un descriptif précis. Afin de faciliter vos démarches, nous avons indiqué les adresses internet des fabricants. Ce travail colossal offre une palette exhaustive de produits indispensables à votre bien-être : des couteaux japonais aux des ustensiles de cuisine finlandais, sans oublier les luminaires italiens et les théières anglaises.

Comme l'a démontré Michael Landy lors du *Break Down* qu'il a organisé à Londres en 2001, nous nous laissons submerger par une quantité d'objets dont nous sommes vite lassés. Pourquoi accumuler des tonnes de gadgets inutiles, des objets kitsch, ou encore de pâles imitations d'un design souvent inaccessible ? En règle générale, toutes ces acquisitions se détériorent avec le temps, se transformant en un véritable bric-à-brac qui envahit notre intérieur. Nous devrions peut-être suivre la doctrine de William Morris : « N'ayez rien dans votre maison que vous ne sachiez utile ou que vous ne jugiez beau. » Au lieu de nous rassurer avec des tas d'objets, ne serait-il pas plus judicieux d'en acheter moins mais de meilleure qualité, privilégiant ainsi des produits design, fonctionnels et d'une esthétique plus raffinée.

L'architecte milanais Ernesto Rogers avance une thèse audacieuse : « Saisissez une cuillère et vous comprendrez qui l'a créée et comment on construit une ville. » Le design contemporain reste une des clés de

prendrez qui l'a créée et comment on construit une ville. » Le design contemporain reste une des clés de voûte de notre univers quotidien où compte seulement la distinction entre l'utile et l'inutile. Les magasins regorgent d'appareils ménagers, mais peu s'adaptent réellement à nos besoins actuels. En effet, à une époque où la planète et sa survie se trouvent au centre des préoccupations de l'humanité, la qualité prend le pas sur la quantité. Le temps où il fallait absolument remplir sa maison avec tout et n'importe quoi est révolu. Les consommateurs du 21ᵉ siècle s'impliquent dans l'environnement et choisissent des produits qui sont à la fois fonctionnels, durables et dont l'esthétique demeure intemporelle, favorisant par là même des objets agréables à regarder et à manipuler et qui sont également des outils essentiels dans nos tâches quotidiennes.

L'une des principales raisons de notre obsession à accumuler des objets est souvent liée à la notion de cadeau. Cet ouvrage propose donc aux consommateurs des cadeaux « utiles ». Un article ménager qui fonctionne parfaitement et dont l'esthétique est originale rend son destinataire bien plus heureux que tous ces objets obsolètes que l'on offre sans vraiment réfléchir à leur utilité. Nous espérons également que ce livre deviendra indispensable pour tous ceux qui souhaitent décorer et équiper leur nouvelle demeure en leur fournissant des choix opportuns. Le design est certes plus cher à l'achat mais s'avère très économique, lorsqu'on le rapporte à son espérance de vie. Cet ouvrage satisfera aussi les personnes dont l'ambition est d'acquérir ce qu'il y a de mieux sur le marché, sans que ce soit hors de prix.

Dans les pays scandinaves, le design incarne « l'art utilitaire », source de confort sans être nécessairement un symbole social. Nous souhaitons réellement que cet ouvrage dédié au design ménager comblera vos attentes et améliorera votre vie quotidienne grâce à ces beaux objets qui sont « des outils pour la vie ».

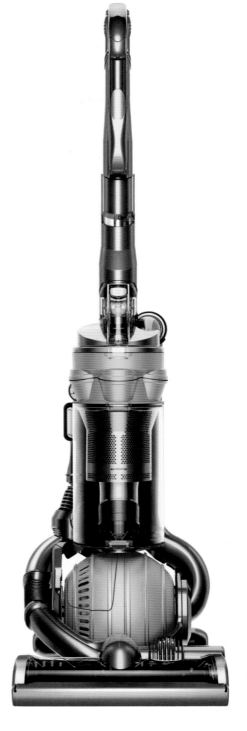

James Dyson, *DC25 All Floor* vacuum cleaner for Dyson, 2005

Kitchenware
Kochkultur
Ustensiles de cuisine

The Japanese company Kyocera develops high-tech ceramics with a wide range of applications: from solar panels and semi-conductors to hip replacements and cutting tools, including various kitchen knives. They also manufacture the rustproof *CP-10N* peeler, which comes in a variety of colours. Its advanced ceramic blade cuts smoothly and evenly, while holding its edge ten times longer than traditional metal peelers.

Der japanische Hersteller Kyocera entwickelt Hightech-Keramik mit vielfältigen Anwendungsmöglichkeiten: von Solarzellen über Halbleiter und künstliche Hüftgelenke bis hin zu Schneidwerkzeugen wie dem rostfreien, in verschiedenen Farben erhältlichen Sparschäler *CP-10N*. Seine Hochleistungskeramikklinge schneidet mühelos und glatt und bleibt dabei zehn Mal länger scharf als traditionelle Metallklingen.

La société japonaise Kyocera développe la céramique de haute technologie à travers nombre d'applications : des panneaux solaires et semi-conducteurs aux prothèses de la hanche et ustensiles tranchants, incluant divers couteaux de cuisine. L'économe *CP-10N* inoxydable existe en plusieurs couleurs. Sa lame en céramique reste affûtée dix fois plus longtemps que celle des éplucheurs classiques et offre une coupe parfaite et sans effort.

CP-10N peeler, 2002
Kyocera Design Team

www.kyocera.com
High-tech ceramic
Zirkoniakeramik
Céramique de haute technologie
Kyocera, Kyoto, Japan

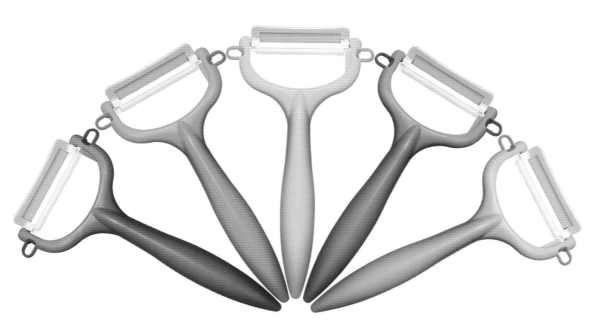

Rex Model 11002 peeler, 1947

Alfred Neweczeral (Switzerland, 1899–1958)

www.zena.ch
Aluminium, stainless-steel
Aluminium, Edelstahl
Aluminium, acier inoxydable
↔ 10.9 cm
Zena, Affoltern, Switzerland

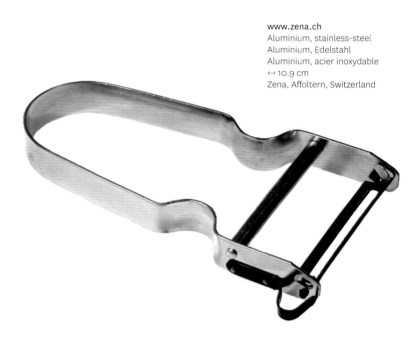

Acknowledged as a design classic in Switzerland, the *Rex* potato peeler has even been featured in a series of postage stamps celebrating iconic Swiss designs. Very affordable yet highly effective, this award-winning, easy-to-clean design is robust and stable, with two indentations that ensure a firm grip. It has the added benefit of being suitable for both right-handed and left-handed users.

Der preisgünstige, aber hocheffiziente Kartoffelschäler *Rex* gilt in der Schweiz als Kultobjekt und wurde sogar in eine Briefmarkenserie mit Schweizer Design-klassikern aufgenommen. Der preis-gekrönte, leicht zu reinigende Schäler ist robust und stabil, und seine beiden seitlichen Einbuchtungen garantieren festen Halt. Darüber hinaus ist er für Rechts- und Linkshänder gleichermaßen geeignet.

Très populaire en Suisse, l'économe *Rex* a illustré une série de timbres poste célébrant les icônes du design suisse. Récompensé par un prix, cet ustensile reste à la portée de tous et offre de nombreuses qualités : efficace, robuste et facile à nettoyer. De plus, les deux échancrures situées sur les côtés per-mettent de le tenir fermement. Droitiers et gauchers l'utiliseront sans effort.

This ingenious, dishwasher-safe design has a non-slip base, which means that it can be pushed downwards onto a countertop if greater leverage is required. It can also, of course, be held in the hand when pressing garlic cloves. The garlic is squeezed through the hopper into a spoon-like collector built into the base, which can then be easily removed to transfer the freshly pressed garlic into a bowl or pan.

Diese raffinierte, spülmaschinenfeste Knoblauchpresse besitzt einen rutschfesten Fuß und kann daher auch auf der Arbeitsplatte betätigt werden, falls größerer Druck beim Pressen nötig ist. Genauso kann man sie aber natürlich auch in der Hand halten. Der Knoblauch wird durch den Trichter gepresst und im direkt in den Fuß integrierten Löffel aufgefangen. Dieser lässt sich leicht entnehmen, um den Inhalt gleich in Schüsseln oder Töpfe zu geben.

Lavable au lave-vaisselle, cette ingénieuse création est recouverte d'une couche antidérapante qui permet son utilisation sur tout support et d'une seule main lorsque vous écrasez la gousse. L'ail broyé tombe alors dans une cuillère amovible qui permet de transvaser son contenu dans un bol ou une poêle. Ce presse-ail est muni d'autre part d'un réservoir transparent qui permet de contrôler la quantité d'ail déjà pressée.

Countertop garlic press, 2007

Cuisipro Design Team

www.cuisipro.com
Zinc alloy, thermoplastic
Zinklegierung, Thermoplastik
Alliage de zinc, thermoplastique
Cuisipro, Markham, Ontario, Canada

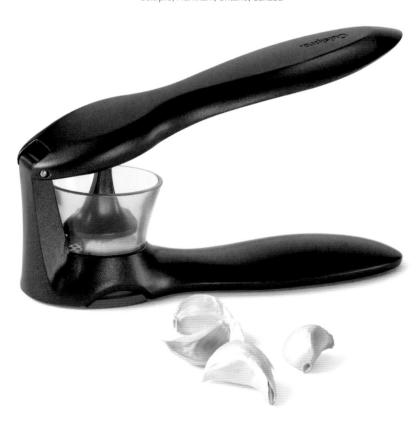

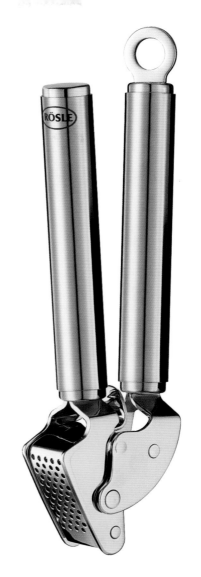

R 12782 garlic press, 2000
Rösle Design Team

www.roesle.de
Stainless steel
Edelstahl
Acier inoxydable
Rösle, Marktoberdorf, Germany

Although a touch more expensive than your average run-of-the-mill garlic press, Rösle's R 12782 garlic press is easily worth the extra cost, not least because its special levering mechanism can even process unpeeled cloves. Easy to use and easy to clean, this press is one of the company's most popular designs, and reflects the German desire for superlatively engineered and rigorously functional products.

Rösles R 12782 mag zwar etwas teurer sein als die herkömmliche Knoblauch-presse, dafür ist sie ihren Preis aber auch mehr als wert – nicht zuletzt, da ihr spezieller Hebelmechanismus sogar ungeschälte Zehen knackt. Ihre einfache Bedienung und Reinigung machen die Presse zu einem der beliebtesten Rösle-Produkte und spiegeln die deutschen Anforderungen wider, was technisch ausgereifte und strikt funktionale Produkte betrifft.

Même si le prix de ce presse-ail est sensiblement plus élevé que d'autres, il se justifie par son mécanisme à levier, permettant de presser des gousses d'ail non pelées. Facile à utiliser et à nettoyer, le modèle R 12782 est l'une des créations les plus connues de cette société, reflétant l'ambition allemande qui consiste à concevoir des produits fonctionnels et de grande qualité.

Good Grips Pro Y peeler & Good Grips Snap-Lock can opener, 1990 & 2003

Smart Design (USA, est. 1978)

www.oxo.com
Stainless steel, zinc, Santoprene/Santoprene, nylon, ABS, polypropylene, stainless steel
Edelstahl, Zink, Santopren/Santopren, Nylon, ABS, Polypropylen, Edelstahl
Acier inoxydable, zinc, Santoprene/Santoprene, nylon, ABS, polypropylène, acier inoxydable
OXO International, New York (NY), USA

Every kitchen needs a well-designed can opener and vegetable peeler. They are essential tools for cooking, yet all too often one finds examples that are difficult, if not downright uncomfortable to use. The concept of 'good design' rests on the idea of fitness for purpose, and Smart Design's ergonomic approach to problem solving is certainly in harmony with this outlook. This results in the creation of better tools, such as these soft-gripped yet sturdy designs.

Ein guter Dosenöffner und Gemüseschäler gehören in jede Küche. Obwohl sie Grundbestandteile jeder Kochausrüstung sind, findet man viel zu oft Exemplare, die schwer, wenn nicht gar schlecht zu handhaben sind. Das Konzept „guten Designs" lebt von der Funktionalität der Entwürfe, und Smart Designs ergonomischer Ansatz ist sicherlich ein Weg, diese Zielsetzung zu verwirklichen. Das Resultat sind bessere Küchenwerkzeuge, wie diese beiden flexiblen und doch stabilen Stücke.

L'ouvre-boîte et l'économe sont indispensables dans une cuisine. Malheureusement, la plupart sont encore trop difficiles à manipuler, et pour certains tout à fait inconfortables. L'approche ergonomique de Smart Design est en totale harmonie avec l'idée, pourtant simple, selon laquelle l'objet doit être avant tout adapté au besoin. En suivant ce précepte, les produits créés sont de meilleure facture, à l'instar de ces deux ustensiles, à la fois résistants et ergonomiques.

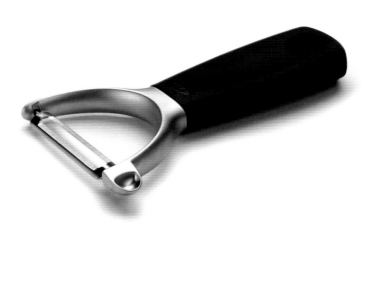

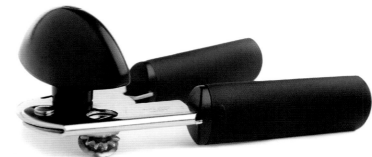

Good Grips Pro Swivel peeler & Good Grips Pro jar opener, 2003

Smart Design (USA, est. 1978)

www.oxo.com
Stainless steel, Santoprene, polypropylene, die-cast zinc/stainless steel,
Santoprene, polypropylene, ABS, TPE
Edelstahl, Santopren Polypropylen, Gusszink/Edelstahl, Santopren,
Polypropylen, ABS, TPE
Acier inoxydable, Santoprene, polypropylène, zinc moulé sous pression/
acier inoxydable, Santoprene, polypropylène, ABS, TPE
oxo International, New York (NY), USA

Smart Design works from a holistic standpoint in order to create responsible designs that humanize technology and foster an emotional connection with their users. Through the success of their numerous kitchenware designs for oxo, this New York-based office has tirelessly promoted the idea of 'inclusive design', such as this user-friendly jar opener and soft-grip peeler.

Smart Design vertritt einen ganzheitlichen, verantwortungsvollen Standpunkt und entwirft Produkte, die Technik menschlicher gestalten und eine emotionale Verbindung zu ihren Benutzern schaffen sollen. Mit ihren zahlreichen erfolgreichen Küchenwerkzeugen für oxo, wie zum Beispiel dem benutzerfreundlichen Schraubdeckelöffner und dem Softgrip-Pendelschäler, hat die New Yorker Agentur immer wieder ihr Prinzip des „integrativen Designs" unterstrichen.

Smart Design travaille à partir d'un point de vue holistique afin de concevoir des créations humanisant la technologie et favorisant un lien affectif avec leurs utilisateurs. Fort du succès de leurs nombreuses créations d'ustensiles de cuisine pour oxo, ce bureau new-yorkais a inlassablement défendu l'idée du « design inclusif » notamment avec cet ouvre-bocal et cet économe éplucheur.

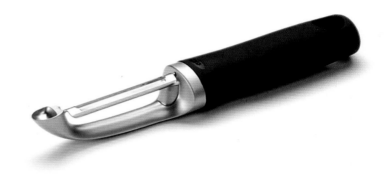

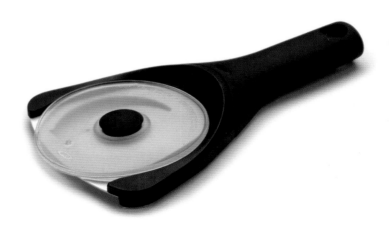

Winning a prestigious Red Dot award in 2007, the *Bistro* herb chopper is a compact design that performs excellently. It allows you to chop herbs like a professional but – thanks to its seven stainless-steel, double-edged, rotary blades – with minimal effort. In addition, the flower-shaped cap enhances the grip, while the transparent base means that the progress of your herbs can be monitored mid-chop.

Der im Jahr 2007 mit dem renommierten Red Dot Award ausgezeichnete *Bistro*-Kräuterschneider überzeugt durch kompaktes Design und hervorragende Leistung. Hacken Sie Ihre Kräuter wie ein Profi, und zwar – dank sieben rotierender beidseitig geschliffener Edelstahlklingen – mit minimalem Aufwand. Der blütenförmige Deckel liegt sicher in der Hand, und mit dem transparenten Behälter haben Sie genau im Blick, wann Ihre Kräuter fein genug gehackt sind.

Grand gagnant du prestigieux Red Dot Award en 2007, le hachoir *Bistro* offre un design ergonomique qui tranche à la perfection. Il émince toutes les herbes grâce à sept lames en inox rotatives particulièrement tranchantes. Son couvercle antidérapant en forme de fleur offre une excellente prise en main et son bol transparent permet de voir si les herbes sont hachées comme il faut.

Bistro herb chopper, 2007

Bodum Design Group

www.bodum.com
Acrylic, non-slip rubber, stainless steel
Acryl, rutschfestes Gummi, Edelstahl
Acrylique, caoutchouc antidérapant, acier inoxydable
Bodum, Triengen, Switzerland

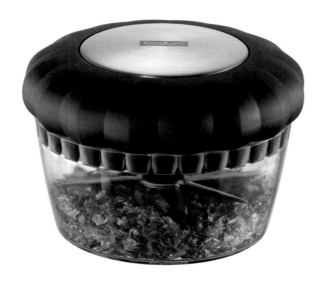

Parmenide cheese grater, 1994

Alejandro Ruiz (Argentina, 1954–)

www.alessi.com
PMMA, stainless steel
PMMA, Edelstahl
PMMA, acier inoxydable
Alessi, Crusinallo, Italy

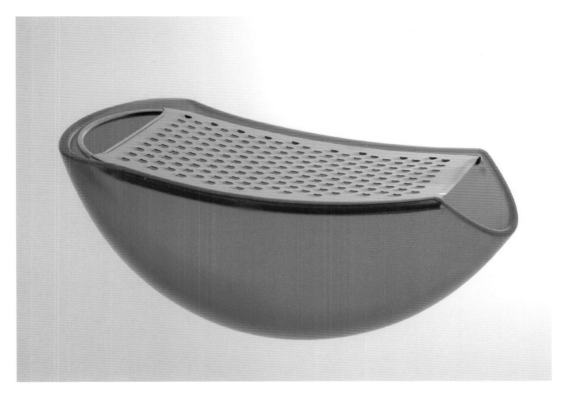

This cheese grater, like so many designs produced by Alessi, is not only aesthetically pleasing but also works exceptionally well. A translucent plastic compartment, that looks like a turtle's back, catches the grated Parmesan cheese as it falls, so that it can be sprinkled directly onto your food or stored for later use. In addition, the stainless-steel grating section can be effortlessly removed for easy cleaning. A stylish design, the *Parmenide* offers a no-mess solution at an affordable price.

Wie so viele Alessi-Produkte ist auch diese Käsereibe nicht nur äußerlich ansprechend, sondern auch überaus zweckmäßig gestaltet. Eine bunte Plastikdose fängt den geriebenen Parmesan direkt auf, sodass man ihn entweder gleich auf die Speisen streuen oder für später aufbewahren kann. Danach lässt sich die Edelstahlreibefläche mühelos entfernen und reinigen. So bietet *Parmenide* eine saubere Lösung und stilvolles Design zum erschwinglichen Preis.

À l'instar de nombreux produits conçus pour Alessi, cette râpe à fromage allie l'esthétique à l'aspect fonctionnel. Un récipient en plastique translucide, semblable à la carapace d'une tortue, récupère et stocke le parmesan râpé. Ainsi vous n'aurez qu'à le verser sur votre plat ou bien le conserver jusqu'à utilisation. La râpe en acier inoxydable est amovible et facile à nettoyer. Cette râpe *Parmenide* est une superbe création, à un prix très raisonnable.

In 1990, Richard and Jeff Grace invented a new tool, the Microplane rasp, with chemically photo-etched, razor-like edges. Three years later, a Canadian homemaker, Lorraine Lee, was baking and used her husband's new rasp to grate an orange. To her amazement, 'lacy shards of zest fell from its surface like snowflakes'. Using the same technology, and achieving the same excellent results, the *Microplane Gourmet* series has six options, from fine through to extra-coarse grating and shaving.

1990 entwickelten Richard und Jeff Grace eine neue Holzraspel mit chemisch fotogeätzten, rasiermesserscharfen Klingen. Drei Jahre später war Lorraine Lee, eine kanadische Hausfrau, gerade beim Backen und benutzte die neue Raspel ihres Mannes, um eine Orange abzureiben. Zu ihrer großen Überraschung fiel die Schale „ganz leicht und locker von der Oberfläche wie Schneeflocken vom Himmel". Die Serie *Microplane Gourmet* mit ihren sechs Stufen von fein bis extragrob nutzt dieselbe Technik und erzielt ebenso hervorragende Ergebnisse.

En 1990, Richard et Jeff Grace créèrent la râpe Microplane par un procédé chimique d'affûtage de ses micro-lames en véritables rasoirs. Trois ans plus tard, Lorraine Lee, une canadienne utilisa la râpe à bois de son mari pour râper une orange. Elle fut émerveillée par les éclats de zeste qui tombaient tel des flocons. Utilisant la même technologie et obtenant d'excellents résultats, la série *Microplane Gourmet* offre six options de râpe : du plus petit grain au plus gros.

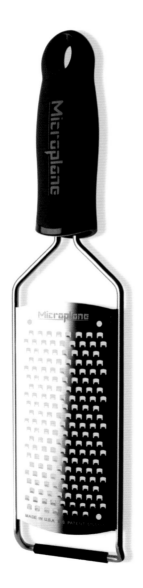

Gourmet 45000 Series graters, 2008
Microplane International Design Team

www.microplaneintl.com
Chemically photo-etched stainless steel, thermoplastic
Chemisch fotogeätzter Edelstahl, Thermoplastik
Procédé chimique d'affûtage, inox, thermoplastique
Microplane International, Russellville (AR), USA

Cuisipro manufactures a range of four flat graters with different gauges depending on the kind of food you need to process. The fine version is perfect for citrus zest or for grating Parmesan cheese, while the ultra-coarse grater can handle softer cheeses such as cheddar or even mozzarella. These razor-sharp graters have larger-than-average grating surfaces, and also boast non-slip feet to provide stability when they are used angled against a countertop.

Cuisipro stellt eine Serie mit vier flachen Reiben her, die in der Stärke auf verschiedene Lebensmittel abgestimmt sind. Die Feinreibe eignet sich perfekt für Zitrusfruchtschalen oder Parmesan, während die ultragrobe Reibe auch mit weichem Käse wie Cheddar oder sogar Mozzarella zurechtkommt. Die extrem scharfen Reiben haben eine größere Fläche als üblich und verfügen außerdem über rutschfeste Füße, sodass man sie beim Benutzen auf die Arbeitsplatte stützen kann.

Cuisipro fabrique une gamme de quatre râpes plates avec des grains adaptés à l'aliment que vous souhaitez râper. Les plus fins sont parfaits pour les agrumes et le parmesan, et les plus gros grains s'utilisent pour les fromages à pâte molle, cheddar ou mozzarella. Cette râpe aux lames tranchantes a des grilles plus larges que d'ordinaire, une poignée ergonomique et des pieds antidérapants qui la maintiennent en place même lorsque celle-ci est inclinée.

Accutec flat grater, 2002

Cuisipro Design Team

www.cuisipro.com
Stainless steel, elastomer
Edelstahl, Elastomer
Acier inoxydable, élastomère
Cuisipro, Markham, Ontario, Canada

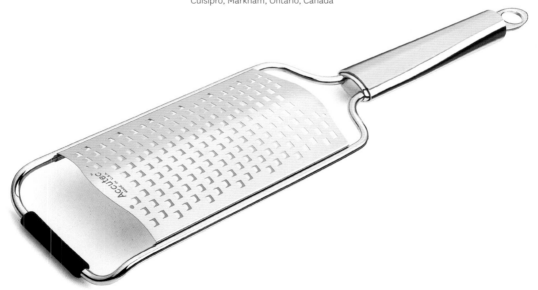

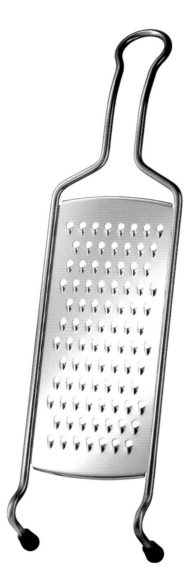

In 1888, a master tinsmith named Karl Theodor Rösle established a company in southern Germany producing roofing components. However, in 1903 the firm diversified into the production of kitchen utensils, and today, Rösle manufactures some of the finest kitchen utensils available. The grater shown here incorporates advanced laser-welding technologies first developed for the automotive industry, which allow the company to deliver higher quality in manufacturing, while also improving hygiene.

1888 gründete der Spenglermeister Karl Theodor Rösle in Süddeutschland zunächst eine Dachbaufirma, erweiterte das Geschäft jedoch 1903 um Kochgeschirr. Heute zählt Rösle zu den Herstellern der besten Küchenwerkzeuge auf dem Markt. Bei der hier gezeigten Feinreibe wurde eine moderne – zunächst für die Autoindustrie entwickelte – Laserschweißtechnologie angewandt, die eine noch hochwertigere und hygienischere Verarbeitung gewährleistet.

En 1888, un maître étameur nommé Karl Theodor Rösle créa une entreprise de composants de toiture dans le sud de l'Allemagne. En 1903 cette société se diversifia dans la production d'ustensiles de cuisine. Actuellement, Rösle produit les meilleurs articles de cuisine à l'instar de le modèle présenté ici. Cet ustensile est créé à partir de techniques avancées comme la soudure au laser développée initialement pour l'industrie automobile. Les ustensiles Rösle sont d'une qualité exceptionnelle.

95020 grater, 2000
Rösle Design Team

www.roesle.de
Stainless steel
Edelstahl
Acier inoxydable
Rösle, Marktoberdorf, Germany

Profi Tools grater, 2007

Peter Ramminger (Germany, 1962–)

www.wmf.de
Cromargan stainless steel, thermoplastic
Cromargan-Edelstahl, Thermoplastik
Acier inoxydable Cromargan, thermoplastique
WMF Württembergische Metallwarenfabrik, Geislingen, Germany

A member of WMF's in-house design team since 1999, Peter Ramminger believes design to be, 'the challenge of creating products which enhance each day by making things easier'. His four-sided grater is testament to this idea. Almost razor sharp, the design incorporates a cucumber slicer, fine and coarse vegetable graters, and also a potato grater. It comes with a handy removable plastic base, and a stable handle that ensures a safe grip.

Peter Ramminger, seit 1999 Mitglied des internen Designteams bei WMF, sieht das Entwerfen als „Herausforderung, Produkte zu gestalten, die den Alltag verschönen und erleichtern". Seine Vierkantreibe trägt diesem Prinzip Rechnung. Sie beinhaltet einen Gurkenhobel, einen feinen und einen groben Gemüsehobel und eine Kartoffelreibe – alle rasiermesserscharf. Dazu gehören ein praktischer abnehmbarer Kunststoffboden und ein stabiler Griff für sicheren Halt.

Membre de WMF depuis 1999, Peter Ramminger considère le design comme étant « un défi à concevoir des produits qui améliorent le quotidien en rendant les choses plus faciles ». Sa râpe à quatre faces illustre parfaitement son point de vue. Selon la face choisie, cette râpe tranche le concombre, les légumes plus épais ou les pommes de terre. La poignée assure une prise en main sûre, et la base amovible en plastique s'avère très pratique.

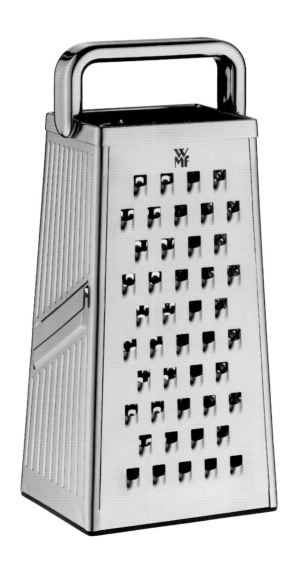

The razor-sharp *Accutec* grater has three grating surfaces – ultra-coarse, coarse and fine – which comprise double-sided, acid-etched blades that can cope with virtually any food products, from soft cheeses and vegetables to chocolate and citrus fruit. With its easy-to-grip handle, its non-slip removable base that catches the grated food, and the handy calibrated measurements displayed on one of its sides, this dishwasher-safe design provides superior performance at little extra cost.

Die extrem scharfe *Accutec*-Reibe hat drei Flächen – ultragrob, grob und fein – mit doppelseitigen, säurege-ätzten Klingen, die es mit so ziemlich jedem Lebensmittel von Weichkäse über Gemüse bis hin zu Schokolade und Zitrusfrüchten aufnehmen. Mit seinem einfach zu haltenden Griff, dem rutschfesten, abnehmbaren Fuß, der das Geriebene auffängt, und den auf der Seite angegebenen Maßeinheiten, bietet dieses spülmaschinenfeste Objekt überragende Leistung zu einem vernünftigen Preis.

La râpe *Accutec* comporte trois grilles : très gros grain, gros grain et grains fins. Ces grilles, équipées de lames tran-chantes, râpent n'importe quel aliment : agrumes, fromages à pâte molle, légumes et chocolat. Sa poignée arrondie en fait un objet facile et agréable à utiliser. De plus sa base amovible antidérapante, qui supporte le lave-vaisselle, permet de récupérer l'aliment râpé. Un ustensile de cuisine de qualité professionnelle à un prix raisonnable.

Accutec three-sided box grater, 2002

Cuisipro Design Team

www.cuisipro.com
Stainless steel, elastomer
Edelstahl, Elastomer
Acier inoxydable, élastomère
Cuisipro, Markham, Ontario, Canada

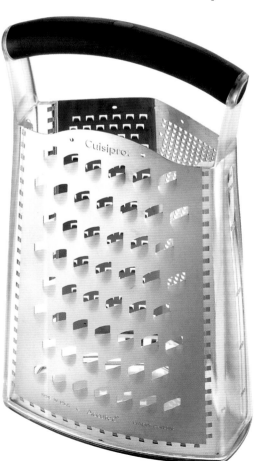

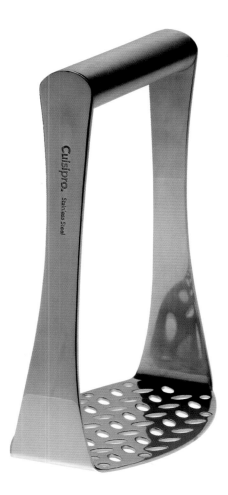

Potato masher, 2000

Cuisipro Design Team

www.cuisipro.com
Stainless steel
Edelstahl
Acier inoxydable
Cuisipro, Markham, Ontario, Canada

The large handle of this heavy-duty, dishwasher-safe, stainless-steel potato masher provides an excellent grip, and ensures efficient mashing. The handle's high position also keeps the hand safely away from the steaming boiled potatoes, while the holes are designed and positioned to give a lump-free result. Cuisipro also produces a similar design in a lightweight but strong reinforced thermoplastic.

Der große Griff dieses spülmaschinenfesten Hochleistungskartoffelstampfers aus Edelstahl garantiert festen Halt und müheloses Stampfen und sitzt außerdem so hoch, dass die Hände nicht mit den dampfend heißen Kartoffeln in Berührung kommen. Position und Größe der Löcher garantieren ein klumpenfreies Ergebnis. Cuisipro bietet dasselbe Design auch als leichte aber robuste Kunststoffversion an.

Ce presse-purée est équipé d'une grande poignée confortable qui assure un travail efficace. De plus, sa position élevée garde les mains à distance des pommes de terre brûlantes. Cet ustensile comporte également des trous conçus de façon à éviter les grumeaux. Il supporte le lave-vaisselle. Cuisipro a créé un autre modèle similaire, plus léger mais tout aussi solide, en thermoplastique renforcé.

Z-Gadget apple corer, 2007
RSVP International Design Team

www.rsvp-intl.com
Chrome-plated zinc alloy
Verchromte Zinklegierung
Alliage chrome-plaqué zinc
RSVP International, Seattle (WA), USA

RSVP International is a Seattle-based manufacturer of durable, high-quality kitchen items, which are stamped with a reassuring American robustness, both in their design and construction. RSVP's *Z-Gadget* apple corer is, as its name suggests, a sturdy, heavyweight design that slices apples with ease and that should survive a lifetime of use.

RSVP International hat seinen Hauptsitz in Seattle und stellt langlebige, erstklassige Küchenwerkzeuge her, die sowohl vom Design als auch von der Verarbeitung her eine angenehme amerikanische Robustheit aufweisen. Der *Z-Gadget* Apfelentkerner ist ein stabiles Schwergewicht, das Äpfel mühelos achtelt und entkernt und auf lebenslangen Gebrauch angelegt ist.

Basé à Seattle, RSVP International fabrique des articles de cuisine résistants, de très grande qualité, illustrant la robustesse des créations américaines, dans leur design comme dans leur conception. Le coupe pomme *Z-Gadget* est un ustensile résistant et lourd qui coupe les pommes sans effort, et ce durant très longtemps.

The downward pressure exerted on a pizza cutter can be quite significant, so it is a good idea to find a design that is really sturdy. All-Clad prides itself on the fact that its *All Professional* range of products are built to last, and certainly this stainless-steel pizza cutter offers excellent performance thanks to its superior strength, while also being comfortable to handle.

Auf Pizzaschneider wird beim Verwenden oft starker Druck ausgeübt, daher ist es sinnvoll, sie so stabil wie möglich zu konzipieren. All-Clad rühmt sich, mit der Serie *All Professional* besonders widerstandsfähige Produkte geschaffen zu haben. Durch seine hohe Stabilität erfüllt dieser Pizzaschneider aus Edelstahl seinen Zweck hervorragend und ist zugleich angenehm in der Handhabung.

La pression exercée vers le bas sur une roulette à pizza peut être assez forte. Il paraît donc judicieux de créer un design vraiment résistant. À ce titre, All Clad souligne volontiers le caractère durable de ses produits professionnels. Ce coupe-pizza en acier inoxydable illustre parfaitement cet objectif grâce à son indéniable résistance associée à une aisance d'emploi déconcertante.

All Professional large pizza cutter, c. 2000
All-Clad Metalcrafters Design Team

www.all-clad.com
Stainless steel
Edelstahl
Acier inoxydable
All-Clad Metalcrafters, Canonsburg (PA), USA

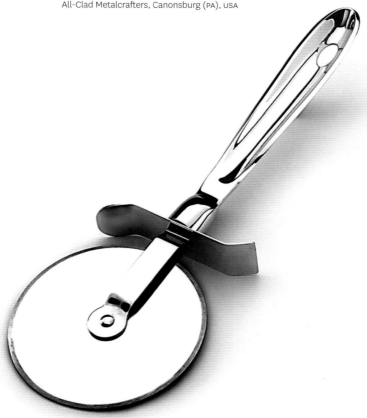

O-Series scissors, 1963–1967 (original design)

Olof Bäckström (Norway, 1922–)

www.fiskars.com
Stainless steel, ABS
Edelstahl, ABS
Acier inoxydable, ABS
Fiskars, Fiskars, Finland

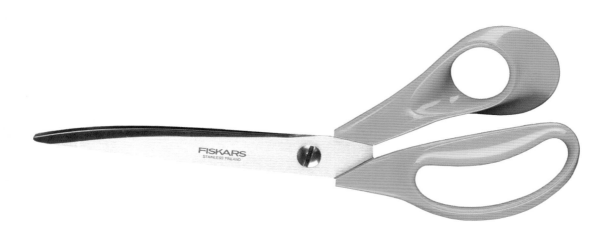

In 1967, Fiskars launched its famous orange-handled scissors. They had been developed by a Norwegian engineer, Olof Bäckström, who had painstakingly carved prototypes of the handles from solid wood to ensure they were as ergonomically resolved as possible. With their ABS handles, the subsequent production models fit beautifully in the hand, and are also available in left-handed versions. Dishwasher-proof and highly durable, these iconic scissors will last a lifetime and are a joy to use on each and every occasion.

1967 brachte Fiskars seine berühmte Schere mit den orangefarbenen Griffen auf den Markt. Ihr Erfinder Olof Bäckström, ein norwegischer Ingenieur, hatte die Griffprototypen immer wieder in mühevoller Kleinarbeit aus Hartholz geschnitzt, bis er sicher war, sie so ergonomisch wie möglich geformt zu haben. Mit ihren ABS-Griffen liegt die Schere nun wunderbar in der Hand und ist auch als Linkshändermodell erhältlich, zudem ist sie spülmaschinenfest und äußerst widerstandsfähig. Ein Kultobjekt, das ein Leben lang hält und bei jeder Benutzung Freude bereitet.

En 1967, Fiskars a lancé ses célèbres ciseaux de cuisine orange. Ils ont été conçus par un ingénieur norvégien, Olof Bäckström, qui a lui-même sculpté minutieusement les prototypes des anneaux en bois massif afin de s'assurer qu'ils étaient aussi ergonomiques que possible. Ses anneaux moulés ABS s'adaptent parfaitement à la main. Ce modèle ingénieux, lavable au lave-vaisselle et ultra robuste, existe également pour les gauchers. Un vrai plaisir à utiliser, et garanti à vie.

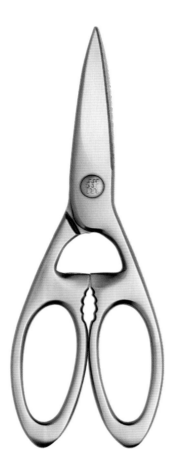

Twin Select kitchen shears, 2003–2004

Zwilling JA Henckels Design Team

www.zwilling.com
Stainless steel
Edelstahl
Acier inoxydable
Zwilling JA Henckels, Solingen, Germany

Founded in Solingen in 1731, Henckels is now renowned worldwide for its superlative knives and scissors, which epitomize the high-quality craftsmanship and design that have come to characterize the label 'Made in Germany'. The company's *Twin Select* series was first introduced in 2001, and includes these useful multipurpose kitchen shears. Their micro-serrated blades can be used to cut virtually anything, from cardboard and string to flowers and silk.

Das Unternehmen Henckels wurde 1731 in Solingen gegründet und ist heute berühmt für seine erstklassigen Messer und Scheren – den Inbegriff hochwertigen Handwerks und Designs ‚Made in Germany'. Die Serie *Twin Select*, zu der auch diese vielseitige Küchenschere gehört, kam 2001 auf den Markt. Ihre Scherenblätter mit der Mikroverzahnung schneiden alles, von Pappe über Bindfaden bis hin zu Blumen und Seide.

Fondé à Solingen en 1731, Henckels est connu dans le monde entier pour ses couteaux et ses ciseaux ménagers, incarnant un savoir-faire de grande qualité, et justifiant aisément le label « Fabriqué en Allemagne ». La gamme *Twin Select* présentée pour la première fois en 2001, inclut ces ciseaux de cuisine multi-usage. Leurs lames à microdenture peuvent théoriquement tout couper, de la soie au carton épais, des fleurs à la ficelle.

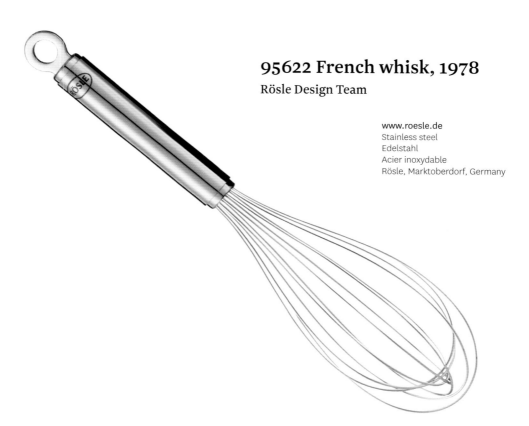

95622 French whisk, 1978

Rösle Design Team

www.roesle.de
Stainless steel
Edelstahl
Acier inoxydable
Rösle, Marktoberdorf, Germany

Rösle makes every imaginable kind of kitchen implement, including nineteen different types of whisk – some are designed to beat eggs, some are balloon whisks for aerating and mixing batters, and others are specifically designed to be used in conjunction with a jug rather than a bowl. Their 'French' whisk, shown here, is not only perfectly balanced and easy to use, but is a beautiful object in its own right, thanks to Rösle's form-follows-function approach to design.

Rösle stellt jede nur erdenkliche Art von Küchengeräten her. Allein neunzehn unterschiedliche Arten Rührbesen gehören zum Sortiment – z.B. Tellerbesen zum Verquirlen von Eiern, Ballonbesen für luftige Cremes und Becherbesen für besonders schmale Gefäße. Dieser Rührbesen ist nicht nur perfekt ausbalanciert und einfach zu benutzen, sondern auch ein wunderschönes Objekt an sich, das Rösles Designanspruch „Form folgt Funktion" vollends gerecht wird.

Rösle fabrique tout ce que l'on peut imaginer en matière d'ustensiles de cuisine. Leur catalogue ne compte pas moins de dix-neuf modèles de fouets : pour battre les œufs ou aérer et mélanger tout type de pâte. Certains ont même été spécialement conçus pour les verres gradués, plus étroits que les saladiers. Ce fouet à pâte est un ustensile facile à manipuler et un objet à part entière répondant ainsi à la devise de Rösle pour qui la fonction détermine la forme.

This restaurant-quality egg slicer has separately mounted, tensioned, stainless-steel wires, and can be used to produce round or oval egg slices. Like so many household products manufactured in Germany, the *1000 Rondy* is a no-nonsense practical design, and is extremely well made. Highly durable and functionally successful, it should also considerably outlast similar products thanks to its superior build quality.

Mit den separat befestigten, straff gespannten Edelstahldrähten dieses Eierteilers in Restaurant-Qualität lassen sich sowohl runde als auch ovale Eierscheiben schneiden. Wie viele in Deutschland hergestellte Haushaltsprodukte ist der *1000 Rondy* ein praktisches Design ohne viel Schnickschnack und hervorragend verarbeitet. Dank seiner großen Strapazierfähigkeit und dem hohen Maß an Funktionalität ist er vielen ähnlichen Produkten überlegen und wird sie mit Sicherheit überdauern.

Ce coupe-œufs de grande qualité est composé de fils tendus en acier inoxydable, capables de couper l'œuf en tranches rondes ou ovales. À l'instar de nombreux produits ménagers fabriqués en Allemagne, le *1000 Rondy* est une création pratique et extrêmement bien conçue. D'une qualité supérieure, cet ustensile est à la fois résistant et fonctionnel.

1000 Rondy egg slicer, 1960s
Famos-Westmark Design Team

www.westmark.de
Aluminium, stainless-steel wires
Aluminium, Edelstahldrähte
Aluminium, fils en acier inoxydable
Famos-Westmark, Lennestadt, Germany

Endurance egg topper, 2000

RSVP International Design Team

www.rsvp-intl.com
Stainless steel
Edelstahl
Acier inoxydable
RSVP International, Seattle, USA

Constructed of high-quality stainless steel, the *Endurance* egg topper is a handy device for people who love boiled eggs but hate peeling eggshell. Basically, you pop the 'topper' on a boiled egg, squeeze its handles together and a ring of teeth pierces the top of the egg: hey presto, your egg is ready to eat, and free of annoying pieces of shell.

Der praktische *Endurance*-Eierköpfer aus hochwertigem Edelstahl ist genau das Richtige für alle, die gern gekochte Eier essen, es aber hassen, vorher die Schale abzupellen. Man setzt den Köpfer einfach auf ein gekochtes Ei, drückt die Griffe zusammen, sodass die Zähne im Ring die Eierschale aufschneiden und voilà, schon kann man sein Ei ohne störende Schalenstückchen genießen.

Réalisé en acier inoxydable de grande qualité, ce ciseau à œuf est idéal pour les amateurs d'œufs à la coque. Placez le ciseau autour de la partie conique de l'œuf, puis serrez les poignées simultanément et un anneau dentelé tranchera le sommet : il n'y a plus qu'à déguster votre œuf accompagné de pain beurré !

A, B, C... cutlery tray, 1996

Jasper Morrison (UK, 1959–)

www.magisdesign.com
Polypropylene
Polypropylen
Polypropylène
↔ 34.5 cm ↕ 28.5 cm
Magis, Motta di Livenza, Italy

From the *Magis Accessories Collection*, Jasper Morrison's *A, B, C...* cutlery tray epitomizes both his essentialist approach to design and the aesthetic and functional purity of his work. This design is an outgrowth of his 'super normal' philosophy, which holds that, 'the super normal object is the result of a long tradition of evolutionary advancement in the shape of everyday things, not attempting to break with the history of form but rather trying to summarize it, knowing its place in the society of things.'

Jasper Morrisons *A, B, C...* Besteckkasten aus Magis' *Accessories Collection* verkörpert sowohl seinen essentialistischen Designanspruch als auch die ästhetische wie funktionale Schlichtheit seiner Arbeit. Der Entwurf entspringt seiner Philosophie des „Supernormalen": „Das supernormale Objekt ist Ergebnis einer langen Tradition schrittweisen Fortschritts in Form alltäglicher Gegenstände; nicht der Versuch, mit der Geschichte einer Form zu brechen, sondern eher, sie zu verdichten und ihren Platz in der Gemeinschaft der Dinge zu kennen."

Le porte-couverts *A, B, C* créé par Jasper Morrison fait partie de l'*Accessories Collection* de Magis. Cet article incarne à la fois l'approche essentialiste du design et la pureté esthétique et fonctionnelle du travail de Morrison. Cette création est un corollaire de sa philosophie dite « super normal » : « L'objet Super Normal est le résultat d'une longue tradition d'avancées évolutionnistes quant à la forme des choses quotidiennes. Il s'agit de perfectionner le meilleur plutôt que de créer du neuf. »

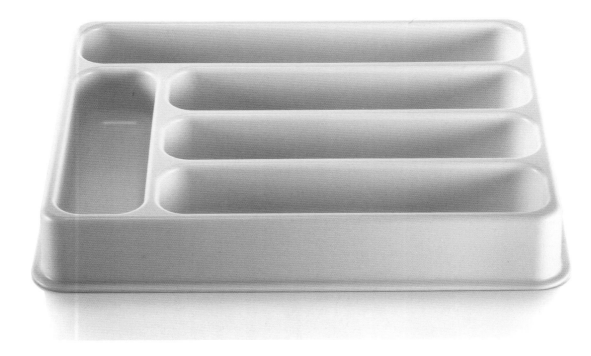

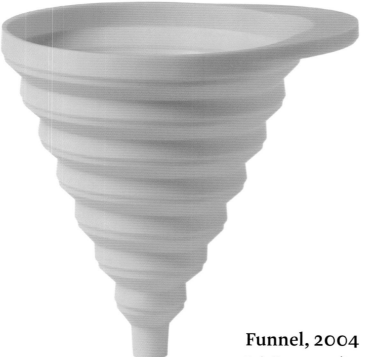

Funnel, 2004
Boje Estermann (Denmark, 1961–)

www.normann-copenhagen.com
Santoprene
Santopren
Santoprene
⌀ 12 cm
Normann Copenhagen, Copenhagen,
Denmark

This dishwasher-safe, space-saving and award-winning funnel is made from a specially developed flexible rubber. As Boje Estermann explains, 'I got inspired to design the funnel during my final assignment at the School of Design in Paris. The main idea was to develop items that didn't take up space in the kitchen. A funnel is a product that can be annoying when not in use, mainly because it takes up space and you can't stack it ... The idea for the folding funnel was originally inspired by my old camera.'

Dieser spülmaschinenfeste, platzsparende und preisgekrönte Trichter besteht aus einem speziell entwickelten flexiblen Gummi. Boje Estermann erklärt: „Die Inspiration für den Trichter kam mir während meiner Abschlussarbeit an der Paris School of Design. Die Grundidee dahinter: Werkzeuge zu entwerfen, die in der Küche keinen Platz wegnehmen. Ein Trichter kann stören, wenn er gerade nicht gebraucht wird, und zwar hauptsächlich, weil er im Weg ist und nicht gestapelt werden kann ... Auf den Trick mit dem Falten kam ich dann durch meinen alten Fotoapparat."

Cet entonnoir est fait dans un caoutchouc flexible spécial qui supporte le passage au lave-vaisselle. Boje Estermann explique : « J'ai créé cet entonnoir dans le cadre de mon dernier projet à l'École nationale supérieure de création industrielle de Paris. L'idée principale était de développer des ustensiles qui ne prennent pas de place dans la cuisine. Un entonnoir est encombrant surtout lorsqu'il n'est pas utilisé. L'idée de l'entonnoir pliable m'est d'abord venue en regardant mon vieil appareil photo. »

Measuring cup set, 2004

All-Clad Metalcrafters Design Team

www.all-clad.com
Stainless steel
Edelstahl
Acier inoxydable
All-Clad Metalcrafters, Canonsburg (PA), USA

Every cook needs a set of measuring cups, especially if they are using a North American recipe book, and the ones manufactured by All-Clad Metalcrafters are of premium quality. This five-piece set is made from high-grade $18/10$ stainless steel, and unlike most on the market this set has angled handles that make the cups easier to hold when measuring out dry or liquid ingredients. Like other cooking equipment produced by All-Clad Metalcrafters, these measuring cups are robust enough to last a lifetime.

Jeder Koch braucht ein Messbecherset, besonders wenn er mit Rezepten aus Nordamerika arbeitet, in denen die Mengenangaben becherweise erfolgen. Die Messbecher von All-Clad Metalcrafters sind von hervorragender Qualität. Das fünfteilige Set ist aus hochwertigem $18/10$ Edelstahl gefertigt und die einzelnen Becher haben, anders als die meisten herkömmlichen Messbecher, abgewinkelte Griffe, durch die man sie beim Abmessen von trockenen oder flüssigen Zutaten besser halten kann. Wie auch andere Produkte von All-Clad sind diese Messbecher so stabil, dass sie ein Leben lang halten.

Chaque cuisinier a besoin d'un jeu de casseroles. Celles conçues par les artisans All-Clad sont considérées parmi les meilleures. Ce jeu de cinq pièces en acier inoxydable $18/10$ est d'excellente qualité, et, contrairement à ce que l'on trouve sur le marché, ces casseroles ont des poignées relevées faciles à tenir lorsque l'on dose les ingrédients secs ou liquides. À l'instar d'autres équipements de cuisine réalisés par les artisans All-Clad, ces casseroles sont robustes et garanties à vie.

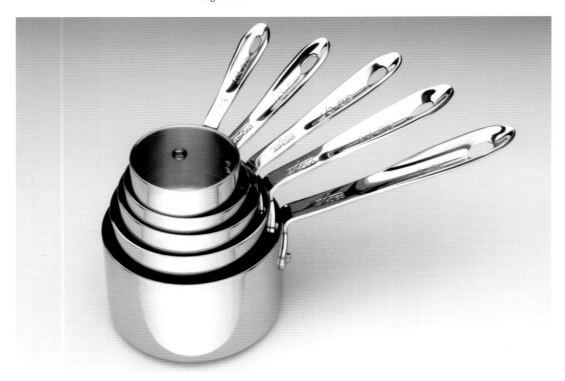

Tape Timer kitchen timer, 2004

Jozeph Forakis (USA, 1962–)

www.kikkerland.com
Aluminium, polycarbonate, ABS
Aluminium, Polykarbonat, ABS
Aluminium, polycarbonate, ABS
↕ 10.2 cm
Kikkerland Design, New York (NY), USA

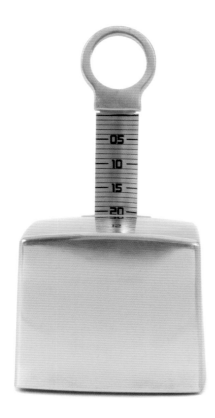

Inspired by a carpenter's measuring tape, this ticking kitchen timer is operated using a pull-ring to extend the tape to the required length of time. *Tape Timer* was based on the years of research Jozeph Forakis has devoted on 'interaction design', and the idea of user experience. According to Forakis, this approach aims to develop a new 'aesthetics of behaviour', which offers a fresh take on products we often take for granted.

Vorbild für diesen tickenden Küchenwecker war das Maßband eines Zimmermanns. Um den Wecker zu stellen, zieht man das Band mithilfe des Rings am oberen Ende bis zur gewünschten Zeit heraus. Der *Tape Timer* basiert auf funktionalen Überlegungen und entstand während der Jahre, in denen Jozeph Forakis „interaktives Design" erforscht hat. Forakis wollte eine neue „Ästhetik des Verhaltens" schaffen, die scheinbar selbstverständliche Produkte aus einer anderen Perspektive betrachtet.

Inspiré par le mètre à ruban d'un charpentier, ce minuteur de cuisine au design innovant fonctionne en tirant sur la toise puis en ajustant la durée souhaitée à l'aide de la molette située sous l'appareil. Ce minuteur est le résultat d'années de recherche que Jozeph Forakis a consacré au « design d'interaction » appuyé par l'expérience des utilisateurs. Selon lui, cette approche vise à développer une nouvelle « esthétique du comportement », envisageant sous une autre lumière les produits que nous tenons pour acquis.

Mini Timer, 1971

Richard Sapper (Germany, 1932–)

www.terraillon.com
ABS
ABS
ABS
↔ 2.9 cm ⌀ 6.7 cm
Terraillon, Chatou Cedex, France

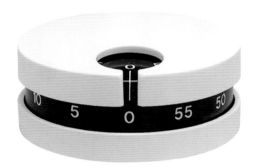

Following the astonishing sales success of Terraillon's *BA 2000* kitchen scales, Richard Sapper went on to design a complementary kitchen-timer for the French company. With its colourful plastic surfaces and bold geometric form, the diminutive yet useful *Mini Timer* possesses a pared-down aesthetic that epitomises 1970s Pop-Minimalism.

Nach dem verblüffenden Verkaufserfolg der Küchenwaage *BA 2000* von Terraillon entwarf Richard Sapper für das französische Unternehmen einen passenden Küchenwecker. Mit seinen farbigen Plastikoberflächen und der betont geometrischen Form besitzt der nützliche Miniaturwecker *Mini Timer* eine „abgespeckte" Ästhetik, die den Minimalismus des Pop in den 1970ern verkörpert.

Après le succès commercial des balances de cuisine *BA 2000* de Terraillon, Richard Sapper conçut un minuteur assorti pour cette société française. Avec ses surfaces en plastique coloré et sa forme géométrique généreuse, *Mini Timer* illustre une esthétique épurée, incarnant le design Pop minimaliste des années 70.

BA 2000 kitchen scale, 1969-1970

Marco Zanuso (Italy, 1916–2001) & Richard Sapper (Germany, 1932–)

www.terraillon.fr
PMMA, ABS
PMMA, ABS
PMMA, ABS
↕ 17 cm ↔ 13 cm ⤢ 11 cm
Terraillon, Chatou, France

Sleek and compact, the *BA 2000* kitchen scales have a bowl (suitable for measuring dry ingredients or liquids) that can be inverted to form a flat-topped lid for easy storage. When first launched in the early 1970s, this classic design became an instant bestseller in France, thanks to its unusual Pop-meets-Bauhaus aesthetic and excellent functionality – which includes an angled magnifying lens that makes the dial easy to read from a counter-top position.

In der Schale der schmalen und kompakten Küchenwaage *BA 2000* kann man feste und flüssige Zutaten abwiegen. Umgedreht dient die Schale als flacher Deckel zum Aufbewahren. Bei seiner Markteinführung in den frühen 1970er Jahren erwies sich dieses klassische Design sofort als Bestseller in Frankreich – dank seiner ungewöhnlichen Verbindung von Pop- und Bauhausästhetik und außergewöhnlicher Funktionalität, die z. B. ein abgewinkeltes Vergrößerungsglas umfasst, damit die Skala auch von der Arbeitsfläche aus gut zu lesen ist.

Célèbre design Terraillon aux formes carrées et compactes avec son bol assorti (idéal pour mesurer les ingrédients secs ou liquides), *BA 2000* arbore un style indémodable. Fonctionnelle, cette balance se range facilement une fois son bol retourné. Elle comporte un grand cadran tournant très pratique. Dès sa parution au début des années 70, *BA 2000* rencontra un succès commercial immédiat en France. Lorsque le style Pop rencontre l'esthétique Bauhaus, c'est la réussite assurée.

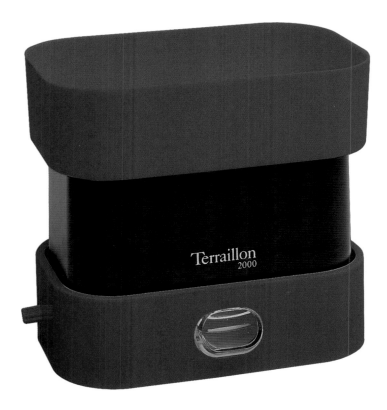

Bistro kitchen scale, 2006

Bodum Design Group

www.bodum.com
Various materials
Verschiedene Materialien
Divers matériaux
↔ 19.7 cm ↕ 17 cm
Bodum, Triengen, Switzerland

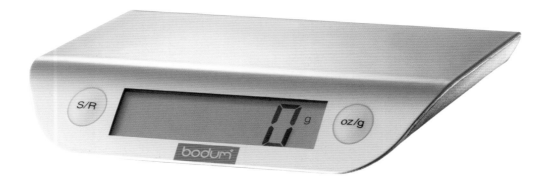

Thanks to its integrated functionality and minimalist aesthetic, this compact digital kitchen scale won a Good Design award, an iF design award and a Red Dot award in 2007. It operates using metric or imperial units of measurement, and also incorporates a tare function that means additional items can be weighed separately. Although relatively small, this wipe-clean scale will weigh amounts up to five kilogrammes, and its cover doubles up as a bowl.

Für ihre ganzheitliche Funktionalität und minimalistische Ästhetik wurde diese digitale Küchenwaage im Jahr 2007 mit einem Good Design Award, einem iF Design Award und einem Red Dot Award ausgezeichnet. Sie wiegt nach dem metrischen oder britischen System und verfügt über eine Zuwiegefunktion, mit der zusätzliche Mengen separat gewogen werden können. Trotz ihrer handlichen Größe wiegt diese leicht zu reinigende Waage Mengen von bis zu fünf Kilogramm, wobei der Deckel als Waagschale verwendet werden kann.

Fonctionnelle et minimaliste, cette balance de cuisine numérique a remporté de nombreux prix : Good Design award, un iF design award et un Red Dot award en 2007. Deux systèmes de mesure sont incorporés : métrique et impérial. Cette balance propose également la fonction tare qui permet de peser séparément chacun des ingrédients. Bien que relativement petite, elle possède un bol faisant office de récipient et pèse des quantités allant jusqu'à cinq kilos.

This ingenious kitchen scale will weigh amounts up to one kilogramme. It is dishwasher-safe and can also be used as a measuring jug. In addition, it has a tare function, which means that it can be zeroed back to weigh additional items, and it is inscribed with metric, imperial and US measuring units. Redefining the humble kitchen scale, this design received various accolades in 2002, including a Form award, an Excellence in Housewares award and a Red Dot award.

Diese geniale Küchenwaage wiegt Mengen von bis zu einem Kilogramm ab. Sie ist spülmaschinenfest und kann auch als Messbecher verwendet werden. Außerdem verfügt sie über eine Zuwiege-funktion – das heißt, man kann sie immer wieder auf Null stellen, um zusätzliche Mengen separat abzuwiegen – und über eine Skala im metrischen, britischen und amerikanischen System. Als Neuinterpre-tation der herkömmlichen Küchenwaage wurde dieses Stück im Jahr 2002 unter anderem mit dem Form Award, dem Excellence in Housewares Award und einem Red Dot Award ausgezeichnet.

Cette balance de cuisine, qui ne manque pas d'originalité, permet de peser jusqu'à un kilo d'ingrédients. Lavable en machine, elle peut également être utilisée comme verre gradué. De plus, cette balance est équipée de la fonction tare qui vous autorise à ajouter la masse d'un ingrédient, sans vider préalablement le récipient de son contenu. Les unités de mesure sont métriques, impériales et américaines. Redéfinissant la balance de cuisine classique, cette création a reçu de nombreuses récompenses en 2002, notamment un Form award, un Excellence in Housewares award et un Red Dot award.

Full Scale kitchen scale, 2002

Hendrik Holbæk (Denmark, 1960–)
& Claus Jensen (Denmark, 1966–)

www.evasolo.com
Stainless steel, glass
Edelstahl, Glas
Acier inoxydable, verre
1 kg
Eva Solo, Maaloev, Denmark

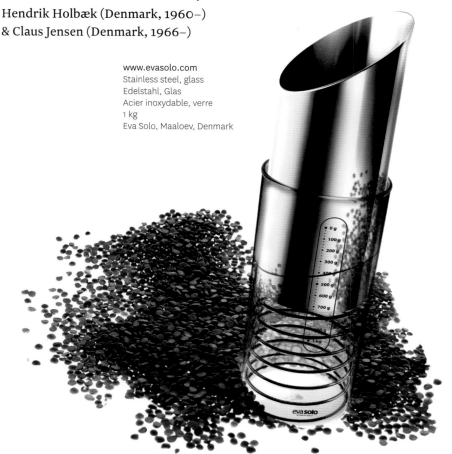

Hot Pot Gourmet measuring jug, 2002

Bodum Design Group

www.bodum.com
Borosilicate glass
Borosilikatglas
Verre borosilicate
0.5 l, 1 l
Bodum, Triengen, Switzerland

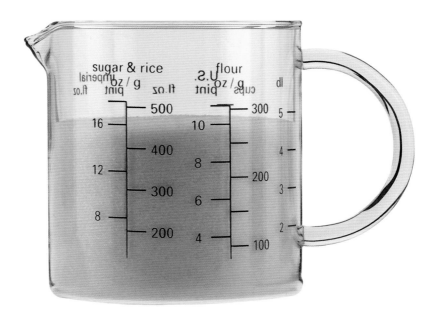

Dishwasher-proof and microwave-safe, the *Hot Pot Gourmet* measuring jug is a practical kitchen tool that epitomizes the democratic approach to design promoted by Bodum. Although originally founded in Denmark, the company relocated to Switzerland in 1980, and its in-house design unit, known as PI-Design, was formed that same year. Since then, the company has produced literally hundreds of household designs that conform to its motto: 'excellent design has to be afford-able to anyone'.

Der mikrowellen- und spülmaschinen-feste Messbecher *Hot Pot Gourmet* ist ein praktisches Küchenutensil, das die demokratische Designauffassung der Firma Bodum vorbildlich verkörpert. Das ursprünglich dänische Unterneh-men zog im Jahr 1980 in die Schweiz um und gründete im selben Jahr seine hauseigene Design-Abteilung, bekannt als PI-Design. Seither hat Bodum buch-stäblich Hunderte von Haushaltsartikeln produziert, alle nach dem Grundsatz: „Gutes Design muss nicht teuer sein."

Lavable en machine et compatible avec le four à micro-ondes, le pichet gradué *Hot Pot Gourmet* est un ustensile de cuisine pratique, incarnant l'approche démocratique du design promue par Bodum. Fondée initialement au Danemark, puis délocalisée en Suisse en 1980, Bodum a créé cette même année son propre bureau de création, PI DESIGN. Depuis, la société a conçu des centaines de produits ménagers conformément à sa devise : « un excellent design doit être accessible à tous ».

Pyrex measuring jugs, 1920s (original design)

Corning Design Team

www.pyrex.com
Pyrex®
Pyrex®
Pyrex®
0.5 l, 1.0 l
Corning, Corning (NY), USA

No kitchen should be without a *Pyrex* measuring jug – they are just so useful and versatile. Available in a range of sizes and styles, they are highly durable thanks to the thermal shock resistance and sturdy strength of their borosilicate glass. These products have the added benefit of not absorbing flavours, odours or stains, and they also come with easy-to-read metric, imperial and cup measurements. Moreover, they are oven, microware and freezer safe.

Keine Küche sollte ohne einen *Pyrex*-Messbecher auskommen müssen, da er so nützlich und vielseitig ist. Dank des hitzebeständigen und stoßfesten, robusten Borosilikatglases ist der in verschiedenen Größen und Ausführungen erhältliche Messbecher äußerst langlebig. Außerdem haben diese Produkte den Vorteil, dass sie keine Gerüche annehmen und Schmutz abweisend sind, und sie bieten eine einfach abzulesende Messskala in Litern, Pints und Cups. Sie sind geeignet für Backofen, Mikrowelle und Gefrierschrank.

Aucune cuisine ne serait complète sans un pichet gradué *Pyrex* ; si utile et polyvalent ! Disponibles dans différents styles et tailles, ils sont très robustes en raison de l'épaisseur et de la résistance aux chocs thermiques de leur verre borosilicate. Ils ont en outre l'avantage de ne pas absorber les saveurs, les odeurs ni les taches ; ils comportent des graduations faciles à lire en systèmes métrique, anglo-saxon et en nombre de tasse. Enfin, ils vont au four, au micro-ondes et au congélateur.

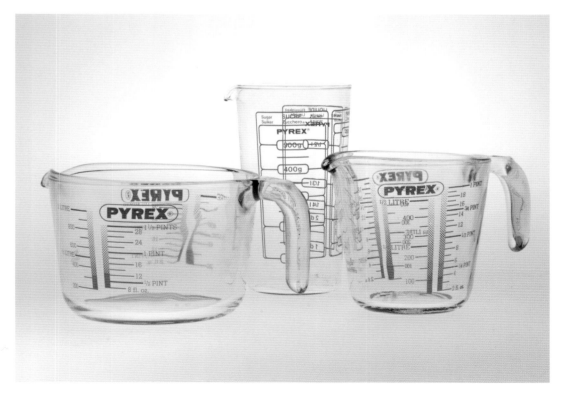

Salad spinners are often quite hard to control, even for the physically able. But imagine trying to keep one stable if you had arthritic hands – it would be a nightmare, and probably a mess too. The *Good Grips* salad spinner addresses this problem by incorporating a non-slip ring, and also a soft elastomer knob that permits a simple, one-handed operation of the spinner.

Selbst für die Geschicktesten unter uns sind Salatschleudern oftmals eine Herausforderung. Wie wäre das dann erst mit Arthritis in den Händen? – Wahrscheinlich nicht nur der reinste Albtraum, sondern wohl auch eine ziemliche Schweinerei. Die Salatschleuder *Good Grips* löst dieses Problem durch einen Ring aus rutschfestem Gummi sowie einen weichen Elastomer-Knauf, der ein einfaches, einhändiges Bedienen ermöglicht.

Les essoreuses à salade classiques sont souvent pénibles à manipuler. Le modèle *Good Grips* fonctionne avec un système unique d'essorage à piston : une simple pression sur le piston central permet d'éliminer l'eau en un instant. Ajoutons que sa base antidérapante assure un meilleur appui. Cette essoreuse est incontournable pour essorer la salade, efficacement et sans effort.

Good Grips salad spinner, 1998
OXO Design Team

www.oxo.com
Thermoplastic, Santoprene
Thermoplastik, Santopren
Thermoplastique, Santoprene
∅ 25.4 cm
OXO International, New York (NY), USA

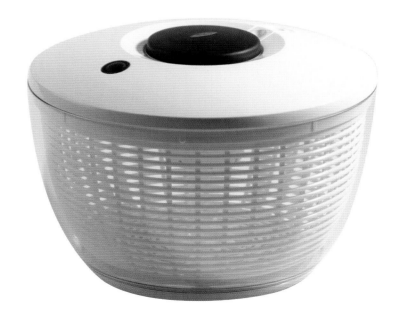

Good Grips convertible colander, 2005

Bally Design (USA, est. 1972)

www.oxo.com
Stainless steel, thermoplastic
Edelstahl, Thermoplastik
Acier inoxydable, thermoplastique
4.73 l
OXO International, New York (NY), USA

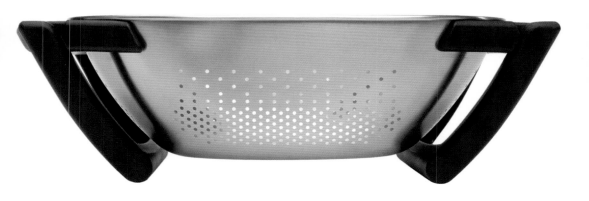

OXO produces affordable, high quality and 'inclusive' kitchenware designs. Their products are also frequently functionally innovative. This colander, for instance, has handles that allow it to be carried safely, yet those same handles can be folded down to create leg-like rests to support the colander, thereby protecting whatever surface it is placed upon – a simple and ingenious solution.

OXO stellt erschwingliche, hochwertige und „integrative" Küchenwerkzeuge her. Dazu sind die Produkte außerdem oft innovativ in der Funktion. Dieser Seiher hat zum Beispiel Griffe, an denen man ihn sicher tragen kann, die sich aber auch nach unten klappen lassen und so Stützen bilden, um ihn darauf abzustellen. So wird die Oberfläche darunter geschützt – eine einfache und doch geniale Idee.

OXO produit des ustensiles extrêmement fonctionnels et de grande qualité, à des prix raisonnables. Cette passoire illustre parfaitement ces qualités, notamment avec ses poignées rétractables servant de socle fixe et assurant un port sans risque. De plus, une fois dépliées, ces poignées s'adaptent à n'importe quel évier, vous laissant les mains libres. Une création novatrice et tout simplement ingénieuse.

Available in three sizes, this generous colander with its distinctive, beaded edge has perforations on its base and sides to ensure quick and efficient drainage. Its two sturdy handles make it easy to carry, while its large capacity is perfect for washing, draining or straining larger quantities of food. It is such a beautiful design that it seems to transcend its simple everyday function.

Dieser großzügig dimensionierte, in drei Größen erhältliche Seiher mit der charakteristischen Stürzkante ist seitlich und am Boden perforiert, um schnelles, gründliches Abseihen zu ermöglichen. Die stabilen Griffe ermöglichen einfaches Tragen und das große Fassungsvermögen ist perfekt, um auch größere Mengen Lebensmittel zu waschen, abzuseihen oder abtropfen zu lassen. Zusätzlich sieht er noch so gut aus, dass seine eigentliche Funktion fast zur Nebensache wird.

Disponible en trois tailles, cette passoire possède des perforations sur les côtés et dans le fond, assurant un égouttage rapide et efficace. De plus, ses deux poignées facilitent la prise en main, et sa large taille permet d'égoutter et de rincer de grandes quantités d'aliments. À la fois élégante et fonctionnelle, cette passoire est un si bel objet qu'elle va bien au-delà de sa simple fonction.

23120 colander, 1989
Rösle Design Team

www.roesle.de
Stainless steel
Edelstahl
Acier inoxydable
11.8 l
Rösle, Marktoberdorf, Germany

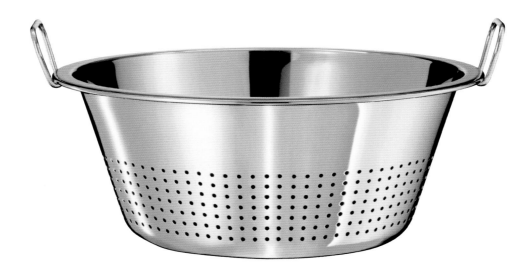

23218 conical strainer & 95190 strainer, 1980

Rösle Design Team

www.roesle.de
Stainless steel
Edelstahl
Acier inoxydable
1.5 l, 1.25 l
Rösle, Marktoberdorf, Germany

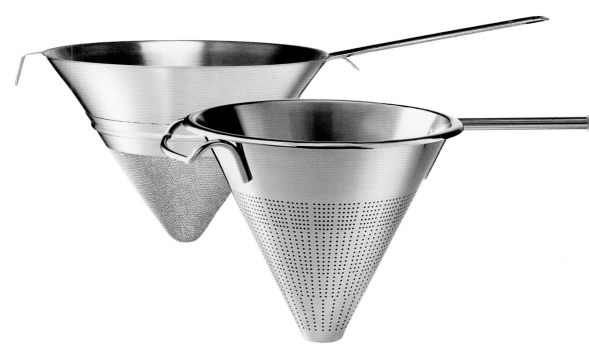

Never underestimate the simple pleasure of using a well-designed strainer that drains quickly and rinses easily. These strainers made by Rösle are exquisitely crafted, and their perfect balance makes them easy to handle. They come in a number of sizes, and have the added advantage of being completely dishwasher-proof. The mesh version is intended for straining sauces or soups, while the other is perfect for straining vegetables, rice or pasta.

Unterschätzen Sie niemals die schlichte Freude, die ein gut gemachtes Sieb bietet, mit dem sich schnell und gründlich abseihen lässt. Diese Rösle-Siebe sind exzellent verarbeitet und durch ihre ausgewogene Konstruktion angenehm zu handhaben. Sie sind in verschiedenen Größen erhältlich und zudem spülmaschinenfest. Das Spitzsieb ist für Saucen und Suppen gedacht, während das runde sich perfekt für Gemüse, Reis oder Pasta eignet.

Ne jamais sous-estimer le plaisir simple d'utiliser une passoire bien conçue, à savoir un égouttage rapide et un rinçage extrêmement facile. Confortables et simples à manipuler, ces ustensiles Rösle sont un enchantement. Ils existent dans différentes tailles et supportent le lave-vaisselle. Le chinois est idéal pour les sauces et les potages tandis que le tamis est utilisé pour les légumes, le riz ou les pâtes.

Endurance Precision Pierced colander, 2003

RSVP International Design Team

www.rsvp-intl.com
Stainless steel
Edelstahl
Acier inoxydable
2.8 l, 4.7 l
RSVP International, Seattle (WA), USA

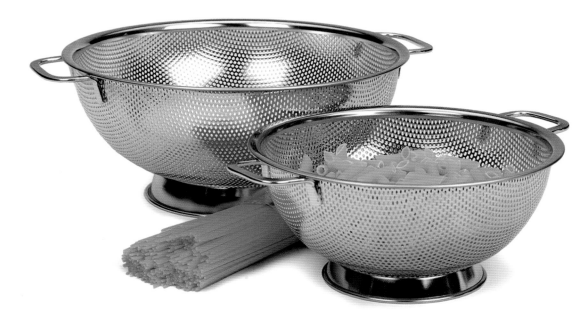

With its precision piercing, this colander drains away surplus water quickly and easily. At the same time, though, its holes are small enough to hold back particles of rice, orzo, couscous or quinoa. Sturdy but light, this easy-to-clean design was voted a favourite by *Cook's Illustrated* magazine, and has received numerous complimentary reviews from users.

Mit seinen präzise gestanzten Löchern lässt dieser Seiher überflüssiges Wasser schnell und problemlos abtropfen. Zugleich sind die Löcher klein genug, um Reis-, Couscous- oder Quinoakörner und kleine Nudeln zurückzuhalten. Dieses robuste und doch leichte, einfach zu reinigende Gerät ist einer der Favoriten der Zeitschrift *Cook's Illustrated* und wurde von seinen Benutzern vielfach positiv bewertet.

Cette passoire est équipée d'un système de perforation extrêmement précis, facilitant l'écoulement de l'eau. De plus, la petitesse des trous empêche certains aliments comme les grains de riz ou la semoule de passer à travers. Résistant et léger à la fois, cet ustensile se nettoie facilement. Recommandé par le magazine *Cook's Illustrated*, ce modèle est très apprécié par les consommateurs.

Stainless-steel bowls & strainers, 1960

Sori Yanagi (Japan, 1915–)

www.gatewayjapan.dk
Stainless steel
Edelstahl
Acier inoxydable
⌀ 13, 16, 19, 23, 27 cm (bowls)
⌀ 16, 19, 23, 27 cm (strainers)
Sori Yanagi, Valby, Denmark

For centuries, the idea of functional simplicity has guided the arts and crafts of Japan, a preoccupation closely linked to the striking aesthetic purity of so much Japanese design. Sori Yanagi's kitchen accessories, such as these stainless-steel bowls and strainers, stand as testament to the vitality of this absorbing design heritage. Like traditional Japanese household wares, these beautiful 'tools' are a joy to use because of the thought and craftsmanship that has informed their design and manufacture.

Seit Jahrhunderten wird das japanische Kunsthandwerk von der Idee der funktionellen Einfachheit geleitet, ein Prinzip, das eng mit der verblüffenden ästhetischen Klarheit so vieler Designs aus Japan verbunden ist. Sori Yanagis Küchenaccessoires, wie beispielsweise diese Edelstahlschüssel mit Sieb, zeugen von der Vitalität dieses faszinierenden Designerbes. Es macht Freude, traditionelle japanische Haushaltsartikel zu benutzen, und diese schönen Küchenhelfer bilden da keine Ausnahme, denn in ihrem Design und ihrer Verarbeitung stecken viele Überlegungen und hohes handwerkliches Können.

Depuis des siècles, le concept de simplicité fonctionnelle est indissociable de l'artisanat japonais, une préoccupation étroitement liée à l'étonnante pureté esthétique d'une grande partie du design de ce pays. Les ustensiles de cuisine de Sori Yanagi, tels que ce saladier et cette passoire en acier inoxydable, témoignent de la vitalité de ce patrimoine. À l'instar des objets de maison traditionnels du Japon, ces beaux « outils » s'utilisent avec plaisir en raison de la considération et de la technique qui ont guidé leur conception et leur fabrication.

Margrethe mixing bowls, 1950

Sigvard Bernadotte (Sweden, 1907–2002) & Acton Bjørn (Denmark, 1910–1992)

www.rosti-housewares.dk
Melamine, rubber
Melamin, Gummi
Mélamine, caoutchouc
1.5 l, 2 l, 3 l, 4 l
Rosti Housewares, Ebeltoft, Denmark

Born into the Swedish royal family, Count Sigvard Bernadotte designed numerous innovative products, many of them in collaboration with his Danish colleague, Acton Bjørn. The *Margrethe* melamine mixing bowls – their response to a brief to design the 'ideal mixing bowl' – are produced in a number of bright colours. These sturdily sculptural nesting bowls have non-slip rubber bases, as well as highly practical pouring spouts and useful handgrips. The bowls were named after Count Bernadotte's niece, Princess Margrethe, now the sovereign of Denmark.

Graf Sigvard Bernadotte, Mitglied der schwedischen Königsfamilie, entwarf zahlreiche Produkte, viele von ihnen gemeinsam mit seinem dänischen Kollegen Acton Bjørn. Die Melamin-Rührschüssel *Margrethe* – die Antwort der beiden auf den Auftrag, die „perfekte Rührschüssel" zu entwerfen – ist in zahlreichen leuchtenden Farben erhältlich. Die stabilen, stapelbaren Schüsseln haben einen rutschfesten Gummifuß, eine praktische Ausgießtülle sowie handliche Griffe. Die Schüsseln sind nach Graf Bernadottes Nichte, Prinzessin Margrethe, der heutigen Königin von Dänemark, benannt.

Issu de la famille royale suédoise, le comte Sigvard Bernadotte a conçu de nombreux produits novateurs, dont certains en collaboration avec son collègue danois, Acton Bjørn. Les bols de préparation en mélamine *Margrethe* existent dans une importante palette de couleurs vives. Non seulement ils sont résistants grâce à la base faite de caoutchouc antidérapant mais ils sont également fonctionnels avec leur bec verseur. Ces bols portent le nom de la nièce du comte Bernadotte, la princesse Margrethe, souveraine du Danemark.

The famous Corning glassworks developed a heat-resistant borosilicate glass in the late 1880s, and in 1911 the company adjusted its formula so that it would be suitable for the manufacture of kitchenware. This new glass was named Pyrex® and in 1915 a range of Pyrex-branded cookware was launched with the motto 'glass dishes for baking'. For over ninety years, the design of these classic, stacking *Pyrex* mixing bowls has altered little – a testament to the relevance and usefulness of the concept.

Der berühmte Glashersteller Corning entwickelte Ende der 1880er Jahre ein hitzebeständiges Borosilikatglas, dessen Formel 1911 so angepasst wurde, dass sie für die Herstellung von Haushalts-artikeln geeignet war. Dieses neue Glas erhielt den Namen Pyrex®, und 1915 wurde unter dem Motto „Glasgeschirr zum Backen" eine Serie von Kochgeschirr auf den Markt gebracht. In mehr als neunzig Jahren hat sich das Design dieser klassischen, stapelbaren *Pyrex*-Rühr-schüssel kaum verändert – ein Beweis für die Bedeutung und Zweckmäßigkeit des Konzepts.

La célèbre verrerie Corning mit au point un verre borosilicate réfractaire à la fin des années 1880 puis, en 1911, modifia sa formule afin de l'adapter à la fabrication d'objets de cuisine. Ce nouveau verre fut baptisé Pyrex® et, dès 1915, une batterie de cuisine fut lancée avec la devise « des plats en verre pour cuire ». Plus de quatre-vingt-dix ans plus tard, le design de ces saladiers classiques empilables *Pyrex* a peu changé, ce qui témoigne de la pertinence et de l'utilité du concept.

Pyrex mixing bowl set, c. 1915 (original design)
Corning Design Team

www.pyrex.com
Pyrex®
Pyrex®
Pyrex®
⌀ 14, 16, 21, 24 cm
Corning, Corning (NY), USA

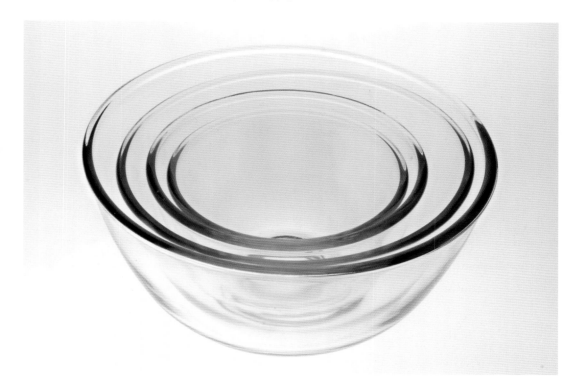

15320 mixing bowl, 1987

Rösle Design Team

www.roesle.de
Stainless steel
Edelstahl
Acier inoxydable
1.48 l, 2.75 l, 4.76 l
Rösle, Marktoberdorf, Germany

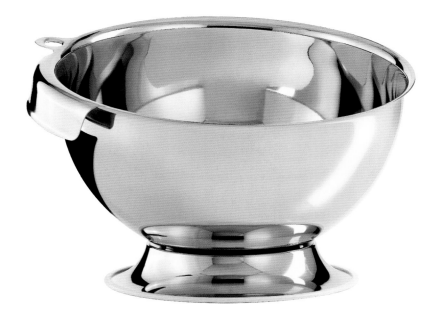

The design of this mixing bowl has been informed by a careful analysis of function. The integrated grip and thumb-ring give the user a firm hold, which is essential when beating egg whites, stirring sauces or making salad dressings. The lipped rim ensures drip-free pouring, while the overall tilt of the bowl makes the act of mixing easier – a beautiful example of form following function.

Das Design dieser Rührschüssel verdankt sich einer sorgfältigen Analyse der Funktion. Der integrierte Haltegriff und Daumenring sorgen für sichere Handhabung beim Aufschlagen von Eiweiß oder Anrühren von Saucen und Salatdressings. Der bordierte Rand ermöglicht tropfenfreies Ausgießen, während die Neigung der Schüssel das Schlagen erleichtert – ein wunderbares Beispiel für das Prinzip „Form folgt Funktion".

La conception de ce saladier répond à une analyse approfondie de la fonction. Son anse intégrée et son anneau pour le pouce assurent une prise ferme, essentielle pour battre des œufs en neige, brasser des sauces ou préparer des vinaigrettes. Son bec verseur évite les coulures tandis que son inclinaison facilite le mélange… un bel exemple de la forme épousant la fonction.

This multi-functional covered bowl can be used for food preparation, marinating, defrosting, storing or even serving at a table. The lid also has an integrated stainless-steel vent that can either be tightly sealed for the transportation of food or opened for ventilation in order to let food breathe. The bowl's unusual asymmetrical rim was designed for efficient pouring of liquids.

Diese multifunktionale Schüssel mit Deckel lässt sich zum Vor- und Zubereiten, Marinieren, Auftauen, Aufbewahren und sogar zum Servieren von Speisen am Tisch verwenden. Der Deckel ist mit einem integrierten Edelstahlventil versehen, das entweder für den Transport von Speisen luftdicht verschlossen oder zum Belüften geöffnet werden kann. Der ungewöhnliche asymmetrische Rand der Schüssel ermöglicht tropfenfreies Ausgießen von Flüssigkeiten.

Ce saladier avec couvercle peut être utilisé pour la préparation des plats, les marinades, la décongélation, la préservation ou même servir à table. Son couvercle est équipé d'une soupape en acier inoxydable qui peut être hermétiquement fermée pour transporter des aliments ou ouvert pour les laisser respirer. Son bord asymétrique inhabituel a été conçu pour verser les liquides plus facilement.

Versalid bowl set, 1995
Rösle Design Team

www.roesle.de
Stainless steel
Edelstahl
Acier inoxydable
1.16 l, 2.43 l, 4.23 l
Rösle, Marktoberdorf, Germany

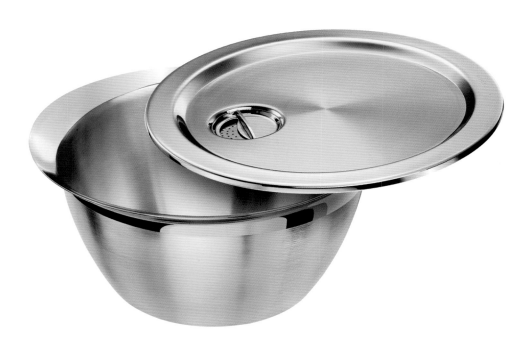

Good Grips rolling pin, 2001

Smart Design (USA, est. 1978)

www.oxo.com
Thermoplastic
Thermoplastik
Thermoplastique
OXO International, New York (NY), USA

Thinking of making cookies or pies? If so, every homemaker needs a good rolling pin that will roll out the dough or pastry uniformly and evenly. Unfortunately, however, most rolling pins are not ergonomically refined, which means that the elderly, and those suffering from arthritis, often find them difficult to use. The exception is the *Good Grips* rolling pin. Its contoured and weighted handles are designed so that hands and knuckles are kept in an optimum raised position, and as such do not painfully hit counter tops when rolling out.

Wollen sie Kekse oder einen amerikanischen Pie backen? Wenn ja, brauchen Sie einen guten Teigroller, mit dem Sie den Teig gleichmäßig dünn ausrollen können. Leider sind die meisten Modelle nicht ergonomisch geformt und daher für Senioren oder Menschen mit Arthritis schwer zu handhaben. Der *Good Grips*-Teigroller bildet da eine Ausnahme. Seine plastisch geformten, extra schweren Griffe ermöglichen Handflächen und Fingerknöchel eine ergonomisch ideale, erhöhte Position und verhindern, dass man sich die Knöchel an der Arbeitsplatte aufreibt.

Vous songez à faire des cookies ou des tartes ? Alors, vous avez indéniablement besoin d'un bon rouleau à pâtisserie afin d'étaler uniformément la pâte. La plupart des rouleaux manquent cruellement d'ergonomie et sont difficiles à manipuler pour des personnes souffrant d'arthrite par exemple. Grâce à ses poignées recourbées et surélevées, le rouleau *Good Grips* est très facile à utiliser et évite notamment que vos mains ne heurtent le plan de travail.

Good Grips pastry brush, 2006

Smart Design (USA, est. 1978)

www.oxo.com
Thermoplastic, silicone
Thermoplastik, Silikon
Thermoplastique, silicone
OXO International, New York (NY), USA

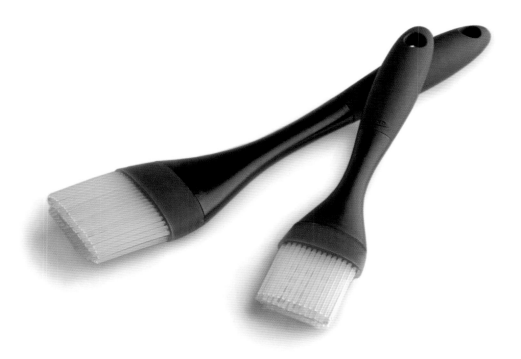

Unlike old-fashioned wooden and bristle pastry brushes, the *Good Grips* version does not clump together, nor does it retain clinging food odours. It can also be placed in the dishwasher and, thanks to its use of silicone for its bristles, it is heat-resistant up to 315°C (600°F). Made from an elastomeric polymer, the handle also provides a comfortably soft grip making it easier to use.

Anders als bei den herkömmlichen Backpinseln mit Holzstielen können beim *Good Grips*-Pinsel keine Borsten miteinander verkleben, und er nimmt auch keine Essensgerüche an. Außerdem ist er spülmaschinenfest und aufgrund seiner Silikon-Borsten bis zu 315°C hitzebeständig. Der Stielgriff ist aus thermoplastischem Kunststoff und daher angenehm griffig und weich.

Fini les pinceaux à pâtisserie en bois et en soie démodés, voici l'ère des *Good Grips*, plus sains et qui ne conservent pas les odeurs de nourriture. Résistants au lave-vaisselle et aux très hautes températures (jusqu'à 315°C) grâce au silicone, leurs poignées fabriquées en matière thermoplastique assurent une prise en main aussi pratique que confortable.

Good Grips trivet & oven mitt, 2008

Smart Design (USA, est. 1978)

www.oxo.com
Silicone/Silicone, fabric, magnet
Silikon/Silikon, Stoff, Magnet
Silicone/Silicone, toile, aimant
OXO International, New York (NY), USA

This trivet and matching oven mitt incorporate high-grade silicone, which is heat-resistant up to an impressive 315°C (600°F). The trivet also doubles up as a useful potholder, while the oven mitt has a thick, multi-layer liner that gives additional thermal insulation. The mitt really fits like a proper glove and its ribbed design provides a secure grip. It also has a long sleeve option to protect the wrist and forearm from accidental burns.

Dieser Untersetzer und der dazu passende Ofenhandschuh aus hochwertigem Silikon sind bis zu beeindruckenden 315°C hitzebeständig. Der Untersetzer lässt sich als zusätzlicher Topflappen benutzen; der Ofenhandschuh hat ein dickes, mehrlagiges Innenfutter, das zusätzlich isoliert, und passt sich der Hand fast wie ein normaler Handschuh an. Die gerippte Oberfläche sorgt für einen sicheren Griff. Außerdem ist er mit einer langen Manschette versehen, die Handgelenk und Unterarm vor Verbrennungen schützen.

Les maniques présentées ici contiennent un silicone d'excellente facture. Elles résistent notamment à la chaleur jusqu'à 315°C. Le dessous-de-plat se plie en deux et le gant possède un revêtement épais multicouche apportant une isolation thermique supplémentaire. De plus, sa structure à nervures assure une prise en main ferme et sûre. Le manchon protège également le poignet et l'avant-bras, évitant ainsi les brûlures accidentelles.

Good Grips spatula, 2007

Smart Design (USA, est. 1978)

www.oxo.com
Wood, silicone
Holz, Silikon
Bois, silicone
OXO International, New York City (NY), USA

Like other kitchen tools concieved by Smart Design for oxo's ubiquitous *Good Grips* range, this spatula is an 'inclusive design', which can be used by most members of society regardless of age or physical ability. Although at first glance it looks like almost any other spatula, the design's large solid wooden handle has been ergonomically shaped to fit the hand. It therefore has a comfortable and stable grip for stirring or scraping. The heat-resistant silicone head can also be removed for cleaning.

Wie andere Küchenutensilien, die Smart Design für oxos allgegenwärtige *Good Grips*-Kollektion entwarf, ist auch dieser Pfannenheber ein Stück „inklusives Design", das von den meisten Menschen ungeachtet ihres Alters oder etwaiger körperlicher Behinderungen ohne Schwierigkeiten benutzt werden kann. Auf den ersten Blick sieht er zwar wie fast alle anderen Pfannenheber aus, aber sein dicker Vollholzgriff ist ergonomisch geformt, so dass er in jeder Hand gut liegt und das Heben und Wenden des jeweiligen Bratguts erleichtert. Der eigentliche Spatel aus hitzebeständigem Silikon ist abnehmbar und lässt sich separat spülen.

À l'instar d'autres ustensiles de cuisine créés par Smart Design pour oxo, cette spatule est conçue selon un « design inclusif », à savoir un objet utilisable par tous, indépendamment de l'âge ou de la capacité physique de chacun. Cette création dispose d'un long manche en bois ergonomique. Le modèle *Good Grips* s'avère donc idéal pour mélanger ou gratter. La partie en silicone est résistante à la chaleur et se retire pour un nettoyage efficace.

Edge chopping block & breadboard, 2005

Pascal Charmolu (France, 1958–)

www.sagaform.com
Oiled oak
Öleiche
Chêne huilé
↕ 10 cm ↔ 30.5 cm ⤢ 30.5 cm
↔ 45 cm ⤢ 22.5 cm
Sagaform, Borås, Sweden

Although a French citizen, Pascal Charmolu studied at the Swedish Academy of Arts and Crafts in Stockholm – a city that has since been his home for more than twenty-five years. During this time he has worked as a freelance designer, receiving numerous awards for his innovative product design solutions. Charmolu has also worked extensively for Sagaform designing, for instance, this sturdy and distinctive chopping block and breadboard.

Der gebürtige Franzose Pascal Charmolu studierte an der Swedish Academy of Arts and Crafts in Stockholm und nennt die Stadt nun schon seit mehr als fünfundzwanzig Jahren sein Zuhause. In dieser Zeit arbeitete er als freiberuflicher Designer und wurde mehrfach für sein innovatives Produktdesign ausgezeichnet. Viele seiner Produkte entwarf er für die Firma Sagaform, wie auch dieses robuste und unverwechselbare Hack- und Brotschneidebrett.

Français d'origine, Pascal Charmolu a étudié à l'Académie suédoise des arts et métiers de Stockholm, ville où il a vécu plus de vingt-cinq ans. À cette époque, il travaillait comme designer indépendant et reçut de nombreux prix pour ses créations de produits novateurs. Charmolu a également beaucoup travaillé pour Sagaform, notamment avec ce billot massif et original ainsi que cette planche à pain.

Edge cheeseboard, 2005
Pascal Charmolu (France, 1958–)

www.sagaform.com
Oiled oak, glass
Geölte Eiche, Glas
Chêne huilé, verre
↕ 45 cm ↔ 22.5 cm
Sagaform, Borås, Sweden

Pascal Charmolu's *Edge* cheeseboard innovatively and seamlessly combines wood with glass to create a design that can be used for cutting bread and serving cheese: perfect for buffets, suppers or dinner parties. Like other Sagaform products, the *Edge* cheeseboard has a Scandinavian simplicity that provides affordable 'good design' for the home.

Nahtlos und innovativ verbindet Pascal Charmolu in seinem *Edge*-Käsebrett Holz und Glas miteinander und schafft damit eine Unterlage, auf der sowohl Brot geschnitten als auch Käse serviert werden kann: perfekt für Büffets oder ein Dîner mit Gästen. Wie andere Produkte aus dem Hause Sagaform zeichnet sich auch das *Edge* Käsebrett durch skandinavische Einfachheit aus, die Designerstücke auch für zu Hause erschwinglich macht.

Le plateau de Pascal Charmolu est novateur, il combine harmonieusement le bois et le verre, et peut être utilisé à la fois pour couper du pain et servir du fromage : idéal pour les buffets ou les dîners. Comme d'autres créations Sagaform, le plateau à fromage *Edge* illustre la simplicité et la pureté du style scandinave tourné vers des produits design et abordables pour la maison.

The term 'Lazy Susan', used to describe a rotating tabletop tray, was first used in an advertisement from 1917 in *Vanity Fair* magazine, and presumably alluded to an idle servant. Certainly a useful device for serving, the Lazy Susan concept has now been reinterpreted by Peter and Eva Moritz in their *Mingle* cheeseboard. Made from subtly grained walnut, its richly coloured surface is ideal for presenting a selection of cheeses.

Hinter der Bezeichnung „Lazy Susan" verbirgt sich eine drehbare Servierplatte. Der Begriff tauchte im Jahr 1917 zum ersten Mal in einer Werbeanzeige der Zeitschrift *Vanity Fair* auf und spielt vermutlich auf ein faules Dienstmädchen an. Dieses praktische Servierkonzept haben Peter und Eva Moritz mit ihrem *Mingle*-Käsebrett nun neu interpretiert. Das dunkle, sanft gemaserte Walnussholz ist der ideale Hintergrund für eine Auswahl edler Käse.

Utilisé pour décrire un plateau tournant sur table, le terme « Lazy Susan » apparaît pour la première fois en 1917, dans une publicité du magazine *Vanity Fair*. Invention utile et fonctionnelle pour le service, le concept de plateau tournant a été réinterprété par Peter et Eva Moritz avec leur plateau à fromage *Mingle*. Réalisé en noyer, sa surface très colorée est idéale pour présenter une sélection de fromages qui la mettra indéniablement en valeur.

Mingle Lazy Susan cheeseboard, 2005

Peter Moritz (Sweden, 1964–) & Eva Moritz (Sweden, 1966–)

www.sagaform.com
Walnut, painted trim
Walnuss, bemalter Rand
Noyer, bord peint
↕ 25.5 cm ↔ 25.5 cm
Sagaform, Borås, Sweden

570 breadboard with knife, 2007

Peter Sägesser (Switzerland, 1952–)

www.saegiag.ch
Cherry or maple, stainless steel
Kirschbaum oder Ahorn, Edelstahl
Merisier ou érable, acier inoxydable
↕ 3 cm ↔ 42 cm ⤢ 24 cm
Sägi, Zurich, Switzerland

Mirroring the national characteristics of order and calm, Swiss-designed products for the home have a reassuring yet understated presence; they do the job well, but don't feel the need to shout about it. The Zurich-based company, Sägi, manufactures products that epitomise Swiss designers' logical yet thoughtful approach to design, such as this beautifully made breadboard.

Haushaltsutensilien nach Schweizer Design haben eine beruhigende, unaufdringliche Präsenz und spiegeln die für das Land typischen Eigenschaften der Ruhe und Ordnung wider; sie sind effizient, ohne damit zu prahlen. Das in Zürich ansässige Unternehmen Sägi stellt Produkte her, die das logische und sorgfältige gestalterische Vorgehen von Schweizer Designern verkörpern, so auch dieses sehr schön gemachte Brotbrett.

Illustrant parfaitement l'ordre et le calme, les créations design suisses concernant la maison sont imprégnées d'un halo rassurant et discret. Ces objets s'avèrent très fonctionnels, sans fioritures ni extravagances. Basée à Zurich, la société Sägi fabrique des produits incarnant la logique des créateurs suisses, pour une approche réfléchie du design. Cette magnifique planche à pain 570 reflète admirablement cet esprit.

560 chopping board, 2007

Peter Sägesser (Switzerland, 1952–)

www.saegiag.ch
Cherrywood or maple, stainless steel
Kirschbaum oder Ahorn, Edelstahl
Merisier ou érable, acier inoxydable
↕ 3 cm ↔ 49.5 cm ⤢ 26 cm
Sägi, Zurich, Switzerland

Swiss Design is generally characterised by a functional clarity and an extraordinary level of detail, as can be seen in Peter Sägesser's 560 chopping board with its stainless steel handles. This simple yet logical design reflects the desire for superior kitchenwares in Switzerland, a country long famed for its culinary arts and teaching. It also reveals the nation's appreciation of high-quality and perfectly engineered designs that will last a lifetime.

Funktionale Klarheit und große Detailgenauigkeit charakterisieren Schweizer Design seit jeher, und dies kommt auch bei Peter Sägessers Tranchierbrett 560 mit seinen Edelstahlgriffen zum Ausdruck. Das schlichte, dennoch logische Design reflektiert den Wunsch nach hochwertigen Küchenutensilien in der Schweiz, einem Land, in dem die Kochkunst einen großen Stellenwert hat. Es zeugt auch davon, wie sehr diese Nation hochwertiges Qualitätsdesign schätzt, das ein Leben lang hält.

Le design suisse se caractérise par une clarté fonctionnelle et un grand souci du détail, comme l'illustre la planche 560, avec ses poignées en acier inoxydable. Ce modèle offre un design simple et rationnel, reflétant le désir des créateurs suisses de concevoir des articles de cuisine de grande qualité. Célèbre pour son art culinaire et son enseignement, la Suisse s'attache à concevoir et à fabriquer d'excellents produits, réalisés pour durer toute une vie.

Shun Pro 2 kitchen knives, 2005

Ken Onion (USA, 1963–) & Alton Brown (USA, 1962–)

www.kershawknives.com
Steel, stainless steel, pakkawood, brass
Stahl, Edelstahl, Pakkaholz, Messing
Acier, inox, pakkawood, cuivre
Kershaw Knives/Kai USA, Tualatin (OR), USA

Although designed and manufactured in America, these super-sharp knives employ an age-old Japanese knife-making technique known as *honyaki*, in which the blade is made from a single piece of high-grade steel. The design also employs the Japanese *kasumi* method, which involves cladding the steel blades with a protective layer of stainless steel and then burnishing it so that – like a *Samurai* sword – they not only have a superior cutting edge but also bear a distinctive Damascene wavy pattern.

Diese extrem scharfen Messer werden zwar in Amerika entworfen und produziert, aber bei ihrer Herstellung kommt eine sehr alte, *Honyaki* genannte japanische Technik zur Anwendung, bei der die Klinge aus einem Stück gefertigt wird. Außerdem werden die Stahlklingen nach der japanischen Methode des *Kasumi* mit einer Schutzschicht aus Edelstahl überzogen und dann geschliffen. Wie ein Samuraischwert besitzen diese Messer damit nicht nur eine überragende Schärfe, sondern weisen auch das charakteristische Wellenmuster einer Damastklinge auf.

Bien que dessinés et fabriqués aux États-Unis, ces couteaux de cuisine super tranchants utilisent une technique japonaise ancestrale, le *honyaki*, où la lame est faite d'une seule pièce d'acier de haute qualité. Ils emploient également la méthode *kasumi*, la lame d'acier étant ensuite gainée d'une couche protectrice en inox avant d'être polie. Telle une épée de samouraï, elle possède un tranchant hors pair et est damasquinée d'un motif ondulé caractéristique.

Global G-8311/K kitchen knife set, 1983

Komin Yamada (Japan, 1947–)

www.yoshikin.co.jp
Stainless steel
Edelstahl
Acier inoxydable
Yoshida Metal Industry Company, Yoshida, Japan

When Komin Yamada's *Global* knife range was launched in 1983, it established a new standard for all-stainless-steel, one-piece knife construction. With their cleverly integrated handles and blades, *Global* knives have excellent cutting and handling characteristics, and they look really good too, with their distinctive and very stylish black-pocked handles. The knife set shown here includes various slicing and chopping tools for preparing fish, meat and vegetables, and for cutting bread.

Als Komin Yamadas *Global*-Messerserie 1983 auf den Markt kam, setzte sie neue Maßstäbe für Messer, bei denen Klinge und Schaft aus einem Stück Edelstahl gefertigt sind. Dank dieser cleveren integrierten Lösung besitzen die *Global*-Messer hervorragende Schneid- und Gebrauchseigenschaften und sehen mit ihren auffälligen, sehr eleganten eingekerbten Griffen auch wirklich sehr gut aus. Das hier gezeigte Messerset umfasst verschiedene Schneide- und Hackwerkzeuge zum Verarbeiten von Fisch, Fleisch, Gemüse und Brot.

Lorsque la ligne *Global* de Komin Yamada fut lancée en 1983, elle établit un nouveau standard dans la conception des couteaux monoblocs en acier inoxydable. Avec leur lame et leur manche ingénieusement intégrés, ils possèdent une exceptionnelle qualité de coupe et sont extrêmement maniables. Avec leur élégant manche parsemé de points noirs, ils sont en outre très beaux. Le jeu montré ici comporte divers instruments pour trancher et hacher, parfaits pour préparer le poisson, la viande ou les légumes comme pour couper le pain.

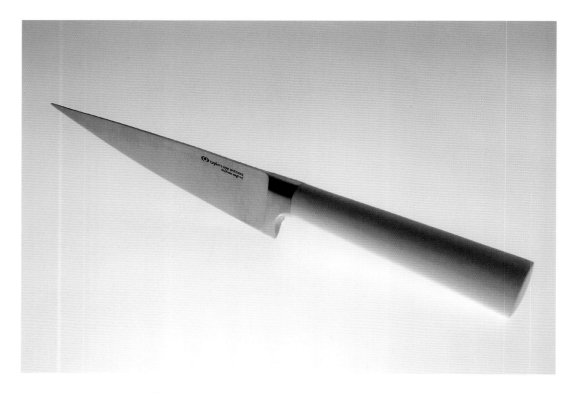

IF4000 knives, 2004

Industrial Facility/Sam Hecht (UK, 1969–) & Kim Colin (USA, 1961–)

www.taylors-eye-witness.co.uk
Stainless steel, ceramic, polyester
Edelstahl, Melamin, Polyester
Acier inoxydable, céramique, polyester
Taylor's Eye Witness, Sheffield, UK

Having manufactured knives in Sheffield – England's historic steelmaking centre – for over 150 years, Taylor's Eye Witness commissioned Industrial Facility to design a new range of kitchen knives. The resulting IF4000 range employs cool-to-the-touch 'advanced ceramic' handles, and high-grade stainless-steel blades that have both strength and flexibility. Winning a Design Plus award and also a gold iF award, this useful and beautiful kitchen knife collection is a veritable classic of contemporary British design.

Das Unternehmen Taylor's Eye Witness, das seit über 150 Jahren Messer in Sheffield, dem historischen Stahlerzeugungszentrum Englands, herstellt, beauftragte Industrial Facility mit dem Entwurf einer neuen Serie von Küchenmessern. Die so entstandene IF4000-Serie überzeugt durch Griffe aus „Hochleistungskeramik", die sich bei Berührung kühl anfühlen, und hochwertige Edelstahlklingen, die nicht nur stark, sondern auch flexibel sind. Ausgezeichnet mit einem Design Plus Award und einen iF Award in Gold, ist diese nützliche und schöne Küchenmesser-Kollektion ein echter Klassiker des modernen britischen Designs.

Taylor's Eye Witness, qui fabrique des couteaux depuis plus de cent cinquante ans à Sheffield, le centre historique de la sidérurgie anglaise, a commandé à Industrial Facility la conception de cette ligne de couteaux de cuisine. Les couteaux IF4000 possèdent des manches en céramique « haute performance » fraîche au toucher et des lames en acier de première qualité à la fois solides et souples. Lauréate d'un prix Design Plus et d'un iF d'or, cette gamme est déjà un véritable classique du design britannique contemporain.

Professional S knives, 1988–1989

Zwilling JA Henckels Design Team

www.zwilling.com
Solid steel, plastic
Rostfreier Spezialstahl, Kunststoff
Acier pris dans la masse, plastique
Zwilling JA Henckels, Solingen, Germany

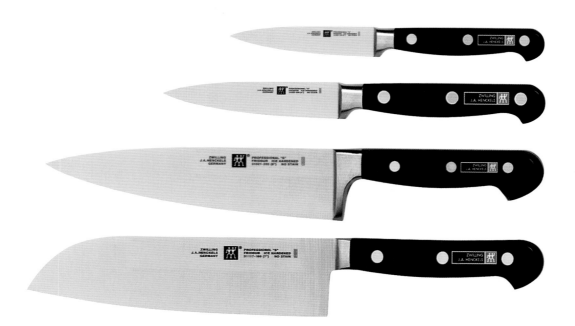

In 1731, the knife maker Peter Henckels registered his famous 'twin' symbol with the Cutlers' Guild in Solingen. Since then, this trademark has become a signifier of product excellence. With solid, all-steel blades and seamless, riveted handles, the *Professional S* range of forty-six knives, designed for every conceivable culinary need, are a favourite among professional chefs, who know they can rely on these superior cutting tools.

Der Messermacher Peter Henckels ließ 1731 sein berühmtes Zwillingssymbol als Schutzmarke bei der Solinger Messermacher Rolle eintragen. Seitdem steht die Marke für hervorragende Produktqualität. Die aus einem Stück Spezialstahl geschmiedete Klinge der *Professional S*-Serie geht nahtlos in den genieteten Griff über. Die sechsundvierzig, für alle kulinarischen Zwecke entwickelten Messer sind besonders bei Profiköchen beliebt, die wissen, dass sie sich auf diese hochwertigen Schneidwerkzeuge verlassen können.

En 1731, Peter Henckels fit inscrire son célèbre logo représentant deux jumeaux dans le registre des couteliers de la ville de Solingen. Depuis, sa marque est devenue synonyme d'excellence. Avec leur lame en acier pris dans la masse et leur manche homogène riveté, les quarante-six couteaux de la gamme *Professional S*, conçus pour toutes les tâches de cuisine imaginables, ont été adoptés par les chefs professionnels qui savent qu'ils peuvent se fier à ces outils hors pair.

Model 130 Professional Sharpening Station knife sharpener, 2005

Dan Friel Sr (USA, 1920–)

www.edgecraft.com
Various materials
Verschiedene Materialien
Divers matériaux
↔ 24.8 cm
Chef's Choice/EdgeCraft, Avondale (PA), USA

Available in four finishes, the user-friendly *Model 130* is a compact professional knife sharpening unit, which uses a three-stage system to sharpen any type of knife you can imagine – from straight-edged to serrated. The first stage uses diamond abrasives to sharpen the edge of the knife, the second stage incorporates a super-hardened steel to create a superior cutting edge, and the final stage employs a flexible stropping disk to polish the edge to 'hair-splitting sharpness'.

Das benutzerfreundliche, in vier Farben erhältliche *Model 130* ist eine professionelle Messerschärfstation, deren Dreistufensystem jedes Messer, ob glatt oder gezahnt, wieder scharf bekommt. Bei der ersten Stufe wird die Messerschneide mithilfe von Diamantstaub geschärft, Stufe zwei fügt mithilfe supergehärteten Stahls eine Mikroverzahnung hinzu, und die flexible Scheibe der letzten Stufe poliert das Messer, bis es so scharf ist, dass man damit Haare spalten könnte.

Disponible en quatre finitions, le *Model 130* est un aiguiseur à couteaux professionnel qui fonctionne selon trois phases : tout d'abord un aiguisage par l'entremise d'un disque à diamant pour affûter le bord tranchant du couteau, puis un affûtage par acier trempé pour optimiser le tranchant et enfin un disque de finition flexible afin de polir les microdentures du tranchant pour une efficacité maximum. Cet aiguiseur permet d'affûter tout type de couteau.

Chantry Modern Knife Sharpener, 2004

Industrial Facility/Sam Hecht (UK, 1969–) & Kim Colin (USA, 1961–)

www.taylors-eye-witness.co.uk
Enamelled metal, spring-loaded steels
Emailliertes Metall, gefederte Stahlscheiben
Métal émaillé, ressorts en acier
↔ 20 cm
Taylor's Eye Witness, Sheffield, UK

Sam Hecht is renowned for his simple yet logical products that innovatively update existing typologies. A prime example is his *Chantry Modern Knife Sharpener* for Taylor's Eye Witness, a Sheffield-based manufacturer that has been making superior-quality knives since 1838. This award-winning design incorporates the company's existing chantry device (two small, spring-loaded butchers' steels positioned at the optimum angle) within a clean-lined and practical knife sharpener.

Sam Hecht ist bekannt für seine simplen und doch logischen Designs, die Traditionelles auf innovative Weise modernisieren. Ein Paradebeispiel ist dieser Messerschärfer für Taylor's Eye Witness, ein Sheffielder Unternehmen, das bereits seit 1838 hochwertige Messer herstellt. In diesem preisgekrönten Objekt greift Hecht das Prinzip der beiden gefederten, im optimalen Winkel zueinander positionierten Wetzstähle des Herstellers auf und integriert sie in einen praktischen Messerschärfer mit klaren Formen.

Sam Hecht est connu pour la simplicité de ses créations, qui partent d'objets existants en vue de les améliorer. C'est le cas par exemple de cet affûteur *Chantry* créé pour Taylor's Eye Witness. Ce fabricant basé à Sheffield est réputé depuis 1838 pour la qualité supérieure de ses couteaux. Cette création plusieurs fois primée s'inspire de l'aiguiseur de la marque (dont le mécanisme s'appuie sur deux petites sections d'acier positionnées selon un angle parfait) pour en faire un aiguiseur élégant à l'usage idéal.

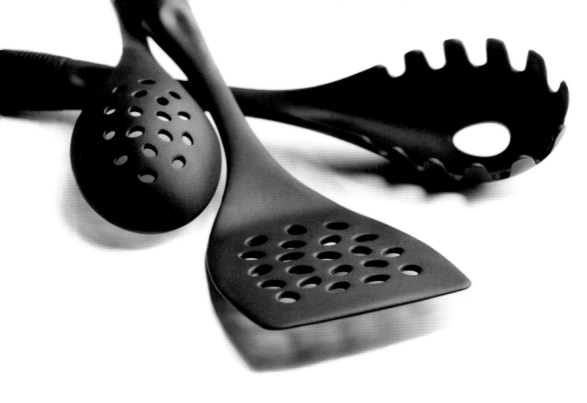

Good Grips kitchen tools, 1996

Smart Design (USA, est. 1978)

www.oxo.com
Polyamide
Polyamid
Polyamide
oxo International, New York (NY), USA

Smart Design has created literally hundreds of designs for oxo, all of which have an inclusive remit that means they are suitable for most users regardless of physical ability. Apart from this ethical dimension, *Good Grips* products, including this extensive range of kitchen tools, also offer high performance and durability at an affordable price, thereby exemplifying the long-held and democratic notion of 'good design' for all.

Smart Design hat buchstäblich Hunderte von Produkten für oxo entworfen, die allesamt so beschaffen sind, dass sie jeder, unabhängig von seinen körperlichen Fähigkeiten, benutzen kann. Abgesehen von dieser ethischen Komponente bieten die *Good Grips*-Produkte, darunter diese breite Auswahl an Küchenwerkzeugen, hohe Leistung und Haltbarkeit bei bezahlbaren Preisen, und verkörpern damit die traditionelle, demokratische Maxime „guten Designs für Jedermann".

Smart Design a conçu des centaines d'objets pour oxo, dont les principales attributions sont d'être utilisables par tous, indépendamment de la force physique. Hormis cette dimension éthique, les produits *Good Grips*, y compris cet impressionnant jeu d'ustensiles de cuisine, allient performance et longévité pour un prix raisonnable, conformément à la devise de la marque qui associe une connotation démocratique au design d'excellence.

Made of solid beech, these sturdy wooden tools are both durable and comfortable to hold. They also have the added benefit of being safe to use with non-stick cookware. The elegant yet no-nonsense salad servers have large contoured handles and flared tines that ensure they are perfect not only for tossing a salad, but for serving and scooping at almost any angle. They exemplify elegant and inclusive design intended to enhance the art of living.

Diese Kochutensilien aus massivem Buchenholz sind sowohl langlebig als auch angenehm griffig und weich genug, um Antihaftbeschichtungen in Pfannen und Töpfen nicht zu zerkratzen. Das schlichte, aber formschöne Salatbesteck hat große Griffe und die Gabel weit gespreizte Zinken, so dass man mit dem Besteck jede Art Salat mit wenigen Handgriffen wenden oder auf einmal eine ordentliche Portion greifen und auf den Essteller befördern kann. Diese beispielhaft eleganten Utensilien sind etwas für ästhetische und kulinarische Genießer.

Fabriqués en bois de hêtre massif, ces ustensiles sont à la fois robustes, fonctionnels et agréables à manipuler. Ces modèles peuvent être utilisés avec des casseroles anti-adhérentes sans risque de les endommager. Ces élégants couverts à salade comportent de longs manches ainsi que de larges dents évasées permettant de retourner la salade aisément et de la servir sans difficulté. Les ustensiles présentés ici incarnent un design élégant destiné à améliorer l'art de vivre.

Good Grips spaghetti servers & wooden spoons, & Good Grips salad servers, 2003–2004 & 2006
Smart Design (USA, est. 1978)

www.oxo.com
Beech
Buche
Hêtre
OXO International, New York (NY), USA

Good Grips serving spatula, 1999
Smart Design (USA, est. 1978)

www.oxo.com
Stainless steel, Santoprene
Edelstahl, Santopren
Acier inoxydable, Santoprene
OXO International, New York City (NY), USA

With its soft, tapering handle made of Santoprene – a thermoplastic elastomer (in other words a synthetic rubber) – this implement is easy to use and is perfect for serving an array of different dishes, from fruit pies to lasagne. Dishwasher-safe and highly robust, it is absolutely perfect for everyday family meals, while sufficiently elegant to bring out when entertaining guests.

Mit ihren weichen, nach unten schmaler werdenden Griffen aus Santopren (einem thermoplastischen Elastomer, das heißt einem unter Hitzeeinwirkung formbaren elastischen Kunststoff) liegen diese Utensilien – Servierspatel, Tortenheber und Vorlegelöffel – gut in der Hand. Sie sind spülmaschinenfest, sehr robust und optimal geeignet für den täglichen Gebrauch am Familientisch. Sie sind aber auch elegant genug, um für die Bewirtung von Gästen benutzt zu werden.

Agréables à saisir grâce à leur manche en Santoprene, un élastomère thermoplastique (caoutchouc synthétique), ces ustensiles sont faciles à manipuler et parfaits pour servir toutes sortes de plats : tartes, lasagnes, légumes ou riz. Ces produits sont résistants et supportent le lave-vaisselle. Indispensables au quotidien, ils feront également sensation lors de vos dîners mondains.

All-Clad's *All-Professional* kitchen tool set comprises the five most essential kitchen implements: a large spoon, a large fork, a ladle, a draining spoon and a spatula. The company, however, also manufactures a host of other tools that similarly feature All-Clad's distinctive and ergonomic stainless-steel handles. These high-quality and durable kitchen tools absolutely epitomize the no-nonsense robustness of American design and manufacture.

Das Küchenset *All-Professional* von All-Clad umfasst die fünf wichtigsten Küchenwerkzeuge: einen großen Löffel und eine Fleischgabel, Schöpfkelle, Schaumlöffel und Pfannenwender. Doch auch die zahlreichen anderen Produkte dieses Herstellers sind alle mit dem typischen, ergonomischen Edelstahlgriff ausgestattet. Die hochwertigen, widerstandsfähigen Küchenhelfer sind der vollkommene Inbegriff geradlinigen und stabilen amerikanischen Designs und seiner Verarbeitung.

Ce jeu d'ustensiles *All-Professional* comprend cinq éléments essentiels en cuisine : une grande cuillère, une grande fourchette, une louche, une écumoire et une spatule. All-Clad fabrique d'autres ustensiles à la fonction similaire, qui se distinguent de la concurrence par leurs manches ergonomiques et résistants. D'une grande qualité et extrêmement résistants, ces ustensiles de cuisine illustrent parfaitement l'incontestable robustesse des créations et des fabrications américaines.

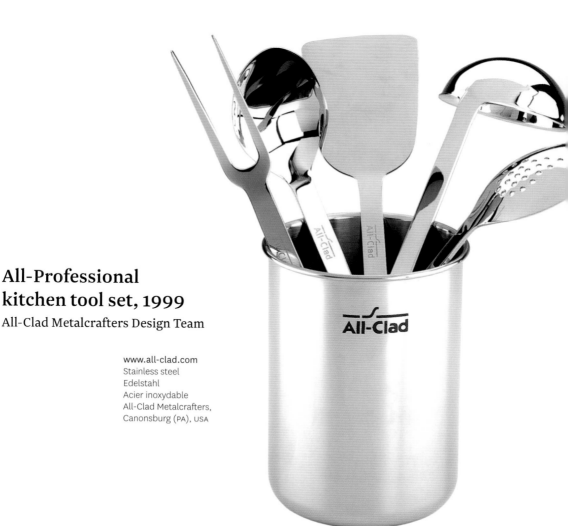

All-Professional kitchen tool set, 1999

All-Clad Metalcrafters Design Team

www.all-clad.com
Stainless steel
Edelstahl
Acier inoxydable
All-Clad Metalcrafters,
Canonsburg (PA), USA

Kitchen utensils with hooks, 1993

Rösle Design Team

www.roesle.de
Stainless steel
Edelstahl
Acier inoxydable
Rösle, Marktoberdorf, Germany

Probably the most comprehensive range of kitchen utensils you can buy, Rösle's series of 'hooked' tools and complimentary racks combines no-nonsense practicality with high-quality manufacture. The range comprises twenty-five utensils, from skimmers and ladles to sausage lifters and spaghetti spoons. Like other Rösle products, these designs have each undergone a rigorous one or two-year development phase to ensure that they meet the exacting demands of the professional sector.

Rösles Serie mit den Haken und passenden Aufhängeleisten ist das wohl umfangreichste Angebot an Küchenwerkzeugen auf dem Markt und kombiniert, schlichte Zweckmäßigkeit mit hochwertiger Verarbeitung. Sie umfasst fünfundzwanzig Utensilien von Schaum- und Schöpfkellen bis hin zu Wurst- und Spaghettihebern. Wie bei allen Rösle-Produkten musste jeder Entwurf eine Testphase von bis zu zwei Jahren durchlaufen, bis seine Eignung für die hohen Ansprüche der Profiküche feststand.

Certainement la plus vaste gamme d'ustensiles de cuisine, la série Rösle « à crochet » combine parfaitement l'aspect fonctionnel et une fabrication de grande qualité. Cette gamme comprend vingt-cinq ustensiles, allant des écumoires et des louches aux pinces à saucisses en passant par les louches à spaghetti. À l'image d'autres produits Rösle, ces créations ont chacune subi une phase de développement rigoureuse d'une ou deux années visant à s'assurer qu'elles répondent bien aux exigences des professionnels.

Kitchen tools, 1997–2000

Sori Yanagi (Japan, 1915–)

www.gatewayjapan.dk
Stainless steel
Edelstahl
Acier inoxydable
Sori Yanagi, Valby, Denmark

Combining functionality with an innate artistry, Sori Yanagi's simple objects possess a rare poetic beauty that elevates the aesthetic standards of homewares. His *Kitchen Tools* range (which includes ladles, a skimmer, turners, and tongs) is produced in the Niigata region of Japan, long famed as a centre for superlative metalworking. Winning the Japanese Good Design Award in 1998, these elegant objects epitomize Yanagi's goal: 'Japanese Design. Universal Use.'

Sori Yanagis schlichte Küchenutensilien kombinieren Funktionalität mit künstlerischer Qualität und sind von seltener poetischer Schönheit. Seine *Kitchen Tools*-Kollektion (Schöpfkellen, Schaumlöffel, Pfannenheber, Kuchenzangen, etc.) werden in der japanischen Stadt Niigata (in der gleichnamigen Präfektur) hergestellt, die seit langem für die Produktion hochwertiger Metallwaren berühmt ist. Yanagis formschöne Geräte wurden 1998 mit dem japanischen Preis für gutes Design ausgezeichnet und sind Ausdruck seines Bestrebens, „japanische Designprodukte für den weltweiten Gebrauch" zu schaffen.

Fonctionnelles et originales, les créations Sori Yanagi sont simples et marquent une grande beauté poétique dans les normes esthétiques des articles ménagers. La gamme *Kitchen Tools* (incluant des louches, une écumoire, un fouet et des pinces) est réalisée dans la région de Niigata au Japon, longtemps réputée comme étant le meilleur centre métallurgiste du pays. Grand gagnant du prix japonais Good Design, ces créations élégantes incarnent l'esprit de Yanagi : « Création japonaise. Utilisation universelle ».

16860 splatter guard, 2002

Rösle Design Team

www.roesle.de
Stainless steel
Edelstahl
Acier inoxydable
⌀ 26, 30, 33.5 cm
Rösle, Marktoberdorf, Germany

This splatter guard is made of high-grade stainless steel, and comes in three different sizes. Like other Rösle kitchenwares, many of which have won awards for their design innovation, this simple tool is extremely well made and is driven by practical considerations – in this case, the long handle keeps hands at a safe distance from hot pans. Unlike inferior designs on the market, this splatter guard will not tarnish or warp, and can also be cleaned easily.

Dieser Spritzschutz aus Hochglanzedelstahl ist in drei Größen erhältlich. Wie andere Rösle-Produkte, von denen viele für ihr innovatives Design prämiert wurden, ist auch dieses simple Küchenwerkzeug qualitativ hochwertig und sehr praxisorientiert gemacht – hier schützt der lange Griff die Hände vor der heißen Pfanne. Anders als ähnliche, minderwertige Produkte auf dem Markt verfärbt oder verformt sich dieser Spritzschutz nicht und lässt sich zudem einfach reinigen.

Cette grille anti projection- en acier inoxydable de grande qualité existe en trois tailles. Comme d'autres ustensiles de cuisine Rösle primés pour leur design novateur, ce modèle privilégie l'aspect fonctionnel. Son long manche assure en effet suffisamment d'espace entre la main et les ustensiles brûlants. Contrairement aux autres produits similaires sur le marché, cette grille ne ternira pas ni ne se déformera. En outre, son nettoyage est un jeu d'enfant.

This professional frying pan is made from hand-cast aluminium and has a titanium-reinforced, non-stick surface that contributes to its exemplary performance in the kitchen. Its specially developed 'thermocore' base means that it can be used on electric rings, gas hobs or even Aga-style hot plates (the exception being induction hobs). The stainless-steel handle of this design is also heat-resistant, which means that this stylish frying pan can also be placed in an oven to keep food warm. The *Titanium 2000 Plus* is offered in six different pan sizes, and with three different options for handle length.

Diese professionelle Bratpfanne aus Aluminium-Handguss mit Titanium verstärkter Antihaft-Oberflächenversiegelung sorgt für perfekte Kochergebnisse. Dank des speziell entwickelten Thermobodens kann sie auf Elektroherden, Gasherden und sogar auf einem Aga-Kochherd verwendet werden (nur nicht auf Induktionsherden). Die Edelstahlgriffe dieses Designs sind hitzeresistent, so dass die stilvolle Bratpfanne auch in den Ofen gestellt werden kann, um Speisen warm zu halten. *Titanium 2000 Plus* wird in sechs verschiedenen Größen und mit drei verschiedenen Grifflängen angeboten.

Cette poêle à frire professionnelle est réalisée en aluminium moulé à la main et possède une surface non adhésive renforcée au titane qui contribue à ses excellentes performances. Avec sa base « thermocore » conçue spécialement, elle peut être utilisée sur les cuisinières électriques, à gaz ou même sur des plaques chauffantes de style Aga (à l'exception des plaques à induction). Sa queue en acier inoxydable résiste à la chaleur, si bien que cette élégante poêle peut également aller au four pour garder les aliments au chaud. Le *Titanium 2000 Plus* existe en six tailles et avec trois différentes longueurs de queue.

Titanium 2000 Plus non-stick frying pan, 1997–1998
SKK Design Team

www.skk-guss.de
Titanium, stainless steel, aluminium
Titan, Edelstahl, Aluminium
Titane, acier inoxydable, aluminium
⌀ 20, 24, 28, 32, 36, 40 cm
SKK Küchen-und Gasgeräte, Viersen-Boisheim, Germany

Diamant 3000 Plus square grill pan, 2005

SKK Design Team

www.skk-guss.de
Titanium, stainless steel, Bakelite
Titan, Edelstahl, Bakelit
Titane, acier inoxydable, bakélite
↔ 26 cm
SKK Küchen-und Gasgeräte, Viersen-Boisheim, Germany

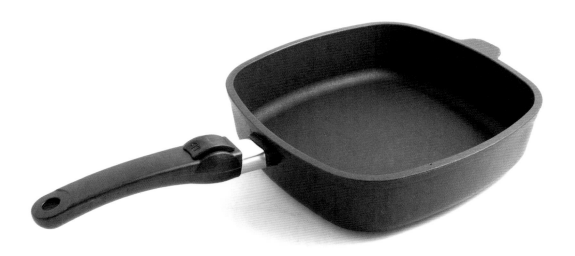

Made from cast aluminium, this professional grill pan boasts a thick, four-layer, non-stick coating both inside and out. As a result, it will not only last a good deal longer than most competing designs on the market, but it will also remain easy to clean. In addition, this useful, high-sided design has a removable handle and a thick base which, unlike cheaper versions, does not deform at high temperatures. Furthermore, the superior manufacture of this pan ensures even heat distribution and enhanced cooking performance.

Diese professionelle Grillpfanne aus Gussaluminium bietet innen wie außen eine dicke, vierschichtige Antihaftbeschichtung. Dadurch hält sie nicht nur wesentlich länger als die meisten anderen Designs auf dem Markt, sie ist auch stets leicht zu reinigen. Außerdem besitzt die nützliche, hochwandige Pfanne einen abnehmbaren Griff und einen dicken Boden, der sich, anders als bei billigeren Modellen, bei hohen Temperaturen nicht verzieht. Die hochwertige Verarbeitung dieser Pfanne sorgt für gleichmäßige Wärmeverteilung und hervorragende Kochergebnisse.

Réalisé en aluminium moulé, ce gril professionnel aux bords hauts possède quatre couches de revêtement anti-adhésif tant à l'intérieur qu'à l'extérieur. Résultat : il dure beaucoup plus longtemps que la plupart des produits équivalents sur le marché tout en restant facile à nettoyer. En outre, il possède un manche amovible et une base épaisse qui, contrairement à des modèles de moins bonne qualité, ne se déforme pas à haute température. L'excellente conception de ce gril assure une distribution uniforme de la chaleur et de très bonnes performances de cuisson.

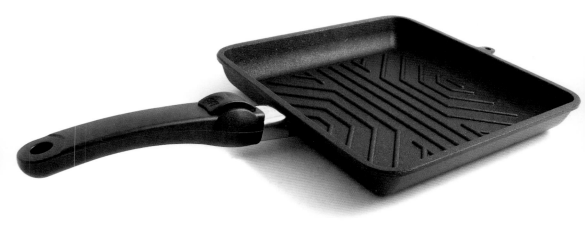

Diamant 3000 Plus grill pan, 2005

SKK Design Team

www.skk-guss.de
Titanium, stainless steel, Bakelite
Titan, Edelstahl, Bakelit
Titane, acier inoxydable, bakélite
↔ 24 cm
SKK Küchen-und Gasgeräte, Viersen-Boisheim, Germany

This German-made grill pan possesses a reassuring, non-nonsense robustness. Unlike most non-stick pans, this model can even be used with metal utensils because of its tough, four-layer 'Titanium 4000' coating. Because the food does not stick readily to the pan's surface, it also means less oil or fat is needed for cooking. The design also has a removable handle, so the pan can be put in an oven to keep its contents warm.

Die *Diamant 300 Plus*-Grillpfanne der deutschen Firma SKK besticht durch ihre Geradlinigkeit und Robustheit. Anders als die meisten anderen Antihaft-Pfannen kann man bei diesem Modell dank der vierfachen Beschichtung aus „Titan 4000" auch Metallutensilien benutzen. Da die Speisen nicht am Pfannenboden kleben bleiben, wird auch weniger Öl oder Fett für die Zubereitung benötigt. Der Griff ist abnehmbar, so dass die Pfanne in den Ofen gestellt werden kann, um Speisen warm zu halten.

Ce gril allemand possède une rassurante robustesse. Contrairement à la plupart des grils antiadhésifs sur le marché, il peut être utilisé avec des ustensiles en métal grâce à ses quatre couches de revêtement en « Titanium 4000 ». Les aliments n'adhérant pas à sa surface de cuisson, il n'est pas nécessaire de rajouter de l'huile ou des matières grasses. Il est équipé d'un manche amovible afin de pouvoir être mis au four pour garder les aliments au chaud.

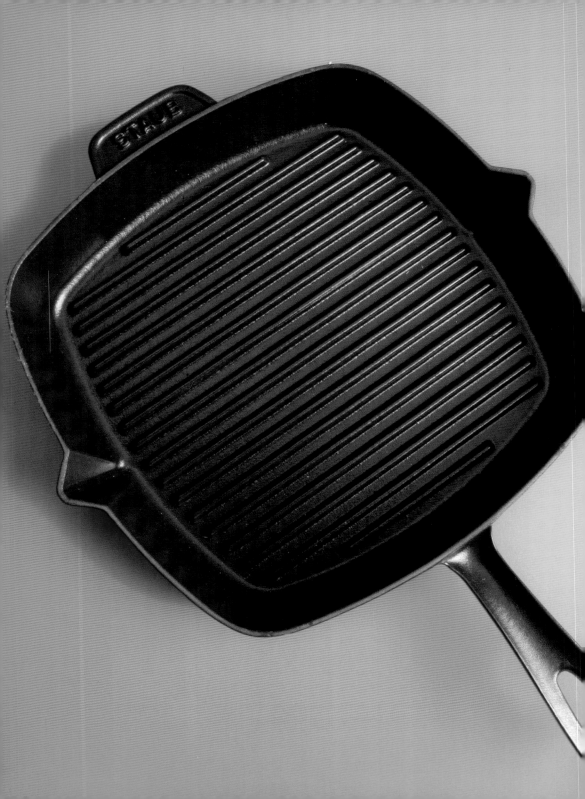

American square grill pan, 2005

Francis Staub (France, active 1970s–2000s)

www.staub.fr
Enamelled cast iron
Emailliertes Gusseisen
Fonte émaillée
↔ 30 cm
Staub, Turckheim, France

Staub manufactures a number of cast-iron grill pans which, when used on the stove top, give meat, fish or vegetables the taste of outdoor grilling. Some of the designs have removable handles so that they can be easily transferred from stove top to oven, and these handles can also be folded for more convenient storage. Using traditional sand-casting techniques, each piece is unique and takes a full day to produce, but the result is some of the best cookware money can buy.

Staub stellt eine Reihe von Grillpfannen aus Gusseisen her, die Fleisch, Fisch und Gemüse einen Geschmack wie vom Holz-kohlegrill verleihen. Einige der Designs haben einen abnehmbaren Griff, so dass sie leicht von der Herdplatte in den Ofen transportiert werden können. Für eine platzsparende Aufbewahrung lassen sich die Griffe außerdem zusammenklap-pen. Dank des Einsatzes traditioneller Sandstrahl-Techniken ist jedes Stück ein Unikat. Die Herstellung dauert einen ganzen Tag, aber das Ergebnis ist eines der besten Kochwerkzeuge, die man für Geld kaufen kann.

Staub produit différents grils en fonte qui, utilisés sur la cuisinière, donnent à la viande, aux poissons ou aux légumes la saveur d'une grillade en plein air. Cer-tains modèles ont un manche amovible afin de pouvoir passer rapidement du brûleur au four. Ces manches se replient pour être rangés plus facilement. Chaque pièce est réalisée selon des techniques traditionnelles dans des moules en sable et nécessite une journée entière de travail, le prix à payer pour un ustensile de cuisine sans pareil.

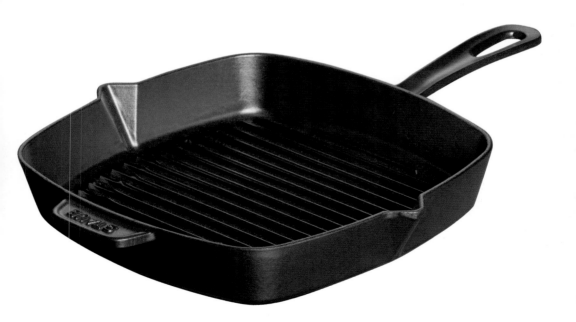

Nambu Tekki saucepan, grill pan & mini brunch pan, 1999

Sori Yanagi (Japan, 1915–)

www.gatewayjapan.dk
Cast iron
Gusseisen
Fonte
Sori Yanagi, Valby, Denmark

Manufactured in Japan, the *Nambu Tekki* pans designed by Sori Yanagi won a Japanese Good Design award in 2001. Their subtle organic forms, with their slightly curved edges, give the designs an enhanced functionality as well as a distinctive beauty. Unlike normal cast iron, Japanese *nambu* cast iron absorbs and distributes heat evenly, making it an ideal material for cookware. Robust and durable, these pans can be used on all kinds of heat sources.

Die in Japan hergestellten, von Sori Yanagi entworfenen Töpfe und Pfannen der Serie *Nambu Tekki* wurden 2001 mit einem japanischen Good Design Award ausgezeichnet. Die subtile organische Form mit den leicht abgerundeten Kanten verleiht dem Design eine hervorragende Funktionalität und eine ganz eigene Ästhetik. Anders als normales Gusseisen absorbiert und verteilt japanisches Nambu die Hitze gleichmäßig und ist somit ein ideales Material für Kochgeschirr. Die robusten und langlebigen Töpfe und Pfannen können auf allen Herdarten verwendet werden.

Fabriquées au Japon, les poêles *Nambu Tekki*, dessinées par Sori Yanagi, ont remporté un prix Japanese Good Design en 2001. Leurs formes organiques subtiles, avec des bords légèrement arrondis, renforcent leur fonctionnalité tout en leur conférant une beauté caractéristique. Contrairement à la fonte ordinaire, la fonte *nambu* japonaise absorbe et répartit la chaleur uniformément, la rendant idéale pour cuisiner. Robustes et durables, ces poêles peuvent être utilisées sur n'importe quelle source de chaleur.

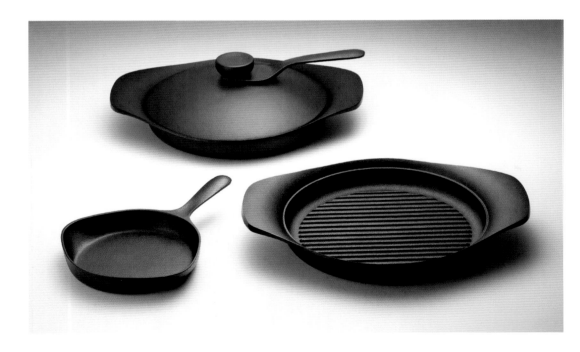

Stainless steel pans & non-stick frying pans, 1990 & 1993

All-Clad Metalcrafters Design Team

www.all-clad.com
Stainless steel, aluminium, non-stick coating
Edelstahl, Aluminium, Antihaftbeschichtung
Acier inoxydable, aluminium, revêtement antiadhésif.
All-Clad Metalcrafters, Canonsburg (PA), USA

All-Clad is held in high esteem across America thanks to the reputation of its premium cookware, which is made using a patented technology for bonding metal. The company's comprehensive *Stainless* range comprises numerous pots and pans of different shapes and sizes from which to make a selection. For example, these three-ply, bonded frying pans have highly durable, non-stick cooking surfaces and, as well as using them on a hob, they are also oven-safe up to 260°C (500°F).

All-Clad genießt in Amerika hohes Ansehen dank des hochwertigen Kochgeschirrs, das mit Hilfe einer patentierten Technologie zur Verbindung von Metall- und Legierungsschichten gefertigt wird. Die umfangreiche *Stainless*-Reihe des Unternehmens umfasst Töpfe und Pfannen von verschiedener Form und Größe. Dazu gehören auch diese, aus drei aufeinander abgestimmten Metallschichten bestehenden Pfannen mit langlebiger Antihaftbeschichtung, die nicht nur auf der Herdplatte, sondern bis 260°C auch im Backofen verwendet werden können.

All-Clad est tenue en haute estime dans tous les États-Unis en raison de l'excellente réputation de ses batteries de cuisine, réalisées avec sa propre technologie brevetée permettant de colaminer l'acier et l'aluminium. Sa vaste gamme *Stainless* comprend de nombreuses pièces de toutes formes et tailles, dont ces poêles comportant trois couches de métal et revêtues d'un antiadhésif. On peut les utiliser sur un feu ouvert mais elles vont également au four jusqu'à 260°C.

America's bestselling premium cookware manufacturer, All-Clad is renowned for the impressive durability and cooking performance of its products. This *sauté* pan and matching saucepans have aluminium cores surrounded by three-ply, bonded stainless steel. This construction method ensures excellent heat distribution and responsive conduction of heat – put simply, they cook brilliantly. Handcrafted in the USA, All-Clad cookware comes with a lifetime warranty.

Amerikas bester Hersteller von Profikochgeschirr heißt All-Clad und ist berühmt für die beeindruckende Langlebigkeit und Leistungsfähigkeit seiner Produkte. Diese Sauteuse und Bratpfanne haben einen Aluminiumkern, umgeben von Verbundmaterial mit dreilagigem Aufbau. Diese Konstruktionsmethode sorgt für hervorragende Wärmeleitung und -verteilung, kurz, mit ihnen lässt sich wunderbar kochen. Auf das von Hand in den USA gefertigte Kochgeschirr wird eine lebenslange Qualitätsgarantie gewährt.

Premier fabricant américain d'articles culinaires haut de gamme, All-Clad est réputé pour l'impressionnante durabilité et performance de ses produits. Ces sauteuses et ces poêles à frire ont un cœur en aluminium entouré de trois couches d'acier inoxydable laminé. Cette structure leur assure une conduction efficace et une distribution uniforme de la chaleur ; autrement dit, elles cuisent merveilleusement. Fabriquées à la main aux États-Unis, les batteries All-Clad sont garanties à vie.

Stainless pots & pans, 1990

All-Clad Metalcrafters Design Team

www.all-clad.com
Stainless steel, aluminium
Edelstahl, Aluminium
Acier inoxydable, aluminium
All-Clad Metalcrafters, Canonsburg (PA), USA

Copper-Core pots & pans, 1999

All-Clad Metalcrafters Design Team

www.all-clad.com
Stainless steel, copper
Edelstahl, Kupfer
Acier inoxydable, cuivre
All-Clad Metalcrafters, Canonsburg (PA), USA

After years of research and development into the bonding of metals, John Ulam discovered that combining dissimilar metals could yield properties that they could never achieve individually. In 1971, he founded All-Clad Metalcrafters and began producing 'bonded' cookware for professional chefs using his patented processes. Today, the company produces a truly comprehensive range of stainless-steel pots and pans, with thick copper cores that distribute the heat evenly.

Nach Jahren der Forschung und Entwicklung zum Thema Metallegierung, entdeckte John Ulam, dass die Kombination unterschiedlicher Metalle zu Eigenschaften führte, die mit einem einzelnen Material nicht erreicht werden konnten. 1971 gründete er das Unternehmen All-Clad Metalcrafters und begann mit der Produktion von Kochwerkzeug nach dem patentierten Verfahren des Roll-Bonding für Profiköche. Heute produziert das Unternehmen eine sehr umfängliche Reihe von Edelstahltöpfen und -pfannen mit dickem Kupferkern, die eine gleichmäßige Wärmeverteilung garantieren.

Après des années de recherches et de développement dans le laminage, John Ulam découvrit que combiner des métaux dissemblables d'une certaine manière permettait d'obtenir des propriétés qu'aucun métal ne pouvait offrir seul. En 1971, il fonda All-Clad Metalcrafters et commença à fabriquer pour des chefs professionnels des ustensiles de cuisine « laminés » avec ses procédés brevetés. Aujourd'hui, la compagnie produit une gamme très complète de casseroles et de poêles en acier inoxydable avec un cœur en cuivre qui diffuse la chaleur uniformément.

M'héritage casserole, sauté pan & saucepan, 1830 (original design)

Mauviel Design Team

www.mauviel.com
Copper, stainless steel, cast iron
Kupfer, Edelstahl, Gusseisen
Cuivre, acier inoxydable, fonte
Mauviel, Villedieu-les-Poêles, France

For centuries, copper pans have been used in the professional kitchens of France to create sublime gourmet food. Building on this tradition, the extensive *M'héritage* range of pots and pans – including this classic sauté pan, saucepan and casserole – combines the good heat conduction properties of traditional copper exteriors with the easy maintenance of modern stainless-steel interiors. Used by top chefs throughout the world, these archetypal cookware designs are available with cast-iron, bronze or stainless-steel handles.

Kupferpfannen werden in den Profiküchen Frankreichs schon seit Jahrhunderten für die Zubereitung erlesener Gourmet-speisen verwendet. Die umfangreiche *M'héritage*-Serie von Töpfen und Pfannen, zu der auch die hier gezeigten klassischen Sautierpfannen und die Kasserolle gehö-ren, baut auf dieser Tradition auf. Die äußere Kupferbeschichtung sorgt für eine gute Wärmleitung, während die Innen-beschichtung aus modernem Edelstahl eine einfache Pflege garantiert. Diese archetypischen Kochwerkzeuge werden von Spitzenköchen auf der ganzen Welt benutzt und sind mit Griffen aus Gussei-sen, Bronze oder Edelstahl erhältlich.

Depuis des siècles, les cuisines profes-sionnelles de France utilisent des poêles en cuivre pour préparer leurs recettes sublimes. S'inspirant de cette tradition, la vaste gamme *M'héritage*, qui inclut cettes sauteuses et ce faitout, associe les propriétés de conduction de chaleur d'une coque en cuivre à l'entretien facile d'un intérieur en acier inoxydable. Uti-lisées par les plus grands chefs à travers le monde, ces batteries archétypales existent avec des poignées en fonte, bronze ou inox.

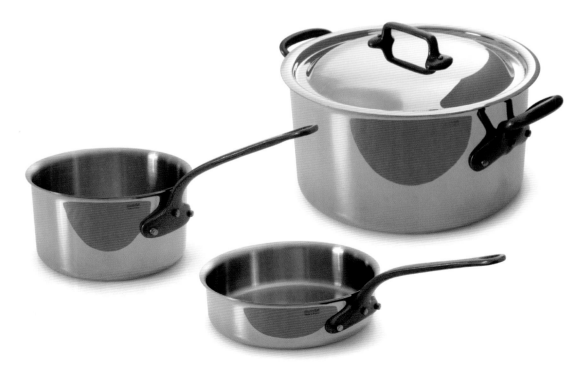

Copper-Core seven-quart stockpot, c. 1999

All-Clad Metalcrafters Design Team

www.all-clad.com
Stainless steel, copper
Edelstahl, Kupfer
Acier inoxydable, cuivre
All-Clad Metalcrafters, Canonsburg (PA), USA

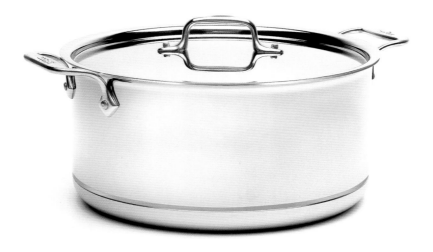

All-Clad Metalcrafters' *Copper-Core* range of pots and pans are made from a unique five-ply, bonded construction of stainless steel and copper. The stainless steel is easy to clean and non-reactive, while the copper core gives optimum heat distribution. Handcrafted in America, the collection is sold with a lifetime guarantee, and includes: saucepans, *sauté* pans, a lidded Dutch oven, a *sauteuse*, *sauciers*, a buffet casserole, lidded casseroles, an open roaster, a butter warmer, a *cassoulet* and, shown here, the seven-quart (6.4-litre) stockpot.

Die Töpfe und Pfannen der Serie *Copper-Core* von All-Clad Metalcrafters bestehen aus einer einzigartigen fünflagigen Verbindung von Edelstahl und Kupfer. Der Edelstahl ist leicht zu reinigen und ist induktionsfrei, während der Kupferkern für optimale Wärmeleitung sorgt. Die in Amerika von Hand gefertigte Kollektion wird mit einer lebenslangen Qualitätsgarantie verkauft und umfasst Töpfe, Sauteusepfannen, einen holländischen Topf, eine Sauteuse, Saucieren, eine Kasserolle mit Stiel, Kasserollen mit Deckel, eine Bratreine, einen Butterwärmer, einen Schmortopf und den hier gezeigten Suppentopf mit 6,4 Liter Fassungsvermögen.

Toutes les casseroles et les poêles de la gamme *Copper-Core* de All-Clad reposent sur un procédé unique de laminage à cinq couches d'acier inoxydable et de cuivre. L'inox est facile à nettoyer et non réactif, tandis que le cœur en cuivre assure une distribution optimale de la chaleur. Fabriquée à la main aux États-Unis, la gamme est garantie à vie et inclut des casseroles, des plats à sauter, des marmites avec couvercle, une sauteuse, des saucières, une casserole à buffet, des faitouts, une rôtissoire, un chauffe-beurre, une marmite à cassoulet et, montrée ici, une marmite de bouillon de 6,4 litres.

Volcanic casserole, 1925

Le Creuset Design Team

www.lecreuset.com
Enamelled cast iron
Emailliertes Gusseisen
Fonte émaillée
Various sizes
Le Creuset, Fresnoy-le-Grand, France

Le Creuset's *Volcanic* collection is the quintessential range of French cast-iron pots and pans. Unbelievably durable and superb for slow cooking, the company's first, orange-enamelled *cocotte* (casserole) was launched in 1925. Since then, the range has grown and new colours have been introduced. Even today, after the pans have been cast, the majority of the finishing is done by hand in order to give as smooth a surface as possible for the subsequent high-fired enamelling.

Die Kollektion *Volcanic* des Herstellers Le Creuset ist der Inbegriff französischer Gusseisentöpfe und -pfannen. Die erste Cocotte in orangefarbenem Emaille kam 1925 auf den Markt. Seitdem ist die Serie stetig angewachsen und neue Farben sind hinzugekommen. Noch heute werden die Pfannen nach dem Guss überwiegend von Hand weiter bearbeitet, um die Oberfläche für den anschließenden Brennvorgang so glatt wie möglich zu machen.

La collection *Volcanic* de Le Creuset est le *nec plus ultra* en matière de batteries de cuisine en fonte. Incroyablement résistante et idéale pour cuire à petit feu, la première cocotte en émail orange de la compagnie fut présentée en 1925. Depuis, la gamme s'est élargie et de nouvelles couleurs ont été introduites. Aujourd'hui encore, après le moulage des pièces, le plus gros des finitions est réalisé à la main afin d'obtenir une surface la plus lisse possible avant l'émaillage.

The Staub company can trace its origins back to 1892, when a cookery store was opened in Alsace. However, it was not until 1974 that the founder's grandson, Francis Staub, purchased a nearby cast iron foundry and began manufacturing distinctive cooking pots to his own design. Unlike other, better-known cast-iron cookware, Staub pots and pans, such as these self-basting casseroles, have a matt-black enamel coating, which makes them virtually indestructible and highly resistant to chipping.

Die Geschichte des Unternehmens Staub beginnt 1892, als im Elsass ein Geschäft für Kochgeschirr eröffnet wurde. Aber erst 1974 kaufte der Enkel des Gründers, Francis Staub, eine nahegelegene Eisengießerei und begann mit der Herstellung von unverwechselbarem Kochgeschirr nach eigenen Entwürfen. Im Gegensatz zu anderen, besser bekannten Kochwerkzeugen aus Gusseisen haben Töpfe und Pfannen von Staub – wie diese Schmortöpfe – eine mattschwarze Emaillierung, die sie so gut wie unzerstörbar und widerstandsfähig gegen Absplitterungen macht.

La maison Staub existe depuis 1892, quand la première boutique d'ustensiles de cuisine ouvrit ses portes en Alsace. Toutefois, ce ne fut qu'en 1974 que le petit-fils du fondateur, Francis Staub, racheta une fonderie voisine et commença à fabriquer ses propres casseroles. Contrairement à d'autres batteries en fonte plus connues, celles de Staub, qui incluent ces cocottes, ont un revêtement en émail noir mat qui les rend virtuellement indestructibles et leur évite de s'écailler.

Cocotte casserole, 1974

Francis Staub (France, active 1970s–2000s)

www.staub.fr
Enamelled cast iron, brass or stainless steel
Emailliertes Gusseisen, Messing oder Edelstahl
Fonte émaillée, laiton ou acier inoxydable
0.25 l, 0.8 l, 1.4 l, 1.71 l, 2.24 l, 3.81 l, 4.6 l, 5.85 l, 8.35 l
Staub, Turckheim, France

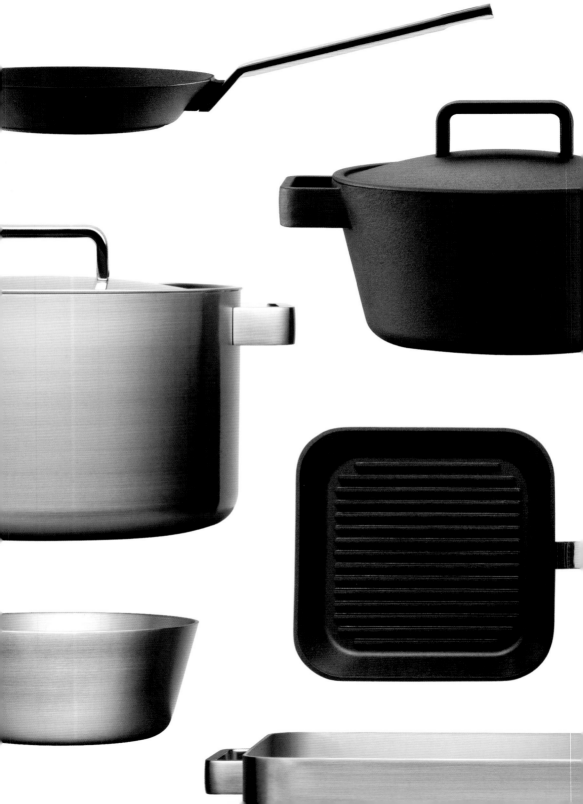

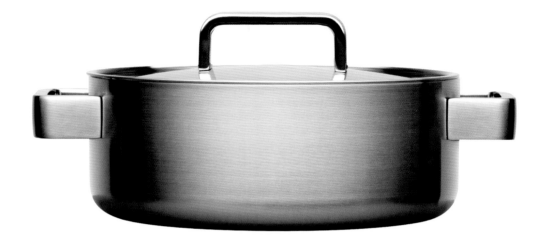

Tools cookware, 1998

Björn Dahlström (Sweden, 1957–)

www.iittala.com
Multi-layered stainless steel or cast iron
Mehrschichtiges Edelstahl oder Gusseisen
Acier inoxydable ou fonte appliqué en plusieurs couches
Iittala, Iittala, Finland

The *Tools* range is simply beautiful and superbly functional – in fact the fifteen pots and pans look so good, with their sturdy handles and satin-finished stainless steel or blackened cast-iron surfaces, that they can also be used to serve food. During their development, Dahlström worked with professional chefs and materials specialists to ensure that only the best and most appropriate materials according to potential use were utilized for each product.

Die *Tools*-Reihe ist einfach schön und äußerst funktionell. Die fünfzehn Töpfe und Pfannen mit ihren massiven Griffen und der Oberfläche aus satiniertem Edelstahl oder schwarzem Gusseisen sehen so gut aus, dass man darin auch Speisen servieren kann. Bei ihrer Entwicklung arbeitete Dahlström mit Profiköchen und Materialspezialisten zusammen, um sicherzustellen, dass für jedes Produkt nur die besten und der potenziellen Nutzung angemessenen Materialien verwendet werden.

La gamme *Tools* est tout simplement superbe et merveilleusement fonctionnelle ; de fait, les quinze casseroles et poêles qui la composent sont si belles, avec leurs robustes poignées, leur acier satiné ou leur fonte noire, qu'on peut les apporter à table. Pour les concevoir, Dahlström a collaboré avec des chefs professionnels et des spécialistes en métallurgie afin de s'assurer que seuls seraient utilisés les matériaux les meilleurs et les mieux adaptés à chaque produit selon ses usages potentiels.

Kokki casserole, 1978

Tapio Yli-Viikari (Finland, 1948–)

www.arabia.fi
Glazed ceramic
Glasierte Keramik
Céramique émaillée
2.25 l, 3.25 l
Arabia/Iittala Group, Helsinki, Finland

As Director of the Ceramics and Glass Department at the University of Art and Design in Helsinki, Tapio Yli-Viikari understands both the aesthetic and manufacturing requirements of the ceramics industry. His wonderful *Kokki* casserole has been stripped of any extraneous detailing and, as such, possesses an ideal form guided by functional considerations. It is the three-dimensional realization of his belief that, 'Appropriateness is beauty'.

Als Leiter des Fachbereichs Glas und Keramik an der University of Art and Design in Helsinki weiß Tapio Yli-Viikari sowohl um die ästhetischen als auch um die fertigungstechnischen Anforderungen der Keramikindustrie. Seine wunderschöne Kasserolle *Kokki* kommt ohne überflüssige Details aus und besitzt daher eine ideale, von funktionellen Überlegungen geprägte Form. Sie ist die dreidimensionale Umsetzung seiner Überzeugung: „Angemessenheit ist Schönheit".

Directeur du département céramique et verrerie de l'université d'art et de design d'Helsinki, Tapio Yli-Viikari comprend l'esthétique et les exigences de l'industrie de la céramique. Dépouillée de tout détail superflu, sa merveilleuse cocotte *Kokki* possède une forme idéale guidée par des considérations fonctionnelles. Elle constitue la concrétisation tridimensionelle de son credo : « Ce qui est approprié est beau. »

Sarpaneva cooking pot, 1960
Timo Sarpaneva (Finland, 1926–2006)

www.iittala.com
Enamelled cast iron, wood
Emailliertes Gusseisen, Holz
Fonte émaillée, bois
3 l
Iittala, Iittala, Finland

Timo Sarpaneva's grandfather was a blacksmith, and as a child he spent time in his forge watching ore magically turn into molten metal. As an adult, this formative experience would lead him to design a stylish and modern interpretation of the traditional, cast-iron cooking pot. Although a basic and essential kitchen item, Sarpaneva was able to bring innovation to his design with a detachable wooden handle that can be used to carry the pot, and also to remove its lid when hot.

Timo Sarpanevas Großvater war Schmied, und als Kind verbrachte er viel Zeit in dessen Schmiede, wo er zusah, wie sich Eisenerz wie durch Magie in geschmolzenes Metall verwandelte. Diese prägende Erfahrung führte dazu, dass er als Erwachsener eine elegante und moderne Interpretation des traditionellen Guss-eisentopfes entwarf. Dabei handelt es sich zwar um ein einfaches und unentbehrliches Küchengerät, aber mit dem abnehmbaren Holzgriff, mit dem man den Topf tragen und den Deckel abheben kann, wenn er heiß ist, verlieh Sarpaneva seinem Design etwas Innovatives.

Enfant, Timo Sarpaneva passait de longues heures dans la forge de son grand-père à regarder les minerais se transformer comme par magie en métal fondu. Adulte, cette expérience formatrice l'a conduit à dessiner cette élégante interprétation moderne de la cocotte en fonte traditionnelle. Il innova cet ustensile de cuisine basique et essentiel en lui ajoutant une poignée en bois amovible qui permet de transporter la cocotte mais aussi de soulever son couvercle sans se brûler.

Pyrex lidded casserole, c.1915 (original design)

Corning Design Team

www.pyrex.com
Pyrex®
Pyrex®
Pyrex®
0.75 l, 1.25 l, 2 l
Corning, Corning (NY), USA

Pyrex® is a type of borosilicate glass that can withstand temperatures up to 300 °C (572 °F). It is also microwave, freezer and dishwasher safe, and stain resistant – making it a highly versatile material for cookware. Easily indentified by its clean lines and slight azure tint, *Pyrex* cookware, such as this classic lidded casserole, is exceptionally functional, eminently affordable and extremely durable.

Pyrex® ist ein Borosilikatglas mit einer Temperaturbeständigkeit von bis zu 300 °C. Es ist nicht nur für Mikrowelle, Gefrierschrank und Spülmaschine geeignet, sondern auch schmutzabweisend und damit ein äußerst vielseitiges Material für Kochgeschirr. Pyrex-Kochgeschirr lässt leicht an den klaren Linien und dem leicht bläulichen Farbton erkennen, so auch diese klassische Kasserolle mit Deckel. Es ist äußerst funktionell, durchaus erschwinglich und extrem haltbar.

Le Pyrex® est un type de verre borosilicate qui peut supporter des températures allant jusqu'à 300 °C. Il résiste aux taches, peut aller au micro-ondes, au congélateur et au lave-vaisselle ; en somme, c'est un matériau extrêmement pratique pour la cuisine. Facilement reconnaissable à ses lignes pures et sa teinte bleutée, la batterie *Pyrex*, qui inclut cette cocotte classique, est extrêmement fonctionnelle, éminemment bon marché et exceptionnellement durable.

Pyrex bakeware, c. 1915 (original design)

Corning Design Team

www.pyrex.com
Pyrex®
Pyrex®
Pyrex®
Various sizes
Corning, Corning (NY), USA

Pyrex bakeware is such a ubiquitous item in so many homes that we have come to take it for granted, and tend to overlook its many attributes. Designed from a completely rational aspect and honed over decades, these classic designs are superbly adapted to their roles. Impressively robust and democratically inexpensive, with proper care they should last a lifetime.

Pyrex-Ofenprodukte sind heute in so vielen Haushalten zu finden, dass wir sie für selbstverständlich halten und ihre vielen guten Eigenschaften schon gar nicht mehr bemerken. Nach absolut rationalen Gesichtspunkten entwickelt und über die Jahrzehnte beständig verbessert, erfüllen diese klassischen Designs ihre Aufgabe optimal. Sie sind erstaunlich robust, demokratisch preisgünstig und halten bei richtiger Pflege ein Leben lang.

Les moules et les plats Pyrex sont si communs dans toutes les maisons qu'on ne leur prête guère d'attention et qu'on oublie leurs nombreuses qualités. Avec leur aspect très rationnel affiné au fil des décennies, ces plats classiques sont merveilleusement adaptés à leur fonction. D'une remarquable robustesse et d'un prix démocratique, s'ils sont bien entretenus, ils sont littéralement inusables.

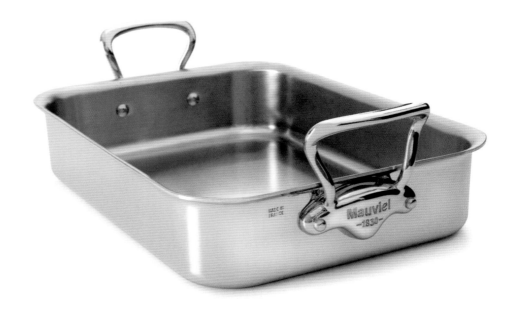

M'cook roasting pan, 2003

Mauviel Design Team

www.mauviel.com
Stainless steel, aluminium
Edelstahl, Aluminium
Acier inoxydable, aluminium
↕ 7 cm ↔ 35 cm ⤢ 25 cm
↕ 8.5 cm ↔ 40 cm ⤢ 30 cm
Mauviel, Villedieu-les-Poêles, France

This sturdy, stainless-steel roasting pan has an aluminium core that provides excellent heat conductivity which, in turn, means an even cooking temperature and better performance all round. Designed to last a lifetime, the roaster has large handles that are easy to grip when using oven mitts. It is made to exacting and traditionally artisanal standards by Mauviel, a French company based near Mont Saint Michel that has specialized in the production of superlative cookware since 1830.

Dieser massive Bräter aus Edelstahl hat einen Boden mit Aluminiumkern, der für hervorragende Wärmeleitung und damit für eine gleichmäßige Kochtemperatur und insgesamt bessere Ergebnisse sorgt. Dank der großen Griffe lässt er sich mit Ofenhandschuhen sicher anfassen. Er ist eine Anschaffung fürs Leben und wird nach strengen traditionellen Standards von Mauviel angefertigt, einem französischen Unternehmen in der Nähe des Mont Saint Michel, das seit 1830 auf die Produktion hochwertiger Kochwerkzeuge spezialisiert ist.

Cette rôtissoire en acier inoxydable possède un cœur en aluminium qui assure une excellente conduction de la chaleur ; cela signifie des températures de cuisson plus uniformes et donc de meilleures performances. Conçue pour durer toute une vie, elle est équipée de grandes poignées faciles à saisir avec des maniques. Elle est fabriquée selon des critères rigoureux artisanaux par Mauviel, une compagnie basée dans la baie du Mont-Saint-Michel et spécialisée dans les ustensiles de cuisine haut de gamme depuis 1830.

Established in 1818, Pillivuyt is one of the leading producers of fine white porcelain in France. The simplicity of its ceramic forms and the absence of any colour or decoration ensure that food is shown to its best advantage – a blank canvas on which the art of fine cuisine can be displayed. These heat-resistant dishes can be used for baking as well as serving, and stack efficiently for storage.

Das 1818 gegründete Unternehmen Pillivuyt ist einer der führenden französischen Hersteller von feinem weißem Porzellan. Die Schlichtheit der Keramikformen und der Verzicht auf jegliche Farbe und Dekoration sorgen dafür, dass die darin servierten Speisen vorteilhaft zur Geltung kommen – eine weiße Leinwand, auf der die Kunst der feinen Küche dargestellt werden kann. Dieses feuerfeste Geschirr lässt sich nicht nur zum Backen und Servieren benutzen, sondern auch platzsparend stapeln.

Fondée en 1818, Pillivuyt est l'une des plus anciennes et plus prestigieuses marques de porcelaine française. La simplicité de ses formes en céramique et l'absence de toute couleur ou décoration met en valeur les aliments. Cette élégance sobre offre une toile vierge sur laquelle l'art de la cuisine fine resplendit. Résistants à la chaleur, ces plats s'utilisent aussi bien pour la cuisson que pour le service. Empilables, ils s'avèrent faciles à ranger.

Sancerre baking/roasting dishes, 1986

Michel Roux (France, 1951–)

www.pillivuyt.fr
Fireproof hardened china
Feuerfestes Hartporzellan
Porcelaine réfractaire
↔ 44.5, 37.5 cm
Pillivuyt, Mehun-sur-Yèvre, France

Oval stackable dishes, 1999

Francis Staub (France, active 1970s–2000s)

www.staub.fr
Enamelled cast iron
Emailliertes Gusseisen
Fonte émaillée
↔ 15, 21, 24, 28, 32 cm
Staub, Turckheim, France

Admired by many celebrated world-class chefs, Staub cookware is not only highly durable but also enables good heat distribution and retention, thereby enhancing the flavours of what is being prepared. Every piece of cookware produced by the company has been personally designed by its founder, Francis Staub, and is individually produced in a sand mould, which is destroyed after each casting. These restaurant-quality roasting dishes are perfect for cooking a wide array of foods, and nest into one another for efficient storage.

Kochgeschirr von Staub ist bei vielen berühmten Spitzenköchen auf der ganzen Welt gefragt. Es ist nicht nur äußerst langlebig, sondern verteilt und hält die Hitze auch so gut, dass die Geschmacks-qualitäten der Zutaten optimal erhalten werden. Jedes einzelne Produkt des Unternehmens wird von Gründer Francis Staub persönlich entwickelt und individuell in einer Sandform gegossen, die anschließend zerstört wird. Diese Bräter in Profiqualität eignen sich perfekt für die Zubereitung einer Vielzahl von Speisen und lassen sich platzsparend stapeln.

Admirées par de nombreux grands chefs à travers le monde, les batteries de cuisine de Staub sont très résistantes et assurent une bonne distribution et rétention de la chaleur, faisant ressortir les saveurs des plats. Chaque pièce produite par la compagnie a été conçue par son fondateur, Francis Staub. Elle est fabriquée individuellement dans un moule en sable qui est ensuite détruit. Ces plats à four de qualité professionnelle peuvent cuire une vaste gamme d'aliments et se rangent facilement en s'emboîtant les uns dans les autres.

L25W3-3630 wok, 1992 (original design)

Le Creuset Design Team

www.lecreuset.com
Enamelled metal, heat-resistant glass, plastic
Emailliertes Metall, hitzebeständiges Glas, Kunststoff
Métal émaillé, verre réfractaire, plastique
⌀ 36 cm
Le Creuset, Fresnoy-le-Grand, France

Part of Le Creuset's *International Range*, this elegant wok was designed specifically for oriental cooking and has a flat base for maximum heat efficiency and stability. Unlike traditional round-based woks, this design is suitable for all types of hobs and is also oven, grill, freezer and dishwasher safe. It can also be used for steaming, poaching and braising, and comes with a handy see-through, heat-resistant cover. The *L25W3-3630* is available in orange, blue, red, grey and black.

Dieser elegante, zur *International Range* von Le Creuset gehörende Wok wurde eigens für die Zubereitung orientalischer Gerichte entworfen und hat einen flachen Boden für optimale Wärmeverteilung und Standfestigkeit. Anders als traditionelle Woks mit abgerundetem Boden kann dieses Design auf allen Herdplatten benutzt werden und ist für Ofen, Grill, Gefrierschrank und Spülmaschine geeignet. Er lässt sich auch zum Dämpfen, Pochieren und Schmoren verwenden und wird mit einem praktischen transparenten Deckel geliefert. Der *L25W3-3630* ist in Orange, Blau, Rot, Grau und Schwarz erhältlich.

Appartenant à la gamme *International Range* de Le Creuset, cet élégant wok a été conçu spécifiquement pour la cuisine orientale et possède une base plate qui lui assure une stabilité maximale et une excellente répartition de la chaleur. Contrairement à d'autres woks à base ronde, il s'adapte à tous les types de feu, peut aller au four, sur le gril, dans le congélateur et au lave-vaisselle. On peut également l'utiliser pour cuire à la vapeur, pocher et braiser. Il s'accompagne d'un couvercle transparent en verre réfractaire. Le *L25W3-3630* existe en orange, bleu, rouge, gris et noir.

Stainless steamer set, 1990s

All-Clad Metalcrafters Design Team

www.all-clad.com
Stainless steel
Edelstahl
Acier inoxydable
11.35 l
All-Clad Metalcrafters, Canonsburg (PA), USA

Probably the best steamer money can buy, this versatile All-Clad design is extremely durable and, according to the testimonies of users, it performs exceptionally well. Perfect for steaming vegetables when used with its steamer insert, this sturdy pan can also be used by itself as a traditional saucepan. All-Clad also manufactures a smaller, 2.5-quart (2.3-litre) version, which is the perfect size for smaller families.

Dieses vielseitige Design von All-Clad ist vermutlich der beste Kochtopf mit Dämpfeinsatz, den man für Geld kaufen kann. Er ist extrem langlebig und hat nach Aussagen von Benutzern hervorragende Kocheigenschaften. Der Dampfeinsatz ist perfekt geeignet zum Dünsten von Gemüse, aber der massive Topf kann auch alleine wie eine traditionelle Kasserolle genutzt werden. All-Clad bietet auch eine 2,3-Liter-Version an, die besonders für kleinere Familien interessant ist.

Probablement la meilleure marmite à la vapeur sur le marché, cet ustensile produit par All-Clad est extrêmement durable et, selon les témoignages d'utilisateurs, exceptionnellement performante. Idéale pour cuire à la vapeur les légumes placés dans son panier intérieur, elle peut également être utilisée comme une casserole traditionnelle. All-Clad propose également une version de 2,3 litres, la taille parfaite pour une petite famille.

Good Grips pop-up steamer, 2006

Bally Design (USA, est. 1972)

www.oxo.com
Stainless steel, Santoprene
Edelstahl, Santopren
Acier inoxydable, Santoprene
⌀ 17.8 cm
OXO International, New York (NY), USA

Although there has been a trend in recent years to use electric steamers, they actually take up a lot of cupboard space when not in use, and their cooking results can be a bit haphazard – vegetables often seem more stewed than steamed. Instead, this simple pop-up steamer is not only compact for storage, but also gives excellent cooking results: less is sometimes more.

Zwar ging der Trend in den letzten Jahren zum elektrischen Dampfgarer, doch dieser nimmt, wenn man ihn gerade nicht braucht, ziemlich viel Platz im Schrank ein, und auch das Kochergebnis ist manchmal mehr Glückssache – so ist das Gemüse hinterher meistens eher geschmort als gedämpft. Dieser einfache, ausklappbare Dämpfeinsatz dagegen lässt sich nicht nur platzsparend lagern, sondern liefert auch noch ein optimales Kochergebnis: Weniger ist eben manchmal mehr.

Depuis ces dernières années, les cuiseurs à vapeur électriques connaissent un véritable succès. Leur principal inconvénient est lié à leur encombrement. Leur cuisson n'est pas non plus aussi précise qu'on le souhaiterait. Les légumes, par exemple, paraissent mieux cuits à l'étouffée qu'à la vapeur. Dans le cas présent, le panier intérieur cuit-vapeur se replie, facilitant ainsi son rangement, tandis que sa qualité de cuisson approche la perfection.

In 1919, Wilhelm Ferdinand Kaiser began manufacturing a small range of European-style bakeware items that incorporated his new 'springform' invention, which allowed the easy release of baked cakes or tortes. Today, the business he founded produces over thirty different *Springform* pans, all of which are manufactured with steel bases. This, in the words of the company, 'provides even and gentle heat distribution for the even browning and baking generally found in professional kitchens … so you can produce a perfectly moist, tender cake'.

Im Jahr 1919 begann Wilhelm Ferdinand Kaiser mit der Herstellung einer kleinen Auswahl von Backformen und Backzubehör. Dazu gehörte auch seine neue Erfindung, die Springform, aus der sich Kuchen und Torten leicht lösen lassen. Heute produziert das von ihm gegründete Unternehmen über dreißig verschiedene Springformen, alle mit Edelstahlboden. Dies „ermöglicht eine gleichmäßige und sanfte Hitzeverteilung für gleichmäßiges Bräunen und Backen, wie es in professionellen Küchen üblich ist … um einen saftigen, zarten Kuchen zu erhalten."

En 1919, Wilhelm Ferdinand Kaiser se lança dans la production d'une petite gamme de plats et moules à gâteaux de style européen qui intégrait sa nouvelle invention, la forme « springform », qui permettait de démouler facilement les cakes et tartes. Aujourd'hui, la maison qu'il a fondée propose plus de trente moules *Springform*, tous avec des bases en acier. Ces derniers, pour reprendre les termes de la compagnie, « diffusent la chaleur de façon douce et régulière pour une cuisson uniforme et des surfaces dorées à souhait dignes de cuisines professionnelles… Vos gâteaux seront parfaitement moelleux et onctueux ».

Springform bakeware, 1919
Wilhelm Ferdinand Kaiser (Germany, active 1910s)

www.kaiserbakeware.com
Stainless steel
Edelstahl
Acier inoxydable
Various sizes
WF Kaiser, Diez, Germany

Original Zeroll ice-cream scoop, 1933

Sherman Kelly (USA, 1869–1952)

www.zeroll.com
Aluminium alloy
Aluminiumlegierung
Alliage d'aluminium
↕ 18 cm
Zeroll, Fort Pierce (FL), USA

Simply the best ice-cream scoop in the world, Zeroll's classic design has been in continuous production for more than seventy years. Designed by the inventor Sherman L Kelly, it uses a heat-conductive liquid in the handle which, when warmed by the hand, assists the bowl to release even the hardest ice cream. Its superior performance and indestructibility make it the scoop of choice in ice-cream parlours across America.

Zerolls Klassiker wird seit über siebzig Jahren produziert und ist schlicht und einfach der beste Eisportionierer der Welt. Sherman L. Kelly, sein Erfinder, hat ihn mit einer Flüssigkeit versehen, die sich beim Kontakt mit der Hand erwärmt und es so ermöglicht, auch die härteste Eiscreme aus dem Behälter zu schöpfen. Seine hervorragende Leistung und Unzerstörbarkeit machen ihn zum beliebtesten Portionierer in amerikanischen Eissalons.

Mondialement connue, cette cuillère à glace du Zeroll, créée par Sherman L. Kelly, est fabriquée depuis plus de soixante-dix ans. Sa poignée contient un fluide réagissant à la chaleur de la main qui permet de faire de belles boules même dans les crèmes glacées les plus dures. Cette cuillère à la fois performante et indestructible est l'outil indispensable des « scooper » chez les glaciers américains.

Epitomizing the effortless sophistication of Danish Modernism, Arne Jacobsen's ice bucket and matching tongs are made from high-grade, satin-polished stainless steel, and the former comes in two sizes: one litre and 2.5 litres. As part of Stelton's well-known *AJ Cylinda Line*, the ice bucket and tongs perfectly compliment other designs from the range, including a serving tray and a revolving ashtray.

Arne Jacobsens Eiseimer und die passende Zange verkörpern die schlichte Raffinesse modernen dänischen Designs. Beide sind aus hochwertigem satinierten Edelstahl, und der Eimer ist in den beiden Größen 1l und 2,5l erhältlich. Sie sind die perfekte Ergänzung zu den anderen Objekten aus Steltons bekannter *AJ Cylinda Line*, wie zum Beispiel einem Serviertablett und einem Aschenbecher mit drehbarer Schale.

Véritable symbole du Modernisme minimaliste danois, ce seau à glace et cette pince d'Arne Jacobsen en inox brossé, de grande qualité, existe en deux tailles : un litre et 2,5 litres. Appartenant à la série *AJ Cylinda Line*, ce seau à glace et sa pince complètent à merveille les autres créations de cette collection, incluant un plateau et un cendrier à bascule.

AJ Cylinda Line ice bucket & tongs, 1967

Arne Jacobsen (Denmark, 1902–1971)

www.stelton.com
Stainless steel
Edelstahl
Acier inoxydable
1 l, 2.5 l
Stelton, Copenhagen, Denmark

16850 trivets, 1997

Rösle Design Team

www.roesle.de
Stainless steel, silicone
Edelstahl, Silikon
Acier inoxydable, silicone
⌀ 12, 18, 25 cm
Rösle, Marktoberdorf, Germany

Rösle's trivets fit into each other for compact storage, and can either be used individually as separate rings or together, in which configuration they resemble a target. Each of the three circular trivets has silicone feet to protect the surface underneath from heat or scratching. Like other Rösle products, these useful designs are also beautiful objects in their own right, and will enhance any kitchen.

Zur platzsparenden Aufbewahrung lassen sich Rösles Tischringe ineinander legen und können entweder einzeln oder gemeinsam – so sehen sie wie eine Zielscheibe aus – verwendet werden. Jeder der drei runden Untersetzer steht auf Silikonfüßen, um die Tischplatte vor Hitze und Kratzern zu schützen. Wie viele andere Rösle-Produkte sind diese Objekte nicht nur nützlich, sondern sehen auch für sich genommen gut aus und werten jede Küche auf.

Afin de faciliter le rangement, les dessous-de-plat Rösle s'emboîtent les uns aux autres, mais peuvent être utilisés séparément. En forme de cible, ces modèles ont des pieds en silicone, empêchant de rayer la table et évitant la transmission de chaleur entre le récipient et la surface de la table. À l'image d'autres produits fonctionnels Rösle, ces créations sont de beaux objets qui embellissent la cuisine.

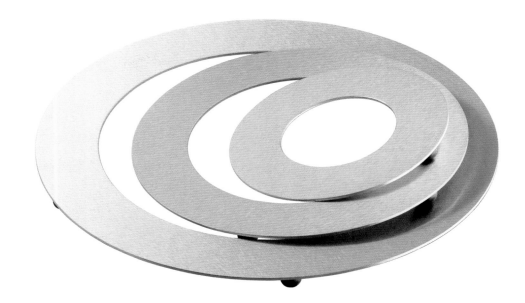

Dé(s)licieux cake knife, 2006

Matali Crasset (France, 1965–) & Pierre Hermé (France, 1961–)

www.forge-de-laguiole.com
Stainless steel, silicone
Edelstahl, Silikon
Acier inoxydable, silicone
Forge de Laguiole, Laguiole, France

Since the late 1980s, the Forge de Laguiole has commissioned various leading French designers to create superior contemporary tools for living.
In 2006, Matali Crasset collaborated with the famous Parisian pastry chef, Pierre Hermé, to create the innovative *Dé(s)licieux* cake knife. This exquisite kitchen implement not only slices *les gateaux* perfectly, but serves them up rather wonderfully too. Comfortable to hold with its softly contoured two-tone handle, this cake knife is also an object of beauty in its own right.

Seit Ende der 1980er Jahre arbeitet Forge de Laguiole mit führenden französischen Designern zusammen, die hochwertige moderne Utensilien für den täglichen Gebrauch gestalten. So entstand in Zusammenarbeit der Designerin Matali Crasset 2006 und des berühmten Pariser Patissiers Pierre Hermé das innovative *Dé(s)licieux* Kuchenmesser. Mit diesem exquisiten Kücheninstrument lässt sich der Kuchen nicht nur perfekt schneiden, sondern auch vollendet servieren. Dank der weichen Konturen des zweifarbigen Griffes liegt dieses wirklich schöne Messer auch sehr gut in der Hand.

Depuis les années 80, la Forge de Laguiole fait appel aux plus grands designers français afin de créer des outils contemporains de grande qualité. En 2006, Matali Crasset collabore avec la star de la pâtisserie parisienne, Pierre Hermé, dans le but de concevoir cet innovant couteau à dessert *Dé(s)licieux*. Cette ingénieuse création permet non seulement de découper un gâteau, mais également de le servir avec élégance. Son manche bicolore en silicone offre un maintien idéal. *Dé(s)licieux* reflète une ligne pure, un design professionnel et généreux.

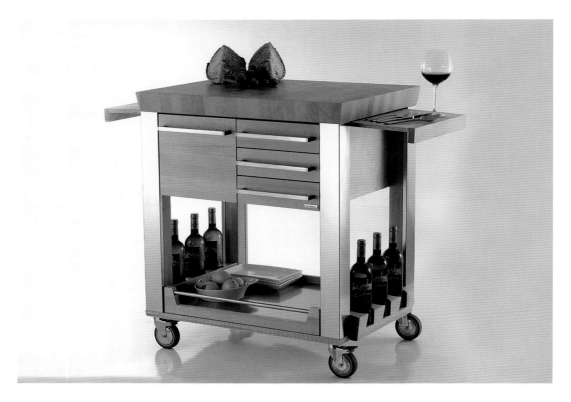

Astoria kitchen cart, 2005
Enrico Albertini (Italy, 1971–)

www.legnoart.it
Solid wood, stainless steel
Massivholz, Edelstahl
Bois massif, acier inoxydable
↕ 92 cm ↔ 80 cm ⤢ 60 cm
Legnoart, Omegna, Italy

Located near Lake Orta, some 50 miles outside Milan, Legnoart is a family business run by Enrico Albertini, who is also the company's chief designer. The original version of this trolley won the coveted Prix de la Découverte at the Maison & Objet exhibition in Paris a decade ago, but was restyled in 2005. This new version boasts a sturdy solid wooden frame, an end-grain worktop, six drawers, a stainless-steel lift-out bin, bottle holders, tool hangers and wheels with stabilizing brakes.

Die Kleinstadt Omegna, Sitz des Familienunternehmens Legnoart, liegt am Ortasee rund achtzig km von Mailand. Enrico Albertini ist Geschäftsführer und Chefdesigner in einer Person. Das Original dieses Küchenwagens gewann vor zehn Jahren auf der Pariser Ausstellung Maison & Objet den begehrten Prix de la Découverte. 2005 kam ein neues mobiles Modell auf den Markt mit stabilem Vollholzgestell, Arbeitsplatte aus Hirnholz, sechs flachen Besteckschubladen, herausnehmbarem Mülleimer, Halterungen für Flaschen und Werkzeuge sowie Rollen.

Située près du lac Orta, à quelques kilomètres de Milan, Legnoart est une entreprise familiale dirigée par Enrico Albertini, également directeur artistique. La version originale de ce chariot a remporté il y a une dizaine d'années le célèbre Prix de la Découverte au salon Maison & Objet de Paris. Élaborée en 2005, cette nouvelle version comporte une solide structure en bois, un plan de travail en grain fin, six tiroirs, une poubelle amovible en inox, un porte-bouteilles et un porte-ustensiles. Elle est équipée de roues dotées d'un système de blocage.

Patented in 1956, Louis Maslow's *Erecta Shelf System* had a remarkable strength-to-weight ratio and its elements could be assembled in numerous configurations for a variety of applications. The shelves' open-construction also minimized the collection of dust and allowed air to freely circulate around stored items. In 1969, the shelving system, after further refinement, was re-named the *Super Erecta* and with its industrial aesthetic became a popular feature in 1970s High-Tech interiors. This ubiquitous shelving system can also be assembled into various useful carts, including the mobile *MW701* with its three wire shelves.

Das 1956 patentierte *Erecta Shelf System* von Louis Maslow besaß ein hervorragendes Festigkeit/Gewichts-Verhältnis und seine Elemente ließen sich in zahlreichen Kombinationen für unterschiedliche Anwendungen anordnen. Die offene Konstruktion der Regalböden sorgte auch dafür, dass sich kaum Staub ansammelte und die Luft um die aufbewahrten Gegenstände frei zirkulieren konnte. Nach weiteren Verbesserungen wurde das Regalsystem in *Super Electra* umbenannt und mit seiner industriellen Ästhetik in den 1970er Jahren zu einem beliebten Objekt in Hightech-Einrichtungen. Das allgegenwärtige Regalsystem lässt sich auch in verschiedenen nützlichen Wagen anordnen, darunter der mobile *MW701* mit seinen drei Regalböden aus Draht.

Breveté en 1956, le système d'étagères *Erecta* de Louis Maslow offre un remarquable rapport résistance/poids et ses éléments modulables proposent différentes configurations. Les étagères de conception « grillagée » minimisent l'accumulation de poussière, permettant à l'air de circuler librement autour des éléments entreposés. Après de nombreuses améliorations, le système d'étagères est rebaptisé *Super Erecta* en 1969. Grâce à son extraordinaire esthétique industrielle, ces étagères envahissent les intérieurs High Tech des années 70. Ce système de rayonnage omniprésent peut également être assemblé en divers chariots très pratiques, notamment le modèle *MW701*, avec ses trois rayons en fil métallique.

Model No. MW701 cart, c. 1968

Louis Maslow (USA, active 1920s–1960s)

www.metro.com
Chromed steel, rubber
Verchromter Stahl, Gummi
Acier chromé, caoutchouc
↕ 99 cm ↔ 61 cm ⤢ 45.7 cm
IntroMetro Industries, Wilkes-Barre (PA), USA

An essentialist rather than a minimalist, Jasper Morrison designs objects with absolute purposeful integrity. Like traditional tools, Morrison's utensils possess a sense of inherent rightness because they have been conceived to do a job rather than to look beautiful. Ironically, though, it is this functional approach to design that often produces the most elegant forms. These 'ideal' storage containers are testament to Morrison's ability to elevate mundane products into objects of useful beauty.

Eigentlich ist Jasper Morrison kein Minimalist, sondern vielmehr ein Essentialist, der seine Produkte mit absolut zielorientierter Integrität gestaltet. Ähnlich wie herkömmliche Gebrauchsgegenstände vermitteln Morrisons Designs den Eindruck, dass sie nur so und nicht anders sein konnten und gezielt zweckmäßig gestaltet sind, statt einfach nur schön auszusehen. Merkwürdigerweise kommen aber beim rein zweckorientierten Design oft die elegantesten Formen heraus. Diese „idealen" Vorratsbehälter sind Beweise für Morrisons Fähigkeit, die alltäglichsten Dinge in Objekte von zweckdienlicher Schönheit zu verwandeln.

Plutôt essentialiste que minimaliste, Jasper Morrison crée des objets en accord avec ce précepte. À l'instar des ustensiles classiques, ceux de Morrisson possèdent un sens de la justesse, conçus pour leur utilité davantage que pour leur esthétique. Paradoxalement, c'est cette approche fonctionnelle qui produit souvent les formes les plus élégantes. Morrisson a le don de transformer des ustensiles ordinaires en véritables objets de décoration à l'utilité évidente. C'est le cas de ces fameuses boîtes hermétiques.

Tin Family containers, 1998

Jasper Morrison (UK, 1959–)

www.alessi.com
Stainless steel
Edelstahl
Acier inoxydable
⌀ 23 cm (largest)
Alessi, Crusinallo, Italy

Storage canister, 1996

Rösle Design Team

www.roesle.de
Stainless steel, glass
Edelstahl, Glas
Acier inoxydable, verre
0.1, 0.2, 0.3, 0.6, 0.7, 1.4, 2.5 l
Rösle, Marktoberdorf, Germany

The German company Rösle produces an enormous range of kitchen tools that are as durable as they are beautiful. The company's attention to detail in terms of how a design should perform is matched by the quality achieved by its manufacturing processes. For example, their range of storage canisters comes in seven different sizes and is made from heavy-duty stainless steel. The canisters' glass lids allow their contents to be viewed easily, while providing a hermetically airtight seal that keeps the food stored in them fresh.

Das deutsche Unternehmen Rösle produziert eine Vielzahl verschiedener Küchenutensilien und -geräte, die ebenso haltbar wie schön sind. Die Produktdesigner der Firma konzentrieren sich mit Akribie auf die Gestaltung jedes technischen, funktionalen und formalen Details, und die sorgfältige und präzise Herstellung trägt ihren Teil zur Schönheit und Qualität der Produkte bei. Die Produktfamilie der Vorratsbehälter aus schwerem Edelstahlblech zum Beispiel wird in sieben Größen produziert und mit Glasdeckeln versehen, so dass man den Inhalt von außen erkennen kann. Silikondichtungsringe sorgen dafür, dass die Behälter luftdicht verschlossen werden.

La société allemande Rösle produit une importante variété d'ustensiles de cuisine, aussi résistants qu'esthétiques. Cette société porte une grande attention à chaque détail afin que leurs produits puissent combiner performance, beauté et longévité. Chaque article est fabriqué avec soin et strictement contrôlé. Cette série de boîtes hermétiques en acier inoxydable existe en sept tailles. Le couvercle en verre permet de vérifier facilement le contenu tout en offrant une fermeture hermétique parfaite.

A classic design that has stood the test of time, the *Le Parfait Super* jar debuted in the 1930s and has changed little over the succeeding years. Durably robust and stylishly utilitarian, 'the perfect' domestic canning jar (as its title translates), with its distinctive orange rubber seal, comes in a range of sizes and can be reused over the years for the preserving of vegetables, fruits and more. Practical and inexpensive, this seminal French design is now gaining popularity as more people rediscover the healthful joys of home canning – today more than twenty million units are sold *per annum*, a fifty per cent increase in ten years.

Das altbewährte, klassische Marmeladen- und Einmachglas mit Produktnamen *Le Parfait Super* wird seit den 1930ern produziert und hat sich im Laufe der Jahrzehnte kaum verändert. Das „perfekte Superglas" ist robust, haltbar, nützlich und mit seiner orangefarbenen Gummidichtung noch dazu hübsch anzusehen. Es ist in verschiedenen Größen erhältlich, kostet nicht viel und lässt sich Jahr für Jahr wieder verwenden, um darin Marmeladen, Kompott oder eingelegtes Gemüse luftdicht aufzubewahren. Im Zuge des wieder erwachten Interesses an Bionahrung, selbst gekochten Marmeladen und anderem Eingemachten erfreut sich dieses französische „Pionierprodukt" einer gesteigerten Popularität: Heute verkauft allein die Firma Le Parfait über zwanzig Millionen Stück pro Jahr – eine fünfzigprozentige Steigerung in zehn Jahren.

Classiques et indémodables, les bocaux *Le Parfait Super* ont été créés dans les années 30 et n'ont guère changé depuis. Dotés d'un joint orange en caoutchouc caractéristique, ils sont résistants et élégamment fonctionnels. Ils existent en plusieurs tailles et conservent parfaitement n'importe quel aliment pendant des années. Pratique et peu coûteuse, cette création française suscite actuellement un réel engouement, car manger sain et équilibré est devenu une priorité pour chacun de nous. Chaque année plus de vingt millions de bocaux sont vendus, soit une augmentation de cinquante pour cent en dix ans.

Le Parfait Super jars, 1930s
Le Parfait Design Team

www.leparfait.com
Glass, metal, rubber
Glas, Metall, Gummi
Verre, métal, caoutchouc
0.5, 0.75, 1, 1.5, 2, 3 l
Le Parfait, Reims, France

Storage kitchen containers, 2002

Bodum Design Group

www.bodum.com
Borosilicate glass, oiled beech, silicone
Borosilikatglas, geölte Buche, Silikon
Verre borosilicate, hêtre huilé, silicone
0.6 l, 1 l, 1.9 l, 2 l, 2.5 l
Bodum, Triengen, Switzerland

Widely used for laboratory wares, borosilicate glass is also an ideal material for storage containers because it is both inert and resistant to heat, water, acids and salt solutions. These inherent properties ensure that it cannot taint any foodstuffs with which it comes into contact. Bodum's storage vessels are also made from a special type of borosilicate glass that contains no lead and has a distinctive brilliance. These functional and durable containers are topped off with oiled beech lids and silicone gaskets to provide an airtight seal.

Das zumeist für Laborgefäße verwendete Borosilikatglas eignet sich auch für Vorratsdosen, weil es kaum auf Temperaturschwankungen reagiert sowie hitze-, wasser-, säure- und salzlösungsbeständig ist. Deswegen werden die aufbewahrten Lebensmittel nicht verunreinigt und verderben nicht. Bodums Vorratsgefäße werden aus einem besonderen, nicht bleihaltigen Borosilikatglas hergestellt, das kristallklar glänzt. Deckel aus geölter Buche und Silikondichtungen verschließen die praktischen und haltbaren Behälter luftdicht.

Très utilisé pour les produits de laboratoire, le verre borosilicate est également un matériau idéal pour les boîtes hermétiques car il est à la fois résistant à la chaleur, aux produits chimiques, à l'eau, aux acides et aux solutions salées. Ces propriétés permettent donc de conserver impeccablement les aliments. Ces boîtes hermétiques sont conçues à partir d'un verre borosilicate particulier, sans plomb, offrant une brillance absolue. Les récipients, fonctionnels et résistants, possèdent des couvercles en hêtre huilé, rendus étanches par leurs joints en silicone.

Intended for both the kitchen and the dining table, the *Endurance* saltcellar can be used to store gourmet sea salt, which is now available in a startling array of colours and flavours, from pink Himalayan salt to Hawaiian black salt.
Its flip-top lid has a silicone gasket that protects the salt crystals from atmospheric moisture, thereby keeping them fresh and dry. Dishwasher proof, the salt cellar's glass bowl holds up to eight ounces of salt (almost a standard cup measure).

Das *Endurance*-Salztöpfchen für den Esstisch besteht aus einem Glasbehälter mit je einem Untersetzer, Deckel und Löffelchen aus Edelstahl und fasst Salzflocken oder grobes Salz, das es heute in verschiedenen Qualitäten und Farben zu kaufen gibt – vom rosafarbenen Himalayasalz bis zum schwarzen Salz aus Hawaii. In den aufklappbaren Deckel ist ein Silikonring eingelassen, der verhindert, dass die Salzkristalle sich mit Luftfeuchtigkeit vollsaugen. Das Glastöpfchen ist spülmaschinenfest.

Destinée à la fois à la cuisine et à la table, la salière *Endurance* optimise la conservation du sel de mer gastronomique. Elle est désormais disponible dans une vaste palette de couleurs et de saveurs, du sel rose de l'Himalaya au sel noir d'Hawaii. Son couvercle à charnière possède un joint en silicone qui protège les cristaux de sel de l'humidité, les maintenant au frais et au sec. Lavable au lave-vaisselle, le récipient en verre de la salière contient environ deux cent trente grammes de sel.

Endurance saltcellar with spoon, 2007

RSVP International Design Team

www.rsvp-intl.com
Stainless steel, glass, silicone
Edelstahl, Glas, Silikon
Acier inoxydable, verre, silicone
0.23 l
RSVP International, Seattle (WA), USA

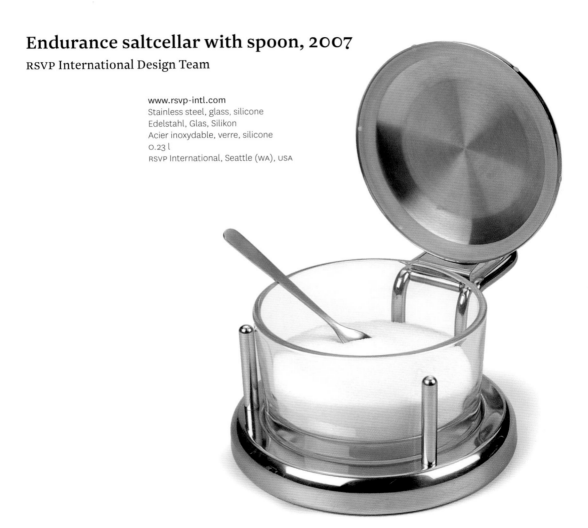

Roll Top bread bin, 2007

Brabantia Design Team

www.brabantia.com
Galfan-coated stainless steel, plastic
Galfanverzinkter Edelstahl, Plastik
Acier inoxydable Galfan, plastique
↕ 18.9 cm ↔ 47.9 cm ⤢ 27.6 cm
Brabantia, Emmerlich, Germany

Widely available and extremely popular, this bread bin has a variety of useful features. Although relatively compact, it has a two-loaf capacity and, thanks to its roll-top door, it doesn't take up too much space on the work surface. It also has a corrosion-resistant coating, a knobbly patterned base for correct ventilation and a plastic noise-dampening stop. Backed up by a ten-year guarantee, this classic German-made design is a no-frills tool that does its job with great efficiency and functional durability.

Dieser äußerst beliebte Brotkasten weist eine Reihe praktischer Besonderheiten auf und steht in vielen Küchen. Trotz seiner relativ kleinen, kompakten Form fasst er zwei Brotlaibe und nimmt dank seines Rolldeckels auch nicht zuviel Platz ein. Der Kasten ist korrosionsfest beschichtet, hat zwecks besserer Durchlüftung einen Boden aus Strukturblech und einen schalldämmenden Plastikverschluss. Der Hersteller gewährt eine zehnjährige Garantie auf dieses schnörkellose Produkt, das seinen Zweck effizient und dauerhaft erfüllt.

Très populaire, la boîte à pain *Roll Top* offre de nombreuses qualités. Ce modèle, esthétique et fonctionnel, dispose d'un couvercle coulissant vers le haut. Elle est recouverte d'une couche anti corrosive résistante et dispose par ailleurs d'une pièce en plastique qui amortit le bruit lors de la fermeture. Compacte mais dotée d'une grande capacité, ce modèle peut contenir deux pains. Garantie dix ans, cette boîte est un classique du design allemand : simple, fonctionnelle et très résistante.

Mary Biscuit container, 1995

Stefano Giovannoni (Italy 1954–)

www.alessi.com
EVA, PMMA
EVA, PMMA
EVA, PMMA
↕ 11.5 cm ↔ 28 cm ⤢ 22 cm
Alessi, Milan, Italy

Stefano Giovannoni will often use metaphor in his playful approach to design. In the *Mary Biscuit* container, the biscuit-shaped lid symbolises the overall concept, while the actual container provides useful airtight storage for cookies. The resulting design is not only functional but emotionally seductive, and makes reaching for the cookies as delightful as eating them.

Stefano Giovannoni geht spielerisch an Design heran und verwendet häufig Metaphern. Bei der Keksdose *Mary Biscuit* symbolisiert der wie ein Keks geformte Deckel das Konzept, während der eigentliche Behälter den Keksen eine luftdichte Aufbewahrung bietet. Giovannonis Design ist nicht nur zweckmäßig, sondern auch verführerisch, sodass der Griff zum Keks genauso viel Freude bereitet wie der Verzehr.

Stefano Giovannoni utilise souvent la métaphore dans son approche ludique du design. Originale et appétissante, la boîte à gâteaux *Mary* comporte un couvercle décoré d'un biscuit, absolument ravissant. Dotée d'une fermeture hermétique, *Mary* conserve parfaitement les gâteaux. Un design « enfantin » tout aussi séduisant que les cookies qu'il renferme.

In 1951, Bill Campbell invented the *Camtray* (a plastic canteen tray) and, along with his brother, founded a company to produce and market his innovative and ubiquitous design to the 'food-service' sector. Later, the Cambro company launched the world's first transparent plastic food container, which has now evolved into the extensive *CamSquares* stackable storage range, with its snap-tight, colour-coded lids and crystal clear or translucent white polycarbonate bodies. Astonishingly, these products can withstand temperatures ranging from –40°C to 99°C (104°F to 210°F).

1951 erfand Bill Campbell ein Kantinenta-blett aus Plastik, das er *Camtray* nannte. Zusammen mit seinem Bruder gründete er ein Unternehmen, das dieses damals neuartige und heute allgegenwärtige Produkt herstellen und an „gastronomi-sche Dienstleistungsbetriebe" verkaufen sollte. Später brachte die Firma Cambro den weltweit ersten Lebensmittelbehäl-ter aus transparentem Kunststoff auf den Markt, den sie inzwischen zur stapel-baren Behälterkollektion *CamSquares* erweitert hat: luftdicht verschließbaren Behältern aus kristallklar transparentem Polycarbonat mit farblich gekennzeich-neten Deckeln. Erstaunlicherweise halten diese Behälter extreme Temperaturen von –40°C bis +99°C aus!

En 1951, Bill Campbell invente le *Camtray* (un plateau de cantine en plastique). Il fonde alors avec son frère une société afin de le produire et de le commercia-liser. Plus tard, l'entreprise Camtray crée la première boîte hermétique transpa-rente qui devait donner le jour à l'impres-sionnante gamme *CamSquares*. Équipées de couvercles de différentes couleurs selon ce que vous conservez, ces boîtes en polycarbonate translucide supportent des températures allant de –40°C à 99°C.

CamSquares storage containers, 1960s (original design)
Cambro Design Team

www.cambro.com
Polycarbonate, polyethylene
Polykarbonat, Polyethylen
Polycarbonate, polyéthylène
2–22 quarts (1.89–20.8 l)
Cambro Manufacturing Company,
Huntington Beach (CA), USA

Elemaris XL Chrome water filter jug, 2005

Brita Design Team

www.brita.co.uk
Plastic, non-slip rubber
Kunststoff, rutschfestes Gummi
Plastique, caoutchouc anti dérapant
2.2 l
Brita, Taunusstein, Germany

Founded in 1966, Brita has been a leader in water filtration or as it puts it 'water optimization' for more than forty years. In 1970, it launched its first water filter jug for domestic use, and has since honed this design to incorporate the latest technologies. Today, its top-of-the-line *Elemaris XL Chrome* water filter jug has an electronic cartridge exchange indicator, an ergonomic soft grip, a non-slip rubber base and an easy-to-fill, pour-through lid.

Das 1966 gegründete Unternehmen Brita ist seit über vierzig Jahren führend im Bereich des Wasserfilterns bzw. der „Wasseroptimierung", wie Brita selbst es formuliert. 1970 brachte es den ersten Wasserfilter für den privaten Gebrauch auf den Markt und hat dieses Design seitdem unter Berücksichtigung der neuesten Technologien stets verbessert. Heute bietet das Spitzenmodell *Elemaris XL Chrome* eine elektronische Kartuschen-Wechselanzeige, einen ergonomisch weichen Griff, einen rutschfesten Gummifuß sowie eine automatische Einfüllöffnung.

Fondée en 1966, Brita est un leader du filtrage de l'eau ou, pour reprendre les termes de la compagnie, de « l'optimisation de l'eau » depuis plus de quarante ans. Elle a lancé sa première carafe filtrante pour la maison en 1970 et n'a cessé depuis de la peaufiner en incorporant les dernières technologies. Aujourd'hui, sa carafe filtrante haut de gamme *Elemaris XL Chrome* est équipée d'un système électronique contrôlant la performance de filtration, d'une poignée ergonomique, d'une base en caoutchouc antidérapante et d'un couvercle percé d'un clapet facilitant le remplissage.

Morrison Toaster, 2004

Jasper Morrison (UK, 1959–)

www.rowenta.com
Polypropylene, steel
Polypropylen, Stahl
Polypropylène, acier
↔ 25.5 cm
Rowenta Werke, Offenbach am Main, Germany

Like other kitchen appliances designed by Jasper Morrison for Rowenta, this toaster is a functionally and aesthetically unified design that is both elegant and timeless. Integrated into its clean white housing are a wide range of innovative features, from a photo-sensor browning control and a soft-eject crumb tray, to an LED display and audible signal. As a pure and essentialist design, the *Morrison Toaster* is reminiscent of the landmark kitchenware designed for Braun in the 1960s by Dieter Rams.

Dieser Toaster stellt – wie alle anderen Küchengeräte, die Jasper Morrison für Rowenta entworfen hat – ein funktional und ästhetisch geschlossenes, ebenso elegantes wie zeitloses Design dar. Das weiße Gehäuse enthält innovative elektronische Technik: vom Photosensor, der den Bräunungsgrad überwacht, und dem langsam ausfahrenden Krümeltablett bis zum LED-Display und Tonsignal. Als minimalistisches Designobjekt steht der *Morrison Toaster* in der Tradition der bahnbrechenden Produkte, die Dieter Rams in den 1960er Jahren für Braun entwarf.

Sobre et élégant, ce grille-pain conçu par Jasper Morrison pour Rowenta bénéficie d'une technologie photo-sensor qui grille le pain à la nuance près grâce à des capteurs visuels reliés à une carte électronique qui contrôle avec précision l'évolution de la couleur du pain. Discret, son plateau ramasse-miettes s'ouvre par simple pression d'un bouton. Esthétique, fonctionnel et intemporel, ce grille-pain au design essentialiste est une réminiscence des ustensiles de cuisine conçus dans les années 60 par Dieter Rams pour Braun.

Morrison Kettle, 2004

Jasper Morrison (UK, 1959–)

www.rowenta.com
Polypropylene, steel
Polypropylen, Edelstahl
Polypropylène, acier
1.5 l
Rowenta Werke, Offenbach am Main, Germany

This cordless electric kettle not only looks good, but also has a powerful and smoothly polished stainless-steel element that combats scaling and provides rapid heating. Like other designs by Morrison, this kettle contains numerous indications of his careful and considered approach, for instance: a removable lid for easy cleaning (which also incorporates a scale-trapping filter), and a base that can be used to store the excess cord. A functional and essentialist design, the *Morrison Kettle* received the Chicago Athenaeum's Good Design Award in 2004.

Dieser kabellose elektrische Wasserkocher sieht nicht nur gut aus, sondern hat auch ein leistungsstarkes Heizelement aus poliertem Edelstahl, das Kalkablagerungen verhindert und das Wasser rasch zum Kochen bringt. Wie bei anderen Designs von Jasper Morrison zeigt sich auch hier, wie sorgfältig durchdacht seine Entwürfe sind. So hat der Wasserkocher zum Beispiel einen abnehmbaren Deckel mit integriertem Kalkfänger und das Kabel lässt sich im Fuß verstauen. Morrisons Wasserkocher erhielt 2004 den Chicago Athenaeum's Good Design Award.

Cette bouilloire électrique sans fil associe un design intemporel, une technologie de pointe et un chauffage rapide. Son interrupteur se trouve sur son socle indépendant et sa résistance est recouverte d'une plaque en inox afin d'éviter tout risque de corrosion. Son couvercle amovible par simple pression permet un nettoyage facile. Bouilloire, elle est aussi carafe grâce à son filtre intégré pour retenir les éventuelles particules de calcaire. Avec sa ligne fonctionnelle et son design essentialiste, ce modèle a reçu le Chicago Athenaeum Good Design en 2004.

Braun Impression HT 600 toaster, 2003

Björn Kling (Germany, 1965–)

www.braun.com
Various materials
Verschiedene Materialien
Divers matériaux
↔ 43 cm
Braun, Kronberg, Germany

Acknowledging that contemporary kitchens are frequently used as living spaces as well as for cooking, Braun's design team created the *Impression Line*. Their guiding principle was that kitchen equipment, such as this long-slotted toaster, should perform its tasks perfectly while also being intrinsically beautiful. As one of Braun's in-house designers, Björn Kling, notes: 'Everyday living should be simple to master – with simplicity that's not only functional, but beautiful. This is the Braun philosophy'.

Da zeitgenössische Küchen häufig als Wohnküchen genutzt werden, entwickelten die Designer von Braun die *Impression*-Designkollektion und ließen sich dabei von dem Gedanken leiten, dass Küchengeräte wie dieser langschlitzige Toaster nicht nur ihren Zweck optimal erfüllen, sondern auch schön sein sollten. Braun-Designer Björn Kling erläutert: „Der Alltag sollte leicht zu bewältigen sein – mit einer Einfachheit und Schlichtheit, die nicht nur funktional, sondern auch schön ist. Das ist die Braun-Philosophie."

Conscients que de nos jours la cuisine s'est transformée en un véritable espace de vie, les créateurs de Braun ont conçu l'*Impression Line*. Leur objectif principal étant l'équipement des nouvelles cuisines, ce grille-pain allie fonctionnalité, performance et esthétique. Figurant parmi cette équipe de designers, Björn Kling explique que « la vie quotidienne doit être simple à maîtriser. Certes simple, mais également fonctionnelle et esthétique, selon la philosophie de Braun ».

Braun Impression WK 600 kettle, 2003

Björn Kling (Germany, 1965–)

www.braun.com
Various materials
Verschiedene Materialien
Divers matériaux
1.7 l
Braun, Kronberg, Germany

Björn Kling's *Impression Line*, including the kettle shown here, raises the aesthetic level of kitchen equipment and reflects his desire to enhance daily life through beautiful design. Although a simple concept, this is sadly one all too often forgotten in the realm of kitchen products. This kettle, with its easy-filling spout and easily readable water level indicator, demonstrates that even the simplest everyday object can be imbued with a sense of style.

Die *Impression Line*, zu der dieser Wasserkocher gehört, setzt neue ästhetische Maßstäbe für Küchengeräte und illustriert das Bestreben des Designers Björn Kling, das tägliche Leben mit gut gestalteten Produkten zu verschönern. Das ist doch eigentlich ein ganz natürlicher Gedanke, der aber im Bereich Haushaltswaren nur allzu oft vernachlässigt wird. Dieser Wasserkocher mit breiter Tülle zum leichten Befüllen und klar lesbarem Wasserstandsanzeiger zeigt, dass selbst die einfachsten Gebrauchsgegenstände formschön und stilvoll sein können.

L'*Impression Line* conçue par Björn Kling inclut cette bouilloire remarquable par son design moderne et son ergonomie, illustrant le désir de créer des objets qui facilitent la vie quotidienne. Un concept simple mais malheureusement peu connu dans le domaine des produits ménagers, cette bouilloire dispose d'un niveau d'eau visible des deux côtés. Sa large ouverture facilite le remplissage. Autant de qualités qui démontrent qu'un simple objet peut être empreint d'un style élégant.

Combi 2×2 toaster, 1948

Max Gore-Barten (UK, 1914–)

www.dualit.com
Chromed stainless steel
Verchromter Edelstahl
Acier inoxydable chromé
↔ 36 cm
Dualit, Crawley, UK

Originally designed for use in commercial kitchens, Dualit's iconic toasters have an endearing, no-nonsense robustness, which makes them incredibly durable. The retro *Combi* incorporates patented and award-winning ProHeat elements, and has a simple mechanical timer to control toasting time. In order to ensure the highest manufacturing quality, the design is still hand-built by the company founded by Max Gore-Barten in 1945.

Die kultigen Dualit-Toaster wurden ursprünglich für den Gastronomiebedarf entworfen und sind einnehmend einfach, robust und unglaublich langlebig. Der *Combi* im Retrolook ist mit patentierten, preisgekrönten ProHeat-Elementen und einem einfachen mechanischen Kurzzeitmesser ausgestattet. Mit dem Ziel, die höchste Qualität sicherzustellen, produziert das 1945 von Max Gore-Barten gegründete Unternehmen den Toaster auch heute noch weitgehend in Handarbeit.

Initialement conçu pour un usage professionnel, ce grille-pain Dualit est devenu incontournable. Sa robustesse légendaire fait de lui un produit ménager extrêmement résistant. Ce combi rétro incorpore des éléments brevetés et récompensés par ProHeat et dispose d'une minuterie mécanique. La société, fondée par Max Gore-Barten en 1945, continue d'élaborer de manière traditionnelle le grille-pain *Combi* afin de préserver sa grande qualité de fabrication.

TW911P2 kettle, 1997

Porsche Design Studio (Austria, est. 1972)

www.siemens-homeappliances.com
Brushed aluminium, other materials
Gebürstetes Aluminium, andere
Materialien
Aluminium brossé, autres matériaux
↕ 27.7 cm
Siemens, Munich, Germany

Manufactured by Siemens, the *Porsche Design Collection* has raised the aesthetic and functional bar of home appliances to a new level. Winning a prestigious iF design award in 2006, the collection's 1.5-litre cordless kettle has a thermally insulated, cool-touch body that incorporates a double-sided water level indicator. A brushed aluminium and black plastic polymer exterior lend style to the design, while its precise engineering alludes to the excellence of Germany's automotive heritage.

Die *Porsche Design Collection* von Siemens hat die ästhetische und funktionelle Messlatte für Haushaltsgeräte heraufgesetzt und wurde 2006 mit dem iF-Designpreis ausgezeichnet. Der kabellose, wärmeisolierte Wasserkocher fasst 1,5 Liter. Er ist beidseitig mit Wasserstandsanzeigern ausgestattet und wirkt mit seinem Äußeren aus gebürstetem Aluminium sowie Gerätefuß und Deckel aus schwarzem Polymer elegant. Seine technische Leistung knüpft an die besten Traditionen deutscher Wertarbeit an.

Fabriquée par Siemens, la collection *Porsche Design* marie à la perfection design, sécurité, confort d'utilisation et efficacité. D'une capacité d'1,5 litre, cette bouilloire revêtue d'aluminium brossé dispose d'un niveau d'eau visible des deux côtés, avec un effet de prisme particulièrement esthétique. Ce modèle comporte un système de sécurité très sophistiqué, avec plusieurs niveaux d'arrêt automatique. Récompensée par un iF design award en 2006, cette bouilloire fait référence à l'excellence du patrimoine automobile allemand par sa technologie de pointe.

This elegant and high-tech design incorporates the *Nespresso* coffee-making system, which employs easy-to-use disposable capsules. Apart from making espressos, this is the first machine of its kind to have a one-touch function to create cappuccinos or café lattes as well. The design also incorporates a special frothing nozzle and cup-warming plate. Using an engineering approach, Porsche Design creates products that are distinguished by a remarkable level of purity and precision.

Bei diesem eleganten, leicht zu bedienenden High-Tech-Espressoautomat wird kochendes Wasser mit Hochdruck durch mit Nespressoextrakt gefüllte Kapseln gedrückt. Die Siemens *Nespresso* ist die erste Espressomaschine auf dem Markt, mit der man nicht nur Espresso, sondern auch Cappuccino oder Latte macchiato zubereiten kann. Außerdem verfügt sie über einen speziellen Milchaufschäumer und eine Warmhalteplatte. Bei der Produktentwicklung geht Porsche Design von technisch-funktionalen Kriterien aus und schafft so Produkte mit einem bemerkenswert klaren Erscheinungsbild.

Cette machine à café *Nespresso* allie l'esthétique à la haute technologie. Fonctionnant avec des capsules jetables, ce modèle est la première machine à café disposant d'une fonction qui permet d'obtenir des capuccinos ainsi que des cafés *latte*. Elle comporte également une nouvelle buse vapeur spéciale pour la mousse et une plaque chauffante. Porsche Design utilise la haute technologie afin de créer des produits à la fois d'une grande précision et esthétiquement remarquable.

Nespresso Siemens TK911N2GB coffee maker, 2005

Porsche Design Studio (Austria, est. 1972)

www.nespresso.com
Brushed aluminum, PMMA
Gebürstetes Aluminium, PMMA
Aluminium brossé, PMMA
↕ 34.7 cm
Siemens, Munich, Germany/Nestlé Nespresso, Paudex, Switzerland

Essenza c90 coffee maker, 2003

Antoine Cahen (Switzerland, 1950–) & Philippe Cahen (Switzerland, 1947–)

www.nespresso.com
ABS, PMMA, stainless steel
ABS, PMMA, Edelstahl
ABS, PMMA, acier inoxydable
↕ 29.1 cm
Nestlé Nespresso, Paudex, Switzerland

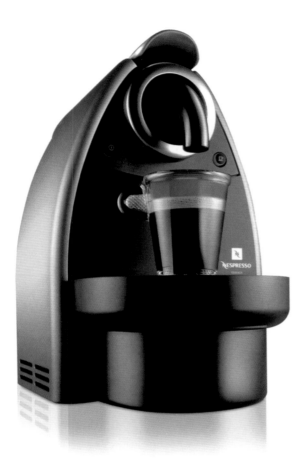

Since 1988, the Swiss brothers Antoine and Philippe Cahen have designed nine coffee-making machines for Nestlé Nespresso. Their *Essenza* machine, which won a Red Dot Best of the Best award in 2005, is a compact machine intended for a wide range of consumers with smaller kitchens, from students to condo owners and the retired. Developed in conjunction with Nespresso's engineers, this machine was designed around a new extraction system through which a smaller and more unified design was achieved.

Seit 1988 haben die Schweizer Brüder Antoine und Philippe Cahen für Nestlé Nespresso neun Kaffeeautomaten entworfen, darunter die kompakte *Essenza*, die 2005 mit dem Red Dot Best of the Best Award ausgezeichnet wurde und für Kunden – von Studenten bis hin zu Senioren in Ein-Zimmer-Appartments – gedacht ist, die in ihren Küchen wenig Platz haben. Die Cahens entwickelten die *Essenza* in Zusammenarbeit mit Ingenieuren von Nestlé Nespresso, und zwar unter Einsatz eines innovativen Filtersystems, das die kleine, kompakte äußere Form ermöglichte.

Depuis 1988, Antoine et Philippe Cahen ont conçu neuf machines à café pour la société Nestlé Nespresso. Récompensé par le Red Dot Best of the Best, leur modèle *Essenza* est une machine compacte destinée à tous ceux qui possèdent une petite cuisine. Cette performance matérielle est le résultat d'une étroite collaboration entre ces créateurs suisses et les ingénieurs de Nestlé .

In 1935, Francesco Illy designed the first automatic espresso machine, known as the *Illetta*, which used compressed air to force steam through coffee grounds. Like its predecessor, the *Francis Francis xi* home espresso machine also makes superlative coffee, while its unusual styling has been described by *Wired* magazine as 'retro-futuristic'. Designed by the Italian architect Luca Trazzi, this eighteen-bar, pump-driven espresso machine has a strong aesthetic presence.

Im Jahr 1935 entwickelte Francesco Illy seine *Illetta*, die weltweit erste automatische Espressomaschine, die mit Druckluft heißen Wasserdampf durch das Kaffeemehl presste. Illys 1995 auf den Markt gebrachte *Francis Francis xi* für den privaten Haushalt produziert ebenso köstlichen Espresso wie ihre Vorgängerin. Die Zeitschrift *Wired* bezeichnete das ungewöhnliche Design Luca Trazzis form-schönen Modells mit seiner Druckleistung von achtzehn Bar als „retro-futuristisch".

En 1935, Francesco Illy conçoit et réalise *Illeta*, la première machine à café avec dosage automatique et jet d'air comprimé. « Rétro-futuriste » selon le magazine *Wired*, *Francis Francis xi* donne une touche de design et de qualité à votre cuisine. Conçue par l'architecte Luca Trazzi, cette machine équipée d'une pression de dix-huit bars combine technologie et esthétique tout en offrant le must du café expresso.

Francis Francis xi espresso machine, 1995

Luca Trazzi (Italy, 1962–)

www.illy.com
Steel, brass, plastic, bronze
Stahl, Messing, Kunststoff, Bronze
Acier, cuivre, plastique, bronze
↕ 30 cm
Illy, Trieste, Italy

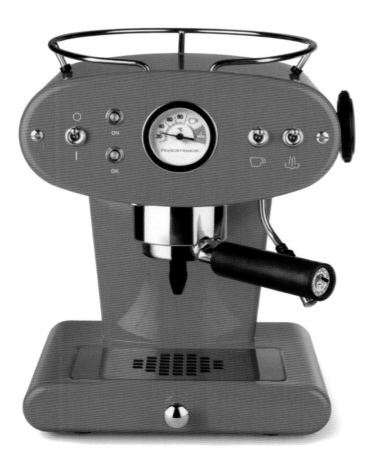

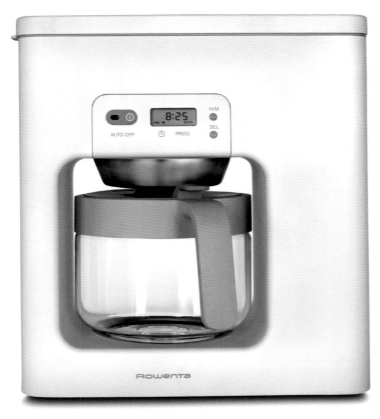

This 'all-in-one' coffee machine has been designed from a purely functional aspect, with its minimalist and Modernist aesthetic following directly from Jasper Morrison's essentialist approach to design. The removable filter holder, coffee measure and filter papers are concealed in the top section. The glass or thermal jugs, however, are integrated into the machine's main body, ensuring a very clean and discreet appearance. The design also incorporates a 'pause-and-serve' feature, and will turn itself off automatically after two hours.

Die äußere Form dieses „Alles-in-einem"-Kaffeeautomaten ergab sich aus seiner technischen Funktion und entspricht in seiner minimalistisch-modernistischen Ästhetik Jasper Morrisons essentialistischen Designauffassung. Der abnehmbare Filter, das Kaffeemaß und die Filtertüten befinden sich im oberen Teil. Die Glas- oder Thermoskanne dagegen steht in einer in das Gehäuse eingelassenen Nische, so dass die Kaffeemaschine kompakt, klar und zurückhaltend wirkt. Sie bietet auch eine „Pausen-und-Ausgieß"-Funktion und schaltet sich nach zwei Stunden automatisch ab.

Cette machine « tout-en-un » a été conçue d'un point de vue purement fonctionnel avec une esthétique minimaliste et moderne illustrant l'approche essentialiste de Jasper Morrison. La partie supérieure de cette machine à café design dissimule un porte-filtre amovible, un doseur de café et le filtre papier. Le récipient en verre s'intègre parfaitement à la structure, lui conférant un aspect moderne et discret. Dotée d'un système d'arrêt automatique après deux heures, elle offre une sécurité optimale.

Morrison Coffee Machine, 2004

Jasper Morrison (UK, 1959–)

www.rowenta.com
Polypropylene, steel, glass
Polypropylen, Stahl, Glas
Polypropylène, acier, verre
↕ 37.6 cm
Rowenta Werke, Offenbach am Main, Germany

Squeeze citrus press & jug, 1999

Hendrik Holbaek (Denmark, 1960–) & Claus Jensen (Denmark, 1966–)

www.evasolo.com
Glass, stainless steel, plastic
Glas, Edelstahl, Plastik
Verre, acier inoxydable, plastique
0.6 l
Eva Solo, Maaloev, Denmark

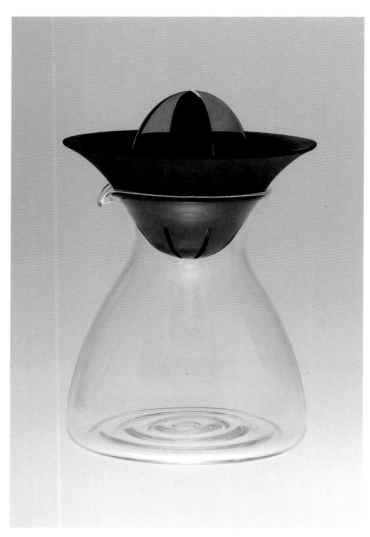

Comprising just three elements – a glass jug, a plastic funnel and a star-shaped dome of polished stainless steel – the *Squeeze* is an elegant and effective citrus-pressing solution. Requiring virtually no force, the juice flows from the cut fruit into the funnel, which filters out any pips, and then pulp-rich juice collects in the jug for immediate serving. This dishwasher-safe design received a Formland award in 1999 and an iF design award in 2002.

Squeeze ist eine elegante und effektive Zitruspresse aus nur drei Elementen: Glaskrug, Plastiktrichter und einem sternförmigen Kegel aus poliertem Edelstahl. Nahezu ohne Kraftaufwand fließt der Saft aus der aufgeschnittenen Frucht durch den Trichter, der die Kerne herausfiltert und den Saft mit viel Fruchtfleisch zum Servieren in den Krug leitet. Das spülmaschinenfeste Design wurde 1999 mit dem Formland Award und 2002 mit dem iF Design Award prämiert.

Composé de trois éléments (un pressoir en acier inoxydable poli brillant, un filtre en plastique et une carafe en verre), ce presse-agrumes est à la fois élégant et efficace. Un simple mouvement de rotation suffit et le jus coule dans la carafe, sans pépin et riche en pulpe. Les trois éléments se séparent aisément et passent au lave-vaisselle. Ce modèle a reçu un prix Formland en 1999 et un iF design award en 2002.

Juice Fountain Elite 800 JEXL
juice extractor, 1999

Breville Design Team

www.breville.com
Die-cast aluminium, zinc, stainless steel
Aluminiumspritzguss, Zink, Edelstahl
Aluminium moulé sous pression, zinc,
acier inoxydable
↕ 40.6 cm
Breville, Sydney, Australia

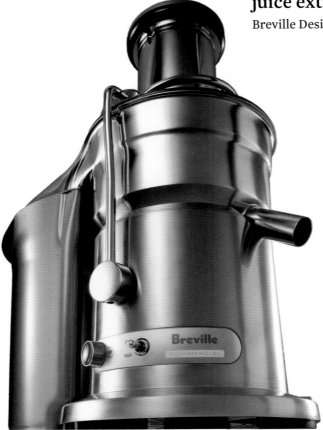

Better known for its toasted sandwich makers, Breville also manufactures the *Juice Fountain Elite* – a commercial-grade juicer designed specifically for the high-end domestic user. Before its launch in 1999, no juicer could process whole apples or pears, and an eight ounce glass of juice took on average more than three minutes to extract. In comparison, the revolutionary *Juice Fountain* takes only five seconds. The reason for this is that its feed tube is placed directly above the center of the cutting disc; and it also incorporates patented, dual-action, stabilizing blades that grind the pulp into smaller particles, thereby producing a higher juice-to-fruit yield.

Der australische Hersteller Breville ist am bekanntesten für seine Sandwichtoaster, produziert aber auch den *Juice Fountain Elite*, einen leistungsstarken Entsafter, der speziell für anspruchsvolle Privatkunden entwickelt wurde. Vor seiner Markteinführung (1999) gab es keinen Entsafter, der ganze Äpfel oder Birnen auspressen konnte, und man brauchte mit den üblichen Modellen im Schnitt länger als drei Minuten, um ein normales Trinkglas zu füllen. Der innovative *Juice Fountain Elite* dagegen braucht nur fünf Sekunden, weil sich das Einfüllrohr direkt zentriert über der Messerscheibe befindet. Das Gerät ist mit einem patentierten dualen Wirkmechanismus und stabilisierenden Messern ausgestattet, die das Obst vor dem Auspressen zerkleinern, so dass die Saftausbeute größer ist als bei anderen Geräten.

Fabriquée par Breville, cette centrifugeuse *Elite* allie puissance, innovation, durabilité et rendement pour des résultats de pointe. Avant son lancement en 1999, aucune centrifugeuse électrique ne permettait de mixer une pomme ou une poire entière en moins de trois minutes. Son moteur de haut calibre avec puce électronique intégrée augmente la puissance du disque de coupe, repoussant ainsi la pulpe du fruit contre le filtre sous une intense pression : la centrifugeuse *Elite* extrait ainsi plus de jus et remplit un verre de 237 ml en cinq secondes.

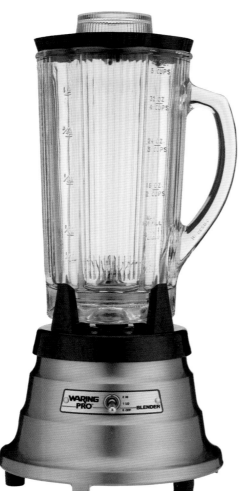

Model MBB520 food & beverage blender, 1998

Waring Design Team

www.waringproducts.com
Metal, plastic, glass
Metall, Plastik, Glas
Métal, plastique, verre
1.18 l
Waring, Torrington (CT), USA

Waring introduced the first blender, known as the *Miracle Mixer* to the American public in 1937. It was designed by Fred Osius, who believed his new invention would 'revolutionize people's eating habits', which it certainly did. Since then, the company has become a well-respected manufacturer of high-quality and durable blenders, including the *Waring Pro MBB Series*. With its trademark cloverleaf glass carafe, heavy-duty metal base and simple two-speed operation, the *Model MBB520* is actually based on an earlier design from 1948 by Peter Muller-Munk.

Waring war 1937 der erste amerikanische Hersteller, der einen Küchenmixer – den *Miracle Mixer* – auf den Markt brachte. Sein Designer Fred Osius war davon überzeugt, dass dieses Produkt die Essgewohnheiten der Amerikaner „revolutionieren" würde. Damit sollte er Recht behalten. Das Unternehmen erwarb sich den Ruf eines Herstellers hochwertiger, langlebiger Mixer, darunter der *Waring Pro MBB*-Serie. Mit dem Kleeblatt-Querschnitt des Glasbehälters – ein Markenzeichen der Waring-Mixer –, dem schweren Metallboden und bedienerfreundlichen Funktion mit zwei Geschwindigkeiten basiert der Entwurf des *MBB520* auf einem früheren Design aus dem Jahr 1948 von Peter Muller-Munk.

En 1937, Waring présenta au public américain le premier mixeur : *Miracle Mixer*. Son créateur, Fred Osius était convaincu que son invention allait révolutionner les habitudes alimentaires. Et il avait raison. Depuis, la société Waring n'a cessé de créer des mixeurs résistants et de grande qualité, comme le *Waring Pro MBB Series*. Avec sa carafe en verre s'apparentant à un trèfle, sa base résistante en métal et simplement deux vitesses, le modèle *MBB520* s'inspire d'une création de Peter Muller-Munk datant de 1948.

In the early 1950s, Roger Perrinjaquet invented the first wand mixer, which was christened the *Bamix*, a catchy abbreviation of the French *'battre et mixer'* ('beat and mix'). Since then, more than seven million of these high-quality and impressively robust hand blenders have been manufactured, each incorporating a virtually indestructible motor that was specially designed for this product. The most recent version, the *Gastro 350* has two speeds and a comfortable soft grip. It is also corrosion-resistant, odour-resistant and, most importantly, taste-resistant, making it the firm favourite of professional chefs.

Anfang der 1950er Jahre schuf Roger Perrinjaquet den ersten Stabmixer, genannt *Bamix*. Der Produktname leitete sich ab vom französischen „battre et mixer" – schlagen und mischen. Bislang sind über sieben Millionen dieser hochwertigen, robusten Stabmixer produziert worden, jeder mit einem praktisch unzerstörbaren Motor, der speziell für dieses Gerät entwickelt wurde. Das neueste Modell, der *Gastro 350*, arbeitet mit zwei Geschwindigkeiten und hat einen gut in der Hand liegenden weichen Griff. Er ist korrosionsbeständig, bleibt geruchsfrei und geschmacksresistent und ist daher ein Lieblingsgerät jedes Profikochs.

Le tout premier mixeur fut inventé au début des années 50 par Roger Perrinjaquet. Baptisé *Bamix*, il doit son nom à l'abréviation de « battre » et « mixeur ». Depuis, plus de sept millions de ces mixers de grande qualité ont été fabriqués. Chacun d'eux dispose d'un moteur quasi indestructible. Légendaire, le design de ce mixeur n'a pratiquement pas changé. Le *Gastro 350* présente une version moderne, comportant deux vitesses et un manche ergonomique. Résistant à la corrosion, aux odeurs et surtout aux saveurs, le *Bamix* demeure une référence pour les cuisiniers professionnels.

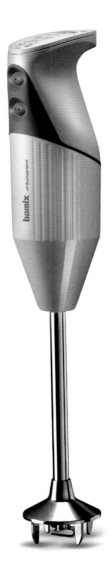

Bamix Gastro 350 hand blender, 2007

Bamix Design Team

www.bamix.com
Various materials
Verschiedene Materialien
Matériaux divers
↕ 49.5 cm
Bamix of Switzerland, Mettlen, Switzerland

In 1948 the first *Kenwood Chef* mixer was launched and immediately became a much-loved labour-saving feature in kitchens across Britain. Twelve years later, a redesigned model by Kenneth Grange was introduced and went on to achieve British 'design icon' status. Against this impressive heritage, Youmeus were tasked to create a new food mixer that brought the values of the well-known brand into the 21st century. The resulting *kMix* is not only visually stunning but also extremely functional.

Als 1948 der erste Kenwood-Chef- Mixer auf den Markt kam, wurde er in den Küchen Großbritanniens sofort zu einem sehr beliebten Gerät, da man mit ihm sehr viel Zeit sparen konnte. Zwölf Jahre später wurde ein neu gestaltetes Modell von Kenneth Grange herausgebracht, das sich zu einer britischen Designikone entwickelte. Angesichts dieses beeindruckenden Vermächtnisses stand Youmeus vor der Aufgabe, einen neuen Mixer zu entwerfen, der die Werte der bekannten Marke ins 21. Jahrhundert transportierte. Das Ergebnis ist der *kMix*, ein nicht nur visuell beeindruckender, sondern auch äußerst funktionaler Stabmixer.

Lancé en 1948, le premier mixeur *Kenwood Chef* devient aussitôt un élément indispensable pour toutes les cuisines en Grande-Bretagne. Douze ans plus tard, Kenneth Grange en propose une nouvelle version, lui conférant le statut « d'icône du design » britannique. Face à ce superbe héritage, Youmeus a été chargé de créer un nouveau robot de cuisine, illustrant les valeurs d'un savoir-faire d'antan au service du 21e siècle. *kMix* répond parfaitement à cette attente, avec un élégant design ultra moderne et une incontestable fonctionnalité.

kMix stand mixer, 2007

Youmeus (UK, est. 2003)

www.kenwoodworld.com
Aluminium, stainless steel
Aluminium, Edelstahl
Aluminium, acier inoxydable
↕ 34.9 cm ↔ 36.1 cm ↗ 22.3 cm
Kenwood, Havant, UK

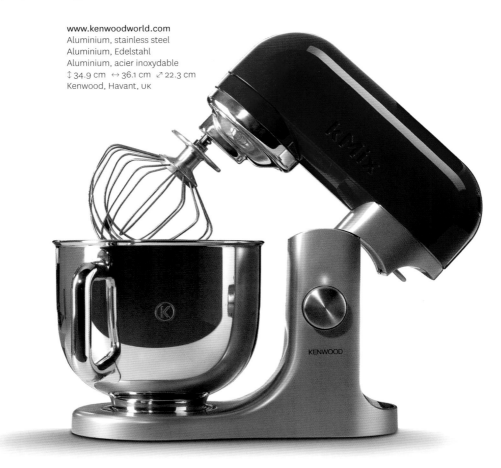

Artisan KSM150 kitchen stand mixer, 1937

Egmont Arens (USA, 1888–1966)

www.kitchenaid.com
Polished stainless steel, other materials
Polierter Edelstahl, andere Materialien
Acier inoxydable poli, autres matériaux
↕ 35.8 cm
KitchenAid, St Joseph (MI), USA

Like other industrial designers who gained prominence in America during the 1930s, Arens was engaged by manufacturers to make their products more alluring to consumers through bold, streamlined styling. His classic mixer for KitchenAid, originally known as the *Model K,* is his best-known design, and it is a tribute to his work that it has remained in production, virtually unaltered, for over seventy years. A true icon of American design, this retro design is a robustly functional yet eye-catching addition to any kitchen.

Wie andere Industriedesigner, die sich in den 1930er Jahren in Amerika einen Namen machten, wurde auch Egmont Arens von Industrieunternehmen engagiert, um ihre Produkte mit stromlinienförmigem Design für potenzielle Käufe attraktiver zu machen. Arens' klassischer Mixer für KitchenAid – ursprünglich als *Model K* vermarktet – ist sein bekanntestes Design. Die Tatsache, dass der Mixer seit über siebzig Jahren fast unverändert produziert wird, ist der beste Beweis für die hohe Qualität und Zeitlosigkeit von Arens' Design.

À l'instar de nombreux designers industriels à succès dans les années 30 aux États-Unis, Arens fut engagé par plusieurs entreprises afin de redessiner leurs produits. Son mixeur classique créé pour KitchenAid reste la plus célèbre de ses œuvres. Pratiquement inchangé depuis sa création il y a soixante-dix ans, ce mixeur est devenu une véritable icône du design américain. Pour les passionnés de cuisine, ce modèle rétro multi fonction allie à merveille efficacité, design et robustesse. Le robot ménager par excellence, indispensable à votre cuisine.

Complete with its five-year warranty, Simplehuman's *Precision* soap pump is a robust yet ergonomically refined design. Its heavy-duty hinged lever can be used to dispense liquid soap, washing-up liquid and also hand lotion. The slide-off lid and generous aperture also ensure that it is easy to refill. Unlike other cheaper soap dispensers, this design will not leak, which means less waste.

Der Hersteller Simplehuman gewährt für diesen robusten, ergonomisch ausgeklügelten Seifenspender mit Pumpmechanismus und stabilem Spenderröhrchen aus Metall eine 5-Jahres-Garantie. Man kann ihn mit Flüssigseife, Spül-, Desinfektionsmittel oder auch mit Handlotion befüllen. Der Schiebedeckel und die weite Flaschenöffnung erleichtern das Nachfüllen. Anders als bei billigen Seifenspendern läuft bei diesem teureren Modell kein Inhalt durch undichte Verbindungen aus.

Garanti cinq ans, le distributeur de savon Simplehuman est une création ergonomique affinée et résistante. Son levier à charnière s'utilise pour distribuer le savon, le produit vaisselle ou une lotion pour les mains. La forme de son couvercle et sa grande ouverture facilitent le remplissage. Contrairement à d'autres distributeurs classiques moins coûteux, ce modèle ne fuit pas et permet donc de véritables économies.

Precision soap dispenser, 2006

Simplehuman Design Team & Lum Design Associates
(USA, est. 1999)

www.simplehuman.com
Chrome-plated zinc and steel, polycarbonate, cast-alloy, plastic
Zink und Stahl (verchromt), Polykarbonat, Gussmetalllegierung, Plastik
Acier et zinc chromé plaqué, polycarbonate, coulé en alliage, plastique
↕ 20 cm
Simplehuman, Torrance (CA), USA

Sensor soap dispenser, 2007

Simplehuman Design Team

www.simplehuman.com
Chrome-plated metal, stainless steel, polycarbonate
Verchromtes Metall, Edelstahl, Polykarbonat
Métal chromé plaqué, acier inoxydable, polycarbonate
↕ 20.8 cm
Simplehuman, Torrance (CA), USA

Simplehuman's CEO and founder, Frank Yang, states that his dream is 'to make products that work well'. Certainly, the products that he manufactures for the home have enjoyed great success as functional objects because they are designed from a human-centric perspective. This simple-to-use yet effective, touch-free soap dispenser – designed by Yang in collaboration with Tzu-Huo Wei and Di-Fong Chang – epitomizes the company's motto: 'tools for efficient living'.

Frank Yang, Firmengründer und Hauptgeschäftsführer von Simplehuman, hat einmal gesagt, sein Traum sei es, „Produkte herzustellen, die gut funktionieren". Das hat er geschafft: Seine Haushaltswaren funktionieren hervorragend und verkaufen sich dementsprechend gut, weil sie alle verbraucherorientiert gestaltet sind. Dieser bedienerfreundliche und sparsame Seifenspender (den Yang zusammen mit Tzu-Huo Wei und Di-Fong Chang entwarf) verkörpert das Motto der Firma: „Geräte für Kraftsparendes Leben".

PDG et fondateur de Simplehuman, Frank Yang, déclare que son rêve consiste simplement « à fabriquer des produits qui fonctionnent bien ». Conçues selon une perspective centrée sur le facteur humain, ses créations connaissent un grand succès pour leur aspect fonctionnel. Simple d'emploi et extrêmement efficace, ce distributeur de savon à senseur intégré, créé par Yang, en collaboration avec Tzu Huo Wei et Di-Fong Chang, incarne la devise de Simplehuman : « des outils pour faciliter la vie ».

Good Grips Stainless Steel soap dispenser, 2005

Smart Design (USA, est. 1978)

www.oxo.com
Stainless steel, polycarbonate
Edelstahl, Polykarbonat
Acier inoxydable, polycarbonate
↕ 22.7 cm
OXO International, New York (NY), USA

Good soap dispensers for the kitchen are difficult to find – most work well for a short while and then start to drip annoyingly. Produced by OXO, this elegant design promises to be different, with an easy-to-dispense mechanism that is ideal for people with age-related dexterity problems. Its non-slip top button allows liquid soap or washing-up liquid to be squirted without difficulty, while the non-slip base ensures stability and the wide-mouthed screw top makes it simple to refill.

Gute Seifenspender für die Küche sind schwer aufzutreiben. Die meisten funktionieren eine Weile problemlos, fangen dann aber ärgerlicherweise an zu kleckern. Dieser elegante Seifenspender von OXO ist anders. Mit seinem bedienerfreundlichen Pumpmechanismus eignet er sich vor allem für Menschen mit altersbedingt verminderter Feinmotorik in den Händen. Man drückt einfach auf den Pumpenkopf aus rutschfestem Plastik, aus dem die Flüssigseife oder das Spülmittel sauber herausfließt, während der ebenfalls rutschfeste Boden der Flasche deren Standfestigkeit garantiert und der Schraubverschluss mit großem Durchmesser das Nachfüllen erleichtert.

Les distributeurs de savon de qualité sont difficiles à trouver. La plupart fonctionnent correctement mais finissent par goutter. Fabriquée par OXO, cette élégante création promet d'être différente. Doté d'un poussoir facile à manipuler, ce distributeur de savon est idéal pour les personnes âgées. Le contenant à goulot large se dévisse facilement et simplifie le remplissage. Une base souple et antidérapante assure une parfaite stabilité.

Quick Load paper towel holder, 2004

Simplehuman Design Team & Lum Design Associates (USA, est. 1999)

www.simplehuman.com
Stainless steel, plastic
Edelstahl, Plastik
Acier inoxydable, plastique
Simplehuman, Torrance (CA), USA

Every kitchen needs one, but most paper towel holders are less than well designed. Simplehuman's answer to this problem is, of course, a product with features that make it easier to use. The *Quick Load* is made from sturdy stainless steel, making it more stable when tearing off a sheet of kitchen roll. It also has a grooved edge along its base to stop the nuisance of unravelling paper, while its quick-release knob permits speedy roll changing.

Ein Küchenpapierrollenhalter gehört in jede moderne Küche, aber die meisten Modelle lassen im Hinblick auf Design und Funktion viel zu wünschen übrig. Natürlich hat sich Simplehuman eine attraktive, nutzerfreundliche Lösung einfallen lassen. Der *Quick Load* besteht aus robustem Edelstahl, und die Küchenrolle springt nie aus der Halterung, wenn man die einzelnen Papiertücher abreißt. Außerdem verhindert die spezielle untere Zackenkante das ungewollte Abrollen des Papiers, während der Auslöseknopf das schnelle Wechseln der Rollen erleichtert.

En général, les porte-rouleaux pour essuie-tout ne sont pas très fonctionnels et ne remplissent que rarement leur fonction. Le modèle *Quick Load* de Simplehuman est fabriqué en acier inoxydable et assure ainsi une parfaite stabilité au moment de détacher une feuille de papier. La base présente une rainure afin d'éviter que le papier ne se déchire. De plus, le système de remplacement des rouleaux est très ingénieux.

One of the most recent additions to the oxo range, the *SteeL* palm brush is meant for dish cleaning, and like other products in the collection has a soft, non-slip grip. Its durable nylon bristles are stiff enough to scrub and scour away baked-on food, yet soft enough to use on non-stick cookware without fear of scratching. Like other products designed by Smart Design for oxo, this handy little brush can be used by all ages thanks to its 'inclusive' ergonomic design.

Ein relativ neues oxo-Produkt ist *SteeL*, eine kleine, kompakte, stiellose Topf- und Tellerbürste aus Stahl mit weich beschichtetem Griff, mit der man sowohl Tafel- als auch Kochgeschirr reinigen kann. Die Nylonborsten sind hart genug, um angebackene oder angetrocknete Essensreste zu entfernen, aber nicht zu hart, um Kochgeschirre mit Anti- haftbeschichtung zu säubern, ohne die Beschichtung zu zerkratzen. Wie andere von Smart Design gestaltete oxo- Produkte kann diese handliche Bürste dank ihrer ergonomischen Form von Menschen aller Altersstufen problemlos benutzt werden.

Cette brosse paume de main, idéale pour nettoyer les plats, fait partie de la gamme d'oxo. À l'instar d'autres créations conçues par Smart Design ce modèle est doté d'une poignée antidé- rapante. Ses poils en nylon sont raides et résistants, permettant de frotter et de récurer les plats. Ils s'avèrent assez doux pour nettoyer sans rayer les casseroles anti-adhérentes. Cette petite brosse est donc facile à manipuler et bénéficie d'une grande ergonomie.

SteeL palm brush, 2007
Smart Design (USA, est. 1978)

www.oxo.com
Steel, Santoprene, nylon
Stahl, Santopren, Nylon
Acier, Santoprene, nylon
oxo International, New York (NY), USA

Long-Handled Cleaning Brush, 2004

Cuisipro Design Team

www.cuisipro.com
Stainless steel, ABS, nylon
Edelstahl, ABS, Nylon
Acier inoxydable, ABS, nylon
Cuisipro, Markham, Ontario, Canada

This ergonomic cleaning brush promises to make light work of dirty dishes, pots and pans. The reservoir of washing-up liquid can be seen inside the handle, and is dispensed though its leak-proof cleaning head using a pump-action mechanism. Three different, interchangeable heads are available: bristle, scrubbing sponge and soft sponge. Made to last with its durable stainless-steel handle, this is a useful yet attractive addition to any kitchen.

In den ergonomisch geformten Griff dieser Spülbürste ist ein kleiner Behälter für das Spülmittel integriert. Er ist transparent, so dass man jederzeit von außen den Füllstand erkennen kann. Das Spülmittel fließt bei Betätigung des Pumpmechanismus ohne Kleckern sparsam in den Bürstenkopf. Die Bürste ist mit drei auswechselbaren Spülköpfen lieferbar: Bürste, Kratzschwamm und Weichschwamm. Mit ihrem Edelstahlgriff ist sie nicht nur haltbar, sondern auch ein praktisches und zugleich ansehnliches Küchenutensil.

Cette brosse ergonomique assure le nettoyage des plats, récipients et casseroles. Le manche contient un réservoir pour le détergent, permettant d'utiliser juste ce qu'il faut de produit grâce à un mécanisme de pompage. Trois têtes de brosses interchangeables sont disponibles : poils, éponge à gratter et éponge douce. Conçu pour durer avec son manche en acier inoxydable, ce modèle fonctionnel et esthétique reste pratique en toutes circonstances.

Marc Newson's dish rack is an innovative and playful solution that has enlivened many a kitchen with its bright colours and unusual form. It has an integral drainer and comes in two pieces so that the collected water can easily be poured away. Alternatively, you can just use the top section on an existing draining board. Funky and futuristic the *Dish Doctor* was an instant success when launched, thanks to the ability of Magis to mould polypropylene so that the surface finish literally glistens.

Marc Newsons Abtropfgestell stellt eine innovative, spielerische Designlösung dar und hat mit seinen fröhlichen Farben und seiner ungewöhnlichen Form schon so manche Küche belebt. Der *Dish Doctor* besteht aus dem Gestell und dem Wasserauffangtablett. Natürlich kann man das Gestell auch auf ein vorhandenes Abtropfbrett stellen. Nach seiner Markteinführung wurde dieses grellfarbige, flippige Modell in kürzester Zeit zum Verkaufsschlager – dank der Fähigkeit von Magis, Polypropylen so zu verarbeiten, dass die veredelte Oberfläche buchstäblich funkelt.

L'égouttoir de Marc Newson est une solution novatrice et originale qui égaye la cuisine par ses couleurs éclatantes et sa forme originale. Composé de deux éléments, son réceptacle incorporé permet de jeter facilement l'eau collectée. Vous pouvez n'utiliser que la partie haute de l'égouttoir, que vous disposerez – ou non – sur un autre réceptacle. « Funky » et futuriste, le *Dish Doctor* a connu un succès immédiat lors de son lancement. Grâce au génie de Magis qui mit au point une technique d'injection du polypropylène, l'objet s'est paré d'un brillant incomparable.

Dish Doctor dish rack, 1997
Marc Newson (Australia, 1963–)

www.magisdesign.com
Injection-moulded glossy polypropylene
Glänzendes, spritzgegossenes Polypropylen
Injection glacée en polypropylène moulé
Magis, Motta di Livenza, Italy

Steel Frame dish rack, 2007

Simplehuman Design Team & Lum Design Associates (USA, est. 1999)

www.simplehuman.com
Coated stainless steel, bamboo, plastic
Edelstahl (beschichtet), Bambus, Plastik
Acier inoxydable (revêtement), bambou, plastique
Simplehuman, Torrance (CA), USA

With extra rungs that can be flipped up when required, and a sliding section for holding cups, this dish rack is a highly space-efficient design that can be adapted according to how many glasses, plates, pots or pans need to be drained. There is also a bamboo knife block to protect knives as they dry. In addition, the rack has been treated with a finger-proof and smudge-resistant coating so that the stainless steel will remain gleaming.

Mit zusätzlichen, bei Bedarf herausklapp-baren Querstäben und einem auszieh-baren Abtropfbrett für Tassen stellt dieses Abtropfgestell eine Platz sparende und – je nachdem, wie viel Geschirr, Pfannen und Töpfe man darauf abstellen muss – flexible Designlösung dar. Außerdem ist es mit einem Messerblock aus Bambus und einer Beschichtung der Edelstahloberfläche ausgestattet, auf der weder Fingerabdrücke noch Fettflecken haften bleiben.

Véritable bijou des ustensiles de cuisine haut de gamme, cet égouttoir aux élé-ments rétractables s'adapte au nombre de verres, d'assiettes, de casseroles à faire sécher et dispose en outre d'un rack pour les tasses avec anse. Un porte-cou-teaux en bambou permet de faire sécher les lames individuellement. Les assiettes s'égouttent dans la partie centrale recou-verte d'un enduit anti tache offrant une brillance éternelle. L'eau s'évacue via une rigole mobile située sous l'égouttoir.

Aga Classic Special Edition 4 heat storage cooker, 1930s

Gustaf Dalén (Sweden, 1869–1937)

www.aga-rayburn.co.uk
Cast iron, other materials
Gusseisen und andere Materialien
Fonte, autres matériaux
↔ 148.7 cm
Aga, Telford, UK

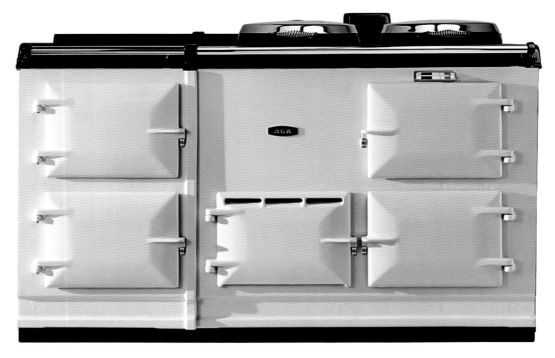

Using the concept of heat storage, the Nobel Prize-winning physicist, Gustaf Dalén, invented the *Aga* cooker in the late 1920s. Incorporating a small but highly efficient heat source, *Aga* cookers have various ovens and hotplates that maintain different temperatures. They can, therefore, be used for different types of cooking, from roasting and grilling to frying and steaming. A veritable icon of durable domestic design, this special edition model is based on an original *Aga* cooker from the 1930s and incorporates four ovens.

Unter Anwendung seines Konzepts der Wärmespeicherung entwickelte der Physiker und Nobelpreisträger Gustaf Dalén Ende der 1920er Jahre den AGA-Herd. Diese Art Herd ist mit einer kleinen, aber hoch leistungsstarken Energiequelle und mit mehreren Ofenröhren, Koch- sowie Warmhalteplatten mit unterschiedlichen Temperaturleistungen ausgestattet. Sie ermöglichen es, die verschiedensten Nahrungsmittel zu kochen, braten, grillen, rösten oder über Dampf zu garen. Diese Reedition eines AGA-Herds mit vier Ofenröhren aus den 1930er Jahren ist Kult – und der Inbegriff eines langlebigen Haushaltsgeräts.

Prix Nobel de physique, Gustaf Dalén a inventé la cuisinière *Aga* dans les années 20 en utilisant le concept de stockage de chaleur. Ces pianos comportent plusieurs fours et des plaques chauffantes qui conservent des températures différentes. Ainsi vous pouvez utiliser des types de cuisson distincts : rôtir, griller, frire et cuire à la vapeur. Véritable incontournable du design domestique, ce modèle en série limité s'inspire de la cuisinière *Aga* des années 30 et comporte quatre fours.

Professional Series range, 1987 (original design)

Viking Design Team

www.vikingrange.com
Stainless steel, glass, other materials
Edelstahl, Glas, andere Materialien
Acier inoxydable, verre, autres matériaux
↔ 121.6 cm
Viking, Greenwood (MS), USA

During the 1970s, a building contractor by the name of Fred Carl Jr noticed that commercial cooking ranges were increasingly being specified for domestic interiors. Their industrial look was, it seemed, in tune with the then fashionable High Tech style. As a result, Carl founded the Viking Range Corporation in the early 1980s to manufacture hybrid, heavy-duty ranges that gave the performance of professional equipment but that were also tailored to the home. Today, Viking manufactures a range of premium equipment suitable for furnishing any chef's dream kitchen.

In den 1970er Jahren fiel dem Bauunternehmer Fred Carl Jr. auf, dass immer mehr private Bauherren sich in ihren neuen Häusern Kochherde einbauen ließen, die eigentlich für die Gastronomie hergestellt wurden. Ihr industrieller Look war, so schien es, im Einklang mit dem damals begehrten High-Tech-Stil. Deshalb gründete Carl Anfang der 1980er Jahre die Viking Range Corporation, um Herde herzustellen, die sozusagen Kreuzungen aus den schweren Modellen für Profiköche und Herden für den Hausgebrauch darstellten. Heute produziert Viking eine Reihe von Herden und Küchenschränken, die das Herz jedes Profi- oder Hobbykochs höher schlagen lassen.

Dans les années 70, c'est le boom de la société de consommation ! Alors entrepreneur, Fred Carl Jr remarque que les cuisinières sont de plus en plus demandées par les ménagères. Leur style industriel était, semble-t-il, en harmonie avec le style High Tech à la mode. Carl fonde alors la Viking Range Corporation au début des années 80 afin de fabriquer des hybrides : de superbes pianos offrant un équipement digne des professionnels. De nos jours, la société Viking manufacture une gamme d'équipements performants idéale pour les passionnés de cuisine.

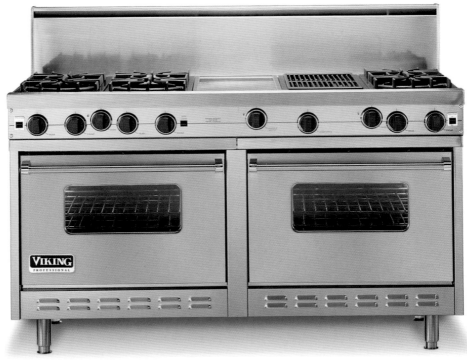

Professional Series combi-steam oven, 2007

Viking Design Team

www.vikingrange.com
Stainless steel, glass, other materials
Edelstahl, Glas und andere Materialien
Acier inoxydable, verre, autres matériaux
↔ 59.4 cm
Viking, Greenwood (MS), USA

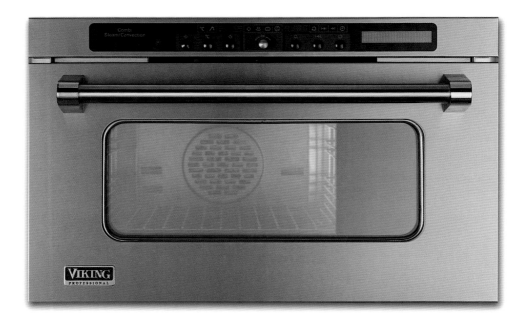

By using a combination of steam and convection heat, this oven provides a fast and healthy way of cooking. As you would expect from Viking, the design boasts numerous professional features, including six different cooking functions – such as the ReHeat Plus option that reheats and defrosts foods using steam. In addition, the design has an automatic de-scaling and cleaning feature.

Die Backröhre dieses Herds kann sowohl mit Konvektionshitze als auch mit Heißdampf betrieben werden. So wird alles, was man hineinschiebt, nicht nur schneller, sondern auch auf gesündere Weise gar oder durchgebacken. Wie man von Viking erwarten kann, ist der Herd mit zahlreichen professionellen Funktionen ausgestattet, einschließlich sechs verschiedenen Koch- und Backfunktionen, darunter die ReHeat Plus-Option, mit der Tiefkühlkost mit Heißdampf aufgetaut und erhitzt wird. Eine weitere Zusatzleistung ist die automatische Entkalkung und Selbstreinigung.

Ce four combiné vapeur permet de réaliser rapidement une cuisine saine. Viking introduit le professionnalisme culinaire en offrant à ses produits des performances exceptionnelles. Ce four comporte six modes de cuisson, incluant celui qui permet de régénérer et décongeler des produits en utilisant un système à vapeur. Ce modèle dispose également d'un mécanisme anti tartre et auto nettoyant.

Professional Series microwave, 2002

Viking Design Team

www.vikingrange.com
Stainless steel, glass, other materials
Edelstahl, Glas, andere Materialien
Acier inoxydable, verre, autres matériaux
↔ 62.5 cm
Viking, Greenwood (MS), USA

Like other premium kitchen equipment manufactured by Viking, the *Professional Series* microware provides performance far beyond the domestic norm with its extra-large capacity and its array of broiling, roasting and baking settings, alongside conventional microwave functions. In a multitude of ways, it will cook or re-heat your food to perfection. Apart from the stainless-steel version, this design comes in twenty-three different colour options, and can either be placed on a counter top or installed as a built-in unit.

Wie die anderen hochwertigen Küchengeräte von Viking bieten auch die Mikrowellen der *Professional Series* mehr Funktionen als die gängigen Modelle für Privathaushalte. Erstens haben sie ein größeres Fassungsvermögen und zweitens zusätzlich zu den üblichen Mikrowellenfunktionen Einstellungen für Grillen, Braten und Backen. So ermöglichen sie das Erhitzen und Garen der verschiedensten Nahrungsmittel. Neben der Edelstahlversion ist die *Professional Series*-Mikrowelle in dreiundzwanzig Farben lieferbar und entweder als Stand- oder Einbaumodell nutzbar.

Les produits Viking Range, y compris ce four à micro-ondes, ont fait entrer la performance de la cuisine professionnelle chez les particuliers. Ce four dispose d'une importante capacité, et offre diverses caractéristiques qui font la différence : capteurs pour la cuisson et mode de cuisson différenciés. Vous pourrez cuire ou réchauffer vos plats à la perfection. La version classique en acier inoxydable s'ajoute à vingt-trois options de couleurs. Ce four à micro-ondes peut être encastré ou simplement posé sur une surface.

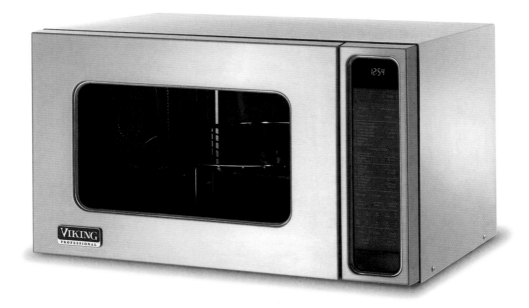

P775-1 ceramic hob, 2001–2002

Smeg Design Team

www.smeg.com
Ceramic, stainless steel
Ceran, Edelstahl
Céramique, acier inoxydable
↔ 60, 72 cm
Smeg, Guastella, Italy

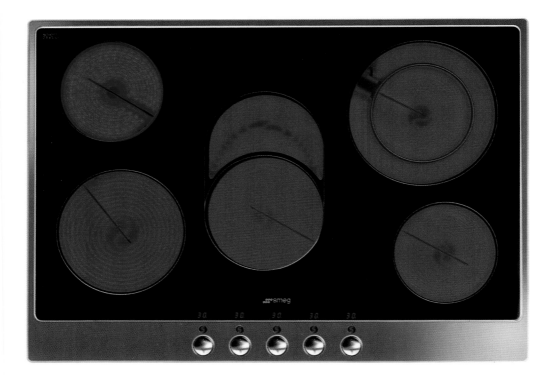

Smeg's motto, 'technology with style', perfectly describes the company's understated yet high-quality kitchen appliances. Engineering excellence, combined with a human-centric approach to design, ensures that Smeg equipment – such as the P775-1 ceramic hob – has a logical and functional elegance that is impervious to the vagaries of fashions. The P775-1's five cooking zones are controlled using the firm's exclusive 'rocker touch control', that provides nine different power levels and an independent time-programming facility.

Smegs Motto „Technologie mit Stil" beschreibt treffend die hochwertigen, raffiniert dezenten Küchengeräte, die das Unternehmen herstellt. Technische Perfektion und kundenorientierte Designs garantieren dem Käufer, dass die Geräte – wie etwa dieses Cerankochfeld – funktional logisch und elegant konstruiert sind und alle Modetrends überdauern. Die fünf Kochplatten dieses Modells werden mit Hilfe des speziellen Steuer-Wipp-Schaltsystem von Smeg bedient, mit dem man neun verschiedene Temperaturstufen und ein Zeitschaltprogramm einstellen kann.

La devise de Smeg « la technologie design » décrit parfaitement cette société qui fut l'une des premières à fabriquer des produits électroménagers en Italie. Ce style exclusif associé à une technologie de pointe confère à la table de cuisson vitrocéramique P775-1 une élégance logique et fonctionnelle, indifférente aux caprices de la mode. Ce modèle compte cinq foyers de cuisson disposant chacun d'un écran visuel qui permet de contrôler les neuf niveaux de puissance, ainsi qu'une sécurité de coupure automatique.

P75 hob, 2005
Piano Design (Italy, est. 1981)

www.smeg.com
Stainless steel
Edelstahl
Acier inoxydable
↔ 72 cm
Smeg, Guastella, Italy

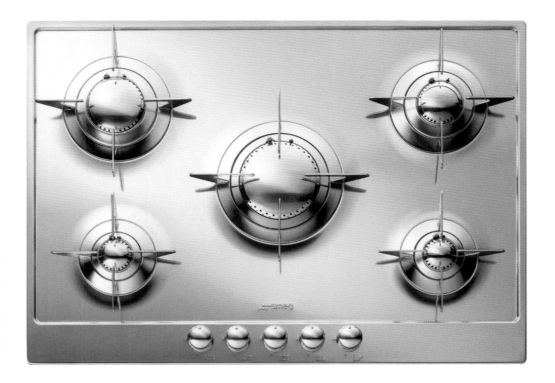

This hob is one of three models designed by Piano Design for Smeg. Like Renzo Piano's architecture, this sleek design – with its harmonious proportions, uncluttered lines and refined detailing (such as the visually stunning pan stands) – can be seen as an elegant expression of post-Miesian Modern Neo-Classicism. In addition, the hob's five burners have safety valves that automatically shut off the gas supply if the flame is accidentally extinguished.

Dieses Gas-Kochfeld ist eines von dreien, die Renzo Piano mit seinem Designbüro Piano Design für Smeg entworfen hat. Wie Pianos Bauten lässt sich auch dieses stromlinienförmige Produkt mit seinen harmonischen Proportionen, klaren Linien und raffinierten Details (zum Beispiel den zackig geformten Topfstegen über den Gasringen) als elegante Version eines post-Mies'schen, zeitgenössischen Neo-Klassizismus interpretieren. Die fünf Gasringe sind mit Sicherheitsventilen ausgestattet, die sofort die Gaszufuhr abstellen, wenn die Flammen versehentlich gelöscht werden.

Cette plaque est l'un des trois modèles conçus par Piano Design pour Smeg. Avec ses dimensions harmonieuses, son design lisse, épuré, et ses détails raffinés, cette création peut être perçue comme une expression élégante du néo-classicisme moderne, au même titre que l'architecture de Renzo Piano. Les cinq foyers de cuisson sont équipés d'une soupape de sécurité fermant automatiquement le gaz lorsque la flamme s'éteint accidentellement.

Professional Series chimney wall hood, 2007 & Professional Series island hood, 2003

Viking Design Team

www.vikingrange.com
Stainless steel
Edelstahl
Acier inoxydable
↔ 75.9, 91.1, 106.4, 121.6, 136.8, 152.1, 167.3 cm
Viking, Greenwood (MS), USA

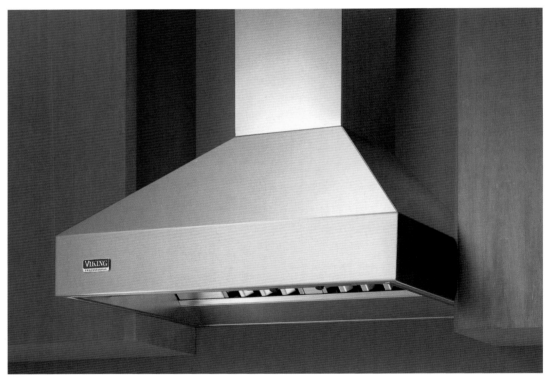

The heavy-duty construction of these professional-style chimney hoods is virtually seamless, with no visible screws. This underwrites their super-stylish looks, and also ensures that it is easier to keep them clean and gleaming. These hoods also outperform most other designs currently on the market thanks to a commercial-standard baffle filter system that quickly and efficiently removes grease and heated vapours from the air.

Diese Dunstabzugshauben für gastronomische Betriebe sind äußerst robust und ohne sichtbare Schrauben nahezu „nahtlos" konstruiert, weshalb sie auch supermodern und elegant aussehen und außerdem leicht zu reinigen sind. In ihrer Funktion übertreffen diese Modelle die meisten Dunstabzugshauben anderer Hersteller, weil sie mit einem Luftleitblech-Filtersystem ausgestattet sind, das Wasserdämpfe schnell und effektiv aus der Küchenluft absaugt.

Cette hotte allie esthétique et fonctionnalité. Son aspect lisse et brillant présente un ensemble uniforme, sans vis apparentes. Agréable à regarder, cette création est également facile à nettoyer. Bien plus performante que les hottes classiques disponibles sur le marché, ce modèle dispose d'un système de filtre Baffle qui élimine rapidement et de manière efficace les émanations de graisse.

J-series refrigerator, 2007

Jasper Morrison (UK, 1959–)

www.samsung.com
Various materials
Verschiedene Materialien
Matériaux divers
↔ 91.2 cm
Samsung, Seoul, Korea

As Jasper Morrison explains, 'Design has taken a foothold in the modern home and appliances now need to exceed customer expectations and offer users an emotional experience.' Certainly, his side-by-side *J-series* refrigerator for Samsung, which took two years to develop, manages harmoniously to synthesize state-of-the-art technology with a pure and modern look. Happily, the resulting design not only offers high functional performance and good energy efficiency, but also has an engaging yet minimalist aesthetic.

Laut Jasper Morrison hat „Design Eingang in die moderne Wohnung gefunden, Haushaltsgeräte müssen heute die Erwartungen der Käufer übertreffen und ihnen ein emotionales Erlebnis bieten". Sein kombinierter Kühl- und Gefrierschrank der *J-Serie* für Samsung, dessen Entwicklung zwei Jahre in Anspruch nahm, stellt eine harmonische Synthese aus ultramoderner Kühltechnik und klarem, modernem Design dar. Glücklicherweise ist er also nicht nur funktional und energieeffizient, sondern auch äußerlich auf ansprechende Weise minimalistisch.

« Le design a pris pied dans les foyers modernes et les appareils ménagers doivent désormais répondre aux attentes des clients et offrir à leurs utilisateurs une expérience émotionnelle », explique Jasper Morrison. Fruit d'une recherche stylistique qui a duré deux ans, le réfrigérateur *Série J* allie une esthétique minimaliste et conviviale à des technologies de pointe afin de proposer un modèle d'exception dont les performances sont aussi impressionnantes que son aspect.

B1-48S refrigerator/freezer, 2010

Sub-Zero Design Team

www.subzero.com
Various materials
Verschiedene Materialien
Matériaux divers
↔ 121.9 cm
Sub-Zero Freezer Company, Madison (WI), USA

Often regarded as the king of cool, Sub-Zero was the first company to introduce built-in home refrigerators in the mid-1950s. Since then, the company has continually refined its concept, and today produces premium, American-style refrigerators that symbolise that nation's alluring vision of scale and plenty. This side-by-side fridge-freezer, fully clad in stainless steel, is one of the company's most stylish models, and boasts an impressive 276.7 litre capacity.

Das Unternehmen Sub-Zero, in den USA häufig als „king of cool" bezeichnet, war der erste amerikanische Hersteller von Kühltechnik, der Mitte der 1950er Jahre Kühlschränke für Privathaushalte auf den Markt brachte. Seitdem hat die Firma ihr Kühlkonzept stetig verfeinert und produziert heute erstklassige Kühlschränke im amerikanischen Stil – in Erfüllung der uramerikanischen Vision von Größe und Fülle. Diese ganz in Edelstahl gekleidete Kühl- und Gefrierschrankkombination gehört zu Sub-Zeros stilvollsten Modellen mit einem eindrucksvollen Fassungsvermögen von 276,7 Litern.

Sub-Zero fut la première société à présenter des réfrigérateurs domestiques intégrés dans les années 50. Depuis, cette société a inlassablement affiné son concept et produit actuellement les meilleurs réfrigérateurs de style américain. Le modèle B1-48S est entièrement revêtu d'acier inoxydable, lui conférant une indéniable élégance. En outre, ce réfrigérateur est le plus spacieux proposé par Sub-Zero, avec une capacité de 276,7 litres.

Blanco Claron 8s-if sink, 2006

Blanco Design Team

www.blanco.de
Stainless steel
Edelstahl
Acier inoxydable
↔ 116 cm
Blanco, Oberderdingen, Germany

The *Blanco Claron 8s-if* double-bowl sink is a premier solution that can be inset into a counter-top or flush mounted. Made of satin-polished stainless steel, this elegantly practical sink has an engineered purity that has become synonymous with the best of modern German design. This revolutionary design has won both a Red Dot design award and an iF product design award, not least for its beautiful and distinctive contours, which prescribe a precise and seamless transition from curves into straight lines.

Das Modell *Blanco Claron 8s-if* ist eine Spüle mit zwei Becken, die man entweder als Auflagespüle oder als flächenbündige Spüle einsetzen kann. Aus mattiertem Edelstahl gefertigt, ist diese elegante und funktionale Spüle von einer Klarheit, die zum Synonym für erstklassige moderne Designlösungen aus Deutschland geworden ist. Das revolutionäre Design ist sowohl mit dem Red Dot Award als auch mit dem iF-Produktdesignpreis ausgezeichnet worden, nicht zuletzt wegen seiner klaren Konturen, die nahtlos von Kurven in gerade Linien übergehen.

L'évier à double bac *Blanco Claron 8s-if* est une solution fort ingénieuse, qui peut être posée ou encastrée dans un plan de travail. Fabriqué en acier inoxydable satiné, cet évier aux finitions parfaites se distingue par la pureté de ses lignes, illustrant ainsi le meilleur du design moderne allemand. Cette création révolutionnaire a d'ailleurs remporté deux prix (Red Dot design et iF Product design) qui témoignent de la réussite du produit. Ses courbes majestueuses offrent une transition douce et harmonieuse entre rotondité et lignes droites.

Winner of a Compasso d'Oro, Nico Moretto has developed an outstanding and truly comprehensive range of kitchen units made up of modular, moveable and independent elements that can be arranged and configured according to need and available space. The design of these units, such as the one shown here, are determined by careful ergonomic study, while their manufacture relies on skilled craftsmen working with the finest grade of stainless steel.

Nico Moretto, Gewinner eines Compasso d'Oro, hat ein außergewöhnliches und sehr umfangreiches System von modularen, mobilen und unabhängigen Küchenelementen entworfen, die entsprechend individueller Bedürfnisse und verfügbarem Raum angeordnet werden können. Das Design dieser Einheiten, zu denen auch die hier gezeigte gehört, wird in sorgfältigen ergonomischen Studien festgelegt, während die Herstellung Fachleuten obliegt, die hochwertigsten Edelstahl verarbeiten.

Récompensé d'un Compasso d'Oro, Nico Moretto a développé une gamme complète d'éléments de cuisine, composée d'unités modulables et indépendantes, à configurer selon les besoins et l'espace disponible. À l'instar de celles présentées ici, la conception de ces unités reflète une étude ergonomique sérieuse ajoutée à une fabrication en acier inoxydable, réalisée par des artisans hautement qualifiés. Un design absolument extraordinaire, à la fois fonctionnel et contemporain.

Kitchen unit (VSR 70 sink, A 478/4G countertop hob, TS/190 counter top, 2CL/190 drawers & cabinet), c. 2008

Nico Moretto (Italy, 1926–)

www.alpesinox.com
Stainless steel
Edelstahl
Acier inoxydable
↔ 190 cm
Alpes-Inox, Bassano del Grappa, Italy

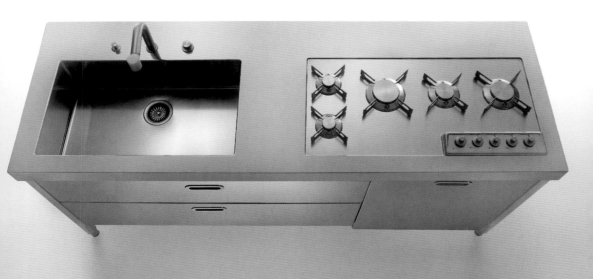

Artematica modular kitchen, 1988

Valcucine Design Team

www.valcucine.it
Aluminium, lacquered MDF, glass, laminates
Aluminium, MDF (lackiert), Glas, Laminat
Aluminium, MDF laqué, verre, laminé
Valcucine, Pordenone, Italy

Valcucine specializes in the manufacture of environmentally friendly modular kitchens. Their production involves a minimum of materials and energy; they are made from recyclable components and sustainably sourced woods; and the company's manufacturing process reduces toxic and polluting chemical emissions. Valcucine's products are also designed to be as durable as possible to ensure their longevity. In addition, their *Artematica* kitchen is extremely functional and elegant, showing that eco-sustainable design can also be exceedingly stylish.

Der italienische Küchenhersteller Valcucine hat sich auf umweltfreundliche modulare Kücheneinrichtungen spezialisiert, deren Fertigung ein Minimum an Material und Energie verbraucht. Sie bestehen aus wieder verwendbaren Teilen sowie Holz aus nachhaltiger Forstwirtschaft. Außerdem hat die Firma die Herstellungsprozesse so gestaltet, dass toxischen Emissionen auf das absolute Minimum reduziert werden. Valcucine-Küchen sind robust und äußerst langlebig. Die *Artematica*-Küche ist außerdem extrem funktional und elegant und demonstriert, dass „grünes Design" auch sehr stilvoll und modern sein kann.

Valcucine est spécialisée dans la fabrication de cuisines modulaires respectueuses de l'environnement. Leur production, réalisée à partir de composants recyclables et de bois, implique un minimum de matériaux et d'énergie. Ce processus de fabrication réduit les émissions polluantes toxiques et chimiques. Les produits Valcucine sont également conçus pour être le plus résistants possible. La cuisine *Artematica* allie l'esthétique à l'aspect fonctionnel, démontrant ainsi que le design éco-durable peut également être chic.

Jacob Jensen is known for his seminal audio-equipment designs for Bang & Olufsen and his eponymous homeware collection, which ranges from alarm clocks to doorbells. With his son Timothy, he has more recently turned his attention to designing on a larger scale. The resulting *Kitchen 1* and *Kitchen 2* were inspired by the landscape of Northern Denmark where the Jensen design studio is located – the surrounding scenery described by Timothy as "pure lines, simple forms, contrasts of light and dark."

Jacob Jensen ist für seine bahnbrechenden eleganten Designs für Bang & Olufsen und die von seiner eigenen, nach ihm selbst benannten Firma hergestellten Designprodukte – von Weckern und Türklingeln bis Kochutensilien – berühmt. Zur Gestalt seiner Designerküchen *Kitchen 1* und *Kitchen 2* ließ er sich von der landschaftlichen Umgebung von Holstebro im Norden Dänemarks (Sitz der Firma) inspirieren, die laut Timothy Jacob Jensen reine Linien, schlichte Formen sowie starke Hell- und Dunkelkontraste aufweist.

Jacob Jensen est connu pour ses créations d'équipement audio pour Bang & Olufsen, et sa collection éponyme d'articles pour la maison, des réveils aux sonnettes. Récemment et en compagnie de son fils Timothy, ce créateur a décidé d'étendre son domaine de compétence. Les meubles de cuisine *Kitchen 1* et *Kitchen 2* s'inspirent des paysages du nord du Danemark, où se situe le studio de design de Jensen. Selon Timothy, ce paysage révèle parfaitement « la pureté des lignes, des formes simples et des contrastes d'ombre et de lumière ».

Kitchen 1, 2005
Jacob Jensen (Denmark, 1926–)
& Timothy Jacob Jensen (Denmark 1962–)

www.lifa-design.com
Teak or maple, aluminium, laminate
Teakholz oder Ahorn, Aluminium, Laminat
Teck ou érable, aluminium, laminés
↗ 90 cm
Lifa Design, Holstebro, Denmark

Kitchen 2, 2007

Jacob Jensen (Denmark, 1926–)
& Timothy Jacob Jensen (Denmark 1962–)

www.lifa-design.com
Laminate, oak, teak or maple
Laminat, Eiche, Teakholz oder Ahorn
Stratifié, chêne, teck ou érable
↗ 90 cm
Lifa Design, Holstebro, Denmark

According to their manufacturer, *Kitchen 1* and *Kitchen 2* are 'the kitchen industry's answer to Formula 1'. The concept behind them is to create a timeless solution that relies on dynamic, faceted forms and simple bold lines. Both kitchens possess a functional purity and, like other Jensen designs, have an extraordinarily high level of build quality. Designed without compromise, these kitchens are available in just two finishes: white or black.

Laut Herstellerangaben entsprechen die Designerküchen *Kitchen 1* und *Kitchen 2* „der Formel 1 der Küchenhersteller". Das Design beruht auf dem Konzept der zeitlosen, dynamischen Funktionalität, die mit ihren facettenreichen Formen und klaren Linien wie andere Jensen-Designs in höchster Vollendung verarbeitet sind. Diese kompromisslos klaren, formschönen Küchenmöbel sind in Weiß oder Schwarz lieferbar.

Selon leur fabricant, *Kitchen 1* et *Kitchen 2* sont à l'industrie de la cuisine ce qu'est la Formule 1 pour l'automobile. Leur concept révèle une solution intemporelle avec des formes dynamiques, à facettes, et des lignes simples mais audacieuses. Ces deux cuisines reflètent une pureté fonctionnelle et, à l'instar d'autres créations de Jensen, elles illustrent une exceptionnelle qualité de réalisation. Conçues sans compromis, ces cuisines sont disponibles en deux finitions, blanc ou noir.

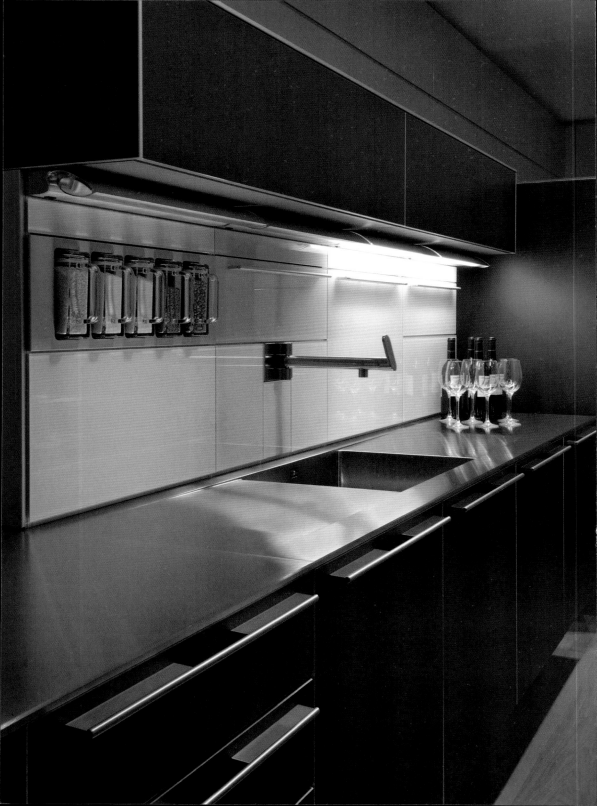

Bulthaup b1 Kitchen System, 2008

Bulthaup Design Team

www.bulthaup.com
Veneered or lacquered MDF
MDF, furniert oder lackiert
MDF verni ou laqué
Bulthaup, Bodenkirchen, Germany

Marketed as the 'essential kitchen', the *Bulthaup b1* is a system of kitchen units with a timelessly beautiful, pared-down aesthetic. Inspired by ideas of 'simplicity, geometry, sensuality', the precision-manufactured modular elements are made from basic cuboid shapes, and can be flexibly combined to suit individual requirements. Thanks to its restrained and essentialist look, the *Bulthaup b1* fits well into any architectural setting.

Die Bulthaup Systemküchenmöbel *b1* werden als „Küche pur" vermarktet und sind von zeitloser, reduzierter Modernität, getreu den Leitmotiven der Firma: „Schlichtheit, Geometrie und Sinnlichkeit". Die präzisionsgefertigten kubischen Module lassen sich nach Belieben flexibel miteinander kombinieren. Dank ihrer Schlichtheit und klaren Formen passt die *Bulthaup b1* ebenso gut in Altbauten wie in moderne Häuser.

Véritable « cuisine à l'état pur », *b1* est minimaliste et épurée. Elle se distingue par sa sobriété, le soin apporté aux détails et la concentration sur l'essentiel. Composée d'éléments modulaires en forme de cubes qui s'intègrent harmonieusement dans les données architectoniques de l'espace de vie, cette cuisine se distingue par ses superbes formes intemporelles.

Tableware
Tischkultur
Arts de la table

Blackhandle cutlery, 1982

Sori Yanagi (Japan, 1915–)

www.soriyanagi.com
Stainless steel, lacquered compressed betula wood
Edelstahl, lackierte und gepresste japanische Birke
Acier inoxydable, betula compressé et laqué
Sori Yanagi, Valby, Denmark

An exquisite expression of Japanese simplicity and functionality, Sori Yanagi's *Blackhandle* cutlery range is manufactured in the Niigata region of Japan, long famed for its traditional metal-working craftsmanship and the superlative quality of its steel. The lacquered handles are made of compressed betula wood (Japanese birch) and have a pleasurable feel when dining. Quite simply, this cutlery range is a superb example of Japanese design that can be used every day.

Sori Yanagis Besteckserie *Blackhandle* ist Ausdruck japanischer Einfachheit und Funktionalität. Sie wird in der japanischen Präfektur Niigata gefertigt, die seit langem berühmt ist für ihre traditionelle Metallkunst und die herausragende Qualität des dort hergestellten Stahls. Die lackierten Griffe sind aus japanischer Birke gefertigt und liegen beim Essen gut in der Hand. Kurz, diese Besteckserie ist ein wunderschönes Beispiel für japanisches Design, das tagtäglich benutzt werden kann.

Reflet exquis de la simplicité et de la fonctionnalité japonaises, les couverts *Blackhandle* de Sori Yanagi sont fabriqués dans le Niigata, une région du Japon renommée pour son travail artisanal du métal et l'excellente qualité de son acier. Les poignées laquées réalisées en betula (bouleau japonais) sont très agréables à manipuler. Cette gamme de couverts est tout simplement un superbe exemple de design japonais que l'on peut utiliser tous les jours.

Steel cutlery, 1974
Sori Yanagi (Japan, 1915–)

www.soriyanagi.com
Stainless steel
Edelstahl
Acier inoxydable
Sori Yanagi, Valby, Denmark

For centuries, Japan's Niigata prefecture has been famed for its tableware, a reputation founded, in turn, on the region's outstanding craftsmanship and the quality of its steel. Sori Yanagi's *Steel* cutlery range, manufactured by skilled craftsmen from this area, is beautifully made and possesses a high degree of functionality, expressed through its clean modern lines. Dishwasher safe, this cutlery won a Japanese Good Design award in 1974, and also a Long Life award in 2001.

Die Präfektur Niigata ist seit Jahrhunderten für qualitativ hochwertiges Besteck bekannt, ein Ruf, der sich auf die herausragende Handwerkskunst der Region und die Güte des Stahls gründet, der dort produziert wird. Sori Yanagis *Steel*-Besteckserie wird von erfahrenen japanischen Schmieden gefertigt und zeichnet sich durch ein hohes Maß an Funktionalität aus, die durch die sauberen modernen Linien zum Ausdruck kommt. Das spülmaschinengeeignete Besteck wurde 1974 mit einem japanischen Good Design Award und 2001 mit einem Long Life Award ausgezeichnet.

Depuis des siècles, la préfecture de Niigata au Japon est renommée pour ses articles de table, une réputation fondée sur la très grande qualité de ses artisans et de son acier. La gamme de couverts *Steel* de Sori Yanagi, fabriquée dans cette région, allie la beauté et une grande fonctionnalité qui s'exprime dans ses lignes modernes et épurées. Elle peut aller au lave-vaisselle et a remporté les prix Japanese Good Design en 1974 et Long Life en 2001.

AJ cutlery, 1957
Arne Jacobsen (Denmark, 1902–1971)

www.georgjensen.com
Stainless steel
Edelstahl
Acier inoxydable
Georg Jensen, Copenhagen, Denmark

Arne Jacobsen originally designed the well-known AJ cutlery range as part of his unified scheme for the SAS Royal Hotel in Copenhagen, which is widely acknowledged as an architectural masterwork of the International Style. Minimal and elegant, the cutlery, which sits comfortably in the hand, must have seemed strikingly futuristic when first launched. In production for over fifty years, it has come to be known as 'cutlery without frills', and still retains a strong sense of contemporary stylishness.

Arne Jacobsen entwarf die bekannte AJ-Besteckserie ursprünglich als Teil seines Gesamtkonzepts für das SAS Hotel in Kopenhagen, das als Meisterwerk des Internationale Styles gilt. Das minimalistische und elegante Besteck liegt gut in der Hand und muss bei seinem Erscheinen unglaublich futuristisch gewirkt haben. Inzwischen als „Besteck ohne Schnickschnack" bekannt, wird es seit über fünfzig Jahren produziert und ist noch immer von großer zeitgenössischer Eleganz.

Arne Jacobsen dessina sa célèbre ligne de couverts AJ dans le cadre de sa conception globale de l'hôtel SAS Royal à Copenhague, reconnu aujourd'hui comme un chef-d'œuvre du Style international. Minimalistes et élégants, ces couverts, qui tiennent confortablement dans la main, durent paraître très futuristes lors de leur lancement. Toujours produits plus de cinquante ans plus tard, ces « couverts sans chichi » conservent une grande élégance contemporaine.

Duna cutlery, 1995

Marco Zanuso (Italy, 1916–2001)

www.alessi.com
Stainless steel
Edelstahl
Acier inoxydable
Alessi, Crusinallo, Italy

The only design created for Alessi by Marco Zanuso, the *Duna* cutlery range derived from an earlier flatware concept he had developed in 1960 for a competition held by Reed & Barton, an American cutlery company. The design's distinctive nipped-in section, described by Zanuso as a 'narrow waist', was intentionally reminiscent of the idealized 1950s homemaker's hourglass physique. Certainly, this dishwasher-safe design has a sensual and swelling form that invites interaction.

Duna ist das einzige Design von Marco Zanuso für Alessi. Die Besteckgarnitur ist vom Konzept eines früheren Essbestecks abgeleitet, das er 1960 für eine Ausschreibung des amerikanischen Besteckherstellers Reed & Barton entworfen hatte. Die ausgeprägte Verjüngung am oberen Teil des Griffs, die Zanuso als „schlanke Taille" beschrieb, sollte bewusst an die ideale, einer Sanduhr ähnlichen Figur der Hausfrau der 1950er Jahre erinnern. Das spülmaschinenfeste Design hat ohne Zweifel etwas Sinnliches, das zur Interaktion einlädt.

Les couverts *Duna*, l'unique création de Marco Zanuso pour Alessi, s'inspirent d'un concept qu'il avait développé en 1960 pour un concours organisé par Reed & Barton, un coutelier américain. Leur silhouette caractéristique très étroite au centre évoque intentionnellement le physique idéalisé de la femme à la taille de guêpe des années 50. Adapté aux lave-vaisselle, la forme sensuelle de ce design tout en courbes invite effectivement à l'interaction.

Kurve cutlery, 1963

Tapio Wirkkala (Finland, 1915–1985)

www.int.rosenthal.de
Stainless steel
Edelstahl
Acier inoxydable
Rosenthal, Selb, Germany

A gifted form giver, Tapio Wirkkala's work expressed his deep understanding of the natural world, and was also informed by his painstaking research into ergonomics. His *Kurve* cutlery was designed to fit comfortably in the human hand, and was the result of numerous studies and drawings based on x-rays. Its ergonomically rational form is not only pleasurable to hold, but is also extremely beautiful to look at – a design that enchants the mind, hand and eye.

Die Arbeit des begnadeten Formgebers Tapio Wirkkala war Ausdruck seiner tiefen Naturverbundenheit und durchdrungen von seiner unermüdlichen Beschäftigung mit Fragen der Ergonomie. Sein Besteck *Kurve* sollte gut in der Hand liegen und war das Ergebnis zahlreicher Studien und Skizzen auf der Grundlage von Röntgebildern. Seine ergonomisch rationale Form macht es nicht nur angenehm in der Handhabung, sondern auch zu einer Augenweide – ein Design, das Geist, Hand und Auge erfreut.

Les créations de Tapio Wirkkala, grand spécialiste de la forme, reflétaient sa profonde compréhension de la nature et ses laborieuses recherches sur l'ergonomie. Ses couverts *Kurve* furent conçus pour bien tenir dans la main, résultat de nombreuses études et dessins basés sur des radiographies. Leur forme ergonomique et rationnelle les rend non seulement agréables à manipuler mais très beaux à regarder... un design qui enchante l'esprit, la main et le regard.

Bertel Gardberg specialized in the design of metalwares and jewellery, which won him international acclaim, numerous medals at the Milan Triennale exhibitions and also the Lunning Prize. His success owed to the fact that he could apply his finely honed craft skills to products intended for mass production, such as his famous *Carelia* flatware for Hackman. An acknowledged icon of Finnish design, the *Carelia* cutlery range has even featured on the country's postage stamps.

Bertel Gardberg war auf das Design von Metallwaren und Schmuck spezialisiert, was ihm internationale Anerkennung, zahlreiche Medaillen bei der Mailänder Triennale und den Lunning Prize einbrachte. Diesen Erfolg verdankte er der Tatsache, dass er seine große Kunstfertigkeit auf Produkte für die Massenfertigung anwenden konnte, darunter seine berühmte Besteckgarnitur *Carelia* für Hackman. Als ausgewiesene Ikone des finnischen Designs wurde die *Carelia*-Serie sogar auf Briefmarken des Landes abgebildet.

Spécialisé dans le design d'objets en métal et en joaillerie, Bertel Gardberg s'est forgé une réputation internationale. Il a remporté de nombreuses médailles à la Triennale de Milan ainsi que le prix Lunning. Il devait sa réussite à sa capacité d'adapter sa grande maîtrise de l'artisanat à des produits destinés à la production de masse, telle que sa célèbre ligne de couverts *Carelia* dessinée pour Hackman. Devenue emblématique du design finlandais, la poste nationale l'a même représentée sur un timbre.

Carelia cutlery, 1963
Bertel Gardberg (Finland, 1916–2007)

www.hackman.fi
Stainless steel
Edelstahl
Acier inoxydable
Hackman/Iittala Group, Iittala, Finland

Designed by the world-renowned architect, Zaha Hadid, this five-piece place setting echoes the vanguard dynamism of her extraordinary and sculptural buildings. The design's fluid and organic form belies its functional and ergonomic resolution. Distinctive and harmonious, the *Zaha* setting reflects WMF's belief that, 'Cutlery belongs within the category of tools that have the strongest and most intimate connection to their users, and whose design is shaped by manners, rituals and historical conventions.'

Die von der weltberühmten Architektin Zaha Hadid gestaltete fünfteilige Besteckgarnitur lässt die avantgardistische Dynamik ihrer ungewöhnlichen, skulpturalen Gebäude anklingen. Die fließende, organische Form des Designs täuscht über seine funktionale und ergonomische Entschiedenheit hinweg. Die außergewöhnliche und harmonische *Zaha*-Garnitur spiegelt die Überzeugung von WMF, dass „Besteck eines der am persönlichsten und am intimsten erlebten Werkzeuge und dabei in seiner Erscheinung von historischen Konventionen und ritualisierten Umgangsformen geprägt" ist.

Dessiné par Zaha Hadid, ce jeu de cinq couverts de table reflète le dynamisme avant-gardiste des extraordinaires édifices sculpturaux de cette architecte de renommée internationale. Les formes fluides et organiques du design cachent une résolution fonctionnelle et ergonomique. Différent et harmonieux, *Zaha* illustre la conviction de WMF : « Les couverts appartiennent à cette catégorie d'outils qui entretiennent une relation très puissante et intime avec leurs utilisateurs et dont le design est façonné par les mœurs, les rituels et les conventions historiques. »

Zaha cutlery, 2007
Zaha Hadid (Iraq/UK, 1950–)

www.wmf.com
Stainless steel
Edelstahl
Acier inoxydable
WMF Württembergische Metallwarenfabrik,
Geislingen, Germany

Balance cutlery, 1993

Matteo Thun (Germany, 1952–)

www.wmf.com
Stainless steel
Edelstahl
Acier inoxydable
WMF Württembergische Metallwarenfabrik, Geislingen, Germany

Matteo Thun's *Balance* cutlery is a modern yet timeless range that not only looks good but feels good too. As WMF explains: 'Soft contours, round shapes and balanced proportions produce the delicate and fascinating impression generated by this cutlery design. Sensual vibrancy and functionality are in perfect equilibrium with *Balance*.' This flatware range won a Design Plus award in 1993.

Matteo Thuns *Balance* ist ein modernes, dennoch zeitloses Besteck, das nicht nur gut aussieht, sondern sich auch gut anfühlt. Nach Ansicht von WMF zeichnet es sich durch „seine weiche Linienführung und runden Formen aus. Die ausgewogenen Proportionen lassen das grazile Besteck in einer faszinierenden Anmutung erscheinen. Sinnliche Ausstrahlung und konsequente Funktionalität sind bei *Balance* vollkommen ausgewogen." Die Garnitur wurde 1993 mit einem Design Plus Award ausgezeichnet.

Les couverts *Balance* de Matteo Thun, modernes et intemporels, sont non seulement beaux mais également agréables à manipuler. Comme l'explique WMF : « Leurs contours doux, leurs formes arrondies et leurs proportions équilibrées produisent une impression délicate et fascinante. Avec *Balance*, on constate un équilibre parfait entre le dynamisme sensuel et la fonctionnalité. » Cette ligne a remporté un prix Design Plus en 1993.

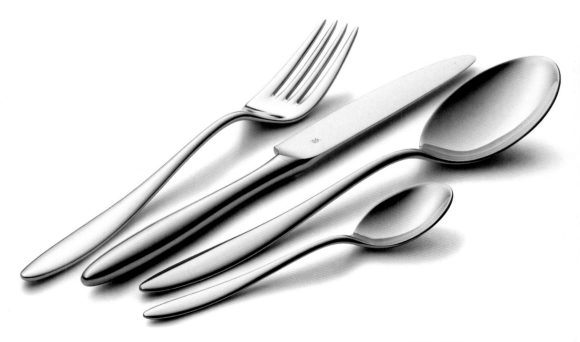

This classic range of cutlery is beautifully designed and exquisitely made. With a quality of construction one would expect from traditional Scandinavian craftsmanship, each handle is individually fitted and polished by hand. Available in either teak or rosewood, these handles are sourced from surplus woods set aside by the Norwegian furniture industry in order to reduce the environmental impact of their manufacture. Options with white or black acrylic handles are also available.

Diese klassische Besteckgarnitur überzeugt durch wunderschönes Design und exquisite Fertigung. Entsprechend der Qualität, die man von traditioneller skandinavischer Handwerkskunst erwarten kann, ist jeder Griff individuell eingepasst und von Hand poliert. Die entweder in Teak oder Rosenholz erhältlichen Griffe werden aus überschüssigem Holz aus der norwegischen Möbelindustrie hergestellt, um die Umweltbelastung durch die Produktion so gering wie möglich zu halten. Alternativ gibt es das Besteck auch mit weißen oder schwarzen Acrylgriffen.

Cette ligne classique de couverts est superbement conçue et réalisée. Avec la qualité de fabrication à laquelle l'artisanat traditionnel scandinave nous a habitué, chaque manche est fixé individuellement et poli à la main. Disponibles en teck ou en bois de rose, ces manches proviennent de stocks de bois en surplus gérés par l'industrie du meuble norvégienne afin de réduire l'impact de leur production sur l'environnement. Il existe également des modèles avec des manches en acrylique noir ou blanc.

Skaugum cutlery, 1944
Uncredited (Norway)

www.skaugum.info
Teak, stainless steel
Teak, Edelstahl
Teck, acier inoxydable
Skaugum/Geilo Jernvarefabrikk, Geilo, Norway

Citterio cutlery, 1998

Antonio Citterio (Italy, 1950–)

www.iittala.com
Stainless steel
Edelstahl
Acier inoxydable
Iittala, Iittala, Finland

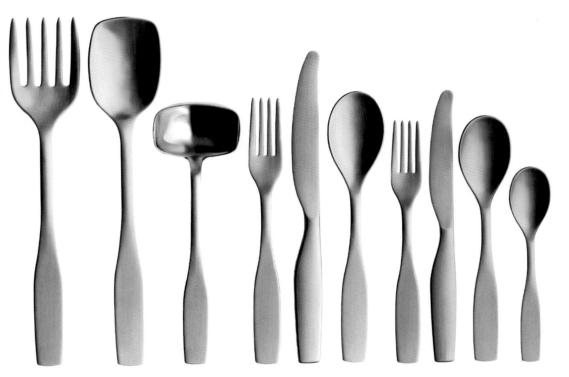

Perfectly balanced and reassuringly weighty, this range of cutlery feels wonderful in the hand. Part of Iittala's *Tools* collection, *Citterio* flatware is not only functionally superlative but has a rare aesthetic refinement that distinguishes it from other contemporary cutlery ranges. Furthermore, it is so beautifully made that it will last a lifetime of daily use.

Dieses perfekt ausgewogene, angenehm schwere Besteck liegt wunderbar in der Hand. *Citterio* gehört zur *Tools*-Kollektion von Iittala und ist nicht nur in funktionaler Hinsicht erstklassig, es überzeugt auch durch eine seltene ästhetische Vollkommenheit, die von anderen zeitgenössischen Bestecken unterscheidet. Außerdem ist es so gut gemacht, dass es ein Leben lang hält.

Parfaitement équilibrés et d'un poids rassurant, ces couverts sont un plaisir à tenir en main. Appartenant à la collection *Tools* de Iittala, la gamme *Citterio* est non seulement très fonctionnelle mais possède également une esthétique d'un raffinement rare qui la distingue des autres lignes de couverts contemporaines. En outre, sa fabrication est d'une telle qualité qu'elle dure toute une vie.

Mono Filio cutlery, 1990

Ralph Krämer (Germany, 1955–)

www.mono.de
Stainless steel
Edelstahl
Acier inoxydable
Mono/Seibel Designpartner, Mettmann, Germany

In the words of Ralph Krämer, 'Good design lies in achieving balance between tension and harmony' – a mission statement thoroughly realized in this flatware design. Inspired by the strict geometry of a trapezoid and the flowing movement of a wave, the *Mono Filio* range's comfort of use coexists with its sculptural eloquence.

Für Ralph Krämer liegt „gute Gestaltung in der Balance zwischen Spannung und Harmonie" – eine Überzeugung, die er beim Design dieser Besteckserie durch und durch umgesetzt hat. Inspiriert von der strengen Geometrie eines Trapezes und den fließenden Bewegungen einer Welle, vereint *Mono Filio* leichte Handhabung und ausdrucksvolle Formgebung.

Pour reprendre les termes de Ralph Krämer : « Le bon design réside dans l'obtention d'un équilibre entre la tension et l'harmonie », un cahier des charges parfaitement rempli avec cette ligne de couverts inspirée par la géométrie rigoureuse du trapèze et le mouvement fluide d'une vague. Le confort d'utilisation de *Mono Filio* n'a d'égal que son éloquence sculpturale.

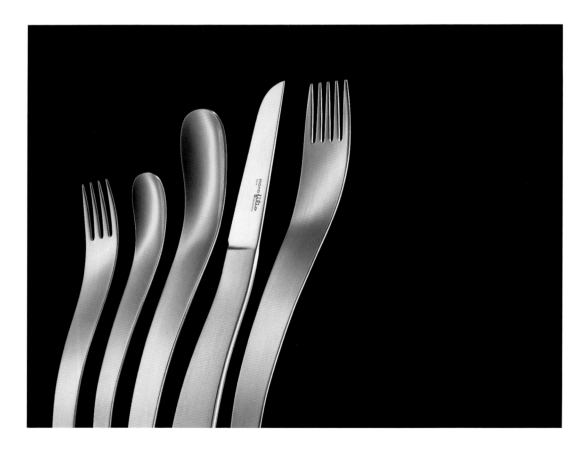

Mono-A cutlery, 1959

Peter Raacke (Germany, 1928–)

www.mono.de
Stainless steel or sterling silver
Edelstahl oder Sterling-Silber
Acier inoxydable ou argent
Mono/Seibel Designpartner, Mettmann, Germany

The *Mono-A* cutlery range was designed by Professor Peter Raacke in the late 1950s, and is generally considered a classic example of German design. With its clean and uncluttered lines, it certainly encapsulates its creator's functionalist approach to design. The *Mono-A* is the best-selling German flatware design of the postwar period, and continues to enjoy widespread popularity thanks to its aesthetic and functional purity.

Die Besteckserie *Mono-A* wurde Ende der 1950er Jahre von Professor Peter Raacke entworfen und gilt allgemein als klassisches Beispiel deutschen Designs. Die klaren, sauberen Linien des Bestecks veranschaulichen den funktionalistischen Designansatz seines Schöpfers. *Mono-A* ist das meistverkaufte deutsche Designbesteck der Nachkriegszeit und erfreut sich dank seiner ästhetischen und funktionalen Klarheit noch immer großer Beliebtheit.

Généralement considérée comme un classique du design allemand, la ménagère *Mono-A* fut dessinée par le professeur Peter Raacke à la fin des années 50. Avec ses lignes nettes et dépouillées, elle illustre à merveille l'approche fonctionnaliste de son créateur. Ce fut la gamme de couverts allemande la plus vendue dans l'après-guerre et elle continue d'être très appréciée en raison de sa pureté esthétique et fonctionnelle.

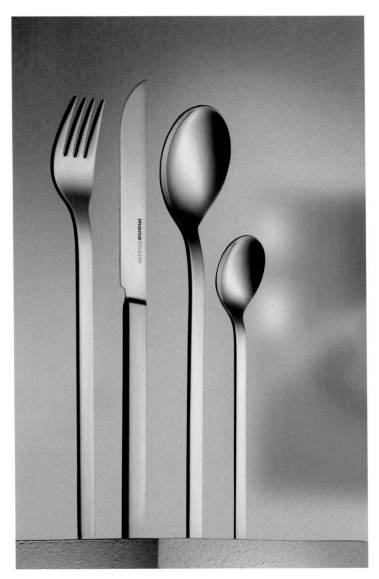

Pott 42 cutlery, 2003
Ralph Krämer (Germany, 1955–)

www.pott-bestecke.de
Stainless steel
Edelstahl
Acier inoxydable
C Hugo Pott/Seibel Designpartner, Mettmann, Germany

In response to the recent trend for using larger and larger plates, Ralph Krämer made his *Pott 42* cutlery range a few centimetres longer than average flatware designs so as to achieve a better proportional balance on the table. Winning a Red Dot award in 2003, this visually striking design with its ergonomic fork and spoons, and its sabre-like knife, is characteristic of the bold functionalism and aesthetic purity of contemporary German design.

Als Reaktion auf den neuerlichen Trend, immer größere Teller zu benutzen, machte Ralph Krämer seine Besteckgarnitur *Pott 42* ein paar Zentimeter länger, um die Ausgewogenheit der Proportionen auf dem Tisch zu wahren. Das visuell auffällige Design wurde 2003 mit einem Red Dot Award ausgezeichnet. Die ergonomisch geformten Gabeln und Löffel und die säbelförmigen Messer sind kennzeichnend für den ausgeprägten Funktionalismus und die ästhetische Klarheit des zeitgenössischen deutschen Designs.

La tendance actuelle étant aux assiettes toujours plus grandes, Ralph Krämer a conçu cette ligne de couverts *Pott 42* quelques centimètres plus longue que la moyenne afin de dresser des tables mieux proportionnées. Lauréat d'un prix Red Dot en 2003, ce service visuellement saisissant avec sa fourchette et ses cuillères ergonomiques et son couteau en forme de sabre est caractéristique du grand fonctionnalisme et de la pureté esthétique du design allemand contemporain.

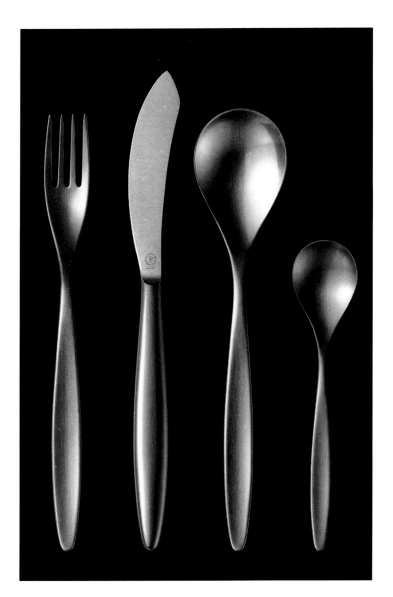

Pott 33 cutlery, 1975

Carl Pott (Germany, 1906–1985)

www.pott–bestecke.de
Stainless steel
Edelstahl
Acier inoxydable
C Hugo Pott/Seibel Designpartner, Mettmann, Germany

Pott began manufacturing high-quality knives in 1904. During the 1930s, the founder's son, Carl Pott – inspired by the teachings of the Bauhaus and the Deutscher Werkbund – began to design Modern-style cutlery remarkable for its functionalist forms. *Pott 33* flatware was one of his last designs, and encapsulates his pared-down style. When first introduced, his five-tined fork was seen as highly innovative, and with its slightly greater width over normal cutlery it certainly proved easier to use.

Pott begann 1904 mit der Herstellung qualitativ hochwertiger Messer. In den 1930er Jahren begann Firmengründer Carl Pott – inspiriert von den Lehren von Bauhaus und Deutschem Werkbund – mit dem Design von Besteck im Stil der Moderne, das besonders durch seine funktionalistische Form überzeugt. Die Besteckgarnitur *Pott 33* war eines seiner letzten Designs und bringt seinen klaren, reduzierten Stil auf den Punkt. Als es auf den Markt kam, galt besonders die Gabel mit fünf Zinken als große Innovation, und da es im Vergleich zu gewöhnlichem Besteck etwas breiter war, erwies es sich auch als einfacher in der Handhabung.

Pott s'est lancé dans la production d'une coutellerie de haute qualité en 1904. Au cours des années 30, le fils du fondateur, Carl Pott, inspiré par les enseignements du Bauhaus et du Deutscher Werkbund, conçut des couverts Modern Style remarquables par leurs formes fonctionnalistes. L'une de ses dernières créations, *Pott 33*, illustre parfaitement son style sobre. Lors de son lancement, sa fourchette à cinq dents paraissait très innovante et, avec sa largeur légèrement supérieure à la moyenne, était plus facile à manier.

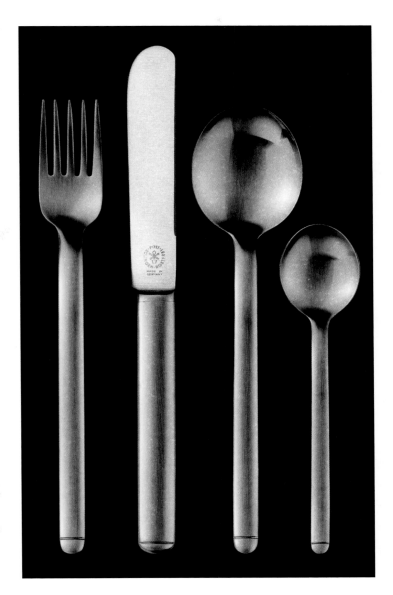

Tulipa cutlery, 2008

Jan Egeberg (Denmark, 1958–)
& Morten Thing (Denmark, 1954–)

www.gense.se
Stainless steel
Edelstahl
Acier inoxydable
Gense, Eskilstuna, Sweden

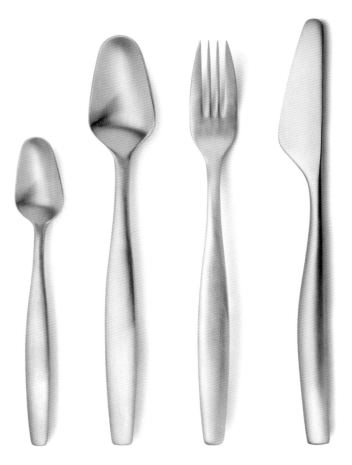

This beautiful cutlery range is a perfect example of the sensual elegance of 21st century organic design. As its title suggests, the *Tulipa's* form was inspired by the swelling shape of a budding tulip, giving the design a remarkable sense of sprouting growth. The organic forms of the different cutlery pieces are also ergonomically resolved, and sit comfortably in the hand as well as being reassuringly well balanced.

Diese schöne Besteckgarnitur ist ein perfektes Beispiel für die sinnliche Eleganz des organischen Designs des 21. Jahrhunderts. Wie der Name bereits andeutet, lieferte die Form einer erblühenden Tulpenknospe die Inspiration für *Tulipa*, und so hat das Design etwas von sprießendem Wachstum. Die organische Form der einzelnen Besteckteile ist auch ergonomisch durchdacht, so dass sie ausgewogen sind und gut in der Hand liegen.

Cette belle ligne de couverts est une parfaite illustration de l'élégance sensuelle du design organique du 21e siècle. Comme le suggère son nom, la forme de *Tulipa* s'inspire de la silhouette bombée d'une tulipe en bouton, créant une remarquable impression d'excroissance tubéreuse. Les formes arrondies des différentes pièces répondent également à un souci ergonomique : elles tiennent agréablement dans la main et sont parfaitement équilibrées.

Focus de Luxe cutlery, 1955–1956

Folke Arström (Sweden, 1907–1997)

www.gense.se
Stainless steel
Edelstahl
Acier inoxydable
Gense, Eskilstuna, Sweden

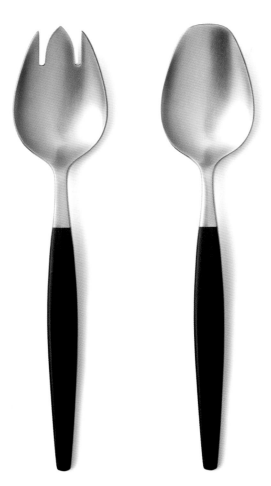

Folke Arström's *Focus de Luxe* is a classic Swedish design that reflects the widespread national belief that good design and quality of life are intertwined. Simple and beautiful, the *Focus* pattern expresses the casual sophistication of postwar Scandinavian design. It was especially successful in the United States, where it helped to associate formal dining with high-quality, Modern flatware in stainless steel, rather than with silverware in traditional patterns.

Focus de Luxe von Folke Arström ist ein klassisches schwedisches Design und reflektiert die in Schweden vorherrschende Ansicht, dass gutes Design und Lebensqualität eng miteinander verbunden sind. Die schlichte und schöne Besteckgarnitur demonstriert die natürliche Eleganz skandinavischen Nachkriegsdesigns. *Focus* war besonders in den Vereinigten Staaten ein Erfolg, wo es dazu beitrug, dass feines Essen mit qualitativ hochwertigem, modernen Edelstahlbesteck, statt mit traditionellem Silberbesteck assoziiert wurde.

Focus de Luxe de Folke Arström est un classique du design suédois qui reflète la conviction nationale selon laquelle un bon design va de pair avec une bonne qualité de vie. Simple et belle, cette ligne exprime la sophistication décontractée du design scandinave de l'après-guerre. Elle rencontra un franc succès aux États-Unis où elle imposa sur les tables formelles des couverts modernes de grande qualité en acier inoxydable à la place de l'argenterie traditionnelle.

Exquisitely balanced and perfectly formed to fit the hand, *Magnum* is Don Wallance's best-known cutlery range, and it is a tribute to his talent that it has remained in production for over forty years. With a no-nonsense robustness that is characteristically American, it also possesses an incredible ergonomic refinement. Almost forgotten today, Wallance was one of the greatest ever designers of flatware.

Magnum, die bekannteste Besteckgarnitur von Don Wallance, überzeugt durch ausgewogene, perfekte Formgebung, und es ist eine Hommage an sein Talent, dass sie bereits seit über vierzig Jahren produziert wird. Zu der schnörkellosen, typisch amerikanischen Robustheit kommt eine unglaubliche ergonomische Perfektion. Der heute fast in Vergessenheit geratene Wallance war einer der größten Besteckdesigner aller Zeiten.

Merveilleusement équilibrée et épousant parfaitement le creux de la main, *Magnum* est la ligne de couverts la plus connue de Don Wallance. Le fait qu'elle soit encore produite quarante ans après son lancement témoigne du talent de son créateur. D'une robustesse typiquement américaine, elle possède un incroyable raffinement ergonomique. Presque oublié aujourd'hui, Wallance fut l'un des plus grands designers de couverts.

Magnum cutlery, 1968
Don Wallance (USA, 1909–1990)

www.stelton.com
Stainless steel
Edelstahl
Acier inoxydable
Norstaal, Bergen, Norway/Stelton, Copenhagen, Denmark

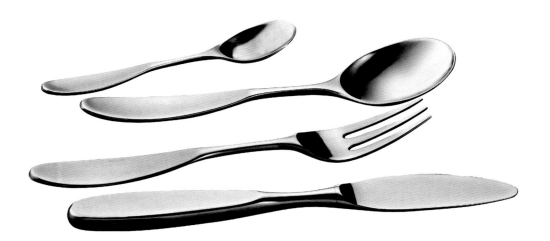

An acknowledged icon of Norwegian design, the distinctive pattern of Tias Eckhoff's *Maya* flatware was inspired by ancient Mayan forms. This cutlery range is also comfortable and stable to use, thanks to its round-edged yet relatively flat handles. Since its launch in 1962, *Maya* has been a best-selling design, receiving the Norwegian Design Award in 1961, and the Classic Award for Design Excellence from the Norwegian Design Council in 1991.

Maya, eine Ikone des norwegischen Designs, greift die Formsprache der Maya auf. Die Besteckserie ist dank ihrer abgerundeten, aber relativ flachen Griffe komfortabel und liegt gut in der Hand. Bereits 1961 mit dem norwegischen Design Award ausgezeichnet, erwies sich das Besteck seit seiner Markteinführung 1962 als Verkaufsschlager. 1991 wurde *Maya* mit dem Classic Award for Design Excellence des norwegischen Designrats ausgezeichnet.

Inspiré par les anciennes formes mayas, la silhouette caractéristique de la ligne de couverts *Maya* de Tias Eckhoff en a fait un objet emblématique reconnu du design norvégien. Grâce à leur manche arrondi et assez plat, les éléments tiennent bien dans la main et sont agréables à manipuler. Depuis son lancement en 1962, *Maya* est un succès commercial. Elle a remporté le Norwegian Design Award en 1961 et le Classic Award for Design Excellence du conseil norvégien du design en 1991.

Maya cutlery, 1960
Tias Eckhoff (Norway, 1926–)

www.stelton.com
Stainless steel
Edelstahl
Acier inoxydable
Norstaal, Bergen, Norway/Stelton, Copenhagen, Denmark

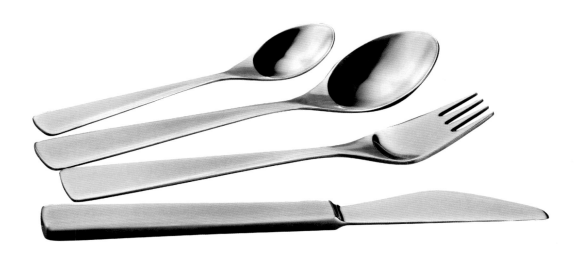

Classic cutlery, 1994

David Mellor (UK, 1930–)

www.davidmellordesign.com
Stainless steel
Edelstahl
Acier inoxydable
David Mellor, Sheffield, UK

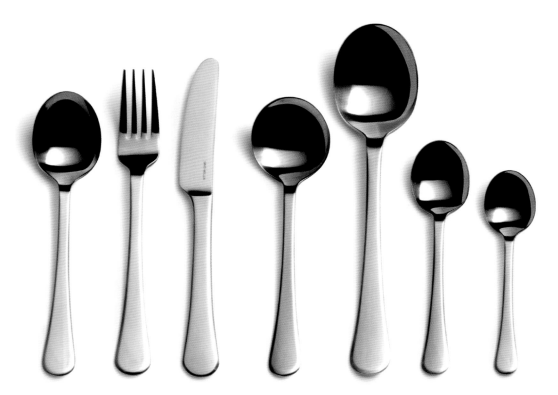

A timeless design with beautifully balanced proportions and careful detailing, Mellor's *Classic* flatware range looks as good in a traditional setting as it does in a modern environment. With a gentle and distinctive faceting around their handles, the nine pieces that make up the setting are comfortable to use and robust enough to give everyday service.

David Mellors Besteckgarnitur *Classic*, ein zeitloses Design mit ausgewogenen Proportionen und sorgfältig gestalteten Details, sieht auf einem traditionell gedeckten Tisch ebenso gut aus wie auf einem modernen. Die leicht facettierten Griffe des neunteiligen Bestecks sorgen dafür, dass es komfortabel in der Hand liegt und robust genug für den täglichen Gebrauch ist.

Design intemporel aux proportions superbement équilibrées et aux détails soignés, la ligne *Classic* de Mellor fait autant d'effet dans un décor traditionnel que dans un environnement moderne. Avec leur manche délicatement facetté, les neuf pièces sont agréables à manipuler et suffisamment robustes pour être utilisées tous les jours.

Provençal cutlery, 1973

David Mellor (UK, 1930–)

www.davidmellordesign.com
Stainless steel, acetal resin, brass rivets
Edelstahl, Acetalharz, Messingnieten
Acier inoxydable, résine acétal, rivets en laiton
David Mellor, Sheffield, UK

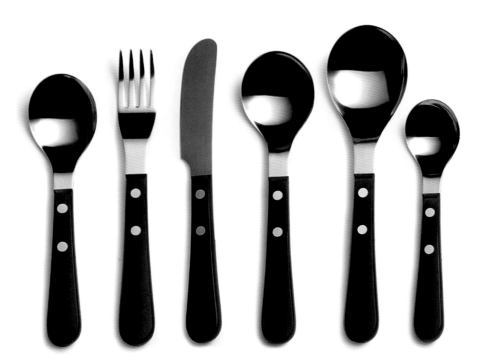

Throughout his illustrious career, David Mellor specialized in the design and manufacture of cutlery with superior performance characteristics. His influential *Provençal* design has an endearingly no-nonsense chunkiness, which was perfectly suited to the more casual lifestyle of the 1970s. It was also the first cutlery range to use handles made from moulded acetal – a rigid engineering plastic. Practical yet stylish, the eleven-piece range comes with a choice of black, blue or green handles.

Während seiner glänzenden Karriere spezialisierte sich David Mellor auf das Design und die Herstellung von Besteck mit hervorragenden Gebrauchseigenschaften. Sein einflussreiches Design *Provençal* ist von einer ansprechenden, schnörkellosen Kompaktheit, die dem zwanglosen Lebensstil der 1970er Jahre perfekt entsprach. Es war auch das erste Besteck, bei dem Griffe aus geformten Acetal, einem sehr harten Werkstoff, eingesetzt wurden. Die praktische, aber elegante elfteilige Besteckgarnitur gibt es mit schwarzen, blauen oder grünen Griffen.

Tout au long de son illustre carrière, David Mellor s'est spécialisé dans la conception et la production d'une coutellerie de haute qualité. Son influente ligne *Provençal* possède un côté rustique attachant qui était parfaitement adapté au style de vie plus décontracté des années 70. C'était également la première à utiliser des manches en acétal moulé, un plastique rigide. Pratique mais élégant, ce service de onze pièces existe avec des manches noirs, bleus ou verts.

Pride cutlery, 1953

David Mellor (UK, 1930–)

www.davidmellordesign.com
Silver-plated or stainless-steel blades, metal or acetal handles
Klingen versilbert oder aus Edelstahl, Griffe aus Metall oder Acetal
Lames en métal argenté ou acier inoxydable, manches en métal ou acétal
David Mellor, Sheffield, UK

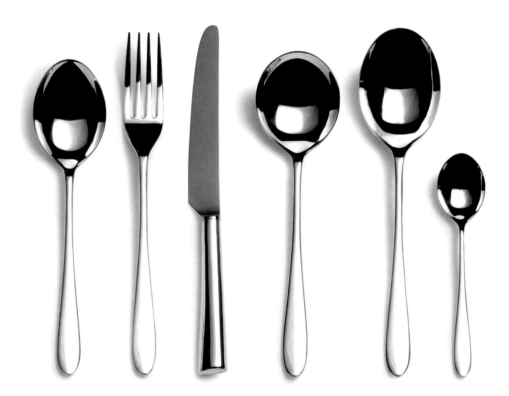

Widely acknowledged as a modern classic, *Pride* was David Mellor's first cutlery design and is also his most famous. Originally available only in silver plate, this flatware range is now also produced in stainless steel. Casual yet elegant, this eight-piece range epitomizes the understated sophistication of British design at its best.

Pride gilt weithin als moderner Klassiker und war nicht nur das erste, sondern auch das berühmtestes Besteckdesign von David Mellor. Die achtteilige Garnitur war ursprünglich nur versilbert erhältlich, wird aber heute auch in Edelstahl produziert. In ihrer zwanglosen Eleganz verkörpert sie die zurückhaltende Raffinesse britischen Designs in Bestform.

Reconnu aujourd'hui comme un classique moderne, *Pride* fut la première ménagère dessinée par David Mellor et sa plus connue. Initialement uniquement disponible en métal argenté, elle est désormais produite en acier inoxydable. Décontractée mais élégante, ses onze pièces incarnent la sophistication discrète du design britannique à son zénith.

Artik cutlery, 1997

Laura Partanen (Finland, 1972–)
& Arto Kankkunen (Finland, 1965–)

www.iittala.com
Stainless steel
Edelstahl
Acier inoxydable
Iittala, Iittala, Finland

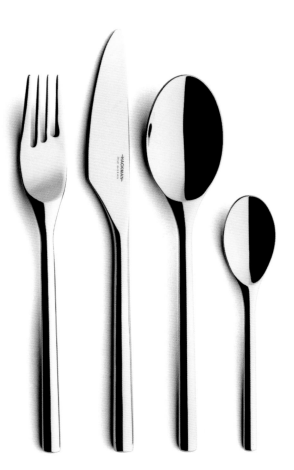

According to its manufacturer, Iittala: 'Artik is sophisticated design at its purest. The simplicity of the design's form is balanced by the sensual oval handles and the diagonal prongs of the fork. The solidity and weight convey a feeling of harmony and quality with every mouthful.' This extensive flatware range also includes a complimentary serving set, a thing of beauty in its own right.

„Artik ist anspruchsvolles Design in Reinform. Die Schlichtheit der Form wird ausbalanciert durch die sinnlichen ovalen Griffe des Bestecks und die diagonalen Zinken der Gabel. Die Stabilität und die Schwere vermitteln mit jedem Mundvoll ein Gefühl von Harmonie und Qualität", so der Hersteller Iittala. Zu der umfangreichen Besteckserie gehört zusätzlich ein wunderschönes Vorlegebesteck.

Selon son fabriquant, Iittala, « Artik incarne le design sophistiqué dans ce qu'il a de plus pur. La simplicité des lignes est équilibrée par la sensualité de l'ovale du manche et des dents obliques de la fourchette. La solidité et le poids des éléments procurent un sentiment d'harmonie et de qualité à chaque bouchée ». Cette vaste gamme une œuvre d'art à part entière.

Form 1382 tableware, 1931

Hermann Gretsch (Germany, 1895–1950)

www.arzberg-porzellan.de
Porcelain
Porzellan
Porcelaine
Arzberg-Porzellan, Schimding, Germany

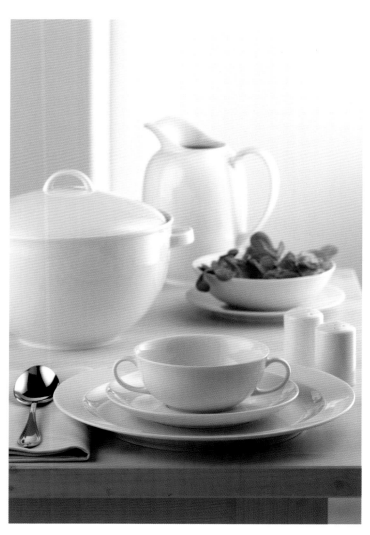

A landmark of German design, *1382* tableware was modern and affordable, and thereby embodied the Bauhaus' democratic ideals. In fact, its unadorned lines were guided foremost by functional considerations – one of Hermann Gretsch's main goals was to create a soup tureen that could be emptied using a ladle. The fact that the *1382* has been produced for over seventy-five years is testament to the enduring appeal of modern functionalism.

Das Tafelgeschirr *1382*, eine Ikone des deutschen Designs, verkörperte das demokratische Bauhausideal, modern und bezahlbar zu sein. Tatsächlich sind seine klaren Linien ohne Dekor Linien primär von funktionellen Kriterien bestimmt: Eines der Hauptziele von Hermann Gretsch war es, eine Suppenterrine zu entwerfen, die sich mit dem Löffel leeren lässt. Die Tatsache, dass *1382* seit mehr als fünfundsiebzig Jahren hergestellt wird, ist ein Beleg für die andauernde Anziehungskraft des modernen Funktionalismus.

Moderne et abordable, la vaisselle *1382* répond parfaitement à l'idéal du Bauhaus pour « un design démocratique ». Véritable icône du design allemand, ce modèle présente des lignes épurées et se concentre sur la fonctionnalité. L'un des principaux objectifs d'Hermann Gretsch était de créer une soupière pouvant être vidée avec une louche. Produite depuis plus de soixante-quinze ans, *1382* démontre l'attrait persistant du fonctionnalisme moderne pour un design intemporel, une esthétique simple mais raffinée.

Sancerre dinnerware, 1983

Michel Roux (France, 1951–)

www.pillivuyt.fr
Porcelain
Porzellan
Porcelaine
Pillivuyt, Mehun-sur-Yèvre, France

The porcelain manufacturer Pillivuyt has been producing fine tableware since 1818, and its *Sancerre* design is seen as *the* classic French, all-white dinner service among culinary *aficionados*. Timeless and durable, it has a stain-resistant glaze and eight different plate sizes, as well as numerous soup and pasta plates, serving and salad bowls, and accessories for coffee and tea. Robust enough for everyday use, the timeless, clean-looking *Sancerre* service is also microwave, oven and freezer safe.

Der Porzellanhersteller Pillivuyt fertigt seit 1818 Tafelgeschirr; und *Sancerre* gilt bei Liebhabern guten Essens als *das* klassische französische, rein weiße Tafelservice. Mit einer zeitlosen und langlebigen, hygienischen Glasuroberfläche versehen, umfasst *Sancerre* Teller in acht verschiedenen Größen sowie zahlreiche Suppen und Pastateller, Servier- und Salatschüsseln und Accessoires für Kaffee und Tee. Die Serie ist robust genug für den täglichen Gebrauch und ideal für Mikrowelle, Backofen und Kühlschrank geeignet.

Le porcelainier Pillivuyt produit de la belle vaisselle depuis 1818. Pour les aficionados, son service d'un blanc immaculé *Sancerre* incarne le classicisme à la française. Intemporel et durable, recouvert d'un vernis résistant aux taches, il comporte huit tailles d'assiettes, de nombreux plats, coupes, soupières, saladiers, accessoires pour le café et le thé. Suffisamment robuste pour un usage quotidien, il peut aller au micro-ondes, au four ou au congélateur.

Ku tableware, 2006

Toyo Ito (Japan, 1941–)

www.alessi.com
Porcelain
Porzellan
Porcelaine
Alessi, Crusinallo, Italy

Toyo Ito, one of the world's most innovative and influential architects, designed this exquisite tableware service for Alessi – a company which, for decades, has enjoyed close working relationships with both world-class designers, and the most progressive architects. Like Ito's buildings, the *Ku* service, with its echoing and gently undulating forms, is an exquisite synthesis of form and material, and possesses a deeply poetic resonance.

Toyo Ito, einer der innovativsten und einflussreichsten Architekten der Welt, entwarf dieses exquisite Tafelservice für Alessi – ein Unternehmen, das seit Jahrzehnten eng mit den erstklassigsten Designern und progressivsten Architekten zusammenarbeitet. Wie Itos Gebäude ist auch das Service *Ku* mit seinen sanft gewellten Formen, die Licht und Schatten reflektieren, eine wunderschöne, sehr poetische Synthese von Form und Material.

Toyo Ito, l'un des architectes les plus innovateurs et influents du monde, a conçu ce ravissant service pour Alessi, une société qui, depuis des décennies, collabore étroitement avec des designers de renommée internationale et les plus avant-gardistes des architectes. À l'instar des édifices d'Ito, *Ku*, avec ses formes doucement ondulées qui se font écho, est une exquise synthèse de la forme et du matériau et possède une profonde résonance poétique.

Waen dinnerware, 2003

Kazuhiro Tominaga (Japan, active 1980s–2000s)

www1.ocn.ne.jp/~hakusan/hakusan-shop.htm
Glazed ceramic
Glasierte Keramik
Céramique vitrifiée
Hakusan Porcelain Company, Nagasaki, Japan

Kazuhiro Tominaga studied craft design at Musashino Art University in Tokyo, graduating in 1982. In 1990, he joined the design office of the Hakusan Pottery Company, and has since won numerous awards for his simple and beautiful ceramic designs. His *Waen* range (which translates as 'Japanese Yen') is a series of inexpensive, high-fired, ceramic stacking dishes available in white, brown and black glazes. It won a Japanese Good Design award in 2003.

Kazuhiro Tominaga studierte bis 1982 Kunst und Design an der Musashino Art University in Tokyo. Seit 1990 arbeitet er für die Designabteilung der Hakusan Pottery Company und hat seitdem zahlreiche Auszeichnungen für seine schlichten und schönen Keramikentwürfe gewonnen. Seine Serie *Waen* (was übersetzt „japanischer Yen" bedeutet) besteht aus preiswerten, hartgebrannten Keramiktellern und -schalen, die sich stapeln lassen und weiß, braun oder schwarz glasiert erhältlich sind. *Waen* wurde 2003 mit dem japanischen Good Design Award ausgezeichnet.

Kazuhiro Tominaga a étudié le design à l'université d'art Musashino de Tokyo. Diplômé en 1982, il a rejoint en 1990 le bureau de design de la faïencerie Hakusan et a depuis remporté de nombreux prix pour ses créations en céramique belles et simples. *Waen* (« Yen japonais ») est une ligne de plats en céramique réfractaire empilables, bon marché, disponibles en blanc, brun ou noir. Elle a remporté un prix du Japanese Good Design en 2003.

With its bold pattern of multicoloured stripes, Alfredo Häberli's *Origo* range of informal, everyday tableware was widely celebrated in the design press when first launched in 1999. Incorporating four sizes of bowls, two sizes of plates, an eggcup and a mug, the collection comes in various mix-and-match colour schemes giving a sense of freshness to any table. The range also works well with other tableware designs manufactured by Iittala, most notably the classic *Teema* collection designed by Kaj Franck in the late 1970s.

Mit ihren kühnen, bunten Streifen wurde Alfredo Häberlis *Origo*, eine Geschirrserie für den täglichen Gebrauch, bei ihrer Vorstellung 1999 von der Design-Presse begeistert gefeiert. Die Serie umfasst Schalen in vier verschiedenen Größen, zwei unterschiedlich große Teller, einen Eierbecher sowie einen Trinkbecher und ist in verschiedenen Farbkombinationen erhältlich, die jedem Tisch etwas Frisches geben. *Origo* lässt sich auch gut mit anderen Designs von Iittala kombinieren, insbesondere mit der klassischen *Teema*-Kollektion aus den 1970er Jahren von Kaj Franck.

Avec ses saisissantes rayures multi-colores, la vaisselle décontractée *Origo* d'Alfredo Häberli, conçue pour un usage quotidien, a été louée par la presse spécialisée lors de son lancement en 1999. Comprenant quatre tailles de bols, deux tailles d'assiettes, un coquetier et un mug, la collection existe dans divers assortiments de couleurs qui apportent de la fraîcheur à toute table. La gamme se marie également fort bien avec d'autres lignes de Iittala, telle la fameuse collection *Teema* dessinée par Kaj Franck dans les années 70.

Origo tableware, 1999
Alfredo Häberli (Argentina/Switzerland, 1964–)

www.iittala.com
Porcelain
Porzellan
Porcelaine
Iittala, Iittala, Finland

Teema tableware, 1977–1980

Kaj Frank (Finland, 1911–1989)

www.arabia.fi
Ceramic
Keramik
Céramique
Arabia/Iittala, Iittala, Finland

An evolution of Kaj Frank's earlier *Kilta* range from 1952, the *Teema* collection is a classic yet utilitarian tableware design based on simplification and essentialism. Using basic geometric forms – the circle, square and rectangle – Frank designed nineteen pieces that were to be used interchangeably with other items, rather than as a formal service. One of the great attractions of this highly versatile range is the way in which its variety of soft-toned colors can be endlessly combined and recombined.

Teema, ein klassisches, dennoch utilitaristisches Geschirrdesign basierend auf Vereinfachung und Essentialismus, ist eine Weiterentwicklung der *Kilta*-Serie von 1952. Unter Verwendung der geometrischen Grundformen Kreis, Quadrat und Rechteck, entwarf Franck neunzehn Teile, die eher mit anderen Stücken kombiniert statt als formales Service verwendet werden sollten. Die endlosen Kombinationsmöglichkeiten der zahlreichen Farbtöne machen die äußerst vielseitige Serie so besonders attraktiv.

Évolution de la ligne antérieure de Kaj Frank, *Kilta*, datant de 1952, la collection *Teema* est une vaisselle classique mais utilitaire dont le design repose sur la simplification et l'essentialisme. Recourant à des formes géométriques basiques – le cercle, le carré et le rectangle – Frank a conçu dix-neuf pièces pouvant être mariées avec d'autres lignes plutôt que comme un service formel. Cette ligne très polyvalente présente en outre le grand attrait de pouvoir être recombinée à l'infini grâce à la gamme variée de ses couleurs douces.

Berså tableware, 1961

Stig Lindberg (Sweden, 1916–1982)

www.fabriksbutiken.com
Glazed ceramic
Glasierte Keramik
Céramique vitrifiée
Gustavsberg, Gustavsberg, Sweden

Recently put back into production, Stig Lindberg's *Berså* tableware has a classic retro style with its repeating pattern of abstracted green leaves. Like much of Lindberg's work, it reminds one of a more innocent era, and has a childlike appeal. Moreover, unlike most patterned services, the *Berså* design also allows food to be attractively displayed, because its pattern is so stylishly simple. Although designed more than forty years ago, this service possesses a remarkable freshness that reflects a very Swedish celebration of nature.

Stig Lindbergs Geschirr *Berså* mit den sich wiederholenden grünen Blättern besticht durch einen klassischen Retrostil und wird seit Kurzem wieder produziert. Wie viele von Lindbergs Arbeiten mutet auch diese fast kindlich an und wirkt wie eine Reminiszenz an eine unschuldigere Zeit. Im Gegensatz zu den meisten anderen gemusterten Services lassen sich mit *Berså* Speisen auch attraktiv anrichten, da sein Muster von einer so stilvoller Schlichtheit ist. Bereits vor über vierzig Jahren entworfen, überzeugt dieses Service durch eine außergewöhnliche Frische, die eine zutiefst schwedische Naturverbundenheit zum Ausdruck bringt.

Récemment relancé sur le marché, le service *Berså* de Stig Lindberg, avec son motif répétitif de feuilles vertes abstraites, possède un style rétro classique qui, comme de nombreuses créations du designer, évoque un passé plus innocent et le monde de l'enfance. En outre, contrairement à la plupart des vaisselles à motifs, son dessin simple et élégant permet de présenter joliment les aliments. Bien que dessiné il y a plus de quarante ans, il possède une remarquable fraîcheur qui reflète une célébration de la nature toute suédoise.

The best-known manufacturer of Cornish Ware the TG Green pottery was founded by Thomas Goodwin Green in 1864, and produced plain earthenware designs for the home. In 1926, and in response to worsening economic times, the pottery decided to launch a more decorative range – its distinctively striped *Cornish Blue*. In 1966, a recent graduate from the Royal College of Art in London, Judith Onions, was enlisted to update this classic British design, and its continuing popularity is testament to its enduring popular appeal.

Der bekannteste Hersteller der so genannten Cornish Ware ist die TG Green Töpferei, die 1864 von Thomas Goodwin Green gegründet wurde und zu Anfang einfaches Steingutgeschirr für den häuslichen Gebrauch produzierte. Angesichts der sich verschlechternden wirtschaftlichen Lage beschloss die Töpferei jedoch 1926, mit dem blau gestreiften *Cornish Blue* eine dekorativere Serie auf den Markt zu bringen. 1966 wurde Judith Onions, die gerade das Royal College of Art in London absolviert hatte, damit beauftragt, dieses klassische britische Design zu aktualisieren, das sich nach wie vor großer Beliebtheit erfreut.

Le plus célèbre faïencier cornouaillais, TG Green, fut fondé par Thomas Goodwin Green en 1864 et produisait initialement des articles simples pour la maison. En 1926, afin de faire face à la crise économique, il décida de lancer une ligne plus décorative, son fameux *Cornish Blue* à rayures. En 1966, fraîchement diplômée du Royal College of Art de Londres, Judith Onions fut engagée pour donner un coup de jeune à ce classique du design britannique dont la popularité ne s'est jamais démentie, preuve de son attrait tenace.

Cornish Blue kitchenware, 1966 (based on a design from 1926)

Judith Onions (UK, active 1960s)

www.tggreen.co.uk
Glazed ceramic
Glasierte Keramik
Céramique vitrifiée
TG Green & Co, London, UK

Swedish Grace dinnerware, 1930

Louise Adelberg (Sweden, 1855–1971)

www.rorstrand.com
Porcelain
Porzellan
Porcelaine
Rörstrand/Iittala Group, Höganäs, Sweden

This range of domestic tableware, with its simple repeating pressed pattern representing ears of wheat – a symbol of nourishment – was first exhibited at the landmark 1930 Stockholm Exhibition. Elegantly simple, this design came to epitomize 'Swedish Grace'– a term coined by the British architectural critic Morton Shand in the *Architectural Review*. This seminal Swedish design combines rustic charm with classical purity, and is available in a range of muted tones: cream, sage, pale blue and royal blue.

Diese Geschirr-Serie mit ihrem schlichten, geprägten Muster sich wiederholender Weizenähren – ein Symbol für Nahrung – wurde erstmals bei der historischen Stockholmer Ausstellung von 1930 vorgestellt. Das wegweisende Design ist von eleganter Einfachheit und wurde zum Inbegriff der „Swedish Grace" – eine Bezeichnung, die von dem britischen Architekturkritiker Morton Shand in der Zeitschrift *Architectural Review* geprägt wurde. Es kombiniert rustikalen Charme mit klassischer Klarheit und ist in einer Reihe gedämpfter Farbtöne erhältlich: Creme, Graugrün, Blassblau und Königsblau.

Cette ligne de vaisselle, avec ses motifs pressés sobres et répétitifs représentant des épis de blé, symbole de nourriture, fut exposée pour la première fois lors de la célèbre exposition de Stockholm en 1930. D'une élégante simplicité, elle incarne « la grâce suédoise », un qualificatif attribué par le critique d'architecture britannique Morton Shand dans *Architectural Review*. Ce design emblématique suédois conjugue le charme rustique et la pureté classique. Il existe dans divers tons sourds : crème, vert sauge, bleu pâle et bleu roi.

Suomi dinnerware, 1976

Timo Sarpaneva (Finland, 1926–2006)

www.int.rosenthal.de
Porcelain
Porzellan
Porcelaine
Rosenthal, Selb, Germany

Suomi is a timeless yet stylishly modern dinner service that comprises an extensive number of pieces, ranging from a sushi plate to a chocolate mug. For its design, the tactile smoothness and soft organic forms of river pebbles inspired Timo Sarpaneva. In tribute to its high aesthetic and functional values the *Suomi* range was awarded the Gold Medal of Faenza – one of the highest accolades in the porcelain industry.

Soumi ist ein zeitloses, aber gleichzeitig stilvoll modernes Tafelgeschirr, das aus zahlreichen Teilen besteht, von der Sushi-Platte bis zum Kakaobecher. Timo Sarpaneva ließ sich für das Design von der glatten Oberfläche und den organischen Formen von Flusskieseln inspirieren. Für ihren hohen ästhetischen und funktionellen Wert erhielt die *Suomi*-Serie die Goldmedaille von Faenza, eine der höchsten Auszeichnungen, die in der Porzellanindustrie verliehen werden.

Suomi est un service intemporel et pourtant d'une élégance toute moderne qui comprend de nombreuses pièces, allant du plat à sushis à la tasse à chocolat. Son créateur Timo Sarpaneva s'est inspiré de galets pour concevoir sa surface lisse agréable au toucher et ses douces formes organiques. Son esthétique raffinée et ses valeurs fonctionnelles lui ont valu la médaille d'or de Faenza, l'une des plus hautes récompenses du monde de la faïence.

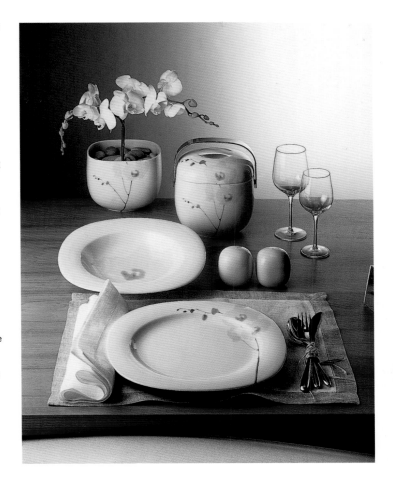

Moon dinnerware, 1997

Jasper Morrison (UK, 1959–)

www.int.rosenthal.de
Porcelain
Porzellan
Porcelaine
Rosenthal, Selb, Germany

Throughout his career, Jasper Morrison has created objects that have an innate purity – both in terms of aesthetics and function. His *Moon* service exemplifies his essentialist approach to design, with its modern reworking of simple archetypal forms. As he explains, 'Design is not to demonstrate the unusual. Only one thing counts: it must function'. In tribute to this product's inherent 'rightness', it won a Red Dot award in 2002 and an iF award in 2003.

Während seiner gesamten Laufbahn hat Jasper Morrison Objekte von außerordentlicher ästhetischer und funktioneller Klarheit geschaffen. Sein Service *Moon* veranschaulicht diesen charakteristischen essentialistischen Designansatz durch eine moderne Interpretation einfacher archetypischer Formen. Wie Morrison erklärt: „Design hat nichts damit zu tun, das Außergewöhnliche zu zeigen. Nur eines zählt: Es muss funktionieren." Für seine inhärente Stimmigkeit wurde das Produkt 2002 mit einem Red Dot Award und 2003 mit dem iF Award ausgezeichnet.

Tout au long de sa carrière, Jasper Morrison a créé des objets d'une grande pureté, tant sur le plan esthétique que fonctionnel. Le service *Moon* illustre son approche essentialiste du design avec sa réinterprétation moderne de formes architecturales simples. Comme il l'explique lui-même : « Le design ne sert pas à démontrer l'inhabituel. Une seule chose compte : il doit fonctionner ». L'inhérente « justesse » de ce produit lui a valu un Red Dot award en 2002 et un iF award en 2003.

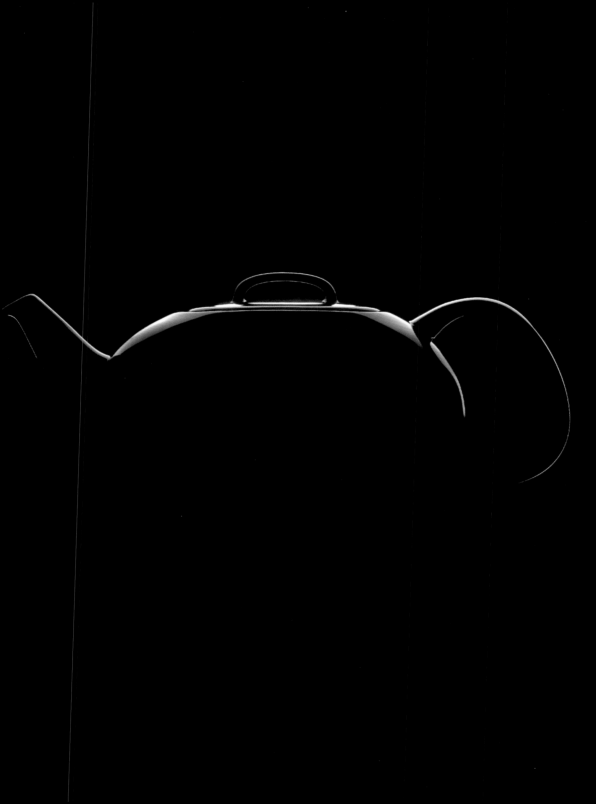

Crested Porcelain tableware, 1988

Sori Yanagi (Japan, 1915–)

www.soriyanagi.com
Glazed porcelain
Glasiertes Porzellan
Porcelaine émaillée
Sori Yanagi, Valby, Denmark

Sori Yanagi's tableware combines practical function with an understated elegance, which expresses the very Japanese love of harmonious balance and exquisite detailing. His *Crested Porcelain* range has a strikingly formal simplicity that is subtly embellished with abstracted decorative motifs that create associations with the centuries-old *marumon* and *musubimon* patterns used as family crests in Japan. Dishwasher and microwave-safe, this stacking tableware range brings a much-needed touch of oriental refinement into our daily environment.

Sori Yanagis Tafelgeschirr verbindet Zweckmäßigkeit mit unaufdringlicher Eleganz – Ausdruck der Vorliebe der Japaner für Ausgewogenheit und raffinierte Details. Seine Kollektion *Crested Porcelain* ist auffallend schlicht, subtil verschönert mit einem abstraktem Dekor, das an das Jahrhundert alte kreisrunde *marumon*-Motiv für japanische Familienwappen erinnert. Spülmaschinenfest und für die Mikrowelle geeignet, verschönert dieses stapelbare Tafelgeschirr den europäischen oder transkontinentalen Alltag mit einem Hauch fernöstlichen Raffinements.

La vaisselle de Sori Yanagi associe l'aspect fonctionnel à l'élégance sobre, exprimant le goût prononcé des Japonais pour l'équilibre et les détails soignés. La série *Crested Porcelain* se compose de pièces faites main, avec une ornementation bleue en forme d'armoiries, symbolisant les anciennes valeurs familiales japonaises. Simple et minimaliste, cette création apporte un raffinement oriental à votre environnement quotidien. Résistante au lave-vaisselle, elle est compatible avec le four à micro-onde.

Semiglazed tableware, 1982

Sori Yanagi (Japan, 1915–)

www.soriyanagi.com
Ceramic
Keramik
Céramique
Sori Yanagi, Valby, Denmark

The matt surface of Sori Yanagi's *Semiglazed* tableware range gives a soft and appealing appearance that invites physical interaction. Available in black or white, a special production method is used so that the semi-glazed ceramic material is much lighter than traditional earthenware, while at the same time remaining more robust than porcelain. The soft contours of the individual pieces also enhance their sensual fluidity, and ensure that they fit comfortably in the hands.

Die matten Oberflächen von Sori Yanagis Tafelgeschirr *Semiglazed* sind von angenehmer haptischer Qualität. Alle Teile sind in Schwarz oder Weiß lieferbar und werden in einem speziellen Verfahren hergestellt, so dass die „halb glasierten" Tonscherben viel leichter sind als traditionell verarbeitetes Keramikmaterial, dabei aber härter als Porzellan. Die fließenden Konturen der verschiedenen Teile steigern deren sinnliche Anmutung und lassen sie gut in der Hand liegen.

La collection *Semiglazed* créée par Sori Yanagi a été conçue pour être plus résistante que la poterie et aussi légère que la porcelaine. Cette semi-porcelaine est un matériau situé entre la porcelaine et la céramique. Résultant d'une technologie avancée, le fini mat très doux de chaque pièce leur confère une fluidité sensuelle à laquelle il est difficile de résister. Disponible en blanc et noir.

Spir gravy boats, 2002

Johan Verde (Norway, 1964–)

www.figgjo.no
Porcelain
Porzellan
Porcelaine
↕ 12, 14 cm
Figgjo, Figgjo, Norway

Part of Johan Verde's award-winning *Spir* range, these sculptural gravy boats come in two sizes. Although their organic form is reminiscent of the biomorphic shapes that were so popular in the 1950s, the timeless elegance of these designs ensure that they compliment Figgjo's other tableware products. Like other designs by Johan Verde, their contours are based on the idea of an encircling 'fold', such as those found in the spirals of seashells.

Diese plastischen Saucieren aus Johan Verdes preisgekrönter *Spir*-Serie sind in zwei Größen erhältlich. In ihrer organischen Erscheinung erinnern sie zwar an die in den 1950er Jahren so beliebten biomorphen Formen, ergänzen aber dank ihrer zeitlosen Eleganz die übrigen Produkte des Porzellanherstellers Figgjo. Wie andere Entwürfe von Johan Verde basieren auch diese auf der Idee einer umschließenden „Hülle", und ihre Konturen erinnern an die Spirale im Inneren einer Muschel.

Appartenant à la ligne de vaisselle primée de Johan Verde, *Spir*, ces saucières sculpturales existent en deux tailles. Bien que leur forme organique rappelle les silhouettes biomorphiques tant prisées dans les années 50, leur élégance intemporelle leur permet de compléter harmonieusement les autres produits de Figgjo. Comme d'autres créations de Johan Verde, leurs contours reposent sur l'idée d'un bord se repliant sur lui-même comme on en observe sur les spirales de coquillages.

Form 2000 dinnerware, 1954

Heinrich Löffelhardt (Germany, 1901–1979)

www.arzberg-porzellan.de
Porcelain
Porzellan
Porcelaine
Arzberg-Porzellan, Schirnding, Germany

Although inspired by Hermann Gretsch's earlier *1382* dinner service for Arzberg, Heinrich Löffelhardt's *Form 2000* range is less utilitarian and more elegant than its famous predecessor. Its soft, ergonomic form also reflects the increasing influence of organic shapes during the 1950s. In fact, Löffelhardt regarded each piece of the service as a sculpture in its own right. In recognition of its 'good design' credentials, the *Form 2000* service received a gold medal at the 1954 Milan Triennale.

Heinrich Löffelhardts *Form 2000* ist zwar von Hermann Gretschs bereits vorher für Arzberg entworfenem Tafelservice *1382* inspiriert, wirkt aber weniger zweckmäßig und eleganter als sein berühmter Vorläufer. Die weiche, ergonomische Form des Services reflektiert zudem den zunehmenden Einfluss des Organischen in den 1950er Jahren, und so betrachtete Löffelhardt auch jedes einzelne Stück des Services als eine eigenständige Plastik. *Form 2000* erhielt 1954 eine Goldmedaille auf der Mailänder Triennale für sein gelungenes Design.

Bien qu'inspiré du service de table d'Hermann Gretsch *1382* pour Azberg, *Form 2000* d'Heinrich Löffelhardt est moins utilitaire et plus élégant que son illustre prédécesseur. Ses formes douces ergonomiques reflètent en outre l'influence croissante des silhouettes organiques au cours des années 50. De fait, Löffelhardt considérait chaque pièce comme une sculpture à part entière. En reconnaissance de ses qualités de « bon design » le service *Form 2000* reçut une médaille d'or lors de la Triennale de Milan de 1954.

Ursula jug, 1992
Ursula Munch-Petersen (Denmark, 1937–)

www.royalcopenhagen.com
Faience
Fayence
Faïence
0.3 l, 0.5 l, 1 l
Royal Copenhagen, Copenhagen, Denmark

Available in three sizes, this distinctive jug compliments the rest of the *Ursula* dinner service, which was designed by Ursula Munch-Petersen in 1992. According to Royal Copenhagen, she 'thought out each piece as an independent entity, and the function of the items is precisely reflected in their vigorous, rounded shapes. She feels that everyday items should reflect people. A handle must almost ask to be gripped'. Munch-Petersen also believes that design should be imbued with a handicraft sensibility even when it relates to mass-production.

Dieser in drei Größen lieferbare Krug gehört zu dem von Ursula Munch-Petersen 1992 entworfenen Tafelgeschirr *Ursula*. Im Werbematerial von Royal Copenhagen heißt es, die Designerin habe jedes Teil als separates Objekt gestaltet, und die Funktionen der verschiedenen Objekte spiegelten sich in ihren kraftvollen Rundungen. Munch-Petersen ist der Meinung, dass alltägliche Gebrauchsgegenstände den Menschen „entgegenkommen" sollten. Ein Griff zum Beispiel müsse geradezu dazu auffordern, ihn anzufassen. Für die Designerin müssen selbst serienmäßig gefertigte Produkte vom Design her den Eindruck handwerklicher Qualität vermitteln.

Disponibles en trois tailles, ces pichets originaux complètent le service *Ursula*, conçu par Ursula Munch-Petersen en 1992. Selon Royal Copenhagen, « chaque pièce est réfléchie de manière indépendante, et la fonction de ces objets apparaît précisément dans leurs formes. Ursula Munch-Petersen est convaincue que les objets utilisés au quotidien doivent refléter les individus. Une poignée doit presque ‹ demander › à être saisie ». Munch-Petersen pense également que le design devrait être imprégné d'une sensibilité artisanale, même lorsqu'il se rapporte à la production industrielle.

Blue Line cream jug & cover, 1965

Grethe Meyer (Denmark, 1918–)

www.royalcopenhagen.com
Porcelain
Porzellan
Porcelaine
0.14 l
Royal Copenhagen, Copenhagen, Denmark

Between 1955 and 1960, Grethe Meyer painstakingly examined the standard dimensions used in housing and consumer products. This early research, as well as her desire to make 'things people can afford', informed her later design of utilitarian housewares, including her *Blue Line* service designed for Royal Copenhagen. This range of ceramics (which includes the cream jug, shown below) with its endearing simplicity borne out of practical functionality, demonstrated her mastery of form as well as her understanding of industrial production.

Von 1955 bis 1960 befasste sich Grethe Meyer eingehend mit den Standardmaßen für Haushaltswaren und Konsumgüter. Die Ergebnisse dieser frühen Studien und ihr Bestreben, „Dinge herzustellen, die die Menschen sich leisten können" prägte ihre späteren Entwürfe von Haushaltswaren, unter anderem ihr Tafelgeschirr *Blue Line* für Royal Copenhagen (darunter das unten abgebildete Sahnekännchen mit Deckel). In ihrer attraktiven Schlichtheit, die auf praktischer Funktionalität beruht, belegen die dazugehörigen Teile Meyers Meisterschaft in der Formgestaltung und ebenso ihre gründliche Kenntnis der industriellen Produktionsabläufe.

Architecte de formation, Grethe Meyer s'attache à créer des produits à la fois esthétiques et fonctionnels. Elle observe attentivement les habitudes de tout un chacun, notamment en matière de logement et de consommation. Ses créations découlent d'une analyse scrupuleuse, son souhait étant celui de réaliser des articles accessibles à tous. Son service *Ligne Bleue*, créé pour Royal Copenhagen, illustre sa volonté de concevoir des modèles fonctionnels tout en exprimant une certaine poésie. Il en résulte des créations aussi belles qu'intemporelles, qui s'intègrent parfaitement à notre quotidien.

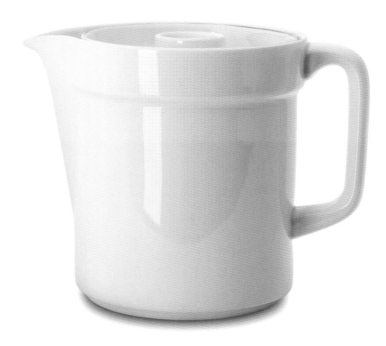

One of the leading lights of contemporary Danish design, Ole Jensen has won numerous accolades for his everyday products that playfully challenge the *status quo*. His *Ole* jug-cum-juicer is a sculptural design that serves its intended function well: the jug's narrow spout traps any pips or pulp, while its integrated hand-hold and rounded base ensure that it is comfortable to use. The white version is made of porcelain, and the coloured options are made of faience – a glazed earthenware.

Als ein führender Vertreter des zeitgenössischen dänischen Produktdesigns hat Ole Jensen zahlreiche Auszeichnungen für seine Gebrauchsgegenstände erhalten, die den gestalterischen Status quo auf spielerische Weise in Frage stellen. Sein wie eine Skulptur geformter Ole-Krug ist gleichzeitig eine Zitruspresse und erfüllt seine Doppelfunktion auf optimale Weise. Die enge Tülle hält Kerne und andere feste Bestandteile zurück, während der integrierte Henkelgriff und die runde Basis die Handhabung der Kanne erleichtern. Die weißen Modelle bestehen aus Porzellan, die farbigen sind Fayencen (glasierte Tonwaren).

Considéré comme l'un des plus grands designers danois contemporains, Ole Jensen a remporté de nombreux prix pour ses créations originales. Son presse-agrumes pichet propose un design sculptural qui allie un style épuré, voire minimaliste, à l'aspect fonctionnel : le bec verseur du pichet est étroit retenant ainsi les pépins et la pulpe, et sa forme arrondie s'avère très ergonomique et facile à manipuler. La version blanche est en porcelaine, ceux en couleur sont en faïence émaillée.

Ole pitcher/citrus press, 1997

Ole Jensen (Denmark, 1958–)

www.royalcopenhagen.com
Porcelain or faience
Porzellan oder Fayence
Porcelaine ou faïence
Royal Copenhagen, Copenhagen, Denmark

Stefan Lindfors's *EgO* range initially comprised an espresso cup, a coffee cup and a breakfast cup, as well as a matching bowl and pitcher. The relatively large-scale saucers that go with these cups are perfect for the serving of an accompanying chocolate, biscuit or pastry. They are also very stable and steady in the hand. Perfect for today's international coffee culture, the *EgO* is a design perfectly in tune with contemporary living. In 2000, additional elements, including large plates and various containers for spices, were also added to the range.

Stefan Lindfors Serie *EgO* umfasste ursprünglich eine Espressotasse, eine Kaffeetasse, eine Frühstückstasse sowie eine dazu passende Schale und eine Kanne. Die relativ großen Unterteller zu diesen Tassen eignen sich perfekt, um Schokolade, Kekse oder Gebäck zum Kaffee zu servieren. Die Produkte der Serie sind zudem sehr robust und liegen angenehm in der Hand. *EgO* ist ein Design, das sehr gut zur heutigen internationalen Kaffeekultur und zum modernen Leben passt. Die Serie wurde 2000 um zusätzliche Elemente erweitert, darunter große Teller und verschiedene Behältnisse für Gewürze.

La ligne *EgO* de Stefan Lindfors comprenait initialement une tasse à expresso, une tasse à café, une tasse de petit déjeuner ainsi qu'un bol et une cruche assortis. Ces saucières relativement grandes les complètent parfaitement pour servir du chocolat, des biscuits ou des pâtisseries. Très stables, elles tiennent bien dans la main. Conforme à la culture internationale du café d'aujourd'hui, la ligne *EgO* s'inscrit à merveille dans la vie contemporaine. En 2000, de nouvelles pièces sont venues l'enrichir, dont de grandes assiettes et divers récipients pour les épices.

EgO tableware, 1998
Stefan Lindfors (Finland, 1962–)

www.iittala.com
Porcelain
Porzellan
Porcelaine
Iittala, Iittala, Finland

Contrast cup, 2007

Hans Christian Gjedde (Denmark, 1970–)

www.royalcopenhagen.com
Porcelain, silicone
Porzellan, Silikon
Porcelaine, silicone
Royal Copenhagen, Copenhagen, Denmark

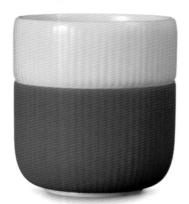 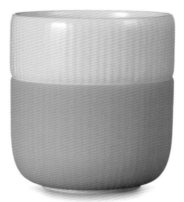 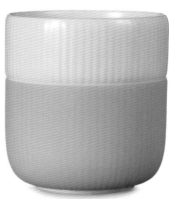

Although harking back to the ancient oriental tradition of tea drinking, Hans Christian Gjedde's *Contrast* cups have a very 21st century twist with their use of pastel-coloured silicone covers that help to protect fingers from burning. As Niels Bastrup, the creative director at Royal Copenhagen, explains: 'Porcelain is perfect for combining with other materials… Royal Copenhagen is world famous for exploring and expanding the potential of porcelain, and with *Contrast* we've dared to take a step in a new direction, with porcelain making up the core of the product, while the colourful silicone cover is the star guest'.

Obwohl sie formal von traditionellen fernöstlichen Teebechern abstammen, wirken Hans Christian Gjeddes henkellose Teebecher mit ihrer isolierenden Silikonbeschichtung in Pastellfarben absolut zeitgenössisch. Niels Bastrup, Kreativdirektor von Royal Copenhagen, erklärt dazu: „Porzellan lässt sich wunderbar mit anderen Materialien verbinden. … Royal Copenhagen ist weltberühmt, weil wir das Potenzial von Porzellan ausgelotet und weiterentwickelt haben. Mit *Contrast* haben wir einen ersten Schritt in eine neue Richtung gewagt: Porzellan ist der Hauptdarsteller, während die farbige Silikonbeschichtung als Stargast auftritt."

Inspirées par la tradition orientale du thé, les tasses *Contrast* conçues par Hans Christian Gjedde comportent une couche de silicone aux couleurs pastel, protégeant les doigts de la chaleur. Ce modèle présente un aspect strié très tendance de nos jours. Selon Niels Bastrup, « la porcelaine se combine parfaitement avec d'autres matériaux. Royal Copenhagen étant mondialement connu pour explorer et développer son potentiel, nous avons osé prendre une nouvelle direction : la porcelaine constitue le cœur du produit, mais c'est la silicone en couleur la véritable star ».

Figgjo Verde mug, 1995

Johan Verde (Norway, 1964–)

www.figgjo.no
Porcelain
Porzellan
Porcelaine
Figgjo, Figgjo, Norway

This diminutive mug is part of the *Figgjo Verde* service, which won the Norwegian Award for Design Excellence in 1996. This functional yet elegant mug is, in fact, one of the manufacturer's most popular products, and as such is found in cafés across Norway. Although possessing a strong Scandinavian Modern aesthetic, the design's Essentialist form also references Oriental Minimalism, and perfectly balances form with utility in the process.

Dieser kleine Becher gehört zum Service *Figgjo Verde*, das 1996 mit dem norwegischen Award for Design Excellence ausgezeichnet wurde. Inzwischen ist der formschöne Becher eines von Figgjos beliebtesten Produkten und findet sich in Cafés in ganz Norwegen. Einerseits wirkt das Design typisch skandinavisch, andererseits mutet der Becher aufgrund seiner schlichten Form aber auch fernöstlich-minimalistisch an und verbindet auf harmonische und ansprechende Weise Form und Funktion.

Ce mug original fait partie du service *Figgjo Verde*, grand gagnant du Prix norvégien pour l'Excellence du Design, en 1996. Elégant et fonctionnel, il représente la création la plus connue de Johan Verde. Véritable symbole de l'esthétique moderne norvégienne, ce modèle a envahi les cafés de Norvège. Cette conception essentialiste fait référence au minimalisme oriental, alliant la beauté de la forme à l'aspect utilitaire.

Java mug, 2008

Åsa Lindberg Svensson (Sweden, 1972–)

www.sagaform.com
Stoneware
Stoneware
Grès
Sagaform, Borås, Sweden

This stoneware mug comes in a white, black, linen or blue glaze, and can be stacked for efficient storage. Like other designs produced by Sagaform, it has a practical utility and aesthetic purity that epitomizes modern Scandinavian design, deservedly famed for its human-centric approach to everyday housewares. Indeed, there is a long-held Nordic belief that well-designed and user-friendly objects can be life enhancing tools for social change – yes, even a humble mug!

Dieser Steinzeugbecher ist mit weißer, schwarzer, leinenfarbener oder blauer Glasur lieferbar und lässt sich Platz sparend stapeln. Wie andere Sagaform-Produkte ist er ein typisches Beispiel skandinavischer Produktdesigns, die allgemein für ihre Zweckmäßigkeit und schlichte Schönheit bekannt sind. Tatsächlich herrscht seit langem in Skandinavien die Auffassung, dass gut gestaltete, bedienerfreundliche Gebrauchsgegenstände – ja, sogar simple Trinkbecher – als lebensverbessernde Instrumente des gesellschaftlichen Wandels wirken können.

Avec ses lignes pures et minimalistes, ce mug en grès incarne à la perfection le design scandinave moderne. Connus pour leur approche centrée sur l+humain, les créateurs scandinaves allient l'esthétique à l'aspect fonctionnel, facilitant ainsi le quotidien de chacun. Comme les autres créations réalisées pour Sagaform, ce mug offre une conception unique et inattendue. Ce modèle est disponible en plusieurs couleurs : blanc, noir, bleu et lin. La preuve qu'un simple mug peut égayer votre vie !

Noguchi teacup & saucer, 1952

Isamu Noguchi (USA, 1904–1988)

www.design-museum.de
Porcelain
Porzellan
Porcelaine
Vitra Design Museum, Weil am Rhein, Germany

Although designed by Isamu Noguchi in 1952, this beautiful, almost zoomorphic teacup was only very recently put into production. Noguchi learnt the skilful handling of ceramics from one of Japan's most acclaimed potters, Rosanjin Kitaoji. It was when Noguchi was living in Kitaoji's compound of traditional buildings in Kita Kamakura that he modelled this curious, horn-handled cup from clay. Its form was based on an old terracotta cup owned by Noguchi himself.

Obwohl Isamu Noguchi diese wunderschöne, an ein Tier erinnernde Teetasse bereits 1952 entwarf, ging sie erst vor Kurzem in Produktion. Noguchi war bei dem anerkannten japanischen Keramiker Rosanjin Kataoji in die Lehre gegangen, als er eines der traditionellen japanischen Holzhäuser auf dessen Anwesen in Kita Kamakura bewohnte. Noguchi formte diese ungewöhnliche Tasse mit einem wie ein Stierhorn geformten Henkel aus Ton nach einer alten Keramiktasse aus seinem Besitz.

Cet ensemble de tasses et de soucoupes conçu par Isamu Noguchi en 1952 est le fruit d'un travail artistique et d'une réflexion sur la fonctionnalité. Noguchi apprit à travailler la céramique aux côtés d'un des potiers les plus renommés du Japon, Rosanjin Kitaoji. C'est à cette époque, à Kita Kamakura, qu'il modela cette tasse, véritable sculpture en porcelaine qui exprime tout le modernisme du design de Noguchi et l'empreinte de ses racines. Ce modèle a récemment été mis en production.

The *Bistro* series comprises an espresso cup, a café latte cup, a regular mug (as shown below), an extra-large mug and three sizes of glasses. The series is available in either double-walled, transparent glass or white porcelain. Also known as the *Corona* range in some countries, the timeless and casual elegance of these functional designs won them a prestigious iF product design award in 2007.

Die *Bistro*-Produktfamilie umfasst Tassen für Espresso und für Milchkaffee, einen kleineren Kaffeebecher (wie abgebildet) und einen extra großen Becher sowie Gläser in drei Größen. Die Serie, die in einigen Ländern unter dem Namen *Corona* vermarktet wird, ist entweder aus doppelwandigem Klarglas oder weißem Porzellan lieferbar. Aufgrund ihrer zeitlosen Formschönheit und Funktionalität gewann dieses Design 2007 den renommierten iF-Produktdesignpreis.

La série *Bistro* comprend une tasse à expresso, une tasse à café au lait, un mug classique (au-dessous), un mug extra-large et trois tailles de verres. Ces tasses double-paroi sont réalisées en verre soufflé transparent ou en porcelaine blanche. Connue également sous le nom de *Corona*, cette collection possède une élégance éternelle et intemporelle, tout en restant fonctionnelle. Elle fut récompensée d'un iF product design award en 2007.

Bistro mug, 2006

Bodum Design Group

www.bodum.com
Glass or porcelain
Glas oder Porzellan
Verre ou porcelaine
Bodum, Triengen, Switzerland

Bora Bora teapot, 2005

Bodum Design Group

www.bodum.com
Borosilicate glass, stainless steel
Borosilikatglas, Edelstahl
Verre borosilicate, acier inoxydable
0.5 l
Bodum, Triengen, Switzerland

Designed to keep your tea hotter for longer, the award-winning *Bora Bora* teapot has a double-walled glass construction to promote the retention of heat. This innovative design also improves the taste of the tea by incorporating Bodum's patented tea press system, which uses a plunger to stop the brewing process once the tea has been steeped to the required strength. The good news for tea drinkers is that this eliminates the tannic bitterness of 'stewed' tea.

Diese preisgekrönte Teekanne hat einen doppelwandigen Glaskörper, der den Tee wie eine Thermoskanne warm hält und den Geschmack des Tees auch dadurch verbessert, dass die Teeblätter nach dem Aufgießen und Ziehen mit Bodums patentiertem Filtersiebsystem nach unten gedrückt und zusammengepresst werden, worauf man sie herausnehmen muss. Die gute Nachricht für Teetrinker ist, dass der aufgebrühte Tee dadurch nicht bitter werden kann.

La théière *Bora Bora* est réalisée en verre à double paroi pour ses qualités isothermiques permettant au thé de rester à une température idéale. Reprenant le système breveté de piston, cette théière arrête le processus d'infusion par une simple pression, isolant le thé du contact des feuilles. Le thé infusé peut être dégusté sans risque d'amertume et satisfait ainsi les plus exigeants. Ce modèle combine la sobriété et la fonctionnalité de manière exquise.

One of Spain's most acclaimed jewellery designers, Helena Rohner's work is characterized by simple elemental forms and interesting combinations of materials. The *Helena* tea set is no exception, with its contemporary twist on the traditional tea service. As the designer explains, 'The round shape of the teapot reminded me of a steamship with its slightly pointed and sloping design. The combination of porcelain and stainless steel gives a soft yet modern appearance.'

Helena Rohner zählt zu den besten Schmuckdesignern Spaniens. Ihre Arbeiten zeichnen sich durch einfache, elementare Formen und ungewöhnliche Materialkombinationen aus, so auch das Teegeschirr *Helena*. Die Designerin erklärt: „Die runde Form der Teekanne erinnerte mich an ein Dampfschiff mit seinem schmaleren Bug und geneigten Rumpf. Die Verbindung von Porzellan und Edelstahl ist hübsch und gleichzeitig modern."

Créatrice de bijoux très renommée en Espagne, Helena Rohner propose un travail caractérisé par des formes simples et des combinaisons originales de matériaux. Ce service à thé *Helena* allie tradition et modernité, respectant les lignes pures du design danois. Rohner déclare : « La forme arrondie de la théière me rappelle celle d'un bateau à vapeur avec son design légèrement pointu et incliné. La combinaison de la porcelaine et de l'acier inoxydable offre un aspect doux et moderne. »

Helena tea set, 2007

Helena Rohner (Spain, 1968–)

www.georgjensen.com
Polished stainless steel, porcelain
Polierter Edelstahl, Porzellan
Acier inoxydable poli, porcelaine
Georg Jensen, Copenhagen, Denmark

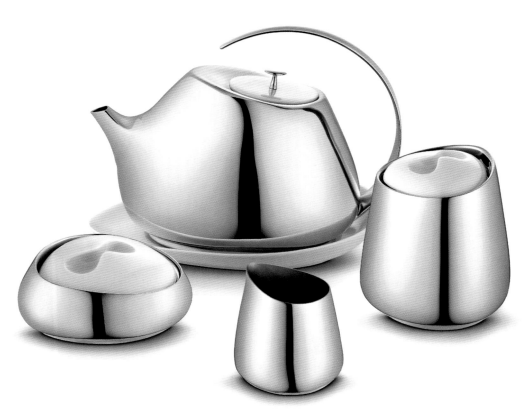

Brown Betty teapot, c.1680s–1840s

Anonymous (UK)

www.cauldonceramics.co.uk
Glazed ceramic
Glasierter Ton
Céramique émaillée
2 cup, 4 cup, 6 cup, 8 cup
Cauldron Ceramics, Stoke-on-Trent, UK

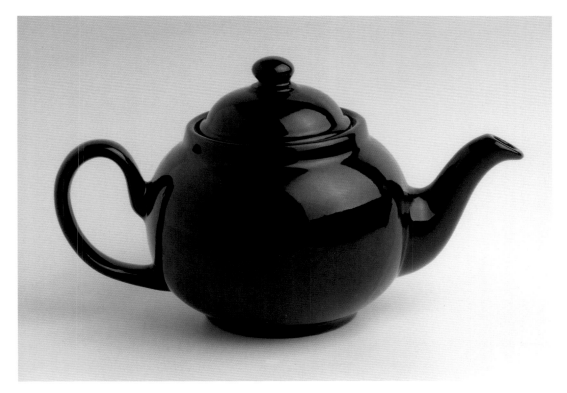

This classic, chestnut-brown, glazed English teapot – sometimes known as the *Brown Betty* – is a wonderful example of anonymous design. Between the late 17th century and the 1840s, this traditional round-bellied teapot evolved to such a high degree that it achieved an exceptional fitness for purpose – it pours well, brews tea to perfection and does not stain. Manufactured by a number of British companies, the *Brown Betty* is a generic and un-improvable design, and if you like a strong 'brew' this is definitely the pot for you.

Diese klassische kastanienbraune, glänzend glasierte englische Teekanne – auch als *Brown Betty* bekannt – ist ein Beispiel für gelungenes „anonymes" Design. Ihre Ursprünge liegen zwischen dem Ende des 17. Jahrhunderts und etwa 1840. Das Design dieser bauchigen Kanne ist so ausgefeilt, dass sie ihren Zweck zur Perfektion erfüllt: Sie gießt gut, verursacht keine Flecken und hält den Tee lange heiß. Die von vielen britischen Herstellern angebotene *Brown Betty* mit ihrem unverwechselbaren Design ist ohne Zweifel die erste Wahl für Teeliebhaber.

Véritable classique, la théière anglaise *Brown Betty* est réputée pour faire le meilleur thé au monde. Couleur chocolat, cette création est le fruit d'un créateur anonyme. Entre la fin du 18e siècle et les années 1840, cette théière traditionnelle ronde fut élaborée à très haute température, permettant ainsi une finition parfaite : elle verse le thé de manière fluide, le prépare à la perfection et ne goutte pas. Fabriquée par de nombreuses sociétés anglaises, la théière *Brown Betty* reste un classique pour les grands amateurs de thé.

Harp teapot, 2004

Ichiro Iwasaki (Japan, 1965–)

www.ricordi–sfera.com
Porcelain, natural or black stained maple plywood
Porzellan, Ahorn (naturbelassen und mit Schwarzoxid gebeizt)
Porcelaine, érable naturel ou teinté noir
Sfera, Kyoto Japan

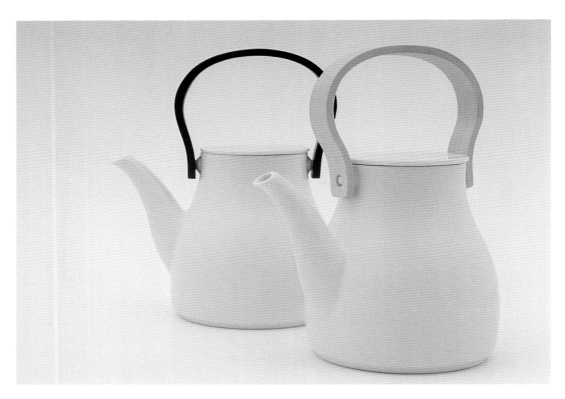

Winning a prestigious Red Dot award in 2007, the *Harp* teapot is a synthesis of English and Japanese tea-drinking traditions. In fact, English tea is now very much a part of everyday life in Japan, and this hybrid design – an English teapot with a Japanese aesthetic – reflects the global cross-pollination of cultures in the 21st century. Suitable for making both English and Japanese tea, this design possesses a sense of both modernity and timelessness.

Das Modell *Harp* stellt eine Synthese traditioneller englischer und japanischer Teekannen dar. Im Jahr 2007 wurde sie mit dem renommierten Red Dot Award ausgezeichnet. Schwarztee nach englischer Art gehört heute unbedingt zum Alltag der Japaner und dieses „Hybrid-Design" – englische Teekanne im japanischen Stil – reflektiert die globale wechselseitige Befruchtung verschiedener Kulturen im 21. Jahrhundert. In der ebenso zeitlosen wie modernen *Harp* kann man selbstredend sowohl englischen als auch japanischen Tee zubereiten.

Gagnante du prestigieux Red Dot award en 2007, la théière *Harp* allie formidablement les traditions anglaises et japonaises. De nos jours le thé anglais fait réellement partie de la vie quotidienne au Japon. Cette création hybride, une théière anglaise à l'esthétique japonaise, reflète admirablement la croisée mondiale des cultures propre au 21e siècle. Idéale pour déguster du thé japonais ou anglais, cette création combine parfaitement modernité et intemporalité.

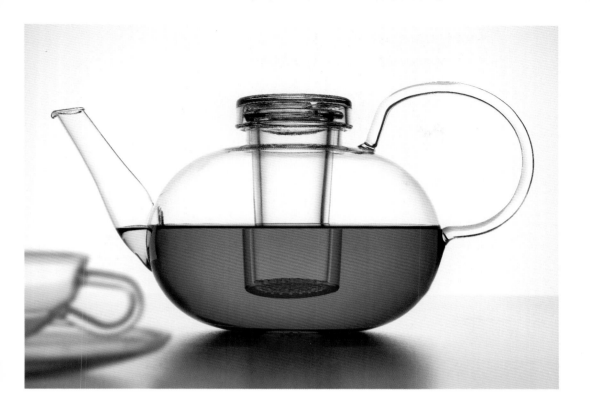

Tea service, 1931

Wilhelm Wagenfeld (Germany, 1900–1990)

www.jenaer-glas.com
Heat-resistant borosilicate glass
Hitzebeständiges Borosilikatglas
Verre borosilicate résistant à la chaleur
Schott Jenaer Glas/Zwiesel Kristallglas, Zwiesel, Germany

A classic Bauhaus design, Wilhelm Wagenfeld's elegant transparent tea set is made from borosilicate glass, which was initially developed for laboratory use, and is heat-resistant up to 450 °C (779 °F). Wagenfeld chose a hand-blown moulding technique that enabled the glass to be stretched particularly thinly, giving the tea service a remarkable visual and physical lightness. With its stripped-down, essentialist aesthetic, this design has a distinctive Modernity.

Wilhelm Wagenfelds elegantes Teege-schirr aus Jenaer Glas gehört längst zu den Klassikern des so genannten Bauhaus-Designs. Borosilikatglas wurde ursprünglich für Laborzwecke entwi-ckelt, da es bis zu 450 °c hitzebeständig ist. Wagenfeld entschied sich für eine Mundblastechnik, mit der die Glasmasse besonders dünnwandig ausgeformt wird, so dass sein Geschirr bemerkenswert leicht erscheint und es auch tatsächlich ist. In seiner reduzierten Ästhetik wirkt es absolut zeitlos.

Un classique de style Bauhaus, ce service à thé conçu par Wilhelm Wagenfeld est réalisé en verre borosilicate, initialement utilisé pour les ustensiles de laboratoire, et résiste à une chaleur extrême jusqu'à 450 °C. Wagenfeld a choisi la technique de moulage soufflé main qui a permis au verre d'être étiré très finement, donnant au service une extraordinaire légèreté visuelle et physique. Élégante et essentialiste, cette création dégage une intemporalité très particulière.

Ciacapo teapot, 2000
Kazuhiko Tomita (Japan, 1965–)

www.covo.com
Cast iron
Gusseisen
Fonte
0.6, 1 l
Covo, Formello, Italy

A contemporary interpretation of the traditional Japanese *tetsubin*, Kazuhiko Tomita's *Ciacapo* teapot combines high-quality craftsmanship with a simple and modern form. As a Japanese designer working in Milan, he is able to synthesize cultural influences from both East and West to create poetic objects that are both aesthetically satisfying and functional. Unlike many traditional Japanese teapots, this design has a spout that always points upwards, which means it is easier to pour.

Kazuhiko Tomitas Teekanne *Ciacapo* ist die zeitgenössische Neuinterpretation der traditionellen japanischen Teekanne aus Gusseisen (*tetsubin*) und verbindet meisterhafte handwerkliche Verarbeitung mit einer schlichten modernen Form. Als japanischer Designer, der in Mailand lebt und arbeitet, ist Tomita in der Lage, kulturelle Einflüsse aus Fernost und Europa zu verschmelzen, um Produkte voller Poesie zu kreieren, die zugleich formschön und funktional sind. Anders als viele traditionelle japanische Teekannen hat diese eine nach oben strebende Tülle, die den Tee in die Tasse fließen lässt, ohne zu kleckern.

La théière *Ciacapo* offre une interprétation contemporaine du *tetsubin* japonais traditionnel : une forme simple et moderne, réalisée avec un artisanat de très grande qualité. Créateur japonais vivant à Milan, Kazuhiko Tomita synthétise à la perfection les influences culturelles de l'Est et de l'Ouest. Il crée des objets poétiques, à la fois esthétiques et fonctionnels. Contrairement à de nombreuses théières japonaises classiques, ce modèle possède un bec verseur pointant vers le haut.

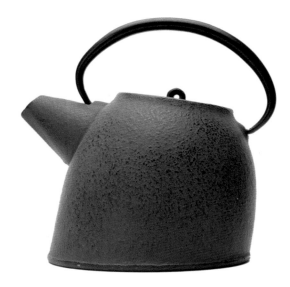
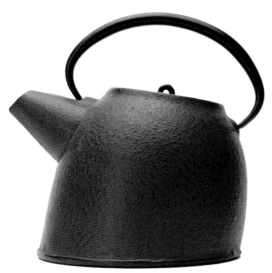

Effortlessly fusing the design sensibilities of East and West, Kazuhiko Tomita's *Sicamba* trivet for Covo takes its scrolling, leaf-like form from a traditional Japanese decorative arabesque pattern, known as *karakusa*. Available in four muted colours, this weighty, cast-iron trivet will last forever, and when several are grouped together on a table they produce a pleasing panel-like effect.

Mit diesem Untersetzer hat der japanische Designer mühelos abend- und morgenländische Designtraditionen verschmolzen, denn die gebogene vierblättrige Form des *Covo* folgt der dekorativen japanischen Tradition des *karakusa* (florales Muster). Der schwere gusseiserne Untersetzer wird in vier dunklen Farben angeboten und ist eine Anschaffung fürs Leben. Wenn man mehrere auf den Tisch legt, ergibt sich ein dekoratives Bild.

Le dessous-de-plat *Sicamba* créé par Kazuhiko Tomita pour Covo combine parfaitement les sensibilités de l'Est et de l'Ouest. Ses courbes en forme de feuille ressemblent à d'anciennes arabesques japonaises aux motifs floraux connues sous le nom de *Karakusa*. Disponible en quatre couleurs, ce dessous-de-plat en fonte est éternel. Lorsque plusieurs modèles sont regroupés sur une table, ils forment un très joli tableau.

Sicamba trivet, 2000
Kazuhiko Tomita (Japan, 1965–)

www.covo.com
Cast iron
Gusseisen
Fonte
↔ 32 cm
Covo, Formello, Italy

Warm tea set, 1998

Brian Keaney (Ireland, 1974–) & Tony Alfström (Finland, 1972–)

www.tonfisk-design.fi
Porcelain, laminated oak, laminated walnut or cork
Porzellan, Eichenschichtholz, Nussbaumschichtholz oder Kork
Porcelaine, teck laminé, noyer ou liège laminé
Tonfisk Design, Turku, Finland

Brian Keaney's motivation for designing this product was a straightforward one: he drinks a great deal of tea. Keaney recalls, however, that at the time he, 'preferred mugs [without handles] to cups with handles. Unfortunately though my father complained that they burned his fingers. Then a fellow student was participating on a materials course where at one stage the wood laminating technique was examined, and this introduced me to its possibilities and so a [handleless] mug which doesn't burn your fingers was developed'. Since its introduction in 1998, various additional pieces have been added to the range, and a black version has also been produced.

Brian Keaney ging bei der Gestaltung dieses Teegeschirrs von sich aus, denn er trinkt täglich Unmengen von Schwarztee. Er erinnert sich, dass er als Student [henkellosen] Bechern den Vorzug vor Tassen mit Henkeln gab: „Leider, denn mein Vater beklagte sich, dass er sich die Finger daran verbrannte. Ein Kommilitone belegte dann ein Seminar zum Thema Materialien, unter anderem Schichtholz. Das gab mir den Anstoß dazu, mich mit diesem Werkstoff zu beschäftigen und schließlich den henkellosen Becher zu entwerfen, an dem man sich nicht die Finger verbrennt." Seit der Markteinführung des Bechers (1998) sind verschiedene andere Teile dazugekommen, und das Teegeschirr wird inzwischen auch in einer schwarzen Version produziert.

La grande motivation de Brian Keaney pour imaginer ce produit est simple : il est un très grand buveur de thé. Keaney se rappelle quand il eut l'idée de créer ce service : « À l'époque, je préférais les mugs (sans anse) aux tasses, même si mon père affirmait qu'ils lui brûlaient les doigts. Un jour, lors d'un cours sur les matériaux, un des étudiants a été interrogé sur la technique du bois stratifié et là, sans le savoir, il venait d'ouvrir mes propres perspectives. C'est ainsi que j'ai réalisé des mugs qui ne brûlent pas. » Depuis sa parution en 1998, diverses pièces ont été ajoutées à la gamme Warm, dont une version noire.

Teamaster tea service, 2004

Jasper Morrison (UK, 1959–)

www.idee.co.jp
Porcelain
Porzellan
Porcelaine
Nikko/Idee, Tokyo, Japan

Designed specifically for the Japanese market, the *Teamaster* is a modern reworking of a traditional Japanese tea set. There is something very special about the way Jasper Morrison manages to create simple objects whose stripped-down essentialist forms lend an extra aesthetic dimension. With Naoto Fukasawa, Morrison has coined the term 'supernormal' to describe ordinary objects that transcend the everyday, and the *Teamaster* is an exemplary realization of this concept.

Das *Teamaster*-Set – eine moderne Interpretation der traditionellen japanischen Teekannen und Becher – wurde speziell für den japanischen Markt entworfen. Jasper Morrison besitzt die besondere Fähigkeit, immer wieder einfache Gebrauchsgegenstände zu entwerfen, die mit reduzierten, essenzialistischen Formen in eine andere Dimension vorzustoßen scheinen. Zusammen mit Naoto Fukasawa hat er hierfür den Begriff „supernormal" geprägt, als Bezeichnung gewöhnlicher Dinge, die aber das Alltägliche transzendieren. Das *Teamaster*-Set verkörpert exemplarisch die Realisierung dieses Konzepts.

Conçue spécialement pour le marché japonais, la gamme *Teamaster* est une version moderne d'un service à thé classique japonais. Jasper Morrison a le don de créer des objets simples, épurés, révélant des formes essentialistes qui leur donnent une esthétique parfaite. En collaboration avec Naoto Fukasawa, Morrison a inventé le terme « super normal » pour décrire des objets ordinaires transcendant le quotidien. La collection *Teamaster* illustre parfaitement ce concept.

TAC tea set, 1969

Walter Gropius (Germany, 1883–1969)

www.int.rosenthal.de
Porcelain
Porzellan
Porcelaine
Rosenthal, Selb, Germany

The founding director of the famous Bauhaus design school, Walter Gropius went onto to found The Architects+ Collaborative (TAC) architectural practice in Cambridge, Massachusetts in 1945. Apart from various landmark buildings, Gropius also designed the TAC tea service, which is part of Rosenthal's renowned *Studio-Line* range, prized for its innovative aesthetics and functional originality. These values are embedded in the design's quasi-streamlined form, which was inspired by symmetrical reflections. The separate pieces are available in either black or white porcelain, and can be combined to create an interesting visual contrast.

Walter Gropius, Gründungsdirektor des legendären Bauhauses in Weimar, gründete nach seiner Emigration in die USA 1945 das Büro The Architects' Collaborative (TAC) in Cambridge, Massachusetts. Neben etlichen herausragenden Gebäuden entwarf Gropius auch das Teegeschirr TAC für Rosenthals berühmte *Studio-Line*, das heute noch wegen seines damals bahnbrechenden modernen Designs und seiner funktionalen Originalität begehrt ist. Originell ist das Geschirr aufgrund seiner Stromlinienform, zu der sich Gropius von symmetrischen Spiegelungen inspirieren ließ. Alle Teile sind einzeln in Schwarz oder Weiß lieferbar, so dass jeder Kunde sich nach Belieben ein Geschirr in beiden Farben zusammenstellen kann.

Directeur fondateur de la célèbre école de design Bauhaus, Walter Gropius fonde l'agence TAC, une association d'architectes en 1945 à Cambridge, Massachusetts. Outre diverses constructions de référence, Gropius a également conçu le service à thé TAC. Cette création fait partie de la somptueuse série *Studio-Line*, à l'esthétique innovante et à l'originalité fonctionnelle. Ces valeurs sont intégrées à travers des formes géométriques simples lui conférant une poésie intemporelle. Les différentes pièces de cette série sont disponibles en blanc et noir, pouvant être combinées afin de créer un contraste visuel inégalable.

Spir tea & coffee set, 2002

Johan Verde (Norway, 1964–)

www.figgjo.no
Porcelain
Porcelain
Porcelaine
Figgjo, Figgjo, Norway

Receiving the Award for Design Excellence from the Norwegian Design Council in 2003, the *Spir* tea and coffee set comprises seven mix-and-match pieces: three coffee/tea pots, three cream jugs and a sugar bowl. Intended to compliment Figgjo's existing white tableware, this range was based on Johan Verde's concept of 'complex simplicity'. It was developed using CAD software which, according to Verde, 'makes possible nearly any thinkable form', allowing 'form to be transformed into matter'.

Diese Tee- und Kaffeegeschirrteile *Spir* wurden 2003 vom norwegischen Design Council mit dem Award for Design Excellence ausgezeichnet und umfassen elf Teile in verschiedenen, aufeinander abgestimmten Formen: Kaffee- und Teekannen, Sahne-/Milchkännchen und Zuckerdosen. Als Ergänzung zu Figgjos weißem Tafelgeschirr gedacht, basiert Johan Verdes Design auf seinem Konzept der „komplexen Einfachheit". Der Designer entwarf die Teile mit Hilfe eines CAD-Programms, das seiner Aussage nach „fast jede denkbare Form möglich macht" und es „der Form erlaubt, in Materie verwandelt zu werden".

Récompensé par le Prix pour l'Excellence du Design attribué par le Norwegian Design Council en 2003, ce service à thé et café *Spir* comprend sept pièces différentes : trois cafetières/théières, trois pots à crème et un sucrier. Destinée à compléter le service blanc *Figgjo*, cette gamme repose sur le concept de Johan Verde : « simplicité complexe ». Cette création a été réalisée à l'aide d'un logiciel de CAO qui, selon Verde, « permet de matérialiser n'importe quelle forme ».

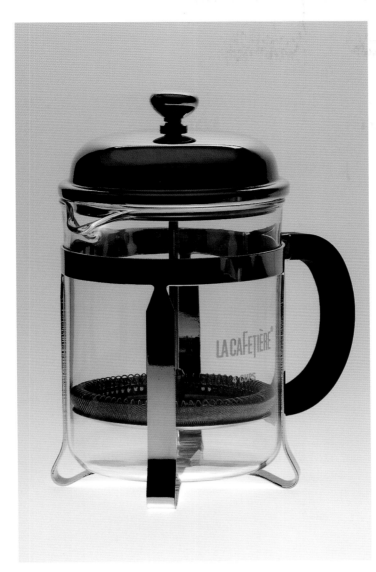

Although *La Cafetière* is often viewed as *the* classic French coffee maker, the plunger/filter system it employs was actually developed in Italy in the late 1920s. It was, however, a French company, Société des Anciens Etablissements Martin, that patented this classic coffee press in the 1950s, distributing it under the name *Chambord*. From the early 1960s onwards a British business, Household Articles Limited, marketed the design with the trade name *La Cafetière*. Thanks to its huge sales success, *'cafetière'* has now become the generic British term for plunge/filter coffee makers.

La Cafetière gilt zwar vielfach als *der* klassische französische Kaffeebereiter, sein Stößel-Filtersystem wurde tatsächlich aber bereits Ende der 1920er Jahre in Italien erfunden. Allerdings war es dann ein französischer Hersteller (Société des Anciens Etablissements Martin), der ihn in den 1950er Jahren patentieren ließ und unter dem Produktnamen *Chambord* vermarktete. Ab Anfang der 1960er Jahre ging die Firma in den Besitz des britischen Unternehmens Household Articles Ltd. über, das das Modell seitdem als *La Cafetière* vertreibt. Dank des enormen Verkaufserfolgs ist das französische Wort „cafetière" in Großbritannien inzwischen zum Gattungsbegriff für Kaffeefilterkannen geworden.

La Cafetière est souvent associée à un fabriquant français, or le système de piston fut élaboré en Italie à la fin des années 20. En revanche, c'est une société française, la Société des Anciens Établissements Martin, qui fit breveter cette invention dans les années 50, la diffusant sous le nom de *Chambord*. En 1960, une entreprise britannique, Household Articles Limited, commercialise ce design novateur sous le nom *La Cafetière*. Grâce au succès de ses ventes, cette appellation est la seule à s'être réellement imposée sur le marché.

La Cafetière coffee press, 1950s
Société des Anciens Établissements Martin (France)

www.lacafetiere.com
Chrome-plated or gold-plated stainless steel, heat-resistant glass, plastic
Verchromter oder vergoldeter Edelstahl, hitzebeständiges Glas, Kunststoff
Acier inoxydable argenté ou doré, verre résistant à la chaleur, plastique
3 cup, 4 cup, 8 cup, 12 cup
La Cafetière, Greenfield, Flintshire, uk

The classic Italian espresso maker, the *Moka Express* is a stovetop coffee pot which introduced steam pressure into coffee making. The design has three main components: a lower, water-holding section which acts as a boiler; a funnel-shaped metal filter in the central section which contains the ground coffee; and an upper, jug-like section where the freshly brewed liquid collects, and from which it can be poured. Inexpensive, the faceted Art Deco *Moka Express* is an iconic Italian design that brings a *Dolce Vita* ambience to any kitchen. It makes great coffee too.

Die klassische dreiteilige italienische Espressokanne, der *Moka Express*, wird auf die Herdplatte gestellt und lässt das Wasser im unteren Teil per Heißluft-dampfdruck durch das Kaffeemehl im Filtereinsatz in die eigentliche Kanne aufsteigen, aus der der fertige Espresso dann in die Tassen gegossen wird. Der preiswerte facettierte *Moka Express* im Art-Déco-Stil ist ein Kultobjekt des itali-enischen Designs, das jeder Küche einen Hauch Dolce Vita verleiht. Außerdem bereitet er köstlichen Kaffee zu!

La *Moka Express* comporte une chaudière hexagonale en aluminium, une soupape de sûreté, un filtre sans couvercle avec un tube au bout, et un pot avec un autre tube central. L'eau de la chaudière entre en ébullition et, sous la pression de la vapeur, traverse le filtre empli de café pour arriver dans le pot via le tube central. Peu coûteuse, cette cafetière au style Art déco apporte une ambiance *dolce vita* à votre cuisine et vous assure la qualité d'un excellent café. C'est la plus célèbre cafetière au monde.

Moka Express espresso maker, 1933

Alfonso Bialetti (Italy, 1888–1970)

www.bialetti.it
Aluminium, Bakelite
Aluminium, Bakelit
Aluminium, Bakélite
3 cup, 6 cup, 9 cup, 12 cup
Bialetti Industrie, Coccaglio, Italy

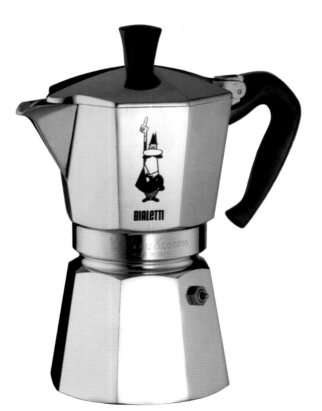

Coffee filter & coffee pot, 1937

Melitta Bentz (Germany, 1873–1950)

www.melitta.com
Porcelain
Porzellan
Porcelaine
6 cup
Melitta Beratungs-und Verwaltungsgesellschaft, Minden, Germany

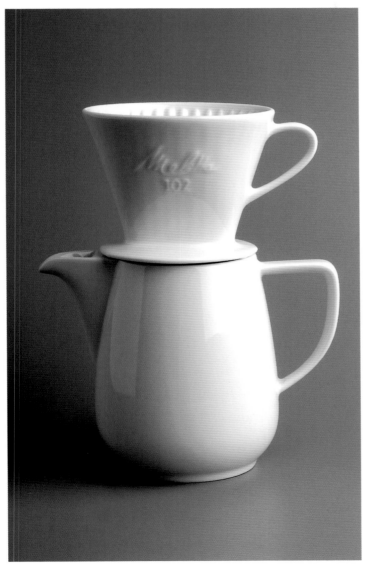

A classic German design, this utilitarian coffee funnel and pot were designed by Melitta Bentz, a Dresden housewife who experimented with her children's blotting paper to produce a properly filtered drink. She patented her famous filtering system in 1908, and in 1937 the now ubiquitous Melitta coffee-filtering bags were developed. They could be used in conjunction with the company's white porcelain funnel and pot whose attractive yet unadorned forms reflected the influence of Bauhaus Modernism.

Diese praktische Kaffeekanne mit dazugehörigem Porzellanfilter ist in Deutschland ein Klassiker. Erfunden wurden sie von der Dresdner Hausfrau Melitta Bentz, die mit Löschpapier aus den Schulheften ihrer Kinder experimentierte, um beim Kaffeekochen mit Filter und Papier den Kaffeesatz herauszufiltern. 1908 meldete sie ihren „Melitta-Filter" zum Patent an. 1937 kamen die ersten Melitta-Filtertüten auf den Markt, zeitgleich mit Kanne und Porzellanfilter, deren ansprechende, aber schmucklose Form den Einfluss des Bauhaus verrät.

Créations allemandes classiques, ces modèles ont été conçus par Melitta Bentz, originaire de Dresde. Amatrice de café, elle eut l'idée d'éliminer le marc de café reposant au fond des tasses en perçant le fond d'un pot en laiton et en plaçant par-dessus un buvard. Le filtre était né. Cette ménagère astucieuse fit breveter son système de filtrage en 1908, et les premiers filtres à café Melitta furent réalisés en 1937. Ceux-ci s'intègrent parfaitement à leur support et au pot en porcelaine blanche dont le design sobre illustre l'influence du Bauhaus.

Classic No.1 thermal jug, 1985

Ole Palsby (Denmark, 1935–)

www.alfi.de
ABS, mirrored glass
ABS, Spiegelglas
ABS, verre à effet miroir
0.94 l
Alfi, Wertheim, Germany

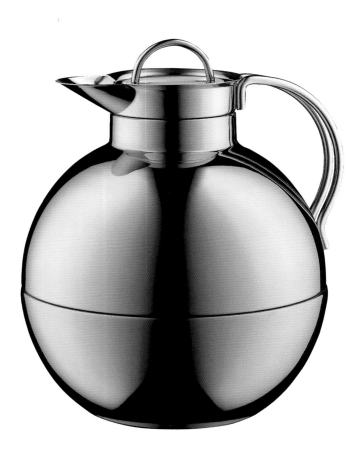

Probably Ole Palsby's best-known design, and certainly his most commercially successful product, the *Classic No.1* thermal jug not only works exceptionally well but also possesses a timeless grace. In fact, its form is an accomplished modern reinterpretation of traditional Channel Island milk 'cans' or 'creamers'. This updating of a vernacular design typology in order to create an 'ideal product' has long been a strong characteristic of Danish design, and in Palsby's career a guiding principle.

Die Thermoskanne *Classic Nr. 1* ist wahrscheinlich das bekannteste und kommerziell erfolgreichste Produkt des dänischen Designers Ole Palsby. Sie ist nicht nur äußerst funktional, sondern auch von zeitloser Formschönheit. Tatsächlich stellt sie in formaler Hinsicht eine gelungene moderne Neuinterpretation der traditionellen Milchkannen der britischen Kanalinseln dar. Diese Art der Aktualisierung eines traditionellen Designs mit dem Ziel ein „ideales Produkt" zu kreieren ist seit langem charakteristisch für dänisches Design wie auch für Palsbys Herangehensweise.

Le *Classic n°1* est à la fois la plus célèbre création d'Ole Palsby, et son produit commercial le plus vendu. Non seulement ce thermos fonctionne divinement bien, mais ses courbes présentent une élégance intemporelle. Sa forme design offre une version moderne du traditionnel pot à lait de Guernesey. Cette mise à jour influencée par un type de design vernaculaire (créer un « produit idéal ») a longtemps été une caractéristique incontournable du design danois, notamment dans la carrière de Palsby.

Basic vacuum flask, 1990

Julian Brown (UK, 1955–)
& Ross Lovegrove (UK, 1958–)

www.alfi.de
PMMA, mirrored glass
PMMA, Spiegelglas
PMMA, verre à effet miroir
0.9 l
Alfi, Wertheim, Germany

Available in four colours – cobalt blue, white, anthracite grey and lava-red – the *Basic* thermal vacuum flask has a 0.9 litre capacity and can be used for both hot and cold drinks. Visually seductive and technologically persuasive, with its transparent scratchproof acrylic casing protecting its silvered liner, the *Basic* carafe inspired a major trend towards transparency in product design. When launched, the design was named Product of the Year by the Fachverband Kunststoff Konsumwaren, and also won the Sonderschau Form Prize at Tendence Frankfurt.

Die *Basic*-Thermoskanne ist in vier Farben lieferbar (Kobaltblau, Weiß, Anthrazit und Lavarot) und fasst 0,9 Liter kalte oder heiße Getränke. Sie überzeugt nicht nur mit ihrer ästhetisch ansprechenden Form, sondern auch mit ihrer technischen Perfektion. Mit ihrem durchsichtigen Äußeren aus kratzfestem Acryl und dem silberbeschichteten Glaskörper im Innern begründete sie Anfang der 1990er Jahre den Trend zu transparenten Produktdesigns. Im Jahr ihrer Markteinführung wurde die *Basic* vom deutschen Fachverband Kunststoff Konsumwaren zum Produkt des Jahres gekürt und gewann auf der Tendence-Messe in Frankfurt am Main den Sonderschau Form-Preis.

Disponible en quatre couleurs : bleu cobalt, blanc, gris anthracite et rouge rubis, cette carafe thermos *Basic* possède une capacité de 0,9 litre. Fabriqué en verre acrylique transparent impossible à rayer, ce thermos accueille tous types de liquides chauds ou froids. Ce modèle esthétique et de très grande qualité a influencé la tendance transparente dans la fabrication de thermos. Lors de son lancement, cette carafe isotherme fut élue produit de l'année par Fachverband Kunststoff Konsumwaren et remporta le prix Sonderschau au salon Tendence de Francfort.

Thermal Carafe, 1976

Erik Magnussen (Denmark, 1940–)

www.stelton.com
ABS, glass
ABS, Glas
ABS, verre
0.5, 1 l
Stelton, Copenhagen, Denmark

Originally intended to compliment Arne Jacobsen's earlier *Cylinda Line* range for Stelton, Erik Magnussen's elegant and practical insulated jug is produced with either a stainless steel or brightly coloured ABS plastic body. Exemplifying some of the key characteristics of Magnussen's design, and available in various colours, the *Thermal Carafe* has a functional and aesthetically pleasing durability that has ensured its appeal for over thirty years. Like other classic icons of Danish design, this highly successful thermos jug has a sophisticated simplicity that makes it both pleasurable to use and easy to manufacture.

Ursprünglich war diese elegante und praktische Isolierkanne von Erik Magnussen als Ergänzung zu Arne Jacobsens *Cylinda*-Serie für Stelton gedacht. Sie wird heute entweder aus Edelstahl oder buntem ABS-Kunststoff produziert. Die *Thermal Carafe* verdeutlicht Magnussens Designauffassung, die dem Produkt seit über dreißig Jahren zum Erfolg verhilft. Wie andere dänische Kultdesigns ist auch diese Thermoskanne von raffinierter Schlichtheit, die zusätzlich den Herstellungsaufwand minimiert.

Véritable best-seller depuis plus de trente ans, le pichet isotherme d'Erik Magnussen est indémodable. Ce modèle se caractérise par sa forme cylindrique, son design minimaliste et sa fonctionnalité très moderne. D'abord réalisé en acier inoxydable, il se décline à présent en plastique ABS de différentes couleurs. Agréable à regarder et facile à fabriquer, ce thermos d'une simplicité sophistiquée illustre la conception de Magnussen en matière de design. Cette création a su résister aux épreuves du temps, devenant un incontournable du design.

Following the huge success of Erik Magnussen's 1970s thermal jug, Stelton recently introduced an evolution of this theme: John Sebastian's *Pingo* vacuum jug, with its distinctive, penguin-like form. Available in two sizes – one litre and 0.25 litre – the design is a sleek reworking of a traditional picnic vacuum jug. Moreover, its 'beak' incorporates new technology that ensures it is both completely childproof, and will not leak when lying flat. This innovative product has won a prestigious iF product design award, and a Design Plus award.

Nach dem Riesenerfolg von Erik Magnussens Thermoskanne von 1970 hat Stelton vor einigen Jahren das Produktthema fortgeführt, und zwar mit John Sebastians Modell *Pingo* in unverkennbar Pinguin-ähnlicher Form. Die Kanne ist in zwei Größen lieferbar (1 und 0,25 l Fassungsvermögen) und stellt eine stromlinienförmige Neuinterpretation der traditionellen Isolierkanne für Picknicks dar. In ihrem „Schnabel" verbirgt sich ein neuer Gießmechanismus, der sie absolut kindersicher macht und verhindert, dass Flüssigkeit austritt, wenn die Kanne versehentlich zu liegen kommt. Aufgrund dieser Innovation gewann die Kanne einen der begehrten iF-Produktdesignpreise sowie den Design Plus Award.

Fort de l'énorme succès du thermos d'Erik Magnussen dans les années 70, Stelton introduit un nouveau modèle : le thermos *Pingo* de John Sebastian en forme de pingouin. Disponible en deux tailles, 1 litre et 0,25 litre, ce modèle offre une version moderne du thermos classique. De plus, son bec verseur intègre une nouvelle technologie impliquant une sécurité totale pour les enfants. Cette création originale a été primée à deux reprises par l'iF product design et le Design Plus.

Pingo vacuum jug, 2005
John Sebastian (Denmark, 1975–)

www.stelton.com
Stainless steel, plastic
Edelstahl, Plastik
Acier inoxydable, plastique
0.25 l, 1 l
Stelton, Copenhagen, Denmark

Ole thermal jug, 1997

Ole Jensen (Denmark, 1958–)

www.royalcopenhagen.com
Porcelain or faience
Porzellan oder Fayence
Porcelaine ou faïence
1 l
Royal Copenhagen, Copenhagen, Denmark

This sculptural thermal jug has an engagingly organic form that invites caressing. Designed to compliment Ole Jensen's innovative *Ole* dinnerware range, this dishwasher-safe jug has an elongated spout that makes it easy to pour. With its distinctive rounded base, it also has a low centre of gravity that gives stability to the design. This pleasing product is a clever and stylish reworking of the traditional thermal jug.

Diese plastisch geformte, spülmaschinenfeste Isolierkanne verlockt dazu, sie zu streicheln. Sie wurde als Ergänzung zu Ole Jensens innovativem Tafelgeschirr *Ole* entworfen und hat eine lang gezogene Tülle, die keine Flecken verursacht. Da die Kanne sich nach unten bauchig rund verbreitert, hat sie eine niedrige Schwerpunkthöhe, die ihr Standfestigkeit verleiht. Dieses schöne Produkt stellt eine pfiffige, stilvolle Neuinterpretation der klassischen Thermoskanne dar.

Ce thermos sculptural d'une forme organique agréable est à la fois chic et fonctionnel. Conçu pour compléter le service innovant d'Ole Jensen, il est équipé d'un bec verseur allongé facilitant l'écoulement du liquide. Avec sa base arrondie et son centre de gravité relativement bas, ce modèle offre une grande stabilité. Résistant au lave-vaisselle, il une version moderne et élégante de la carafe isotherme classique.

Named after its engaging, duck-like form, the *Quack* insulated jug won a Red Dot Best of the Best award in 2003. Available in brown, green or beige, it keeps liquids warm for up to four hours, and can also be used for cold drinks. As Maria Berntsen explains, 'A shape should awake feelings and tell a story. A thing should never just be a thing. A body or sculpture...[has] shapes I never tire of looking at. I hope my designs awake the same emotions'.

Diese Isolierkanne wurde aufgrund ihrer entenförmigen Gestalt *Quack* getauft und ist in Braun, Grün oder Beige lieferbar. Im Jahr 2003 wurde sie mit dem Red Dot Best of the Best Award ausgezeichnet. Sie hält heiße Getränke bis zu vier Stunden lang heiß, kann aber ebenso gut für kalte Getränke benutzt werden. Maria Berntsen erklärt: „Eine Form sollte Gefühle wecken und eine Geschichte erzählen. Ein Ding sollte niemals nur ein Ding sein. Ein Körper oder eine Skulptur [... hat] Formen, an denen ich mich nie satt sehen kann. Ich hoffe, dass meine Designs bei den Betrachtern dieselben Emotionen wecken."

Le thermos *Quack* s'apparente au corps d'un canard et existe en marron, vert et beige. Récompensé par le Red Dot Best of the Best en 2003, ce modèle original garde les liquides, chauds ou froids, durant quatre heures. Selon Maria Berntsen, « la forme devrait susciter des sentiments et raconter une histoire. Un objet ne devrait jamais être considéré comme un simple objet. Un corps ou une sculpture offre des formes dont je ne me lasse pas. Je souhaite que mes créations éveillent les mêmes émotions ».

Quack insulated jug, 2003
Maria Berntsen (Denmark, 1961–)

www.georgjensen.com
ABS, polyurethane, aluminium
ABS, Polyurethan, Aluminium
ABS, polyuréthane, aluminium
0.9 l
Georg Jensen, Copenhagen, Denmark

Stelton produced the *AJ Cylinda Line* range, including this tea and coffee set, from some 'terse, logical and functional' drawings of cylindrical forms sketched by Arne Jacobsen in 1964. At the time, the technology required to translate these drawings into three-dimensional products did not exist. In order to manufacture these classic hollow-ware designs (which were launched in 1967), Stelton therefore had to develop a variety of new machines and welding techniques.

Die Herstellung der *AJ Cylinda Line*, zu der dieses Geschirr gehört, erfolgt auf der Basis „prägnanter, logischer und funktionaler" Zeichnungen zylindrischer Formen, die Arne Jacobsen im Jahr 1964 zu Papier gebracht hatte. Damals gab es noch keine maschinellen Verfahren, mit denen man die Zeichnungen in dreidimensionale Produkte hätte „übersetzen" können. Um diese klassischen Hohlzylinder zu produzieren (die 1967 auf den Markt kamen) musste Stelton ganz neue Produktionsmaschinen bauen und spezielle Schweißtechniken erfinden.

La série *AJ Cylinda Line*, dessinée en 1964 par Arne Jacobsen, incluant ce service à thé et à café, présente une collection d'art de la table aux lignes cylindriques en acier inoxydable. À l'époque, la technologie nécessaire pour transformer des dessins en produits tridimensionnels n'existait pas. Afin de fabriquer ces créations novatrices (lancées en 1967), Stelton dut développer une série de nouvelles machines ainsi qu'une technique de soudure particulière.

AJ Cylinda Line tea & coffee service, 1967

Arne Jacobsen (Denmark, 1902–1971)

www.stelton.com
Stainless steel, thermoset plastic
Edelstahl, Duroplast
Acier inoxydable, plastique
thermodurcissable
Stelton, Copenhagen, Denmark

Opus carafe, 2007

Ole Palsby (Denmark, 1935–)

www.rosendahl.dk
Glass
Glas
Verre
Rosendahl, Hørsholm, Denmark

Believing throughout his career that 'design should be for the hand and the eye', Ole Palsby has created useful, beautiful and simple objects for the home. This award-winning carafe is part of his *Opus* range, which grew from the principle that function should determine the choice of material – in this case, clear glass. Thanks to its size and shape, the carafe can be cooled in a fridge door, while its airtight stopper ensures freshness.

Entsprechend seinem Grundsatz, dass Design „etwas für die Hand wie für das Auge" sei, kreiert Ole Palsby einfache, nützliche und zugleich schön anzuschauende Haushaltsutensilien. Diese preisgekrönte Karaffe ist Teil seiner *Opus*-Serie, in der die Funktion die Wahl des Materials – in diesem Fall reines Glas – bestimmt. Dank ihrer Form und Größe passt die Karaffe wunderbar in die Kühlschranktür und der luftdichte Verschluss hält den Inhalt lange frisch.

Au cours de sa carrière, Ole Palsby a déclaré que « le design devait être pour la main et l'œil » et c'est ainsi qu'il créa des objets pour la maison à la fois beaux, utiles et simples. Cette carafe, primée, fait partie de la gamme *Opus* qui repose sur le principe selon lequel la fonction détermine le choix du matériau, ici le verre transparent. Grâce à sa taille et à sa forme, cette carafe tient dans la porte du réfrigérateur et son bouchon hermétique conserve la fraîcheur.

Available in aqua green, ruby red, smoky topaz, olive green, amber and clear glass, the *Canasta* fruit bowl is an attractive design that can be carried to a tabletop almost like a basket – indeed, its name means 'basket' in Spanish. Godoy created this design using old manufacturers' moulds, which he then modified. The concept of recycling and then adapting moulds is a novel one, and it allows Godoy to create new designs in a highly sustainable way.

Die schön gestaltete Obstschale *Canasta* ist in den Farben grün, rubinrot, rauchtopas, olivgrün, bernstein und transparent erhältlich und kann fast wie ein Korb – ihr Name bedeutet auf Spanisch tatsächlich „Korb" – zu Tisch getragen werden. Godoy fertigte diese Schüsseln aus alten Industriegießformen, die er neu bearbeitete. Dieses Konzept des Recyclings und der Bearbeitung alter Formen ist eine völlige Neuheit und noch dazu höchst umweltfreundlich.

Disponible en vert d'eau, rouge rubis, topaze fumé, vert olive ambré et verre transparent, la coupe à fruit *Canasta* est une création ravissante, illustrant à merveille son nom, « panier » en espagnol. Godoy a créé ce design à partir de vieux moules manufacturés qu'il a ensuite lui-même modifiés. Le concept de recyclage et l'adaptation d'anciens moules sont une première à l'époque. Il a permis à Godoy de concevoir des produits innovants et durables.

Canasta fruit bowl, 2008

Emiliano Godoy (Mexico, 1974–)

www.nouvelstudio.com
Glass
Glas
Verre
⌀ 21.7 cm
Nouvel Studio, Naucalpan, Mexico

Free Spirit bowl, 2004

Robin Platt (UK, 1962–)

www.rosenthal.de
Porcelain
Porzellan
Porcelaine
Rosenthal AG, Selb, Germany

The *Free Spirit* dish is part of a range of serving wares designed by Robin Platt for Rosenthal's well-known *Studio-Line* collection. These dishes also compliment Platt's extensive porcelain dinner service bearing the same name, which shares the same abstracted biomorphic free forms. As its name suggests, the *Free Sprit* range is intended to be functionally flexible and the antithesis of traditional and overly formal dinner services.

Die *Free Spirit* Schale gehört zu einer Geschirr-Serie, die Robin Platt für die bekannte Kollektion *Studio-Line* von Rosenthal entworfen hat. Sie ist zudem Teil von Platts umfangreichem Porzellan-service gleichen Namens, das auch die gleichen abstrakten, biomorphen freien Formen aufweist. Wie der Name bereits andeutet, zielt die *Free Spirit* Serie auf funktionelle Flexibilität ab und bildet damit die Antithese des traditionellen und übermäßig formalen Tafelgeschirrs.

Ce plat fait partie de la ligne *Free Spirit* dessinée par Robin Platt pour la célèbre collection *Studio-Line* de Rosenthal. Il accompagne le vaste service en porcelaine du même nom, caractérisé par ses formes abstraites biomorphiques. Les pièces de cette ligne justement baptisée « esprit libre » s'associent librement et se veulent l'antithèse des services traditionnels trop formels.

Butterfly bowl, c. 1951

Richard K Thomas (USA, active 1950s)

www.nambe.com
Nambé alloy
Nambé-Legierung
Nambé
Nambé, Santa Fe (NM), USA

During the Manhattan Project in the 1940s, a new proprietary metal alloy (given the name Nambé) was developed at the Los Alamos National Laboratory, which was capable of retaining heat and cold for long periods of time. In 1951, Nambé Ware Mills was established to produce home wares from this new silver-like, non-tarnishing, eight-metal alloy. Richard K Thomas, a sculptor, created some of the company's early designs, including the *Butterfly* bowl, which epitomizes the bold sculptural forms that marked American design during the 1950s.

Im Rahmen des so genannten Manhattan-Projekts wurde in den 1940er Jahren im Los Alamos National Laboratory eine neue, patentrechtliche geschützte Metalllegierung entwickelt, die Wärme und Kälte außerordentlich gut speichern konnte und den Namen Nambé erhielt. 1951 wurden die Nambé Ware Mills gegründet, um Haushaltswaren aus dieser neuen silberartigen, anlaufbeständigen Legierung aus acht Metallen herzustellen. Der Bildhauer Richard K. Thomas entwarf einige der ersten Designs des Unternehmens, darunter auch *Butterfly*. Die Schale verkörpert die kühnen plastischen Formen, die das amerikanische Design der 1950er Jahre kennzeichnen.

Au cours du Projet Manhattan dans les années 40, un nouvel alliage (baptisé Nambé) capable de retenir la chaleur et le froid pendant de longues périodes fut mis au point dans le laboratoire national de Los Alamos. Nambé Ware Mills fut créé en 1951 pour produire des articles de table avec ce nouveau matériau ressemblant à l'argent, ne se ternissant pas et composé de huit métaux. Le sculpteur Richard K. Thomas dessina certains des premiers produits de la compagnie, dont cette coupe *Butterfly* qui illustre les puissantes lignes sculpturales caractéristiques du design américain des années 50.

Model No. 4505 Collection serving bowl with handles, 1996

Lovisa Wattman (Sweden, 1967–)

www.hoganaskeramik.se
Glazed earthenware
Glasiertes Steinzeug
Faïence
2 l
Höganäs Keramik/Iittala Group, Höganäs, Sweden

Available in nine colours, this attractive serving bowl expresses the long-held Nordic belief that beautiful everyday objects can enrich life. With its soft organic form, this design invites physical interaction, while its handles enable it to be carried easily to the table. Specializing in the design of kitchenware and tableware, Lovisa Wattman is a true *formgivare* – the Swedish term for 'designer' that can be translated still more directly as 'form giver'.

Diese attraktive, in neun Farben erhältliche Servierschüssel bringt den lange gehegten nordischen Glauben zum Ausdruck, dass schöne Alltagsobjekte das Leben bereichern können. Die sanfte organische Form des Designs lädt zu physischer Interaktion ein, und die Griffe sorgen dafür, dass es sich leicht an den Tisch bringen lässt. Die auf das Design von Küchen- und Tafelgeschirr spezialisierte Lovisa Wattmann ist ein echter *formgivare* – das schwedische Wort für Designer, das sich jedoch direkter als „Formgeber" übersetzen lässt.

Disponible en neuf couleurs, cette belle coupe illustre la conviction nordique que la beauté des objets quotidiens améliore la qualité de vie. Avec sa douce forme organique, elle invite à l'interaction physique tandis que ses poignées la rendent facile à apporter à table. Spécialisée dans la conception d'ustensiles de cuisine et d'articles de table, Lovisa Wattman est une vraie *formgivare*, le terme suédois pour « designer » et pouvant se traduire littéralement par « donneuse de formes ».

Concept salad bowl, 2000s

Jenaer Glas Design Team

www.jenaer–glas.com
Heat-resistant glass
Hitzebeständiges Glas
Verre réfractaire
2 l, 4 l
Jenaer Glas/Zwiesel Kristallglas, Zwiesel, Germany

In 1884, the chemist Otto Schott, together with Carl Zeiss and his son Roderich, established a glass research laboratory in Jena that developed the world's first ovenproof household glass. Their glassworks subsequently worked with Bauhaus designers to create functional objects for the kitchen. It was in this tradition that the *Concept Collection* by Jenaer Glas (including the salad bowl shown here) was devised, conceived as adding a few timeless, everyday 'basics' to the kitchen environment.

Im Jahr 1884 gründete der Chemiker Otto Schott zusammen mit Carl Zeiss und dessen Sohn Roderich ein Glastechnisches Laboratorium in Jena, in dem das erste hitzebeständige Haushaltsglas der Welt entwickelt wurde. Ihr Glaswerk arbeitete später mit Designern des Bauhauses zusammen und schuf funktionale Küchenobjekte. In dieser Tradition wurde auch die *Concept Collection* von Jenaer Glas (einschließlich dieser Salatschüssel) entworfen, um die täglich verwendete Küchenausstattung um einige zeitlose „Basics" zu bereichern.

En 1884, le chimiste Otto Schott, Carl Zeiss et le fils de ce dernier, Roderich, ouvrirent à Jena un laboratoire de recherche où ils mirent au point le premier verre capable de résister à la chaleur d'un four. Leur verrerie a ensuite collaboré avec des designers du Bauhaus afin de créer des articles de table fonctionnels. La *Concept Collection* de Jenaer Glas (qui inclut le saladier présenté ici) relève de cette tradition, ajoutant quelques « basiques » de cuisine pour tous les jours.

Saladia bowls, 2001

Kazuhiko Tomita (Japan, 1965–)

www.covo.com
Matt-glazed ceramic
Matt glasierte Keramik
Céramique vernissée mate
Covo, Formello, Italy

These elegant bowls combine a matt rust glaze with a shiny black or cream glaze in order to create an interesting textural quality, while their soft curves also make them pleasant to hold. Essentially a modern reworking of a traditional Japanese noodle bowl, the *Saladia* is an understated design that goes beyond simple practicality with its purity of form and tactility. Like other designs by Kazuhiko Tomita, the *Saladia* is a 'quiet object' of great refinement, representative of the aesthetic and functional sensitivity of Japanese home wares.

Diese eleganten Schüsseln erhalten durch die Kombination von matter Glasur in Rost und glänzender schwarzer Glasur eine interessante Struktur und lassen sich wegen ihrer sanft geschwungenen Rundungen angenehm in der Hand halten. Die *Saladia* ist im Prinzip eine moderne Version einer klassischen japanischen Nudelschale, ein unaufdringliches Design, das durch seine klare Form und taktile Qualität über das rein Praktische hinausgeht. Wie andere Designs von Kazuhiko Tomito ist auch die *Saladia* ein „stilles Objekt" von großer Vornehmheit, das für die ästhetische und funktionelle Sensibilität japanischen Geschirrs steht.

Ces bols élégants associent un vernis rouille mat et un vernis noir satiné qui créent une intéressante qualité texturale tandis que leurs courbes douces les rendent agréables à manipuler. Réinterprétation moderne du bol à nouilles traditionnel, le design sobre de *Saladia*, avec sa forme épurée et sa douceur au toucher, va au-delà du simple sens pratique. À l'instar d'autres créations de Kazuhiko Tomita, c'est un « objet tranquille » d'un grand raffinement, représentatif de l'esthétique et de la sensibilité fonctionnelle de l'art de la table japonais.

As the design-engineer, Herbert Krenchel, explains, "In 1953, the idea was to make a beautiful bowl, preferably so functional and delicate that it was equally suited for use in the kitchen, on the dining table and as a decoration in the sitting room. As a material researcher I really concentrated on getting the different materials to match and look good together, as well as making them equally compatible to use together." Having recently been reissued, these much-loved icons of Danish design are accessible once more.

„1953 entstand die Idee, eine schöne Schale zu gestalten, die nach Möglichkeit so funktional und zart sein sollte, dass sie ebenso für den Gebrauch in der Küche wie auf dem Esstisch und als Dekoration im Wohnzimmer dienen konnte. Als Materialforscher war es mir vor allem wichtig, dass die verschiedenen Materialien zusammenpassten und zusammen auch gut aussahen", so der Designer und Ingenieur Herbert Krenchel. Diese sehr beliebten Ikonen des dänischen Designs wurden vor kurzem neu aufgelegt und sind jetzt wieder zu haben.

Comme l'explique l'ingénieur Herbert Krenchel : « En 1953, l'idée était de créer un superbe saladier, de préférence fonctionnel et délicat, qui serait à la fois utile dans la cuisine et sur la table, et qui puisse servir de décoration dans un salon. Chercheur en matériaux, je voulais associer deux matières différentes mais compatibles, pour un effet brillant et précieux. » Récemment réédité, ce symbole du design minimaliste danois est de nouveau disponible. Un grand classique intemporel, étonnamment contemporain.

Krenit bowl & Krenit salad bowl, 1953

Herbert Krenchel (Denmark, 1922–)

www.normann-copenhagen.com
Enamelled iron
Emailliertes Eisen
Fer émaillé
∅ 25, 38 cm
Normann Copenhagen, Copenhagen, Denmark

One can almost imagine this bowl being used by Goldilocks when she sampled the bears' porridge. It certainly has a reassuringly rustic quality, with its use of two-tone bamboo. Yet, at the same time, it has a contemporary sculptural elegance and a functional logic, especially in the way the spoon's indentation 'locks' it to the rim of the bowl for one-handed carrying.

Man sieht Goldlöckchen fast vor sich, wie sie aus dieser Schale den Haferbrei der drei Bären kostet. Die Mischung der zwei Bambustöne verleiht der Schale einen angenehm rustikalen Charme. Gleichzeitig strahlt sie moderne plastische Eleganz und funktionelle Logik aus, besonders die Einkerbung im Löffel, mit der sich dieser für den einhändigen Transport am Rand der Schüssel einhaken lässt.

On peut imaginer que c'est dans de petits saladiers comme ceux-là que Boucle d'Or goûta la bouillie des ours. Rustique et original grâce aux deux couleurs naturelles du bambou, ce saladier a une élégance sculpturale contemporaine. L'encoche située sur le bord sert à bloquer la cuillère, illustrant l'aspect fonctionnel de cet ustensile que l'on peut tenir d'une seule main.

Small bowl with spoon, 2008

Peter Moritz (Sweden, 1964–) & Eva Moritz (Sweden, 1966–)

www.sagaform.com
Bamboo
Bambus
Bambou
⌀ 13 cm
Sagaform, Borås, Sweden

Large serving bowl, 2008

Peter Moritz (Sweden, 1964–) & Eva Moritz (Sweden, 1966–)

www.sagaform.com
Bamboo
Bambus
Bambou
⌀ 26 cm
Sagaform, Borås, Sweden

A good and environmentally friendly alternative to the ubiquitous teak salad bowl, this large-size serving bowl is made of sustainably grown bamboo. Its lightweight portability and two-tone colour scheme attractively differentiate it from your average salad bowl design – a simple, yet subtly different eco-design.

Diese aus nachhaltig angebautem Bambus gefertigte Servierschale ist eine gute und umweltfreundliche Alternative zur allgegenwärtigen Teakholz-Salatschüssel. Durch die handliche Leichtigkeit und das zweifarbige Muster unterscheidet sie sich von herkömmlichen Salatschüsseln – ein einfaches, aber subtil anderes, umweltverträgliches Design.

Représentant une alternative originale et respectueuse de l'environnement au saladier classique en teck, ce grand saladier est fait en bambou, de culture écologique. Sa légèreté et la combinaison de deux tons naturels le différencient subtilement du saladier traditionnel : une ingénieuse création écologique.

Although bamboo has been used to make household products in the Far East for millennia, it is only in the last decade or so that it has become a more viable manufacturing material in the West. This *Chip & Dip* bowl is made from laminated strips of bamboo and, although light in weight, it is surprisingly strong. In fact, bamboo is denser than most hardwoods, but has a re-harvesting cycle of less than five years, whereas most hardwoods take between thirty and sixty years to reach maturity.

In Fernost wird Bambus seit Jahrtausenden zur Herstellung von Haushaltsartikeln verwendet, aber im Westen ist es erst seit etwa zehn Jahren ein gängiges Produktionsmaterial. Die Schale *Chip & Dip* aus laminierten Bambusstreifen ist zwar leicht, aber erstaunlich stark. Bambus ist dichter als die meisten Harthölzer und kann im Gegensatz zu diesen bereits nach weniger als fünf Jahren wieder geerntet werden. Die meisten Harthölzer benötigen zwischen dreißig und sechzig Jahren bis zur Reife.

Si en Extrême-Orient le bambou est utilisé pour les objets quotidiens depuis des millénaires, ce n'est qu'au cours de la dernière décennie qu'il est entré dans la production industrielle occidentale. Cette coupe *Chip & Dip* est réalisée en lamelles de bambou. Bien que légère, elle est d'une robustesse surprenante. En fait, le bambou est plus dense que la plupart des bois durs mais, contrairement à ces derniers qui atteignent leur maturité entre trente et soixante ans, il repousse en moins de cinq ans.

Chip & Dip bowl, 2006

Tom Sullivan (USA, 1957–) & Joanne Chen (USA, 1952–)

www.totallybamboo.com
Bamboo
Bambus
Bambou
⌀ 34 cm
Totally Bamboo, San Marcos (CA), USA

One hundred per cent renewable, bamboo is the most sustainable and eco-friendly wood-type material available to designers, manufacturers, and consumers. This large and elegant serving bowl demonstrates that stylish houseware designs can be made from this ecologically renewable alternative to hardwoods. Not only is it better for the environment, but the abundance and sustainability of bamboo also make it less expensive to produce.

Bambus ist ein zu hundert Prozent nachwachsender Rohstoff und damit das umweltfreundlichste holzartige Material, das Designern, Herstellern und Konsumenten zur Verfügung steht. Diese große, elegante Servierschüssel zeigt, dass sich aus der ökologisch erneuerbaren Alternative zu Hartholz stilvolle Haushaltswaren gestalten lassen. Das Material ist umweltverträglicher und wegen seines reichhaltigen Vorkommens und seiner Nachhaltigkeit auch preiswerter in der Produktion.

Cent pour cent renouvelable, le bambou est le bois le plus durable et écologique dont disposent les designers, les fabricants, et les consommateurs. Cette grande coupe démontre que l'on peut concevoir d'élégants articles de table à partir de cette alternative aux bois durs. Non seulement c'est préférable pour l'environnement mais, en outre, l'abondance et la pérennité du bambou le rendent moins cher à produire.

Super Big bowl, 2006

Tom Sullivan (USA, 1957–) & Joanne Chen (USA, 1952–)

www.totallybamboo.com
Bamboo
Bambus
Bambou
∅ 34 cm
Totally Bamboo, San Marcos (CA), USA

A few years ago, Tom Sullivan and Joanne Chen set up a design and manufacturing studio in north Hollywood, and began producing customized director's chairs. Trying to make their chairs ever lighter, they began experimenting with bamboo and were impressed with its strength-to-weight ratio as well as its ecological credentials. Shortly afterwards, they established their own company, Totally Bamboo, producing housewares – such as the bowls shown here – made to their own designs from this remarkable, renewable material.

Vor einigen Jahren gründeten Tom Sullivan und Joanne Chen ein Design- und Herstellungsstudio und begannen mit der Produktion maßgefertigter Regiestühle. In dem Versuch, die Stühle noch leichter zu machen, experimentierten sie mit Bambus und waren von dessen Verhältnis von Eigengewicht zu Nutzlast und den ökologischen Vorzügen begeistert. Kurz darauf gründeten sie mit Totally Bamboo ihr eigenes Unternehmen und fertigten Haushaltswaren – wie die hier gezeigten Schalen – nach ihrem eigenen Design aus diesem verblüffenden, erneuerbaren Rohstoff.

Il y a quelques années, Tom Sullivan et Joanne Chen ont monté un atelier de design à North Hollywood où ils réalisaient des fauteuils de metteurs en scène customisés. Cherchant à les rendre toujours plus légers, ils ont expérimenté avec le bambou et ont été impressionnés par sa résistance ainsi que par son côté écologique. Peu après, ils ont lancé leur propre compagnie, Totally Bamboo, produisant des articles de table tels que les coupes présentées ici, réalisant leur propres créations à partir de ce matériau remarquable et renouvelable.

Round bowls, 2001

Tom Sullivan (USA, 1957–) & Joanne Chen (USA, 1952–)

www.totallybamboo.com
Bamboo
Bambus
Bambou
⌀ 5–30.5 cm
Totally Bamboo, San Marcos (CA), USA

101001 large cork bowl & 101101 low cork bowl, 2009

Rachel Speth (USA, 1962–)

www.bambuhome.com
Untreated cork
Kork (naturbelassen)
Liège non traité
↕ 10 cm ⌀ 30.5 cm
↕ 6 cm ⌀ 30.5 cm
Bambu, Mineola (NY), USA

A popular material in the late 1970s, cork is now experiencing something of a renaissance thanks to its eco-friendly credentials. An impermeable, buoyant and fire-resistant material stripped from the trunks of cork oak trees, it has a multitude of uses from champagne stoppers to floor tiles. These two bowls – designed by the co-founder of Bambu, Rachel Speth – are made from cork that is sustainably harvested without harming the tree. Interestingly this durable, lightweight and slip-resistant material is also naturally hypo-allergenic, anti-microbial, and anti-fungal.

Kork, Ende der 1970er Jahre ein beliebter Werkstoff, erlebt derzeit wegen seiner Nachhaltigkeit eine Renaissance. Die Rinde der Korkeichen ist wasserfest, elastisch und feuerfest und wird zu vielen verschiedenen Produkten verarbeitet: von Champagnerkorken bis hin zu Bodenbelägen. Das Korkmaterial für diese Schalen von Rachel Speth (Mitbegründerin der Firma Bambu) stammt von einer nachhaltig bewirtschafteten Korkeichenplantage. Interessanterweise ist dieses langlebige, rutschfeste Leichtmaterial auch hypoallergen, antimikrobiell und resistent gegen Schimmelbefall.

Très populaire à la fin des années 70, le liège reprend du galon grâce à ses qualités écologiques. En effet, il s'agit d'un matériau résistant au feu, et un parfait isolant thermique. Provenant de l'écorçage des troncs de chêne-liège, ce matériau offre une multitude de configurations, des bouchons de champagne au carrelage. Conçus par la cofondatrice de Bambu, Rachel Speth, ces deux coupelles sont réalisées avec du liège retiré proprement de l'arbre, de manière à ne pas lui nuire. Robuste et léger à la fois, ce matériau antidérapant s'avère naturellement hypoallergénique, antimicrobien et antifongique.

Salad servers, 2008

Peter Moritz (Sweden, 1964–) & Eva Moritz (Sweden, 1966–)

www.sagaform.com
Bamboo
Bambus
Bambou
↕ 33 cm
Sagaform, Borås, Sweden

Both Peter and Eva Moritz studied at the Konstfack – the University College of Arts, Crafts and Design in Stockholm – before establishing their own design studio in Lund in 1998. Since then, they have specialized in the design of household objects and furniture for mass production, while also pursuing more craft-related projects. Their distinctive designs have a strong sculptural quality, as is demonstrated by these salad servers for Sagaform, which are made of sustainably grown bamboo.

Peter und Eva Moritz studierten beide an der Konstfack, der Hochschule für Kunst, Handwerk und Design in Stockholm, bevor sie 1998 ihr Designstudio in Lund eröffneten. Seither widmen sie sich hauptsächlich dem Design von Haushaltsutensilien und Möbeln für die Massenanfertigung, verfolgen nebenbei aber auch handwerklich anspruchsvollere Projekte. Ihr unverkennbarer Stil zeigt klare bildhauerische Einflüsse, wie auch dieses Salatbesteck für Sagaform, das aus nachhaltig produziertem Bambus gefertigt ist.

Peter et Eva ont étudié au Konstfack, école d'art, de design et d'arts graphiques de Stockholm, avant de créer leur propre agence de design, à Lund en 1998. Depuis, ils se sont spécialisés dans la création d'objets ménagers et de meubles pour la grande distribution tout en poursuivant des projets plus proches de leur formation d'artisan. Leurs créations ont une puissante qualité sculpturale, révélée notamment dans ces couverts à salade en bambou de culture écologique, réalisés pour Sagaform.

Made of sustainably harvested bamboo, this butter knife is sold as a set of two. Its rounded, organic form makes it perfect for spreading butter, margarine, jam or indeed anything you might want on your daily bread. Like other designs by Peter and Eva Moritz, this simple tool for living reveals a very human-centric and sensual approach to design.

Dieses Buttermesser aus nachhaltig angebautem Bambus wird im Zweierset verkauft. Durch seine abgerundete, natürliche Form eignet es sich perfekt zum Verstreichen von Butter, Margarine, Marmelade und allem, was Sie sonst auf Ihrem Brot mögen. Wie auch andere Kreationen von Peter und Eva Moritz verkörpert dieses einfache Utensil ein sehr sinnliches, homozentrisches Design-verständnis.

Réalisés en bambou de culture écologique particulièrement résistant, ces couteaux à beurre sont vendus par deux. Leur forme arrondie et organique est idéale pour étaler le beurre, la margarine ou la confiture sur du pain. Comme d'autres créations de Peter et Eva Moritz, cet ustensile, à la fois simple et épuré, révèle une approche très humaine et sensuelle.

Butter knife, 2008

Peter Moritz (Sweden, 1964–) & Eva Moritz (Sweden, 1966–)

www.sagaform.com
Bamboo
Bambus
Bambou
↔ 17.5 cm
Sagaform, Borås, Sweden

Caravel salad servers, 1957

Henning Koppel (Denmark, 1918–1981)

www.georgjensen.com
Stainless steel, polycarbonate
Edelstahl, Polykarbonat
Acier inoxydable, polycarbonate
Georg Jensen, Copenhagen, Denmark

These elegant salad servers were origi-nally manufactured in silver to compli-ment Henning Koppel's *Caravel* flatware collection, which won the prestigious Der goldene Löffel award in 1963. Today, however, they are made from stainless steel and plastic, and a matching salad bowl designed by Koppel in the 1970s has also been produced. With their fluid and unadorned lines, the *Caravel* salad serv-ers have a timeless appeal and typify the understated sophistication of Koppel's sculptural design language.

Als Ergänzung zu Henning Koppels Besteckgarnitur *Caravel*, die 1963 den Preis Der goldene Löffel erhielt, wurde das elegante Salatbesteck ursprünglich in Silber angefertigt. Heute besteht es jedoch aus Edelstahl und Kunststoff, und zur Ergänzung entwarf Koppel in den 1970er Jahren eine dazu passende Salatschüssel. Die fließenden, klaren Linien des *Caravel*-Salatbestecks haben etwas Zeitloses und versinnbildlichen die zurückhaltende Eleganz von Koppels plastischer Designsprache.

Ces élégants couverts à salade furent initialement fabriqués en argent afin de compléter la ménagère *Caravel* d'Henning Koppel qui remporta le pres-tigieux prix Der goldene Löffel en 1963. Aujourd'hui, réalisés en acier inoxydable et plastique, ils s'accompagnent d'un saladier assorti dessiné par Koppel dans les années 70. Avec leurs lignes fluides et dépouillées, ils ont un attrait intemporel et illustrent à merveille la sophistication discrète du langage sculptural de Koppel.

Mono-C2 salad servers, 2004

Ute Schniedermann (Germany, 1959–)

www.mono.de
Stainless steel
Edelstahl
Acier inoxydable
Mono/Seibel Designpartner, Mettmann, Germany

These classic salad servers will grace any table with their elegantly modern aesthetic. They epitomize the manufacturing quality, the painstaking attention to engineering detail, and the rigorous focus on function which, over the decades, we have come to expect from German housewares. Above all, these salad servers are a sublime example of contemporary German design.

Dieses klassische Salatbesteck mit seiner eleganten modernen Ästhetik schmückt jeden Tisch. Es verkörpert die Fertigungsqualität, die große Sorgfalt, die auf technische Details verwendet wird, und das Primat der Funktion – Eigenschaften, die man seit Jahrzehnten von deutschen Haushaltswaren erwartet. So ist Mono-C2 vor allem ein hervorragendes Beispiel für zeitgenössisches deutsches Design.

Ces couverts à salade classiques réhaussent toute table grâce à leur esthétique moderne et élégante. Ils incarnent la qualité de fabrication, le soin laborieux du détail technique et la concentration rigoureuse sur la fonction qui, depuis des décennies, caractérisent les articles de table allemands. Mais surtout, ils constituent un exemple sublime du design allemand contemporain.

Tools salad servers, 1998

Carina Seth-Andersson (Denmark, 1965–)

www.iittala.com
Heat-treated birch
Wärmebehandelte Birke
Bouleau traité thermiquement
↕ 36 cm
Iittala, Iittala, Finland

Only recently put back into production, Carina Seth-Andersson's *Tools* salad servers are an exquisite example of Scandinavian design at its very best. Harmoniously balanced, and beautifully crafted from heat-treated birch, they are extremely comfortable to handle and go well with almost any modern-style salad bowl. Like other designs from Iittala's *Tools* range, these salad servers have an appealing organic essentialism.

Carina Seth-Anderssons Salatbesteck *Tools* wird erst seit Kurzem wieder produziert und ist ein wunderbares Beispiel für skandinavisches Design in seiner reinsten Form. Harmonisch ausbalanciert und wunderschön gestaltet, ist das Besteck aus veredeltem Birkenholz besonders handlich und passt gut zu fast jeder modernen Salatschüssel. Wie auch andere Artikel aus der Iittala *Tools*-Serie, bestechen diese Stücke durch einen angenehm natürlichen Essentialismus.

Récemment remis en production, les couverts à salade de Carina Seth-Andersson illustrent à la perfection le meilleur du design scandinave. Harmonieux et merveilleusement travaillés à partir de bouleau traité thermiquement, ils sont très faciles à manipuler et se combinent parfaitement avec presque tous les saladiers modernes. À l'instar d'autres créations de la série *Tools* pour Iittala, ces couverts à salade ont un style épuré attrayant.

Good Grips serving tongs, 1997

Smart Design (USA, est. 1978)

www.oxo.com
Stainless steel, Santoprene
Edelstahl, Santopren
Acier inoxydable, Santoprene
↔ 34.5 cm
oxo International, New York (NY), USA

These sturdy tongs are made of high-quality stainless steel and, like other products created by Smart Design for oxo, their superior ergonomic refinement means that users of almost any physical ability can use them comfortably and safely. The Santoprene elastomeric grips also provide stability when serving anything from salad to chicken.

Diese stabile Servierzange ist aus hochwertigem Edelstahl gefertigt und, wie auch andere Produkte von Smart Design für oxo, dank ihrer außergewöhnlichen ergonomischen Gestaltung für jeden Nutzer einfach und sicher zu bedienen, ungeachtet seiner körperlichen Fähigkeiten. Die Santopren-Elastomer-Griffe sorgen für Stabilität beim Servieren, vom Salat bis zum Hühnchen.

Ces pinces sont en acier inoxydable de très grande qualité, et, à l'instar d'autres produits créés par Smart Design pour oxo, leur élégance ergonomique permet à tout utilisateur de les manier aisément et sans risque. Les poignées en élastomère Santoprene leur confèrent une prise en main idéale quel que soit le mets servi, de la salade au poulet.

Selandia dish, 1952

Per Lütken (Denmark, 1916–1998)

www.holmegaard.com
Glass
Glas
Verre
↔ 31 cm
Holmegaard Glasværk, Holmegaard, Denmark

Inspired by traditional glassmaking techniques, the circular motion of a spinning glassblower's pipe makes the appealing organic form of the *Selandia* dish, which is available in clear, blue and smoked glass variants. Driven by, 'A feeling for glass. A feeling for glassmaking. A feeling for what people need', Per Lütken worked as a designer for Holmegaard for more than fifty years and created over 3,000 glassware designs, with the *Selandia* being, perhaps, the most iconic of his oeuvre.

Inspiriert von den Techniken der traditionellen Glasherstellung, insbesondere den Drehbewegungen des Glasbläsers, entstand die ansprechende organische Form dieser Schale, die in Klarglas, in einem blauen und einem Rauchton erhältlich ist. Peter Lütkens Arbeit war motiviert von Gefühl: „Ein Gefühl für Glas. Ein Gefühl für die Glasherstellung. Ein Gefühl für das, was die Menschen brauchen". Er arbeitete über fünfzig Jahre als Designer für Holmegaard und kreierte über 3.000 Glas-Designs. *Selandia* ist das vielleicht ikonischste Design seines Oeuvres.

La belle forme organique du plat *Selandia*, existant en verre transparent, bleu ou fumé, s'inspire des mouvements circulaires que décrit un souffleur de verre avec sa canne. Animé par « une sensibilité pour le verre ; une sensibilité pour le travail du verre ; une sensibilité pour les besoins des gens », Per Lütken fut designer pour Holmegaard pendant plus de cinquante ans et conçut plus de trois mille pièces en verre dont *Selandia*, sans doute la plus représentative de son œuvre.

Provence bowl, c. 1956

Per Lütken (Denmark, 1916–1998)

www.holmegaard.com
Glass
Glas
Verre
⌀ 13, 19, 25, 31 cm
Holmegaard Glasværk, Holmegaard, Denmark

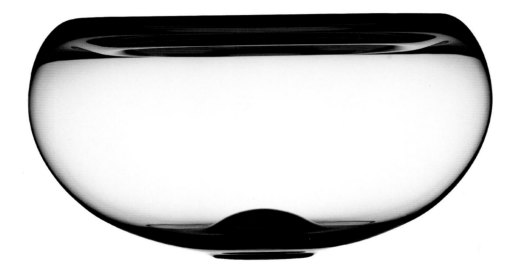

An acclaimed classic of Danish Modernism, the *Provence* bowl, with its beautifully curved form, reflects Per Lütken's sheer mastery of form and material. Capturing the spiritual essence of molten glass with its soft, undulating shape, the *Provence* bowl also came to epitomize the gentle organic forms that were to dominate Scandinavian design during the postwar period. Holmegaard produces four different versions of the design: clear, blue, green and smoked glass.

Die Glasschale *Provence* ist ein gefeierter Klassiker der dänischen Moderne und spiegelt in ihrer formvollendeten Rundung Per Lütkens meisterhaften Umgang mit Form und Material wider. Die sanfte, geschwungene Schale verkörpert das Wesen von geschmolzenem Glas und versinnbildlicht auch die weichen organischen Formen, die das skandinavische Design der Nachkriegszeit beherrschten. Holmegaard produziert dieses Design in vier verschiedenen Varianten: Klar, Blau, Grün und Rauch.

La coupelle *Provence* est devenue un grand classique du modernisme danois. Avec ses belles courbes sensuelles, elle reflète l'exceptionnelle maîtrise de la forme et du matériau de Per Lütken. Capturant l'essence spirituelle du verre en fusion avec sa silhouette douce et ondulante, elle incarne également les formes organiques fluides qui dominèrent le design scandinave de l'après-guerre. Holmegaard en propose quatre versions différentes : en verre transparent, bleu, vert et fumé.

With its abstracted, bird-like form, Henning Koppel's 992 jug is an iconic Mid-Century design. Like other designs by this master form giver, its organic shape accentuates the gleaming qualities of the silver, while its flowing lines make the metal appear almost molten. Imbued with a strong sculptural presence, this pitcher is an exquisite example of Danish design excellence and superlative craftsmanship.

Mit seiner abstrahierten Vogelform ist Henning Koppels Krug 992 ein ikonisches Design der 1950er Jahre. Wie bei anderen Entwürfen dieses Meisters der Formgebung akzentuiert die organische Form auch hier das glänzende Silber, während die fließenden Linien das Edelmetall fast aussehen lassen, als sei es geschmolzen. Dieser Krug besitzt eine starke skulpturale Präsenz und ist ein hervorragendes Beispiel für dänische Designkunst und erlesenes Handwerk.

Avec sa forme abstraite évoquant un oiseau, la cruche 992 d'Henning Koppel est emblématique du design du milieu du 20ᵉ siècle. Comme d'autres créations de ce maître de la forme, sa silhouette organique accentue l'éclat de l'argent tandis que ses lignes fluides donnent au métal un aspect presque mou. Sa forte présence sculpturale en fait un exemple exquis de l'excellence du travail et du design danois.

992 pitcher, 1952
Henning Koppel (Denmark, 1918–1981)

www.georgjensen.com
Sterling silver
Sterling-Silber
Argent sterling
↕ 28.7 cm
Georg Jensen, Copenhagen, Denmark

During the 1920s, Kay Fisker sought to modernize Danish design through the creation of Art Deco silverware that prioritized strong geometric forms. In 1928, his work was awarded the Eckersberg Medal and, that same year, he designed this elegant pitcher, possessing an understated beauty bound to its functional purity. An exquisite Art Deco object, the *KF* presaged the more organic forms of the postwar era.

Kay Fisker wollte das dänische Design in den 1920er Jahren durch die Kreation von Silberwaren im Art-Deco-Stil modernisieren, die sich durch starke geometrische Formen auszeichneten. Für seine Arbeit erhielt er 1929 die Eckersberg-Medaille, und im selben Jahr entwarf er diesen eleganten Krug von zurückhaltender Schönheit und funktioneller Klarheit. *KF* ist ein exquisites Art-Deco-Objekt, das die organischeren Formen der Nachkriegszeit vorwegnimmt.

Au cours des années 20, Kay Fisher décida de moderniser le design danois en créant une argenterie Art déco qui mettait l'accent sur de fortes formes géométriques. En 1928, il reçut la médaille Eckerberg et, la même année, dessina cette élégante cruche qui doit sa beauté discrète à sa pureté fonctionnelle. Exquis objet Art déco, la *KF* annonçait déjà les formes plus organiques de la période de l'après-guerre.

KF pitcher, 1928
Kay Fisker (Denmark, 1893–1965)

www.georgjensen.com
Sterling silver
Sterling-Silber
Argent sterling
↕ 25 cm
Georg Jensen, Copenhagen, Denmark

980A bowl, 1948
Henning Koppel (Denmark, 1918–1981)

www.georgjensen.com
Sterling silver
Sterling-Silber
Argent sterling
⌀ 39.5 cm
Georg Jensen, Copenhagen, Denmark

Henning Koppel started his career as a sculptor, notably working with granite, but in 1945 he began creating jewellery for Georg Jensen in a far more malleable material: silver. He subsequently designed home wares in silver for the same company. Modelled into expressive and oozing biomorphic forms – such as this exquisite solid silver bowl – his designs fully exploited the plastic potential of this beautiful and luminous metal.

Henning Koppel begann seine Karriere als Bildhauer und arbeitete hauptsächlich in Granit, bis er 1945 begann, für Georg Jensen Schmuck in einem weitaus geschmeidigeren Material zu fertigen: Silber. Später entwarf er auch Tafelsilber für dieses Unternehmen. Die ausdrucksvollen und überaus biomorphen Formen seiner Designs – wie diese erlesene, massive Silberschale – schöpften das plastische Potenzial dieses wunderschönen glänzenden Materials voll aus.

Henning Koppel fut d'abord sculpteur, travaillant surtout le granit, avant de commencer à dessiner des bijoux pour Georg Jensen en 1945 dans un matériau beaucoup plus malléable : l'argent. Il a ensuite continué à réaliser de l'argenterie pour la même compagnie. Avec leurs formes biomorphiques expressives et fluides, comme cette superbe coupe en argent massif, ses créations exploitaient au maximum le potentiel plastique de ce beau métal lumineux.

1026 covered fish dish, 1954

Henning Koppel (Denmark, 1918–1981)

www.georgjensen.com
Sterling silver
Sterling-Silber
Argent sterling
↔ 68 cm
Georg Jensen, Copenhagen, Denmark

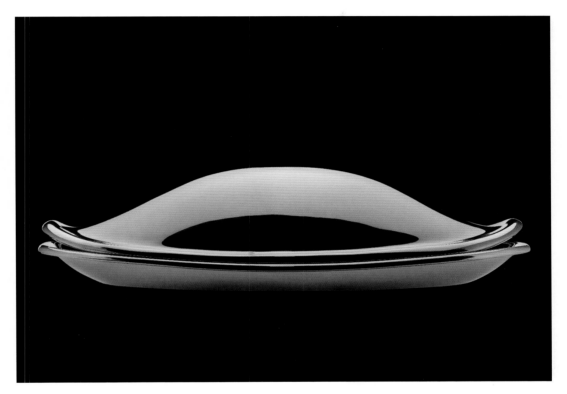

One of the most iconic designs produced by Georg Jensen, the *1026* covered fish dish is impressively large, being able to accommodate a sizeable salmon. It is also imposing as a sculptural object, with its gleaming surfaces emphasizing the flowing, gestural lines of its organic form. Like other designs by Henning Koppel, this design has an enduring appeal due to a sensual aesthetic that delights both hand and eye.

Eines der ikonischsten Designs des Unternehmens Georg Jensen ist diese Fischplatte mit Deckel, auf der sogar ein kapitaler Lachs Platz findet. Aber die leuchtende Oberfläche von *1026*, welche die fließenden, gestischen Linien ihrer organischen Form unterstreicht, macht sie auch zu einem beeindruckenden plastischen Objekt. Ebenso wie andere Designs von Henning Koppel ist auch *1026* dank der sinnlichen Ästhetik, die sowohl das Auge als auch die Hand anspricht, von bleibender Attraktivität.

Un des objets les plus emblématiques produit par Georg Jensen, cette grande poissonnière *1026* peut accueillir un saumon de bonne taille. C'est également un objet sculptural imposant avec ses surfaces étincelantes qui accentuent les lignes fluides et gestuelles de sa forme organique. Comme d'autres créations d'Henning Koppel, ce design n'a rien perdu de son charme grâce à une esthétique sensuelle aussi agréable à regarder qu'à toucher.

Henning Koppel decanter, 1970
Henning Koppel (Denmark, 1918–1981)

www.holmegaard.com
Glass
Glas
Verre
↕ 22 cm
Holmegaard Glasværk, Holmegaard, Denmark

This decanter is an outstanding example not only of Danish glassmaking, but also of Henning Koppel's distinctively sculptural approach to design. Its sensuous and fluid form ensures that it pours beautifully, while its rounded curves also allow the wine to breathe properly, and so taste better – a perfect case of form enhancing function. The design can also be used as a water carafe, and even when not in use it is a truly beautiful object in its own right.

Dieser Weindekanter ist nicht nur ein Muster dänischer Glasbläserkunst, sondern ebenso typisch für Henning Koppels ganz eigenen, bildhauerisch anmutenden Stil. Die sinnliche, fließende Form erlaubt ein elegantes Ausgießen und lässt den Wein gleichzeitig atmen und damit seinen vollen Geschmack entwickeln – ein klassischer Fall von Form gebender Funktionalität. Der Dekanter kann auch als Wasserkaraffe genutzt werden oder ist, wenn er einmal nicht gebraucht wird, einfach schön anzusehen.

Cette carafe illustre parfaitement la fabrication de verre danois mais aussi l'approche sculpturale de Henning Koppel dans ses créations. Grâce à sa forme sensuelle et fluide cette carafe permet au vin de s'écouler élégamment tandis que ses courbes arrondies avantagent sa respiration, améliorant ainsi sa saveur : un parfait exemple de forme raffinant la fonction. Cette carafe peut également être utilisée pour l'eau ou comme un très bel objet décoratif.

Using a logical, hands-on approach to the design process, Ole Palsby hones his designs for housewares to such a level of perfection that they frequently meet his ultimate goal of looking, 'as natural as if the design had just occurred of its own accord'. For instance, his *925s* wine decanter for Georg Jensen, with its silver drip-catching lip, has an understated Scandinavian elegance that belies the extreme refinement of Palsby's evolutionary design methodology.

Durch seine logische, gebrauchsorientierte Herangehensweise treibt Ole Palsby die Gestaltung seiner Haushaltsutensilien zu solcher Perfektion, dass er seinem höchsten Anspruch, die Gegenstände „so natürlich, als hätten sie sich selbst geschaffen" zu gestalten, oft mehr als gerecht wird. So zeichnet sich zum Beispiel der Weindekanter *925s* mit seiner silbernen Tropfschutzkante durch schlichte skandinavische Eleganz aus, hinter der seine überaus raffinierte evolutionäre Designmethodik zurücktritt.

Mettant en œuvre une approche logique du processus de conception, Ole Palsby parfait ses créations d'articles ménagers avec un tel souci de l'idéal qu'elles tendent vers la perfection : « aussi naturel que si l'objet s'était créé lui-même ». Sa carafe à décanter *925s* créée pour Georg Jensen dispose d'un rebord en argent, conçu pour retenir la dernière goutte. Un bel exemple de l'élégance scandinave qui dévoile l'extrême raffinement du processus créatif évolutionniste de Palsby.

925S wine decanter, 2004

Ole Palsby (Denmark, 1935–)

www.georgjensen.com
Glass, sterling silver
Glas, Sterlingsilber
Verre, argent sterling
0.75 l, 1 l
Georg Jensen, Copenhagen, Denmark

Riedel can trace its origins in northern Bohemian glass-making back to the 17th century. Indeed, eleven generations of the Riedel family have nurtured the company's development into the world's most renowned manufacturer of wine glasses. In recent years, the company has also developed several innovative decanters, including the lyre-shaped *Amadeo*, which is free-blown by master craftsmen using clear or black lead crystal.

Die Wurzeln der nordböhmischen Glasmacherkunst der Firma Riedel lassen sich bis ins 17. Jahrhundert zurückverfolgen. Ganze elf Generationen der Familie Riedel haben seither zum Aufstieg des Unternehmens zum weltweit renommiertesten Hersteller von Weingläsern beigetragen. In den letzten Jahren hat die Firma mehrere Dekanter in innovativen Designs auf den Markt gebracht, wie zum Beispiel den von Meistern dieses Kunsthandwerks mundgeblasenen *Amadeo*, dessen Form an einen Leier erinnert.

Riedel trouve ses origines dans le cristal de Bohême du nord depuis le 17e siècle. Onze générations Riedel ont participé au développement de cette entreprise, et en ont fait la plus renommée au monde dans le domaine des verres à vin. Riedel a développé récemment plusieurs carafes innovatrices, notamment le modèle *Amadeo* en forme de lyre, soufflé bouche par des maîtres verriers utilisant le cristal de plomb.

Amadeo decanter, 2006

Stefan Umdash (Austria, 1963–)

www.riedel.com
Hand-blown lead crystal
Mundgeblasener Bleikristall
Cristal de plomb soufflé bouche
↕ 35 cm 750 cl
Riedel Glas, Kufstein, Austria

Swan decanter, 2007

Georg Riedel (Austria, 1949–) & Maximilian Riedel (Austria, 1977–)

www.riedel.com
Hand-blown lead crystal
Mundgeblasener Bleikristall
Cristal de plomb soufflé bouche
↕ 60 cm 1.5 l
Riedel Glas, Kufstein, Austria

With its elegantly slender and elongated neck, softly swelling body and upturned tail, the Swan decanter is not only a functional wine server but also a beautiful and sculptural object that would enhance any dining room sideboard. Like all decanters, the bird-inspired Swan exposes the wine, whether a fine vintage or a younger one, to more oxygen. This, in turn, allows it to reach its optimum, flavoursome potential.

Mit seinem langen, elegant geschwungenen Hals, dem sanft gerundeten Körper und dem aufgestellten Bürzel, ist der Swan nicht nur eine praktische Weinkaraffe, sondern auch eine formschöne Zierde für jedes Esszimmerregal. Wie alle Dekanter lässt dieser „Schwan" den Wein – ob junger Tischwein oder großer Jahrgang – atmen, also Sauerstoff aufnehmen, sodass er sein geschmackliches Potenzial voll entfalten kann.

Comme son nom l'indique, la carafe Swan imite parfaitement les courbes du cygne (Swan signifie « cygne » en anglais), notamment son cou mince et allongé, puis son corps et enfin sa queue retournée. Idéale et fonctionnelle, cette carafe est également un véritable chef-d'œuvre qui embellit toutes les tables. Ce modèle Swan oxygène le vin, jeune ou millésimé, ce qui lui permet de s'ouvrir plus facilement en révélant toute la subtilité de ses saveurs.

Marketed by Screwpull as 'the best corkscrew in the world', the *LM-400* incorporates a patented rotational technology that allows bottles to be uncorked effortlessly just by raising and then lowering the design's handle-like lever. To remove the cork from the corkscrew is a similarly easy, two-stage 'up-down' action. Underwritten by a ten-year guarantee, this design also incorporates a non-stick coating on its screw section, and was specifically designed for removing synthetic corks.

Von Screwpull als „bester Korkenzieher der Welt" beworben, verfügt der *LM-400* über eine patentierte Rotationstechnologie, die ein müheloses Entkorken ermöglicht, indem der Hebel einmal auf- und abwärts bewegt wird. Mit einem ebenso einfachen Handgriff lässt sich der Korken auch wieder aus dem Korkenzieher entfernen. Dieses Designerstück, auf das es zehn Jahre Garantie gibt, hat eine anti-haftbeschichtete Spirale und ist speziell für synthetische Korken konzipiert.

Commercialisé par Screwpull et considéré comme « le meilleur tire-bouchon du monde », le *LM-400* intègre une technologie rotative brevetée qui permet de déboucher aisément les bouteilles en levant puis en abaissant la poignée. Retirer le bouchon est tout aussi facile : on procède du haut vers le bas. Garanti dix ans et spécialement conçu pour retirer les bouchons synthétiques, ce modèle intègre un revêtement anti-adhérent sur la partie de la vis.

LM-400 corkscrew, 2003
Screwpull Design Team

www.screwpull.com
Zamak (zinc-plated aluminium alloy)
Zamak (verzinkte Aluminiumlegierung)
Zamak (alliage plaqué zinc-aluminium)
Screwpull/Le Creuset, Fresnoy-le-Grand, France

LM-200 corkscrew, 1979

Screwpull Design Team

www.screwpull.com
Glass-reinforced polyamide
Glasverstärktes Polyamid
Polyamide renforcé
Screwpull/Le Creuset, Fresnoy-le-Grand, France

Invented in the late 1970s, the LM-200 was the first lever-action corkscrew and, although its 'up-down' mechanism has often been copied, it has never been equalled in performance. In fact, the LM-200 holds the Guinness world record for the greatest number of wine bottles opened in one minute: a total of eight. Its ergonomic design ensures a comfortable grip, while its incorporation of a non-stick coating guarantees that the screw glides through even the toughest cork.

Der LM-200 wurde in den 1970er Jahren als erster Hebelkorkenzieher entwickelt. Sein „Auf-und-ab"-Mechanismus wurde zwar oft kopiert, seine Qualität blieb jedoch unerreicht. Der LM-200 hält sogar den Guinness-Weltrekord für die meisten entkorkten Weinflaschen in einer Minute: acht. Durch seine ergonomische Form liegt er angenehm in der Hand, während die antihaftbeschichtete Spirale selbst den härtesten Korken bezwingt.

Créé à la fin des années 70, le LM-200 fut le premier tire-bouchon à levier. Son mécanisme du « haut vers le bas » a souvent été imité, mais jamais égalé. Ce modèle détient en effet le record du monde Guinness du plus grand nombre de bouteilles ouvertes en une minute : huit au total. Sa forme ergonomique assure un confort d'utilisation tandis que la couche antiadhérente permet à la vis de pénétrer n'importe quel bouchon.

Socrates corkscrew, 1998

Jasper Morrison (UK, 1959–)

www.alessi.com
Stainless steel
Edelstahl
Acier inoxydable
Alessi, Crusinallo, Italy

The *Socrates* corkscrew by Jasper Morrison might not be particularly ergonomic, but its fine engineering and thoughtful design certainly mean that it works well. Like other essentialist designs by Morrison, its functional purity and industrial aesthetic give it a distinctively masculine presence, and help to convey that this is no plaything but a tool that is resolutely fit for purpose.

Der *Sokrates*-Korkenzieher von Jasper Morrison ist vielleicht nicht gerade ergonomisch geformt, trotzdem leistet er durch seine brillante Technik und das vollendete Design wunderbare Dienste. Wie es für Morrisons essentialistisch geprägte Entwürfe typisch ist, verleihen sein funktioneller Purismus und die ans Industriezeitalter angelehnte Ästhetik dem Korkenzieher eine unbestritten maskuline Präsenz und betonen die Zweckmäßigkeit dieses Gebrauchsgegenstands.

Créé par Jasper Morrison, le tire-bouchon *Socrates* peut sembler manquer d'ergonomie alors qu'il est en fait aussi fonctionnel qu'élégant. Comme dans bon nombre de ses créations, Morrisson confère à l'objet une identité masculine. Sa pureté et son esthétique rappellent étrangement un jouet, pourtant il s'agit bien d'un outil performant.

This patented design was created for the wine connoisseur who wants to open a vintage bottle without fear of damaging the cork. The *Soft Machine* has a unique gearing system that extracts the cork in one continuous movement: slicing through the foil with a cutting wheel positioned inside the lever arm, twisting the screw into the cork, and then releasing the cork with the handle's upward motion. Sommelierly simple.

Dieses patentierte Stück wurde für Weingenießer entwickelt, die eine wertvolle Flasche öffnen möchte, ohne dabei den Korken zu beschädigen. Der *Soft Machine*-Korkenzieher verfügt über eine einzigartige Verzahnung, die es ermöglicht, den Korken in einer einzigen, fließenden Bewegung herauszuziehen. Die Kapsel mit dem integrierten Schneidrädchen entfernen, die Spirale in den Korken drehen und diesen mit einer Aufwärtsbewegung des Hebels herausziehen: (W)einfacher geht's nicht.

Ce design breveté a été créé pour les grands amateurs de vin afin de leur permettre d'ouvrir un grand millésime sans crainte d'endommager le bouchon. Le modèle *Soft Machine* extrait le bouchon en un seul mouvement continu, grâce à son système d'engrenage à crans qui, après avoir perforé la feuille d'aluminium grâce à un rouage tranchant placé à l'intérieur du levier, tourne la vis dans le bouchon, lequel s'extrait sans effort lorsqu'on fait remonter le levier.

Soft Machine corkscrew, 2006
L'Atelier du Vin Design Team

www.atelierduvin.com
Elastomer-coated ABS, metal
Mit Elastomer überzogenes ABS
Élastomère ABS (revêtement), métal
L'Atelier du Vin, Breteuil-sur-Noye, France

Graceful yet practical, this design can either be used as a wine cooler or as a lidded ice bucket with matching ice-tongs. It efficiently keeps the cold in, while simultaneously collecting conden-sation. Like so many other Danish designs for the home, Jakob Wagner's Icebucket/ Winecooler has a sophisticated elegance that derives from the country's long-standing tradition of design-engineering excellence.

Dieses elegante und doch praktische Stück kann wahlweise als Weinkühler oder als Eiseimer mit Deckel und passen-der Eiszange verwendet werden. Es hält wunderbar die Kälte und sammelt gleich-zeitig Kondenswasser. Wie viele andere dänische Designerstücke für zu Hause versprüht auch Jakob Wagners Eiseimer/ Weinkühler eine intellektuelle Eleganz, die in der langjährigen schnörkellosen Designtradition Dänemarks begründet liegt.

Ce seau à glace sert à conserver des glaçons ou le vin au frais grâce à son cou-vercle et ses pinces. Hermétique, il garde parfaitement le froid tout en recueillant la condensation. À l'instar d'autres créa-tions danoises pour la maison, le seau à glace de Jakob Wagner offre une élé-gance raffinée issue d'une vieille tradition du pays du design par excellence.

Icebucket/Winecooler, 2005
Jakob Wagner (Denmark, 1963–)

www.menu.as
Stainless steel, plastic, glass
Edelstahl, Plastik, Glas
Acier inoxydable, plastique, verre
↕ 22.5 cm
Menu, Fredensborg, Denmark

5052 wine cooler, 1979

Ettore Sottsass (Italy, 1917–2007)

www.alessi.com
Polished stainless steel
Polierter Edelstahl
Acier inoxydable brillant
↕ 23 cm
Alessi, Crusinallo, Italy

A contemporary interpretation of the traditional wine cooler, the 5052 by Ettore Sottsass has a gleaming, mirror-like outer surface of polished stainless steel, which subtly contrasts with its satin-finished interior. Large enough to accommodate two bottles of Sancerre, Chablis or champagne, this design is also deep enough for bottles to be cooled up to their necks. Moreover, its distinctive handles and rolled rim allow it to be carried easily with just one hand.

Ettore Sottsass' zeitgemäße Interpretation des traditionellen Weinkühlers hat eine schimmernde, spiegelartige Außenseite aus poliertem Edelstahl, die in subtilem Kontrast zu dem satinierten Inneren steht. Der Weinkühler fasst zwei Sancerre-, Chablis- oder Champagnerflaschen, die bis zum Hals darin gekühlt werden können. Durch die charakteristischen Griffe und den gewölbten Rand lässt sich der Kühler auch mit einer Hand gut tragen.

Avec ce modèle 5052, Ettore Sottsass offre une interprétation contemporaine du seau à champagne classique. Son éblouissante surface extérieure s'apparente à un miroir par l'emploi d'un inox brillant, contrastant subtilement avec son intérieur satiné. Suffisamment grand et profond pour accueillir deux bouteilles de sancerre, de chablis ou de champagne, et les maintenir au frais, ce seau comporte également des poignées originales, avec un bord laminé, permettant ainsi de le tenir d'une seule main.

Sommeliers wine glasses, 1973

Claus Josef Riedel (Austria, 1925–2004)

www.riedel.com
Blow-moulded lead crystal
Formgeblasener Bleikristall
Cristal de plomb soufflé bouche
Riedel Glas, Kufstein, Austria

In 1973 the famous Austrian wine-glass-making company, Riedel launched its landmark *Sommeliers* range of ten wine glasses, which Claus Josef Riedel had designed with the assistance of the Associazione Italiana Sommerliers. For the first time, the design of each glass was based on the individual character of the wine it was meant to contain. Unlike traditional cut-crystal goblets, these unadorned long-stemmed glasses emphasized the qualities of their contents and in so doing helped to change the perception of wine, while also enhancing its taste.

Im Jahr 1973 brachte der österreichische Weinglasfabrikant Riedel seine berühmte zehnteilige Weinglas-Serie *Sommeliers* auf den Markt, entworfen von Josef Riedel in Zusammenarbeit mit der Associazione Italiana Sommeliers. Zum ersten Mal wurde das Design der Gläser auf den individuellen Charakter verschiedener Weinsorten abgestimmt. Anders als die herkömmlichen Kristallkelche betonten diese schmucklosen, langstieligen Gläser die Qualität ihres Inhalts. Dies verbesserte nicht nur den Geschmack, sondern führte außerdem zu einer völlig neuen Wahrnehmung des Weins.

En 1973, la célèbre société autrichienne de fabrication de verres à vin Riedel a lancé une série *Sommeliers* de dix verres que Claus Josef Riedel avait conçu en collaboration avec l'Association des sommeliers italiens. Pour la première fois, le design de chaque verre était fondé sur le caractère individuel du vin qu'il était censé contenir. Contrairement aux traditionnels verres à pied en cristal, cette série donne au vin de l'espace, lui permettant de respirer. Elle change la perception du breuvage dont elle transcende magistralement la complexité et la finesse.

This classic yet unique wine glass features an 'aroma line': a raised internal ridge that helps the wine to release its bouquet when swirled around in the glass for a couple of minutes. For restaurants, this means that their diners can enjoy a bottle of wine at its best, without the impracticalities of opening it an hour in advance to let it breathe. The same principle can, of course, be applied at home.

Dieses klassische und doch einzigartige Weinglas verfügt über einen sogenannten "Aromakamm": eine erhabene Linie auf der Innenseite, die dafür sorgt, dass sich das Bouquet beim Schwenken des Glases optimal entfalten kann. Im Restaurant hat dies den Vorteil, dass der Gast seinen Wein in bestmöglicher Qualität genießen kann, ohne dass die Flasche schon eine Stunde vorher geöffnet werden muss, damit der Wein atmen kann. Dasselbe gilt natürlich auch für den Gebrauch zu Hause.

Ce verre à vin classique offre une « ligne d'arôme » : la nervure qui part de la base du verre vers l'extérieur aide le vin à libérer son bouquet lorsqu'il tourbillonne autour durant deux à trois minutes. Pour les restaurateurs cela signifie que leurs clients peuvent apprécier la qualité du vin sans pour autant ouvrir la bouteille une heure avant, afin de laisser respirer le nectar. Le même principe peut également être appliqué chez soi.

L'Exploreur wine glass, 2000
L'Atelier du Vin Design Team

www.atelierduvin.com
Glass
Glas
Verre
L'Atelier du Vin, Breteuil-sur-Noye, France

TAC 02 glassware, 2002

Rosenthal Creative Center (Germany, est. 1961)

www.rosenthal.de
Glass
Glas
Verre
Various sizes
Rosenthal, Selb, Germany

The inspiration for this graceful glassware comes from Walter Gropius' earlier *TAC I* tea service, which epitomises the functional and aesthetic refinement of German Modernism. The Rosenthal Creative Center – formerly known as the Design Studio – was established in 1961 and not only works with outside artists and designers, but also creates designs of its own. Rosenthal's hallmark is to combine contemporary form with timeless elegance, as displayed in the *TAC 02* stemware range.

Die Inspiration zu diesen eleganten Gläsern stammt von Walter Gropius' früherem Teeservice *TAC I* für Rosenthal, das die funktionale und ästhetische Vollendung der deutschen Moderne verkörpert. Das Rosenthal Creative Center – ehemals Rosenthal Design Studio – wurde 1961 gegründet und arbeitet nicht nur mit externen Künstlern und Designern zusammen, sondern bringt auch eigene Designs hervor. Das Markenzeichen von Rosenthal ist die Verbindung von modernen Formen und zeitloser Eleganz, wie es auch bei den *TAC 02* Stielgläsern zum Ausdruck kommt.

L'élégance simple et vaporeuse de la série de verre *TAC 02* s'inspire du service à thé classique *TAC I*, de Walter Gropius, illustrant le raffinement fonctionnel et esthétique du modernisme allemand. Fondé en 1961, le Rosenthal Creative Center, autrefois connu comme Design Studio, travaille non seulement avec des artistes et des créateurs étrangers, mais conçoit également ses propres modèles. La caractéristique de Rosenthal est de combiner la forme contemporaine avec une élégance intemporelle. *TAC 02* illustre parfaitement ce concept.

Illusion glassware, 1950s

Nils Landberg (Sweden, 1907–1991)

www.orrefors.com
Glass
Glas
Verre
Various sizes
Orrefors Kosta Boda, Orrefors, Sweden

Nils Landberg originally designed this classic glassware range in the 1950s, and since then the collection has been expanded in order to meet the demand for new types of drinking glasses. In the 1980s Olle Alberius added new glasses for Burgundy and water, and more recently Malin Lindahl has created two extra-large glasses with generous bowls that enhance the bouquet and flavour of the wine being served.

Nils Landberg entwarf diese klassischen Gläser bereits in den 1950er Jahren. Seitdem ist die Kollektion ständig erweitert worden, um die Nachfrage nach neuen Formen von Trinkgläsern zu befriedigen. In den 1980er Jahren ergänzte Olle Alberius sie um neue Gläser für Burgunder und Wasser, und vor kurzem entwarf Malin Lindahl zwei extragroße, bauchige Gläser, die das Bouquet und den Geschmack des darin servierten Weines voll zur Geltung kommen lassen.

Nils Landberg conçoit cette collection de verrerie classique dans les années 50. Depuis, cette gamme s'est agrandie afin de satisfaire la demande de nouveaux types de verres. Dans les années 80, Olle Alberius ajoute des verres plus modernes pour le bourgogne et l'eau. Récemment, Malin Lindahl a créé deux modèles extra-larges, avec une coupe généreuse, améliorant ainsi le bouquet et la saveur du vin servi.

870 cocktail shaker, 1957

Luigi Massoni (Italy, 1930–) & Carlo Mazzeri (Italy, 1927–)

www.alessi.com
Polished stainless steel
Polierter Edelstahl
Acier inoxydable poli
0.25 l, 0.5 l
Alessi, Crusinallo, Italy

One of the first objects created for Alessi by outside designers, the *870* cocktail shaker is a classic Mid-Century design. It was Mazzeri and Massoni's first project for the company, and subsequently became one of its all-time bestsellers, with over 1.5 million units sold to date. Now found in countless bars across the world, this mirror-surfaced design is not only highly practical but also epitomizes the casual elegance of Italian design.

Der Cocktailshaker *870*, eine der ersten Kreationen eines externen Designers für Alessi, ist ein klassisches Design der 1950er Jahre. Für Mazzeri und Massoni war er das erste Projekt in Zusammenarbeit mit Alessi und entwickelte sich mit der Zeit zu einem Bestseller. Bis heute wurde er über 1,5 Millionen Mal verkauft. Dank seiner praktischen Gestaltung, die die lässige Eleganz italienischen Designs verkörpert, kommt der Shaker heute in Bars auf der ganzen Welt zum Einsatz.

Grand classique des années 50, le shaker *870* est l'un des premiers objets créés pour Alessi par des designers externes. Premier projet réalisé par Mazzeri et Massoni, il est devenu l'une des meilleures ventes de tous les temps, avec plus d'1,5 million d'objets vendus à ce jour. Quantité de bars dans le monde entier l'utilisent. Non seulement cet objet en miroir poli est indispensable pour la réalisation des cocktails mais il incarne également l'élégance décontractée du design italien.

Cheese Dome, 2005

Helene Tiedemann (Sweden, 1960–)

www.sagaform.com
Hand-blown glass, oak
Mundgeblasenes Glas, Eiche
Verre soufflé bouche, chêne
⌀ 18 cm
Sagaform, Borås, Sweden

Helene Tiedemann studied industrial design in London before training as an architect in Stockholm. Today, she runs her own Stockholm-based office specializing in interior, retail and product design. Her sensual yet functional design language gives her products, such as the *Cheese Dome* for Sagaform, an engagingly soft-edged, human-centric quality.

Helene Tiedemann studierte in London Industriedesign, bevor sie in Stockholm eine Ausbildung zur Architektin machte. Heute leitet sie dort ihre eigene Agentur, die sich auf Inneneinrichtung sowie Produkt- und gewerbliches Design spezialisiert hat. Mit ihrer sinnlichen und zugleich funktionalen Designsprache verleiht sie ihren Produkten, wie dem *Cheese Dome* für Sagaform, eine angenehm weiche, homozentrische Note.

Helene Tiedemann a étudié le design à Londres puis a suivi une formation d'architecte à Stockholm, d'où elle dirige son propre bureau, spécialisé dans le design intérieur, la vente au détail et la création de produits. En matière de design son langage sensuel mais fonctionnel donne des résultats somptueux, à l'image de cette cloche à fromage créée pour Sagaform.

The idea behind the *Concept* range produced by Jenaer Glas was to create a number of essential 'basics' for everyday use. The *Concept* cheese dome, for instance, was intended to look good on a kitchen countertop, while simultaneously harmonising with any tableware service so that it could also be used when dining. In the tradition of Wilhelm Wagenfeld, who designed for the company during the 1930s, this design exhibits a timeless functional simplicity.

Die Idee hinter der von Jenaer Glas produzierten *Concept*-Serie war es, eine Reihe von nützlichen Utensilien für den alltäglichen Gebrauch zu kreieren. Die Käseglocke *Concept* zum Beispiel sollte für sich im Küchenregal gut aussehen, gleichzeitig aber zu jedem Tafelservice passen, sodass sie auch bei Tisch zum Einsatz kommen kann. In der Tradition von Wilhelm Wagenfeld, der in den 1930er Jahren für das Unternehmen entwarf, strahlt dieses Stück eine zeitlose funktionale Einfachheit aus.

L'objectif de la gamme *Concept* réalisée par Jenaer Glas était de concevoir plusieurs éléments de base utilisés au quotidien. Ainsi, la cloche à fromage *Concept* devait être magnifique sur un comptoir de cuisine comme sur une table, s'harmonisant parfaitement avec n'importe quelle vaisselle. Respectant la tradition imposée par Wilhelm Wagenfeld qui a beaucoup travaillé pour cette société dans les années 30, ce design intemporel et esthétique propose une forme simple et fonctionnelle.

Concept cheese dome, 2007

Jenaer Glas Design Team

www.jenaer-glas.com
Glass, stainless steel
Glas, Edelstahl
Verre, acier inoxydable
↕ 12.9 cm
Jenaer Glas/Zwiesel Kristallglas, Zwiesel, Germany

These two wooden-handled knives were designed to cut all types of cheese – the long and strong 'fine cutter' is perfect for slicing and stabbing soft or pressed cheeses, while the hatchet-like 'extra-strong cutter' copes easily with firm, hard or semi-soft cheeses. Their solid wood handles also have an excellent and reassuring grip. It is not surprising that a country that so reveres the art of cheese making, should have devised such excellent tools for eating it.

Diese beiden Messer mit Holzgriff wurden zum Schneiden aller Sorten von Käse entworfen – das lange und starke „feine Messer" ist perfekt geeignet, um Weichkäse oder Schmelzkäse zu schneiden und aufzuspießen, während das beilähnliche „extrastarke Messer" mühelos mit Hartkäse oder halbfestem Schnittkäse fertig wird. Die stabilen Holzgriffe liegen gut und sicher in der Hand. Es überrascht nicht, dass ein Land, das die Kunst der Käseherstellung so sehr schätzt, ein so hervorragendes Werkzeug für seinen Verzehr entwickelt hat.

Ces deux couteaux au manche en bois ont été conçus pour découper tous types de fromage. La « lame de finesse », longue et forte, est parfaite pour couper ou piquer les pâtes molles ou pressées. La « lame de force », en forme de hachette, convient pour les croûtes fermes, dures ou mi-dures. Les manches solides en bois assurent une belle prise en main. Il n'est pas surprenant qu'un pays qui vénère autant l'art du fromage ait créé d'excellents outils pour le déguster.

Duo de Coutellerie cheese knives, c. 2005

L'Atelier du Vin Design Team

www.atelierduvin.com
Stainless steel, wood
Edelstahl, Holz
Acier inoxydable, bois
L'Atelier du Vin, Breteuil-sur-Noye, France

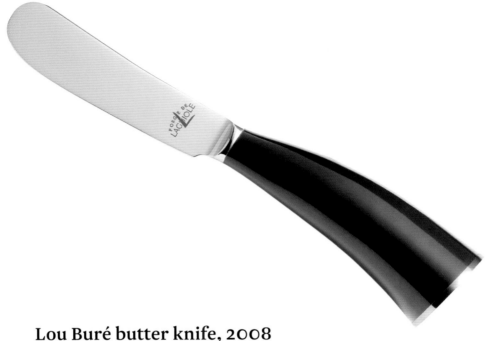

Lou Buré butter knife, 2008

Stéphane Rambaud (France, 1968–)

www.laguiole.com
Stainless steel, horn
Edelstahl, Horn
Acier inoxydable, corne
Forge de Laguiole, Laguiole, France

Famous around the world for its distinctive folding knives and cutlery, the Forge de Laguiole can trace its history back to 1829. In that year, it produced its first knife, inspired by a local fixed-blade design, as well as a traditional, folding utility knife from Spain, known as a *Navaja*. Since then, Laguiole has diversified its product line to include various types of knives and household implements, including this stylishly simple butter knife.

Die Schmiede Forge de Laguiole ist weltweit berühmt für ihre charakteristischen Klappmesser und wurde bereits 1829 gegründet. In diesem Jahr produzierte sie ihr erstes feststehendes Messer, das von einem lokalen, dolchartigen Messer inspiriert war, sowie ein traditionelles Klappmesser aus Spanien, das *Navaja*. Seitdem hat Laguiole seine Produktlinie ausgeweitet und fertigt inzwischen auch andere Messer und Tafelbesteck, darunter dieses stilvolle Buttermesser.

L'histoire de la Forge de Laguiole, célèbre dans le monde entier pour ses canifs et couteaux, remonte à 1829. Cette année-là, elle produisit son premier couteau, inspiré par un modèle local à la lame fixe, et un couteau traditionnel espagnol à lame repliable, le *navaja*. Depuis, Laguiole a diversifié ses produits, incluant différents types de couteaux et d'articles de table, dont ce couteau à beurre d'une élégante simplicité.

Cheese knife & cheese plane, 2007

Forge de Laguiole Design Team & Roland Barthélemy (France, 1949–)

www.laguiole.com
Stainless steel, juniper
Edelstahl, Wacholderholz
Acier inoxydable, genévrier
Forge de Laguiole, Laguiole, France

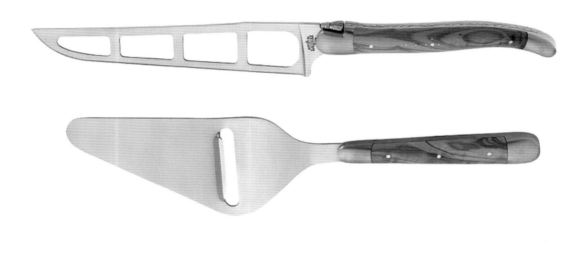

The French love of cheese is legendary, and so it is perhaps predictable that some of the best 'cheese tools' are manufactured in France. This cheese knife and plane were created in conjunction with Roland Barthélemy, the renowned master cheese maker and president of the Guilde des Fromagers (the guild of French cheese makers). The resulting implements are not only beautifully crafted but are also superior to use.

Die Liebe der Franzosen zum Käse ist legendär, und so ist es vielleicht auch selbstverständlich, dass einige der besten „Käse-Werkzeuge" in Frankreich hergestellt werden. Dieses Käsemesser und der Käsehobel wurden in Zusammenarbeit mit Roland Bartélemy entwickelt, einer der bekanntesten Käsespezialisten des Landes und Vorsitzender der Guilde des Fromagers (Gilde der französischen Käsemeister). Das Ergebnis sind handwerklich hochwertige, sehr schöne Utensilien, die ihre Aufgabe perfekt erfüllen.

L'amour des Français pour le fromage est légendaire et il donc naturel que certains des meilleurs « outils à fromage » soient fabriqués en France. Ce couteau et sa mouchette furent créés en collaboration avec Roland Barthélemy, le célèbre maître fromager et président de la Guilde des fromagers. D'une superbe facture, ce sont également des instruments hors pair.

Collective Tools cheese knife & cheese slicer, 2000

Antonio Citterio (Italy, 1950–)
& Glen Oliver Löw (Germany, 1959–)

www.iittala.com
Stainless steel
Edelstahl
Acier inoxydable
Iittala, Iittala, Finland

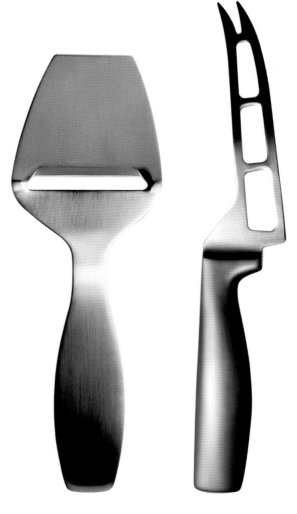

Made of satin-finish, high-grade stainless steel, Antonio Citterio and Glen Oliver Löw's cheese knife and cheese slicer belong to their *Collective Tools* range for Iittala – renowned for its distinctive styling and superb ergonomic handling. The handles of these useful 'tools for living' fit comfortably in the hand, and have a deeply satisfying sense of weighty balance.

Antonio Citterios und Glen Oliver Löws Käsemesser und -hobel aus satiniertem Edelstahl gehören zu der für Iittala entworfenen Serie *Collective Tools*, die durch ihr unverwechselbares Design und ihre fabelhafte, ergonomische Form bekannt wurde. Die Griffe dieser nützlichen ‚Tools for Living' liegen perfekt ausbalanciert und angenehm schwer in der Hand.

Fabriqués en acier inoxydable poli et de grande qualité, le couteau et la râpe à fromage d'Antonio Citterio et Glen Oliver Löw font partie de la collection *Collective Tools*, créés pour Iittala. Renommés pour leur originalité et leur parfaite ergonomie, ces modèles possèdent un manche agréable à tenir qui fait d'eux des ustensiles à la fois fonctionnels et agréables à utiliser.

Designed to compliment perfectly the *Mingle Lazy Susan* cheese-board, this three-piece set incorporates a slicer for hard cheeses, a sharp knife for semi-soft cheeses (such as Brie or Camembert) and a trowel-like implement for cream cheeses. Like most Scandinavian-designed objects for the home, these simple tools have an aesthetic and functional beauty derived from their respectful attentiveness to the requirements of everyday life.

Dieses dreiteilige Set aus einem Käsehobel für Hartkäse, einem scharfem Messer für Weichkäse wie Brie und Camembert und einer Art Spachtel für Frischkäse wurde passend zum drehbaren *Mingle-Käsebrett* entworfen. Wie die meisten skandinavischen Haushaltsobjekte besitzen auch diese schlichten Küchenwerkzeuge eine funktionale Ästhetik, die der respektvollen Aufmerksamkeit für die Anforderungen täglichen Lebens entspringt.

Conçu afin de parfaire le plateau à fromage *Lazy Susan*, ce jeu de trois pièces comporte une râpe pour des fromages à pâte dure, un couteau tranchant pour ceux à pâte molle (brie ou camembert) et une pelle pour les fromages frais. Comme nombre de créations scandinaves pour la maison, ces ustensiles sont à la fois simples, beaux et fonctionnels.

Mingle three-piece cheese set, 2005

Peter Moritz (Sweden, 1964–) & Eva Moritz (Sweden, 1966–)

www.sagaform.com
Stainless steel
Edelstahl
Acier inoxydable
Sagaform, Borås, Sweden

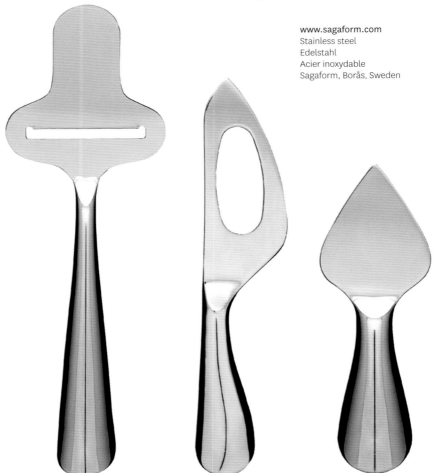

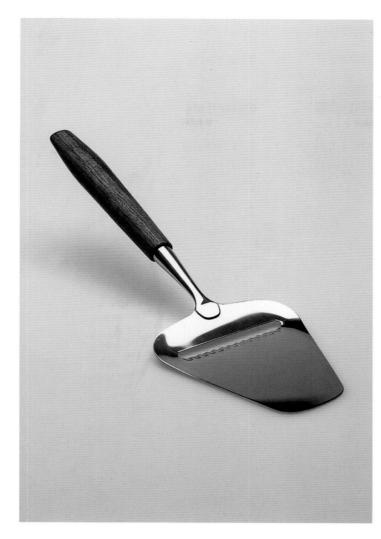

One day, the Norwegian furniture maker Thor Bjørklund wanted to slice some cheese for a sandwich while in his carpentry shop. He decided to use his carpenter's plane, and was so impressed with the resulting even slivers of cheese that, in 1925, he designed a smaller, kitchen-sized version, thereby creating the world's first hand-held cheese slicer. When they saw how well it worked, his friends and relatives all wanted one too, which convinced Bjørklund that his idea was good enough to patent. The version shown here, based on Bjørklund's original design, is the best-selling model manufactured by the company he founded.

Als der norwegische Möbelhersteller Thor Bjørklund sich eines Tages in der Werkstatt ein paar Scheiben Käse für ein Butterbrot abschneiden wollte, benutzte er dafür einfach seinen Hobel. Die Scheiben wurden so gleichmäßig, dass er 1925 eine kleinere Version für die Küche und damit den ersten Handkäsehobel der Welt entwickelte. Als seine Freunde und Verwandten sahen, wie gut er funktionierte, wollte jeder ein Exemplar, was Bjørklund davon überzeugte, dass seine Idee gut genug war, um sie patentieren zu lassen. Die hier gezeigte Version basiert auf seinem Originaldesign und ist das bestverkaufte Modell der von ihm gegründeten Firma.

On raconte qu'un jour le fabricant de meubles Thor Bjørklund voulut se couper un morceau de fromage pour son sandwich alors qu'il était dans son atelier. Il utilisa pour cela son rabot et fut si impressionné par le résultat qu'il décida d'en concevoir un plus petit, utilisable en cuisine. Il venait de créer la toute première râpe à fromage au monde, en 1925. Cet ustensile était si bien conçu que les proches de Bjørklund, parents et amis, lui en commandèrent et le persuadèrent de faire breveter l'idée. Le modèle présenté ici, s'inspirant fortement de l'original, constitue la meilleure vente de la société fondée par Bjørklund.

Allround-høvel cheese slicer, 1925

Thor Bjørklund (Norway, 1889–1975)

www.bjorklund-1925.no
Stainless steel, teak
Edelstahl, Teakholz
Acier inoxydable, teck
Thor Bjørklund & Sønner, Lillehammer, Norway

Kartio tumblers, 1958

Kaj Franck (Finland, 1911–1989)

www.iittala.com
Pressed glass
Gepresstes Glas
Verre pressé
Iittala, Iittala, Finland

Like his *Kilta* dinner service, Kaj Franck's *Kartio* glassware was intended for everyday use. Stackable and practical, this tumbler range and its matching pitcher were specifically designed to be mass-produced from clear pressed glass in a number of mix-and-match, earthy-toned colours. The range was christened *Kartio* in 1993, a Finnish word meaning 'cone' or 'taper' – highly appropriate considering its elemental, funnel-like form.

Wie Kaj Francks Tafelservice *Kilta* war auch seine *Kartio*-Reihe für den täglichen Gebrauch bestimmt. Die praktischen, stapelbaren Gläser und die dazu passende Karaffe wurden eigens für die Massenproduktion aus gepresstem Glas entworfen und sind in vielen, miteinander kombinierbaren Farbnuancen erhältlich. Die Reihe wurde 1993 *Kartio* genannt, was im Finnischen soviel wie „Konus" bedeutet – ein sehr passender Name für die schlichte, trichterartige Form der Gläser.

À l'instar de son service de table *Kilta*, la verrerie *Kartio* de Kaj Franck était destinée à un usage quotidien. Empilable et pratique, cette gamme de verres et de carafes fut conçue pour être produite en masse en verre pressé dans une déclinaison de couleurs ocrées s'harmonisant entre elles. En 1993, cette ligne fut baptisée *Kartio*, du mot finnois pour « cône » ou « fuselé », un terme très approprié compte tenu de sa forme géométrique élémentaire.

Classic tumblers, 1948

Freda Diamond (USA, 1905–1998)

www.libbey.com
Pressed glass
Gepresstes Glas
Verre pressé
Libbey Glass, Toledo (OH), USA

In the early 1940s, and at the suggestion of Walter Dorwin Teague, Libbey glassworks hired a female design consultant, Freda Diamond. Two years later, Diamond commissioned a survey of consumer tastes, and used the resulting market research data to, as she put it, 'shape demand'. A strong advocate of 'good design', Diamond put theory into practice with her affordable, practical and stylish *Classic* tumblers, which are available in aqua, mocha, olive, smoked and clear glass.

Zu Beginn der 1940er Jahre stellte der Glashersteller Libbey auf Empfehlung von Walter Dorwin Teague Freda Diamond als Beraterin ein. Zwei Jahre später gab Diamond eine Untersuchung von Verbrauchervorlieben in Auftrag und verwendete die Daten der Marktstudie um „die Nachfrage zu formen", wie sie es nannte. Als überzeugte Vertreterin des „guten Designs" setzte sie die Theorie in die Praxis um und kreierte die erschwinglichen, praktischen und stilvollen *Classic*-Tumbler, die in klarem Glas sowie in den Farbtönen Aqua, Mokka, Olive und Rauch erhältlich sind.

Au début des années 40, sur les conseils de Walter Dorwin Teague, les verreries Libbey recrutèrent une consultante en design, Freda Diamond. Deux ans plus tard, celle-ci commanda une enquête sur les goûts des consommateurs, utilisant les résultats de cette étude de marché pour « façonner la demande », pour reprendre ses termes. Ardent apôtre du « bon design », elle mit ses théories en pratique en créant ces verres droits *Classic*, élégants, pratiques et bon marché, qui existent en verre transparent, fumé, olive, moka ou aqua.

Aino Aalto, the wife and business partner of the famous Finnish architect, Alvar Aalto was an accomplished designer in her own right. This pressed glass set was initially designed as a submission for a competition sponsored by the Karhula-Iittala glassworks in 1932, where it won second prize. Originally named *Bölgeblick*, which means 'wave view', the chunkily ribbed *Aalto* range – comprising glasses, bowls, plates and an elegant pitcher – revealed Aino's concern for practicality and standardization in design.

Aino Aalto, die Ehefrau und Geschäftspartnerin des berühmten finnischen Architekten Alvar Aalto, war ebenfalls eine erfolgreiche Designerin. Sie entwarf die hier gezeigte Glasserie ursprünglich für eine Ausschreibung des Glasherstellers Karhula-Iittala 1932 und erhielt dafür den zweiten Preis. Zu Anfang trug sie den Namen *Bölgeblick*, der die Wellen beschreibt, die ein ins Wasser geworfener Stein auf der Wasseroberfläche erzeugt. Die kompakte, gerippte *Aalto*-Serie umfasst Trinkgläser, Schalen, Platten sowie eine elegante Karaffe und verkörpert Ainos Prinzip des praktischen, kompatiblen Designs.

Aino Aalto, l'épouse et associée du célèbre architecte finlandais, était elle-même une designer accomplie. Ce service en verre pressé fut initialement conçu pour un concours organisé par les verreries Karhula-Iittala en 1932, où il remporta le second prix. Initialement baptisée *Bölgeblick* (les vaguelettes concentriques provoquées par une pierre jetée dans l'eau), la ligne *Aalto*, aux motifs simples en anneaux, comprend des verres, des coupes, des assiettes et une élégante carafe. Elle témoigne du goût d'Aino pour un design pratique et standardisé.

Aalto glassware, 1932
Aino Aalto (Finland, 1894–1949)

www.iittala.com
Pressed glass
Gepresstes Glas
Verre pressé
Iittala, Iittala, Finland

Gibraltar tumblers, 1977

Libbey Glass New Products Development Group

www.libbey.com
Pressed glass
Gepresstes Glas
Verre pressé
Libbey Glass, Toledo (OH), USA

Another seminal design manufactured by Libbey, the *Gibraltar* pattern was inspired by a Baccarat tumbler that Freda Diamond had seen on one of her many travels. This range of large and robust utility glassware is a classic of American design: a masculine, no-nonsense, durable and chunky pattern for the everyman that eloquently reflects the casual lifestyle and seemingly classless nature of American society.

Gibraltar ist ein weiteres wegweisendes Design von Libbey und geht auf einen Baccarat-Tumbler zurück, den Freda Diamond auf eine ihrer vielen Reisen gesehen hatte. Diese Serie großer, robuster Gläser ist ein Klassiker des amerikanischen Designs: ein maskulines, schnörkelloses, langlebiges und massives Modell, das den lässigen Lebensstil und die scheinbar klassenlose Gesellschaft Amerikas reflektiert.

Autre produit emblématique des verreries Libbey, le service *Gibraltar* fut inspiré par un verre droit en baccarat que Freda Diamond avait vu au cours de l'un de ses nombreux voyages. Grands et robustes, ces verres destinés à un usage quotidien sont désormais un classique du design américain avec leurs lignes masculines, pragmatiques et durables qui reflètent avec éloquence le style de vie informel et la nature apparemment égalitaire de la société américaine.

Aarne glassware, 1948

Göran Hongell (Finland, 1902–1973)

www.iittala.com
Mould-blown glass
Mundgeblasenes Glas
Verre soufflé bouche
Iittala, Iittala, Finland

One of the great pioneers of Finnish glass design, Göran Hongell was an artistic adviser to the Karhula glassworks during the 1930s. During the 1940s, he began to design glassware characterized by simplified forms and undecorated surfaces. His classic *Aarne* glassware has an innovative form that falls somewhere between a tumbler and a stemmed glass. While reassuringly chunky in the hand, it remains pleasing to the eye.

Göran Hongell, einer der großen Pioniere des finnischen Glasdesigns, war in den 1930er Jahren künstlerischer Berater der Glasfabrik Karhula. In den 1940er Jahren begann er mit dem Design von Glaswaren, die sich durch vereinfachte Formen und schlichte Oberflächen auszeichnen. Sein Klassiker *Aarne* überzeugt durch eine innovative Form, die irgendwo zwischen Tumbler und Stielglas anzusiedeln ist. Die massiven Gläser liegen sicher in der Hand und sind zudem schön anzusehen.

Un des grands pionniers de l'art du verre finlandais, Göran Hongell fut conseiller artistique des verreries Karhula dans les années 30. Dans les années 40, il dessina des objets en verre caractérisés par des formes simples et des surfaces sans ornements. Son fameux service *Aarne* présente un forme innovante à mi-chemin entre le verre droit et le verre à pied. Robuste et tenant bien dans la main, c'est également un plaisir pour les yeux.

Tapio glassware, 1952
Tapio Wirkkala (Finland, 1915–1985)

www.iittala.com
Mould-blown glass
Mundgeblasenes Glas
Verre soufflé bouche
Iittala, Iittala, Finland

One of the most accomplished designers of all time, Tapio Wirkkala created sculpturally beautiful objects that possess breathtaking originality. The *Tapio* glassware range is a testament to his understanding of materials and natural forms, as well as to his mastery of glassmaking techniques. It has an engaging, ice-like presence, and the air bubbles trapped inside the heavy stem of each glass are placed there through the skilful use of a wet stick.

Tapio Wirkkala gehört zu den fähigsten Designern aller Zeiten und kreierte wunderschöne, wie Skulpturen anmutende Objekte von atemberaubender Originalität. Die Trinkglasserie *Tapio* veranschaulicht seine Auffassung von Material und natürlicher Form sowie seine meisterhafte Beherrschung der Glasherstellungstechnik. Die Gläser wirken, als seien sie aus Eis, und die Luftblase gelangt durch den geschickten Einsatz eines feuchten Stocks in ihrem massiven Fuß.

Un des designers les plus accomplis de tous les temps, Tapio Wirkkala créait de superbes objets sculpturaux d'une originalité stupéfiante. La gamme *Tapio* témoigne de sa profonde connaissance des matériaux et des formes naturelles, ainsi que de sa maîtrise des techniques de la fabrication du verre. La bulle d'air piégée à l'intérieur de l'épais pied de chaque verre comme dans un morceau de glace est produite grâce à l'application habile d'une tige mouillée.

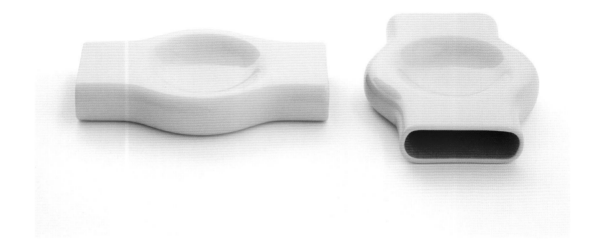

Smoky ashtray, 2007

Carlo Contin (Italy, 1967–)

www.sphaus.com
Glazed ceramic
Glasierte Keramik
Céramique émaillée
SpHaus, Milan, Italy

This stylish ashtray works equally well as a change holder or key rest. Echoing the shapes found in Italian design during the 1960s, this is a Neo-Pop design that is just a really nice object to live with. Made from glazed ceramic, *Smoky* is available with a black or white exterior and interior options including red, fuchsia, yellow or orange. Highly sculptural, the design is also easy to pick up thanks to the handle-like projections set either side of its hollowed bowl.

Dieser stilvolle Aschenbecher lässt sich ebenso gut für die Aufbewahrung von Kleingeld oder Schlüsseln nutzen. Er reflektiert die Formen des italienischen Designs der 1960er Jahre, ein Neo-Pop-Objekt, mit dem man sich gerne umgibt. *Smoky* ist aus glasierter Keramik gefertigt und in den Farbkombinationen Schwarz bzw. Weiß mit Rot, Fuchsie, Gelb oder Orange erhältlich. Das ausgesprochen skulpturale Design ist dank der griffartigen Öffnungen zu beiden Seiten der Hohlform leicht zu handhaben.

Cet élégant cendrier fait également un excellent vide-poche. Évoquant les lignes du design italien des années 60, c'est un objet néo pop agréable à vivre. Réalisé en céramique émaillée, *Smoky* est disponible avec un extérieur noir ou blanc et l'intérieur de différents coloris dont rouge, fuchsia, jaune et orange. Très sculptural, il est également facile à saisir grâce à ses deux anses saillant de part et d'autre du centre concave.

Over the decades, British design has often been characterised by a subtle refinement and understated elegance that is exemplified in these beautifully simple yet highly functional coasters. Made of sterling silver and maple, this exquisite British-made set possesses an essentialist aesthetic that gives it an enduring timeless quality.

Subtile Verfeinerung und unaufdringliche Eleganz bestimmen seit Jahrzehnten das britische Design – so auch zu sehen in diesen einfachen und zugleich überaus zweckmäßigen Untersetzern. Dieses britische Set in Sterlingsilber und Ahorn strahlt eine essenzialistische Ästhetik aus, die ihm eine zeitlose Qualität verleiht.

Le design britannique est souvent synonyme de raffinement subtil et d'élégance discrète. Ce set de trois sous-verre aux lignes pures illustre parfaitement cette pensée. Réalisée avec des matériaux nobles, l'argent sterling et l'érable, cette exquise création « so British » reflète une élégance à la fois essentialiste et intemporelle.

Drinks coasters & stand, 1998

John Campbell (UK, 1943–)

www.jacampbell.co.uk
Sterling silver, maple wood
Sterlingsilber, Ahorn
Argent sterling, bois d'érable
∅ 9.5 cm
JA Campbell, Brentwood, UK

5070 condiment set, 1978

Ettore Sottsass (Italy, 1917–2007)

www.alessi.com
Glass, polished stainless steel
Glas, polierter Edelstahl
Cristal, acier inoxydable poli
↕ 17.5 cm ↔ 8 cm
Alessi, Crusinallo, Italy

The 5070 condiment set designed by Ettore Sottsass is a veritable Italian design icon and is used everywhere in Italy – in homes, cafés, bars and restaurants. Holding two large cruets for oil and vinegar, and two smaller shakers for salt and pepper, it is as practical as it is stylish. The silhouette of this engaging design almost conjures up a vision of a miniature cityscape, with its domed towers nestling in their handy holder.

Das von Ettore Sottsass entworfene Gewürzbehälterset 5070 ist eine wahre Ikone italienischen Designs und findet in Italien überall Anwendung – sei es zu Hause, in Cafés, Bars oder Restaurants. Mit den zwei größeren Flaschen für Essig und Öl und den beiden kleineren Salz- und Pfefferstreuern ist das Set genauso praktisch wie stilvoll. Die Silhouette dieser wunderschönen Kreation mit den zwei gewölbten Türmen in ihrem handlichen Halter erinnert an die Skyline einer Miniaturstadt.

Créé par Ettore Sottsass, ce porte- condiments est devenu une véritable icône du design italien. Particuliers, cafés, bars et restaurants, tout le monde l'utilise en Italie. Composé de deux grands flacons pour l'huile et le vinaigre, et de deux plus petits pour le sel et le poivre, ce set est à la fois chic et pratique. Le contour de cet objet à l'élégance raffinée évoque un paysage urbain en miniature, avec ses tours à coupoles nichées dans leur support.

5071 Parmesan cheese cellar, 1978

Ettore Sottsass (Italy, 1917–2007)

www.alessi.com
Glass, polished stainless steel
Glas, polierter Edelstahl
Cristal, acier inoxydable brillant
↕ 10 cm ⌀ 11 cm
Alessi, Crusinallo, Italy

The quintessential Parmesan cheese holder, this design is ubiquitous in Italy – every *trattoria* on every corner seems to possess at least one. Conceived by Ettore Sottsass in the late 1970s, it was intended to compliment his classic *5070* condiment set, also produced Alessi. It has a capacity of twenty centilitres, which makes it easy to hold and ensures that just the right amount of grated Parmesan is stored at any one time.

Die Parmesandose in typisch italienischem Stil – eben wie man sie in Italien in jeder Trattoria findet. Ettore Sottsass hat das Objekt in den späten 1970er Jahren für seine ebenfalls von Alessi produzierte Gewürzbehälterserie *5070* kreiert. Die handliche Dose fasst 200 Milliliter, sodass immer gerade die richtige Menge an geriebenem Parmesan vorrätig ist.

Cette superbe boîte à parmesan est un ustensile indispensable en Italie. Toutes les trattorias en possèdent au moins une. Conçue par Ettore Sottsass dans les années 70, elle était destinée à compléter le classique porte- condiments *5070*, également créé par Alessi. D'une contenance de vingt centilitres, cette boîte est facile à prendre en main et permet de stocker la quantité souhaitée de parmesan râpé.

486 napkin holder, 1997

Peter Holmblad (Denmark, 1934–)

www.stelton.com
Stainless steel
Edelstahl
Acier inoxydable
↔ 19 cm
Stelton, Copenhagen, Denmark

In Scandinavia there is a widespread belief that well-designed objects, especially those destined for the home, can enhance daily life. This would certainly explain the high-quality design engineering found in Peter Holmblad's remarkable products. His satin-polished stainless-steel 486 napkin holder, for example, is both rationally conceived and stylishly minimal. As such, it exemplifies the aesthetic purity and functional practicality of Danish design.

In Skandinavien herrscht weithin die Überzeugung, dass gut gestaltete Gegenstände – besonders Haushaltswaren – den Alltag verschönern. Das erklärt wohl auch die bemerkenswert hohe funktionale und ästhetische Qualität der von Peter Holmblad gestalteten Produkte. Seinen Serviettenring 486 aus mattiertem rostfreiem Stahl zum Beispiel ist sowohl rational-funktional als auch stilvoll minimalistisch und steht beispielhaft für die ästhetische Klarheit und praktische Zweckmäßigkeit dänischer Produktdesigns.

Selon une croyance très répandue en Scandinavie, les objets de design, et plus particulièrement ceux destinés à la maison, améliorent la vie quotidienne. Ceci explique certainement les créations de très grande qualité qui y sont réalisées, notamment celles de Peter Holmblad. Le porte-serviettes 486 en acier inoxydable poli illustre parfaitement ce propos. De par son style épuré, chic et fonctionnel, il s'avère un bel exemple de design danois.

SG64 Mami oil cruet, 2003

Stefano Giovannoni (Italy, 1954–)

www.alessi.com
Stainless steel, plastic
Edelstahl, Plastik
Acier inoxydable, plastique
↕ 25 cm
Alessi, Crusinallo, Italy

Part of Stefano Giovannoni's extensive *Mami* cooking range for Alessi, this oil cruet is a useful addition to the kitchen as well as an attractive item in its own right. Its name, which means 'mummy' in Italian, reveals that the maternal female body inspired its soft curvaceous form. Able to contain up to sixty-five centilitres of olive oil, this is a really handy design to keep near the hob or stovetop.

Dieser Ölbehälter, aus Stefano Giovannonis umfangreicher Küchenserie *Mami* für Alessi, ist nicht nur ein nützliches Utensil, sondern auch ein wunderschöner Blickfang für Ihr Küchenregal. Wie der Name bereits andeutet, ist die geschwungene Form dem mütterlichen Körper nachempfunden. Der handliche Behälter fasst bis zu 650 Milliliter Olivenöl und sollte an keinem Herd fehlen.

Pièce de l'impressionnante gamme de cuisine créée par Stefano Giovannoni pour Alessi, cet huilier constitue un complément indispensable à la cuisine tout en étant un objet sophistiqué. Signifiant « maman » en italien, son nom illustre parfaitement sa forme, le corps d'une mère aux belles courbes. Il peut contenir soixante-cinq centilitres d'huile d'olive. Une création fonctionnelle à garder à portée de main.

ACO1 oil & vinegar set, 1984
Achille Castiglioni (Italy, 1918–2002)

www.alessi.com
Glass, polished stainless steel
Glas, polierter Edelstahl
Verre, acier inoxydable poli
↕ 16.5 cm
Alessi, Crusinallo, Italy

One of Achille Castiglioni's best-loved designs, the *ACO1* oil and vinegar set reflects this design maestro's ability to create functionally resolved and visually engaging objects. The unusual angles of the dispensers create a sense of aesthetic tension, but also help them to pour easily and cleanly.

Der Menageständer *ACO1* zählt zu den beliebtesten Designerstücken Achille Castiglionis und spiegelt die Fähigkeit des Künstlers, perfekt funktionierende und zugleich schön anzuschauende Objekte zu schaffen. Die ungewöhnliche, schräge Anordnung der Flaschen schafft eine ästhetische Spannung und sorgt gleichzeitig für ein einfaches und sauberes Ausgießen.

Le set *ACO1* est l'une des créations les plus appréciées d+Achille Castiglioni, révélant le génie du designer qui a su créer un ustensile à la fois fonctionnel, original et élégant. La forme légèrement incurvée des flacons permet de verser facilement et proprement huile et vinaigre.

Mushroom salt & pepper mills, c.1963
William Bounds Design Team

www.wmboundsltd.com
Metal, acrylic
Metall, Acryl
Métal, acrylique
↕ 13.5 cm
William Bounds, Torrance (CA), USA

For the last forty years, William Bounds has, to the best of our knowledge, manufactured the finest salt and pepper mills in the world. Incorporating a patented three-step adjusting ring and milling mechanism, the mills crush rather than grind the salt and pepper into three different grades of coarseness. Additionally, because the system does not grind metal against metal, the mills last for decades. In fact, the company has never had to replace a single one – although it still offers a somewhat superfluous lifetime warranty.

Seit vierzig Jahren gilt William Bounds als Hersteller der edelsten Salz- und Pfeffermühlen der Welt. Durch den patentierten Mahlmechanismus werden Salz und Pfeffer eher zerdrückt denn zerrieben, wobei zwischen drei verschiedenen Körnungsgraden gewählt werden kann. Und da bei diesem System nicht Metall auf Metall reibt, halten die Mühlen außerdem jahrzehntelang. Tatsächlich hat die Firma noch nicht eine einzige Mühle ersetzen müssen – was das lebenslange Garantieversprechen geradezu überflüssig macht.

Depuis quarante ans, William Bounds fabrique probablement les plus beaux moulins à poivre et à sel du monde. La bague de sélection permet de choisir entre trois moutures : fine, moyenne ou concassée. Ils disposent d'un mécanisme composé d'un cône en acier inoxydable dans lequel tourne un rotor en céramique. Ces deux pièces ne se touchant jamais, l'ustensile ne s'use pas. C'est ainsi que l'entreprise n'a jamais eu à remplacer un seul de ses moulins, et offre une garantie à vie que l'on pourrait presque qualifier de superflue.

This unusual combination grinder for salt and pepper won an iF product design award in 2007. The idea behind the design is, according to Bodum, to make 'your chef life easier. Its two-grinders-in-one approach lets you spice up your cooking with two easy twists'. If you turn the cap to the right you get pepper, and if you twist it to the left you get salt: a simply ingenious solution.

Diese ungewöhnliche Kombinationsmühle für Salz und Pfeffer wurde im Jahr 2007 mit dem iF-Award für Produktdesign ausgezeichnet. Die Idee hinter diesem Design von Bodum ist es, Ihnen das Kochen zu erleichtern. Das Zweimühlen-system erlaubt es Ihnen, Ihren Speisen mit nur zwei einfachen Handgriffen die richtige Würze zu verleihen, so der Hersteller. Genial: Je nach Drehrich-tung des Griffs wird Salz oder Pfeffer gemahlen.

Ce moulin combinant le sel et le poivre a gagné un iF product design award en 2007. À travers son design original, Bodum vise la simplicité d'utilisation. Le concept de deux moulins en un permet en effet de relever votre cuisine grâce à deux mouvements circulaires : si vous tournez vers la droite vous poivrez, et vers la gauche, vous salez. Une idée tout simplement géniale.

Twin salt & pepper mill, 2007
Bodum Design Group

www.bodum.com
Acrylic, non-slip rubber
Acryl, rutschfestes Gummi
Acrylique, caoutchouc antidérapant
↕ 13 cm
Bodum, Triengen, Switzerland

The Hungarian-born ceramicist Eva Zeisel emigrated to the United States in 1938, and has since become one of the country's most celebrated designers. Despite her advanced years, she continues to create timeless and sculptural designs for the home, such as these exquisite salt and pepper shakers for Nambé, which echo the form of her *Harmony* vase and look like two miniature bowling pins with their organic, hourglass form. As with other Nambé products, they are made from a highly polished metal alloy that accentuates their alluring contours.

Die ungarische Keramikerin Eva Zeisel emigrierte 1938 in die USA, wo sie sich seither als eine der berühmtesten Produktdesignerinnen des Landes einen Namen gemacht hat. Inzwischen hoch betagt, kreiert sie auch heute noch zeitlose, skulpturale Haushaltswaren wie zum Beispiel diese exquisiten Salz- und Pfefferstreuer für die Firma Nambé in Santa Fé, New Mexico, die der Form nach an Zeisels Vase *Harmony* erinnern und mit ihrer „eingeschnürten Taille" wie zwei Sanduhren oder Miniaturkegel aussehen. Wie andere Nambé-Produkte auch werden sie aus einer speziellen, hoch glänzend polierten Metalllegierung gefertigt, die ihre geschwungenen Konturen hervorhebt.

D'origine hongroise, Eva Zeisel a émigré aux États-Unis en 1938 pour devenir une créatrice des plus célèbres. Elle continue encore aujourd'hui à créer un type de design intemporel et sculptural destiné à la maison. Sa salière et sa poivrière rappellent son vase *Harmony*, suggérant une nouvelle forme, organique et harmonieuse. Le modèle *Eva Zeisel* s'apparente à deux quilles miniatures, et comme de nombreux produits Nambe, elles sont fabriquées dans un alliage de métal poli qui souligne leurs contours.

Eva Zeisel salt & pepper shakers, 1999

Eva Zeisel (Hungary/USA, 1906–)

www.nambe.com
Nambé alloy
Nambé-Legierung
Alliage Nambé
↕ 10.7 cm
Nambé, Santa Fe (NM), USA

Good Grips salt & pepper grinders, 2007–2008

Factors NY (USA, est. 1974)

www.oxo.com
Stainless steel, acrylic, plastic, ceramic
Edelstahl, Acryl, Kunststoff, Ton
Acier inoxydable, verre acrylique, plastique, céramique
↕ 13.9 cm
OXO International, New York City (NY), USA

The *Good Grips* range includes numerous straightforward products that can be used by people from almost all age groups, and even by those suffering from conditions such as arthritis. These salt and pepper grinders, for instance, have soft, non-slip grips that are extremely comfortable to hold. Moreover, their ability to rest flat when inverted, and their easy-to-unscrew caps, mean that they are also much simpler to refill than conventional grinders. Their clear acrylic bodies also show at a glance how full they are.

Die *Good Grips*-Kollektion umfasst zahlreiche einfache Küchenutensilien für Menschen jeden Alters und jeder Art von körperlicher Verfassung, darunter auch solchen, die an Gelenkarthrose und Arthritis leiden. Die abgebildeten Salz- und Gewürzmühlen sind zum Beispiel in der Mitte mit weichen, rutschfesten Ringen versehen, die das Festhalten erleichtern. Aufgrund des flachen Deckels stehen diese Modelle fest, wenn man sie auf den Kopf stellt, und lassen sich so leichter wieder füllen als andere Gewürzmühlen. Ihre transparenten Acrylbehälter lassen auf einen Blick die Füllmenge erkennen.

La gamme *Good Grips* se compose d'une vaste gamme de produits destinés à tous les publics, y compris ceux qui souffrent d'arthrite. Ces moulins à poivre et sel antidérapants sont très agréables et simples à manipuler. Ingénieux, ils tombent à plat lorsqu'ils se renversent. Leur couvercle s'ouvre sans effort, et il est donc nettement plus aisé de les remplir en comparaison des moulins classiques. Le compartiment principal en verre acrylique transparent permet de juger rapidement de la quantité de sel ou de poivre.

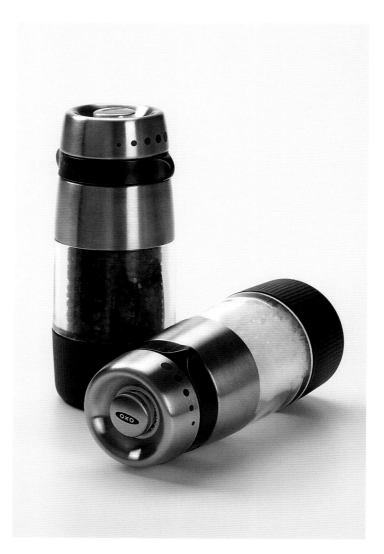

Hobart nutcracker, 1964
Robert Welch (UK, 1930–2000)

www.welch.co.uk
Cast iron, stainless steel
Gusseisen, Edelstahl
Fonte, acier inoxydable
↕ 15 cm
Robert Welch, Chipping Campden, UK

The highly effective, vice-like screw element of this robust yet stylish cast-iron nutcracker will defeat even the toughest nut. Impervious to the vagaries of time, this solid and weighty design is built to last. Its endearing, 'industrial craft' aesthetic is a characteristic shared by all of Robert Welch's numerous kitchenware designs.

Das Gewinde dieses robusten und doch eleganten Nussknackers aus Gusseisen, der einem Schraubstock ähnelt, nimmt es auch mit der härtesten Nuss auf. Das schwere, solide Objekt trotzt dem Wandel der Zeit und ist quasi für die Ewigkeit gebaut. Sein liebenswertes, ans Industriezeitalter angelehntes Design findet sich bei allen von Robert Welchs Küchenprodukten.

Ce casse-noix en fonte est incroyablement efficace grâce à son système de vis agissant comme un étau, broyant ainsi tout type de noix. Construit pour durer, ce modèle défie les caprices du temps. Son charme et son esthétique « artisanale » sont une spécificité présente dans tous les ustensiles de cuisine créés par Robert Welch.

Lokerovati platter, 1957

Kaj Franck (Finland, 1911–1989)

www.arabia.fi
Vitreous china
Halbporzellan
Porcelaine vitrée
↔ 24 cm
Arabia, Iittala Group, Helsinki, Finland

Designed by Kaj Franck in the late 1950s, the *Lokerovati* platter adorns many homes in Finland, where it is rightly regarded as a design classic. Certainly it has a very Japanese aesthetic, with its origami-like form giving it a strong graphic quality. Apart from its undeniable beauty, it is also a very practical design that is perfect for the serving of *hors-d'œuvres*.

Die Ende der 1950er Jahre von Kaj Franck entworfene *Lokerovati*-Servierplatte ist in vielen Haushalten in Finnland zu finden, wo sie zu Recht als Designklassiker gilt. Die an Origami erinnernde Form verleiht dem Design eine ausgeprägte graphische Qualität und eine sehr japanische Ästhetik. Es ist nicht nur schön, sondern auch sehr praktisch und perfekt zum Servieren von Hors-d'œuvres geeignet.

Conçu par Kaj Franck à la fin des années 50 et considéré à juste titre comme un classique du design en Finlande, le plateau *Lokerovati* a envahi de nombreux intérieurs finlandais. Cette création illustre une esthétique japonaise, en forme d'origami, lui conférant une superbe qualité graphique. Outre son indéniable raffinement, *Lokerovati* s'avère extrêmement fonctionnel, idéal pour servir les hors-d'œuvre.

An elegant modern reworking of a classic cake stand, the *Babell étagères* come in two sizes: the larger *Model No. 3180* is perfect for cookies, fruit or *canapés*; while the smaller *Model No. 3081* is ideal for chocolates, candies and *petit fours*. The three stacking parts can also be used separately, and come in five different colours – white, pink, green, black and red.

Babell, eine elegante, moderne Interpretation der klassischen Kuchenetagere, ist in zwei Größen erhältlich: *Nr. 3180*, das größere Modell, ist ideal für Plätzchen, Obst oder Kanapees, das kleinere Modell, *Nr. 3081*, perfekt geeignet für Pralinen, Bonbons und Petits Fours. Die drei Elemente können auch getrennt voneinander genutzt werden und sind in verschiedenen Farben lieferbar – Anthrazit/Grau/Hellgrau, Orange, Schwarz, Rot, Violett, Grasgrün und Petrol.

Les modèles *Babell* sont une nouvelle version, moderne et élégante, de supports de présentation. Ils existent en deux tailles : le grand modèle n°3180, parfait pour les cookies, les fruits ou les canapés ; et, le petit modèle n°3081, idéal pour les chocolats, les bonbons et les petits fours. Les trois coupes superposées peuvent également être utilisées séparément. Ce modèle existe en blanc, rose, vert, noir et rouge.

Model No. 3180 & Model No. 3081 Babell stands, 1996

Hints-Wien (Austria, active 1990s)

www.koziol.de
Thermoplastic
Thermoplastik
Thermoplastique
↕ 35, 20.8 cm
Koziol, Erbach, Germany

A modern reworking of a traditional kerosene oil lamp, the *1002* table light provides a subtle glow that promotes a warm and relaxed mood – especially on a dark winter's evening. Essentially a two-part cylinder of satin-polished stainless steel and milky translucent glass, this modern-yet-elegant design complements other pieces in the Stelton range. Burning the midnight oil can have a practical purpose too; the lamp is a useful standby in case of power supply problems.

Als moderne Interpretation der traditionellen Kerosinlampe verbreitet die *1002* Tischleuchte ein dezentes Licht, das – vor allem an dunklen Winterabenden – für eine warme und entspannte Atmosphäre sorgt. Im Prinzip ist die *1002* ein zweiteiliger Zylinder aus seidig poliertem Edelstahl mit einem milchig durchscheinenden Glas. Ihr modernes und zugleich elegantes Design ergänzt die *Stelton*-Kollektion. Mit einer Brenndauer bis spät in die Nacht ist die *1002* im Falle eines Stromausfalls auch überaus praktisch.

Version moderne de la traditionnelle lampe à huile, le modèle *1002* diffuse une lumière douce, favorisant une ambiance chaleureuse et détendue, notamment lors des longues soirées d'hiver. Composée de deux parties cylindriques en acier poli inoxydable et en verre translucide, *1002* complète la collection de lampes *Stelton*. Sobre et élégante, elle s'avère également très pratique lors d'une coupure de courant. Conçue par Erik Magnussen, cette lampe ajoute aux soirées entre amis une note conviviale et contemporaine.

1002 oil table lamp, 1983
Erik Magnussen (Denmark, 1940–)

www.stelton.com
Stainless steel, glass
Edelstahl, Glas
Acier inoxydable, verre
↕ 24 cm ⌀ 13 cm
Stelton, Copenhagen, Denmark

Em & Em candleholder, 2005

Bastiaan Arler (Netherlands, 1972–)

www.sphaus.com
Glazed ceramic
Glasierte Keramik
Céramique émaillée
SpHaus, Milan, Italy

Among the thousands of tea-light hold-
ers available for purchase, Bastiaan
Arler's *Em & Em* candleholder stands
out. This is not only a result of the per-
fect undulating proportions that make
it function so well as a centerpiece,
but is also attributable to its two-way
design that allows candles of two differ-
ent diameters to be used depending on
which way up you place it. The glazed
ceramic *Em & Em* has a glossy surface
and is available in black, white or red.

Unter den Tausenden von Teelichthal-
tern, die es zu kaufen gibt, sticht *Em &
Em* von Bastiaan Arlers deutlich hervor.
Das liegt nicht nur an den perfekten
wellenförmigen Proportionen, die ihn so
gut als Tafelaufsatz zur Geltung kommen
lassen, sondern auch an dem doppelsei-
tigen Design, das die Verwendung von
Kerzen verschiedenen Durchmessers
ermöglicht. Der aus glasierter Keramik
gefertigte *Em & Em* hat eine glänzende
Oberfläche und ist in Schwarz, Weiß
oder Rot erhältlich.

Em & Em de Bastiaan Arler se distingue
parmi les milliers de supports de
veilleuses sur le marché. Non seulement
ses proportions sinueuses parfaites
en font un beau centre de table mais
sa conception permet d'utiliser des
veilleuses de deux diamètres différents
selon le sens dans lequel on le pose.
Avec une surface brillante émaillée, il
existe en noir, rouge et blanc.

Heikki Orvola's *Kivi* votive candleholder has remained popular for over twenty years, thanks to its pure and simple cylindrical form, and its rainbow choice of twenty-three colours. As its designer explains, 'When I got the commission, I knew what they [Iittala] wanted from me: a Scandinavian glass candleholder. I gave it some thought and then that "blunt piece of tubing" began to take shape in my mind…When I sketched the shape, I thought, that's it right there – the only right solution'.

Dank seiner klaren und einfachen zylindrischen Form und der großen Auswahl von dreiundzwanzig Farben erfreut sich Heikki Orvolas *Kivi* Kerzenleuchter auch nach über 20 Jahren noch großer Beliebtheit. „Als ich den Auftrag bekam, wusste ich, was sie [Iittala] von mir wollten: einen skandinavischen Kerzenhalter aus Glas. Als ich darüber nachdachte, nahm allmählich dieses ‚schlichte Röhrenstück' vor meinem geistigen Auge Gestalt an… Als ich die Form skizzierte, dachte ich, das ist es – die einzig richtige Lösung," so Orvola über sein Design.

Avec sa forme cylindrique pure et simple déclinée en vingt-trois couleurs différentes, le petit photophore *Kivi* d'Heikki Orvola remporte toujours autant de succès plus de vingt ans après son apparition. Comme l'explique son créateur : « En recevant la commande, je savais ce qu'ils (Iittala) voulaient : un bougeoir en verre scandinave. J'y ai réfléchi et ce morceau de tube a pris forme dans mon esprit. En le dessinant, je me suis dit : "Je l'ai ! La seule bonne solution" ».

Kivi tea light holder, 1988
Heikki Orvola (Finland, 1943–)

www.iittala.com
Blow-moulded glass
Mundgeblasenes Glas
Verre soufflé bouche
Iittala, Iittala, Finland

Lotus tea light holder, 1993

Torben Jørgensen (Denmark, 1945–)

www.holmegaard.com
Glass
Glas
Verre
↕ 6.5, 7, 9 cm
Holmegaard Glasværk, Holmegaard, Denmark

One of the most popular designs produced by Holmegaard, the *Lotus* tea-light holder is created using a technique originally developed in the 1930s, in which molten glass is allowed to 'float' from the mould. Based on a classic flower shape, the resulting abstracted form has an engaging, ice-like quality. As Jørgensen notes: 'As an artist I get great satisfaction out of being able to create good everyday items that people can enjoy and with which they can give pleasure to others.'

Der *Lotus*-Teelichthalter, eines der populärsten Designs von Holmegaard, wird mit Hilfe einer in den 1930er Jahren entwickelten Technik hergestellt, bei der geschmolzenes Glas aus der Form heraus „gleitet". Die so entstehende, auf einer klassischen Blütenform basierende abstrahierte Form hat eine faszinierende, an Eis erinnernde Qualität. „Als Künstler verschafft es mir große Befriedigung, gute Alltagsobjekte schaffen zu können, an denen die Menschen sich erfreuen und mit denen sie anderen eine Freude machen können", so Jørgensen.

L'un des produits les plus prisés de Holmegaard, le photophore *Lotus,* est réalisé à l'aide d'une technique mise au point dans les années 30, où le verre fondu se détache de lui-même de son moule en « flottant ». S'inspirant de la forme classique d'une fleur, sa silhouette abstraite a une qualité attachante évoquant la glace. Comme l'observe Jørgensen : « J'éprouve une grande satisfaction à pouvoir créer de bons objets quotidiens que les gens peuvent apprécier et avec lesquels ils peuvent donner du plaisir aux autres. »

Lantern candleholder, 1999

Harri Koskinen (Finland, 1970–)

www.iittala.com
Blow-moulded glass
Mundgeblasenes Glas
Verre soufflé bouche
↕ 19 cm
Iittala, Iittala, Finland

The highly respected Finnish designer, Harri Koskinen is blessed with an extraordinary ability to create essentialist products that have a quiet, restrained beauty. For example, his large *Lantern* candleholder is an accomplished modern reworking of a traditional storm lantern, stripped of all superfluous detailing to reveal a pure, function-driven form. Koskinen has also created a smaller tabletop version, shown here, which can be used with tea lights.

Der angesehene finnische Designer Harri Koskinen ist mit der außergewöhnlichen Fähigkeit gesegnet, essentialistische Produkte von stiller, zurückhaltender Schönheit zu kreieren. So ist sein großes *Lantern*-Windlicht die vollendete Neuauflage einer traditionellen Sturmlaterne, eine klare, von allen überflüssigen Details befreite und von der Funktion bestimmte Form. Koskinen hat auch eine kleinere Tischversion entworfen, die mit Teelichtern bestückt wird.

L'éminent designer finlandais Harri Koskinen a le don extraordinaire de créer des objets essentialistes à la beauté tranquille et retenue. Ce grand photophore *Lantern* est une superbe réinterprétation moderne de la lampe-tempête. Elle est dépouillée de tout détail superflu pour révéler une forme pure dictée par la fonction. Koskinen en a crée une autre version plus petite accueillant une veilleuse.

Hobart candlestick, 1962

Robert Welch (UK, 1930–2000)

www.welch.co.uk
Cast iron
Gusseisen
Fonte
Robert Welch, Chipping Campden, UK

This iconic 1960s candlestick design has recently been put back into small-scale production and is available in two sizes. It was Robert Welch's first cast iron design to incorporate what he described as 'curved flanged forms', which he later repeated in several of his other kitchenware designs. This weighty and robust design has a striking silhouette and helped to define the British 'Contemporary Look'.

Das Gewinde dieses robusten und doch eleganten Nussknackers aus Gusseisen, der einem Schraubstock ähnelt, nimmt es auch mit der härtesten Nuss auf. Das schwere, solide Objekt trotzt dem Wandel der Zeit und ist quasi für die Ewigkeit gebaut. Sein liebenswertes, ans Industriezeitalter angelehntes Design findet sich bei allen von Robert Welchs Küchenprodukten.

Ce bougeoir emblématique des années 60 a été récemment re-commercialisé à petite échelle en deux tailles. Ce fut le premier objet en fonte de Robert Welch à présenter ce qu'il appelait « des formes arrondies à ailettes », qu'il a ensuite reproduites dans plusieurs de ses ustensiles de cuisine. Cet objet lourd et robuste à la silhouette saisissante a contribué à définir le « look contemporain » anglais.

A rational idealist, an acclaimed mathematician and an award-winning designer, Piet Hein's proportionally harmonious products have a rare refinement born of true genius. During a trip to the Southern Hemisphere, Hein remarked how much he missed the Northern sky, and particularly the constellation known as The Great Bear. He was inspired to design this stunning candelabra, which has seven branches that can be adjusted into the position of the stars in 'Ursa Major' – or turn them in other directions to create a constellation of your own.

Der Däne Piet Hein – rationaler Idealist, anerkannter Mathematiker und preisgekrönter Designer – entwirft harmonisch proportionierte Produkte von geradezu genialer Raffinesse. Auf einer Reise durch Länder südlich des Äquators vermisste Hein am nächtlichen Himmel die Sternbilder der Nordhemisphäre, besonders den Großen Bären. Das inspirierte ihn zum Design dieses fantastischen Kronleuchters mit sieben Schwenkarmen und Lampen an deren Enden, die sich in die Positionen der Sterne des Großen Bären schwenken oder beliebig zu anderen Konstellationen verstellen lassen.

Idéaliste rationnel, mathématicien de renom et designer plusieurs fois récompensé, Piet Hein a le don de créer des produits harmonieux et équilibrés, avec un raffinement délicat. Lors d'un voyage dans l'hémisphère sud, Hein réalisa qu'il avait trop longtemps délaissé le ciel du Nord et sa magnifique constellation de la « Grande Ours ». En hommage à tant de beauté, il créa ce magnifique chandelier à sept branches ajustables dans la position des étoiles de la dite constellation. Ces branches proposent d'autres configurations, selon votre propre « constellation ».

The Great Bear Candelabra, 1966

Piet Hein (Denmark, 1905–1996)

www.piethein.com
Stainless steel
Edelstahl
Acier inoxydable
↕ 63 cm
Piet Hein, Middelfart, Denmark

One of the most inventive and imaginative designers of his generation, Tom Dixon has always imbued his work with a visually distinctive craft sensibility. Dixon's sculptural *PO/9801A* and *PO/9801C* each have three bowl-like elements that can be used to store objects or hold candles respectively. Part of Cappellini's influential *Progetto Oggetto* collection, they also look wonderful if the tiered bowls are used to contain food, fruit or flowers.

Tom Dixon gehört zu den erfindungs-reichsten und fantasiebegabtesten Designern seiner Generation. Seine Designs sind stets deutlich handwerklich geprägt. Dixons skulpturaler Tischständer *PO/9801A* und Kerzenständer *PO/9801C* halten jeweils drei Schalen für Kleinigkeiten oder dicke Kerzen. Sie gehören zu Cappellinis einflussreicher Kollektion *Progetto Oggetto* und lassen sich – mit Obst oder Blumen gefüllt – auch als attraktive Tischdekoration nutzen.

Tom Dixon est l'un des créateurs les plus inventifs et imaginatifs de sa génération. Il imprègne son travail d'une sensibilité visuelle reflétant un vrai travail d'artisan. *PO/9801A* et *PO/9801C* disposent chacun de trois coupelles pouvant accueillir toutes sortes d'objets ou des bougies. Éléments de l'incontournable collection *Progetto Oggetto* conçue par Cappellini, ces créations s'avèrent tout aussi attrayantes si les coupelles disposées à différentes hauteurs contiennent des fruits ou des pots-pourris.

PO/9801A object-holder & PO/9801C candleholder, 1998

Tom Dixon (UK, 1959–)

www.cappellini.it
Silver-plated metal or polished copper
Silberplatiniertes Metall oder polierter Kupfer
Métal argenté ou cuivre poli
↕ 50 cm ↔ 50 cm ⤢ 45 cm
Cappellini, Arosio, Italy

Lucia candlestick, 1995

Thomas Sandell (Finland/Sweden, 1959–)

www.asplund.org
Polished aluminium
Poliertes Aluminium
Aluminium poli
↕ 28 cm
Asplund, Stockholm, Sweden

During the late 1980s and throughout the 1990s, there was a revival of design innovation in Scandinavia, with young designers exploring the impressive design legacy of their forefathers. They also created iconic designs of their own, often notable for their strong graphic quality. Thomas Sandell's *Lucia* candlesticks epitomize this phenomenon, and remain an elegant addition to any dining table or mantelpiece.

Ende der 1980er und in den 1990er Jahren kam es in Skandinavien zu einem Revival der Design-Innovation, als junge Designer das beeindruckende Vermächtnis ihrer Vorväter erforschten. Sie schufen eigene ikonische Designs, die häufig durch ihre starke grafische Qualität auffielen. Thomas Sandells *Lucia*-Kerzenhalter verkörpern dieses Phänomen und sind nach wie vor eine elegante Aufwertung eines jeden Esstischs oder Kaminsimses.

À la fin des années 80 et tout au long des années 90, la Scandinavie a connu un regain de créativité en design, la nouvelle génération revisitant l'impressionnant héritage de ses pères. Ces jeunes designers ont également créé leur propre style, souvent remarquable par ses fortes qualités graphiques. Les élégants bougeoirs *Lucia* de Thomas Sandell en sont une belle illustration et n'ont pas pris une ride.

Crevasse vases, 2005

Zaha Hadid (Iraq/UK, 1950–)

www.alessi.com
Polished stainless steel
Polierter Edelstahl
Acier inoxydable poli
Alessi, Crusinallo, Italy

One of today's most visionary architects, Zaha Hadid has also recently turned her hand to the design of furniture, lighting and homewares. Her counterpoised *Crevasse* flower vases for Alessi are like two miniature skyscrapers, with their highly polished surfaces twisting upwards and reflecting each other. Like her buildings, these distinctive vases are formally progressive and have a strong sculptural presence.

Zaha Hadid, eine der visionärsten Architektinnen unserer Zeit, widmet sich seit kurzem auch dem Design von Möbeln, Leuchten und Haushaltswaren. Gegenübergestellt sehen die *Crevasse* Blumenvasen für Alessi aus wie zwei Miniatur-Wolkenkratzer, deren hochglanzpolierte, nach oben gedrehte Oberflächen sich gegenseitig spiegeln. Ebenso wie ihre Bauten sind auch diese außergewöhnlichen Vasen formal progressiv und besitzen eine ausgeprägte skulpturale Präsenz.

L'architecte Zaha Hadid, qui compte parmi les plus visionnaires de notre époque, s'est tournée depuis peu vers le mobilier, les luminaires et les objets pour la maison. Ses vases *Crevasse* pour Alessi rappellent deux mini gratte-ciel se tournant l'un vers l'autre et se reflétant l'un dans l'autre. Comme ses bâtiments, ces vases sont formellement progressistes et ont une puissante présence sculpturale.

Alvar Aalto Collection bowl, 1936

Alvar Aalto (Finland, 1898–1976)

www.iittala.com
Mould-blown glass
Mundgeblasenes Glas
Verre soufflé bouche
Iittala, Iittala, Finland

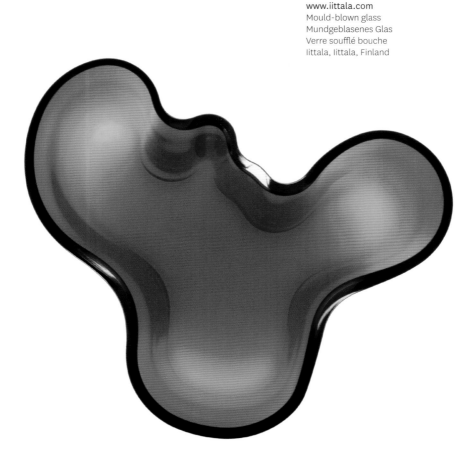

Alvar Aalto would never demonstrate how his glass objects should be used, desiring instead that people should decide for themselves. It is, perhaps, this freedom to interpret their function that has helped to keep the components of the *Aalto* collection so contemporary and fresh. The bowl that is shown here comes in various sizes and colours, and can also be used as a low vase. With its amorphous shape, this mould-blown bowl captures the abstract essence of nature, and recalls the ebbing of water along a shoreline.

Aalto hat nie vorgegeben, wie seine Glasobjekte zu benutzen seien, sondern wollte die Leute lieber selbst entscheiden lassen. Vielleicht hat diese Freiheit, die Funktion selbst zu interpretieren, dazu beigetragen, dass die *Aalto*-Kollektion auch heute noch so modern und frisch wirkt. Die hier gezeigte mundgeblasene Schale ist in verschiedenen Größen und Farben zu haben und kann auch als niedrige Vase genutzt werden. Mit ihrer amorphen Form fängt sie das Abstrakte der Natur ein und erinnert an das hin und her wogende Wasser an einer Küste.

Alvar Aalto refusait d'expliquer comment ses objets en verre devaient être utilisés, répondant que chacun devait décider par lui-même. Cette liberté d'interpréter la fonction a sans doute contribué à entretenir la fraîcheur et la contemporanéité des différentes pièces de la collection *Aalto*. La coupe présentée ici existe en différentes tailles et couleurs ; elle peut également servir de vase bas. Avec ses contours ondoyants en verre soufflé, elle capture l'essence abstraite de la nature et évoque le reflux des vagues le long du rivage.

Alvar Aalto created the *Aalto* vase in various shapes, sizes and colours for the World Fair in Paris in 1937 – including the *Savoy* version (shown below). Reputedly, the vase's form is based on sketches intriguingly titled, 'The Eskimo Woman's Leather Breeches'; but Aalto was also the son of a cartographer, so perhaps the shape could be derived from the Finnish landscape and lakes. One of the world's most famous and recognizable designs, the *Aalto* vase is a glorious example of Finnish art glass, and represents Alvar Aalto's influential and organic interpretation of Modernism.

Für die Weltausstellung 1937 in Paris schuf Alvar Aalto die *Aalto*-Vase in verschiedenen Formen, Größen und Farben – darunter auch die *Savoy*-Version (hier unten). Die Form der Vase geht angeblich auf Skizzen mit dem kuriosen Namen „Lederhose der Eskimofrau" zurück, aber da *Aalto* auch der Sohn eines Kartografen war, ist die Form vielleicht der finnischen Landschaft und den Seen nachempfunden. Als eines der weltweit berühmtesten Designs von hohem Wiedererkennungswert ist die Aalto-Vase ein wunderbares Beispiel für finnische Glaskunst und repräsentiert Alvar Aaltos einflussreiche und organische Interpretation der Moderne.

Alvar Aalto a créé le vase *Aalto* en plusieurs tailles, formes et couleurs pour l'Exposition internationale de Paris en 1937, y compris le modèle *Savoy* (ci-dessous). Sa forme serait basée sur des croquis au titre intrigant : « Les culottes en cuir de la femme esquimau ». Toutefois, Aalto étant le fils d'un cartographe, elle pourrait également s'inspirer des paysages et des lacs finlandais. Ce design, l'un des plus célèbres et reconnaissables du monde, est un glorieux exemple de l'art du verre finlandais et représente l'influente interprétation organique du modernisme selon Aalto.

Aalto vase, 1936
Alvar Aalto (Finland, 1898–1976)

www.iittala.com
Mould-blown glass
Mundgeblasenes Glas
Verre soufflé bouche
↕ 9.5, 12, 16 cm
Iittala, Iittala, Finland

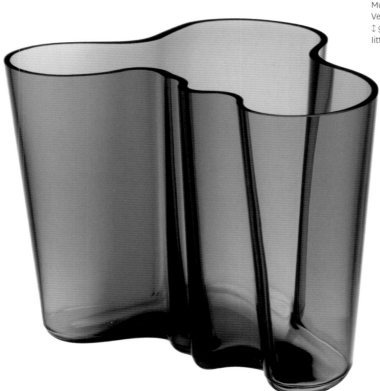

Shape vase, 2005

Peter Svarrer (Denmark, 1957–)

www.holmegaard.com
Glass
Glas
Verre
↕ 17, 21 cm
Holmegaard Glasværk,
Holmegaard, Denmark

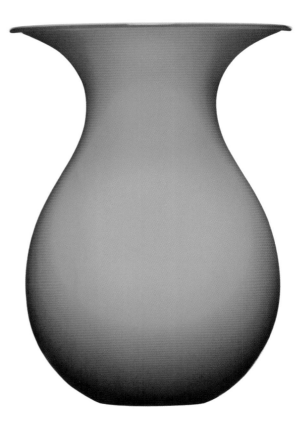

An accomplished glassware designer, Peter Svarrer runs his own glass studio in Vanløse, Denmark. Since 1997, he has also designed a large number of pieces for Holmegaard, including his exquisite, hand-blown *Shape* vase, which is available in turquoise, lime green, red, opal white, clear and black. An archetypal design, this vase provides the perfect, eye-catching support for any floral arrangement.

Der erfolgreiche Glasdesigner Peter Svarrer führt im dänischen Vanløse ein eigenes Glas-Studio. Seit 1997 hat er auch eine Reihe von Stücken für Holmegaard entworfen, beispielsweise die hier gezeigte stilvolle, mundgeblasene Vase *Shape*, die es in Türkis, Hellgrün, Rot, Opalweiß, Schwarz und klar gibt. Wegen ihres archetypischen Designs macht diese Vase jedes Blumenarrangement zum Blickfang.

Designer accompli, Peter Svarrer possède son propre atelier de verrerie à Vanløse au Danemark. Depuis 1997, il a également dessiné de nombreuses pièces pour Holmegaard, dont ce ravissant vase en verre soufflé à la bouche, *Shape*. Il existe en turquoise, vert citron, rouge, blanc opalescent, transparent et noir. Design archétypal, il caresse le regard et met en valeur n'importe quelle composition florale.

Harmony vase, 2001

Eva Zeisel (Hungary/USA, 1906–)

www.nambe.com
Nambé alloy
Nambé-Legierung
Nambé
↕ 12.7 cm
Nambé, Santa Fe (NM), USA

This small vase, just five inches high, is perfect on a dining table because it requires so little space, while at the same time its powerful, sculptural presence still commands attention. With its curvaceous and organic form, *Harmony* suggests the abstracted shape of an unfurling bud about to blossom. The hand-polished metal alloy further accentuates the vase's harmonious proportions. This small and perfectly balanced design is testament to Eva Zeisel's esteemed position among the roster of design maestros.

Diese kleine, nur dreizehn Zentimeter große Vase ist perfekt für die Dekoration eines Esstischs geeignet, weil sie so wenig Platz braucht, wegen ihrer starken plastischen Präsenz aber gleichzeitig Aufmerksamkeit erregt. Die geschwungene organische Form von *Harmony* suggeriert eine abstrahierte Knospe kurz vor dem Erblühen, und ihre harmonischen Proportionen werden noch durch die handpolierte Metalllegierung akzentuiert. Dieses kleine, perfekt ausgewogene Design unterstreicht Eva Zeisels angesehene Position in der Riege der Design-Maestros.

Ce petit vase qui ne mesure que treize centimètres de hauteur est parfait pour la table du dîner. En effet, il n'occupe pas d'espace mais attire l'attention par sa puissante présence sculpturale. Avec sa forme courbe et organique, *Harmony* évoque un bourgeon sur le point d'éclore. Son alliage en métal poli à la main accentue ses proportions harmonieuses. Devant ce petit objet parfaitement équilibré, on comprend le rang qu'occupe la très estimée Eva Zeisel parmi les maîtres du design.

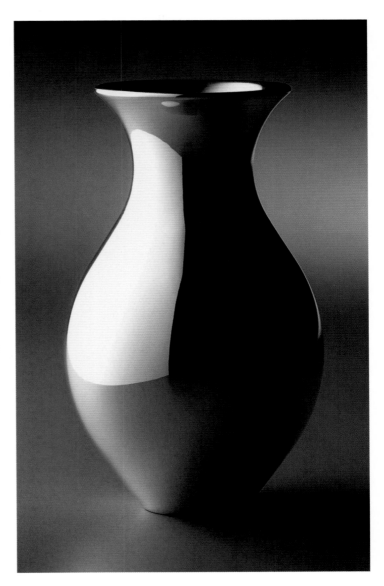

Furniture
Möbel
Le mobilier

Manufactured in nineteen different lacquered colours, the *Series 7* range is one of the most commercially successful seating systems of all time. The seat shell, which comprises nine plywood layers and two cotton layers, is available in a variety of veneered wooden finishes or upholstered in either fabric or leather. There is also a wide range of bases – from the best-selling, stackable four-legged version to elegant pedestal and swivelling options – which make it a truly versatile design.

Die Stühle der *Series 7* werden in neunzehn verschiedenen Farben hergestellt, und das Programm gehört mittlerweile zum meistverkauften aller Zeiten. Die Sitzschale aus neun verleimten Holzschichten und zwei Baumwollschichten ist in einer Vielzahl von Furnieren bzw. mit leder- oder stoffbezogenem Polster erhältlich. Außerdem gibt es den Stuhl mit verschiedenen Gestellen – von der stapelbaren Version mit vier Beinen bis zum eleganten Säulengestell und dem höhenverstellbaren Drehgestell – was ihn zu einem wirklich vielseitigen Design macht.

Réalisée en dix-neuf couleurs laquées, la *Série 7* représente l'un des produits commerciaux les plus rentables de tous les temps. Fabriquée avec neuf couches de contreplaqué et deux en coton, cette chaise aux lignes sobres et aux matériaux nobles s'avère intemporelle et sophistiquée. Elle existe en bois de placage ou en tissu. Une vaste gamme de bases a été créée à partir de l'originale, pivotante et empilable avec quatre pieds élégants pour une conception véritablement polyvalente.

Series 7 chair, 1955

Arne Jacobsen (Denmark, 1902–1971)

www.fritzhansen.com
Plywood, tubular steel
Schichtholz, Stahlrohr
Contreplaqué, acier tubulaire
↕ 78 cm ↔ 50 cm ↗ 52 cm
Fritz Hansen, Allerød, Denmark

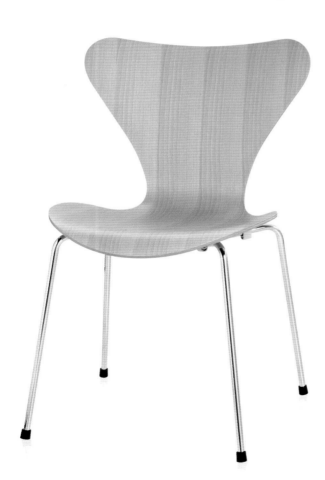

One of the great innovators of mid-century design, George Nelson always created furniture and objects that were technically cutting-edge as well as aesthetically surprising. This visually striking armchair has an ergonomic seat shell with sufficient flexibility to be comfortable without upholstery. The two-piece shell rests on a distinctive base with tapering "swag legs" made from 16-gauge steel. The overall sculptural effect expresses an understated yet stylish casual sophistication.

George Nelson, einer der großen Innovatoren des Designs Mitte des 20. Jahrhunderts, schuf stets technisch wegweisende und ästhetisch überraschende Möbel und Objekte. Dieser auffällige Sessel bietet eine ergonomisch geformte Sitzschale von so großer Flexibilität, dass sie auch ohne Polster bequem ist. Die aus zwei Teilen bestehende Schale liegt auf einem Sockel mit spitz zulaufenden, „stolzierenden" Beinen aus 1,2 mm Stahlrohr, so dass ein skulpturaler Gesamteindruck von zurückhaltender, aber stilvoller und lässiger Eleganz entsteht.

George Nelson est l'un des créateurs avant-gardistes les plus innovants du 20e siècle. Ce fauteuil, à la fois surprenant et élégant, dispose d'un siège ergonomique d'une telle flexibilité qu'il offre un confort absolu. Le dossier et le siège séparés par une ouverture s'apparentent à un coquillage et reposent sur un piètement en acier de calibre 16. L'effet sculptural de ce fauteuil exprime une sophistication à la fois raffinée et informelle.

Swag Leg armchair, 1957

George Nelson (USA, 1907–1986)

www.hermanmiller.com
Polypropylene, steel
Polypropylen, Stahl
Polypropylène, acier
Herman Miller Inc., Zeeland (MI), USA

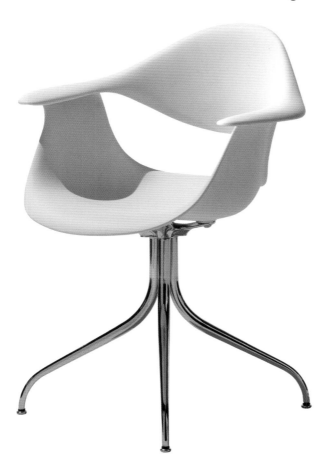

In 1948, Charles and Ray Eames devised a series of moulded fibreglass chairs for the Museum of Modern Art's 'International Competition for Low-Cost Furniture Design' in New York. These led on to their innovative *Plastic Shell Group* which was developed in collaboration with Herman Miller, Zenith Plastics and the engineering department of the University of California, Los Angeles. This seminal seating programme, which includes the DAW armchair, was based on the concept of a universal seat shell (now produced in polypropylene) that could be used with a variety of interchangeable bases to provide numerous variations.

Charles und Ray Eames entwarfen 1948 eine Reihe von Stühlen aus geformtem Fiberglas für den internationalen Wettbewerb Low-Cost Furniture Design des Museum of Modern Art in New York. Dies führte zu der innovativen *Plastic Shell Group*, die in Zusammenarbeit mit Herman Miller, Zenith Plastics und der Fakultät für Ingenieurwesen der University of California in Los Angeles entstand. Das wegweisende Sitzmöbel-Programm, zu dem auch der DAW-Sessel gehört, basierte auf dem Konzept einer universellen Sitzschale (heute aus Polypropylen gefertigt), die mit einer Vielzahl austauschbarer Untergestelle verwendet werden kann.

Lors du concours Low Cost Furniture Design organisé par le musée d'Art moderne de New York, Charles et Ray Eames ont créé une série de chaises moulées en fibre de verre. De là est né leur innovant *Plastic Shell Group*, conçu en collaboration avec Herman Miller, Zenith Plastics et le département d'ingénierie de l'université de Californie à Los Angeles. Ce programme incluant la chaise DAW s+appuie sur le concept d'une coque synthétique aux lignes organiques. La version actuelle en polypropylène permet de varier les bases et offre ainsi de nombreuses possibilités.

DAW armchair, 1950

Charles Eames (USA, 1907–1978) & Ray Eames (USA, 1912–1988)

www.vitra.com
www.hermanmiller.com
Polypropylene, chromed metal, metal wire, wood or cast aluminium
Polypropylen, verchromtes Metall, Metalldraht, Holz oder Aluminiumguss
Polypropylène, métal chromé, fil métallique, bois ou aluminium coulé
↕ 80.5 cm ↔ 62.5 cm ↗ 60 cm
Herman Miller, Zeeland (MI), USA/Vitra, Weil am Rhein, Germany

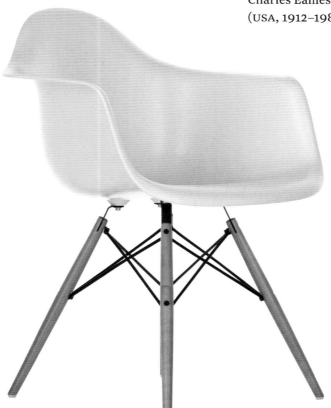

Although originally manufactured in fibreglass, the well-known *DSR* – with its distinctive 'Eiffel Tower' base – now has a seat shell made of injection-moulded polypropylene. This gives greater flexibility and resilience, thereby enhancing this classic side chair's comfort and durability. Vitra and Herman Miller also offer a variety of other base options, including examples that allow the chair to be efficiently stacked.

Der bekannte, ursprünglich aus Fiberglas gefertigte *DSR* mit seinem charakteristischen, an den Eifelturm erinnernden Untergestell wird heute mit einer Sitzschale aus spritzgegossenem Polypropylen hergestellt. Dies sorgt für größere Flexibilität und Widerstandsfähigkeit und verbessert den Komfort und die Haltbarkeit des klassischen Side Chairs. Vitra und Herman Miller bieten auch eine Vielzahl anderer Untergestelle an, darunter solche, mit denen sich der Stuhl stapeln lässt.

Initialement fabriquée en fibre de verre, la célèbre chaise *DSR* (et sa base « Tour Eiffel ») dispose désormais d'une coque en polypropylène moulé par injection. Ce matériau lui confère une plus grande flexibilité ainsi qu'une certaine élasticité, améliorant ainsi le confort et la durabilité. Vitra et Herman Miller proposent différentes options, notamment celle qui permet d'empiler aisément les chaises.

DSR side chair, 1950
Charles Eames (USA, 1907–1978) & Ray Eames (USA, 1912–1988)

www.vitra.com
www.hermanmiller.com
Polypropylene, chromed metal, metal wire, wood or cast aluminium
Polypropylen, verchromtes Metall, Metalldraht, Holz oder Aluminiumguss
Polypropylène, métal chromé, fil métallique, bois ou aluminium coulé
↕ 81 cm ↔ 46.5 cm ↗ 55 cm
Herman Miller, Zeeland (MI), USA/Vitra, Weil am Rhein, Germany

Supernatural chair, 2005

Ross Lovegrove (UK, 1958–)

www.moroso.it
Gas-injection-moulded, fibreglass-reinforced polypropylene
Im Spritzgussverfahren hergestelltes, glasfaserverstärktes Polypropylen
Gaz moulé par injection, fibre de verre renforcée de polypropylène
↕ 81 cm ↔ 53 cm ⤢ 51 cm
Moroso, Udine, Italy

According to its designer, Ross Lovegrove, the stackable indoor/outdoor *Supernatural* chair represents, 'a new vision of form, generated by digital data... The liquid, organic nature of its form combines the beauty of the human anatomy with the most advanced process of industrialisation of 21st century polymers'. This striking design comes in white, grey, orange, green, blue and black. It is also available with either a solid or perforated back, the latter forming an abstract pattern that creates interesting shadows.

Laut Designer Ross Lovegrove ist der stapelbare, innen und außen verwendbare *Supernatural* „eine neue Vision der Form, erzeugt durch digitale Daten ... Die flüssige, organische Natur der Form verschmilzt durch das modernste Industrialisierungsverfahren für Polymere des 21. Jahrhunderts mit der Schönheit des menschlichen Körpers." Dieses beeindruckende Design ist in den Farben Weiß,Grau, Orange, Grün, Blau und Schwarz erhältlich. Es gibt den Stuhl nicht nur mit einer vollen, sondern auch mit einer gelochten Rückenlehne, deren abstraktes Muster für interessante Schatten sorgt.

Selon son créateur Ross Lovegrove « la structure de ce siège part d'un nouveau concept de formes générées par des données numériques assurant la création d'une chaise parfaitement fonctionnelle. La nature liquide et organique de sa forme s'inspire des qualités esthétiques de l'anatomie humaine, tout en employant le processus le plus avancé d'industrialisation des polymères au 21e siècle ». Disponible en différentes couleurs très tendance, *Supernatural* existe également avec le dossier ajouré. Les perforations jouent avec la lumière, donnant naissance à de superbes projections d'ombres.

Supernatural armchair, 2007

Ross Lovegrove (UK, 1958–)

www.moroso.it
Gas-injection-moulded, fibreglass-reinforced polypropylene
Im Spritzgussverfahren hergestelltes, glasfaserverstärktes Polypropylen
Gaz moulé par injection, fibre de verre renforcé de polypropylène
↕ 79 cm ↔ 64 cm ↗ 56 cm
Moroso, Udine, Italy

Using an innovative gas-assisted injection-moulding process, the attractive *Supernatural* armchair is a state-of-the-art design that was developed using cutting-edge CAD software. The design is also the result of Ross Lovegrove's extraordinary ability to sculpt functional forms that are absolutely in harmony with the human body. Sculptural and visually seductive, this organic seating design is not only beautiful to look at but also highly ergonomically resolved.

Der attraktive *Supernatural*-Armlehnstuhl, bei dessen Herstellung eine innovative Spritzgusstechnologie mit glasfaserverstärktem Polypropylen angewendet wird, ist ein hochmodernes Design, das mit Hilfe aktuellster CAD-Software entwickelt wurde. Es ist zudem das Ergebnis von Ross Lovegroves außergewöhnlicher Fähigkeit, funktionale Formen zu schaffen, die vollkommen in Einklang mit dem menschlichen Körper stehen. Dieses organische, skulpturale Design ist nicht nur schön anzuschauen, sondern auch ergonomisch äußerst stimmig.

Supernatural utilise un processus de moulage par injection développé grâce aux performances des logiciels de CAD. Réalisé en polypropylène renforcé avec des fibres de verre, ce fauteuil résiste aux intempéries et se déplace de l'intérieur à l'extérieur au gré de vos envies. Parfaitement ergonomique, cette création est le fruit du génie de Ross Lovegrove. Sculpturale et originale, cette création représente une véritable prouesse technologique.

Air–Chair, 1999

Jasper Morrison (UK, 1959–)

www.magisdesign.com
Gas–assisted, injection–moulded polypropylene, glass fibre
Glasfaserverstärktes, im Gaseinspritzverfahren verarbeitetes Polypropylen
Assisté au gaz, injection de prolypropylène moulé, fibre de verre
Magis, Motta di Livenza, Italy

The groundbreaking *Air-Chair* is an elegant and highly rational one piece/one material construction made entirely from polypropylene strengthened with glass fibre. Using a state-of-the-art technique, nitrogen gas is injected at high pressure during the plastic moulding process. This not only reduces the length of the production cycle but also introduces an internal cavity so that less material is required.

Der bahnbrechende *Air-Chair* ist eine elegante und äußerst rationelle Konstruktion aus einem Stück und einem Material, die vollständig aus glasfaserverstärktem Polypropylen besteht. Mit Hilfe einer hochmodernen Technik wird Stickstoffgas unter hohem Druck während des Formprozesses in das Plastik eingespritzt. Da auf diese Art nicht nur der Herstellungsvorgang verkürzt, sondern auch ein Hohlkörper geschaffen wird, ist weniger Material erforderlich.

Air-Chair est une création révolutionnaire. Il s'agit en effet de la première chaise au monde conçue pour être réalisée en une seule pièce grâce à la technologie d'injection assistée au gaz. Elle est fabriquée en polypropylène renforcé avec de la fibre de verre. Ce processus permet non seulement de réduire le cycle de production, mais permet également une économie de matériau.

Suitable for indoor and outdoor use, the *Air-Armchair*, like its armless and better known older brother, is manufactured using a sophisticated moulding process that involves polypropylene reinforced with strengthening glass fibres. The resulting plastic material is unbelievably durable and resilient while, at the same time, this un-upholstered chair also has the advantage of being comfortable.

Der für den Innen- und den Außenbereich geeignete *Air-Armchair* wird wie sein besser bekannter, älterer Bruder ohne Armlehnen in einem aufwändigen Formverfahren mit glasfaserverstärktem Polypropylen hergestellt. Das so produzierte Plastik ist unglaublich haltbar und robust, aber gleichzeitig ist dieser ungepolsterte Stuhl auch sehr bequem.

En intérieur comme en extérieur, *Air-Armchair* se prête facilement à une déco gaie et colorée. À l'instar de sa petite « sœur », il est moulé en un seul bloc, fabriqué en polypropylène renforcé avec de la fibre de verre. Le plastique issu de ce processus est incroyablement résistant. Avec sa forme carrée et sa ligne arrondie, ce modèle combine confort et esthétique.

Air–Armchair, 2002–2005

Jasper Morrison (UK, 1959–)

www.magisdesign.com
Gas–assisted, injection–moulded polypropylene, glass fibre
Glasfaserverstärktes, im Gaseinspritzverfahren verarbeitetes Polypropylen
Assisté au gaz, injection de prolypropylène moulé, fibre de verre
Magis, Motta di Livenza, Italy

Laleggera 301 chair, 1996

Riccardo Blumer (Italy, 1959–)

www.aliasdesign.it
Veneered maple or ash, polyurethane foam
Ahorn- oder Eschefurnier, Polyurethanschaumstoff
Érable plaqué ou frêne, mousse de polyuréthane
↕ 79 cm ↔ 44 cm ⤢ 53 cm
Alias, Grumello del Monte, Italy

Strong yet very light, the *Laleggera* won a Compasso d'Oro award in 1998 for its innovative, sandwich-like construction. A unique design, it is made from sheets of wood that enclose a hidden filling of polyurethane foam. Cut and bent into the required form from a single sheet of this composite material, this comfortable chair has an engaging structural and visual unity. With its lightweight core, it is also easy to transport and comes in a variety of colours and veneered wooden finishes.

Der starke, dennoch sehr leichte *Laleggera 301* erhielt 1998 den Designpreis Compasso d'Oro für seine innovative sandwichartige Konstruktion. Das einzigartige Design besteht aus geschichtetem Holz mit einer Füllung aus eingespritztem Polyurethan. Der bequeme Stuhl, der aus einem einzigen Stück dieses Verbundmaterials zurechtgeschnitten und geformt wird, überzeugt durch strukturelle und visuelle Stimmigkeit. Wegen seines leichten Kerns ist er zudem einfach zu transportieren und wird in einer Reihe verschiedener Farben und Furniere angeboten.

Récompensée par un Compasso d'Or pour son caractère innovant, cette chaise empilable offre des lignes sobres et élégantes. Son secret réside dans la légèreté issue de la conception de sa structure portante en bois massif, revêtue de deux feuilles de placage, dissimulant une couche de mousse de polyuréthane pour une conception unique. Taillée selon la forme requise, cette chaise confortable révèle une parfaite unité visuelle et structurelle. Facile à transporter, *Laleggera 301* existe dans une gamme de couleurs variées et dans différents placages.

Mosquito chair, 2007

Michaël Bihain (Belgium, 1975–)

www.wildspirit.be
www.bihain.com
Painted or oak-veneered plywood
Lackiertes oder eichefurniertes Schichtholz
Peint ou en contreplaqué de chêne plaqué
↕ 80 cm ↔ 57 cm ⤢ 47 cm
Wildspirit, Gent, Belgium/Bihain, Louvelgné, Belgium

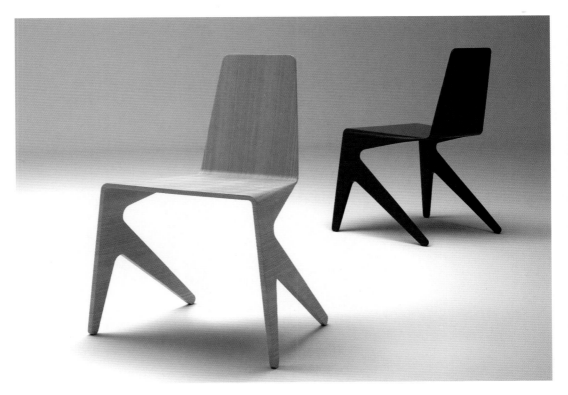

Moulded from a single sheet of plywood, the *Mosquito* chair is a constructional *tour-de-force* that possesses material, structural and aesthetic unity. It also enjoys a visual lightness yet, at the same time, has a strong sculptural presence – characteristics not normally associated with a practical stacking chair. In 2007 it was nominated for a Design Report Award.

Der aus einer einzigen Multilayer-Platte gebogene *Mosquito*-Stuhl ist eine konstruktionstechnische Meisterleistung, die nicht nur durch werkstoffliche, sondern auch formale und ästhetische Geschlossenheit besticht. Ungeachtet seiner visuellen Leichtigkeit wohnt ihm eine starke skulpturale Präsenz inne – ein Charakteristikum, das man nicht unbedingt mit einem praktischen Stuhl, der sich sogar stapeln lässt, verbindet. Der *Mosquito* wurde 2007 für den Design Report Award nominiert.

Nominée pour le prix du *Design Report* en 2007, *Mosquito* est le résultat d'une réflexion portant sur l'humanisme et l'autonomie du meuble, pour une chaise dont la forme rappelle celle d+un être vivant. Réalisée à partir d'une seule feuille de contreplaqué, *Mosquito* reflète une incroyable légèreté et une esthétique sublime. Elle peut s'empiler de deux manières : pragmatique ou graphique.

Bambu chair & table, 2007

Artek Studio

www.artek.fi
Laminated bamboo
Laminierter Bambus
Bambou stratifié
↕ 80 cm ↔ 42 cm ⤢ 61 cm (chair)
↕ 74 cm ↔ 186 cm ⤢ 92 cm (table)
Artek, Helsinki, Finland

Launched in 2007, the *Bambu* chair and matching table – designed by Artek Studio, under the direction of Tom Dixon – reflected a new ecological direction in furniture design. Moulded from laminated bamboo, this chair is more environmentally sustainable than its wooden or plastic contemporaries because bamboo is a fast-growing and renewable resource. This remarkable material also has a high strength-to-weight ratio that gives the chair an inherent lightness, while also providing a pleasing, 'natural' look.

Der von Artek Studio unter der Leitung von Tom Dixon entworfene *Bambu*-Stuhl und der passende Tisch kamen 2007 auf den Markt und waren Ausdruck einer neuen ökologischen Ausrichtung im Möbeldesign. Aus laminiertem Bambus geformt, ist dieser Stuhl umweltverträglicher als zeitgenössische Pendants aus Holz oder Plastik, da Bambus ein rasch nachwachsender erneuerbarer Rohstoff ist. Das außergewöhnliche Material zeichnet sich auch durch ein günstiges Verhältnis von Eigengewicht zu Nutzlast aus, so dass der Stuhl sehr leicht ist und gleichzeitig angenehm „natürlich" aussieht.

Conçues en 2007 par Artek Studio sous la direction de Tom Dixon, la chaise et la table *Bambu* orientent le design vers une conception écologique. Moulée à partir de bambou stratifié, cette chaise s'avère plus respectueuse de l'environnement que ses concurrentes en bois ou en plastique, le bambou étant une ressource à croissance rapide et renouvelable. Ce remarquable matériau fournit ainsi un rapport résistance-poids qui procure à la chaise une légèreté intrinsèque tout en présentant une apparence « naturelle ».

One of the best-selling seating designs in recent years, the *Louis Ghost* armchair is a sophisticated and quirky interpretation of a classic Louis XV-style chair from the 18th century. The crystal-clear PMMA gives this Post-Modern design a jewel-like quality, and emphasizes the idea that plastic can be a noble material. Like so many designs by Starck, this stylish armchair has a strong identity that makes it emotionally engaging.

Der Armlehnstuhl *Louis Ghost* ist nicht nur eine der meistverkauften Sitzlösungen der letzten Jahre, sondern auch eine gleichzeitig elegante und ausgefallene Interpretation eines klassischen Stuhls im Stil von Louis XV aus dem 18. Jahrhundert. Das kristallklare PMMA verleiht dem postmodernen Design etwas von einem Schmuckstück und zeigt, dass Plastik ein durchaus edles Material sein kann. Wie so viele Designs von Starck besitzt auch dieser stilvolle Armlehnstuhl eine starke Identität, die ihn sehr einnehmend macht.

Défi technologique et esthétique, le fauteuil *Louis Ghost* est le fruit du génie créatif de Starck. Moulé dans du polycarbonate translucide, il offre une interprétation sophistiquée et décalée du célèbre fauteuil Louis XV, datant du 18e siècle. À l'instar d'autres créations de Starck, ce modèle exprime une personnalité forte et charismatique. Ce mariage étonnant entre le high-tech et le mobilier de style donne vie à un design novateur et ultramoderne.

Louis Ghost armchair, 2002
Philippe Starck (France, 1949–)

www.kartell.com
PMMA
PMMA
PMMA
Kartell, Milan, Italy

Like Philippe Starck's highly successful *Louis Ghost* chair, the *Victoria Ghost* side chair is made from a polycarbonate plastic that has been injection-moulded in a single piece – a technically challenging process especially given its medallion-shaped back section. Available in either clear or opaque plastic, the *Victoria Ghost* echoes the elegance of Victorian salons and is a highly durable Post-Modern design that encapsulates the symbolic playfulness at the heart of Philippe Starck's work.

Wie Philippe Starcks äußerst erfolgreicher *Louis Ghost*-Armlehnstuhl wird auch der *Victoria Ghost* in einem Stück im Spritzgussverfahren gefertigt – ein technisch anspruchsvoller Prozess, insbesondere hinsichtlich der Rückenlehne in Form eines Medaillons. Der in transparentem oder farbigem Polykarbonat erhältliche *Victoria Ghost* reflektiert die Eleganz viktorianischer Salons und ist ein überaus stabiles postmodernes Design, das die Philippe Starcks Arbeit zugrundeliegende, symbolische Verspieltheit vermittelt.

La chaise *Victoria Ghost* est née des lignes classiques du fauteuil *Louis Ghost*. Le dossier arrondi rappelle la forme des médaillons anciens, tandis que le siège est linéaire et géométrique. Cette chaise moulée par injection en une seule pièce est en polycarbonate transparent ou opaque. Elle illustre le désir de Starck de démocratiser le « beau » tout en privilégiant la qualité et de transformer les objets de la vie quotidienne en objets d'art.

Victoria Ghost side chair, 2005
Philippe Starck (France, 1949–)

www.kartell.com
PMMA
PMMA
PMMA
Kartell, Milan, Italy

Originally trained as a potter, Alexander Begge has designed only one furniture line, the *Casalino* – a remarkable range of plastic indoor/outdoor furniture that looks as fresh today as when it was first launched in the early 1970s. While working at the Casala factory, Begge had a vision of 'a wisp of fog', which became the inspiration for this influential design. Sadly for the world of furniture, Begge subsequently founded a firm manufacturing furnaces, and abandoned his promising design career.

Alexander Begge, der eigentlich Keramik-design studiert hat, entwarf nur ein einziges Stuhlprogramm, den *Casalino* – ein außergewöhnliches Sitzmöbel aus Plastik für den Innen- und Außenbereich, das heute noch genauso frisch und modern aussieht wie zu Beginn der 1970er Jahre. Als er damals bei Casala arbeitete, hatte Begge die Vision eines „sphärischen Nebels", der die Inspiration für dieses einflussreiche Design lieferte. Leider musste die Möbelwelt dann auf Begge verzichten, da er eine Firma für Ofenbau gründete und seine vielversprechende Karriere als Designer aufgab.

Potier de formation, Alexander Begge créa une seule ligne de meubles : la *Casalino*. Esprit vintage des années 70, cette chaise design en plastique s'adapte aussi bien en intérieur qu'en extérieur. Inspiré par un passage de brume, Begge conçut *Casalino*, à la fois organique, élégante et robuste. Malheureusement ce génie se retira du monde du design pour monter une entreprise spécialisée dans la construction de fours industriels. Cette version réalisée avec les moules d'origine reste très tendance.

Casalino 2004 side chair & Casalino 2007 armchair, 1970–1971

Alexander Begge (Germany, 1941–)

www.casala.com
Glass-reinforced polyamide
Glasverstärktes Polyamid
Polyamide renforcé de verre
↕ 77 cm ↔ 49 cm ⤢ 50 cm
↕ 72 cm ↔ 58 cm ⤢ 54 cm
Casala Meubelen Nederland, Culemborg, Netherlands

MYTO stacking chair, 2007

Konstantin Grcic (Germany, 1965–)

www.plank.it
Ultradur® High Speed plastic
Ultardur® High Speed Kunststoff
Ultradur® High Speed plastique
↕ 82 cm ↔ 51 cm ⤢ 55 cm
Plank Collezioni, Ora, Italy

The German chemical company BASF invited Konstantin Grcic to design a product incorporating their newly developed Ultradur® High Speed plastic, the formula of which can be changed to make it either very flexible or robustly rigid. Combining state-of-the-art technology with sophisticated design, the resulting MYTO cantilevered chair uses the minimum amount of material to maximum effect. Comfortable, recyclable, stackable and aesthetically pleasing, the MYTO (available in black, white, red, orange, grey, green, aubergine, pale blue) caused a sensation when it was launched at the Milan Furniture Fair in 2008.

Der deutsche Chemiekonzern BASF bat Konstantin Grcic, ein Produkt unter Verwendung des neu entwickelten Kunststoffs Ultradur® High Speed zu entwerfen, der entweder weich und biegsam oder inflexibel und hart verarbeitet werden kann. Herausgekommen ist der MYTO-Freischwinger, eine Kombination aus modernster Technik und ausgeklügeltem Design, die mit minimalem Materialeinsatz einen maximalen Effekt erzielt. Bequem, recyclebar, stapelbar und ästhetisch ansprechend, sorgte der MYTO (erhältlich in Schwarz, Weiß, Rot, Orange, Grau, Grün, Aubergine und Hellblau) für eine Sensation, als er 2007 auf der Möbelmesse in Mailand vorgestellt wurde.

La société allemande BASF proposa à Konstantin Grcic de créer des produits à partir du plastique Ultradur® High Speed. MYTO est une chaise monobloc illustrant la remarquable performance technique permise par la fantastique fluidité du plastique BASH. La chaise cantilever MYTO est née de la combinaison d'une technologie de pointe et d'un design sophistiqué : effet garanti avec un minimum de matériau. À la fois confortable, recyclable et esthétique ce modèle existe en plusieurs couleurs : noir, blanc, rouge, orange, vert, aubergine et bleu pâle. MYTO fit sensation lors de son lancement au Salon du meuble de Milan en 2007.

Elegantly refined, the *Low Pad* lounge chair is an accomplished *tour-de-force* of cool functional essentialism. Equally at home in a stylish domestic interior or a hip office environment, this design is a contemporary take on iconic club chair designs, such as Ludwig Mies van der Rohe's seminal *Barcelona* chair from the 1920s. Upholstered in either fabric or leather, the *Low Pad* has a comfortable ergonomic 'spine-line' and is also available with armrests.

Der elegante *Low Pad*-Clubsessel ist eine vollendete Tour de Force des coolen funktionellen Essentialismus. Er passt ebenso gut in ein stilvoll eingerichtetes Heim wie in ein schickes, modernes Büro – eine zeitgenössische Interpretation ikonischer Clubsessel-Designs wie beispielsweise Ludwig Mies van der Rohes wegweisender *Barcelona*-Sessel aus den 1920er Jahren. Der entweder mit Stoff oder Leder bezogene *Low Pad* bietet eine bequeme ergonomische „Rückenlinie" und ist auch mit Armlehnen erhältlich.

D'une élégance raffinée, ce fauteuil *Low Pad* est un véritable tour de force en matière d'essentialisme fonctionnel décontracté. Cette création offre une version contemporaine de la chaise *Barcelone*, réalisée dans les années 20 par Ludwig Mies van der Rohe. Ce modèle s'adapte aussi bien à un intérieur classique qu'à un bureau design. Ce fauteuil *Low Pad* existe en tissu ou en cuir, avec ou sans accoudoirs. Son dossier ergonomique prouve que design rime avec confort.

Low Pad lounge chair, 1999

Jasper Morrison (UK, 1959–)

www.cappellini.it
Stainless steel, plywood, leather- or fabric-covered polyurethane foam upholstery
Edelstahl, Schichtholz, Polster aus Polyurethanschaum mit Leder- oder Stoffbezug
Acier inoxydable, contreplaqué, cuir, ou recouvert de mousse de polyuréthane
↕ 75 cm ↔ 57.5 cm ⤢ 70.5 cm
Cappellini, Arosio, Italy

Little Tulip F163 chair, 1965

Pierre Paulin (France, 1927–2009)

www.artifort.com
Upholstered polyurethane foam, chromed metal, metal
Gepolsterter Polyurethanschaumstoff, verchromtes Metall, Metall
Mousse de polyuréthane tapissée, métal chromé, métal
↕ 77 cm ↔ 68 cm ↗ 58 cm
Artifort, Maastricht, Netherlands

With its petal-like elements, the *Little Tulip F163* chair has an inviting character and a strong sculptural profile – a combination that ensures it looks good in any setting. Although in tune with the Flower Power sentiments of its period, this chair is also highly aesthetically refined and marked a new confidence in seating design. Like other seating solutions by Paulin, it is also extremely comfortable.

Die an Blütenblätter erinnernden Elemente verleihen dem *Little Tulip F163* etwas sehr Einladendes und sorgen für ein starkes skulpturales Profil – eine Kombination, die dafür sorgt, dass er in jedem Ambiente gut aussieht. Auch wenn er mit dem Geist der Flower Power seiner Entstehungszeit im Einklang steht, so ist dieser Stuhl doch von großer ästhetischer Vollkommenheit und verkörpert eine neue Zuversicht im Design von Sitzmöbeln. Ebenso wie andere Sitzlösungen von Paulin ist auch *Little Tulip F163* äußerst bequem.

Dotée de pétales, la chaise *Little Tulip F163* est rassurante, esthétique et s'adapte à tout type d'intérieur. En harmonie avec le mouvement *Flower Power* de l'époque, cette chaise propose des formes raffinées et marque une nouvelle ère dans la conception des sièges. À l'instar des autres créations de Paulin, ce modèle s'avère très confortable.

Ero/s/ chair, 2001

Philippe Starck (France, 1949–)

www.kartell.com
Batch-dyed or transparent PMMA, die-cast aluminium or chromed steel
Durchgefärbtes oder transparentes PMMA, Aluminiumguss oder verchromter Stahl
PMMA transparent, fonte d'aluminium ou acier chromé
↕ 79 cm ↔ 62 cm ⤢ 70 cm
Kartell, Milan, Italy

With its glistening, jewel-like seat shell moulded in transparent acrylic, the *Ero/s/* chair is not only a technically sophisticated design, but also a seductively elegant addition to any home. It comes with a choice of base options: either an elegant pedestal version made of aluminium that harks back to Eero Saarinen's 1950s *Tulip* chair, or a chromed rod version reminiscent of the famous 'Eiffel Tower' bases used by Charles and Ray Eames in their *Plastic Shell Group* chairs. This blending of the retro with the new is typical of Starck's work, and helps to imbue this beautiful chair with associations and emotional resonance.

Mit seiner wie Juwelen funkelnden Sitzschale aus transparentem Acryl ist der *Ero/s/* Stuhl nicht nur ein technisch vollkommenes Design, sondern auch ein verführerisch elegantes Accessoire für das Heim. Er ist in einer Reihe von Grundausführungen erhältlich: entweder mit elegantem Aluminiumfuß, der auf Eero Saarinens *Tulip* aus den 1950er Jahren zurückgeht, oder mit verchromten Beinen, die an die berühmten „Eiffelturm"-Untergestelle der *Plastic Shell Group*-Stühle von Charles und Ray Eames erinnern. Diese Kombination von Retro und Neu ist typisch für Starcks Arbeit und sorgt dafür, dass auch dieser wunderschöne Stuhl viele Assoziationen weckt und einen emotionalen Nachklang hat.

Ero/s/ est une chaise dont la forme organique en œuf se caractérise par une combinaison raffinée de finitions. La coque du siège est moulée en acrylique transparent. Novatrice et confortable, *Eros* s'avère idéale pour tout type d'intérieur. Deux versions sont disponibles : un pied central pivotant en aluminium rappelant la chaise *Tulip* d'Eero Saarinen créée dans les années 50, ou quatre pieds en acier chromé, sur la base « Tour Eiffel » utilisée par Charles et Ray Eames pour leurs chaises *Plastic Shell Group*. Cette combinaison rétro/moderne illustre parfaitement l'œuvre de Starck, offrant un mariage réussi entre légèreté, confort et élégance.

Tulip chair, 1955–1956

Eero Saarinen (USA, 1910–1961)

www.knoll.com
Fibreglass, aluminium, upholstery
Glasfaser, Aluminium, Polsterung
Fibre de verre, aluminium, tissus d'ameublement
↕ 81 cm ↔ 49 cm ↗ 53 cm (side chair)
↕ 81 cm ↔ 66 cm ↗ 59 cm (armchair)
Knoll International, New York, USA

Designed as an exercise in the simplification of form, Eero Saarinen's *Tulip* chair group brought a fresh sculptural confidence to chair design. Saarinen's objective was to create a single material/single form design. However, plastics technology was not sufficiently advanced in the mid-1950s for this to be achievable. Despite this setback, the award-winning *Tulip* group of chairs set new standards for modern seating design, and fulfilled its designer's objective of cleaning up the 'slum of legs' within the domestic interior.

Entworfen als eine Übung in der Vereinfachung der Form, sorgte Eero Saarinens *Tulip*-Stuhlgruppe für neues Vertrauen in das Skulpturale des Stuhldesigns. Saarinen wollte ein Design aus einem Material und einer Form schaffen, aber die Kunststofftechnologie Mitte der 1950er Jahre war dafür noch nicht weit genug entwickelt. Trotz dieses Rückschlags setzten die preisgekrönten *Tulip*-Stühle neue Maßstäbe für modernes Sitzmöbeldesign und erfüllten das Ziel des Designers, die häusliche Einrichtung von dem „Durcheinander von Beinen" zu befreien.

Avec *Tulip*, Eero Saarinen souhaite « se débarrasser du désordre des pieds et rêve d'un siège d'un seul tenant, moulé en un seul bloc, constitué d'un seul matériau ». Le projet tient debout, la chaise aussi. Cependant, la technologie du plastique n'étant guère avancée dans les années 50, la réalisation de *Tulip* fut compromise. Il reste que cette magnifique collection de sièges *Tulip* maintes fois primée marque le passage de l'assise de représentation à celle du confort. Galbées et élancées, ces chaises demeurent le must du vintage.

Acclaimed by the German magazine *Schöner Wohnen* as a 'Neue Klassiker' ('New Classic'), Karri Monni's *Thin s16* chair is a remarkable achievement in the technology of plywood moulding. Available with or without arms, its continuously moulded seat and back section has an extraordinarily slender profile – indeed, the plywood has been thinned on the edges to give an even greater sense of lightness. Options include a bleached oak or walnut-coloured veneer, or a finish in black lacquer.

Karri Monnis Stuhl *Thin s16*, der laut *Schöner Wohnen* zu den „Neuen Klassikern" zählt, ist eine außerordentliche Errungenschaft der Formholz-Technologie. Sitzschale und Rückenteil des mit oder ohne Armlehnen erhältlichen Designs gehen nahtlos ineinander über und sorgen für ein außergewöhnlich schlankes Profil; das Schichtholz wurde an den Rändern verjüngt, um den Stuhl noch leichter wirken zu lassen. Er ist in verschiedenen Holzfarben, etwa gebeizte Eiche oder Nussbaum, oder schwarz lackiert erhältlich.

Acclamé par le magazine allemand *Schöner Wohnen* comme étant un « nouveau classique », la chaise *Thin s16* de Karri Monni propose des lignes épurées et élégantes. Réalisée grâce à la technologie de moulage du contreplaqué, l'assise et le dossier ne font qu'un. Ingénieusement éclairci sur les bords, *Thin s16* révèle un profil d'une grande finesse donnant une impression de légèreté. Disponible avec ou sans accoudoirs, en chêne blanchi ou laqué noir.

Thin s16 chair, 2004
Karri Monni (Finland, 1969–)

www.lapalma.it
Sandblasted stainless steel, plywood
Sandgestrahlter Edelstahl, Schichtholz
Acier inoxydable sable, contreplaqué
↕ 78 cm ↔ 43 cm ⤢ 52 cm
La Palma, Cadoneghe, Italy

Cox chair, 2005

Andreas Ostwald (Germany, 1964–) & Klaus Nolting (Germany 1964–)

www.lapalma.it
Moulded plywood, stainless steel
Gebogenes Schichtholz, Edelstahl
Contreplaqué moulé, acier inoxydable
↕ 83 cm ↔ 60 cm ⤢ 60 cm
La Palma, Cadoneghe, Italy

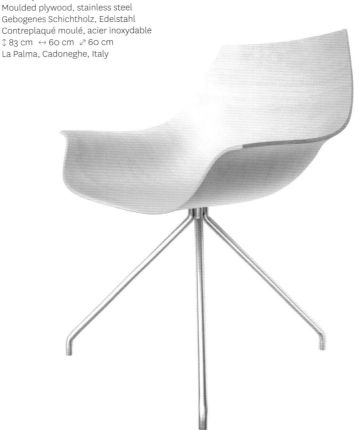

La Palma specializes in the manufacture of beautiful plywood furniture that is notable for its exquisitely thin profiles and precise detailing. The Cox chair is one of the company's most extraordinary accomplishments. Its compound-moulded plywood seat shell is produced using a special three-dimensional formable 6 mm veneer developed by the German-based company, Reholz. Pushing the constructional possibilities of plywood to the limit, this beautiful chair swivels on a sandblasted steel base and received a Design Plus award in 2005 for its use of innovative technology.

La Palma hat sich auf die Manufaktur wunderschöner Schichtholzmöbel spezialisiert, die durch ihre extrem schmalen Profile und präzise Detaillierung bestechen. Der Cox-Sessel ist eines der herausragenden Glanzstücke von La Palma. Dank einem von der deutschen Firma Reholz entwickelten Verfahren werden die Verarbeitungsmöglichkeiten von Schichtholz bis zum Äußersten ausgereizt: Die Schichtholzschale wird aus einem sechs Millimeter dicken Furnier dreidimensional in Form gebogen. Der außergewöhnliche Stuhl, der 2005 für seine innovative Technologie den Design Plus Award erhielt, liegt schwingend auf einem sandgestrahlten Stahlgestell auf.

Récompensé d'un Design Plus en 2005 pour l'utilisation de technologies innovantes, Cox nous fait découvrir le bois sous un nouvel angle : l'assise en contreplaqué arbore des formes courbes et fluides, totalement inédites. La coque en bois est moulée grâce à une technologie tridimensionnelle développée par la société Reholz, basée en Allemagne. Ce procédé permet d'obtenir une épaisseur d'à peine 6 mm. Ce fauteuil pivotant, aux formes enveloppantes, dispose d'un piètement en acier sablé. Cox illustre l'une des réalisations les plus extraordinaires de La Palma.

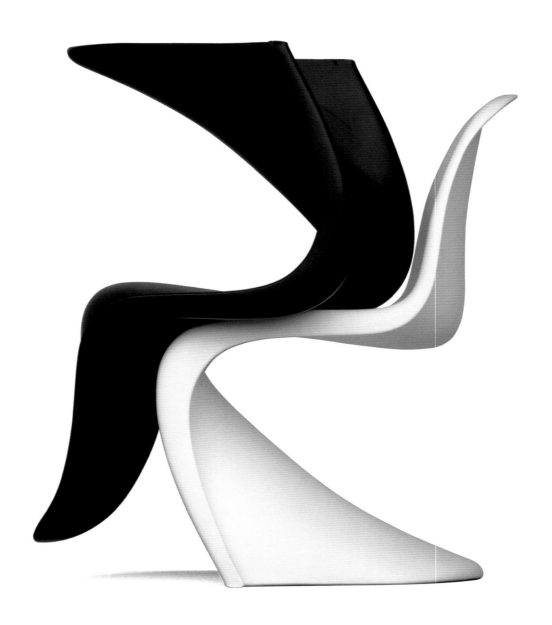

The cantilevered *Panton Chair* was the first single-material, single-piece injection-moulded plastic chair ever produced, and this visually arrestingly object has since become a much-loved and celebrated icon of 20th century design. Its seductive, serpentine form cleans up "the slum of legs" (as Eero Saarinen so eloquently put it) around a dining table, while its continuous single-form shape possesses a strong sculptural quality that's still effortlessly stylish more than half a century later.

Der freischwingende *Panton* ist der erste, jemals aus einem Stück und einem einzigen Material im Spritzgussverfahren hergestellte Kunststoffstuhl. Dank seiner optisch einnehmenden Anmutung ist er zu einer allseits beliebten und berühmten Ikone des Designs des 20. Jahrhunderts geworden. Seine verführerisch geschwungene Form räumt – wie Eero Saarinen es eloquent formulierte – mit dem „Elend der vielen Beine" rund um den Esstisch auf. Die ausgeprägt skulpturale Qualität der durchgehend fließenden Kontur wirkt auch ein halbes Jahrhundert später mühelos immer noch sehr elegant.

La chaise *Panton* fut le prototype d'un modèle révolutionnaire en forme de « s » constitué d'un monobloc en plastique moulé par injection. Véritable icône du design moderne, cette chaise offre des courbes innovantes et ludiques. Parfaite autour d'une table, *Panton* reflète une vision à la fois futuriste et élégante. Avec sa forme sculpturale, cette chaise assure un design intemporel : une pure merveille des années 60.

Panton Chair, 1959–1960

Verner Panton (Denmark, 1926–1998)

www.vitra.com
Lacquered polyurethane hard foam or polypropylene
Spritzguss-Plastikschale, klarlackiert oder Polypropylen
Coque en plastique rigide, surface laquée ou polypropylène
↕ 83 cm ↔ 50 cm ⤢ 60 cm
Vitra, Weil am Rhein, Switzerland

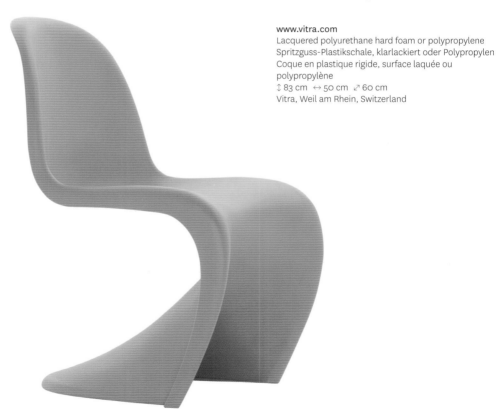

The *Nube* chair is visually striking with its two-tone felt-upholstered seating section elegantly supported on a Minimalist chromed steel frame. The soft-edged geometric form of the seat was intended by its designers to combine the strict linear orthodoxy of contemporary living spaces with the soft curves of the human body. The resulting design is not only highly sculptural but also very comfortable, and the armchairs can, if required, be linked together to form straight-line or angled configurations.

Mit seiner zweifarbigen Sitzpolsterung aus Filz, die elegant auf einem minimalistischen verchromten Stahlgestell ruht, fällt der *Nube*-Sessel sofort ins Auge. Die sanft abgerundeten Ecken der geometrischen Formen sollen an die Formen des menschlichen Körpers erinnern und wurden von dem Designer bewusst gewählt, um einen Kontrapunkt zur strengen Linearität heutiger Wohnräume zu setzen. Das Design ist nicht nur sehr plastisch, sondern auch äußerst bequem. Die Sessel lassen sich, je nach Wunsch, geradlinig linear oder im Winkel zueinander als Sitzgruppe positionieren.

Nube vient de la combinaison entre la stricte orthodoxie des espaces contemporains et les formes du corps humain. Constituée d'un tube massif chromé, sa structure souligne le contour du fauteuil tout en étant presque invisible. Deux teintes de tissus sont utilisées pour le garnissage du fauteuil, mettant en valeur la sobriété des lignes. *Nube* offre un incroyable aspect sculptural et un confort optimal. Minimaliste, ce fauteuil s'adapte partout, en ligne ou en angle.

Nube chair, 2007

Jesús Gasca (Spain, 1939–) & Jon Gasca (Spain, 1967–)

www.stua.com
Chromed steel, wool upholstery
Verchromter Stahl, Wollpolsterung
Acier chromé, tapisserie de laine
↕ 64 cm ↔ 69 cm ⤢ 69 cm
Stua, Astigarraga, Spain

Nobody chair, 2007

Komplot Design (Denmark, est. 1987)

www.hay.dk
PET
PET
PET
↕ 78 cm ↔ 58 cm ⤢ 58 cm
Hay, Horsens, Denmark

A few years ago, Boris Berlin and Poul Christiansen of Komplot Design were asked to design a chair for a Swedish prison – one that was lightweight, comfortable, cavity-free, noise-less and could not be used as a weapon. They never took the challenge up, but it did make them think about designing a chair that would meet these needs. Employing the same heated-press-moulding technology used by the automotive industry to make car boot (trunk) liners, their resulting *Nobody* chair is made of a polymer fibre mat derived from recycled plastic soft drinks bottles. A wholly self-supporting one-piece structure produced from 100% recycled material, this attractive stackable design is also extremely resilient and durable.

Vor einigen Jahren wurden Boris Berlin und Poul Christiansen von Komplot Design gebeten, einen Stuhl für ein schwedisches Gefängnis zu entwerfen – er sollte leicht, bequem, ohne Hohlräume sowie geräuschlos sein und sich nicht als Waffe eignen. Obwohl sie diese Herausforderung nicht annahmen, überlegten sie, wie ein Stuhl aussehen könnte, der diesen Anforderungen gerecht wird. Das Designerduo setzte eine thermoplastische Spritzgusstechnik ein, die in der Automobilindustrie zur Herstellung von Ablagen und Stützen für Kofferräume verwendet wird. Der *Nobody*-Stuhl wird aus einer Polymerfasermatte geformt, die ihrerseits aus recycelten Plastikflaschen hergestellt wurde. Die einteilige selbsttragende Konstruktion besteht also aus 100% recycelten Materialien und ist nicht nur stapel-, sondern auch äußerst belast- und haltbar.

Les deux designers Boris Berlin et Poul Christiansen de *Komplot Design* ont été sollicités il y a plusieurs années par une prison suédoise afin de créer des chaises à la fois légères, confortables et silencieuses et sûres en cas d+attaque. Ils n'ont jamais relevé le défi. En revanche, ils conçurent *Nobody*, une chaise entièrement réalisée sur une base textile. Cette chaise fait rimer simplicité, légèreté et éco-production. À la fois pratique, empilable et esthétique, ce modèle utilise un matériau durable, le feutre PET issu de bouteilles en plastique, recyclable à 100%. Entièrement moulée et thermoformée de PET recyclé, *Nobody* s'avère résistante tout en offrant un excellent confort.

Ribbon F582 chair, 1966

Pierre Paulin (France, 1927–2009)

www.artifort.com
Metal, upholstered polyurethane foam, lacquered pressed wood
Metall, gepolsterter Polyurethanschaumstoff, lackiertes gepresstes Holz
Métal, mousse de polyuréthane tapissée, bois pressé laqué
↕ 72 cm ↔ 100 cm ⤢ 74 cm
Artifort, Maastricht, Netherlands

Probably the most comfortable chair in the world, the *Ribbon F582* is a loop of upholstered foam that gently cradles the body, and gives cushioned support whether you are sitting upright or even lounging across it. Highly sculptural, the *Ribbon* is an aesthetically bold statement, especially when placed alone in an uncluttered space. Despite its space-age connotations, this extraordinary chair has a timeless appeal thanks to its sinuously organic form.

Der *Ribbon F582* ist der wahrscheinlich bequemste Sessel der Welt, eine runde, gepolsterte Form, die sich sanft an den Körper schmiegt und ihn angenehm stützt, ob man aufrecht darin sitzt oder sich bequem hinein lümmelt. Dieses äußerst skulpturale Sitzmöbel ist ein kühnes ästhetisches Statement, besonders wenn es für sich allein in einem minimalistisch eingerichteten Raum steht. Trotz seiner futuristischen Anklänge hat dieser außergewöhnliche Sessel dank der geschwungenen, organischen Form etwas Zeitloses.

Entièrement capitonné, le fauteuil *Ribbon F582* est certainement le siège le plus confortable au monde. De fait, il berce doucement le corps, assurant une détente optimale. Cette création illustre une vision professionnelle et novatrice et demeure un exemple éclatant d'art appliqué. Sculptural, ce fauteuil propose une esthétique audacieuse, notamment lorsqu'il est placé dans un espace épuré, voire minimaliste. Malgré sa connotation « spatiale », cet extraordinaire fauteuil reste intemporel grâce à sa forme organique sinueuse.

Groovy F598 armchair, 1972

Pierre Paulin (France, 1927–2009)

www.artifort.com
Upholstered polyurethane foam, chromed metal, metal
Gepolsterter Polyurethanschaumstoff, verchromtes Metall, Metall
Mousse de polyuréthane renforcée, métal chromé, métal
↕ 63 cm ↔ 85 cm ↗ 68 cm
Artifort, Maastricht, Netherlands

Pierre Paulin designed the *F598* in 1972, and almost at once this 'groovy' sinuous seat was embraced by the trend-setting design *cognoscenti* of the day. And no wonder, it is just a fabulous seating design: sublimely comfortable, good-looking and available in a rainbow of colours. Although mainly used in office waiting areas when first produced, the *F598* is also an excellent choice for domestic interiors.

Pierre Paulin entwarf den *Groovy F598* im Jahr 1972, und dieser „irre", geschwun-gene Schalensitz wurde von avantgardis-tischen Designkennern der damaligen Zeit sofort begeistert aufgenommen. Kein Wunder, denn es ist einfach ein hervorra-gendes Sitz-Design: überaus komfortabel, gutaussehend und in allen Regenbogen-farben erhältlich. Als er auf den Markt kam, wurde der *F598* hauptsächlich in Wartebereichen von Büros genutzt, ist jedoch auch eine hervorragende Wahl für Zuhause.

Conçu par Pierre Paulin en 1972, le fauteuil *Groovy F598* a immédiatement été remarqué dans le domaine de la création de mobilier. Et pour cause ! Cette fabuleuse création est incroya-blement confortable et existe dans une magnifique gamme de couleurs. Le *F598* a envahi les salles d'attente lors de sa parution, mais son design original s'avère un excellent choix pour un intérieur plus personnel.

Like all Pierre Paulin's seating designs for Artifort, the *Mushroom F560* chair is not only perfectly proportioned but also extremely comfortable. The reason for this is that the design provides continuous support, which means that this toadstool-shaped seat remains comfy whatever position you adopt. This design looks especially good when several are clustered around a low table, and a matching ottoman is also available.

Wie alle Sitzmöbel-Designs von Pierre Paulin für Artifort ist auch der *Mushroom F560* nicht nur perfekt proportioniert, sondern auch sehr komfortabel. Dies liegt daran, dass das Design den Körper kontinuierlich stützt. Egal welche Position man einnimmt, die wie ein Pilz geformte Sitzschale bleibt immer bequem. Besonders gut sieht es aus, wenn mehrere Sessel rund um einen niedrigen Tisch gruppiert werden. Außerdem gibt es noch einen passenden Hocker.

Comme tous les modèles de sièges créés par Pierre Paulin pour Artifort, le fauteuil *Mushroom F560* est parfaitement proportionné. Équipé d'un système de support continu, ce siège en forme de champignon reste confortable quelle que soit votre position. Cette création s'avère idéale autour d'une table basse. Un pouf du même modèle est également disponible.

Mushroom F560 chair, 1960

Pierre Paulin (France, 1927–2009)

www.artifort.com
Metal, upholstered polyurethane foam
Metall, gepolsterter Polyurethanschaum
Métal, mousse de polyuréthane tapissée
↕ 67 cm ↔ 90 cm ↗ 85 cm
Artifort, Maastricht, Netherlands

Little Globe chair, 1960

Pierre Paulin (France, 1927–2009)

www.artifort.com
Foam upholstered shell, chromed metal
Gepolsterte Schaumstoffschale, verchromtes Metall
Coquille en mousse tapissée, métal chromé
↕ 79, 83 cm ↔ 83 cm ↗ 67 cm
Artifort, Schijndel, The Netherlands

A master of chair design, Pierre Paulin was renowned for creating innovative seating solutions that offered an extraordinary level of comfort. Although less well known than some of his other designs, the *Little Globe* chair is extremely resolved both in aesthetic and functional terms, with its elegantly rounded seat shell and swivelling pedestal base, which give it a suave sophistication.

Pierre Paulin war ein Meister des Stuhl-Designs und berühmt für seine innovativen, überaus bequemen Sitzlösungen. Der *Little Globe*-Stuhl ist zwar weniger bekannt als einige seiner anderen Designs, aber sowohl in ästhetischer als auch in funktionaler Hinsicht äußerst durchdacht. Die elegant gerundete Sitzschale und der drehbare Sockelfuß verleihen ihm etwas sehr Ansprechendes und Raffiniertes.

Maître incontestable dans la création de siège, Pierre Paulin est reconnu pour ses créations novatrices extrêmement confortables. Peu connu, *Little Globe* offre de belles courbes rondes, une esthétique originale tout en étant très fonctionnelle. Sa coquille élégamment arrondie et son piètement central pivotant lui confèrent un raffinement délicat. *Little Globe* illustre un design à la fois très contemporain et intemporel.

Suitable for indoor or outdoor use, the *Voido* rocking chair is a mass-produced design manufactured using rotational-moulding – a process that allows for the creation of hollow plastic objects. This 21st century rocking chair was realized using advanced computer-aided design technologies, which facilitate the creation of complex forms that are both sculptural and functional. The *Voido* does not possess a single straight line.

Der auch für den Außenbereich geeignete *Voido*-Schaukelstuhl ist ein massenproduziertes Design, das im Rotationsverfahren hergestellt wird – eine Technik, mit der Hohlkörper aus Kunststoff gefertigt werden können. Dieser Schaukelstuhl des 21. Jahrhunderts wurde mit Hilfe neuester computergestützter Design-Technologien entwickelt, mit denen sich komplexe, sowohl skulpturale als auch funktionale Formen verwirklichen lassen. Der *Voido* weist nicht eine einzige gerade Linie auf.

Ce magnifique fauteuil à bascule *Voido* a été fabriqué grâce à la technique du rotomoulage permettant de réaliser des objets creux en plastique. Cette chaise du 21ᵉ siècle a été réalisée grâce à l'apport des technologies de conception assistée par ordinateur afin de créer des formes complexes, à la fois sculpturales et fonctionnelles. *Voido* ne présente aucune ligne droite. Il peut être placé à l'extérieur.

Voido rocking chair, 2006

Ron Arad (Israel/UK, 1951–)

www.magisdesign.com
Rotational-moulded polyethylene
Rotationsgeformtes Polyethylen
Polyéthylène rotomoulé
↕ 78 cm ↔ 58 cm ↗ 114 cm
Magis, Motta di Livenza, Italy

Multichair, 1970

Joe Colombo (Italy, 1930–1971)

www.b-line.it
Upholstered polyurethane foam, steel, aluminium, leather
Gepolsterter Polyurethanschaumstoff, Stahl, Aluminium, Leder
Mousse de polyuréthane tapissée, acier, aluminium, cuir
↕ 67 cm ↔ 58 cm ⤢ 72 cm
B-Line, Grisignano di Zocco, Italy

Available in black, red and blue, the *Multichair* (as its name implies) is a transformable seating design. It features two stretchable jersey-upholstered elements that can be connected, using its aluminium hooks and leather straps, in different positions to create various seating options. Its designer, Joe Colombo was the absolute master of futuristic, multi-functional adaptable furniture and this seating system is one of his most accomplished design solutions.

Der in Schwarz, Rot und Blau erhältliche *Multichair* ist (wie sein Name impliziert) ein veränderbares Sitz-Design. Er besteht aus zwei, mit elastiziertem Jersey bezogenen, gepolsterten Elementen, die mit Hilfe von Aluminiumhaken und Lederriemen in unterschiedlichen Positionen zu verschiedenen Sitzmöglichkeiten miteinander verbunden werden können. Sein Designer, Joe Colombo, war der unerreichte Meister futuristischer, multifunktionaler Möbel und hat mit diesem Sitz-System eine vollendete Designlösung geschaffen.

Disponible en noir, rouge et bleu, *Multichair* (comme son nom l'indique) dispose d'un système transformable grâce aux deux éléments distincts qui le composent. Les coussins rembourrés en polyuréthane sont revêtus de laine élastique, tandis que le jeu dans les formes est obtenu par deux sangles en cuir et des crochets en acier chromé et satiné. Le style de Joe Colombo se caractérise par une approche innovante, futuriste, voire utopique.

Designed by Arne Jacobsen specifically for the SAS Royal Hotel in Copenhagen, the *Swan* chair was a revolutionary and sculptural design that redefined the age-old form of the humble armchair. Its abstracted bird-like form, resting on an elegant pedestal base, is cushioned in leather or fabric-covered foam and comfortably supports the body without restricting movement. The *Swan* chair looks especially good when several are clustered as a group.

Der von Arne Jacobsen eigens für das SAS Royal Hotel in Kopenhagen entworfene *Swan*-Sessel war zur damaligen Zeit ein revolutionäres, skulpturales Design, das die überkommene Form des eher bescheidenen Sessels neu definierte. Die abstrakte, an einen Vogel erinnernde Sitzschale, die auf einem eleganten Gestell ruht, ist gepolstert und mit Leder oder Stoff bezogen; sie stützt den Körper auf angenehme Art, ohne seine Bewegungsfreiheit einzuschränken. Der *Schwan* kommt besonders gut zur Geltung, wenn mehrere Exemplare zu einer Gruppe angeordnet werden.

Créé à l'origine pour l'Hôtel Royal SAS à Copenhague par Arne Jacobsen, le fauteuil *Swan* est devenu en l'espace d'un demi-siècle une référence du design moderne. Son originalité est marquée par un design tout en courbe, sans ligne droite. Moulé dans une matière synthétique reposant sur un large pied métallique, ce fauteuil indémodable offre un confort exceptionnel. Élégant et fonctionnel, ce modèle capitonné existe en cuir ou en tissu.

Swan chair, 1957–1958

Arne Jacobsen (Denmark, 1902–1971)

www.fritzhansen.com
Aluminium, fibreglass, upholstered latex foam
Aluminium, Fiberglas, gepolsterter Latexschaum
Aluminium, fibre de verre, mousse de latex tapissée
↕ 85 cm ↔ 74 cm ↗ 68 cm
Fritz Hansen, Allerød, Denmark

Egg chair, 1957–1958

Arne Jacobsen (Denmark, 1902–1971)

www.fritzhansen.com
Aluminium, fibreglass, upholstered latex foam
Aluminium, Fiberglas, gepolsterter Latexschaum
Aluminium, fibre de verre, mousse de latex tapissée
↕ 107 cm ↔ 86 cm ↗ 79 cm
Fritz Hansen, Allerød, Denmark

Instantly recognizable, the *Egg* chair is a truly iconic Mid-Century seating design that is as sculptural as it is functional. Originally designed as part of the unified furnishing scheme for the SAS Royal Hotel in Copenhagen, the *Egg* has an engagingly fluid form that comfortably embraces the body. The design works in almost any interior setting, whether modern or antique.

Der unverwechselbare *Egg* Sessel ist ein wirklich ikonisches, ebenso skulpturales wie funktionales Design der 1950er Jahre. Ursprünglich im Rahmen des einheitlichen Einrichtungsschemas für das SAS Royal Hotel in Kopenhagen entworfen, besitzt dieser Sessel eine ansprechende fließende Form, die den Körper angenehm umschließt. Das Design funktioniert in fast jeder Einrichtung, ob modern oder antik.

Véritable icône du design contemporain, le fauteuil *Egg* s'avère extrêmement confortable avec sa forme ovoïde fluide qui épouse parfaitement le corps. À l'origine, ce modèle faisait partie de la série de meubles conçue pour l'Hôtel Royal SAS à Copenhague. Sculptural et fonctionnel, ce fauteuil se combine facilement avec n'importe quel style. Un chef d'œuvre intemporel.

Fly Me chair, 2008

Geir Sætveit (Norway, 1978–)

www.martela.com
Upholstered, chromed or natural stainless steel
Verchromter Stahl oder Edelstahl, Polsterung
Rembourré, acier inoxydable naturel ou chromé
↕ 74 cm ↔ 76 cm ⤢ 70 cm
Martela, Helsinki, Finland

Intended to almost cradle the sitter, Geir Sætveit's reclining *Fly Me* chair has an ergonomic cup-shaped seating section mounted on an automatic spring-back mechanism. With its petal-like form, this dynamic design almost seems to float in air and has a strong formal presence. Like other designs by the young award-winning Norwegian, it combines bold sculptural beauty with an inventive approach to function.

Geir Sætveits Kippstuhl *Fly Me* wirkt mit seiner ergonomisch geformten Sitzschale, die auf einem automatischen Federungsmechanismus aufliegt, fast wie eine Wiege. Das Design erinnert in seiner starken formalen Präsenz an ein Blütenblatt, das in der Luft zu schweben scheint. Wie auch in anderen Entwürfen des jungen, vielfach preisgekrönten Norwegers, vereinen sich hier eine ausgeprägt bildhauerische Formschönheit mit einem innovativen Funktionsansatz.

À la fois élégant, dynamique et intemporel, le fauteuil inclinable *Fly Me* reflète un design particulièrement raffiné. Avec sa forme de pétale, il inspire le flottement, la légèreté, voire l'envol. Ergonomique, l'assise s'avère particulièrement confortable, et son mécanisme automatique de retour permet une inclinaison facile et légère. À l'instar d'autres créations de ce jeune norvégien déjà récompensé, ce fauteuil présente une beauté sculpturale.

Low Lotus chair, 2008

René Holten (Netherlands, 1961–)

www.artifort.com
Stainless steel, Cristalplant®
Edelstahl, Cristalplant®
Acier inoxydable, Cristalplant®
↕ 65 cm ↔ 93 cm ↗ 66 cm
Artifort, Schijndel, The Netherlands

Winner of a Good Industrial Design Award in 2008, the *Low Lotus* chair is constructed of Cristalplant, a marble-like snow-white composite material that is soft to the touch and easy to clean. In this design, René Holten has pushed this newly developed material to its physical limits, especially through the integrated moulded tablet that seamless flows from the seat section. Available with or without upholstery, this eye-catching low-slung chair is not only dynamically sculptural but also comfortable with its gently sloping seat shell that cradles the sitter.

Der Stuhl *Low Lotus* wird aus dem schneeweißen, marmorähnlichen modernen Verbundmaterial Cristalplant hergestellt und wurde 2008 mit einem Good Industrial Design Award ausgezeichnet. Bei diesem Design hat René Holten die Formbarkeit des Materials voll ausgeschöpft, indem er die Sitzschale auf der rechten Seite in ein Tablett übergehen ließ. Der niedrige Schalenstuhl ist mit oder ohne Polster erhältlich. Er wirkt wie eine schwungvolle Skulptur, bietet aber auch großen Sitzkomfort.

Récompensé d'un Good Industrial Design en 2008, le fauteuil *Low Lotus* est réalisé en Cristalplant, un matériau composite blanc comme la neige, dur comme le marbre, doux au toucher et extrêmement facile à nettoyer. Afin de réaliser ce fauteuil, René Holten a repoussé les limites physiques de ce nouveau matériau, notamment avec la tablette intégrée moulée qui découle naturellement de l'assise. *Low Lotus* révèle une extraordinaire beauté sculpturale. Une prouesse technologique extrêmement confortable, avec sa coque légèrement inclinée.

EJ100 Oxchair & ottoman, 1960

Hans Wegner (Denmark, 1914–2007)

www.erik-joergensen.com
Chromed steel, leather or fabric
upholstered polyurethane foam
Verchromter Stahl, mit Leder oder Stoff
bezogener Polyurethanschaum
Acier chromé, cuir ou tissu mousse de
polyuréthane tapissée
↕90 cm ↔ 99 cm ⤢ 99 cm (chair)
Erik Jørgensen, Svendborg, Denmark

Widely regarded as a 'design classic', the *Oxchair* is a stylish interpretation of the historic club chair, with its horn-like winged back and sumptuous leather upholstery. Amply proportioned, the design is also comfortable, with its polyurethane foam upholstery providing good support. With its tilted back and optional ottoman, the *Oxchair* is ideal for relaxing. Its blatantly masculine aesthetic, also makes it the perfect refuge for the man of the house.

Der von vielen als „Designklassiker" bezeichnete *Oxchair* mit dem wie Hörner geschwungenen Rückenteil und der aufwendigen Lederpolsterung ist eine elegante Interpretation des historischen Clubsessels. Er ist großzügig proportioniert und durch das Polster aus Polyurethanschaum nicht nur bequem, sondern auch stützend. Dank der abgeschrägten Rückenlehne und des optionalen Hockers lässt sich in ihm perfekt entspannen. Die ausgesprochen maskuline Ästhetik macht ihn außerdem zum idealen Refugium für den Herrn des Hauses.

Oxchair propose une interprétation moderne et élégante du fauteuil club classique. Son esthétique sculpturale lui confère une élégance raffinée. Ample et agréable à souhait, ce fauteuil offre un confort optimal grâce à son rembourrage en mousse de polyuréthane. Son dossier légèrement incliné et son repose-pied (optionnel) garantissent de grands moments de détente. Sa version en cuir combine à la perfection bien-être et design.

EJ5 Corona chair, 1961
Poul Volther (Denmark, 1923–2001)

www.erik–joergensen.com
Chromed steel, plywood, upholstered
polyurethane foam
Verchromter Stahl, Schichtholz, bezogener
Polyurethanschaum
Acier chromé, contreplaqué, mousse de
polyuréthane tapissée
↕ 97 cm ↔ 88 cm ⤢ 82 cm
Erik Jørgensen, Copenhagen, Denmark

Inspired by time-lapsed images of solar eclipses, the high-backed *Corona* chair has elliptical segments that appear to float, giving the design a distinctive sculptural presence in any interior setting. Extremely comfortable as well as eye-catching, this swiveling chair is also an accomplished example of Scandinavian organic design, with its form subtly alluding to the spinal column and ribs of the human body. Produced in numerous colours, this classic design also comes with a matching ottoman.

Die von den Zeitrafferbildern einer Sonnenfinsternis inspirierten elliptischen Segmente des *Corona* Sessels scheinen zu schweben und verleihen dem Design eine ausgeprägte skulpturale Präsenz in jedem Raum. Der äußerst bequeme Drehsessel ist ein Blickfang und seine organische Form, die subtil auf die Wirbelsäule und die Rippen des menschlichen Körpers anspielt, macht ihn zu einem vollendeten Beispiel skandinavischen Designs. Zu dem in zahlreichen Farben produzierten klassischen Design gibt es auch einen passenden Polsterhocker.

Avant-gardiste pour son époque, ce magnifique fauteuil est considéré comme un classique moderne. Ses segments elliptiques semblent flotter et offrent une esthétique sculpturale qui s'impose dans n'importe quel type d'intérieur. Le fauteuil *Corona* allie l'expression organique à la rationalisation technique. Ce siège pivotant offre un style épuré extrêmement confortable. Sa forme rappelle subtilement celle de la colonne vertébrale. Véritable emblème du design scandinave, ce modèle est disponible en plusieurs couleurs. Livré avec un pouf.

The *Model 670 Eames* lounge chair with its matching footstool is a quintessentially American design that exudes a casual and stylishly laid-back attitude. Charles Eames intended that the design should look like a well-worn baseball glove, and it is certainly one design that actually gets better looking the more use and abuse it receives. The licenced Vitra version of this much-admired design classic is subtly different to the Herman Miller edition having slightly tauter upholstery.

Der *Model 670 Eames* Lounge Chair mit dazu passendem Fußhocker ist ein typisch amerikanisches Design, das eine ungezwungene und stilvoll entspannte Haltung ausstrahlt. Charles Eames wollte, dass sein Design einem vielbenutzten Baseball-Handschuh glich, und tatsächlich sieht es umso besser aus, je häufiger es benutzt und strapaziert wird. Die lizenzierte Version von Vitra, dieses sehr beliebten Designklassikers, unterscheidet sich subtil von der Herman Miller Edition, da sie eine etwas straffere Polsterung aufweist.

Le fauteuil *670* et son repose-pied illustrent parfaitement le design industriel américain, à la fois chic et décontracté. Charles Eames conçut ce modèle en pensant aux formes chaleureuses d'un gant de baseball usé. Confortable et intemporel, le cuir de ce fauteuil se patine divinement avec le temps. Vitra produit une version classique différant quelque peu de celle d'Herman Miller et dont le capitonnage est légèrement plus tendu.

Model 670 lounge chair & Model 671 ottoman, 1956

Charles Eames (USA, 1907–1978) & Ray Eames (USA, 1912–1988)

www.hermanmiller.com
Veneered plywood, leather-covered polyurethane foam, die-cast aluminium
Furniertes Schichtholz, lederbezogener Polyurethanschaumstoff, Gussaluminium
Contreplaqué, mousse de polyuréthane recouverte de cuir, fonte d'aluminium
↕ 81.3 cm ↔ 83.2 cm ↗ 83.2 cm (chair)
↕ 43.8 cm ↔ 66 cm ↗ 54.6 cm (ottoman)
Herman Miller, Zeeland (MI), USA/Vitra,
Weil am Rhein, Germany

Karuselli chair, 1964

Yrjö Kukkapuro (Finland, 1933–)

www.avarte.fi
Fibreglass, leather-covered foam upholstery, chromed steel
Fiberglas, lederbezogener Schaumstoff, verchromter Stahl
Fibre de verre, rembourrage en mousse recouvert de cuir, acier chromé
↕ 92 cm ↔ 80 cm ⤢ 97.5 cm
Avarte Oy, Helsinki, Finland

A much-loved icon of Finnish design, the rocking and swivelling *Karuselli* chair is available in either black or white fibreglass. The shape of the design was inspired by the imprint of a body in the snow, or more correctly Kukkapuro's own body imprint after a good night out. As such, it is an ergonomically resolved design, with its elegant and sculptural contours providing a high degree of comfort.

Der *Karuselli*-Sessel, eine sehr beliebte Ikone des finnischen Designs, ist in schwarzem oder weißem Fiberglas erhältlich. Er ist nicht nur drehbar, sondern erlaubt auch Schaukelbewegungen. Die Form der Sitzschale wurde inspiriert vom Abdruck eines Körpers im Schnee, um genauer zu sein, Kukkapuros eigener Körperabdruck nach einer durchzechten Nacht. Es ist also ein ergonomisch klares Design, das mit seinen eleganten, skulpturalen Konturen ein hohes Maß an Komfort bietet.

Véritable emblème du design finlandais, le fauteuil *Karuselli* propose une note futuriste avec sa coque moulée en fibre de verre (noire ou blanche) et sa base pivotante. Ses formes s'inspirent de l'empreinte d'un corps laissée dans la neige, et plus précisément de celle de Kukkapuro. Ce modèle présente un design ergonomique, avec ses contours élégants et sculpturaux qui garantissent un confort optimal.

Omni series, 2007
Carl Öjerstam (Sweden, 1971–)

www.materia.se
Cast aluminium, cold-cured polyurethane foam, plywood, steel, oak veneer or waxed cork
Gegossenes Aluminium, kalt vulkanisierter Polyurethanschaum, Schichtholz, Stahl, Eichenfurnier oder gewachstes Kork
Aluminium coulé, mousse de polyuréthane séchée à froid, contreplaqué, acier, feuille de placage de chêne ou liège ciré
↕ 72 cm ⌀ 81 cm (chair)
↕ 41.6 cm ⌀ 81 cm (footstool)
↕ 51 cm ⌀ 81 cm (table)
Materia, Tranås, Sweden

The winner of a Red Dot award in 2008, the attractive *Omni* series includes a low, swivelling easy chair, a footstool and a matching table. Designed initially for use in hotel lobbies and office reception areas, this eye-catching furniture range is also a good option for the home environment as the pieces can be arranged into different configurations. The table is available with either an oak or cork top.

Die 2008 mit dem Red Dot Award ausgezeichnete, attraktive *Omni*-Serie umfasst einen niedrigen drehbaren Sessel, einen Fußhocker und einen passenden Tisch. Diese ursprünglich für Hotellobbys und Empfangsbereiche entworfene auffällige Möbelserie eignet sich genauso gut für den häuslichen Bereich, da die Einzelteile variabel platziert werden können. Der Tisch ist mit einer Eichen- oder Korkplatte erhältlich.

Primée d'un Red Dot en 2008, la séduisante collection *Omni* comprend un fauteuil bas pivotant, un tabouret et une table. Initialement prévue à usage professionnel (hall d'hôtel et salle d'attente), cette originale gamme de meubles s'adapte parfaitement dans un intérieur plus personnel, voire familial. En outre, elle propose différentes configurations apportant une touche d'élégance et de confort incomparable. Le plateau de la table existe en liège ou en chêne.

Anatomia chair, 1968

Ahti Kotikoski (Finland, 1941–)

www.profeeldesign.fi
Fibreglass
Fiberglas
Fibre de verre
↕ 72 cm ↔ 67 cm ⤢ 78 cm
Artekno for Pro Feel Design, Espoo, Finland

In 1968 the Finnish furniture manufac-
turer Asko Oy held a furniture design
competition and the *Anatomia* chair won
first prize. As the jury (including Tapio
Wirkkala, Arne Jacobsen and Robin
Day) noted, Ahti Kotikoski 'examined the
anatomy of the chair by using himself and
his friends as guinea pigs. In this way an
exceptional chair was formed that, when
considering its sitting comfort, construc-
tion and cost, approaches some universal
trends.' Recently reissued, this chair is a
long-forgotten design classic that is as
durable as it is beautiful.

Der *Anatomia-v*Stuhl gewann 1968 einen
von dem finnischen Möbelhersteller Asko
Oy ausgeschriebenen Designwettbewerb.
Die Jury, unter ihnen Tapio Wirkkala,
Arne Jacobsen und Robin Day, bemerkte:
„Ahti Kotikoski untersuchte die Anatomie
des Stuhls, indem er sich selbst und seine
Freude zu Versuchskaninchen machte. So
entstand ein außergewöhnlicher Stuhl,
der in Hinblick auf Sitzkomfort, Konst-
ruktion und Kosten universellen Trends
gerecht wird." Bei diesem gleichermaßen
langlebigen wie schönen Stuhl handelt es
sich um einen lange vergessenen Desi-
gnklassiker, der kürzlich neu aufgelegt
wurde.

Anatomia reflète avec brio le design
scandinave avec ses lignes pures et
minimalistes. En 1968, cette création
remporta le premier prix du concours de
design organisé par Asko Oy, fabricant
de meubles finlandais. Le jury (Tapio
Wirkkala, Arne Jacobsen et Robin Day)
annonce qu'Ahti Kotikoski « a étudié lui-
même l'anatomie de la chaise en servant
de cobaye avec ses amis. *Anatomia* offre
un confort incontestable, et un excellent
rapport qualité-prix. Cette chaise illustre
certaines tendances universelles ». Long-
temps oublié, ce classique du « design
durable » et esthétique est actuellement
réédité.

The *Déjà-vu* chair, as its name suggests, is a Post-Modern homage to the ubiquitous, anonymously designed four-legged wooden chair that we have all seen a thousand times. Although Fukasawa's design adopts the same construction as an ordinary chair, its choice of materials is a radical departure; combining polished extruded aluminium legs and a polished die-cast aluminium seat with a backrest made from either oak, black or white ABS, or polished die-cast aluminium.

Wie der Name schon andeutet, handelt es sich bei dem *Déjà-vu* um eine postmodernistische Hommage an den von einem unbekannten Designer entworfenen allgegenwärtigen vierbeinigen Holzstuhl, den wir alle schon Tausende Male gesehen haben. Zwar bedient sich Fukasawas Design derselben Konstruktion, die Wahl der Materialien steht aber für eine radikale Abkehr: Der *Déjà-vu* vereint Beine aus poliertem Aluminium und einen Sitz aus poliertem spritzgegossenem Aluminium mit einer Rückenlehne aus Eiche, weißem oder schwarzem ABS oder poliertem spritzgegossenem Aluminium.

Déjà-vu revisite la chaise de cuisine typique de notre enfance. Avec son style épuré, cette chaise offre un design simple, moderne et d'une élégance extrême. Pour cela, le créateur Fukasawa a choisi de superbes matériaux : l'assise et le dossier sont en fonte d'aluminium, et les pieds en aluminium poli. Son originalité réside dans le revêtement postérieur du dossier (ABS noir ou blanc, chêne, aluminium poli), se distinguant du reste de la chaise.

Déjà-vu chair, 2007
Naoto Fukasawa (Japan, 1956–)

www.magisdesign.com
Extruded aluminium with die-cast aluminium, injection-moulded ABS or wood
Stranggepresstes Aluminium mit spritzgegossenem Aluminium, spritzgegossenes ABS oder Holz
Aluminium extrudé avec de l'aluminium moulé sous pression, injecté poli ou en ABS ou bois
↕ 79 cm ↔ 40 cm ↗ 44 cm
Magis, Motta di Livenza, Italy

Although not as well known as his stretch jersey-cover upholstered seating designs for Artifort, the *C130* chair by Geoffrey Harcourt is a recently re-issued 'design classic' from the 1960s that possesses an elegant sculptural refinement and an exceptional visual lightness. The seat shell made from a continuous loop of moulded plywood is a remarkable technical achievement and is testament to the high level of skill found within Italy's furniture manufacturing industry. A four-legged version of this chair is also available as is an upholstered seat shell option (shown here).

Auch wenn er nicht so bekannt ist wie seine gepolsterten, mit Jersey bezogenen Sitzlösungen für Artifort, so ist doch auch der vor kurzem neu aufgelegte *C130*-Sessel von Geoffrey Harcourt ein Designklassiker der 1960er Jahre von eleganter Formgebung und außergewöhnlicher visueller Leichtigkeit. Die aus einer ununterbrochenen Schleife formgepresste aus Schichtholz gefertigte Sitzschale ist eine bemerkenswerte technische Leistung, die von den großen Fertigkeiten in der italienischen Möbelherstellung zeugt. Eine Version mit vier Stuhlbeinen ist ebenso erhältlich wie ein Modell mit gepolsterter Sitzschale.

Moins connue que ses créations destinées à Artifort, la chaise *C130* de Geoffrey Harcourt propose une nouvelle version de ce « classique du design » des années 60. Cette pièce dévoile une élégance raffinée et sculpturale ainsi qu'une exceptionnelle légèreté visuelle. La coque, réalisée à partir d'une boucle continue en contreplaqué moulé, illustre une véritable prouesse technique et témoigne du niveau hautement élevé des compétences industrielles dans la fabrication de meubles en Italie. Une version dotée d'un quadruple piètement est également disponible, ainsi qu'une coque d'assise tapissée.

C130 chair, 1963
Geoffrey Harcourt (UK, 1935–)

www.emmemobili.it
Wenge, oak or stained oak veneered moulded beech plywood, cast aluminium, upholstery
Wenge, gebogenes Buchenschichtholz mit klar lackiertem oder gebeiztem Eichenfurnier, Aluminiumguss, Polsterung
Contreplaqué moulé en chêne et wengé, fonte d'aluminium, tapisserie d'ameublement
↕ 73 cm ↔ 54 cm ⤢ 50 cm
Emmemobili, Cantù, Italy

Log stacking stool, 2001
Shin Azumi (Japan, 1965–) & Tomoko Azumi (Japan, 1966–)

www.lapalma.it
Beech, oak veneer or stained walnut plywood
Buche, Eichenfurnier oder gebeiztes Nussbaum-Schichtholz
Hêtre, placage en chêne ou contreplaqué teinté noyer
↕ 43 cm ↔ 49 cm ⤢ 38 cm
La Palma, Cadoneghe, Italy

Shin and Tomoko Azumi have created a number of groundbreaking furniture designs that are both sculptural and practical, and their *Log* stool epitomizes the East-meets-West approach they bring to design. Made of moulded beech plywood, this elemental stacking design has an inherent simplicity that belies its functional and aesthetic refinement.

Shin und Tomoko Azumi haben eine Reihe wegweisender, skulpturaler und dennoch praktischer Möbeldesigns geschaffen, und der *Log*-Hocker verkörpert ihren Designansatz, der Einflüsse des Orients und des Okzidents miteinander verbindet. Das zeitlose, stapelbare Design aus formgepresstem Buchen-Schichtholz überzeugt durch eine inhärente Schlichtheit, die über seine funktionale und ästhetische Vollkommenheit hinwegtäuscht.

Shin et Tomoko Azumi sont auteurs d'un certain nombre de meubles design révolutionnaires, tant par leur aspect sculptural que pour leur fonctionnalité. Minimaliste, leur tabouret *Log* incarne la rencontre de « l'Est et de l'Ouest ». Fabriqué en contreplaqué de hêtre moulé, *Log* séduit par sa simplicité inhérente, son esthétique et sa fonctionnalité.

Yuyu stacking stool, 2000

Stefano Giovannoni (Italy, 1954–)

www.magisdesign.com
Gas-assisted, injection-moulded polypropylene, glass fibre
Glasfaserverstärktes, im Gaseinspritzverfahren verarbeitetes Polypropylen
Assisté au gaz, injection de prolypropylène moulé, fibre de verre
↕ 60 cm ↔ 42.5 cm ⤢ 44 cm
Magis, Motta di Livenza, Italy

Like Jasper Morrison's *Air-Chair*, also made by Magis, the *Yuyu* stacking stool is manufactured using an injection moulding process that involves nitrogen gas being introduced into the mould at high pressure. This cutting-edge technique leaves a cavity inside the polypropylene with the consequence that the design requires less material. Highly durable and available in a variety of colours, the *Yuyu* stool is suitable for indoor and outdoor use.

Wie Jasper Morrisons, ebenfalls von Magis produzierter *Air-Chair*, wird auch der stapelbare *Yuyu*-Hocker in einem Verfahren hergestellt, bei dem Stickstoffgas unter hohem Druck während des Formprozesses in das Plastik eingespritzt wird. Da durch diese bahnbrechende Technik ein Hohlkörper entsteht, ist für das Design weniger Material erforderlich. Der äußerst robuste und in verschiedenen Farben erhältliche Hocker ist für den Innen- und den Außenbereich geeignet.

Tout comme *Air-Chair* créée par Jasper Morisson, *Yuyu* a été conçu pour Magis. Ce tabouret est un monobloc entièrement creux. Fabriqué grâce à la technologie d'injection assistée au gaz et conçu en polypropylène chargé de fibres de verre, sa réalisation a nécessité peu de matériaux. À la fois léger, résistant et rigide, ce tabouret design aux lignes fluides et dynamiques peut être utilisé aussi bien à l'extérieur qu'à l'intérieur. Il est disponible en plusieurs couleurs.

One of the greatest proponents of Japanese post-war design, Sori Yanagi founded the Yanagi Industrial Design Institute in 1952, out of which emerged numerous landmark housewares and furniture designs. The simple, lightweight, stackable *Elephant* stool is available in black or white and has an elemental functionalism. It can be used indoors or outdoors: in a garden, on a balcony or as an easy-to-carry picnic seat.

1952 gründete Sori Yanagi, einer der bedeutendsten Vertreter des japanischen Designs der Nachkriegszeit, das Yanagi Industrial Design Institute, aus dem zahllose bahnbrechende Haushalts- und Möbeldesigns hervorgingen. Der einfache, leichte und stapelbare *Elephant*-Hocker ist von grundlegender Funktionalität und in Schwarz oder Weiß erhältlich. Er kann drinnen wie draußen genutzt werden – im Garten, auf dem Balkon oder als leicht zu transportierender Picknickstuhl.

Grand partisan du design japonais d'après-guerre, Sori Yanagi fonde l'Institut de Design industriel Yanagi, et crée de nombreux articles ménagers et des meubles. Minimaliste, le tabouret *Elephant* séduit par son langage formel clair et sa fonctionnalité. A la fois léger et empilable, ce tabouret s'utilise aussi bien en intérieur qu'en extérieur. Facile à transporter, ce modèle s'avère idéal pour un pique-nique. Disponible en blanc et noir.

Elephant stool, 1954
Sori Yanagi (Japan, 1915–)

www.vitra.com
Polypropylene
Polypropylen
Polypropylène
↕ 37 cm ↔ 51 cm ↗ 46.5 cm
Vitra, Weil am Rhein, Switzerland

Bubu stool, 1991

Philippe Starck (France, 1949–)

www.xo-design.com
Polypropylene
Polypropylen
Polypropylène
↕ 43 cm ⌀ 32.5 cm
xo, Servon, France

One of the best-selling designs of the 1990s, Philippe Starck's playful *Bubu* stool has a characteristically whimsical humour that epitomizes the designer's mischievous, tongue-in-cheek approach to design. With its simple construction – just two injection-moulded elements made of colourful and robust polypropylene – this highly useful 'container stool' is easily mass-produced and therefore relatively inexpensive to buy. Manufactured in nine solid colours and five transluscent colours of polypropylene, and also in ABS with a gold or silver lacquer, the *Bubu* brings a touch of inexpensive glamour and cutting-edge style to the everyday home environment.

Der pfiffige und praktische Hocker *Bubu* – ein Bestseller der 1990er Jahre – verdeutlicht Starcks ironisch- humorvollen Designansatz. Mit seiner einfachen zweiteiligen Konstruktion aus robustem spritzgegossenem Polypropylen ist *Bubu* leicht herzustellen und deshalb preiswert. Er ist in neun „blickdichten" und fünf transluzenten Farbversionen sowie in ABS mit Gold- und Silberbeschichtung lieferbar und bringt einen Hauch Glamour und modernen Pfiff in jede Wohnung.

Le tabouret *Bubu* de Philippe Starck est l'une des créations les plus vendues des années 90. Tout aussi insolite qu'esthétique, ce tabouret ludique incarne l'espièglerie du créateur, dévoilant une approche ironique du design. *Bubu* se compose de deux éléments moulés par injection, en propylène coloré. Simple à fabriquer, ce tabouret-rangement reste très abordable. Réalisé en cinq couleurs de polypropylène translucide, en neuf coloris opaques et en ABS, laqué or ou argent. Véritable icône du design démocratique, et symbole du « bon marché de pointe » *Bubu* apporte une touche glamour à votre intérieur.

A truly iconic design from Scandinavia, Alvar Aalto's *Stool 60* is still as practical and durable as when it was launched over seventy years ago. It is quite simply *the* ideal stool; it not only stacks efficiently but also has a reassuring soft-edged modernity. Importantly, it is one piece of furniture that actually gets better with age, as over time an attractive patina builds up on the birch surface.

Alvar Aaltos *Stool 60* ist skandinavisches Kultdesign im wahrsten Sinne des Wortes und heute noch genauso praktisch und haltbar wie bei seiner Markteinführung vor mehr als siebzig Jahren. *Stool 60* ist einfach *der* ideale Hocker – er lässt sich gut stapeln und wirkt gleichzeitig unaufdringlich modern. Dabei handelt es sich um ein Möbel, das tatsächlich mit der Zeit besser wird, weil sich eine reizvolle Patina über die Oberfläche aus Birke legt.

Véritable icône du design scandinave, le tabouret *60* conçu par Alvar Aalto illustre parfaitement une ctréation durable et de qualité. Malgré son âge vénérable, ce tabouret montre une étonnante intemporalité et trouve encore parfaitement sa place dans un intérieur design. Imité mais jamais égalé, ce tabouret est tout simplement idéal. Avec le temps, le bouleau se patine accentuant la beauté naturelle de ce meuble indémodable.

Stool 60, 1933
Alvar Aalto (Finland, 1898–1976)

www.artek.fi
Natural or lacquered birch
Birke, unbehandelt oder lackiert
Bouleau naturel ou laqué
↕ 44 cm ⌀ 38 cm
Artek, Helsinki, Finland

Designed by the Azúamoliné design studio, the *Flod* stool hails a renaissance in Spanish contemporary design. With its tilted seat and integrated footrest, this one-piece stool keeps the sitter's posture ergonomically correct and, therefore, provides a good level of comfort. Available in four muted colours – black, grey, red and yellow – this design is virtually indestructible and is eminently suitable for outdoor usage.

Der vom Designstudio Azúamoliné entworfene *Flod*-Barhocker läutet eine Renaissance im zeitgenössischen spanischen Design ein. Mit seiner abgeschrägten Sitzfläche und der integrierten Fußstütze ermöglicht der in einem Stück gefertigte Hocker eine ergonomische und daher bequeme Sitzhaltung. Das in vier gedeckten Farben – Schwarz, Grau, Rot und Gelb – erhältliche Design ist äußerst robust und sehr gut für den Außenbereich geeignet.

Conçu par le studio de design Azúamoliné, le tabouret *Flod* offre des formes simples mais dynamiques. Avec son siège incliné et son repose-pied intégré, ce tabouret permet de garder une bonne posture. Ergonomique et chic, ce modèle existe en quatre couleurs : noir, gris, rouge et jaune. Réalisé en polyéthylène, *Flod* est à la fois léger et résistant, et s'utilise aussi bien à l'intérieur qu'a l'extérieur.

Flod stool, 2008

Martin Azúa (Spain, 1965–) & Gerard Moliné (Spain, 1977–)

www.mobles114.com
Rotationally moulded polypropylene
Im Rotationsverfahren hergestelltes Polypropylen
Polypropylène rotomoulé
↕ 84 cm ↔ 38 cm ⤢ 41.5 cm
Mobles 114, Barcelona, Spain

Miura stool, 2007
Konstantin Grcic (Germany, 1965–)

www.plank.it
Reinforced polypropylene
Verstärktes Polypropylen
Polypropylène renforcé
↕ 78, 81 cm ↔ 47 cm ↗ 40 cm
Plank, Ora, Italy

Konstantin Grcic's *Miura* stool has won numerous awards, including the Design Award of the Federal Republic of Germany in 2007. The reason for its critical success lies in its innovative use of reinforced polypropylene. The stool is a single-piece mono-bloc construction that is not only suitable for indoor and outdoor use, but is also 100% recyclable. Like other designs by Grcic, the *Miura* employs a dynamic faceted form that ensures the molten plastic flows with ease when the stool is being injection-moulded, while also enabling it to stack very efficiently.

Konstantin Grcic's Barhocker *Miura* hat unzählige Auszeichnungen erhalten, u. a. 2007 den Designpreis der Bundesrepublik Deutschland. Ausschlaggebend für seinen Erfolg ist die innovative Verwendung von verstärktem Polypropylen. Der Barhocker *Miura* ist in einem Guss gefertigt, so eignet er sich sowohl für den Innen- wie für den Außenbereich und lässt sich zu 100% recyceln. Genau wie andere Designs von Grcic hat auch der *Miura* eine dynamisch facettierte Form – sie erlaubt dem geschmolzenen Kunststoff während des Spritzgusses leicht in die Form zu fließen. Darüber hinaus lässt sich der Hocker so platzsparend stapeln.

Réalisé en polypropylène à partir d'une technique de moulage injecté, *Miura* illustre un langage sculptural et une esthétique néo futuriste. À l'instar d'autres créations de Konstantin Grcic, ce tabouret monobloc propose une réflexion sur le thème des facettes. Filiforme et angulaire, *Miura* dispose d'une structure et d'une assise aux lignes acérées et géométriques qui semblent avoir été obtenues par pliage. Idéale à l'extérieur comme à l'intérieur, cette création est 100 % recyclable. Le tabouret *Miura* a reçu de nombreuses récompenses, notamment le prix du meilleur Design de la République fédérale d'Allemagne, en 2007.

Shin Azumi first got the idea for the KAI stool's seating section when playing with a piece of paper; first folding it to get a crisp edge, then bending it to create a gentle curvature. In Japanese the word 'kai' means 'seashell', and certainly the semi-elliptical form of the seat and back sections echo the shape of an open mollusc. These soft flowing lines also accord with the contours of the human body, making the design ergonomically comfortable.

Die Idee für die Sitzfläche des KAI-Barhockers hatte Shin Azumi, als er mit einem Blatt Papier spielte, das er so faltete, dass sich zunächst scharfe Kanten zeigten, die er dann zu einer sanften Wölbung bog. Das japanische kai bedeutet übersetzt „Muschelschale". Und tatsächlich ist die halbelliptische Form von Sitz und Rücken eine Reminiszenz an eine geöffnete Muschel. Da die sanft fließenden Linien mit den Konturen des menschlichen Körpers übereinstimmen ist das Design ergonomisch und bequem.

C'est en jouant avec une feuille de papier que le designer Shin Azumi eut l'idée de créer ce tabouret. Il a retranscrit dans le bois les plis délicats et les subtils renfoncements du papier froissé. « Kai » signifie « coquillage » en japonais, d'où un dossier en forme de coquille et une assise profonde assurant un confort maximal. Kai dispose de lignes douces, semblables à celles du corps humain pour une conception ergonomique absolument extraordinaire.

KAI stool, 2007
Shin Azumi (Japan, 1965–)

www.lapalma.it
Stainless steel, moulded plywood
Edelstahl, geformtes Schichtholz
Acier inoxydable, contreplaqué moulé
↕ 54-79 cm ↔ 37 cm ↗ 44 cm
La Palma, Cadoneghe, Italy

Phenomenally successful, the height-adjustable *LEM* stool was one of the most influential seating designs of the 'noughties', and became an almost omnipresent feature of public interiors. It received the Design Product of the Year FX Award in 2000, as well as a Good Design award from Japan's Industrial Design Promotion Organization in 2001. Notwithstanding its apparent ubiquity, the *LEM* – described by the Azumis as 'a loop... floating in air' – is also the perfect stool to use in the home, especially as part of a kitchen counter arrangement.

Der phänomenal erfolgreiche, höhenverstellbare *LEM*-Hocker war eines der einflussreichsten Sitzmöbel-Designs des ersten Jahrzehnts des 21. Jahrhunderts und wurde schon bald zum Bestandteil der Einrichtung zahlreicher öffentlicher Gebäude. Er wurde 2000 mit dem Design Product of the Year FX Award und 2001 mit einem Good Design Award von der japanischen Industrial Design Promotion Organization ausgezeichnet. Trotz seiner scheinbaren Allgegenwärtigkeit ist der *LEM* – den die Azumis selbst als „in der Luft schwebende Schleife" beschrieben haben – auch der perfekte Hocker für Zuhause, besonders für Küchentheken.

Devenu un grand classique du design, le tabouret *LEM* réglable en hauteur a envahi les lieux publics. Récompensé en 2000 par le FX International Design ainsi que par le prix Good Design décerné par l'Organisation du design industriel du Japon en 2001, ce tabouret séduit par son ergonomie et sa ligne minimaliste. Esthétique parfaite, le repose-pied est totalement intégré à la structure. En dépit de son omniprésence apparente, *LEM* s'avère idéal pour la maison, en particulier pour les cuisines équipées d'un bar.

LEM high stool, 2000

Shin Azumi (Japan, 1965–)
& Tomoko Azumi (Japan, 1966–)

www.lapalma.it
Chromed steel, plywood, beech or walnut veneer
Verchromter Stahl, Sperrholz, Buche- oder Nussbaumfurnier
Acier chromé, contreplaqué, placage en hêtre ou en noyer
↕ 55–67 cm ↔ 37 cm ⤢ 42 cm (low version)
↕ 66–79 cm ↔ 37 cm ⤢ 42 cm (high version)
↕ 80cm ↔ 37 cm ⤢ 42 cm (fixed version)
La Palma, Cadoneghe, Italy

Suzanne double lounge chair, 1965

Kazuhide Takahama (Japan, 1930–)

www.knoll.com
Extruded aluminium, polished aluminium, MDF, upholstered polyurethane foam
Fließgepresstes Aluminium, poliertes Aluminium, MDF, gepolsterter
Polyurethanschaumstoff
Aluminium extrudé, aluminium poli, MDF, mousse de polyuréthane tapissée
↕ 69 cm ↔ 150 cm ↗ 78 cm
Knoll International, New York (NY), USA

Recently reissued, Kazuhide Takahama's *Suzanne* is a sculptural seating unit with a sophisticated Minimalist aesthetic that works incredibly well in interiors hung with contemporary art. In fact, it was originally designed precisely with gallery spaces in mind. The central dividing element functions either as a backrest or an armrest, depending on how you choose to sit. Two people can sit back-to-back or side-by-side on this relatively low, comfortably casual yet visually sophisticated seat.

Seit kurzem gibt es eine Neuauflage von Kazuhide Takahamas *Suzanne*, einem skulpturalen Sitzmöbel von eleganter minimalistischer Ästhetik, das ausgesprochen gut in Räumen mit zeitgenössischer Kunst an den Wänden zur Geltung kommt – kein Wunder, denn *Suzanne* wurde ursprünglich eigens für Ausstellungsräume entworfen. Das Trennelement in der Mitte fungiert entweder als Rücken- oder als Armlehne, je nachdem, wie man darauf sitzen möchte. Zwei Personen können Rücken an Rücken oder Seite an Seite auf diesem relativ niedrigen, angenehm legeren und doch visuell eleganten Sessel Platz nehmen.

Récemment rééditée, *Suzanne* de Kazuhide Takahama offre une collection de sièges à la fois sculpturaux, sophistiqués et minimalistes : une esthétique parfaite pour un intérieur contemporain. Selon votre position, l'élément de division central s'utilise comme un dossier ou un accoudoir. De fait, deux personnes peuvent donc s'asseoir dos à dos ou à côte. Il s'agit d'une création originale, extrêmement confortable, alliant à merveille esthétisme et fonctionnalité.

Le Bambole sofa, 1972

Mario Bellini (Italy, 1935–)

www.bebitalia.it
Metal, rigid polyurethane, upholstered polyurethane foam
Metall, nicht verformbares Polyurethan, gepolsterter Polyurethanschaumstoff
Métal, mousse de polyuréthane rigide tapissée
↕ 74 cm ↔ 166 cm ↗ 89 cm
B&B Italia, Novedrate , Italy

The curious name of this squishy sofa means 'the dolls' and, when it was first launched, B&B Italia ran a provocative advertising campaign featuring a blonde topless model and the byline "dolls that leave … dolls that stay" – inferring that the design was more reliable than the dolly-bird. A quintessential seventies design, the sofa appears not to have a supporting structure, and thanks to its innovative form and construction it was awarded a Compasso d'Oro in 1979.

Der eigenartige Name dieses weichen Sofas bedeutet „die Puppen". Als es auf den Markt kam, startete B&B Italia eine provokative Werbekampagne mit einem blonden Oben-ohne-Model und der Zeile: „Puppen, die gehen … Puppen, die bleiben", um darauf hinzuweisen, dass das Design zuverlässiger sei als die Mieze. Dieses typische 1970er-Jahre-Design scheint ohne Stützstruktur auszukommen und erhielt 1979 für seine innovative Form und Konstruktion den Compasso d'Oro.

Pour ce fameux modèle, B&B Italia réalisa une campagne publicitaire fort remarquée. Le message suggérait qu'entre *Bambole* (« poupée » en italien) et la plantureuse blonde de la publicité, il était plus réaliste d'imaginer qu'avec le sofa, la relation s'avérerait plus durable ! Créé dans les années 70, ce modèle présente une forme novatrice : sa structure ne comporte aucun appui rigide, pas d'accoudoir ni de pieds. Ce sofa, original et design, reçut un Compasso d'Oro en 1979 pour sa combinaison sans précédent de matériaux à divers degrés d'élasticité.

It is often difficult to find a small but chic sofa, yet Prospero Rasulo's *Club* sofa fits the bill perfectly. This mono-bloc-style product recalls the classic Sixties furniture of Pierre Paulin, and its low-backed profile gives the design a casual look and doesn't take up too much visual or physical space. The *Club* comes with removable covers in either leather or fabric, and its elasticised polyurethane upholstery provides support and comfort. A matching chair is also available.

Es ist nicht einfach, ein kleines und gleichzeitig schickes Sofa zu finden – Prospero Rasulos *Club*-Sofa erfüllt diese Anforderungen. Stilistisch wie aus einem einzigen Block erinnert es an die klassischen Entwürfe eines Paul Paulins aus den 1960er Jahren. Der niedrige Rücken verleiht *Club* etwas Zwangloses und nimmt weder optisch noch räumlich zu viel Raum ein. Der Bezug aus Leder oder Stoff ist abnehmbar, und die elastische Federung mit Polyurethanpolsterung stützt und ist bequem. Zudem gibt es noch einen passenden Sessel.

Avec son sofa *Club*, Prospero Rasulo a réalisé un remarquable travail sur les volumes. Ce canapé monobloc s'apparente aux meubles de Pierre Paulin, conçus dans les années 60. Elliptique et ovoïde, il est accueillant à l'instar d'une alcôve protectrice et enveloppante. Une pièce hybride entre l'organique et le technologique. Son rembourrage en mousse polyuréthane à densité variable assure un confort optimal. Il existe en revêtement cuir ou tissu déhoussable. Un fauteuil assorti est également disponible.

Club sofa, 2008
Prospero Rasulo (Italy, 1953–)

www.zanotta.it
Steel, elastic strapping, polyurethane
Stahl, Federung mit elastischen Gurten, Polyurethan
Acier, sangle élastique, polyuréthane
↕ 65 cm ↔ 191 cm ⤢ 79 cm
Zanotta, Milan, Italy

ABCD sofa, 1968

Pierre Paulin (France, 1927–2009)

www.artifort.com
Fibreglass, upholstered latex foam
Fiberglas, gepolsterter Latexschaum
Fibre de verre, mousse de latex tapissée
↕ 66 cm ↔ 165, 242 cm ↗ 86 cm
Artifort, Maastricht, Netherlands

Inspired by the shape of an egg box, Pierre Paulin's *ABCD* seating range was originally designed for hotel lobbies and other public spaces. However, it is also a design that works well in domestic settings. Its undulating, wave-like organic form delineates a comfortable personal space for each person sitting on it. A truly innovative and sculptural design, the *ABCD* seating system won the Monza Design Award in 1969.

Das von der Form einer Eierschachtel inspirierte *ABCD*-Sofa von Pierre Paulin wurde ursprünglich für Hotellobbys und andere öffentliche Räume entworfen, aber das Design wirkt auch im privaten Heim sehr gut. Durch die geschwungene, wellenartige organische Form wird für jede Person, die auf *ABCD* Platz nimmt, ein bequemer persönlicher Sitz abgegrenzt. Das wirklich innovative und skulpturale Design wurde 1969 mit dem Monza Design Award ausgezeichnet.

Inspiré par une boîte d'œufs, la *collection ABCD* de Pierre Paulin a été initialement conçue pour les halls d'hôtel et autres lieux publics. Sculptural avec ses ondulations formant de petits accoudoirs pour chacune des personnes assises, ce canapé offre des courbes généreuses et ergonomiques. Récompensé par le prix Monza Design en 1969 pour son design innovant, *ABCD* s'adapte également dans un espace plus personnel.

Freeform sofa & ottoman, 1946

Isamu Noguchi (USA, 1904–1988)

www.vitra.com
Solid wood, fabric-covered upholstery
Massivholz, mit Stoff bezogenes Polster
Bois massif, recouvert de tissu d'ameublement
↕ 72 cm ↔ 300 cm ⤢ 130 cm (sofa)
↕ 38 cm ↔ 120 cm ⤢ 71 cm (ottoman)
Vitra, Weil am Rhein, Germany

Isamu Noguchi described this sculptural sofa design as a 'soft rock', and with its matching stool it certainly does conjure up associations with water-smoothed pebbles. Originally known as the *IN70* sofa and *IN71* ottoman, their abstract biomorphic forms were hugely influential in the late 1940s and early 1950s, especially in America. Synthesizing Western and Eastern influences, Noguchi's sculptural Mid-Century designs for the home managed quietly to express the organic essence of natural landscapes.

Isami Noguchi beschrieb dieses skulpturale Sofadesign als „soft rock", und mit passendem Ottoman weckt es auch tatsächlich Assoziationen eines vom Wasser geschliffenen Flusskiesels. Das Sofa hieß ursprünglich *IN70* und der Ottoman *IN71*, und die abstrakt biomorphen Formen der Designs waren Ende der 1940er und Anfang der 1950er Jahre besonders in Amerika außerordentlich einflussreich. Noguchis skulpturale Designs für Zuhause aus dieser Zeit synthetisierten westliche und östliche Einflüsse und bringen auf zurückhaltende Art das Organische natürlicher Landschaften zum Ausdruck.

Le canapé et le pouf *Freeform* offrent des lignes sculpturales qui évoquent d'immenses galets polis par les eaux. Noguchi lui-même les qualifiait de *soft rock*. Initialement connus sous le nom de canapé *IN70* et ottoman *IN71*, leur forme abstraite biomorphique eut une grande influence en Amérique dans les années 40 et au début des années 50. Synthétisant l'Occident et l'Orient, les créations de Noguchi expriment l'essence organique des paysages naturels.

Woodgate modular sofa system, 1996

Terence Woodgate (UK, 1953–)

www.scp.co.uk
Solid beech, steel springs, elasticated webbing, multi-density foam,
feather cushioning, stainless steel
Massive Buche, Stahlfedern, elastischer Bezug, Multi Density Foam, Kissen
mit Federfüllung, Edelstahl
Bois massif, ressorts en acier, sangle élastique, multidensité de la
mousse, rembourré de plumes, acier inoxydable
↕ 70 cm ↔ various ↗ 85 cm
SCP, London, UK

The London-based manufacturer SCP produces furniture with a very English understated sophistication. The *Woodgate* seating system epitomizes this attribute with its simple yet strikingly elemental, low profile form. Its modular design allows it to be configured in a number of ways, from a simple armchair to a two-, three- or four-seater sofa, or even as corner units. This versatile design can be also upholstered in a rainbow of different colours to match any interior scheme.

Der in London ansässige Hersteller SCP fertigt Möbel, die sich durch eine sehr englische, zurückhaltende Eleganz auszeichnen. Das *Woodgate*-Sitzsystem verkörpert diese Eigenschaft mit seiner schlichten, aber verblüffend elementaren, unauffälligen Form. Dank seines modularen Designs lässt es sich auf viele verschiedene Arten anordnen – als einfachen Sessel, zwei-, drei- oder viersitziges Sofa oder sogar als Ecksofa. Außerdem kann es in zahlreichen Farben bezogen werden und passt so in jede Einrichtung.

La société londonienne SCP produit des meubles dans le plus pur raffinement anglais. Avec sa simplicité élégante, le sofa *Woodgate* incarne parfaitement l'esprit de cette entreprise. Sa conception modulaire permet différentes configurations : un simple canapé de deux, trois ou quatre places, voire même un fauteuil d'angle. Tapissé selon une importante palette de couleurs, ce design polyvalent s'adapte à tout type d'intérieur. Sobre et chic, *Woodgate* est une pure merveille.

276 Aspen sofa, 2005

Jean-Marie Massaud (France, 1966–)

www.cassina.com
Chromed steel, upholstered polyurethane foam
Verchromter Stahl, gepolsterter Polyurethanschaum
Acier chromé, mousse de polyuréthane tapissée
↕ 72 cm ↔ 180, 260 cm ↗ 90 cm
Cassina, Meda, Italy

Jean-Marie Massaud's *276 Aspen* sofa is an eye-catching design that reflects the designer's desire for light and pared-down forms. It encapsulates his belief that the use of symbolic forms can offer a way of imbuing a design with universality and timelessness. With its sloping back, the sofa evokes the form of a mountain set against the seating section's low horizon, while its chrome-plated, inverted, T-shaped legs provide a lightness and elegance.

Jean-Marie Massauds Sofa *Aspen* ist ein Blickfang, der die Vorliebe des Designers für leichte, reduzierte Formen widerspiegelt. Es verkörpert seine Auffassung, dass die Verwendung symbolischer Formen eine Möglichkeit sein kann, einem Design Universalität und Zeitlosigkeit zu verleihen. Die asymmetrische Rückenlehne des Sofas erinnert an die Form eines Berges, die vor dem tiefen Einschnitt der Sitzfläche erscheint, während die verchromten, T-förmigen Füße für Leichtigkeit und Eleganz sorgen.

Avec *Aspen 276*, Jean-Marie Massaud réinvente le canapé. Composé de deux modules nés d'un seul plan rembourré, il se plie pour former le dossier. Celui-ci devient place d'assise et vice versa. Il en découle une forme filante à la marque fluide. Les pieds minces en métal chromé occupent une position qui laisse imaginer que le canapé flotte dans l'air.

Terminal 1 daybed, 2008

Jean-Marie Massaud (France, 1966–)

www.bebitalia.it
Polyurethane, varnished tubular steel, thermoplastic, cold-shaped polyurethane foam
Polyurethan, lackiertes Stahlrohr, Thermoplastik, kalt geformter Polyurethanschaumstoff
Polyuréthane, acier tubulaire verni, thermoplastique, mousse de polyuréthane moulé à
froid
↕ 74 cm ↔ 203 cm ↗ 79 cm
B&B Italia, Novedrate, Italy

Designed for those of us who like to indulge in daytime power-naps or maybe for people who just want to put their feet up and read, Jean-Marie Massaud's *Terminal 1* day-bed is a stunning piece of furniture with a captivating presence. Like other pieces of furniture designed by Massaud, this unusual and beautiful design – which is also available upholstered in leather – has a striking visual lightness. At the same time, its soft and undulating lines have a distinctive gestural quality reminiscent of natural landscapes.

Für all jene, die tagsüber gerne ein kurzes Nickerchen machen, oder einfach für Leute, die nur die Füße hochlegen und lesen wollen, ist Jean-Marie Massauds Chaiselongue *Terminal 1* ein tolles Möbel von faszinierender Präsenz. Wie andere Designs von Massaud besitzt auch dieses ungewöhnliche und wunderschöne Stück – das auch mit Lederpolster erhältlich ist – eine verblüffende visuelle Leichtigkeit. Gleichzeitig hat seine weiche, fließende Linienführung eine ausgeprägte gestische Qualität, die an natürliche Landschaften erinnert.

Spécialement conçue pour les adeptes de la sieste ou pour ceux qui lisent les pieds surélevés, la méridienne *Terminal 1* de Jean-Marie Massaud est une pure merveille à l'allure aérienne. À l'instar d'autres meubles imaginés par Massaud, cette création offre un design inhabituel et d'une grande beauté. Ses lignes fluides lui confèrent une exceptionnelle légèreté. Disponible également avec un rembourrage en cuir, cette méridienne aux courbes douces et ondulées existe en différentes couleurs pour un effet monochrome accentuant l'élégance de ses formes.

Cuba System modular seating elements, 1986

Rodolfo Dordoni (Italy, 1954–)

www.cappellini.it
Wood, metal, upholstered polyurethane foam
Holz, Metall, gepolsterter Polyurethanschaumstoff
Bois, métal, mousse de polyuréthane tapissée
↕ 65 cm ↔ various ⤢ 85 cm
Cappellini, Arosio, Italy

The Italian architect and designer, Rodolfo Dordoni, perpetuates the Milanese design tradition pioneered by Achille Castiglioni and Vico Magistretti, with stylishly modern work that has an emotional pull as well as a functional logic. For instance, his elemental *Cuba System* for Cappellini is a flexible range of nine modular seating units that can be variously configured to create whatever size and shape of sofa you desire.

Der italienische Architekt und Designer Rodolfo Dordoni setzt die von Achille Castiglioni und Vico Magistretti begonnene Mailänder Designtradition mit stilvoll modernen Arbeiten fort, die sowohl emotionale Anziehungskraft als auch funktionale Logik besitzen. So ist beispielsweise sein modulares *Cuba System* für Cappellini eine flexible, aus neun Elementen bestehende Sitzlösung, die zu einem Sofa in der gewünschten Form und Größe angeordnet werden können.

L'architecte et designer italien Rodolfo Dordoni perpétue la tradition du design milanais lancé par Achille Castiglioni et Vico Magistretti : une élégance moderne sertie d'émotion et de fonctionnalité. Conçue pour Cappellini, sa série *Cuba* se compose de neuf unités modulaires, offrant des configurations variées. En fonction de vos attentes vous pourrez créer des canapés aux dimensions et aux formes variées. Une œuvre à la fois moderne et fonctionnelle.

Of Chinese parentage, Kho Liang Ie emigrated to Holland around 1949 and in the late 1950s began designing furniture for Artifort. His seating designs mostly featured foam-upholstered constructions and were notable for their restrained simplicity and comfort. Apart from his 1960s interior scheme for Schiphol Airport, his best known design was – and still is – the c683 sofa, which with its elegant linearity exemplifies the aesthetic purity of his work. Available either as a 2.5 or 3 seater, the low-slung c683 is a relatively compact sofa that is a comfortable yet understated option that works well in almost any interior setting.

In China geboren, kam Kho Liang-le um 1949 nach Holland, wo er ab Ende der 1950er Jahre, für die Firma Artifort Möbel entwarf. Fast alle seiner Sitzmöbel sind gepolstert und gerade wegen ihrer Schlichtheit und Bequemlichkeit bemerkenswert. Neben seiner Inneneinrichtung des Abfertigungsgebäudes am Flughafen Schiphol aus den 1960er Jahren, gehört das Sofa c683 noch heute zu seinen bekanntesten Designs und steht mit seiner eleganten Geradlinigkeit beispielhaft für die ästhetische Reinheit von Khos Arbeiten. Das niedrige Sofa gibt es als 2,5- oder 3-Sitzer. Es ist relativ kompakt, bequem und so „ausgefallen unauffällig", dass es in jedes Interieur passt.

D'origine chinoise, Kho Liang le émigre aux Pays-Bas vers 1949, et commence à concevoir des meubles pour Artifort dès la fin des années 50. La conception de ses sièges rembourrés en mousse était célèbre pour leur simplicité et leur confort. Hormis son remarquable travail d'aménagement intérieur de l'aéroport de Schiphol dans les années 60, sa plus belle création reste le sofa c683. Avec l'élégance de sa ligne, ce sofa illustre la pureté esthétique de son œuvre. Disponible en deux, trois ou cinq places, c683 s'avère relativement compact et extrêmement confortable. Un design clair et chaleureux, idéal quelle que soit votre décoration intérieure.

c683 sofa, 1968

Kho Liang Ie (Indonesia/Netherlands, 1927–1975)

www.artifort.com
Chromed metal, pressed beech, polyurethane foam
Metall, verchromt, Buchenpressholz, Polyurethanschaum
Métal chromé, hêtre pressé, mousse de polyuréthane
↕ 79 cm ↔ 155, 185 cm ↗ 87 cm
Artifort, Schijndel, Netherlands

Marcel Wanders' *Bottoni* is a reinterpretation of the classic buttoned *Chesterfield*. Its quirkiness is very Dutch, with its exaggerated geometric form and buttoned detailing found on both sides of its back section. A tongue-in-cheek homage to the Italian Rationalist architect Piero Bottoni, this sofa has a simple block-like construction and comes in three sizes, while a matching chair is also available.

Marcel Wanders' *Bottoni* ist eine Reedition des klassischen, mit Knöpfen gehefteten *Chesterfield*-Sofas. Von typisch niederländischer Spitzfindigkeit sind die ausladenden geometrischen Formen und die Knopfdetails an beiden Seiten des Rückens. Als hintergründige Hommage an den rationalistischen italienischen Architekten Piero Bottoni hat dieses Sofa eine einfache blockartige Struktur. Es ist in drei Größen sowie mit passendem Sessel erhältlich.

Réinterprétation du *Chesterfield* classique, Bottoni révèle une ligne épurée, pour un confort absolu. Discrètement capitonné, cet élégant sofa illustre le talent de son créateur à concevoir des produits ingénieux et novateurs. Véritable hommage à l'architecte italien Piero Bottoni, la structure de ce sofa paraît uniforme, avec le dossier situé à la même hauteur que les accoudoirs. Bottoni existe en trois tailles. Un fauteuil assorti est également disponible.

Bottoni sofa, 2002

Marcel Wanders (Netherlands, 1963–)

www.moooi.com
Plywood, aluminium, HR foam, upholstery
Schichtholz, Aluminium, HR Schaum, Polsterung
Contreplaqué, aluminium, mousse HR, tapisserie d'ameublement
↕ 62 cm ↔ 235 cm ↗ 86 cm
Moooi, Breda, Netherlands

Alma sofa, 2005

Jasper Morrison (UK, 1959–)

www.cappellini.it
Fabric- or leather-covered polyurethane foam, plastic
Mit Stoff oder Leder bezogener Polyurethan-Schaum, Kunststoff
Tissu ou cuir recouvert de mousse de polyuréthane, plastique
↕ 61 cm ↔ 200, 240 cm ↗ 90 cm
Cappellini, Arosio, Italy

Available in two sizes, the *Alma* sofa has a minimal elegance, derived from Jasper Morrison's preference for functional utility over expressive styling. It is a design with a profound 'rightness' as well as a contemporary modernity; or as Vico Magistretti might have described it: 'a design without adjectives'. Using varying thicknesses of expanded foam padding clad in removable covers, it is also a comfortable and practical seating solution.

Das in zwei Größen erhältliche *Alma*-Sofa besticht durch minimalistische Eleganz, denn Jasper Morrison stellt funktionalen Nutzen über expressives Styling. Dieses Design zeichnet sich durch eine fundierte „Geradlinigkeit" und eine zeitgenössische Modernität aus, oder, wie Vico Magistretti es ausgedrückt haben könnte: „Ein Design ohne Adjektive". Durch die verschieden dichten Schaumstoffelemente mit abnehmbarem Bezug ist es vor allem auch ein bequemes und praktisches Sitzmöbel.

Disponible en deux tailles, le canapé *Alma* offre une élégance minimaliste, qui selon Jasper Morrison doit allier fonctionnalité et style. Il s'agit d'une création dotée à la fois d'une profonde justesse et d'une modernité contemporaine. Selon Vico Magistretti, il s'agit d'« un design sans adjectifs ». Ce canapé entièrement déhoussable est réalisé en mousse de polyuréthane et dispose d'un rembourrage expansé de diverses densités. Confortable et pratique, *Alma* est idéal dans un salon.

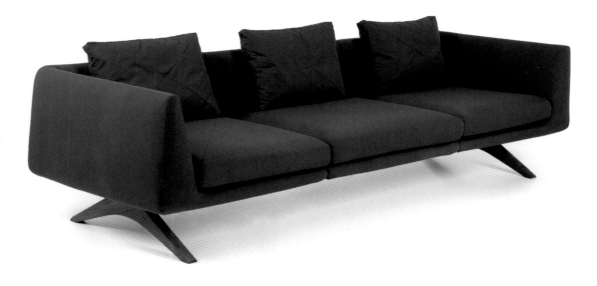

Hepburn modular sofa, 2008

Matthew Hilton (UK, 1957–)

www.delaespada.com
Walnut or oak, upholstery
Walnuss oder Eiche, Polsterung
Noyer ou chêne, tapisserie
↕ 70 cm ↔ 180, 270 cm ↗ 90 cm
De La Espada, London, UK

Having produced designs for a number of well-known manufacturers, Matthew Hilton launched his own company in 2007 to create a range of beautifully designed furnishings that would be manufactured on a small scale and under licence using hand-skills-based manufacturing techniques. The resulting designs, such as the *Hepburn* modular sofa, are built to last and with their timeless aesthetic, are set to become the much-loved antiques of tomorrow.

Nach einer Vielzahl von Entwürfen für bekannte Möbelhersteller gründete Matthew Hilton 2007 sein eigenes Unternehmen, in dem er in limitierter Auflage und lizensierten Serien wunderschöne Möbel in traditionellen handwerklichen Manufakturtechniken herstellt. Hiltons Möbel, wie etwa das modulare *Hepburn*-Sofa, sind für die Ewigkeit geschaffen und werden mit ihrer zeitlosen Ästhetik sicherlich die allseits beliebten Antiquitäten von Morgen werden.

Après avoir conçu de nombreux designs pour des fabricants renommés, Matthew Hilton fonda sa société en 2007. Désireux de créer une gamme de mobilier en série limitée, et sous licence d'un savoir-faire basé sur les techniques industrielles, il élabore le sofa modulable *Hepburn*. Construit pour durer, ce magnifique canapé offre une beauté intemporelle, en passe de devenir une pièce très recherchée.

A comprehensive and highly flexible modular sofa system, the *Alfa* features clean modern lines, while also providing an excellent level of comfort. Its thin-profiled chrome-plated steel base gives the various elements a visual lightness, which helps to provide a sense of uncluttered space within a room. The *Alfa* is also highly practical thanks to its removable covers, which are available in a wide choice of fabrics and leathers.

Als überaus flexibles System aus kombinierbaren Elementen dominieren bei *Alfa* klare moderne Linien in Verbindung mit äußerstem Komfort. Das schmal profilierte, verchromte Stahlgestell verleiht den verschiedenen Elementen eine optische Leichtigkeit, was dem Raum eine luftige und aufgeräumte Atmosphäre verleiht. Zudem ist *Alfa* wegen seiner abnehmbaren Bezüge, die in einer großen Auswahl an Ledern und Stoffen erhältlich sind, überaus praktisch.

La collection *Alfa* se compose de canapés modulables de différentes dimensions. Raffiné et extrêmement confortable, le sofa *Alfa* séduit par sa ligne géométrique et minimaliste. Sa fine structure en acier chromé suscite une interprétation moderne et sophistiquée, insufflant un sentiment d'espace épuré. Amovible, le revêtement en tissu se décline en une importante palette de couleurs. Une version cuir est également disponible.

1326 Alfa modular sofa, 1999
Emaf Progetti (Italy, est. 1982)

www.zanotta.it
Steel, elastic strapping, polyurethane
Stahl, Federung mit elastischen Gurten, Polyurethan
Acier, sangle élastique, polyuréthane
↕ 65 cm ↔ 227 cm ⤢ 162 cm (variation shown)
Zanotta, Milan, Italy

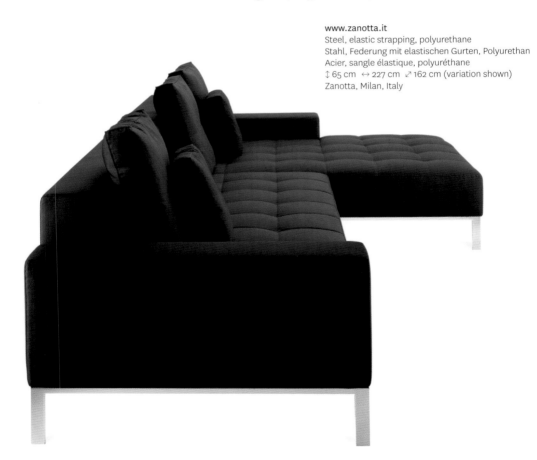

Refolo modular seating unit, 1953

Charlotte Perriand (France, 1903–1999)

www.cassina.com
Natural or stained oak, upholstered polyurethane, polyester wadding
Eiche natur und gebeizt, gepolstertes Polyurethan, Polyesterwatte
Chêne naturel ou teinté, mousse de polyuréthane tapissée, ouate de polyester
↕ 27 cm ↔ 141 cm ↗ 76 cm
Cassina, Meda, Italy

Part of Cassina's famous *I Maestri* range, Charlotte Perriand's *Refolo* consists of a low table/bench. Seat, backrest and armrest cushions can then be attached by means of a simple assembly system to construct either a padded bench or a stylish sofa. With its horizontal section made up of nineteen oak laths supported on simple wooden legs, this design has a strong architectural sensibility and reflects the profound influence of Japanese culture on Perriand's work.

Charlotte Perriands *Refolo* gehört zur berühmten *I Maestri*-Serie von Cassina und kann als niedriger Tisch oder als Bank genutzt werden. Kissen für Sitz, Rückenlehne und Armlehne können mit Hilfe eines einfachen Systems an der Struktur befestigt werden, so dass entweder eine gepolsterte Bank oder ein elegantes Sofa entsteht. Die Fläche besteht aus neunzehn Eichenleisten und wird von schlichten Holzfüßen gestützt. Dadurch erhält das Design etwas sehr Architektonisches und reflektiert den starken Einfluss der japanischen Kultur auf Perriands Arbeit.

Composante de la célèbre collection *I Maestri* de Cassina, la banquette *Refolo* de Charlotte Perriand est constituée d'une desserte banc capitonné. Les coussins de l'assise, du dossier et des accoudoirs s'encastrent facilement grâce à un système de montage simple pour composer un banc ou un élégant canapé. Les dix-neuf lattes parallèles en chêne dans lesquelles sont placés les coussins, illustrent une conception architecturale sensuelle. Cette création reflète l'influence de la culture japonaise dans l'œuvre de Perriand.

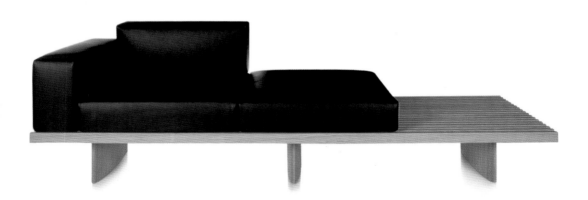

George modular sofa system, 2001

Antonio Citterio (Italy, 1950–)

www.bebitalia.it
Tubular steel, die-cast aluminium, upholstered polyurethane foam
Stahlrohr, Aluminiumguss, gepolsterter Polyurethanschaumstoff
Tubes d'acier, fonte d'aluminium, mousse de polyuréthane tapissée
↕ 88 cm ↔ various ⤢ 110 cm
B&B Italia, Novedrate, Italy

Since 1973, Antonio Citterio has designed numerous furniture pieces for B&B Italia. Characterized by simple, uncluttered forms and a soft, modern-yet-human aesthetic, they are easy to place within almost any interior setting. His *George* sofa system comprises various seating modules that can be used to create different sofa configurations. Because of its understated simplicity, it works as well in ultra-modern living rooms as it does in more traditional domestic environments.

Seit 1973 hat Antonio Citterio zahlreiche Möbel für B&B Italia entworfen. Sie zeichnen sich durch schlichte, schnörkellose Formen und eine weiche moderne, aber am Menschen orientierte Ästhetik aus, so dass sie in fast jede Einrichtung passen. Sein Sofasystem *George* umfasst verschiedene Sitzmodule, die sich zu unterschiedlichen Sofa-Formen anordnen lassen. Wegen seiner zurückhaltenden Schlichtheit funktioniert dieses Möbel ebenso gut in einem ultra-modernen Wohnzimmer wie in einer eher traditionellen Einrichtung.

Depuis 1973, Antonio Citterio a conçu de nombreux meubles pour B&B Italia. Caractérisé es par des formes simples et épurées, ses créations illustrent une esthétique moderne en harmonie avec n'importe quel intérieur. Son canapé modulable *George* se compose de plusieurs éléments qui permettent de créer différentes configurations de sofas. À la fois simple et sophistiqué, *George* s'adapte aussi bien dans un salon ultra-moderne que dans une ambiance plus classique.

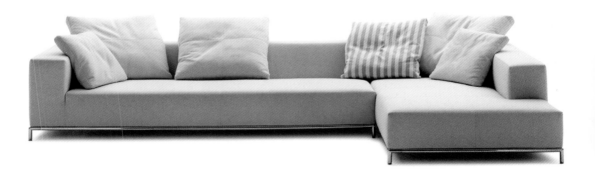

First conceived in 1993, the *Op-La* tray/table is an ingenious modern reworking of a traditional butler's tray and stand – a furniture type that became popular during the Georgian and Victorian periods. Morrison's design, like its antique predecessors, is a highly functional piece of furniture that is perfect for serving food or drinks. Like other designs by Morrison, the *Op-La* is characterized by the use of a familiar form that has been simplified and reduced to its most essential expression.

Die bereits 1993 entworfene Kombination aus Tablett und Tisch ist eine geniale moderne Interpretation eines traditionellen Butler-Tabletts und Beistelltisches, ein Möbel, das in der georgianischen und viktorianischen Ära beliebt war. Morrisons Design ist, ebenso wie seine antiken Vorläufer, äußerst funktionell und perfekt geeignet, um Speisen und Getränke zu servieren. *Op-La* ist ein typisches Morrison-Design, bei dem eine vertraute Form vereinfacht und auf das Wesentlichste reduziert wurde.

Conçue en 1993, la table/plateau *Op-La* présente une version moderne et ingénieuse du plateau classique d'un maître d'hôtel sur pied. Ce type de meuble était très populaire aux époques géorgienne et victorienne. À l'instar de ses prédécesseurs, ce modèle conçu par Morrison offre une indéniable fonctionnalité, idéal pour servir des plats ou des boissons. Cette table *Op-La* illustre à la perfection le point de vue de Morrison : des meubles réduits à leur plus simple expression.

Op-La tray/table, 1993–1998

Jasper Morrison (UK, 1959–)

www.alessi.com
Stainless steel, ABS
Edelstahl, ABS
Acier inoxydable, ABS
↕ 52 cm ⌀ 48 cm
Alessi, Crusinallo, Italy

Miura folding table, 2007

Konstantin Grcic (Germany, 1965–)

www.plank.it
Zinc-plated, powder-coated steel
Verzinkter, pulverbeschichteter Stahl
Acier laqué revêtu de poudre polyester
↕ 45, 75, 109 cm ∅ 60 cm
Plank, Ora, Italy

This attractive folding table was designed by Konstantin Grcic to complement his award-winning *Miura* barstool. Its three-branched base is formed from steel and has an unusual elliptical profile, which is produced using a state-of-the-art 3D laser technique. Its tabletop can also be tilted vertically when not in use for easy space-saving storage. This practical design is available in five different colours as well as three different heights.

Konstantin Grcic hat diesen attraktiven klappbaren Stehtisch als Ergänzung zu seinem preisgekrönten *Miura*-Barhocker entworfen. Das dreibeinige Tischgestell aus Stahl hat ein ungewöhnliches, elliptisches Profil, das mittels moderner 3-D-Lasertechnik hergestellt wird. Die Tischplatte lässt sich vertikal abklappen, so dass der *Miura* platzsparend verstaut werden kann. Das praktische Design ist in fünf verschiedenen Farben und drei unterschiedlichen Höhen lieferbar.

Conçue par Konstantin Grcic, cette table pliante complète le tabouret primé *Miura*. Son originalité réside dans son piètement tripode, réalisé grâce à une technique laser 3D. Cette création dispose d'un plateau qui se rabat aisément, permettant un gain de place non négligeable. Entièrement réalisée en acier laqué, *Miura* offre une élégance à la fois sobre et sculpturale. Disponible en cinq couleurs et en trois hauteurs différentes.

Prismatic table, 1957
Isamu Noguchi (USA, 1904–1988)

www.vitra.com
Coated sheet aluminium
Beschichtetes Aluminiumblech
Tôle d'aluminium laquée
↕ 37.5 cm ↔ 41 cm ↗ 41 cm
Vitra, Weil am Rhein, Germany

Inspired by the Japanese art of origami, the small *Prismatic* table is made from folded sheet aluminium, and was originally designed for Alcoa's Design Forecast Programme, which promoted new design applications for this material. The early Alcoa prototype was multi-coloured, and this modular design was not put into mass production until very recently. Today, Vitra manufactures the *Prismatic* table with either a black or white finish.

Der von der japanischen Papierfaltkunst des *Origami* inspirierte kleine Tisch *Prismatic* besteht aus gefalztem Aluminiumblech und wurde ursprünglich für das Design Forecast Programme von Alcoa (Aluminium Company of America) entworfen, die damit den Einsatz des Produktes im Bereich Design demonstrieren wollte. Der frühere Prototyp für Alcora war vielfarbig, und das modulare Design wird erst seit kurzem in Serie produziert. Heute stellt Vitra den *Prismatic*-Tisch entweder mit weißem oder schwarzem Finish her.

Inspirée de la technique traditionnelle japonaise de l'origami, la petite table *Primastic* s'inscrit dans un langage formel purement géométrique. Elle est réalisée en tôle d'aluminium pliée pour Alcoa, présentant ainsi une nouvelle utilisation de ce matériau. Cette table d'appoint offre un merveilleux exemple de l'harmonieux mariage du travail sculptural et du design de mobilier. Le premier prototype était multicolore, toutefois Vitra fabrique *Prismatic* uniquement en blanc ou noir.

Tray table, 1949

George Nelson (USA, 1907–1986)

www.vitra.com
Maple, black ash or cherry-veneered
plywood, steel, aluminium
Ahorn, Schichtholz mit Furnier aus
schwarzer Esche oder Kirschbaum, Stahl,
Aluminium
Plaquage en érable, frêne noir, ou cerisier
stratifié, acier, aluminium
↕ 49.5–69.5 cm ↔ 38.7 cm ↗ 38.7 cm
Vitra, Weil am Rhein, Germany

A Mid-Century Modern version of the traditional tray table, George Nelson's structurally elegant design is height-adjustable and was intended to be functionally flexible. It can be used as a side table beside an armchair, for dinners in front of the television, or as a table to use in bed either for indulgent breakfasts or when confined there by illness.

George Nelson's strukturell elegantes Design aus den 1950er Jahren, eine moderne Version des traditionellen Beistelltisches, ist höhenverstellbar und sollte funktional flexibel sein. Tray kann neben einen Sessel gestellt, als Esstisch vor dem Fernseher oder für das Früh-stück im Bett verwendet werden.

Version moderne des années 50, la table Tray de George Nelson se caractérise par son élégance sobre et ses éléments de structure filigranés. Grâce à un réglage en hauteur commandé par un mécanisme simple, Tray peut être disposée auprès d'un fauteuil, d'un canapé ou même d'un lit. Une création asymétrique très utile pour le petit déjeuner ou lorsque vous souhaitez rester au lit.

Yo-Yo table, 2004

Jakob Wagner (Denmark, 1963–)

www.moroso.it
Lacquered beech plywood
Lackiertes Buchenschichtholz
Contreplaqué de hêtre laqué
↕ 45 cm ↔ 40 cm ⤢ 43 cm
Moroso, Cavalicco, Italy

One of Scandinavia's most talented contemporary designers, Jakob Wagner is fascinated by the concept of meaningful form and his work is characterised by a playful blending of the organic and the geometric, the masculine and the feminine. This attractive table is an excellent example of how he creates practical and useful objects that have visually seductive forms and a compelling sculptural simplicity.

Jakob Wagner, einer der begabtesten zeitgenössischen skandinavischen Designer, ist fasziniert von der Vorstellung der ausgeklügelten Form, und seine Arbeiten sind bestimmt von dem spielerischen Zusammenspiel des Organischen und Geometrischen, des Männlichen und des Weiblichen. Dieser attraktive Tisch ist ein ausgezeichnetes Beispiel für seine praktischen und zweckmäßigen Objekte, deren Formen zugleich optisch verführerisch und beeindruckend formal vereinfacht sind.

Jakob Wagner est l'un des designers contemporains les plus talentueux de Scandinavie. Fasciné par le concept de forme significative, son œuvre se caractérise par une combinaison ludique de l'organique et de la géométrie, du masculin et du féminin. Cette petite table d'appoint illustre parfaitement la manière dont ce créateur conçoit des objets fonctionnels avec des formes séduisantes et une simplicité sculpturale.

Twist Table, 2007

Philip Edis (Sweden, 1980–)

www.designhousestockholm.com
Lacquered MDF, powder-coated metal
Lackiertes MDF, pulverbeschichtetes Metall
MDF laqué, métal revêtu
↕ 59 cm ⌀ 55 cm
Design House Stockholm, Stockholm, Sweden

Design House Stockholm is one of the most important purveyors of contemporary Swedish design, and its products perpetuate the casual, understated purity that has long been emblematic of Scandinavian living. The *Twist Table* reflects this, with its simple yet space-saving, multi-storied form. Four lacquered MDF discs are positioned one above the other on a single pole, but the two middle ones are moveable, and pivot round the axis.

Design House Stockholm ist einer der bedeutendsten Hersteller modernen schwedischen Designs, und die Produkte des Unternehmens besitzen die zwanglose, unaufdringliche Klarheit, die seit jeher mit skandinavischer Lebensart assoziiert wird. Der *Twist Table* mit seiner einfachen, dennoch platzsparenden, mehrstöckigen Form ist ein gutes Beispiel dafür. Vier lackierte MDF-Böden sind übereinander an einem einzigen Stab angeordnet, die beiden mittleren lassen sich um die eigene Achse drehen.

Design House Stockholm représente l'un des plus importants fournisseurs du design suédois contemporain. Ses créations perpétuent la pureté sobre et informelle qui a longtemps symbolisé la vie scandinave. La table *Twist* illustre parfaitement ce point de vue, avec sa construction déstructurée de plateaux superposés, peu encombrante. Cette table se compose de quatre disques en MDF laqué superposés sur un seul pôle, les deux plateaux centraux pivotant autour de l'axe.

Oki Sato, whose Tokyo-based design studio, Nendo, has won numerous awards for its progressive work, designed the *Island Table*. It comprises two laser-cut steel elements of different heights and different dimensions that can be used together to create various table configurations. These elements are available in a black or white lacquered finish, as well as in the three primary colours: red, yellow and blue.

Oki Satos Tokioter Designstudio Nendo, das für seine progressiven Arbeiten bereits mit mehreren Preisen ausgezeichnet wurde, entwarf den hier gezeigten *Island Table*. Er besteht aus zwei lasergeschnittenen Stahlelementen von unterschiedlicher Höhe und Abmessung, die sich zu verschiedenen Tischmodellen anordnen lassen. Die Elemente sind mit lackiertem Finish in Schwarz oder Weiß sowie in den drei Grundfarben Rot, Gelb und Blau erhältlich.

Récompensé à plusieurs reprises pour son travail progressif, Oki Sato est l'auteur d'*Island Table*. Composée de deux éléments de hauteurs différentes, en acier découpés au laser, cette table propose diverses configurations. Ces éléments sont disponibles en laqué noir ou blanc, ainsi que dans les trois couleurs primaires : rouge, jaune et bleu. Ce créateur, dont l'agence se trouve à Tokyo, propose un design moderne très tendance.

Island Table, 2007

Oki Sato (Japan, 1977–)

www.cappellini.it
Lacquered, laser-cut sheet metal
Lackiertes, lasergeschnittenes Metallblech
Laqué, tôle découpée au laser
↕ 28 cm ↔ 128 cm ↗ 96 cm (*IT/1*)
↕ 32 cm ↔ 102 cm ↗ 67 cm (*IT/2*)
Cappellini, Arosio, Italy

Ninfea coffee table, 2008

Matteo Ragni (Italy, 1972–)

www.poltronafrau.it
MDF, walnut, ebony or oak and saddle hide
MDF, Walnuss, Ebenholz oder Eiche und Sattelkernleder
MDF, noyer, ébène ou chêne et cuir sellier
↕ 23 cm ↔ 121 cm ⤢ 121 cm
Poltrona Frau, Tolentino, Italy

Harmoniously combining wood with saddle-stitched leather, the *Ninfea* coffee table creates, according to its manu-facturer 'an island of design, floating in the living room.' Usefully, the top of the raised central bay can be opened to reveal a discreet but useful storage area to keep everyday items in. With its high rim, the sunken moat-like section is also the perfect surface for resting drinking glasses on, as they are less likely to get knocked over accidentally.

Der *Ninfea*-Kaffeetisch kombiniert harmonisch Holz mit abgestepptem Sattelleder und schafft – so der Herstel-ler – eine „im Wohnraum schwebende Insel des Designs". Unter der praktischen, in der Mitte herausragenden Tischplatte versteckt sich ein nützliches Ablagefach für allerlei Kleinkram. Durch die hohen Ränder und der wie aus einem Graben ragenden Platte bietet die Oberfläche auch eine perfekte Standfläche für Gläser, weil einem versehentlichen Umstoßen vorgebeugt ist.

Un extraordinaire jeu de géométrie simple et intelligent pour cette table à la base carrée et aux angles arrondis. Selon son créateur, *Ninfea* s'apparente à véritable îlot flottant dans votre salon. Le plan se trouve au centre d'un ample interstice qui crée tout autour un accueillant espace de rangement d'objets. Situé en contrebas, cet espace permet de poser les verres sans risque qu'ils se renversent accidentellement. Véritable complément de modernité essentielle et de beauté, cette table propose une simplicité sophistiquée.

Brasilia table, 2002

Eero Koivisto (Sweden, 1958–) & Ola Rune (Sweden, 1963–)

www.swedese.se
Birch, oak or walnut-veneered laminated wood
Schichtformverleimte Birke, Eiche oder Nussbaum
Bouleau, chêne ou noyer en placage de bois stratifié laqué
↕ 28 cm ↔ 100, 120 cm ↗ 100, 120 cm
Swedese Möbler, Vaggeryd, Sweden

Sometimes a design comes along that has a logical inevitability – an inherent 'rightness'. The *Brasilia* table is just such a design, with its simple trapezoid shape forming a continuous loop of laminated wood. Its form echoes the strong, sculptural dynamism of Oscar Niemeyer's architecture in Brasilia: Brazil's utopian, Modernist-inspired capital city. The table's loop, however, also has a more practical application as a useful place to store magazines or books.

Manchmal gibt es Designs, die eine logische Zwangsläufigkeit besitzen – eine inhärente „Stimmigkeit". Dazu gehört auch der Tisch *Brasilia* aus schicht-verleimten Holz, dessen einfache Trapezform eine Art geschlossene Schlaufe bildet. Diese Form greift die starke skulpturale Dynamik von Oscar Niemeyers Architektur in Brasilia auf, der utopischen, von der Moderne inspirierten brasilianischen Hauptstadt. Aber sie hat auch einen praktischen Nutzen, denn unter der Tischplatte lassen sich gut Zeitschriften und Bücher verstauen.

Parfois, le design présente une justesse intrinsèque. Avec sa forme trapézoïde simple formant une boucle continue de bois stratifié, la table *Brasilia* illustre parfaitement ce concept. Ses courbes font écho au dynamisme sculptural de l'architecture d'Oscar Niemeyer à Brasilia, une capitale inspirée par le Modernisme. La boucle de la table n'en demeure pas moins fonctionnelle avec sa forme en circuit fermé permettant d'entreposer des livres ou des magazines.

Like other furniture designed by Eric Pfeiffer for the American manufacturer Offi & Company, the *Scando* coffee table is a simple yet ingenious solution that looks good in almost any setting. Made from a single piece of moulded plywood, this elegant no-nonsense table is low enough to make it perfect for more casual lifestyle environments, while its U-shaped section is handy for storing magazines and newspapers.

Wie andere, von Eric Pfeiffer für den amerikanischen Hersteller Offi & Company entworfenen Möbel ist auch der *Scando*-Couchtisch eine einfache, aber geniale Lösung, die in fast jeder Einrichtung gut aussieht. Dieser elegante und schnörkellose, aus einem Stück schichtverleimtem Sperrholz bestehende Tisch ist niedrig genug für eine eher zwanglose Wohnwelt, und in dem praktischen U-förmigen Einschnitt lassen sich Zeitungen und Zeitschriften aufbewahren.

À l'instar d'autres meubles conçus par Eric Pfeiffer pour la société américaine Offi & Company, la table basse *Scando* offre un design simple mais ingénieux. Réalisée à partir d'un seul morceau de contreplaqué moulé, cette table présente des lignes douces et courbes. Élégante et originale, cette création vintage s'adapte parfaitement à un environnement décontracté. Sa forme en U est idéale pour entreposer des magazines et des journaux.

Scando coffee table, 2006

Eric Pfeiffer (USA, 1969–)

www.offi.com
Walnut, birch or oak veneer, or colour-finished moulded plywood
Gebogenes Schichtholz mit Walnuss-, Birke- oder Eichefurnier oder lackiert
Noyer, bouleau, placage en chêne ou de couleur en contreplaqué moulé
↕ 28 cm ↔ 110.5 cm ⤢ 71 cm
Offi & Company, Tiburon (CA), USA

Seven table, 2008

Jean-Marie Massaud (France, 1966–)

www.bebitalia.it
MDF, oak veneer
MDF, Eichenfurnier
MDF, placage de chêne
↕ 74 cm ↔ 234 cm ↗ 157 cm
B&B Italia, Novedrate, Italia

This unusual table has a curious asymmetrical top with three sides of different lengths. This gives it a strong organic presence that is further emphasised by the branch-like form of its base, which is itself echoed in the graphic decoration on the table's surface. Its name derives from the fact that the dining version is intended to accommodate up to seven people or as Jean-Marie Massaud likes to say, "6+1" or "3+2+2". The top and base are also available in a number of different colour combinations.

Die asymmetrische Platte mit ihren drei unterschiedlich langen Seiten verleiht diesem ungewöhnlichen Tisch eine betont organische Präsenz, noch unterstrichen durch die Basis in Form einer Astgabel, die sich im graphischen Dekor der Platte spiegelt. Wie der Name sagt, ist der Tisch für sieben Personen konzipiert – oder wie Jean-Marie Massaud es gerne ausdrückt: „6+1" oder „3+2+2". Tischplatte und -gestell sind in unterschiedlichen Farbkombinationen erhältlich.

Voici une table dont le principe visuel interpelle, avec sa forme asymétrique et ses trois côtés de longueurs différentes. La table *Seven* révèle une forte présence organique, accentuée par un piètement de même forme, faisant écho à la décoration graphique du plateau. Comme son nom l'indique, cette table accueille sept personnes, ou « 6+1 » « 3+2+2 » comme le souligne Jean-Marie Massaud. Le plateau et le piètement se déclinent en de nombreuses combinaisons de couleurs différentes.

Noguchi coffee table, 1948

Isamu Noguchi (USA, 1904–1988)

www.vitra.com
www.hermanmiller.com
Varnished and stained ash, walnut or maple, glass
Lackiertes und gebeiztes Esche-, Nussbaum- oder Ahornholz, Glas
Frêne verni et coloré, noyer ou érable, verre
↕ 40 cm ↔ 128 cm ↗ 93 cm
Vitra, Weil am Rhein, Germany/Herman Miller, Zeeland (MI), USA

Among the most seminal designs of the postwar years, Isamu Noguchi's coffee table was a highly influential, free-form design that captured the new organic spirit that permeated the applied arts during the Mid-Century period. Noguchi sought to synthesize art and design through his visually seductive and sophisticated furniture designs, and he was profoundly successful in striking a harmonious balance between aesthetics and function.

Isamu Noguchis Kaffeetisch gehört zu den einflussreichsten Freeform-Designs der Nachkriegsjahre und verkörperte den neuen organischen Ansatz der angewandten Künste Mitte der 1950er Jahre. Mit seinen visuell beeindrucken-den, vollendeten Möbeldesigns strebte Noguchi nach einer Synthese von Kunst und Design, und in diesem Streben gelang es ihm, ein harmonisches Gleich-gewicht zwischen Ästhetik und Funktion zu schaffen.

La table basse Noguchi demeure parmi les créations les plus marquantes de l'après-guerre. Élégante et minimaliste, cette table transpose de manière authen-tique les éléments biomorphiques du langage formel d'un meuble à l'esthétique sculpturale. Un somptueux exemple du nouvel esprit organique qui influençait les arts appliqués dans les années 50. Noguchi offre un équilibre harmonieux entre l'esthétique et la fonction.

Yard table, 2003

Paolo Piva, (Italy, 1950–)

www.poliform.it
Wenge or walnut and chromed metal
Wenge oder Walnuss, verchromtes Metall
Wengé ou noyer et métal chromé
↕ 29.5 cm ↔ 120 cm ⤢ 120 cm (variation shown)
Poliform, Inverigo, Italy

Paolo Piva's *Yard* collection of tables comprises a variety of round and square models, with either wenge, walnut or chromed metal bases. There is also a wide range of tabletop finishes, from coloured matt or glossy lacquered MDF in attractive muted tones to walnut, wenge or hide. This variety of choice means the range is highly versatile and can be customised to one's specific needs.

Paolo Pivas Tischkollektion *Yard* umfasst verschiedene runde und eckige Modelle. Das Gestell ist in Wenge, Walnuss oder verchromten Stahl erhältlich; die verschiedenen Tischplatten gibt es in farbigem klar oder matt lackiertem MDF sowie in attraktiven gedeckten Farben von Wenge, Walnuss bis Leder. Die große Auswahl garantiert Flexibilität, so dass sich die Serie ganz auf die jeweiligen Bedürfnisse zuschneiden lässt.

La collection *Yard* de Paola Piva comprend plusieurs tables contemporaines. Certains modèles sont ronds ou carrés, avec une base en wengé, noyer ou métal chromé. Une vaste palette de finitions propose des couleurs mates ou du MDF laqué brillant, dans des tons aux nuances discrètes, rappelant le wengé et le noyer. Cette variété de choix implique une gamme polyvalente qui se compose en fonction de vos besoins.

The Table range designed by Monica Armani incorporates ten different low tables as well as matching dining tables and consoles. A self-confessed Neo-Rationalist, Monica Armani's work is characterized by a strong geometric purity and has a powerful architectural quality. As B&B Italia notes, her designs are: 'Sophisticated and measured, while being sharp as a knife, they exclude anything superfluous. They are the result of a gradual evolution, a steadily advancing process of continuous refinement'.

Die von Monica Armani entworfene Reihe *The Table* umfasst zehn verschiedene Couchtische sowie dazu passende Esstische und Konsolen. Die Arbeiten der selbstbekennenden Neo-Rationalistin zeichnen sich durch starke geometrische Klarheit und architektonische Qualität aus. B&B Italia sagt über ihre Designs: „Durchdacht, ausgewogen und gleichzeitig messerscharf, verzichten sie auf alles Überflüssige. Sie sind das Ergebnis einer allmählichen Evolution, eines fortschreitenden Prozesses kontinuierlicher Verfeinerung."

La collection *The Table* dessinée par Monica Armani propose différentes tailles de consoles et de tables. D'inspiration néo-rationaliste, le travail de cette créatrice se caractérise par une pureté géométrique et une forte qualité architecturale. B&B Italia déclare que ses créations sont à la fois sophistiquées et épurées. Dénuée de superflu, son œuvre est le résultat d'une évolution progressive mais constante qui ne cesse d'évoluer.

The Table low table, 2006

Monica Armani (Italy, 1964–)

www.bebitalia.it
Varnished or chromed steel, glass or marble
Lackierter oder verchromter Stahl, Glas oder Marmor
Verni ou acier chromé, verre ou marbre
↕ 21 cm ↔ 119 cm ↗ 119 cm (variation shown)
B&B Italia, Novedrate, Italy

Having studied at the prestigious Design Academy in Eindhoven, René Holten has gone on to design a number of sculptural yet rational furniture pieces for Artifort. With its timeless proportions, his stylishly understated low-slung *Mare T* coffee table accords with his stated goal to create "high-level products with a long lifespan [that are] designed in an environmentally friendly way." The tabletop is also available in walnut, ash, bamboo, beech, cherry, maple, oak, or zebrano.

René Holten – Absolvent der anerkannten Design-Akademie in Eindhoven – hat für Artifort eine Reihe skulpturaler, dabei aber äußerst praktisch-funktionaler Möbel entworfen. Mit seinen zeitlos gültigen Proportionen und seinem stilistischen Understatement entspricht der niedrige Couchtisch *Mare T* dem Ziel des Designers, hochwertige und langlebige Produkte zu schaffen, die noch dazu die Umwelt schonen. Die Tischplatte ist in Nussbaum, Esche, Bambus, Buche, Kirschbaum, Ahorn, Eiche oder Zebrano lieferbar.

Diplômé de la prestigieuse Académie de Design d'Eindhoven, René Holten a conçu de nombreux meubles à l'allure sculpturale pour Artifort. Avec ses proportions intemporelles et son style épuré, voire minimaliste, la table basse *Mare T* illustre sa façon d'appréhender le design, pour « des produits haut de gamme de longue durée de vie, conçus dans le plus pur respect de l'environnement ». Le plateau de cette table est disponible en noyer, frêne, bambou, hêtre, merisier, érable, chêne ou zebrano.

Mare T coffee table, 2003

René Holten (Netherlands, 1961–)

www.artifort.com
Aluminium, wenge
Aluminium, Wenge
Aluminium, wengé
↕ 26 cm ↔ 115 cm ⤢ 115 cm
Artifort, Schijndel, The Netherlands

The term 'Made in Italy' has come to be synonymous with style, and certainly Kristalia's range of elegant yet slightly quirky products are beautifully designed and made. The *Lilium* table, for example, rests on slender, shapely supports that recall the stems of flowers, and are produced from pressurised die-cast aluminium. The overall effect is both sculptural and proportionally harmonious. Three rectangular top and two square top models are available.

Der Begriff „Made in Italy" ist schon lange gleichbedeutend mit Stil, und die eleganten, wenn auch etwas eigenwilligen Produkte von Kristalia überzeugen zweifellos durch schönes Design und perfekte Herstellung. So erinnern beispielsweise die schlanken, formschönen Stützen des *Lilium*-Tischs aus Aluminiumguss an Blütenstiele – ein skulptural wirkendes Design von ausgewogenen Proportionen. Die Platte von *Lilium* ist in drei unterschiedlichen rechteckigen und zwei quadratischen Versionen erhältlich.

La collection Kristalia présente des produits élégants, légèrement excentriques, pour des créations bien conçues et d'une fabrication de grande qualité. *Lilium* repose sur un quadruple piètement en aluminium moulé sous pression, s'affinant vers le haut à la manière d'une tige florale. Cette conception lui confère un extraordinaire aspect sculptural, révélant des proportions harmonieuses. Différents modèles de plateaux haut de gamme sont disponibles, trois rectangulaires et deux carrés. « Fabriqué en Italie » est définitivement synonyme de style.

Lilium table, 2008

Bartoli Design (Italy, est. 1999)

www.kristalia.it
Aluminium, glass
Aluminium, Glas
Aluminium, verre
↕ 75 cm ↔ 150 cm ↗ 150 cm (variation shown)
Kristalia, Brugnera, Italy

Featuring a seamless connection between its top and its base, the *Krefeld* table is a masterpiece of understated International Style elegance. Like Mies van der Rohe's buildings, this mathematically proportioned design exudes a sense of masculine Modernity and practical functionality. Originally designed site-specifically as part of a suite of furniture for a pair of brick-and-glass villas in Krefeld, Germany, this table has been faithfully reissued using Mies' original drawings.

Mit seiner nahtlosen Verbindung von Platte und Basis ist *Krefeld* ein Paradebeispiel für die unaufdringliche Eleganz des International Styles. Genau wie seine Bauwerke verströmt auch dieses mathematisch proportionierte Design Mies van der Rohes eine Aura maskuliner Modernität und praktischer Funktionalität. Ursprünglich war der Beistelltisch Teil einer Möbellinie für zwei vom Architekten entworfene Villen in Krefeld. Die Reedition folgt van der Rohes Originalzeichnungen.

Krefeld révèle des proportions parfaitement équilibrées entre le plateau et la structure. De Style international, cette table est un chef-d'œuvre d'élégance et de raffinement. À l'instar des constructions de Mies, cette création illustre un sentiment de modernité masculine et fournit une fonctionnalité pratique. Initialement conçue comme élément d'une collection de meubles réalisée pour plusieurs maisons à Krefeld en Allemagne, cette table est rééditée selon les dessins originaux de Mies van der Rohe.

Krefeld table, 1927
Ludwig Mies van der Rohe (Germany, 1886–1969)

www.knoll.com
Oak
Eiche
Chêne
↕ 45 cm ↔ 137 cm ⤢ 70 cm
Knoll, New York (NY), USA

Astrid table, 2005

Roberto Lazzeroni (Italy, 1950–)

www.poliform.it
MDF, walnut, wenge or lacquered oak
MDF, Nussbaum, Wenge oder lackierte Eiche
MDF, noyer, wengé ou chêne laqué
↕ 74 cm ↔ 240 cm ⤢ 100 cm
Poliform, Inverigo, Italy

Roberto Lazzeroni is the creator of exquisitely proportioned forms that have a forceful emotional resonance. His *Astrid* collection of tables, for instance, is characterised by the visual interplay of the constituent elements, which are of different thicknesses. The solid wood legs are especially striking with their elliptical section. The *Astrid* table is available in either rectangular or round configurations.

Roberto Lazzeroni kreiert perfekt proportionierte Formen von starker emotionaler Ausdruckskraft. So zeichnet sich etwa seine Tischkollektion *Astrid* durch das visuelle Zusammenspiel der einzelnen, unterschiedlich starken Komponenten aus. Besonders auffällig sind die massiven Holzbeine mit ihrer elliptisch angeschnittenen Form. Die *Astrid*-Tische gibt es entweder in rechteckiger oder in runder Form.

Roberto Lazzeroni crée des formes parfaitement proportionnées, dotées d'une puissante résonance émotionnelle. Sa collection de tables *Astrid* se caractérise par l'interaction visuelle des éléments de différentes épaisseurs. Les pieds en bois massif s'avèrent originaux de par leur section elliptique. *Astrid* est disponible en configurations rectangulaires ou rondes. Cette table reflète un style à la fois élégant et minimaliste.

Ipsilon table, 2004

Raul Barbieri (Italy, 1946–)

www.ycami.com
Anodised aluminium
Eloxiertes Aluminium
Aluminium anodisé
↕ 74 cm ↔ 180 cm ⤢ 90 cm (variation shown)
Ycami, Novedrate, Italy

A relatively recent newcomer to the world of Italian furniture, Ycami was founded in 1990 as the brand of the Caimi group, which already had a considerable reputation for supplying aluminium components to the furnishings sector. Since then the company has collaborated with leading designers to create high-tech manufactured 'global' products for every area of the home, including the *Ipsilon* table, which comes in six sizes and a number of different finishes.

Ycami ist noch ein Neuling in der Welt der italienischen Möbel und wurde 1990 als Handelsmarke der Firmengruppe Caimi gegründet, die bereits einen guten Ruf als Hersteller von Aluminiumteilen für die Möbelindustrie besaß. Seitdem arbeitet das Unternehmen mit führenden Designern zusammen und bietet „globale" Hightech-Kreationen für jeden Bereich des Hauses. Dazu gehört auch der *Ipsilon*-Tisch, der in sechs verschiedenen Größen und einer Reihe verschiedener Finishes erhältlich ist.

Installée récemment dans le monde des meubles italiens, Ycami a été fondée en 1990 en tant que marque du groupe Caimi. Ce groupe bénéficie d'une grande renommée quant à ses composants d'aluminium utilisés pour le mobilier. Depuis lors, Ycami a collaboré avec de grands designers afin de concevoir des produits high-tech pour toutes les pièces de la maison, notamment cette table *Ipsilon*. Disponible en six tailles et dans une importante gamme de finitions.

Ilvolo table, 1996
Riccardo Blumer (Italy, 1959–)

www.aliasdesign.it
Veneered maple or ash, structural polyurethane foam
Ahorn- oder Eschefurnier, eingespritzter Polyurethanschaumstoff
Érable ou frêne plaqué, mousse de polyuréthane
↕ 73, 120 cm ↔ 90, 120, 240 cm ↗ 90, 120 cm
Alias, Grumello del Monte, Italy

Riccardo Blumer's *Ilvolo* table was designed to compliment his award-winning stacking *La Leggera* chair. As such, it incorporates the same innovative structure, with injected polyurethane foam layered between sheets of solid maple or ash in a strong yet lightweight sandwich. The sheets are then veneered in a range of different woods, including: natural maple, wenge, cherry and whitened oak. The *Ilvolo* is also available in a range of matt coloured finishes.

Riccardo Blumer entwarf den *Ilvolo* als Ergänzung zu seinem preisgekrönten stapelbaren Stuhl *La Leggera*. Er überzeugt durch die gleiche innovative Konstruktion, bei der Polyurethanschaumstoff zwischen zwei Schichten aus Ahorn oder Esche eingespritzt wird, so dass ein starkes und dennoch leichtes Sandwich entsteht. Die Schichten werden dann mit einer Reihe unterschiedlicher Furniere überzogen: Ahorn natur, Wenge, Kirschbaum oder gebleichte Eiche. *Ilvolo* ist auch in verschiedenen matten Farblackierungen erhältlich.

La table *Il Volo* de Ricardo Blumer a été conçue afin de compléter la chaise empilable *La Leggera*, récompensée par de nombreux prix. *Il Volo* possède une structure en bois massif, revêtue de plusieurs feuilles de placage, dans une large gamme de bois : érable naturel, frêne, merisier, wengé et chêne blanchi. Le choix du bois injecté de mousse polyuréthane demeure le secret de sa légèreté. Ce modèle existe également dans une importante gamme de couleurs opaques.

Fat Fat tables, 2004

Patricia Urquiola (Italy, 1961–)

www.bebitalia.it
Lacquered sheet steel, steel, thermoplastic
Lackiertes Stahlblech, Stahl, Thermoplastik
Tôle d'acier laqué, acier, thermoplastique
↕ 26 cm ⌀ 42 cm
↕ 32 cm ⌀ 62 cm
↕ 39 cm ⌀ 92 cm
B&B Italia, Novedrate, Italy

Inspired by an oriental aesthetic sensibility, the *Fat Fat* is a stunning update of the traditional tray table. It comes in three sizes and can be used singularly or together to form a useful suite of nesting tables. The tray-like tops come in six attractive colours, and rest on slender steel supports that can either be chromed or lacquered in the same colour as the tabletops.

Der von orientalischer Ästhetik inspirierte *Fat Fat* ist eine verblüffende Neuinterpretation des traditionellen Beistelltisches. Die Tische sind in drei Größen erhältlich und können einzeln, zu mehreren und verschachtelt aufgestellt werden. Die tablettartigen, in sechs attraktiven Farben erhältlichen Tischplatten liegen auf einem schlanken Stahlgestell, das entweder verchromt oder in der gleichen Farbe wie die Tischplatte zu haben ist.

Inspirées par une sensibilité esthétique orientale, les tables *Fat Fat* représentent une nouvelle version de la table plateau classique. Ces créations existent en trois tailles et peuvent s'utiliser séparément ou ensemble pour former une suite de tables gigognes. Les plateaux sont disponibles en six couleurs vives, soutenus par un fin piètement en acier chromé ou laqué dans la même couleur que les plateaux.

Trays tables, 2002

Piero Lissoni (Italy, 1956–)

www.kartell.it
Chrome-plated steel, batch-dyed PMMA
Verchromtes Stahlrohr, durchgefärbtes PMMA
Acier chromé, PMMA teint
↕ 25 cm ↔ 80 cm ⤢ 40 cm (model 4410)
↕ 25 cm ↔ 80 cm ⤢ 80 cm (model 4412)
↕ 25 cm ↔ 140 cm ⤢ 40 cm (model 4414)
Kartell, Milan, Italy

Piero Lissoni's *Trays* is a versatile system of three different-sized tables that have a remarkably refined simplicity. Although reminiscent of Japanese lacquered trays, the tables' tops (two rectangular and one square) are made of resilient thermoplastic and come in either high-gloss black or white PMMA. These fix onto elegantly pared-down steel bases that are either floor-standing or set on castors for greater mobility.

Bei Piero Lissonis *Trays* handelt es sich um ein flexibles System von Tischen in drei verschiedenen Größen, die durch ihre beeindruckende Schlichtheit bestechen. Sie erinnern an japanische Lacktabletts, allerdings sind die Tischplatten (zwei rechteckige und eine quadratische) aus einem unverwüstlichen thermoplastischen Kunststoff – entweder weiß oder schwarz glänzend lackiert oder mit weißem PMMA. Die Platten ruhen auf eleganten, sich nach unten verjüngenden Stahlgestellen, die fest stehen oder auf Rollen angebracht sind, um größere Beweglichkeit zu ermöglichen.

Créé par Piero Lissoni, ce système modulable composé de trois tables basses de différentes tailles révèle un design pur et élégant. Les plateaux (deux rectangulaires, un carré), réalisés en thermoplastique et PMMA brillant noir ou blanc, évoquent les laqués japonais. Fixées sur une structure en acier chromé, mobile (avec roulettes) ou stable, ces tables présentent une vision à la fois minimaliste et sophistiquée.

Swag Leg dining table, 1956–1958

George Nelson (USA, 1907–1986)

www.hermanmiller.com
Walnut veneered laminate, chromed metal
Laminat mit Nussbaumfurnier, verchromtes Metall
Placage en noyer stratifié, métal chromé
↕ 74 cm ↔ 137 cm ↗ 91.5 cm
Herman Miller, Zeeland (MI), USA

George Nelson's *Swag Leg* range of tables and chairs are veritable Mid-Century design icons that look as good today as they did half a century ago. This influential furniture group started life with its designer musing, 'Wouldn't it be beautiful to have some kind of sculptured leg on a piece of furniture?' Instead of using the obvious choice of carved wood, Nelson used pressure to taper and curve tubular metal – a process known as 'swaging' that gave this much-loved group its distinctive name.

George Nelsons Serie von Tischen und Stühlen *Swag Leg* sind echte Designikonen der 1950er Jahre und sehen heute noch so gut aus wie vor über einem halben Jahrhundert. Diese einflussreiche Gruppe von Möbeln wurde mit der Überlegung des Designers ins Leben gerufen: „Wäre es nicht schön, eine Art modelliertes Bein an einem Möbelstück zu haben?" Statt sich für das Naheliegende zu entscheiden und geschnitztes Holz zu verwenden, ließ Nelson Metallrohr abdrehen und biegen – ein Verfahren, das als „swaging" (Gesenkschmieden) bezeichnet wird und der beliebten Gruppe ihren eigenwilligen Namen gab.

La collection de tables et de chaises *Swag Leg* créée par George Nelson sont de véritables icônes du design des années 50. Toujours très tendance, cette collection vit le jour lors d'une réflexion inspirée du designer : « Ne serait-il pas merveilleux de sculpter la jambe d'un meuble ? » Au lieu d'employer le bois sculpté, Nelson utilisa la pression pour effiler et courber le métal tubulaire grâce au processus « swaging », d'où le nom de cette collection avant-gardiste.

Ferruccio Laviani's *Four* table has a highly distinctive, strong geometric form. Functionally flexible, it is perfect for dining but can also be used as a workstation – there is plenty of room beneath its slim-line top for filing cabinets or other office-style storage units. Appropriately enough, the *Four* table comes in four different sizes and a number of colour options.

Ferruccio Lavianis vielseitiger *Four*-Tisch besticht durch seine ausgeprägte geometrische Form. Er eignet sich perfekt als Esstisch, kann aber auch als Arbeitsplatz genutzt werden – unter der schmalen Platte ist reichlich Platz für Aktenablagen oder andere Büroelemente. Wie der Name schon andeutet, gibt es den *Four*-Tisch in vier verschiedenen Größen und einer Reihe von Farben.

Créée par Ferruccio Laviani, *Four* s'avère fonctionnelle et raffinée, au design rigoureux et géométrique. Cette table est idéale pour le bureau comme pour la maison. Grâce à une solution conceptuelle élégante et au grand espace situé sous son plateau d'une extrême finesse, *Four* s'agrémente parfaitement de tiroirs et de meubles de rangement. Disponible en quatre tailles et dans une importante gamme de couleurs.

Four table, 2004
Ferruccio Laviani (Italy, 1960–)

www.kartell.it
Painted steel, laminate
Lackierter Stahl, Laminat
Acier peint, stratifié
↕ 72 cm ↔ 158 cm ↗ 79 cm (variation shown)
Kartell, Milan, Italy

Frame table, 2007

Romano Marcato (Italy, 1951–)

www.lapalma.it
Lacquered metal, wood or laminate
Lackiertes Metall, Holz oder Laminat
Métal laqué, bois ou stratifié
↕ 73 cm ↔ 128 cm ⤢ 128 cm (variation shown)
La Palma, Cadoneghe, Italy

After studying at Padua's Industrial Technical Institute, Romano Marcato worked in the high-precision component industry. Then, in 1979, and in partnership with his brother, he founded the furniture manufacturing company, La Palma. He has since designed a number of furnishings for the firm, including the pared-down *Frame* table, with its distinctively essentialist aesthetic.

Nach seinem Studium am Institut für Industrietechnik in Padua arbeitete Romano Marcato in der Präzisionsindustrie. Zusammen mit seinem Bruder gründete er 1979 das Unternehmen La Palma. Seitdem hat er eine Reihe von Möbeln für das Unternehmen entworfen, darunter auch den schlichten Tisch *Frame* mit seiner markanten essentialistischen Ästhetik.

Après ses études à l'Institut technique Industriel de Padoue, Romano Marcato travaille dans une société de fabrication de pièces de haute précision. Il s'associe ensuite avec son frère et fonde en 1979 une entreprise de fabrication de meubles, La Palma. Depuis, il conçoit de nombreux articles d'ameublement pour les entreprises, dont *Frame*, une table simple, élégante et contemporaine.

With its pure lines and striking combination of aluminium and blue-tinged glass, the *Deneb* table can be used for dining or as a stylish home-office desk. It comes in eight different sizes, and there are lower coffee table versions available too. The base is constructed of only four elements that are easy to disassemble for transportation, while the tempered glass top is an impressive 10 mm thick.

Dank seiner klaren Linienführung und der auffälligen Kombination aus Aluminium und blau satiniertem Glas kann der *Deneb*-Tisch ebenso gut als Esstisch wie als stilvoller Schreibtisch für das Home Office genutzt werden. Es gibt ihn in acht verschiedenen Größen sowie als niedrigere Couchtisch-Version. Der Rahmen besteht aus nur vier Elementen, die sich für den Transport leicht zerlegen lassen, während die Hartglasplatte ganze 10 mm stark ist.

Avec ses lignes pures et la surprenante association d'un verre bleuté avec l'aluminium, *Deneb* s'avère idéale comme table de salle à manger, mais elle se transforme également en un superbe bureau design pour la maison. Disponible en huit dimensions, *Deneb* dispose d'un quadruple piètement, facile à démonter lors d'un déménagement. Réalisé en verre trempé, le plateau ne mesure que dix millimètres d'épaisseur. Des versions tables basses sont également disponibles.

Deneb table, 1987
Jesús Gasca (Spain, 1939–)

www.stua.com
Aluminium, glass
Aluminium, Glas
Aluminium, verre
↕ 73 cm ↔ 160 cm ⤢ 90 cm
(variation shown)
Stua, Astigarraga, Spain

Surface Table, 2008
Terence Woodgate (UK, 1953–) & John Barnard (UK, 1946–)

www.establishedandsons.com
Carbon fibre, walnut veneer, lacquer, steel
Karbonfaser, Nussbaumfurnier, Lack, Stahl
Fibre de carbone, placage en noyer, laque, acier
↕ 75 cm ↔ 240, 300 cm ↗ 100 cm
Established & Sons, London, UK

Part of Established & Sons' exclusive *Signature Collection*, the *Surface Table* is an astonishing, super-slim design that is the result of a remarkable collaboration between the furniture designer, Terence Woodgate, and the Formula 1 racing car designer, John Barnard. Spanning three metres, the edges of this extremely elegant dining table measure only 2mm thanks to its utilisation of strong yet superlight carbon fibre.

Der *Surface-Table* ist Teil der *Signature Collection* von Established & Sons. Das sehr filigrane Design ist das Ergebnis einer bemerkenswerten Zusammenarbeit von Möbeldesigner Terence Woodgate und Konstrukteur John Barnard, der auch Formel-1-Wagen entwirft. Das Oberblatt des äußerst eleganten, drei Meter langen Esstisches besteht aus starker, aber sehr leichter Karbonfaser und ist daher nur zwei Millimeter dick.

Surface fait partie de la collection *Signature*, spécialement conçue pour Established & Sons. La surface de cette table offre un design étonnant, extra-fin, fruit d'une collaboration remarquable entre le designer de meubles Terence Woodgate et celui des voitures de Formule 1, John Barnard. Elégante, *Surface* mesure trois mètres de long pour une épaisseur d'à peine deux millimètres, grâce à la fibre de carbone à la fois légère et extrêmement robuste.

Keramik table, 2004

Bruno Fattorini (Italy, 1939–)

www.mdfitalia.it
Ceramic laminate, lacquered aluminium
Porzellankeramik, lackiertes Aluminium
Porcelaine laminée, aluminium laqué
↕ 72 cm ↔ 200 cm ↗ 90 cm (variation shown)
MDF Italia, Milan, Italy

The *Keramik* range of tables comes in either square or rectangular options and in seventeen different sizes. The elegantly slender lacquered aluminium frames are available in three shades of grey or white, and have built-in tops made of a durable ceramic laminate. The transition between the frame and the top is seamless, which gives the design a satisfying unity. Two sizes of matching consoles are also produced.

Die Tischkollektion *Keramik* ist in sieben verschiedenen Größen mit quadratischen oder rechteckigen Platten erhältlich. Bei den schlanken und eleganten lackierten Rahmen kann man zwischen drei Grautönen und Weiß wählen; die einliegenden Tischplatten bestehen aus widerstandsfähiger Porzellankeramik. Rahmen und Beine gehen nahtlos ineinander über, so dass das Design etwas sehr Einheitliches erhält. Außerdem werden passende Beistelltische in zwei verschiedenen Größen produziert.

La collection de tables *Keramik* propose des plateaux carrés ou rectangulaires, dans dix-sept formats. Table aux lignes graphiques et épurées, elle est constituée d'une structure et piètement en aluminium laqué, disponible en trois nuances de gris ou blanc, et d'un plateau encastré composé d'un panneau en porcelaine laminée. Les consoles assorties sont proposées en deux tailles.

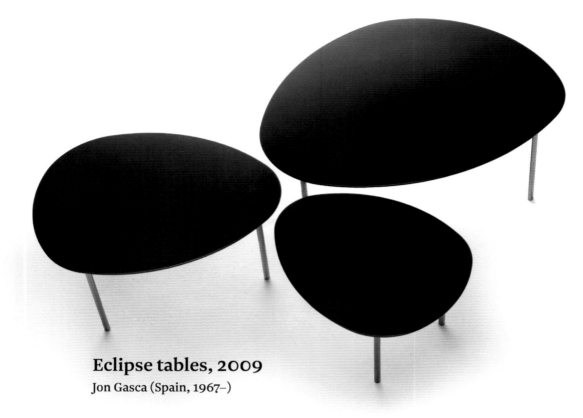

Eclipse tables, 2009

Jon Gasca (Spain, 1967–)

www.stua.com
Maple, beech, bleached oak, walnut or wenge, tubular metal
Ahorn, Buche, gebleichte Eiche, Nussbaum oder Wenge, Metallrohr
Érable, hêtre, chêne blanchi, noyer ou wengé, métal tubulaire
↕ 35 cm ↔ 77 cm ⤢ 111 cm
↕ 30 cm ↔ 56 cm ⤢ 71 cm
↕ 25 cm ↔ 55 cm ⤢ 44 cm
↕ 20 cm ↔ 46 cm ⤢ 37 cm
Stua, Astigarraga, Spain

Inspired by organic forms found in nature, the *Eclipse* range of four differently sized tables can be nested – with the smaller ones being concealed under the larger ones just like in a natural eclipse. The tables' tops are also slightly different in shape from each other and are set at different heights, which means that they can be used separately or together to make free-flowing combinations with a dynamic spatial quality.

Die von den organischen Formen der Natur inspirierte *Eclipse*-Kollektion besteht aus vier verschieden großen Tischen, die sich so ineinander schieben lassen, dass die kleineren wie bei einer natürlichen Sonnenfinsternis, einer Eklipse, unter den größeren verschwinden. Auch die Tischplatten sind leicht unterschiedlich geformt und verschieden hoch, so dass sie entweder einzeln genutzt oder zu fließenden Kombinationen von dynamischer räumlicher Qualität zusammengestellt werden können.

Inspirée par les formes organiques rencontrées dans la nature, la collection *Eclipse* propose quatre tables de tailles variées, s'imbriquant de manière à créer une éclipse naturelle (les petites à peine dissimulées sous les grandes). La forme et la hauteur des plateaux étant légèrement différentes, ces tables s'utilisent séparément ou ensemble. De fait, plusieurs configurations sont possibles, offrant une dynamique « spatiale ».

The *Déjà-Vu* table is a stylish reinterpretation of a traditional four-legged table, hence its title. With its highly polished aluminium legs, the table looks especially good in a loft-style space, as it has a slightly industrial and utilitarian aesthetic. It also looks wonderful when surrounded by the matching *Déjà-Vu* chairs, as part of an understated, but cool-looking dining suite. A larger and two smaller sizes are also available.

Der *Déjà-Vu*-Tisch ist, wie der Name suggeriert, eine elegante Neuinterpretation des traditionellen vierbeinigen Tischs. Mit seinen polierten Aluminiumbeinen kommt der Tisch mit seiner Anmutung an Industrie- und Gebrauchsästhetik besonders in einem Loft gut zur Geltung. In Kombination mit den passenden *Déjà-Vu*-Stühlen ergibt sich ein wunderbar unaufdringlicher, aber cooler Essbereich. Erhältlich ist der *Déjà-Vu* in zwei großen und einer kleinen Ausführung.

La table *Déjà-Vu* offre une réinterprétation de la table classique à quatre pieds, d'où son nom. Avec son piètement en aluminium poli et son esthétique légèrement industrielle, cette table s'avère idéale dans un espace style loft. *Déjà-Vu* forme un ensemble parfait avec les chaises de la même collection, tout en harmonie de couleurs et de formes. Une taille plus grande et deux plus petites sont également disponibles.

Déjà-Vu table, 2008
Naoto Fukasawa (Japan, 1956–)

www.magisdesign.it
Aluminium, MDF, oak veneer
Aluminium, MDF, Eichenfurnier
Aluminium, MDF, placage en chêne
↕ 74 cm ↔ 160 cm ⤢ 98 cm
Magis, Motta di Vicenza, Italy

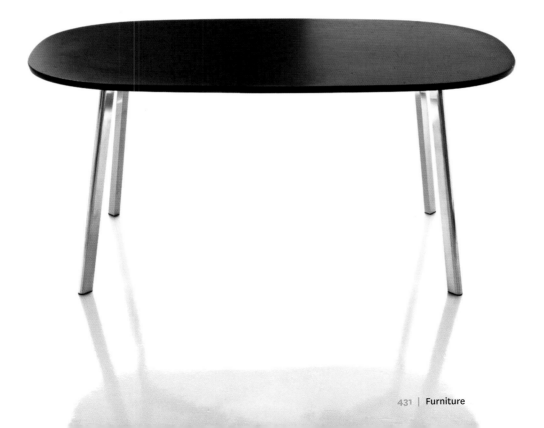

Container Table, 2003

Marcel Wanders (Netherlands, 1963–)

www.moooi.com
Lacquered steel, laminate, plastic
Lackierter Stahl, Laminat, Plastik
Acier laqué, stratifié, plastique
↕ 45, 70, 100 cm ⌀ 70, 90, 120, 140, 160, 180 cm
Moooi, Breda, Netherlands

Marcel Wanders is the great protagonist of the Dutch Neo-Decorative Movement, yet despite his love of stylistic excess and quirky symbolism, a few of his designs have a functional rationality too. His *Container Table* collection is a good example of this; and the range comes in a number of sizes with the option of either square or round tabletops. The formal relationship between the slightly upwardly tapering base and its top gives these pieces a distinctive architectonic authority.

Marcel Wanders ist der große Protagonist des so genannten niederländischen Neo-Decorative Movement, aber trotz seiner Vorliebe für stilistischen Überschwang und skurrilen Symbolismus überzeugen einige seiner Designs auch durch durchdachte Zweckmäßigkeit. Das *Container-Table*-Konzept ist dafür ein gutes Beispiel, denn die Tische sind in verschiedenen Größen mit rechteckiger oder runder Platte erhältlich. Die formale Beziehung zwischen dem nach oben etwas schmäler werdenden Tischbeins und der Platte verleiht diesem Design eine ausgeprägte architektonische Qualität.

Marcel Wanders est le grand protagoniste du mouvement néo-décoratif néerlandais. Malgré un penchant pour une stylistique excessive et un symbolisme excentrique, ce créateur élabore également des conceptions fonctionnelles, comme par exemple sa collection de tables *Container*. Cette gamme se décline en plusieurs tailles et propose des plateaux ronds ou carrés. La relation formelle entre le piètement central en forme de cylindre conique, légèrement fuselé vers le haut et le plateau confère à ces tables une autorité architectonique originale.

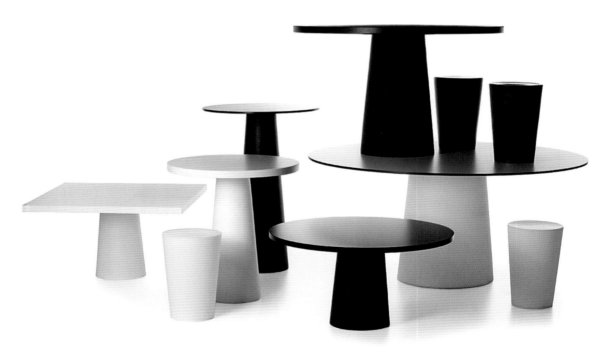

Lunario table, 1970

Cini Boeri (Italy, 1924–)

www.knoll-int.com
Tempered glass, steel
Hartglas, Stahl
Verre trempé, acier
↕ 29, 41, 70 cm ↔ 150 cm ⤢ 110 cm
Knoll, New York (NY), USA

The *Lunario* was the quintessential coffee table of the 1970s, epitomising the optical experimentation and functional playfulness in Milanese design of the period. Almost appearing to defy gravity, the tempered glass top seems to float in space, while the highly polished columnar base gives the design an architectural quality. The *Lunario* is available in low and medium coffee table heights and in dining table height.

Der *Lunario* war der ultimative Kaffeetisch der 1970er Jahre und verkörperte die visuelle Experimentierfreudigkeit und den spielerischen Umgang des zeitgenössischen Mailänder Designs mit der Funktion. Die Hartglasplatte scheint fast schwerelos im Raum zu schweben, während die säulenförmige Basis aus poliertem Stahl dem Entwurf seine architektonische Qualität verleiht. Den *Lunario* gibt es als niedrigen und mittleren Kaffeetisch sowie in einer hohen Version als Esszimmertisch.

Réminiscence de la table basse des années 70, *Lunario* incarne l'expérimentation optique et ludique du design fonctionnel milanais de l'époque. Défiant la gravité, la partie supérieure en verre trempé semble flotter dans l'espace, tandis que le piètement décalé en acier poli ajoute une incontestable qualité architecturale à cette création. Disponible en table basse, moyenne et de salle à manger, cette collection reflète une élégance délicate.

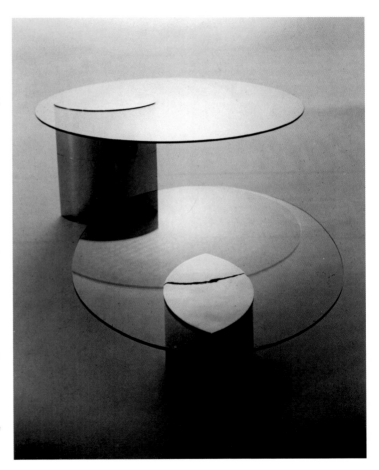

Round Table, 2008

Ross Lovegrove (UK, 1958–)

www.knoll.com
Powder-coated steel, aluminium, laminate, bamboo,
Starphire™ glass, acid-etched glass or bronzed glass
Pulverbeschichteter Stahl, Aluminium, Laminat, Bambus,
Starphire™ Glas, säuregeätztes oder bronziertes Glas
Acier revêtu, aluminium, stratifié, bambou,
verre Starphire™, verre gravé à l'acide ou verre bronzé
↕ 71 cm ⌀ 106.5, 122, 137, 152.5 cm
Knoll, New York (NY), USA

Ross Lovegrove is a master form-giver whose organically inspired designs are characterised by a functional logic and a strong sculptural confidence. His *Round Table* for Knoll utilises tubular steel to create an inverted branch-like base that gives the design a visually uplifting quality. The base comes in various finishes, while the top is available in four different diameters as well as a host of different materials, from bamboo to clear glass.

Ross Lovegrove ist ein Meister unter den Formgebern. Sein organisch inspiriertes Design ist von zweckmäßiger Logik und Vertrauen in Formgebung geprägt. Das Stahlrohrgestell seines *Round Table* für Knoll erinnert an eine Kopf stehende Astgabel, was dem Design optisch eine Aufwärtsbewegung verleiht. Das Gestell gibt es in verschiedenen Beschichtungen, die Tischplatte in vier verschiedenen Durchmessern und einer Vielzahl von Materialien – von Bambus bis Klarglas.

Ross Lovegrove détient une incontestable maîtrise de la forme, caractérisée par une logique fonctionnelle et une forte présence sculpturale. Réalisée pour Knoll, la table *Round* comporte de l'acier tubulaire afin de créer un piètement semblable à une branche inversée, conférant à cette création un très bel aspect visuel. La base existe en plusieurs finitions et le plateau est disponible en quatre diamètres, dans différents matériaux : du bambou au verre transparent.

During the 1960s, Artifort produced jersey-covered, foam-upholstered seating designs by Pierre Paulin and Geoffrey Harcourt that were some of the most comfortable chairs of all time. The low-slung T978 coffee table was designed to compliment these sculptural designs, with its perfectly circular top set above a simple pedestal base. In conjunction with Artifort's chairs from the Sixties, the T978 can become the centerpiece for some really dramatic furniture groupings.

In den 1960er Jahren produzierte Artifort von Pierre Paulin und Geoffrey Harcourt entworfene Sessel mit Jerseybezug und Schaumstoffpolsterung, die zu den bequemsten aller Zeiten gehören. Der niedrige T978 Kaffeetisch mit perfekter runder Platte auf einem schlichten Fuß entstand als Ergänzung zu diesen skulpturalen Designs. Zusammen mit den Sesseln von Artifort aus den 1960ern kann T978 zum Mittelpunkt einer wirklich beeindruckenden Gruppierung von Möbeln werden.

Durant les années 60, Artifort a réalisé de nombreuses créations de sièges conçues par Pierre Paulin et Geoffrey Harcourt. La table basse T978 a été créée afin de compléter ces designs sculpturaux, avec son plateau circulaire posé sur un piètement simple et épuré. En parfaite harmonie avec les fauteuils Artifort des années 60, la T978 est devenue la pièce maîtresse de certaines collections de meubles véritablement exceptionnels.

T978 table, 1968
Geoffrey Harcourt (UK, 1935–)

www.artifort.com
Aluminium, veneered wood or laminate-surfaced wood
Aluminium, Holzfurnier oder Holzlaminat
Aluminium, bois plaqué ou bois stratifié en surface
↕ 40 cm ⌀ 60, 100 cm
Artifort, Maastricht, Netherlands

An elegantly restrained design, the functional *Zero* table has a slightly industrial-looking central pedestal made of anodised aluminium that supports either a circular or square top. There is a choice of either a 12mm tempered glass top, a wooden top veneered in beech, maple, bleached oak or stained wenge or alternatively lacquered white.

Bei dem funktionalen *Zero*-Tisch handelt es sich um ein elegant zurückhaltendes Design mit einem leicht industriell anmutenden Standfuß aus anodisiertem Aluminium, auf dem entweder eine runde oder eine rechteckige Platte ruht. Die Tischplatte ist entweder aus zwölf Millimeter starkem Hartglas, aus Holz mit Furnier aus Buche, Ahorn, gebleichter Eiche, gebeiztem Wenge oder auch weiß lackiert zu haben.

Fonctionnelle, la table *Zero* dispose d'un plateau circulaire ou carré, posé sur un piètement au style légèrement industriel, révélant un design d'une élégance sobre. Le plateau de douze miliimètres d'épaisseur se décline en différentes finitions, en verre trempé, bois plaqué en hêtre, érable, chêne blanchi ou wengé teinté ou laqué blanc.

Zero table, 1995

Jesús Gasca (Spain, 1939–)

www.stua.com
Anodised aluminium, chromed steel, tempered glass, veneered wood or lacquered wood
Anodisiertes Aluminium, verchromter Stahl, Hartglas, Holzfurnier oder lackiertes Holz
Aluminium anodisé, acier chromé, verre trempé, bois peint ou en contreplaqué
↕ 73 cm ⌀ 60, 70, 90, 110, 120 cm
Stua, Astigarraga, Spain

Rondo table, 2007

Romano Marcato (Italy, 1951–)

www.lapalma.it
Chromed stainless steel, veneered or laminated plywood
Verchromter Edelstahl, furniertes oder laminiertes Schichtholz
Acier inoxydable chromé, contreplaqué stratifié ou plaqué
↕ 73 cm ⌀ 120 cm
La Palma, Cadoneghe, Italy

La Palma's furniture is highly distinctive with a Minimalist aesthetic and an exquisite attention to detail that reflects the high level of craftsmanship and design-engineering know-how that still exists in Italy. The *Rondo* is the perfect small dining table and, with its different top options and simple uncluttered lines, it works well in almost any contemporary-style domestic setting.

Die minimalistische Ästhetik und Detailgenauigkeit der unverwechselbaren Möbel von La Palma sind Ausdruck der hohen Handwerkskunst und des designtechnischen Know-hows, wie es in Italien noch anzutreffen ist. Rondo ist der perfekte kleine Esstisch und funktioniert mit seinen verschiedenen Plattenoptionen und seiner schlichten, schnörkellosen Linienführung in fast jeder modernen Einrichtung.

Connu dans le monde du design pour son mobilier élégant et raffiné, La Palma offre un artisanat de grande qualité associé à un savoir-faire d'étude de conception toujours présent en Italie. *Rondo* est une table bistrot affirmant un style épuré : simple, moderne, d'une élégance extrême. Cette table s'intègre aussi bien dans des intérieurs modernes que classiques.

Saarinen Collection dining, side & coffee tables, 1955–1956

Eero Saarinen (USA, 1910–1961)

www.knoll.com
Rislan-finished aluminium, polyester-coated laminate, marble or granite
Rislanbeschichtetes Aluminium, polyesterbeschichtetes Laminat, Marmor oder Granit
Aluminium, polyester enduit stratifié, marbre ou granit
Various dimensions
Knoll International, New York, USA

A truly iconic mid-century design, the *Saarinen Collection*, which includes these pedestal-base tables, was groundbreaking when it was first launched over fifty years ago. Exemplifying the sculptural qualities of organic design this visually harmonious collection of tables and chairs offered an alternative and humanizing approach to Modernism, rejecting the hard-edged aesthetic of Bauhaus-style furnishings. In tune with the increasingly relaxed and casual lifestyle of its era, the *Saarinen Collection* is still a great option.

Die *Saarinen Collection*, zu der auch die hier abgebildeten Tische mit Säulenfuß gehören, ist ein wahrhaft ikonisches Design der 1950er Jahre, das damals neue Maßstäbe setzte. Als Veranschaulichung der skulpturalen Qualitäten des organischen Designs bot diese harmonische Kollektion von Tischen und Stühlen eine alternative und humanisierende Betrachtungsweise der Modernität, indem sie sich der kantigen Ästhetik der Bauhaus-Möbel widersetzte. Passend zu der deutlich entspannteren und lockeren Lebensart ihrer Zeit ist die *Saarinen Collection* noch immer eine überzeugende Option.

Véritable icône du design des années 50, la collection *Saarinen* rassemble des tables hautes et des guéridons. Lors de son lancement il y a cinquante ans, cette création fut véritablement révolutionnaire. Illustrant les qualités sculpturales du design organique, cette collection ravit par ses courbes harmonieuses. Le Modernisme s'humanise et s'impose face à la rigueur de l'esthétique des meubles de style Bauhaus. À la fin des années 50, la mode se veut décontractée et la collection *Saarinen* devient un incontournable.

Big Bombo table, 2002–2003

Stefano Giovannoni (Italy, 1954–)

www.magisdesign.it
Chromed steel, acrylic, polyurethane
Verchromter Stahl, Acryl, Polyurethan
Acier chromé, acrylique, polyuréthane
↕ 75.5 cm ⌀ 130 cm
Magis, Motta di Vicenza, Italy

Stefano Giovannoni is one of the most commercially successful designers working today, and the reason for this is that his products and furniture not only function well but also have a strong emotional pull. The *Big Bombo* table is no exception, with its soft-edged form that playfully invites physical interaction. Part of the *Bombo* family, this table is intended to complement his bestselling *Bombo* chairs and stools, which when used together results in an extremely attractive grouping.

Stefano Giovannoni zählt zu den wirtschaftlich erfolgreichsten Designern unserer Zeit. Ein Grund ist, dass seine Produkte und Möbel nicht nur zweckmäßig sind, sondern auch emotional ansprechen. Mit seinen sanften abgerundeten Formen lädt der *Big Bombo* spielerisch zu Interaktion ein. Als Teil der *Bombo*-Familie ergänzt der Tisch die Bestseller *Bombo*-Sessel und -Stühle, mit denen er gemeinsam ein sehr attraktives Arrangement bildet.

Designer très prisé, Stefano Giovannoni crée des produits et des meubles fonctionnels, réalisés avec des matériaux nobles illustrant une forte puissance émotionnelle. *Big Bombo* ne déroge pas à la règle, avec ses bords souples qui invitent à l'interaction physique. Élégante et confortable, cette table complète la collection *Bombo*, composée de chaises et de tabourets de bar. Ces créations dégagent une parfaite harmonie lorsqu'elles sont réunies dans une même pièce. Cette collection rime avec esprit et modernité.

4/4 modular shelving/table, 1969

Rodolfo Bonetto (Italy, 1929–1991)

www.b-line.it
Injection-moulded ABS
Spritzgegossenes ABS
ABS moulé par injection
↕ 30 cm ↔ 50 cm ⤢ 50 cm
B-Line, Grisignano di Zocco, Italy

During the late 1960s, Italian manufacturers began producing youthful Pop-inspired designs in colourful shiny ABS plastic. They were often modular and functionally flexible, as exemplified by Rodolfo Bonetto's 4/4 low coffee table. This playful design is configured from four quarter-segment elements, which can also be stacked to make a corner-shelving unit. Available in white, red, orange and semi-transparent violet, the 4/4 is an iconic Italian design that is both useful and eye-catching.

Ende der 1960er Jahre begannen italienische Hersteller mit der Fertigung jugendlicher, Pop-inspirierter Designs in buntem ABS-Kunststoff. Sie waren häufig modular und funktionell flexibel, wie Rodolfo Bonettos niedriger 4/4 Beistelltisch. Dieses verspielte Design besteht aus vier Viertel-Elementen, die auch zu einem Eckregal übereinander gestapelt werden können. 4/4 ist in Weiß, Rot, Orange oder halbtransparentem Violett erhältlich, ein ikonisches italienisches Design, das nicht nur nützlich, sondern auch ein Blickfang ist.

La fin des années 60 marque un tournant décisif dans le design italien. Apparaissent alors des créations innovantes de style Pop. Les fabricants utilisent alors le plastique ABS pour une déclinaison de couleurs vives. Ces créations sont le plus souvent modulables et fonctionnelles. Ludique, la table basse 4/4 de Rodolfo Bonetto comporte quatre éléments modulables permettant de créer des tables ou des étagères d'angle. Disponible en blanc, rouge, violet ou semi-transparent, 4/4 est devenu un incontournable du design italien.

Boby storage trolley, 1970

Joe Colombo (Italy, 1930–1971)

www.b-line.it
Injection-moulded ABS
Spritzgegossenes ABS
ABS moulé par injection
↕ various ↔ 43 cm ⤢ 42 cm
B-Line, Grisignano di Zocco, Italy

One of Joe Colombo's best-loved designs, the *Boby* trolley is a mobile storage unit that can be used in both the home and office. It is a highly versatile modular design that can be extended vertically, and which has excellent storage capacity with its many swing-out drawers. It was awarded first prize at SMAU in 1971, and has since entered the permanent collections of design museums all over the world as a bold icon of Italian Pop design.

Der *Boby*-Rollcontainer ist eines von Joe Colombos beliebtesten Designs und kann sowohl Zuhause als auch im Büro verwendet werden. Das äußerst vielseitige modulare Möbel lässt sich vertikal erweitern und hat mit seinen vielen ausklappbaren Schubladen ein enormes Fassungsvermögen. Es erhielt den ersten Preis auf der SMAU 1971 und hat seitdem als mutige Ikone des italienischen Pop-Designs Einzug in die permanenten Sammlungen von Designmuseen auf der ganzen Welt gehalten.

Le chariot *Boby* est l'une des créations préférées de Joe Colombo. Ce modèle vise à proposer une solution multifonctionnelle au besoin de rangement, à la maison ou au bureau. Il s'agit d'un meuble à roulettes que l'utilisateur module à volonté. Bobby s'élargit ainsi à la verticale et offre une grande capacité de rangement grâce à ses tiroirs. Cette création futuriste a reçu le premier prix au SMAU de 1971. Icône du design Pop italien, ce chariot fait partie des collections permanentes des musées du design du monde entier.

Componibili storage system, 1969

Anna Castelli Ferrieri (Italy, 1920–)

www.kartell.com
Injection-moulded ABS
Spritzgegossenes ABS
ABS moulé par injection
↕ 40, 58.5 cm ⌀ 32 cm (2 or 3 element units)
↕ 38.5 cm ⌀ 42 cm (single large unit)
Kartell, Milan, Italy

One of the best-loved storage systems of all time, Anna Castelli Ferrieri's *Componibili* units can be used singularly or stacked together to create storage towers. There are two sizes, and a square-shaped variant and a tray-like element tops the units to create a useful flat surface. The units' flexibility is further enhanced by the availability of optional castors. Functionally ideal for various rooms in the home – bathroom, bedroom, kitchen, lounge or home office – these modular units with their sliding door-fronts have remained a popular choice for over forty years.

Anna Castelli Ferrieri hat mit *Componibili* eines der beliebtesten Aufbewahrungssysteme aller Zeiten geschaffen, dessen Baukastenelemente einzeln verwendet oder zu Türmen aufgestapelt werden können. Es gibt eine runde und eine quadratische Version, und den Abschluss bildet ein tablettartiges Element, mit dem eine nützliche flache Oberfläche entsteht. Die Elemente sind auch mit Rollen erhältlich, was sie noch flexibler macht. Außerdem sind sie mit Schiebetüren ausgestattet und können überall aufgestellt werden, ob im Bad, im Schlafzimmer, in der Küche, im Wohn- oder Arbeitszimmer – ein begehrter Klassiker seit mehr als vierzig Jahren.

Fabriqués depuis plus de quarante ans, ces meubles créés par Anna Castelli Ferrieri répondent à plusieurs exigences d'utilisation et trouvent leur place dans toutes les pièces de la maison : table de nuit, petit meuble dans le salon, rangement pour le bureau, la cuisine ou la salle de bains. Conçus selon un système de superposition simple mais robuste, ces meubles se composent de différents éléments modulables qui répondent parfaitement à leur fonction. Ronds ou carrés, ces éléments peuvent être équipés de roulettes.

Big Box container, 2004

Enrico Cesana (Italy, 1970–)

www.sphaus.com
Lacquered MDF, plywood
Lackiertes MDF, Schichtholz
MDF laqué, contreplaqué
↕ 40 cm ↔ various ⤢ 65 cm
SpHaus, Milan, Italy

The Milan-based architect Enrico Cesana designed the *Big Box* container for SpHaus's first collection, launched at the Milan Furniture Fair in 2004. Like other designs manufactured by this innovative company, the *Big Box* has a futuristic, space-age aesthetic. It is also a very flexible piece of case furniture based on a system of three linear modules and one L-shaped module, which can be configured in a number of ways and that contain large sliding drawers.

Der in Mailand lebende Architekt Enrico Cesana entwarf den *Big Box*-Container für die erste Kollektion von SpHaus, die 2004 bei der Mailänder Möbelmesse vorgestellt wurde. Wie andere, von diesem innovativen Unternehmen hergestellte Designs besitzt auch die *Big Box* eine futuristische Ästhetik. Das äußerst flexible Kastenmöbel basiert auf einem System aus drei linearen und einem L-förmigen Modul, die auf vielfältige Art kombiniert werden können und große Rollschubladen enthalten.

Basé à Milan, l'architecte Enrico Cesana conçut le meuble *Big Box* pour la première collection de SpHaus, inaugurée au Salon du meuble de Milan en 2004. À l'instar d'autres modèles fabriqués par cette entreprise innovante, *Big Box* offre une vision originale et futuriste. Composée de trois modules linéaires dont l'un en forme de L, ce meuble présente des lignes épurées et lisses. Modulable selon vos attentes, *Big Box* dispose également de grands tiroirs coulissants.

Hole Box container, 2007

Enrico Cesana (Italy, 1970–)

www.sphaus.com
Lacquered MDF, plywood
Lackiertes MDF, Schichtholz
MDF laqué, contreplaqué
↕ 45 cm ↔ 300 cm ↗ 63 cm
SpHaus, Milan, Italy

The *Hole Box* container comprises four modular units that can be joined together to form the required length of storage space. The central unit with the hole cut into it is specifically intended to accommodate home cinema equipment, a DVD player or a digital box. Sleek yet futuristic, the *Hole Box* is a thoroughly contemporary solution that stylishly updates the idea of the traditional sideboard.

Das *Hole Box*-Sideboard besteht aus vier Modulen, die zur gewünschten Länge zusammengesetzt werden können. Das zentrale Modul hat eine Öffnung für die Unterbringung von Geräten wie DVD Player oder Digital-Receiver. Elegant und doch futuristisch, ist die *Hole Box* eine durch und durch zeitgenössische Lösung, eine stilvolle Aktualisierung des traditionellen Sideboards.

Le buffet *Hole Box* comporte quatre modules qui peuvent être assemblés sur la longueur, se transformant ainsi en un immense meuble de rangement design. L'unité centrale est idéale pour accueillir un équipement home cinéma, un lecteur DVD ou un décodeur numérique. Élégant et futuriste à la fois, *Hole Box* offre une version contemporaine du bahut traditionnel.

Simplon storage units, 2003

Jasper Morrison (UK, 1959–)

www.cappellini.it
Solid aluminium, oak veneer, polished lacquer or anodised honeycomb aluminium composite
Aluminium Massives mit Eichefurnier oder Hochglanzlack, Füße aus exloxiertem Aluminium
Aluminium massif, placage en chêne laqué ou nid-d'abeilles en aluminium anodisé
↕ 78 cm ↔ 240 cm ↗ 44 cm (variation shown)
Cappellini, Arosio, Italy

Inspired by the work of Dieter Rams, Jasper Morrison has always tried to find essential solutions to design problems that are unobtrusive yet aesthetically pleasing, durable and useful; and which express an honesty in structure and materials. His *Simplon* range of high and low storage units exhibit this guiding desire for simple integrity within design. The purity of their aesthetic also ensures that it is impervious to the vagaries of fashion.

Inspiriert von den Arbeiten von Dieter Rams, hat Jasper Morrison stets versucht, essentielle Lösungen für Designprobleme zu finden, die unaufdringlich, aber ästhetisch ansprechend, beständig und nützlich zugleich sind und in Struktur und Material etwas Aufrichtiges zum Ausdruck bringen. Sein *Simplon*-Sideboard aus hohen und niedrigen Behältern veranschaulicht diesen Wunsch nach einfacher Integrität im Design. Die schlichte Ästhetik sorgt außerdem dafür, dass es für die Launen der Mode unanfällig ist.

Influencé par l'œuvre de Dieter Rams, Jasper Morrison s'évertue à trouver des solutions pratiques aux problèmes de conception en créant des meubles à la fois esthétiques, fonctionnels et résistants. Ses créations offrent un style épuré, tant dans leur structure que dans les matériaux. Les meubles de rangement de la gamme *Simplon* illustrent ce désir d'une conception simple. La pureté de leur esthétique leur confère un charme intemporel, indifférent aux caprices de la mode.

Snow cabinets, 1993

Thomas Sandell (Finland, 1959–) & Jonas Bohlin (Sweden, 1953–)

www.asplund.org
Lacquered MDF, solid wood
Lackiertes MDF, Massivholz
MDF laqué, bois massif
↕ 109 cm ↔ 90 cm ↗ 42 cm (variation shown)
Asplund, Stockholm, Sweden

Available in eight muted colours, ranging from dove grey to midnight blue, the extensive *Snow* cabinet range is a superb storage system for the home and home-office. Comprising eleven different units (including a wardrobe, various chests-of-drawers and glass-fronted cabinets) the collection was designed to address all conceivable storage needs. Beautifully made, the *Snow* cabinets express the subtle aesthetic purity of modern Scandinavian design.

Die umfangreiche, in acht gedeckten Farben – von Taubengrau bis Nachtblau – erhältliche *Snow*-Schrankserie ist ein hervorragendes Aufbewahrungssystem für Heim und Büro. Sie besteht aus elf verschiedenen Teilen (darunter eine Garderobe, mehrere Kommoden und Schränke mit Glastüren) und wurde für alle erdenklichen Aufbewahrungsbedürfnisse entworfen. Die schönen *Snow*-Schränke veranschaulichen die subtile ästhetische Klarheit des modernen skandinavischen Designs.

Disponible en huit couleurs douces, du gris tourterelle au bleu nuit, la gamme de meubles *Snow* offre un magnifique système de rangement pour la maison et le bureau. Composée de onze unités différentes (penderie, commodes et meubles vitrés), cette collection répond aisément aux soucis de rangement. Extrêmement bien conçus, les meubles *Snow* reflètent la pureté esthétique du design danois contemporain.

Ando chests-of-drawers, 2001

Paolo Piva (Italy, 1950–)

www.poliform.it
Wenge, oak or laminate
Wenge, Eiche oder Laminat
Wengé, chêne ou stratifié
↕ 98 cm ↔ 95 cm ⤢ 53 cm
↕ 69 cm ↔ 156 cm ⤢ 53 cm
Poliform, Inverigo, Italy

Paolo Piva is a prolific furniture designer whose work is characterised by perfect mathematical proportions, which in turn give his designs a distinctive elemental and architectonic quality. His *Ando* bedroom range for Poliform includes these two elegantly simple chests-of-drawers. Available in a choice of wood-veneered or matt lacquered finishes, these designs would look great in almost any interior scheme.

Die Arbeit des produktiven Möbeldesigners Paolo Piva besticht durch perfekte mathematische Proportionen, die seinen Designs eine sehr elementare und architektonische Qualität verleihen. Die beiden hier gezeigten eleganten Kommoden gehören zu seiner *Ando*-Schlafzimmer-Reihe für Poliform. Sie sind mit verschiedenem Holzfurnier oder lackiertem Finish zu haben und sehen in fast jeder Einrichtung sehr gut aus.

Paolo Piva est une designer de meubles dont l'œuvre se caractérise par de parfaites proportions mathématiques, révélant des créations d'une qualité distinctive et architectonique. Conçue pour Poliform, sa collection de chambre à coucher *Ando* comprend ces deux élégantes commodes. Disponibles dans une palette de bois plaqué ou en finitions laquées mat, ces créations s'adaptent à tous les styles d'intérieur.

KAST 01 cupboard system, 2003

Bert van der Aa (Netherlands, 1968–)

www.artifort.com
Steel, MDF
Stahl, MDF
Acier, MDF
↕ 40 cm ↔ 160 cm ↗ 45 cm
Artifort, Schijndel, The Netherlands

Since the advent of the De Stijl movement in 1917, Dutch design has been identified with the use of strong geometric forms. Bert van der Aa's KAST 01 cupboard system continues this tradition with its bold architectonic massing which comes in eight different configurations, with the option of one, two or three drawers. The cupboards, including the low version shown here, are available in white lacquer, red lacquer or wood veneer.

Seit den Tagen der De-Stijl-Bewegung, die 1917 ihren Anfang nahm, wird niederländisches Design mit starken Primärfarben und geometrischen Körpern identifiziert. Bert van der Aas Schranksystem KAST 01 setzt diese Tradition mit massigen Modulen fort, die in acht verschiedenen Konfigurationen kombinierbar und jeweils mit einer, zwei oder drei Schubladen lieferbar sind. Die Schrankelemente gibt es weiß oder rot lackiert oder mit Holz furniert.

Depuis l'avènement du mouvement De Stijl en 1917, le design néerlandais s'inspire de formes géométriques fortes. Conçu par Bert van der Aa, KAST 01 poursuit cette tradition avec sa masse architectonique audacieuse. Cette commode illustre une ligne sobre et minimaliste, révélant un meuble à la fois discret et très tendance. Existe en huit configurations, avec un, deux ou trois tiroirs. Ces différents modèles sont disponibles en laqué blanc ou rouge ou en bois de placage.

WrongWoods sideboard & wall unit, 2007

Sebastian Wrong (UK, 1971–) & Richard Woods (UK, 1966–)

www.establishedandsons.com
Silkscreen-printed laminate
Laminat mit Siebdruck
Sérigraphie stratifiée
↕ 64.5 cm ↔ 260 cm ↗ 40.5 cm
↕ 38 cm ↔ 100.5 cm ↗ 34 cm
Established & Sons, London, UK

The quirky *WrongWoods* collection is the result of a creative collaboration between the British artist, Richard Woods – known for his colourful cartoon-like art installations – and the leading British product designer, Sebastian Wrong. A playful fusion of art and design, the *Wrong-Woods* range utilises a silkscreen-printed laminate, which is decorated with a floorboard motif in either different shades of green or in yellow, orange and red. This very eccentrically British range of furniture not only epitomises the increasingly popularity of bold patterning within home furnishings, but also the desire for furnishings with a strong character or personality.

Die unkonventionelle *WrongWoods*-Kollektion ist das Ergebnis der fruchtbaren Zusammenarbeit zwischen dem britischen Künstler Richard Woods, der für seine, an Cartoons erinnernde Kunstinstallationen bekannt ist, und Sebastian Wrong, einem der führenden britischen Produktdesigner. *WrongWoods* basiert auf Laminat mit Siebdruck – entweder eines Fußbodenmotivs oder in verschiedenen Schattierungen von Grün oder Gelb, Orange und Rot – und vereint so spielerisch Kunst und Design. Diese eher exzentrische britische Möbelserie steht für die zunehmende Popularität unerschrockener Muster in der häuslichen Einrichtung und spiegelt zugleich den Wunsch nach Möblierung mit starkem Charakter und Persönlichkeit wieder.

L'originalité de ces meubles *Wrong-Woods* vient de la volonté des designers Sebastian Wrong et Richard Woods de se moquer du faux bon goût des intérieurs bourgeois. Ces créateurs proposent un design peu conventionnel entre l'art contemporain et le style classique, les meubles arborant des couleurs flashy du plus bel effet. Réalisées en contreplaqué, ces créations sont habillées d'un imprimé façon *cartoon* imitant des planches de bois coloré, nuances vertes et jaunes ou rouges et orange. Un style british survitaminé, plein de fantaisie qui amuse par son ironie, offrant un résultat volontairement tape-à-l'œil.

Florence Knoll credenza, 1961

Florence Knoll (USA, 1917–)

www.knoll.com
Ebonised oak, polished steel, marble
Ebonisierte Eiche, polierter Stahl, Marmor
Chêne ébonisé, acier poli, marbre
↕ 65 cm ↔ 189 cm ↗ 45.5 cm
Knoll, New York (NY), USA

One of the great champions of Modern-ism in America, Florence Knoll revolu-tionised the spatial planning of interiors, while her belief in encompassing "total design" contributed greatly to the suc-cess of Knoll International. Her designs for the company also became acknowl-edged Mid-Century classics, such as this credenza that was originally designed as part of her 1961 *Executive Collection* and which still brings a stylish sophistication to any interior.

Als eine der Vorreiterinnen der us-amerikanischen Moderne revolutio-nierte Florence Knoll die Raumplanung bei Inneneinrichtungen. Ihr Glaube an die allumfassende Kraft des „totalen Designs" trug maßgeblich zum Erfolg von Knoll International bei. Ihre Möbelent-würfe sind berühmte Mid-Century-Klas-siker, so auch dieses Buffet. Das 1961 für Knolls *Executive Collection* entworfene Möbel verleiht bis heute jeder Einrichtung eine elegante Note.

Véritable emblème du Modernisme en Amérique, Florence Knoll propose des produits reflétant l'excellence et l'innovation technologique. Sa devise « la réussite d'un produit passe par un design de qualité » reste toujours d'actualité. Bouleversant la disposition des espaces, ses créations sont devenues des clas-siques incontournables des années 50. Élégant et sophistiqué, ce buffet conçu initialement pour compléter sa collection *Executive* de 1961 offre un design intem-porel, très prisé.

Sapporo storage system, 1998

Jesús Gasca (Spain, 1939–)

www.stua.com
Lacquered MDF, steel
lackiertes MDF, Stahl
MDF laqué, acier
↕ 54 cm ↔ 120 cm ↗ 35 cm (single unit)
Stua, Astigarraga, Spain

Jesús Gasca's *Sapporo* storage system is an attractive and highly flexible design based on modular elements that can be stacked up to six units high. The units rest on a steel base that is either fixed or movable with castors. The system elements can also be fitted with sliding doors, which come in a variety of materials: transparent or frosted tempered glass, coloured Perspex or a reversible variant with walnut on one side and oak on the other.

Bei Jesús Gascas Aufbewahrungssystem *Sapporo* handelt es sich um ein reizvolles, überaus flexibles Design, bei dem bis zu sechs modulare Elemente übereinander gestapelt werden können. Das Ganze ruht auf einer Stahlbasis, die wahlweise fest montiert ist oder beweglich auf Rollen. Für die Elemente können Schiebetüren in verschiedenen Materialien gewählt werden: klares oder sandgestrahltes Glas, farbiges Plexiglas oder – in einer doppelseitigen Variante – mit Walnuss auf der einen und Eiche auf der anderen Seite.

Réalisé par Jesús Gasca, ce système de rangement se compose de tiroirs individuels et modulables qui s'empilent pour former une étagère de un à six étages. Qu'ils soient fixes ou mobiles (avec roulettes), chaque élément dispose d'une base en acier et les portes coulissantes des tiroirs sont transparentes, en verre givré ou plexiglas Perspex. Une version réversible avec un côté en noyer et l'autre en chêne est également disponible. Contemporain, ce meuble allie à la perfection esthétique et fonctionnalité.

Box & Box credenza, 2008

Piero Lissoni (Italy, 1956–)

www.artelano.com
MDF, glass
MDF, Glas
MDF, verre
↕ 55, 75 cm ↔ 190 cm ⤢ 50 cm
Artelano, Paris, France

A prolific furniture designer, Piero Lissoni is renowned for beautifully balancing function with aesthetics. His work, such as the *Box & Box* credenza, is particularly notable for its sparse elegance and linear purity. The box-like exterior of this design conceals two large sliding drawers, and comes in either white or charcoal grey. A highly useful piece of furniture, the *Box & Box* is also available in two heights.

Der sehr produktive Möbeldesigner Piero Lissoni versteht es, Funktion und Ästhetik in ein harmonisches Verhältnis zu setzen. Seine Arbeiten zeichnen sich vor allem durch zurückhaltende Eleganz und klare Linienführung aus, so auch die Anrichte *Box & Box*. Hinter dem kastenartigen Äußeren des Designs, das entweder in Weiß oder in Anthrazit erhältlich ist, verbergen sich zwei große Rollschubladen. *Box & Box* ist ein ausgesprochen zweckmäßiges Möbel, das außerdem in zwei verschiedenen Höhen zu haben ist.

Piero Lissoni est un designer connu pour équilibrer parfaitement la fonction et l'esthétique. Son œuvre, à l'instar du buffet *Box & Box*, se démarque par son élégance rare et sa pureté linéaire. La surface extérieure de ce modèle dissimule deux grands tiroirs coulissants, blanc ou gris charbon. Disponible en deux hauteurs, *Box & Box* constitue un meuble de rangement raffiné extrêmement pratique.

Epiplos I cabinet, 2004
Antonia Astori (Italy, 1940−)

www.driade.it
MDF, aluminium, painted steel
MDF, Aluminium, lackierter Stahl
MDF, aluminium, acier peint
↕ 75 cm ↔ 135 cm ⤢ 52.5 cm
Driade, Fossadello di Caorso, Italy

Renowned throughout the world for its incredible range of progressive furniture, Driade is a truly Milanese company, and Antonia Astori (the sister of its founder) is a truly Milanese designer. Her furniture, such as the *Epiplos I* cabinet, is marked by a strong architectonic quality that manages to combine practical function with a distinctive and stylish Minimalism.

Driade, weltweit für ein unglaubliches Angebot an progressiven Möbeln bekannt, ist ein typisches Mailänder Unternehmen, und Antonia Astori (die Schwester des Unternehmensgründers) ist eine typische Mailänder Designerin. Ihre Möbel, wie beispielsweise die Kommode *Epiplos I*, zeichnen sich durch eine starke architektonische Qualität aus und kombinieren praktische Funktion mit ausgeprägtem, stilvollem Minimalismus.

Connue dans le monde entier pour sa collection de mobilier progressiste, Driade est une authentique entreprise milanaise au même titre qu'Antonia Astori (sœur du fondateur de la société), une créatrice milanaise. Ses meubles, comme par exemple le buffet *Epiplos I*, reflètent une qualité architecturale marquée, combinant merveilleusement la fonction pratique à un minimalisme élégant et raffiné.

Tide credenza, 2006

Karim Rashid (Canada/USA, 1960–)

www.horm.it
MDF, laquer, metal
MDF, Lack, Metall
MDF, laqué, métal
↕ 96 cm ↔ 192 cm ⤢ 60 cm (variation shown)
Horm, Pordenone, Italy

Available in three different sizes, Karim Rashid's *Tide* credenza is a stunning design with its sweeping wave of thin slats. Known for its commitment to manufacturing quality and design innovation, Horm manufactures this remarkable piece in ten different coloured finishes, and it can be configured with either two drawers and one fall flap, or two deep drawers. Like other designs by Rashid, the *Tide* combines a sculptural dynamism with functional practicality.

Das Design des in drei Größen erhältlichen Sideboards *Tide* von Karim Rashid verblüfft durch die ausladende Wölbung mit schmalen Leisten. Der italienische Hersteller Horm hat sich seit jeher der Verbindung von handwerklicher Qualität und innovativem Design verschrieben. Dieses beeindruckende Möbel ist in zehn verschieden farbigen Oberflächen lieferbar und kann entweder mit zwei Schubladen und einer Klappe oder mit zwei großen Schubladen bestückt werden. Wie alle Designs von Rashid verbindet auch *Tide* Funktionalität mit skulpturaler Dynamik.

Réalisé en trois tailles, le buffet *Tide* de Karim Rashid offre un design exceptionnel, avec ses fines lames semblables à des vagues fluides. Connue pour sa qualité de fabrication et ses designs novateurs, Horm réalise ce remarquable buffet en dix finitions de différentes couleurs. Disponible avec deux tiroirs et un large abattant ou seulement deux tiroirs très profonds. À l'instar d'autres créations de Rashid, *Tide* combine fonctionnalité et dynamisme sculptural pour une simplicité spectaculaire.

Crash sideboard, 2008

Ferruccio Laviani (Italy, 1960–)

www.emmemobili.it
Oak, wenge
Eiche, Wenge
Chêne, wengé
↕ 95 cm
Emmemobili, Cantù, Italy

This impressive sideboard is distinguished by its unusual faceted form, which gives the design a strong sculptural identity. By utilizing specialised cabinet-making skills honed over decades by Italian craftsmen, Ferruccio Laviani has managed to maintain the direction of the sideboard's wood grain, despite the different thicknesses and asymmetrical shapes of the facing veneers.

Dieses eindrucksvolle Buffet zeichnet sich durch seine ungewöhnlich facettierte Form und – daraus folgend – seinem skulpturalen Charakter aus. Indem er sich auf das in Jahrzehnten angesammelte Fachwissen und Können italienischer Möbeltischler verließ, gelang es Ferruccio Laviani trotz der unterschiedlichen Stärken und asymmetrischen Formen der Furniertäfelchen, den natürlichen Maserungsverlauf des Holzes zu erhalten bzw. wieder herzustellen.

Ce buffet se distingue par sa forme inhabituelle à multiples facettes, illustrant une forte identité sculpturale. Utilisant les compétences d'ébénisterie perfectionnées durant des décennies par des artisans italiens, Ferruccio Laviani réussit à maintenir la qualité du grain des bois malgré les différentes épaisseurs et les formes asymétriques des feuilles de placage de la surface du meuble.

Lerici two-drawer unit, 2002

Ferruccio Laviani (Italy, 1960–)

www.emmemobili.it
Wenge or oak, plywood
Wenge oder Eiche, Schichtholz
Chêne ou wengé, contreplaqué
↕ 46 cm ↔ 60 cm ⤢ 44 cm
Emmemobili, Cantù, Italy

Ferruccio Laviani's undulating *Lerici* range includes a two-drawer unit (shown here) that can be used as a bedside cabinet or elsewhere in the home, and a four-drawer chest-of-drawers. Both case pieces incorporate distinctive wave-like curved plywood drawer fronts. Available in wenge, natural oak or a number of stained wood finishes, the *Lerici* cabinets combine traditional Italian craftsmanship with striking contemporary Italian design.

Ferruccio Lavianis *Lerici*-Kollektion umfasst das abgebildete Element mit zwei Schubladen, das als Nachtschränk-chen oder Beistelltisch dienen kann, und außerdem eine Kommode mit vier Schubladen. Beide Stücke haben wellen-förmig geschwungene Schubladenfronten aus Schichtholz und sind mit Furnieren aus Wenge, naturbelassener Eiche oder anderen gebeizten Hölzern lieferbar. Die *Lerici*-Schubladenmöbel verbinden traditionelle italienische Möbeltischler-kunst mit zeitgenössischem italienischen Design.

La collection très en « vague » de Fer-ruccio Laviani comprend une commode à deux tiroirs, idéale comme table de chevet ou meuble d'appoint. Une version à quatre compartiments est également disponible. Ces deux modèles disposent de tiroirs en contreplaqué aux courbes ondulées extrêmement élégantes. Les commodes *Lerici* allient l'artisanat tradi-tionnel italien au style épuré du design italien contemporain. Existe en wengé, chêne naturel ou dans une palette de finitions en bois teinté.

Kaar shelves, 2005

Setsu Ito (Japan, 1964–) & Shinobu Ito (Japan, 1966–)

www.sphaus.com
Lacquered plywood
Lackiertes Schichtholz
Contreplaqué laqué
↕ 39 cm ↔ 50 cm ↗ 50 cm (single unit)
SpHaus, Seregno, Italy

A contemporary take on the classical *étagère*, the *Kaar* is made up of single modules that are stacked one on top of the other using a rotating element. Available either as one, two or three module versions, the *Kaar* has a distinctive looping profile, which explains the choice of its name, a word that in Sikh culture means 'unending'. These storage/display units look especially striking when positioned at different angles.

Als zeitgenössische Neudefinition der klassischen Etagere besteht *Kaar* aus einzelnen Modulen, die mit Hilfe eines drehbaren Elements aufeinander gestapelt werden können. Es ist als Version aus einem, zwei oder drei Modulen erhältlich und hat ein charakteristisches Looping-Profil, das dem Design seinen Namen gab – das Wort bedeutet in der Kultur der Sikhs „endlos". Diese Aufbewahrungs-/Ausstellungsmodule sehen besonders eindrucksvoll aus, wenn sie in verschiedenen Winkeln positioniert werden.

Version contemporaine de l'étagère classique, *Kaar* est composée de modules individuels qui s'empilent les uns sur les autres grâce à un élément rotatif. Disponible en un, deux ou trois modules, *Kaar* se distingue par sa silhouette en boucle et illustre le choix de son nom signifiant « sans fin » dans la culture sikh. Ces modules prennent tout leur sens lorsqu'ils sont placés sous différents angles.

Plan storage system, 1999

Jasper Morrison (UK, 1959–)

www.cappellini.it
Satin stainless steel, rubber; with natural oak, ebony-stained oak, or lacquered/polished macroter
Satinierter Edelstahl, Gummi; in Eiche natur, Eiche Farbton Ebenholz oder Macroter- bzw. Hochglanzlack
Satin d'acier inoxydable, caoutchouc, chêne naturel, chêne teinté ébène, ou laqué/macroter poli
↕ 108 cm ↔ 120 cm ↗ 60 cm
↕ 54 cm ↔ 60 cm ↗ 60 cm
↕ 18 cm ↔ 120 cm ↗ 90 cm
Cappellini, Arosio, Italy

Based on the idea of a modular system, the *Plan* collection is a highly adaptable case furniture range comprising cupboards and drawer units of different sizes. Available in a natural oak veneer or with a colourful high-gloss lacquered finish, this versatile design offers a degree of customization in that its units can be mixed and matched according to personal preferences. When stacked, the drawer units are reminiscent of an architect's plan chest – hence the title of the design – and optional CD holder inserts are also available.

Die *Plan*-Kollektion basiert auf der Idee eines modularen Systems und ist eine äußerst anpassungsfähige Auswahl von Containermöbeln, bestehend aus verschieden großen Schränken und Schubladenelementen. Die Module dieses vielseitigen, in Eichefurnier oder buntem Hochglanzfinish erhältlichen Designs lassen sich individuell kombinieren. Übereinander gestapelt, erinnern die Schubladenelemente an einen Planschrank – daher auch der Name des Designs; optional können auch CD-Halter eingesetzt werden.

La collection *Plan* est une série d'éléments juxtaposables, incluant des armoires disposant de tiroirs de différentes tailles. Disponible en placage en chêne naturel ou coloré avec une finition laquée étincelante, ce modèle à usages multiples se combine selon vos envies. Une fois empilés, les tiroirs rappellent le coffre d'un plan de travail d'architecte, d'où son nom. Un range-CD est également disponible.

Layout A+C storage unit, 2004

Michele De Lucchi (Italy, 1951–)

www.aliasdesign.it
Anodised or enamelled extruded aluminium, MDF
Eloxiertes oder fließgepresstes emailliertes Aluminium, MDF
Aluminium extrudé, anodisé ou laqué, MDF
↕ 199.5 cm ↔ 172 cm ⤢ 79 cm (large)
Alias, Grumello del Monte, Italy

With its undulating wave-like form made of extruded aluminium, the *Layout A+C* storage unit is the absolute antithesis of the dull and ubiquitous cuboid cupboard. Like other furniture manufactured by Alias, Michele De Lucchi's design is not only visually engaging but also a *tour-de-force* of precision engineering. With its four doors and eight shelves accessed from both sides, this unusual yet attractively organic design makes an excellent and useful room divider. Shorter versions are also available.

Das Schranksystem *Layout A+C* bildet mit seiner wellenartigen Form aus fließgepresstem Aluminium eine echte Antithese zum allgegenwärtigen kubischen Schrank. Wie viele andere Möbel aus der Herstellung von Alias ist auch Michele De Lucchis Design nicht nur ein Hingucker, sondern auch ein ingenieurstechnischer Parforceritt. Die vier Türen und acht Regale sind von beiden Seiten zugänglich und machen dieses attraktive organische Design so zu einem großartigen und praktischen Raumteiler. *Layout A+C* ist auch in kleineren Ausführungen erhältlich.

Avec ses vagues ondulantes en aluminium extrudé, *Layout A+C* s'oppose à la traditionnelle armoire cuboïde. À l'instar d'autres créations conçues par Michele De Lucchi, cette armoire présente une esthétique visuelle originale et illustre une prouesse technologique impressionnante. Avec ses quatre portes et ses huit étagères accessibles des deux côtés, cette création organique comporte des joints antipoussière, préservant l'intérieur. Ce modèle propose différentes configurations permettant de s'intégrer dans n'importe quel espace architectural. Également disponible en version plus courte.

Paesaggi Italiani wardrobes, 1995–2005

Massimo Morozzi (Italy, 1941–)

www.edra.com
Wood, aluminium, steel, PMMA
Holz, Aluminium, Stahl, PMMA
Bois, aluminium, acier, PMMA
↕ 51–291 cm ↔ 45, 93 cm ⤢ 39.5, 58.5 cm
Edra, Perignano, Italy

Like giant building blocks, Massimo Morozzi's storage units can be configured to provide a high level of customisation. Although originally designed in 1995, each year new mix-and-match elements have been added and new compositions explored so as to provide novel 'Italian landscapes' (the English translation of the design's title). One of the great attractions of this modular storage system is that it can be added to over time, as and when one needs more cupboard space. Available in two widths, two depths, six heights and a rainbow of seventy-five colours and finishes, this classic design is a truly versatile solution.

Massimo Morozzis Aufbewahrungs-einheiten passen sich überaus flexibel den individuellen Bedürfnissen an. Das ursprünglich aus dem Jahr 1995 stammende Design wurde jedes Jahr um weitere passende Elemente zum Kombinieren ergänzt, sodass immer neue „Italienische Landschaften" (so die deutsche Übersetzung des Namens) entstehen. Besonders attraktiv machen die Paesaggi Italiani, dass man sie im Laufe der Zeit, sollte man mehr Stauraum benötigen, einfach um weitere Elemente ergänzen kann. Mit zwei Breiten, zwei Tiefen, sechs Höhen und einem wahren Regenbogen von fünfundsiebzig Farben und Oberflächen ist dieses klassische Design wahrhaft wandlungsfähig.

Semblable à des cubes géants de construction, ce meuble de rangement créé par Massimo Morozzi propose différentes configurations, en fonction de vos besoins. Initialement conçu en 1995, ce meuble n'a cessé d'évoluer grâce à de nouveaux éléments rajoutés au fil des ans. De nouvelles compositions ont été testées afin de créer un nouveau « paysage italien » (traduction du nom du meuble). Le principal intérêt de cette création modulable est sa capacité à être agrandie d'année en année. Disponible en deux largeurs, deux profondeurs, six hauteurs et en une palette de soixante-quinze couleurs, ce meuble s'avère extrêmement polyvalent.

During the mid-1970s geometric-based functional design made a strong comeback after a decade of sculptural space-age fantasies. Giulio Polvara's modular *4760* was one of the most successful shelving systems of the period and is still an excellent and affordable choice, which can be easily added to when more units are needed. Like building blocks, the self-supporting elements lock together without the need of screws, while the container cube unit comes in a number of colours and functions as a handy storage drawer.

Nach einem Jahrzehnt voller Anleihen an Science-Fiction-Filmsets erlebte das streng geometrische und funktionale Design Mitte der 1970er Jahre ein Comeback. Giulio Polvaras modulares *4760* war eines der erfolgreichsten Regalsysteme jener Zeit und ist immer noch eine ausgezeichnete, bezahlbare Wahl. Wie bei einem Baukasten lassen sich die selbsttragenden Elemente ohne Schrauben miteinander verbinden und, falls erforderlich, erweitern. Dazu gibt es Container-Regalwürfel in verschiedenen Farben, die sich gut als praktische Aufbewahrungsboxen eignen.

Après une période ludique et novatrice, le design fonctionnel opère un retour en force au milieu des années 70. La bibliothèque modulable *4760* de Giulio Polvara s'apparente à un jeu de construction, permettant de créer des rayonnages aux formes et aux dimensions illimitées. L'assemblage s'effectue au moyen d'un simple emboîtement à pression des éléments sans utiliser de vis. Cette bibliothèque s'accompagne d'un grand cube proposé en différentes couleurs. Conçu comme accessoire utile et coloré de la bibliothèque, ce cube s'utilise également comme élément de rangement.

4760 modular bookshelf, 1975
Giulio Polvara (Italy, active 1970s)

www.kartell.it
ABS
ABS
ABS
↕ 35.5 cm ↔ 35.5 cm ↗ 35.5 cm (Cube unit)
Kartell, Milan, Italy

Shelf bookcase (model no. SL66), 2006

Naoto Fukasawa (Japan, 1956–)

www.bebitalia.it
Acrylic resin
Acrylharz
Résine d'acrylique
↕ 145 cm ↔ 66 cm ⤢ 37 cm
B&B Italia, Novedrate, Italy

When B&B Italia first launched this range of visually striking bookcases as a limited edition of 300 pieces, it was made of enamelled metal. Today, however, the more affordable unlimited version is made from a white resin known as Natural Acrylic Stone LG. This tough-wearing composite material, made from a blend of 75% natural minerals suspended in an acrylic matrix, has a seductive and tactile marble-like surface, while also being highly durable and stain-resistant.

Als B&B Italia diese Serie optisch verblüffender Bücherregale erstmals in einer limitierten Auflage von 300 herausbrachte, waren sie noch aus emailliertem Metall. Heute ist die nicht limitierte und daher erschwingliche Neuauflage aus einem weißen Kunststoffgranulat, besser bekannt unter dem Namen Natural Acrylic Stone LG. Dieser robuste Verbundwerkstoff aus 75% Naturmaterialen wird mit einer Acrylgrundmasse abgebunden und verleiht dem *Model No. SL66* seine seidig warme, sinnlich ansprechende marmorartige Oberfläche, die zugleich strapazierfähig und fleckenabweisend ist.

Lors du lancement initial de cette gamme de bibliothèque, B&B Italia avait opté pour une édition limitée de trois cents pièces, en métal émaillé. Réalisée de nos jours en résine blanche connue sous le nom de Natural Acrylic Stone LG, cette version contemporaine est éditée de manière permanente. Composé d'un mélange contenant 75 % de pigments et minéraux naturels fixés par un liant acrylique, entièrement recyclable, ce matériau s'avère à la fois esthétique, imperméable, lisse et résistant aux taches.

Alinata shelving system, 2007

Satyendra Pakhalé (India, 1967–)

www.erreti.com
Aluminium extrusion, glass, wood
Stranggezogenes Aluminium, Glas, Holz
Extrusion d'aluminium, verre, bois
↕ 133 cm ↔ 167 cm ⤢ 38.7 cm (configuration shown)
Erreti, Ravenna, Italy

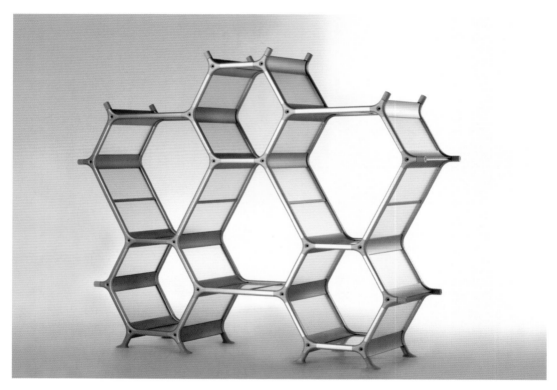

This extraordinary freestanding shelving system is highly engineered yet, at the same time, highly sculptural. Like other designs by Satyendra Pakhalé, the *Alinata* has a strong poetic quality that reflects his desire to create work that is both original and humancentric. Its modular cell-like elements, which look as though they have come from a giant sci-fi beehive, are made of extruded aluminium. When used in conjunction with either wood or glass panels, they can be configured to create endless eye-catching yet functional combinations.

Dieses technisch ausgereifte, freistehende Regalsystem wirkt wie eine Skulptur. Wie andere Entwürfe von Satyendra Pakhalé hat auch *Alinata* eine fast poetische Note, die seinen Wunsch widerspiegelt, bei seinen originellen Arbeiten den Mensch in den Mittelpunkt zu stellen. Seine modularen, wabenartigen Elemente aus stranggepresstem Aluminium wirken wie aus einem gigantischen Science-Fiction-Bienenstock. Mit Holz- oder Glaspaneelen lassen sie sich zu endlosen, zweckmäßigen, ins Auge springenden Kombinationen zusammenfügen.

À la fois sophistiquées et sculpturales, les étagères *Alinata* dévoilent une forte qualité poétique. À l'instar des autres créations de Satyendra Pakhalé, ces étagères reflètent son désir de créer une œuvre à la fois originale et anthropocentrique. Modulable, sa structure aux allures futuristes permet différentes possibilités. L'ossature se combine avec du bois ou du verre, mettant en valeur une infinité de configurations, toutes aussi fonctionnelles qu'esthétiques. Semblable à une immense ruche, *Alinata* fournit une touche originale, voire ludique, dans un intérieur contemporain.

'93–'08 bookshelf, 1993 (updated 2008)

Carlo Cumini (Italy, 1953–)

www.horm.it
Lacquered MDF, lacquered beech or walnut
MDF, Birke oder Walnuss, lackiert
MDF laqué, hêtre ou noyer laqué
↕ 218 cm ↔ 227 cm ⤢ 32 cm
Horm, Pordenone, Italy

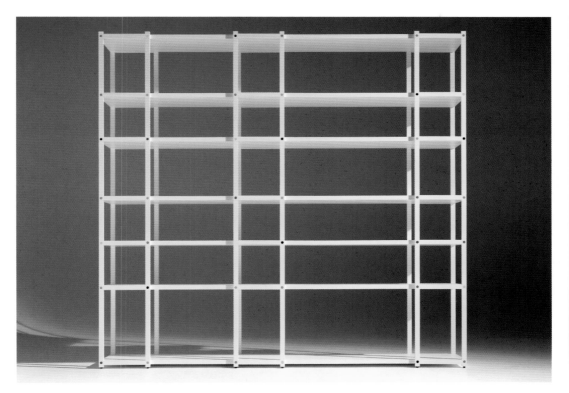

When it was originally designed in 1993, this elegant bookshelf was known as the *Solaio*. In 2008, however, it was updated and renamed – notably the back elements were removed, giving the shelving a greater spatial dynamism. Inspired by the International Style architecture of Ignazio Gardella, this highly versatile neo-rationalist design has various additional options, including a cabinet unit with fall-front door and a bar shelf.

Der erste Entwurf dieses eleganten Bücherregals aus dem Jahr 1993 trug den Namen *Solaio*. 2008 wurde es als *'93–'08* mit aktualisiertem Redesign vorgestellt, bei dem v. a. die Rückwände entfernt wurden, wodurch das Regal eine stärkere räumliche Dynamik entfaltete. Das von der International-Style-Architektur eines Ignazio Gardella inspirierte Regal mit seinem sehr wandlungsfähigen, neo-rationalistischen Design lässt sich um zusätzliche Komponenten ergänzen, einschließlich einer Schrankeinheit mit aufklappbarer Tür und Barfach.

Lors de sa création en 1993, cette bibliothèque se nommait *Solaio*. Rebaptisée et actualisée en 2008, une nouvelle version propose certaines variantes. Les éléments arrière ont été enlevés, donnant aux rayonnages une certaine profondeur. Inspiré par l'architecture de Style international d'Ignazio Gardella, ce design néo-rationaliste offre différentes configurations grâce à certains éléments optionnels, notamment un petit placard et une étagère de bar.

The leading Japanese architect, Toyo Ito's de-materialist buildings are characterised by his playful experimentation with materials, which often leads to tactile and visual surprises. Using the same methodology for furniture, Ito's *Sendai 2005* bookshelf is a masterwork that Horm describes as an 'exhibition sculpture'. Certainly it possesses an aesthetic beauty and dynamic tension, with the wooden supports set at different angles seeming to defy gravity.

Das spielerische Experiment mit dem Material, ein Charakteristikum der de-materialistischen Gebäude des japanischen Stararchitekten Toyo Ito, hält viele visuelle und fühlbare Überraschungen bereit. Auf die Möbelmanufaktur übertragen ist Itos Regal *Sendai 2005* ein echtes Meisterwerk, das dessen Hersteller Horm zu Recht als „Ausstellungskulptur" bezeichnet. Die in unterschiedlichen Winkeln angebrachten Holzstützen scheinen mit ihrer sublimen Schönheit und dynamischen Spannung buchstäblich der Schwerkraft zu trotzen.

Grand architecte japonais contemporain, Toyo Ito maîtrise une grande variété de matériaux, le conduisant à des créations architecturales ludiques voire surprenantes. Lorsqu'il conçoit des meubles, il procède de la même manière. Considérée par Horm comme étant « une sculpture de présentation » *Sendai 2005* est un véritable chef-d'œuvre. Cette étagère en verre, dotée de montants en noyer et en aulne défiant la gravité, dévoile une sublime beauté esthétique.

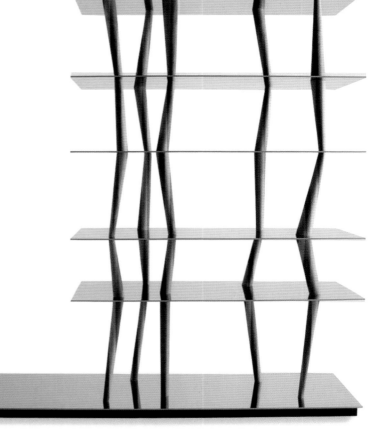

Sendai 2005 bookshelf, 2005

Toyo Ito (Japan, 1941–)

www.horm.it
Polished laminated stainless steel, walnut, alder wood
Polierter laminierter Edelstahl, Walnuss, Erle
Acier inoxydable poli-miroir et stratifié, noyer, bois d'aulne
↕ 192 cm ↔ 192 cm ↗ 48 cm
Horm, Pordenone, Italy

Level bookcase, 2007

Arik Levy (Israel, 1963–)

www.zanotta.it
MDF, aluminium, oak veneer
MDF, Aluminium, Eichenfurnier
MDF, aluminium, placage de chêne
↕ 190 cm ↔ 148 cm ⤢ 32 cm
Zanotta, Milan, Italy

The antithesis of a bland and boring bookcase, Arik Levy's *Level* is reminiscent of a De Stijl painting with its strong vertical and horizontal elements interspersed with blocks of bold colour in grey, orange and green. These elements with coloured interiors can be positioned according to one's requirements and give the bookcase a strong, rhythmic quality. Storage container elements are also available, giving the system an enhanced level of flexibility and functionality.

Arik Levys *Level* ist das Gegenteil eines farblosen, langweiligen Bücherregals. Mit seinen ausgeprägten vertikalen und horizontalen Elementen, die von intensiven Farbblöcken in Grau, Orange und Grün durchbrochen werden, erinnert es vielmehr an ein De-Stijl-Gemälde. Die farbigen Rückpaneele können je nach Wunsch positioniert werden, wodurch eine ausgeprägt rhythmische Qualität erreicht wird. Ebenfalls erhältliche Aufbewahrungseinheiten verleihen dem Regalsystem weitere Flexibilität und Funktionalität.

Véritable réminiscence d'une peinture de De Stijl, cette grande structure géométrique s'apparente à un puzzle géant dans lequel viennent s'imbriquer des bacs colorés. Conçue par Arik Levy, *Level* occupe superbement l'espace. En position verticale ou horizontale, cette bibliothèque architecturale est une pure merveille, reflétant un esprit très graphique. Le design novateur est ici associé à une recherche sur les matériaux. Une bibliothèque contemporaine, à la fois esthétique et fonctionnelle.

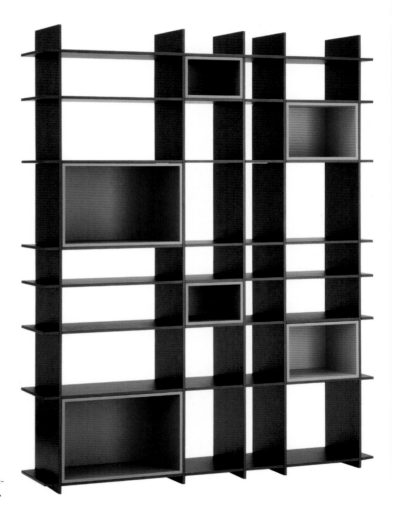

Bookworm shelf, 1997

Ron Arad (Israel/UK, 1951–)

www.kartell.com
Technopolymer
Technopolymer
Technopolymère
↕ 19 cm ↔ 320, 520, 820 cm ⤢ 20 cm
Kartell, Milan, Italy

A truly inventive design genius, Ron Arad's work is always imaginative and playful, such as his squirming *Bookworm* shelving for Kartell. This idiosyncratic design also offers scope for personal creativity in that one can decide how to shape the curving flexible shelf when fixing it to the wall. Made from a colourful extrusion of batch-dyed translucent technopolymer, the shelf is extremely easy to manufacture and is also reasonably strong, with every bookend section capable of supporting ten kilos.

Ron Arad ist ein äußerst erfinderisches Design-Genie, dessen Arbeiten stets fantasievoll und verspielt sind, wie auch dieses gewundene *Bookworm*-Regal für Kartell. Das eigenwillige Design bietet darüber hinaus Raum für persönliche Kreativität, denn der Benutzer kann beim Anbringen an die Wand selbst entscheiden, welche Form er dem biegsamen Regal gibt. Es besteht aus durchgefärbtem, im Fließpressverfahren hergestellten, transparenten Technopolymer und ist nicht nur extrem leicht zu produzieren, sondern auch sehr stabil, denn die Traglast zwischen zwei Buchstützen beträgt bis zu zehn Kilo.

Lorsque la combinaison entre technologie et poésie rencontre le goût pour la beauté anticonformiste. Flexible et fonctionnelle, cette étagère réalisée par Ron Arad pour Kartell se plie à toutes vos fantaisies. Vous pourrez créer librement des formes originales pour tous vos livres. Capable de soutenir une dizaine de kilos, *Bookworm* existe également en plusieurs couleurs. Une magnifique étagère design qui fournit un certain cachet à vos murs en offrant une décoration personnalisée à votre pièce.

606 Universal Shelving System, 1960

Dieter Rams (Germany, 1932–)

www.vitsoe.com
Powder-coated aluminium, with beech or lacquered MDF
Pulverbeschichtetes Aluminium, Buche oder lackiertes MDF
Aluminium revêtu, hêtre ou MDF laqué
↔ 65.5, 90 cm ↗ 16, 22, 30, 36 cm (shelves)
Vitsœ, London, UK

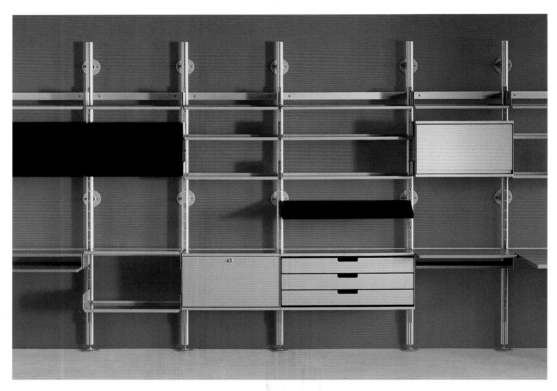

Impervious to fashion and resilient to the wear-and-tear of everyday life, Dieter Rams' *606 Universal Shelving System* is probably the best shelving system you can buy. It is a highly adaptive and functional solution that has a quiet, purist aesthetic, which means it places well in any environment. It can also grow with your requirements with the purchase of extra shelves, cabinets or desk elements. As Vitsœ notes, this iconic German design is 'timeless, movable and constantly evolving.'

Immun gegenüber den Launen der Mode und unverwüstlich im alltäglichen Gebrauch ist das anpassungsfähige und funktionale *606 Universal Shelving System* von Dieter Rams das vielleicht beste Regalsystem, das man für Geld kaufen kann. Dank seiner zurückhaltenden und puristischen Ästhetik passt es sich in jede Umgebung ein. Durch den Erwerb von zusätzlichen Brettern, Kästen oder Tischelementen lässt es sich beliebig erweitern. Vitsœ beschreibt diesen Klassiker des deutschen Designs als „zeitlos, beweglich und sich stetig weiter entwickelnd".

Conçu par Dieter Rams en 1960, le système d'étagères universel *606* s'avère intemporel, incarnant le fonctionnalisme allemand. Ses lignes à dessiner au mur au fil des besoins permettent diverses configurations, le nombre et la composition de ses rayons évoluant à l'aune de vos attentes. Ainsi, des étagères d'appoint, des armoires ou des éléments de bureau enrichiront cet incroyable système à géométrie variable. Comme le souligne Vitsœ, cette icône du design allemand est « indémodable, modulable et en constante évolution ».

Minima 29-40 shelving, 1998

Bruno Fattorini (Italy, 1939–)

www.mdfitalia.it
Extruded anodised aluminium, MDF
Stranggezogenes anodisiertes Aluminium, MDF
Aluminium anodisé naturel, MDF
↔ 34.3, 70 cm ⤢ 29, 40 cm (shelves)
MDF Italia, Milan, Italy

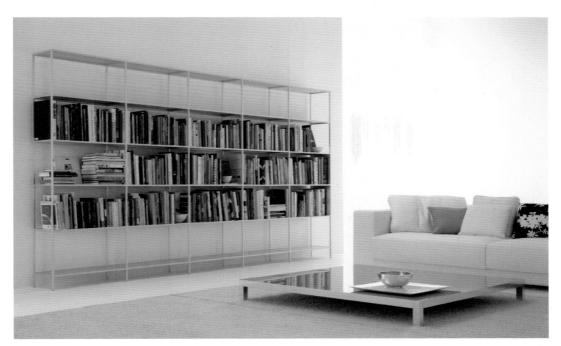

The Nineties saw a move away from the excesses of the previous decade, and in design there was a tendency towards stripped-down Minimalism. Bruno Fattorini's *Minima* shelving system reflected this desire for visually simple solutions, yet it was also a highly rational design that received a Compasso d'Oro special mention. The extruded anodised aluminium frame-like structure was designed so that back panels, side panels, doors and drawers could be easily added and repositioned. This flexible shelving system can either be wall-mounted or used as a freestanding room divider.

Die 1990er Jahre verzeichneten eine Abkehr von den Ausschweifungen der vorangegangenen Dekade, das Design tendierte zu einem reduzierten Minimalismus. In Bruno Fattorinis *Minima*-Regalsystem zeigt sich dieser Wunsch nach einfachen Lösungen. Zugleich ist es ein überaus durchdachtes Design, das bei der Verleihung des Compasso d'Oros besondere Erwähnung fand. Die rahmenartige Struktur aus stranggezogenem, anodisiertem Aluminium ist so beschaffen, dass Rück- und Seitenwände, Türen und Schubladen einfach ergänzt oder neu kombiniert werden können. Das flexible Regalsystem kann entweder an der Wand befestigt oder freistehend als Raumteiler verwendet werden.

Le design des années 90 diffère de la décennie précédente et opte pour un style minimaliste épuré, axé sur l'essentiel. Créé par Bruno Fattorini, ce système d'étagères illustre cette volonté de solutions simples, à travers une conception rationnelle. Récompensé par un Compasso d'Oro, *Minima 29-40* dispose d'une structure en aluminium naturel conçue de manière à permettre le rajout ou le repositionnement de panneaux arrière et latéraux, de portes et de tiroirs. Ce système d'étagères se fixe au mur ou s'utilise comme cloison de séparation.

Pantos 2 Composition XXI wardrobe, 1993

Antonia Astori (Italy, 1940–)

www.driade.it
Aluminium, glass, fluorescent light
Aluminium, Glas, fluoreszierendes Licht
Aluminium, verre, lumière fluorescente
↕ 266 cm ↔ 270 cm ↗ 60 cm (variation shown)
Driade, Fossadello di Caorso, Italy

Since 1968, the Milanese architect Antonia Astori has worked as a designer for Driade, a company founded by her brother, Enrico. During these years she has created various innovative furnishing systems – including the *Pantos* range – that are intended to function as 'room architecture'. The *Pantos* collection includes nine differently configured wardrobes and storage cupboards, including one that is designed specifically for use in kitchens.

Seit 1968 arbeitet die Mailänder Architektin Antonia Astori als Designerin für Driade, der Firma ihres Bruders Enrico. Seitdem hat sie einige höchst innovative Möbelsysteme entworfen. Ihre Möbel, zu denen auch die *Pantos*-Serie zählt, sind als „Raumarchitekturen" konzipiert. Die *Pantos*-Kollektion umfasst neun verschiedene Kleider- und Aufbewahrungsschränke – einschließlich eines speziell für die Küche entworfenen Schranks.

Depuis 1968, l'architecte milanaise Antonia Astori travaille comme designer pour Driade, société fondée par son frère Enrico. Durant ces années, elle a créé divers systèmes d'ameublement très novateurs, incluant la gamme *Range*. La collection *Pantos* comprend neuf armoires proposant différentes configurations, ainsi que des placards de rangement dont un spécialement conçu pour la cuisine. Contemporaine et extrêmement fonctionnelle, cette armoire *Pantos 2* optimise le rangement.

String shelving system, 1949

Nisse Strinning (Sweden, 1917–2006)

www.string.se
Lacquered metal rod; birch, oak, walnut or lacquered MDF
Wand- und Bodenleitern aus lackiertem Stahl; Böden aus Birke,
Eiche oder lackiertes MDF
Métal laqué, bouleau, chêne ou MDF laqué
↕ 80, 110, 175, 220 cm ↔ 58, 78 cm (shelf) ↗ 20, 30 cm (shelf)
String Furniture AB, Malmö, Sweden

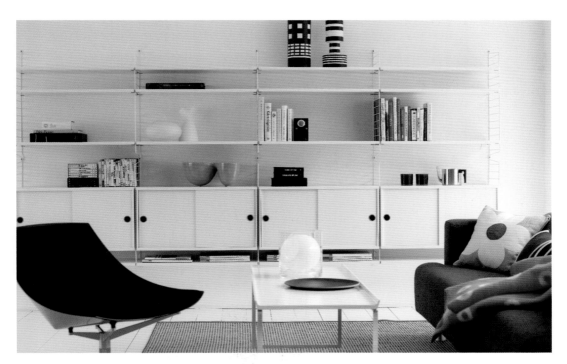

The Swedish architect Nisse Strinning designed this practical shelving system in the late 1940s, using ingenious ladder-like vertical elements that support the shelves and cabinet units. Lightweight but sturdy, the *String* shelving system was subsequently awarded a Gold Medal at the 1954 Milan Triennale and is now widely recognized as an affordable landmark in Swedish design. Available in a variety of colours, this distinctive yet understated expression of Scandinavian Modern design works well in the home or the office and is easy to assemble and extend.

Der schwedische Architekt Nisse Strinning entwarf dieses praktische Regalsystem Ende der 1940er Jahre und sah geniale, Leitern ähnliche vertikale Elemente vor, welche die Regale und Schrankelemente tragen. Leicht und dennoch robust, erhielt das *String* Regalsystem 1954 bei der Mailänder Triennale eine Goldmedaille und gilt heute weithin als ein erschwinglicher Meilenstein des schwedischen Designs. Dieses unverwechselbare, jedoch zurückhaltende Beispiel modernen skandinavischen Designs ist in einer Vielzahl von Farben erhältlich, leicht zusammenzubauen und zu erweitern und für zu Hause ebenso geeignet wie für das Büro.

L'architecte suédois Nisse Strinning a réalisé ce système de rayonnage à la fin des années 40. Les étagères et les meubles sont soutenus par une structure en échelle. Léger et robuste, *String* reçut une médaille d'or à la Triennale de Milan en 1954. Il fait aujourd'hui partie des incontournables du design suédois notamment pour son prix abordable. Ce modèle au style minimaliste illustre parfaitement le design des pays scandinaves. Facile à assembler, *String* s'intègre aussi bien dans la maison qu'au bureau. Il est disponible en plusieurs coloris.

Loop bedside cabinet, 2005

Nazanin Kamali (UK 1966–)

www.casefurniture.co.uk
Oak-veneered birch plywood, glass
Eichenfurniertes Birkenschichtholz, Glas
Contreplaqué de bouleau, placage de chêne, verre
↕ 38 cm ↔ 57 cm ⤢ 40 cm
Case Furniture, London, UK

The perfect bedside cabinet, the sleek *Loop* has an understated charm, while also being functionally useful with its unobtrusive recessed drawer that glides gently open and shut. This elegant yet practical design, which is beautifully crafted from a loop of moulded birch plywood, also complements the matching *Loop* bed and mirrors in order to provide a completely integrated contemporary bedroom range.

Mit seinem unaufdringlichen Charme überzeugt der seidig glänzende *Loop* als perfekter Nachttisch, während die versenkte Schublade, die lautlos auf und zu gleitet, von durchdachter Funktionalität zeugt. Das schöne, elegante und zugleich praktische Design wird aufwändig aus gebogenem Birkenschichtholz gefertigt und ergänzt sich mit passenden *Loop*-Betten und -Spiegeln zu einer einheitlichen zeitgenössischen Schlafzimmer-Serie.

À la fois discrète et très élégante, *Loop* est réalisée en contreplaqué en bouleau avec une finition en placage de chêne. Cette table de chevet s'avère très fonctionnelle avec son tiroir totalement intégré glissant doucement, d'une discrétion absolue. La table de chevet *Loop* complète joliment le lit et le miroir de la même collection, offrant à votre chambre un ensemble contemporain très séduisant.

SMCC1-Hyponos Simplice night table, 2002

Antonio Citterio (Italy, 1950–)

www.bebitalia.it
MDF, wood veneer, steel, plastic
MDF, Holzfurnier, Stahl, Plastik
MDF, placage en bois, acier, plastique
↕ 53.5 cm ↔ 80 cm ⤢ 46 cm
Maxalto/B&B Italia, Novedrate, Italy

Elegant simplicity and high-quality construction can be hard to find, especially in the realm of cabinet furniture. Maxalto, however, produces a number of coordinated furniture collections that include several excellent options, not least the *SMCC1-Hyponos Simplice* night table with its gently rounded corners and its useful cubbyhole and sliding drawer.

Elegante Schlichtheit und qualitativ hochwertige Konstruktion sind manchmal schwer zu finden, besonders wenn es um Kleinmöbel geht. Maxalto stellt jedoch eine Reihe von abgestimmten Möbelkollektionen her, die mehrere hervorragende Optionen umfasst, wozu auch der Nachttisch *SMCC1-Hyponos Simplice* mit seinen sanft abgerundeten Kanten, dem praktischen Kasten und der Schublade gehört.

Simplicité élégante et fabrication de grande qualité sont parfois difficiles à combiner, surtout dans le mobilier. Maxalto produit pourtant plusieurs collections de meubles coordonnés qui proposent d'excellentes options comme *SMCC1-Hyponos Simplice*, avec ses angles légèrement arrondis, son casier et son tiroir coulissant.

Oscar 642 night table, 2005

Emaf Progetti (Italy, est. 1982)

www.zanotta.it
Chrome-plated or graphite painted steel, aluminium, veneered or lacquered MDF
Stahl, verchromt oder Graphit lackiert, Aluminium, MDF, Furnier
Acier chromé ou verni couleur graphite, aluminium, MDF, placage
↕ 45 cm ↔ 40 cm ↗ 40 cm
Zanotta, Milan, Italy

With its strong geometric form, the *Oscar* night table is a striking adornment to any bedroom. It is also a highly practical design with its handy drawer. Available in a variety of veneers and lacquered finishes, the table is also perfectly sized to hold a few things without looking cluttered – just big enough to accommodate a table light, a glass of water and a book or two.

Die strenge geometrische Form macht den *Oscar*-Nachtisch zu einem Blickfang in jedem Schlafzimmer, aber dank der Schublade ist er auch ein sehr praktisches Möbel. Der Tisch, der unterschiedlich furniert oder lackiert erhältlich ist, hat die perfekte Größe, um ein paar Kleinigkeiten darauf abzustellen, ohne dass er gleich überladen aussieht – gerade groß genug für eine Lampe, ein Glas Wasser und ein bis zwei Bücher.

Avec sa forme géométrique forte, la table de chevet *Oscar* offre un design surprenant à tous les styles de chambres à coucher. Son tiroir à portée de main illustre un design pratique et fonctionnel. Disponible dans une variété de placages et de finitions laquées, *Oscar* dispose d'une taille idéale permettant d'accueillir, par exemple, une lampe de chevet, un verre d'eau et un ou deux livres, sans jamais paraître encombrée.

Diva cabinet, 2008
Holzmanufaktur Design Team

www.holzmanufaktur.com
Solid beech, wild beech, maple, cherry or walnut
Massive Buche, Kernbuche, Ahorn, Kirschbaum oder Nussbaum
Hêtre massif, hêtre sauvage, érable, merisier, ou noyer
↕ 94 cm ↔ 210 cm ↗ 45 cm
Holzmanufaktur, Stuttgart, Germany

There is something about solid wood that gives a design an undeniable tactile quality – you just want to touch it. The *Diva* cabinet is solidly constructed by skilled German craftsmen in Stuttgart, a city long famed for the excellence of its design and manufacturing output. Its simple form emphasises the beautiful grain of the wood and, designed and built to last, this piece could easily become an 'antique of tomorrow'.

Massivholz verleiht einem Design zweifellos etwas Sinnliches – man möchte es einfach berühren. Die stabile *Diva*-Kommode wird von erfahrenen deutschen Handwerkern in Stuttgart gebaut, einer Stadt, die berühmt ist für hervorragendes Design und ausgezeichnete Verarbeitung. Ihre schlichte Form hebt die schöne Maserung des Holzes hervor, und dieses Möbel, das für die Ewigkeit entworfen und gebaut scheint, könnte gut und gerne eine „Antiquität von morgen" werden.

Il réside dans le bois quelque chose d'indescriptible, conférant au design une exceptionnelle qualité tactile qui incite au toucher. Le meuble *Diva* a été réalisé par des artisans allemands talentueux, à Stuttgart, ville réputée pour l'excellence de son design et la qualité de sa production industrielle. Cette création révèle une forme simple, mettant l'accent sur la beauté du grain des bois. Conçue et réalisée pour durer, *Diva* deviendra certainement une « antiquité de demain ».

Motley sideboard, wardrobe & bookcase, 2008

Samuel Chan (Hong Kong/UK, 1964–)

www.channelsdesign.com
Oak, laminate
Eiche, Laminat
Chêne, stratifié
↕ 72 cm ↔ 220 cm ⤢ 50 cm (sideboard)
↕ 220 cm ↔ 70 cm ⤢ 60 cm (wardrobe)
↕ 220 cm ↔ 70 cm ⤢ 40 cm (bookcase)
Channels, London, UK

Samuel Chan is one of the most accomplished furniture designer-makers of his generation. His award-winning work fuses the design sensibilities of the East and the West and is visually attractive, functionally purposeful and crafted with an extraordinary level of detailing. Chan's *Motley* sideboard, wardrobe and bookcase share an unpretentious refinement that is reflected in all the furniture and household objects that his London-based company, Channels, produces.

Samuel Chan ist einer der begabtestsn Möbeldesigner seiner Generation. Seine preisgekrönten Arbeiten verbinden die Designqualitäten des Ostens und des Westens, sind visuell attraktiv, äußerst funktional und mit außergewöhnlicher Detailgenauigkeit gefertigt. Chans *Motley*-Sideboard, -Schrank und -Bücherregal besitzen eine unprätentiöse Raffinesse, die alle Möbel und Haushaltsartikel des in London ansässigen Unternehmens Channels auszeichnet.

Samuel Chan est l'un des créateurs de meubles les plus compétents de sa génération. Son travail, souvent récompensé, réunit la sensibilité du design de l'Orient et de l'Occident, offrant ainsi des créations séduisantes, fonctionnelles et épurées. Créés par Chan, le buffet, l'armoire et la bibliothèque *Motley* partagent un raffinement sans prétention, présent dans tous les meubles et objets que produit sa société londonienne Channels.

Part of a noteworthy range of bedroom furniture designed by Nazanin Kamali, the wall-mounted *Loop* mirror is formed from moulded birch plywood that is veneered with finely grained oak. With its contemporary soft-edged aesthetic, the *Loop* mirror not only looks good, but it is also a highly functional design, and its integrated shallow shelf provides a useful place to store perfumes, creams, etc.

Der zu einer bemerkenswerten, von Nazanin Kamali entworfenen Schlafzimmermöbel-Kollektion gehörende Wandspiegel *Loop* ist aus gepresstem, mit fein gemaserter Eiche furniertem Birkenschichtholz gefertigt. Die modernen, runden Konturen sorgen nicht nur dafür, dass das Design gut aussieht, sondern machen es auch sehr funktional. Auf der flachen integrierten Ablage lassen sich sehr gut Parfümflakons, Cremetiegel und andere Utensilien unterbringen.

Élément de la superbe collection de mobilier de chambre à coucher créée par Nazanin Kamali, ce miroir mural *Loop* est réalisé en contreplaqué de bouleau moulé, en finition plaqué de chêne à grain fin. Avec ses contours arrondis, *Loop* dévoile un design contemporain, hautement fonctionnel grâce à son étagère incorporée, peu profonde, permettant de stocker des parfums ou des crèmes, entre autres.

Loop mirror, 2005

Nazanin Kamali (UK, 1966–)

www.casefurniture.co.uk
Birch plywood, oak veneer, mirrored glass
Birkenschichtholz, Eichefurnier, Spiegelglas
Contreplaqué en bouleau, placage en chêne, miroir en verre
↕ 100 cm ↔ 40 cm ⤢ 25 cm
Case Furniture, London, UK

SMS2 Simplice mirror, 2001

Antonio Citterio (Italy 1950–)

www.bebitalia.it
Melamine-covered MDF, mirrored glass, steel, plastic
Melaminbeschichtetes MDF, verspiegeltes Glas, Stahl, Plastik
MDF recouvert de mélamine, miroir de verre, acier, plastique
↕ 185 cm ↔ 120 cm
Maxalto/B&B Italia, Novedrate, Italy

This full-length mirror has a stylish sophistication that belies its utter simplicity. Designed so that it can be leant against a wall without any fixings, the installation of this mirror is completely effortless. This Minimalist design also comes in a narrower yet taller version (SMS1), and can be used to make a room appear more spacious with the minimum of effort.

Dieser Standspiegel ist äußerst schlicht, aber ungeheuer elegant und raffiniert. Er kann ohne Befestigung gegen eine Wand gelehnt werden und lässt sich absolut mühelos aufstellen. Das minimalistische Design ist auch in einer schmaleren, aber höheren Version (SMS1) erhältlich und kann mit einem Minimum an Aufwand so eingesetzt werden, dass es einen Raum größer erscheinen lässt.

Emprunté à la collection *Simplice*, le miroir *SMS2* présente deux hauteurs et largeurs différentes (*SMS1* est le plus haut) qui permettent chacune de se voir en pied. Il s'appuie contre le mur, sans aucune fixation pour une installation facilitée. Cette conception minimaliste et raffinée convient à n'importe pièce de la maison où l'on souhaite créer des reflets suggestifs.

Dark Birch Large Double Bed, 2002
Muji Design Team

www.muji.net
Stained birch, plywood
Gebeizte Birke, Schichtholz
Bouleau teinté, contreplaqué
↕ 62 cm ↔ 200.5 cm ⤢ 144.5 cm
MUJI/Ryohin Keikaku Co. Ltd., Tokyo, Japan

Since its founding in 1980, Muji has based its retail philosophy on three central concepts: 'selection of materials', 'streamlining processes' and 'simplification of packaging'. The result has been an impressive catalogue of simple yet functional objects for the home offering good value for money and possessing a pure Japanese-style aesthetic. The bed shown here is no exception, with its simple yet solidly constructed frame and firm mattress.

Seit der Gründung 1980 basiert die Unternehmensphilosophie von Muji auf drei zentralen Prinzipien: „Auswahl der Materialien", „Rationalisierung der Herstellungsprozesse" und „Reduzierung der Verpackung". Das Ergebnis ist ein beeindruckender Katalog einfacher, aber funktioneller Objekte für Zuhause, die ein gutes Preis-Leistungs-Verhältnis und eine klare Ästhetik im japanischen Stil bieten. Diese Kriterien erfüllt auch das hier gezeigte Bett mit seinem einfachen, aber solide konstruierten Rahmen und der festen Matratze.

Depuis sa création en 1980, Muji a fondé sa philosophie de vente au détail sur trois grands principes : la sélection des matériaux, la rationalisation des processus et la simplification des emballages. Cette société propose un grand catalogue de produits conçus dans un pur style japonais, avec un excellent rapport qualité/prix. Il s'agit de présenter des objets simples mais fonctionnels, comme le lit *Dark Birch* composé d'une structure et d'un matelas ferme.

Com:Ci bed, 2008

Holzmanufaktur Design Team

www.holzmanufaktur.com
Solid beech, wild beech, maple, cherry or walnut
Massive Buche, Kernbuche, Ahorn, Kirschbaum oder Nussbaum
Hêtre massif, hêtre sauvage, érable, merisier, ou noyer
↔ 190, 200, 210, 220 cm ↗ 90, 100, 120, 124, 160, 180, 200 cm
Holzmanufaktur, Stuttgart, Germany

Wood is a wonderful organic material, which may be why we find it so easy to connect with on an emotional level. Holzmanufaktur's *Com:Ci* bed is strongly built from solid timber, and as such has a psychologically reassuring quality. Its simple elemental form should also ensure that it is impervious to the fickle winds of fashion, whilst its robust construction guarantees it will last a lifetime.

Holz ist ein wunderbares organisches Material, und vielleicht stellen wir aus diesem Grund so leicht eine emotionale Verbindung zu ihm her. So strahlt auch das Massivholzbett *Com:Ci* von Holzmanufaktur etwas Beruhigendes aus. Dank seiner schlichten, elementaren Form ist dieses Bett gegen die Launen der Mode immun, während die robuste Konstruktion garantiert, dass es ein Leben lang hält.

Le bois est une merveilleuse matière organique avec laquelle il est facile de communiquer, sur un plan émotionnel. Conçu par Holzmanufaktur, le lit *Com:Ci* est entièrement réalisé en bois massif, lui conférant une qualité psychologiquement rassurante. Indémodable grâce à sa forme simple et intemporelle, cette création enveloppe votre sommeil de sérénité et de plénitude. Robuste, *Com:Ci* vous accompagnera durant toute votre vie.

Loop bed, 2005

Nazanin Kamali (UK, 1966–)

www.casefurniture.co.uk
Birch plywood, oak veneer
Birkenschichtholz, Eichenfurnier
Contreplaqué en bouleau, placage en chêne
↗ 81 cm ↔ 211 cm ↗ 161 cm
↗ 81 cm ↔ 211 cm ↗ 201 cm
↗ 81 cm ↔ 208 cm ↗ 168 cm
Case Furniture, London, UK

Founded in 2006, Case Furniture specialises in the manufacture of simple yet beautifully crafted pieces of furniture with a very British understated quality. The *Loop* range by Nazanin Kamali includes a stylishly contemporary bed that is made from a continuous loop of moulded birch plywood. Available with or without a headboard, the *Loop* bed's curves provide a soft-edged, feminine aesthetic.

Das 2006 gegründete Unternehmen Case Furniture ist auf die Herstellung schlichter, aber sehr gut gefertigter Möbelstücke spezialisiert, die sich durch ein sehr britisches Understatement auszeichnen. Zu der *Loop*-Reihe von Nanzanin Kamali gehört auch dieses stilvolle moderne Bett aus einer kontinuierlichen Schleife aus formgepresstem Birkenschichtholz. Mit oder ohne Kopfteil erhältlich, verleiht ihm die geschwungene Form eine sehr weiche, feminine Ästhetik.

Fondée en 2006, Case Furniture se spécialise dans la fabrication de meubles simples mais joliment conçus, d'une qualité britannique sobre. La collection *Loop* créée par Nazanin Kamali comprend ce lit à l'élégance contemporaine, réalisé à partir d'une boucle continue en contreplaqué de bouleau. Disponibles avec ou sans tête de lit, les courbes de *Loop* offrent une esthétique très féminine, avec leur contour arrondi et doux.

Ayrton bed, 2007

Ora-Ïto (France, est 1998)

www.frighetto.it
Varnished wood, leather-covered polyurethane, chromed steel
Lackiertes Holz, lederbezogenes Polyurethan, verchromter Stahl
Bois verni, polyuréthane recouvert de cuir, acier chromé
↕ 37 cm ↔ 234, 242, 252, 262, 275 cm ⤢ 223 cm
Frighetto, Vicenza, Italy

The *Ayrton* bed has a matt-varnished wooden frame that comprises bedside table elements on either side, with cavities to store a book or two. A headboard can also be added if desired. Like other designs by Ora-Ïto, the distinctive *Ayrton* reflects the studio's desire for 'Simplex' – a synthesis of simplicity and complexity that provides a good level of functionality combined with a slightly quirky and endearing aesthetic.

Das *Ayrton*-Bett hat einen matt lackierten Holzrahmen mit Nachttisch-Elementen auf beiden Seiten, in denen man ein paar Bücher unterbringen kann. Auf Wunsch kann es auch mit einem Kopfteil versehen werden. Wie andere Designs von Ora-Ïto zeugt auch dieses von dem Wunsch des Studios nach „Simplex" – eine Synthese aus Einfachheit und Komplexität, die sich durch ein hohes Maß an Funktionalität, kombiniert mit einer etwas verschrobenen und sympathischen Ästhetik auszeichnet.

Le lit *Ayrton* dispose d'une structure en bois verni et s'accompagne d'une paire de tables de chevet permettant de ranger quelques livres. La tête de lit est facultative. À l'instar d'autres créations d'Ora-Ïto, *Ayrton* reflète une volonté de « simplexité » : l'art de rester simple tout en faisant face à un ensemble de contraintes ou de fonctions compliquées. Un esprit minimaliste, épuré mais très fonctionnel.

XEN L15 bed, 1997

Hannes Wettstein (Switzerland, 1958–)

www.cassina.com
Pine, rubber, lacquered steel, with beech, stained cherry, or wenge
Kiefer, Gummi, lackierter Stahl, mit Buche, gebeiztem Kirschbaum oder Wenge
Pin, caoutchouc, acier laqué, hêtre, cerisier teinté ou wengé
↕ 81 cm ↔ 175, 185, 195 cm ↗ 216 cm
Cassina, Meda, Italy

With its simple clean lines, the XEN L15 bed's supporting frame can be fitted with two different bedside tables, complete with either open shelves (as shown) or sliding doors. Other matching accessories can also be specified, including a cushioned bench, a three-drawer chest, and a chest of drawers with a wooden top suitable for a television. The headboard can also be ordered with removable padded upholstery.

Dank seiner einfachen, klaren Linien kann der Auflagerahmen des XEN L15 Betts mit zwei verschiedenen Nachtschränkchen versehen werden, entweder mit sichtbaren Regalböden (wie hier gezeigt) oder mit Schiebetür. Es gibt auch noch andere passende Zubehörteile, darunter eine Bank mit Polster, ein Schrank mit drei Schubladen und ein Schubladenschrank mit Trägerplatte aus Holz für einen Fernseher. Das Kopfteil ist auch mit einem abnehmbaren, gepolsterten Bezug erhältlich.

La structure portante du lit XEN L15 peut être équipée au choix de deux tables de chevet avec étagères ouvertes ou volet coulissant. Minimaliste et élégant, ce modèle offre également un ensemble d'accessoires facultatifs : banquette, commode en bois à trois tiroirs et commode avec plan porte-télévision en bois. La tête de lit peut être dotée d'un revêtement rembourré en tissu amovible.

Aluminium bed, 2001

Bruno Fattorini (Italy, 1939–)

www.mdfitalia.it
Anodised aluminium
Eloxiertes Aluminium
Aluminium anodisé
↕ 57, 78 cm ↔ 210 cm ⤢ 100 , 150 , 160 , 170, 180, 190, 210 cm
MDF Italia, Milan, Italy

With its pure geometric lines, Bruno Fattorini's *Aluminium* bed is perfect for those who like order and visual calm. This sophisticated minimal design is available in seven different widths, and its frame comes in either finely polished aluminium or coloured lacquered finishes. The headboard is optional, and there is also a canopy version for which a mosquito net is available.

Die klaren geometrischen Linien machen Bruno Fattorinis *Aluminium*-Bett zur perfekten Wahl für all jene, die Ordnung und eine ruhige Optik lieben. Dieses elegante minimale Design ist in sieben verschiedenen Breiten und einem Rahmen aus poliertem oder farbig lackiertem Aluminium erhältlich. Auf Wunsch kann es auch mit einem Kopfteil versehen werden, und es gibt auch eine Version als Himmelbett – auf Wunsch mit Moskitonetz.

Avec ses lignes géométriques pures, le lit *Aluminium* de Bruno Fattorini saura satisfaire les plus exigeants en matière de confort de sommeil. Ce design sophistiqué et minimaliste existe en sept largeurs différentes, et sa structure est disponible en aluminium poli ou en finition laquée colorée. La tête de lit est facultative. Il existe également une version baldaquin, avec une moustiquaire en option.

Siena bed, 2007

Naoto Fukasawa (Japan, 1956–)

www.bebitalia.it
Tubular steel, wood, upholstery
Stahlrohr, Holz, Polster
Acier tubulaire, bois, tapisserie d'ameublement
↕ 77 cm ↔ 244 cm ⤢ 176, 196, 216 cm
B&B Italia, Novedrate, Italy

Sleek and minimal, the *Siena* bed is infused with an oriental simplicity. Like other designs by Naoto Fukasawa, it has an ethereal quality, an almost visual transcendence, as it seemingly floats upon its tubular metal supports. The upholstered base projecting around the perimeter of the mattress section gives the overall design a distinctive edge, while the gently upturned headboard is set at an angle to provide additional comfort.

Das minimalistische und elegante *Siena*-Bett ist von orientalischer Einfachheit durchdrungen. Wie andere Designs von Naoto Fukasawa besitzt auch dieses etwas Ätherisches, eine fast visuelle Transzendenz, denn es scheint förmlich auf dem Gestell aus Stahlrohr zu schweben. Die gepolsterte Auflage, die über die Matratze hinausragt, verleiht dem Gesamtdesign etwas ganz Eigenes, während das leicht nach hinten gebogene, abgerundete Kopfteil zusätzlichen Komfort bietet.

Élégant et minimaliste, le lit *Siena* est emprunt de la simplicité orientale. À l'instar d'autres créations de Naoto Fukasawa, ce modèle dévoile une qualité éthérée, lui conférant une légèreté visuelle. Son design épuré donne la sensation que le lit flotte sur son piètement en métal tubulaire. La base tapissée située autour du matelas dépasse, apportant au design un rebord original. La tête de lit, légèrement recourbée et positionnée selon un certain angle, assure un confort supplémentaire.

ACLE AC bed, 2003

Antonio Citterio (Italy, 1950–)

www.bebitalia.it

Solid wood, MDF, wood veneer, fabric or leather, steel, polyurethane foam, polyester fibre

Massivholz, MDF, Holzfurnier, Stoff oder Leder, Stahl, Polyurethanschaumstoff, Polyesterfaser

Bois massif, MDF, placage en bois, tissu ou cuir, acier, mousse de polyuréthane, fibre de polyester

↕ 210 cm ↔ 230 cm ↗ 230 cm

Maxalto/B&B Italia, Novedrate, Italy

A contemporary take on the traditional four-poster bed, the *ACLE AC* bed from Antonio Citterio's *AC Collection* incorporates a gas-operated raising mechanism. With its simple, almost Zen-like aesthetic, this design reflects a growing desire for uncluttered calm in our increasingly stressful world. With this aim, it provides a little cube of serenity in which you can slumber.

ACLE AC aus Antonio Citterios *AC Collection* ist eine moderne Interpretation des traditionellen Himmelbetts und enthält einen gasbetriebenen Hebemechanismus. Mit seiner schlichten, fast an Zen erinnernden Ästhetik reflektiert dieses Design den immer mehr verbreiteten Wunsch nach überschaubarer Ruhe in unserer zunehmend hektischen Welt. So bietet das *ACLE AC* Himmelbett eine kleine Nische der Gelassenheit, in der man schlummern kann.

Élément de la collection *AC*, le lit *ACLE AC* d'Antonio Citterio propose un mécanisme de levée au gaz. Version contemporaine du lit à baldaquin classique, cette création zen et épurée offre un véritable havre de paix dans un monde où règne le stress. Incorporé dans un cube emprunt de sérénité, *ACLE AC* garantit un repos optimal.

Lighting
Beleuchtung
L'éclairage

Luxo L-1 task light, 1937

Jacob Jacobsen (Norway, 1901–1996)

www.luxo.com
Enamelled or chromed aluminium
Lackiertes oder verchromtes Aluminium
Aluminium émaillé ou chromé
↕ 104 cm (max)
Luxo ASA, Oslo, Norway

In 1937, Jacob Jacobsen acquired the Scandinavian manufacturing licence for George Carwardine's revolutionary *Anglepoise* light. That same year he designed his own task light, the *Luxo L-1*, which integrated a similar system of auto-balancing springs based on the constant-tension principle of human limbs. Still in production after seventy years, Jacobsen's design is not only a veritable icon of Norwegian design, but is also one of the best-selling lights of all time with over twenty-five million units sold worldwide.

1937 erwarb Jacob Jacobsen die skandinavischen Produktionsrechte für George Carwardines revolutionäre *Anglepoise*-Leuchte. Im gleichen Jahr entwarf er mit der *Luxo L-1* seine eigene Arbeitsleuchte, bei der er, inspiriert von der Muskelspannung der Gliedmaßen, ein ähnliches System ausbalancierter Spiralfedern einsetzte. Jacobsens Entwurf wird seit siebzig Jahren produziert und ist nicht nur eine echte Ikone des norwegischen Designs, sondern mit über fünfundzwanzig Millionen Exemplaren auch eine der weltweit meistverkauften Leuchten aller Zeiten.

En 1937, Jacob Jacobsen acheta la licence de fabrication pour la Scandinavie de la lampe révolutionnaire de George Carwardine, *Anglepoise*. La même année, il conçut la *Luxo L-1*, intégrant un système similaire de ressorts reproduisant le principe de tension perpétuelle des muscles d'un bras humain. Toujours produite soixante-dix ans plus tard, sa création, véritable emblème du design scandinave, reste l'une des lampes les plus prisées de tous les temps, avec plus de vingt-cinq millions d'unités vendues dans le monde.

Berenice task light, 1985

Alberto Meda (Italy, 1945–) & Paolo Rizzatto (Italy, 1941–)

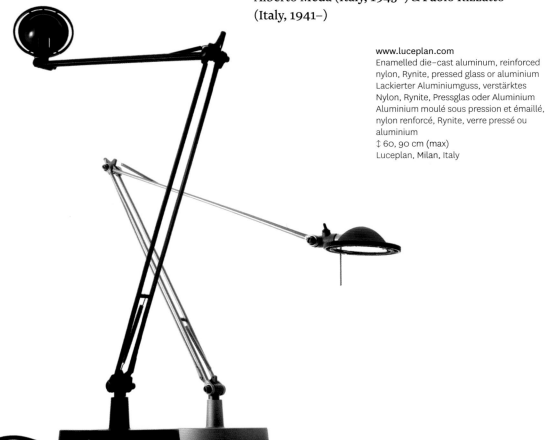

www.luceplan.com
Enamelled die–cast aluminum, reinforced nylon, Rynite, pressed glass or aluminium
Lackierter Aluminiumguss, verstärktes Nylon, Rynite, Pressglas oder Aluminium
Aluminium moulé sous pression et émaillé, nylon renforcé, Rynite, verre pressé ou aluminium
↕ 60, 90 cm (max)
Luceplan, Milan, Italy

This classic Italian task light won a Compasso d'Oro award in 1987 for its innovative minimalist design. Incorporating a transformer in its base, the design's rod-like metal arm carries the low-tension current to the bulb without the need of electrical cable, thereby ensuring an eye-catching, slender form. Highly functional, the *Berenice* is available with either an aluminium or a red, blue or green glass shade. Luceplan also manufacture wall and floor versions of this elegantly sophisticated design.

Diese klassische italienische Arbeitsleuchte wurde 1987 für ihr innovatives, minimalistisches Design mit dem Compasso d'Oro ausgezeichnet. Durch einen im Fuß integrierten elektronischen Transformator wird der Schwachstrom direkt über den stabförmigen Metallarm der Leuchte zur Glühlampe geleitet, so dass kein Elektrokabel erforderlich ist, was die Form besonders attraktiv und schlank wirken lässt. Die äußerst funktionale *Berenice* ist entweder mit einem Reflektor aus Aluminium oder aus rotem, blauem bzw. grünem Glas erhältlich. In diesem eleganten, anspruchsvollen Design produziert Luceplan auch eine Wand- und Bodenleuchte.

Le design minimaliste innovant de ce classique italien lui valut de remporter un Compasso d'Oro en 1987. Le socle renferme un transformateur et la tige métallique du bras achemine le courant à basse tension jusqu'à l'ampoule sans câble électrique, ce qui lui permet d'avoir cette allure gracile et élégante. Hautement fonctionnelle, *Berenice* existe avec un diffuseur en aluminium ou en verre rouge, bleu ou vert. Luceplan la produit également en version lampadaire et applique murale.

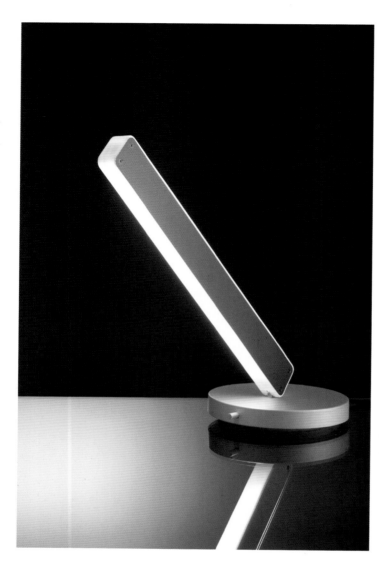

The Japanese word for chopsticks is 'hashi', but it can also mean 'bridge'. Certainly Naoto Fukasawa's light of the same name has an architectural quality with its 90° rotation mechanism that, like a drawbridge, allows the vertical stem of the light to be raised or lowered. The precision engineering of this design gives it a high-object-integrity, while an opaline diffuser casts an indirect light that softens its sharp minimalist design.

„Hashi" ist das japanische Wort für Essstäbchen, kann aber auch „Brücke" bedeuten. Mit ihrem 90°-Schwenkmechanismus wirkt Naoto Fukasawas Lampenmodell *Hashi Long* ein wenig wie eine Zugbrückenkonstruktion, weil sich der vertikale Leuchtenkörper heben oder senken lässt. Die Feinmechanik verleiht dieser Tischlampe ihre elegant minimalistische Form und Funktion. Die Polykarbonat-Diffusoren verbreiten ein indirektes Licht, das die harten Konturen der Lampe optisch verwischt.

Cette lampe au design minimaliste utilise une source fluorescente linéaire miniaturisée. Le corps d'*Hashi Long* dispose de deux côtés en aluminium, faisant office de paroi diffusante. La lumière est filtrée au travers de ces diffuseurs opalins créant une atmosphère particulièrement suggestive. Le corps de cette lampe comporte un mécanisme de rotation à 90° grâce à une charnière placée sur la base en aluminium. Une formidable prouesse technologique.

Hashi Long table light, 2005

Naoto Fukasawa (Japan, 1956–)

www.artemide.com
Extruded aluminium, polycarbonate, die-cast aluminium
Stranggepresstes und druckgegossenes Aluminium, Polykarbonat
Aluminium extrudé, polycarbonate, aluminium moulé sous pression
↕ 50 cm ⌀ 18.5 cm
Artemide, Pregnana Milanese, Italy

Tolomeo task light, 1987

Michele De Lucchi (Italy, 1951–) & Giancarlo Fassina (Italy, 1935–)

www.artemide.com
Polished aluminium, matt anodised aluminium
Poliertes Aluminium, matt-eloxiertes Aluminium
Aluminium poli, aluminium anodisé mat
↕ 129 cm (max) ↔ 122 cm (max)
Artemide, Pregnana Milanese, Italy

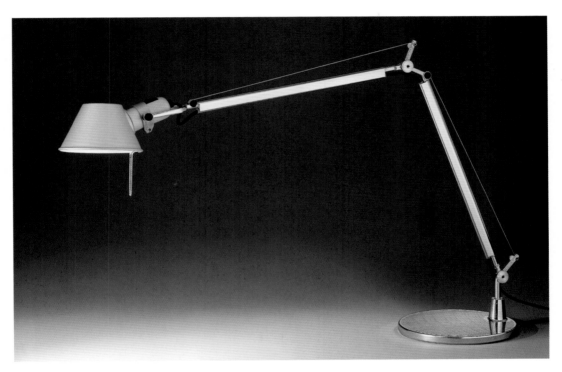

The extraordinary commercial success of the *Tolomeo* task light lies in its superlative function and engaging soft-tech aesthetic, that makes it suitable not only for traditional workplace environments but also home offices. Not surprisingly, it won a coveted *Compasso d'Oro* award in 1989 for its innovative design and high-quality precision engineering. The light's aluminum cantilevered arm allows for easy positioning, while its diffuser rotates in all directions, providing an amazing degree of adjustment.

Die außergewöhnliche Zweckmäßigkeit, kombiniert mit einer gewinnend einfachen wie technisch verblüffenden Ästhetik erklärt den ungemein kommerziellen Erfolg der *Tolomeo*-Arbeitsleuchte. Sie eignet sich sowohl für die Standardbüroausstattung als auch für das Home Office. Es überrascht nicht, dass ihr innovatives Design und die hochwertige Ingenieursleistung 1989 mit dem begehrten Compasso d'Oro ausgezeichnet wurden. Der leichte, freitragende Aluminiumarm lässt sich einfach verstellen, und auch der Lampenschirm lässt sich in alle Richtungen drehen, was die Leuchte überaus variabel macht.

À la fois élégante et pratique grâce à son bras articulé et son diffuseur orientable dans toutes les directions, *Tolomeo* connaît un immense succès commercial. Récompensée d'un Compasso d'Oro en 1989 pour son design novateur et sa qualité high-tech, cette lampe s'adapte à n'importe quelle ambiance, dans un bureau personnel ou professionnel. Les bras ajustables au système d'articulation raffiné font de cette lampe de bureau délicate une marque de renom.

Leaf task light, 2006

Yves Béhar (France, 1967–)

www.hermanmiller.com
Aluminium, LED
Aluminium, LED
Aluminium, LED
↕ 56 cm ↔ 22 cm ⤢ 58.5 cm
Herman Miller, Zeeland, (MI), USA

A multi-award-winning design, the *Leaf* task light was Yves Béhar's first lighting design for Herman Miller, and is as functionally practical as it is visually striking. It is the first LED task light that allows the user to chose between a warm mood light or a cool work light, while also boasting an impressive level of energy efficiency (using 40% less energy than an equivalent compact fluorescent with the same light output). In addition, its sculptural aluminium body has a universal touch interface.

Die mehrfach preisgekrönte Schreibtischlampe *Leaf* war der erste Beleuchtungskörper, den Ives Béhar für Herman Miller entwarf. Diese weltweit erste LED-Schreibtischlampe ist ebenso funktional wie optisch auffallend. Der Nutzer kann zwischen warmem oder kaltem Licht wählen. Die *Leaf* ist sehr energieeffizient (sie verbraucht 40% weniger Strom als eine Kompaktleuchtstofflampe mit gleicher Lichtleistung) und wird durch Berühren ihrer skulpturalen Aluminiumform ein- und ausgeschaltet.

Les lampes LED sont certainement l'avenir des lampes de bureau, permettant de gérer l'intensité de la lumière tout en proposant une faible consommation (40 % de moins qu'une lampe fluorescente). Alliant technologie novatrice et design, Yves Béhar créa *Leaf* pour Herman Miller. Composée de nombreuses liaisons pivot, cette lampe « offre à son utilisateur un éventail de choix pour exprimer les variations sensorielles et magiques de la lumière », dixit Béhar. Récompensée à plusieurs reprises, *Leaf* dévoile un corps sculptural en aluminium doté d'une interface tactile universelle.

The result of years of research and development, the *Soon* halogen light incorporates a number of identical translucent polycarbonate elements into its distinctive flexible spine column, which is insulated and strengthened by two power-carrying strips of steel. This innovative mechanism enables this serpentine light to be adjusted with ease. Additionally, there is a lever for even more precise positioning of the light source head.

Die Halogenleuchte *Soon* ist das Ergebnis jahrelanger Forschung und Entwicklung. Der verstellbare Arm besteht aus einer Vielzahl identischer verstellbarer Glieder aus durchsichtigem Polykarbonat, isoliert und gestützt von zwei stromführenden Flachstahlbändern. Ihr technisch ausgeklügelter Mechanismus erlaubt eine einfache Positionierung der geschwungenen Leuchte. Zusätzlich ist der Kopf der Leuchte mithilfe eines Hebels schwenkbar.

Soon est le fruit de plusieurs années de recherche et de développement. Sa forme caractéristique vient de l'addition d'un certain nombre d'éléments identiques en polycarbonate translucide, lui conférant la forme d'une colonne vertébrale. Celle-ci est renforcée par une double bande plate en acier assurant une parfaite isolation. Flexible, ce mécanisme novateur permet différentes configurations. La luminosité est contrôlée par un commutateur pour un design original très contemporain.

Soon table light, 2000
Tobias Grau (Germany, 1957–)

www.tobias-grau.com
Aluminium, steel, polycarbonate
Aluminium, Stahl, Polykarbonat
Aluminium, acier, polycarbonate
↕ 50 cm (max) ⌀ 19.4 cm
Tobias Grau, Rellingen, Germany

Dalù table light, 1965

Vico Magistretti (Italy, 1920–2006)

www.artemide.com
PMMA or ABS
PMMA oder ABS
PMMA ou ABS
↕ 26 cm ↔ 18.4 cm ⤢ 18.4 cm
Artemide, Pregnana Milanese, Italy

One of the guiding aims of Modern design has been the creation of single-material, single-piece constructions – the idea being that the fewer the parts, the easier the assembly, and thereby the greater the manufacturing efficiency. In the mid-1960s Vico Magistretti eloquently demonstrated this concept of design unity in his *Dalú* table light for Artemide. Made of shiny ABS plastic or translucent acrylic, this diminutive design unifies the base with the shade through its innovative one-piece cantilevered form.

Eine der Leitlinien modernen Designs war es, Gebrauchsgegenstände aus einem einzigen Werkstoff und in einem Stück zu fertigen. Dahinter stand die Idee: Je weniger Teile, desto einfacher die Montage und umso größer die Effizienz bei der Herstellung. Mitte der 1960er Jahre setzte Vico Magistretti dieses Designkonzept geschickt bei *Dalú*, eine Tischleuchte für Artemide, um: In einer innovativen, freischwingenden Form verbinden sich in diesem Miniaturdesign Basis und Schirm aus glänzendem ABS-Kunststoff miteinander.

Conçue avec intelligence dans une esthétique minimaliste propre à certaines créations des années 60, la lampe *Dalù* de Vico Magistretti séduit par ses lignes pures. Cette lampe monobloc développe un audacieux porte-à-faux en plastique ABS brillant. Rééditée pour Artemide, *Dalù* se décline en version transparente ou opaque, en quatre coloris afin de conserver son design original. Idéale en lampe de chevet, elle apporte une touche originale et offre une lumière douce très séduisante.

Ingeniously simple, the *Taccia* table light comprises just three basic parts – an aluminium column, a rotating glass bowl, and a curved aluminium reflector. This light-filled bowl can be rotated through 360 degrees, and provides a pleasantly diffused light. While the *Taccia* eloquently demonstrates the Castiglionis' goal of achieving pleasing results with minimum means, it also has a strong architectural presence that reminds one of the fluted shaft of a classical column.

Die genial einfache *Taccia*-Tischleuchte besteht aus nur drei Grundelementen – einer Aluminiumsäule, einer drehbaren Glasschale und einem gewölbten Aluminiumreflektor. Die Leuchtenschale kann um 360 Grad gedreht werden und bietet ein angenehm diffuses Licht. Die *Taccia* demonstriert nicht nur auf überzeugende Art das Ziel der Castiglionis, mit minimalen Mitteln ansprechende Ergebnisse zu erzielen, sondern besitzt auch eine starke architektonische Präsenz, die an den kannelierten Schaft einer klassischen Säule erinnert.

D'une simplicité ingénieuse, la *Taccia* est essentiellement composée de trois parties : une colonne en aluminium, une cloche en verre pouvant pivoter à 360° et un réflecteur incurvé en aluminium. La cloche projette une belle lumière diffuse. Tout en illustrant à merveille l'objectif des Castiglioni, à savoir obtenir de beaux résultats esthétiques avec un minimum de moyens, elle a une forte présence architecturale qui rappelle les cannelures d'une colonne classique.

Taccia table light, 1962

Achille Castiglioni (Italy, 1918-2002) & Pier Giacomo Castiglioni (Italy, 1913–1968)

www.flos.com
Steel, enamelled aluminium, glass
Stahl, lackiertes Aluminium, Glas
Acier, aluminium émaillé, verre
↕ 54 cm ⌀ 49.5 cm
Flos, Bovezzo, Brescia, Italy

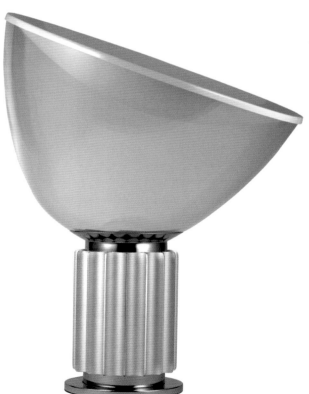

Inspired by the loveable 'Peanuts' character's protruding nose, the *Snoopy* light is a humorous but essentially rational design. With its marble stem, it exudes a sense of quality and luxury, while its unusually shaped black enamelled shade gives it a chic sophistication. Achille Castiglioni enjoyed creating objects that were both witty and stylishly functional, and the *Snoopy* is testament to this and to his love of irony in design.

Die *Snoopy*, für den die hervorstehende Nase der liebenswerten Figur aus der Comicserie *Die Peanuts* Pate stand, ist ein humorvolles, aber dennoch absolut rationales Design. Der Marmorfuß strahlt Qualität und Luxus aus, während der ungewöhnlich geformte, schwarz lackierte Schirm der Leuchte eine stilvolle Raffinesse verleiht. Achille Castiglione genoss es, witzige und gleichzeitig elegante und funktionale Objekte zu schaffen, und *Snoopy* veranschaulicht dies sowie seine Vorliebe für Ironie im Design.

Inspiré de la truffe de l'attachant personnage des *Peanuts*, le design de *Snoopy* est humoristique et éminemment rationnel. Avec son pied en marbre, il exsude la qualité et le luxe tandis que son abat-jour émaillé noir à la forme inhabituelle lui confère un chic sophistiqué. Achille Castiglioni aimait créer des objets fonctionnels et élégants, ce que sa lampe *Snoopy* incarne parfaitement, tout comme son goût du design emprunt d'ironie.

Snoopy table light, 1967

Achille Castiglioni (Italy, 1918-2002) & Pier Giacomo Castiglioni (Italy, 1913–1968)

www.flos.com
Marble, enamelled steel, glass
Marmor, lackierter Stahl, Glas
Marbre, acier émaillé, verre
↕ 37 cm ⤢ 39.5 cm
Flos, Bovezzo, Brescia, Italy

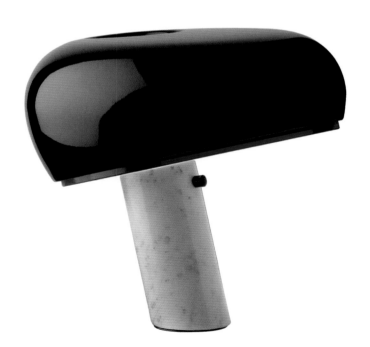

Costanza table light, 1986

Paolo Rizzatto (Italy, 1941–)

www.luceplan.com
Enamelled aluminium, silk-screened polycarbonate
Lackiertes Aluminium, siebgedrucktes Polykarbonat
Aluminium émaillé, polycarbonate sérigraphié
↕ 110 cm (max) ⌀ 40 cm
Luceplan, Milan, Italy

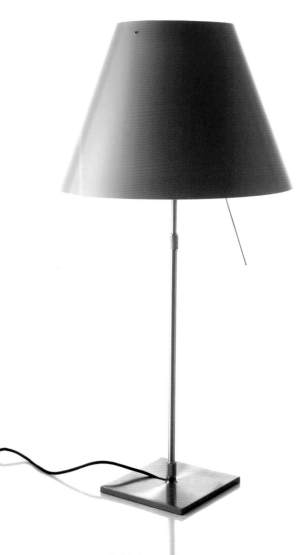

Unobtrusive and elegant, the *Costanza* table light incorporates a washable polycarbonate shade, a height-adjustable stem, and an unusual touch-sensitive control rod that functions as an on/off switch as well as a dimmer. Stripped of all extraneous detailing, this design has a timeless essentialism that seems impervious to the whims of fashion. Its quiet aesthetic also ensures that the *Costanza* works well in almost any interior.

Die zurückhaltende und elegante *Costanza*-Tischleuchte besteht aus einem abwaschbaren Schirm aus Polykarbonat, einem höhenverstellbaren Schaft und einem ungewöhnlichen Sensorstäbchen, das als An/Aus-Schalter und als Dimmer fungiert. Dieser Entwurf kommt ohne überflüssige Details aus und besitzt etwas zeitlos Essentialistisches, das von den Launen der Mode unberührt bleibt. Die schlichte Ästhetik der *Costanza* sorgt auch dafür, dass sie zu fast jeder Einrichtung passt.

Discrète et élégante, la *Costanza* est équipée d'un abat-jour lavable en polycarbonate, d'un pied réglable et d'une tige de contrôle sensorielle servant à la fois d'interrupteur et de variateur. Dépouillée de tout détail superflu, cette lampe possède un essentialisme intemporel qui semble à l'abri des caprices de la mode. Son esthétique sobre lui permet également de trouver sa place dans pratiquement tous les types d'intérieurs.

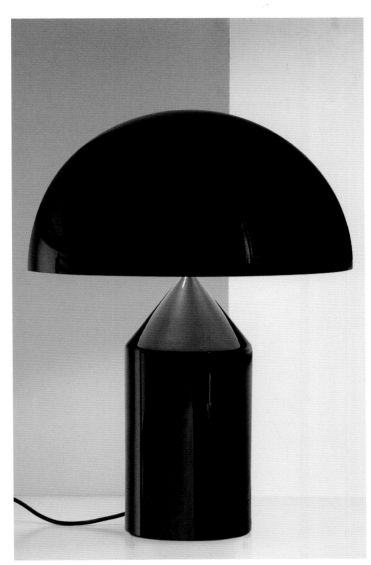

A truly iconic lighting design, the *Atollo* represents Vico Magistretti's desire to explore "the very essence of the object, looking at usual things with an unusual eye." Its powerful elemental form derives from his use of Euclidean geometric forms – the hemisphere, cylinder and cone – which he has arranged in such a way that they produce the abstracted shape of a traditional table light. Available in black or white, and three different sizes, the *Atollo* is a visually engaging design that is both sculptural and symbolic.

Atollo ist eine echte Ikone *des* Leuchtendesigns und steht für Vico Magistrettis Wunsch, „dem Wesen des Objekts auf den Grund zu gehen, indem man gewöhnliche Alltagsgegenstände aus einem ungewöhnlichen Blickwinkel betrachtet." Die kraftvoll-elementare Form bezieht ihre Wirkung aus dem Zusammenspiel von drei euklydischen Formen – Halbkugel, Zylinder und Kegel, deren Konturen die Abstraktion einer traditionellen Tischleuchte nachzeichnen. Ihre Attraktivität ist in diesem Symbolismus wie ihrer kühnen skulpturalen Form begründet. *Atollo* ist in drei Größen in Schwarz oder Weiß erhältlich.

Atollo raconte l'attirance de Vico Magistretti pour les volumes géométriques forts et majestueusement équilibrés : « J'aime les formes géométriques. J'aime créer des formes essentielles qui ressemblent à de simples volutes. » Cette lampe est composée d'un abat-jour demi-sphérique porté sur un pied cylindrique. Les volumes primitifs et proportionnels sont mis en évidence par la lumière qui opère un jeu de clair-obscur. Une fois allumée, cette lampe, pure et sculpturale, semble flotter dans les airs. Un véritable chef-d'œuvre. Disponible en blanc ou noir.

Atollo 233 table light, 1977
Vico Magistretti (Italy, 1920–2006)

www.oluce.com
Enamelled metal (or opaline glass)
Emalliertes Metall (oder Opalglas)
Métal émaillé (ou verre opaline)
↕ 70 cm ∅ 50 cm
Oluce, San Giuliano Milanese, Italy

No other designer manages to so consistently surprise and delight as Ross Lovegrove; he is a visionary who creates objects that literally pull the future into the present. With their hydro-formed mirror-treated diffusers, the *Aqua Cil* and *Aqua Ell* table lights suggest 'a vortex floating in mid air that brings a magical dynamic to space'. In this way, these lights function more like light sculptures with a dematerialising yet sensual presence.

Kein anderer Produktdesigner überrascht und entzückt uns so regelmäßig wie Ross Lovegrove. Er ist ein Visionär und kreiert Objekte, welche die Zukunft in die Gegenwart versetzen. Mit ihren hydrogeformten, auf Hochglanz polierten Lichtverteilern wirken die *Aqua Cil Tavolo* und die *Aqua Ell Tavolo* wie wirbelnde Wasserwellen, die den Raum mit dynamischem Zauber erfüllen. So erscheinen sie auch wie Lichtskulpturen von nahezu unstofflicher, aber dennoch sinnlicher Präsenz.

Véritable visionnaire, Ross Lovegrove a l'art et la manière de créer des objets attirant littéralement l'avenir dans le présent. Les lampes *Aqua* reflètent une inspiration puisée dans les formes simples de la nature. *Aqua Cil* et *Aqua Ell* suggèrent « un tourbillon flottant en l'air et donnant un dynamisme magique à l'espace ». D'une technologie numérique innovante, *Aqua* donne un effet poétique saisissant grâce à sa présence et à sa sensualité.

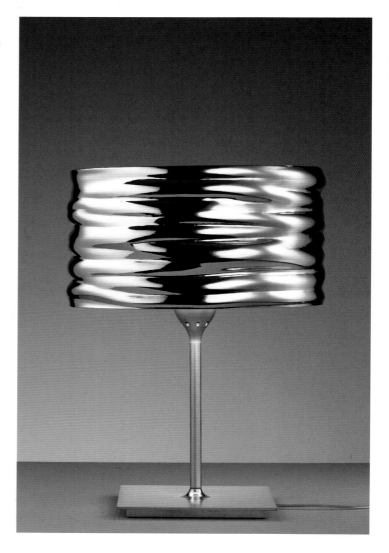

Aqua Cil Tavolo table light, 2007
& Aqua Ell Tavolo table light, 2007

Ross Lovegrove (UK, 1958–)

www.artemide.com
Die-cast aluminium, steel, aluminium
Druckgussaluminium, Stahl, Aluminium
Aluminium moulé sous-pression, acier, aluminium
↕ 44 cm ⌀ 32 cm
↕ 43 cm ⌀ 36 cm
Artemide, Pregnana Milanese, Italy

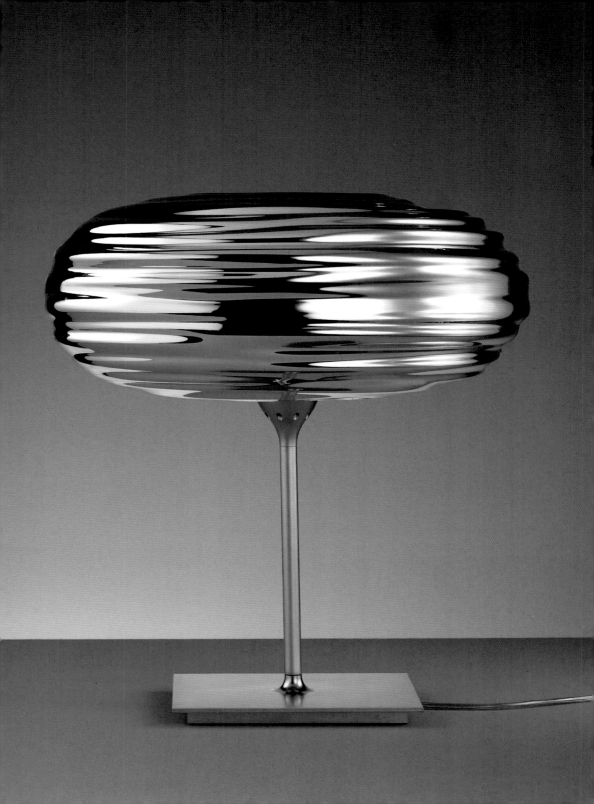

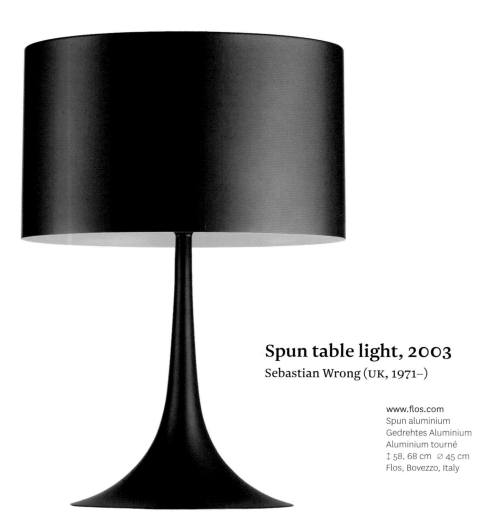

Spun table light, 2003

Sebastian Wrong (UK, 1971–)

www.flos.com
Spun aluminium
Gedrehtes Aluminium
Aluminium tourné
↕ 58, 68 cm ⌀ 45 cm
Flos, Bovezzo, Italy

The *Spun* light derives its name from its manufacturing process – metal spinning – an age-old technique brought to seamless, high-tech perfection in this design. 'The essence of the *Spun* light', reflects Sebastian Wrong, 'is simplicity', while its exquisite form communicates the 'dynamic fluid aesthetics' of the metal. With either a natural aluminium or black finish, the *Spun* light is also available in a floor version.

Die *Spun*-Leuchte hat ihren Namen von dem Fertigungsverfahren des Metall-drückens – eine sehr alte Technik, die in diesem Entwurf zu hochtechnologischer Perfektion gebracht wird. „Die Essenz der *Spun*-Leuchte", so Sebastian Wrong, „ist Einfachheit", während ihre exquisite Form die „dynamische, fließende Ästhetik" des Metalls kommuniziert. Mit einem Finish in natürlichem Aluminium oder schwarz lackiert, ist die *Spun* auch als Boden-leuchte erhältlich.

La lampe *Spun* tire son nom de son processus de fabrication, le tournage sur métal (« spinning »), une technique ancestrale amenée ici à une perfection high-tech. Comme l'explique Sebastian Wrong l'« essence de la lampe *Spun* est la simplicité » tandis que sa forme exquise traduit « l'esthétique dynamique fluide » du métal. En aluminium naturel ou avec une finition noire, *Spun* existe également en version lampadaire.

One of Philippe Starck's best-selling designs, *Miss Sissi* is a diminutive table light made of injection-moulded polycarbonate plastic, that ensures it is as affordable as it is stylish. Offered in seven translucent colours, Starck's industrially produced design also cleverly calls to mind the idea of handicraft with its faux-stitched detailing. Like so many of his designs, this small yet perfectly formed light has been given a characterful name in order to evoke a sense of personality.

Miss Sissi ist einer von Philippe Starcks meistverkauften Entwürfen, eine zierliche Tischleuchte aus spritzgegossenem Polykarbonat, die ebenso erschwinglich wie elegant ist. Starcks industriell hergestellte Leuchte, die in sieben transparenten Farben erhältlich ist, erinnert mit ihren imitierten Nähten auf clevere Art an handwerkliche Fertigung. Wie so vielen seiner Entwürfe gab er auch diesem einen charakteristischen Namen, um die Vorstellung einer Persönlichkeit zu wecken.

L'une des créations de Philippe Starck les plus vendues, *Miss Sissi* est en plastique polycarbonate moulé par injection, ce qui la rend aussi économique qu'élégante. Proposée en sept couleurs translucides, ce design industriel fait un clin d'œil à l'artisanat avec sa fausse « couture » latérale. Comme bon nombre des créations de Starck, cette lampe toute petite mais parfaitement conçue porte un nom charmant qui lui confère encore un peu plus de personnalité.

Miss Sissi table light, 1991

Philippe Starck (France, 1949–)

www.flos.com
Coloured, injection-moulded polycarbonate
Farbiges Spritzguss-Technopolymer
Technopolymère moulé par injection et teinté
↕ 28.4 cm ⌀ 14.3 cm
Flos, Bovezzo, Italy

Steam table light, 2007

Rikke Hagen (Denmark, 1970–)

www.holmegaard.com
Opalescent glass, smoked glass
Opalglas, Rauchglas
Verre opalin, verre fumé
↕ 29, 40 cm ∅ 25, 35 cm
Holmegaard Glasværk, Holmegaard,
Denmark

Futuristic yet at the same time quite retro, Rikke Hagen's *Steam* table light translates the form of a table lamp into a sculptural incarnation of elegance. The one-piece shade and base is made from an interesting combination of white opalescent glass and smoked glass, which is then contrasted with a turquoise cable that boldly emerges from inside the lamp. Available in two sizes, this unusual and innovative lighting design won a prestigious iF Design Award.

Futuristisch, aber gleichzeitig ziemlich retro, übersetzt Rikke Hagens *Steam* die Form einer Tischleuchte in eine skulpturale Verkörperung von Eleganz. Schirm und Fuß bestehen aus einer interessanten Kombination aus weißem Opalglas und Rauchglas, kontrastiert durch ein türkisfarbenes Kabel, das sich aus dem Inneren der Leuchte herausschlängelt. Dieses ungewöhnliche, in zwei Größen erhältliche Leuchtendesign wurde mit dem renommierten iF Design Award ausgezeichnet.

À la fois futuriste et un brin rétro, la *Steam* de Rikke Hagen transforme la lampe de table en incarnation sculpturale de l'élégance. L'abat-jour et la base sont réalisés d'une seule pièce dans une intéressante combinaison de verre blanc opalin et de verre fumé, le câble turquoise qui émerge du cœur de la lampe offrant un contraste de couleur. Existant en deux tailles, cette création originale et innovante a remporté le prestigieux prix iF Design.

Rha table light, 2007

Diego Sferrazza (Italy, 1976–)

www.sphaus.com
Thermoformed methacrylate
Thermogeformtes Methacrylat
Méthacrylate thermoformé
↕ 35 cm ⌀ 40 cm
SpHaus, Milan, Italy

This unusual light by Diego Sferrazza casts a soft, diffused light and is available in either opalescent white or glossy black acrylic. Like other lights manufactured by SpHaus it is, according to the company, 'characterized by a pure, non-decorative design…functional, not minimal'. As an elegant and understated design, the *Rha* conveys the manufacturing refinement and formal innovation of contemporary Italian design.

Diese ausgefallene Leuchte von Diego Sferrazza verströmt sanftes, diffuses Licht und ist entweder in opalisierendem weißem oder glänzend schwarzem Acryl erhältlich. Wie andere, von SpHaus hergestellte Leuchten ist auch diese, so das Unternehmen, „durch ein pures, nicht dekoratives Design charakterisiert … funktional, nicht minimal." Die elegante, zurückhaltende *Rha* steht für die edle Fertigung und formale Innovation des modernen italienischen Designs.

Cette lampe originale signée Diego Sferrazza diffuse une lumière douce et indirecte. Elle existe en blanc opalin ou en acrylique noir satiné. Comme d'autres luminaires édités par SpHaus, elle se caractérise (selon la compagnie) « par un design pur, non décoratif… fonctionnel mais pas minimal ». Élégante et discrète, *Rha* illustre le raffinement de la fabrication et l'innovation formelle du design italien contemporain.

Agaricon table light, 2001

Ross Lovegrove (UK, 1958–)

www.luceplan.com
Injection-moulded polycarbonate, aluminium
Spritzguss-Polykarbonat, Aluminium
Polycarbonate moulé par injection, aluminium
↕ 28 cm ⌀ 41 cm
Luceplan, Milan, Italy

Ross Lovegrove's luminous toadstool light looks as though it has been plucked from an exotic sci-fi landscape. Rather than using a traditional on/off switch, the light level is controlled by a touch-sensitive aluminium ring encircling the ribbed polycarbonate body, which is available in three different colors – mandarin orange, jade green and milky white. The design's name, *Agaricon*, was used by the Greeks for a specific type of mushroom, which reputedly grew in abundance in the Sarmatian town of Agaria.

Ross Lovegroves Leuchtpilz wirkt als stamme er aus einer exotischen Science-Fiction-Landschaft. Statt durch einen traditionellen An/Aus-Schalter wird die Lichtintensität durch einen Sensorring aus Aluminium rund um den gerippten Leuchtenkörper reguliert, der in drei verschiedenen Farben erhältlich ist – Mandarinorange, Jadegrün und Milch-weiß. Der Name *Agaricon* bezeichnete bei den alten Griechen einen bestimmten Pilz, der angeblich besonders zahlreich in der Stadt Agaria in Sarmatien wuchs.

Ce champignon lumineux de Ross Lovegrove semble avoir été cueilli dans un paysage exotique de science-fiction. Plutôt que par un interrupteur classique, l'intensité lumineuse est contrôlée en effleurant l'anneau sensoriel en aluminium qui encercle le corps nervuré en polycarbonate, proposé en trois couleurs : orange mandarine, vert jade ou blanc laiteux. *Agaricon* est le nom grec de l'agaric, un champignon qui aurait poussé en abondance dans la ville sarmate d'Agaria.

Jones Master floor light, 2003

Uwe Fischer (Germany, 1958–)

www.serien.com
Aluminium, fibreglass laminate
Aluminium, Glashartgewebe
Aluminium, fibre de verre laminée
↕ 172 (max) cm ⌀ 45 cm
Serien Raumleuchten, Rodgau, Germany

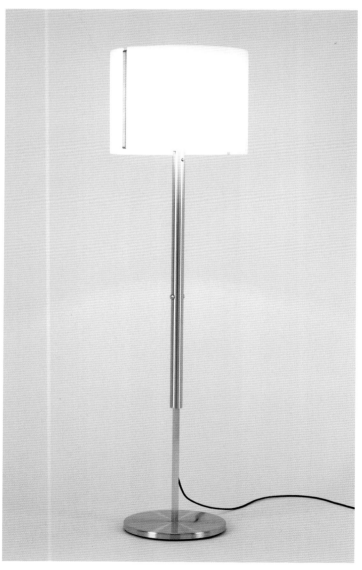

With its pleasing contemporary aesthetic, the *Jones Master* floor light is a multi-functional design that can be used either as an uplighter or as a reading light. On its height-adjustable stem there are two switches that direct the emitted light upwards or downwards, and also control the level of luminosity. The reflector in the shade also has coloured filters that give the option of an ambient and atmospheric orange, blue or yellow glow.

Die *Jones Master* ist eine multifunktionale Bodenleuchte von ansprechender moderner Ästhetik, die sowohl als Deckenfluter wie auch als Leseleuchte genutzt werden kann. Über die beiden Knöpfe an dem höhenverstellbaren Standrohr lassen sich die Lichtstärke regeln und das Licht nach oben oder nach unten lenken. Für den Glaseinsatz im Schirm sind Farbfilter erhältlich, mit denen sich ein diffuses und atmosphärisches Licht in Orange, Blau oder Gelb erzeugen lässt.

Doté d'une agréable esthétique contemporaine, le lampadaire *Jones Master* est multifonctionnel. Son pied réglable comporte deux boutons qui permettent de diffuser la lumière vers le plafond ou vers le bas, devenant lampe de lecture. Il est également pourvu d'un variateur. Le réflecteur dans l'abat-jour possède des filtres de couleur offrant la possibilité de créer une lumière d'ambiance orange, bleue ou dorée.

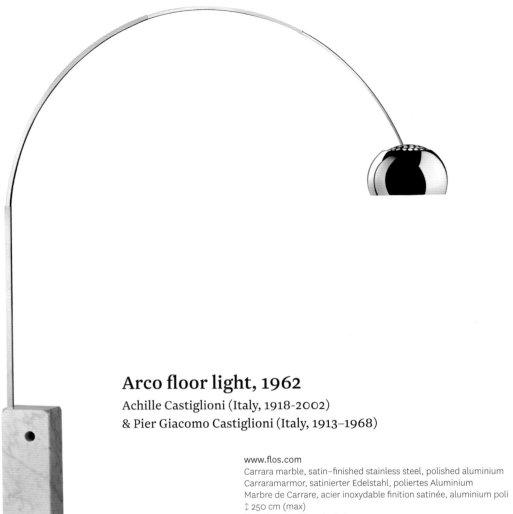

Arco floor light, 1962

Achille Castiglioni (Italy, 1918-2002)
& Pier Giacomo Castiglioni (Italy, 1913–1968)

www.flos.com
Carrara marble, satin-finished stainless steel, polished aluminium
Carraramarmor, satinierter Edelstahl, poliertes Aluminium
Marbre de Carrare, acier inoxydable finition satinée, aluminium poli
↕ 250 cm (max)
Flos, Bovezzo, Brescia, Italy

Lightheartedly subverting conventional norms, the *Arco* transforms the ceiling light into a freestanding floor unit. Inspired by street lighting, this well-known arching light was originally designed for dining areas – with the light source positioned sufficiently away from the base to allow enough space for a table and chairs. Its space-age connotations have ensured its continuing popularity, while its strong aesthetic presence makes it a good central focus for an interior scheme.

Die *Arco* widersetzt sich unbeschwert jeder konventionellen Norm und verwandelt die Deckenleuchte in ein freistehendes Bodenelement. Diese bekannte, von Straßenlampen inspirierte Bogenleuchte wurde ursprünglich für den Essbereich entworfen – die Lichtquelle sollte weit genug vom Fuß entfernt sein, um ausreichend Platz für einen Tisch und Stühle zu lassen. Dank ihrer futuristischen Konnotationen erfreut sie sich beständiger Beliebtheit, und ihre starke ästhetische Präsenz macht sie zum zentralen Fokus eines Raums.

Subvertissant allègrement les normes conventionnelles, l'*Arco* transforme le plafonnier traditionnel en lampadaire. Inspiré par l'éclairage de rue, il fut conçu pour les coins repas, la source lumineuse étant suffisamment distante de la base pour laisser de la place à une table et des chaises. Ses connotations futuristes lui ont permis de traverser les époques et sa forte présence esthétique attire le regard dans n'importe quelle pièce.

Available in three different finishes – white lacquer, black lacquer and matt nickel – the *Nature* floor light casts interesting decorative shadows from its incised diffuser of abstracted floral motifs. With its cylindrical shade and tapering base that flares downwards, the formal geometry of the light heightens its strong graphic quality, thereby distinguishing it from the plethora of floor lights currently on offer.

Die Stehlampe *Nature* ist weiß oder schwarz lackiert oder matt vernickelt lieferbar. Durch die Einschnitte im Lampenschirm wirft sie abstrakte florale Licht- und Schattenmuster auf Boden und Wände. Mit dem zylindrischen Schirm und dem sich nach unten verbreiternden Schaft, der nahtlos in die Standfläche übergeht, ist die Lampe von großer grafischer Ausdruckskraft, was sie aus der Masse des Stehlampenangebots heraushebt.

Disponible en trois finitions, laqué blanc ou noir, et nickel mat, le lampadaire *Nature* reflète des ombres décoratives grâce à son abat-jour incrusté de motifs floraux. Cet abat-jour cylindrique est posé sur une tige très fine, légèrement évasée vers le bas. La géométrie formelle de la lumière intensifie sa qualité graphique, la différenciant des autres lampadaires actuellement sur le marché.

Nature floor light, 2006
Diego Fortunato (Argentina/Spain, 1971–)

www.vibia.es
Lacquered or nickel-plated metal
Lackiertes oder vernickeltes Metal
Métal peint ou nickelé
↕ 160 cm ⌀ 50 cm
Vibia, Barcelona, Spain

Mix task light, 2005

Alberto Meda (Italy, 1945–) & Paolo Rizzatto (Italy, 1941–)

www.luceplan.com
Aluminium, PMMA, steel
Aluminium, PMMA, Stahl
Aluminium, PMMA, acier
↕ 69 cm ↔ 10 cm
Luceplan, Milan, Italy

Alberto Meda and Paolo Rizzatto have co-designed numerous award-winning products, including the elegant *Mix* task light, which won a prestigious Compasso d'Oro in 2008 as well as a DesignPlus and Good Design award. The user can choose between a warm or cool light depending on requirements, while the methacrylate head incorporating energy-efficient LEDS can be easily positioned via the *Mix*'s sinuously slender flexible aluminium stem.

Alberto Meda und Paolo Rizzatto haben gemeinsam bereits zahlreiche preisgekrönte Produkte entworfen, darunter auch die elegante *Mix*-Leseleuchte, die 2008 mit dem angesehenen Compasso d'Oro sowie mit einen DesignPlus und einem Good Design Award ausgezeichnet wurde. Je nach Erfordernis kann der Benutzer zwischen warmem oder kaltem Licht wählen. Der Kopf aus Methacrilat, der energieeffiziente Leuchtdioden enthält, lässt sich dank des feingliedrigen und flexiblen Aluminiumarms leicht verstellen.

Ensemble, Alberto Meda et Paolo Rizzatto ont réalisé de nombreuses créations primées, notamment la lampe de bureau *Mix*. Récompensée par le prestigieux Compasso d'Oro en 2008, le Design Plus et le Good Design, cette lampe innovante et sophistiquée donne un éclairage chaud ou froid selon vos exigences. La tête en méthacrylate intègre la technologie LED assurant une économie d'énergie considérable. Grâce à son profil fin en aluminium flexible, *Mix* s'incline facilement.

Chimera floor light, 1969

Vico Magistretti (Italy, 1920–2006)

www.artemide.com
PMMA, enamelled metal
PMMA, emalliertes Metall
PMMA, métal émaillé
↕ 180 cm ⌀ 22 cm
Artemide, Pregnana Milanese, Italy

Vico Magistretti's serpentine *Chimera* light is a self-supporting structure that incorporates an eye-catching wave-like sheet of white acrylic. The elegant and undulating single-piece plastic construction of the *Chimera* diffuses and softens the emitted light, while also providing the design with a strong aesthetic presence. More an illuminated sculpture than a floor light, Magistretti's iconic design reflects the sophisticated simplicity so often found in Italian design from the 1960s and 1970s.

Vico Magistrettis geschwungene *Chimera*-Stehleuchte hat eine selbsttragende Struktur mit einem auffälligen wellenartigen Bogen aus weißem Acryl. Die elegante, einteilige gebogene Plastikkonstruktion der *Chimera* bündelt das Licht und wirft es sanft zurück, sodass das Design eine außergewöhnliche ästhetische Präsenz erhält. Magistrettis Kultdesign erinnert eher an eine beleuchtete Skulptur als an eine Stehleuchte. Darin spiegelt sich die ausgeklügelte Einfachheit des italienischen Designs der 1960er und 1970er Jahre.

Créée par Vico Magistretti, *Chimera* reflète une simplicité sophistiquée, caractéristique du design italien des années 60 et 70. Semblable à un ruban, voire un drapé, cette lampe a été courbée à chaud afin de lui insuffler un aspect à la fois léger et rigide. Ces ondes lumineuses en feuille d'acrylique blanc dégagent une clarté agréable et diffuse dans toute la pièce. Design intemporel, *Chimera* révèle une incroyable beauté sculpturale.

Cadmo floor light, 2006

Karim Rashid (Canada/USA, 1960–)

www.artemide.com
Painted steel
Lackierter Stahl
Acier peint
↕ 174 cm ⌀ 32 cm
Artemide, Pregnana Milanese, Italy

Widely acclaimed for his imaginative manipulation of form and function, Karim Rashid's designs are characterised by a strong aesthetic presence. His *Cadmo* floor light is an elegantly sculptural 'uplighter' that has an almost totemic quality. Made of painted sheet steel, its bold yet simple construction is visually enhanced by his choice of two colour combinations – white/white or black/white.

Für seine phantasievollen Manipulationen von Form und Funktion wird Karim Rashid gefeiert, denn seine Entwürfe charakterisiert eine starke ästhetische Präsenz. Wie auch bei seiner *Cadmo*-Bodenleuchte, einem elegant skulpturalen Deckenfluter von fast schon totemistischer Qualität. Die einfache Konstruktion aus lackierten Stahlblättern wird optisch unterstrichen durch die gewählte Zweifarbigkeit – weiß/weiß oder schwarz/weiß.

Conçue par Karim Rashid, *Cadmo* présente une conception imaginative. Une feuille d'acier verni enveloppe délicatement deux sources lumineuses, gérées séparément, pour un éclairage indirect ou diffus. Doté d'une élégance sculpturale, ce lampadaire illustre une conception audacieuse et simple à la fois, mise en valeur par son choix de deux combinaisons de couleurs : blanc/blanc ou noir/blanc.

Carrara floor light, 2000

Alfredo Häberli (Argentina/Switzerland, 1964–)

www.luceplan.com
Expanded polyurethane, tempered glass
Aufgeschäumtes Polyurethan, Hartglas
Polyuréthane expansé, verre trempé
↕ 185 cm ↔ 35 cm ↗ 22.5 cm
Luceplan, Milan, Italy

This elegant floor light epitomizes Alfredo Häberli's desire for 'simplicity with an added value'. Constructed from a single piece of fire-retardant expanded polyurethane, the *Carrara* has a totemic sculptural form, while its internally concealed electronic ballast allows light levels to be controlled with ease. As a modern re-interpretation of Pietro Chiesa's famous *Luminator* of 1933, the *Carrara* uses fluorescent tubes so as to ensure high levels of luminosity as well as low energy consumption.

Diese elegante Bodenleuchte verkörpert Alfredo Häberlis Wunsch nach „Einfachheit mit einem Mehrwert". Die aus einem einzigen Stück feuerhemmendem Polyurethan hergestellte *Carrara* hat die Form einer totemistischen Skulptur, und ihre Helligkeitsstufen können durch den im Inneren versteckten elektronischen Ballast leicht geregelt werden. Als eine moderne Neuinterpretation von Pietro Chiesas berühmter *Luminator* von 1933 sorgt die *Carrara* mit Leuchtstoffröhren für hohe Lichtintensität bei niedrigem Energieverbrauch.

Cet élégant lampadaire illustre l'aspiration d'Alfredo Häberli à « la simplicité avec une valeur ajoutée ». Construit d'une seule pièce en polyuréthane expansé et ignifugé, sa forme totémique sculpturale cache un ballast électronique qui permet de contrôler facilement l'intensité lumineuse. Réinterprétation moderne du célèbre *Luminator* de Pietro Chiesa (1933), le *Carrara* utilise des tubes fluorescents qui garantissent une forte luminosité et une faible consommation énergétique.

Sigma floor light, 2007

Lievore Altherr Molina (Spain, est. 1991)

www.vibia.es
Lacquered high-density resin
Lackiertes, hoch-verdichtetes Harz
Laqué de résine à haute densité
↕ 148 cm ↔ 38 cm ↗ 109 cm
Vibia, Barcelona, Spain

Spanish design has been undergoing something of a renaissance recently thanks in part to the work of the Barcelona design office of Lievore Altherr Molina. Alberto Lievore, Jeannette Altherr and Manel Molina believe that it is not only important for objects, such as their *Sigma* floor light, to function well, but also to be imbued with a sensuality that will provoke an emotional connection between user and object. Certainly this remarkable light has a gestural elegance that invites interaction and contemplation.

Dass das spanische Design eine Renaissance erlebt, ist nicht zuletzt das Verdienst der Arbeiten des in Barcelona ansässigen Designbüros Lievore Altherr Molina. Alberto Lievore, Jeannette Altherr und Manel Molina sind überzeugt, dass Objekte wie ihre *Sigma*-Stehleuchte nicht nur funktionieren, sondern auch sinnlich sein müssen, damit eine gefühlsmäßige Bindung zwischen Objekt und Nutzer entsteht. Mit ihrer gestischen Eleganz lädt diese beeindruckende Leuchte zweifellos zu Interaktion und Besinnung ein.

Le design espagnol subit une sorte de renaissance, notamment grâce au studio de design de Barcelone dirigé par Lievore Altherr Molina. Alberto Lievore, Jeannette Altherr et Manel Molina pensent que les objets n'ont pas pour unique finalité d'être fonctionnels, à l'instar de leur lampe *Sigma*, mais qu'ils doivent également être imprégnés d'une sensualité provoquant un lien émotionnel entre l'utilisateur et l'objet. *Sigma* offre une remarquable élégance qui invite à l'interaction et à la contemplation.

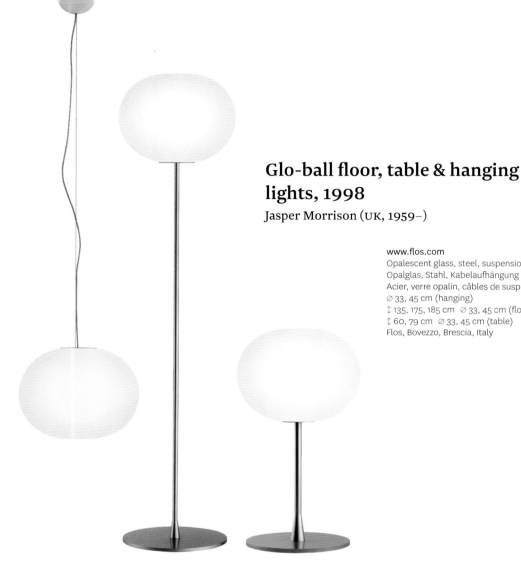

Glo-ball floor, table & hanging lights, 1998

Jasper Morrison (UK, 1959–)

www.flos.com
Opalescent glass, steel, suspension wires
Opalglas, Stahl, Kabelaufhängung
Acier, verre opalin, câbles de suspension
⌀ 33, 45 cm (hanging)
↕ 135, 175, 185 cm ⌀ 33, 45 cm (floor)
↕ 60, 79 cm ⌀ 33, 45 cm (table)
Flos, Bovezzo, Brescia, Italy

A true design purist, Jasper Morrison's products are stripped of ornamentation in order to reveal their most essential form. His successful *Glo-ball* lighting range has an innate simplicity that, as its title suggests, has a universal appeal. With its quiet presence, the *Glo-ball* is a very useful group of lights, complimenting virtually any interior scheme and, perhaps, the 'model' contemporary lighting collection – timeless yet modern.

Als echter Design-Purist verzichtet Jasper Morrison bei seinen Entwürfen auf jegliches Ornament, um die essentielle Form zu zur Geltung zu bringen. Seine erfolgreiche *Glo-ball*-Leuchtenserie ist von natürlicher Einfachheit und, wie der Name bereits andeutet, von universeller Attraktivität. Ihre zurückhaltende Präsenz macht *Glo-ball* zu einer sehr zweckmäßigen Gruppe von Leuchten, die jeden Raum aufwerten. Sie ist vielleicht das „Vorbild" der zeitgenössischen Leuchtenkollektion – zeitlos und dennoch modern.

Vrai puriste du design, Jasper Morrison créé des objets dépouillés d'ornements afin de révéler leur forme la plus essentielle. La simplicité de sa série de lampes *Glo-ball* a, comme son titre le laisse entendre, un attrait universel. Avec leur présence discrète, elles sont très pratiques et s'intègrent dans presque tous les styles d'intérieur. C'est peut-être la collection « modèle » de luminaires, moderne et intemporelle à la fois.

The *Foglio* wall light illustrates the way in which Italian designers during the 1960s used inventiveness to create artistic yet functional designs using the minimum means. Essentially a strip of metal that has been rolled up at its sides to conceal its light sources, the *Foglio* acts as a reflector that produces a softly diffused glow of light. With its name meaning 'sheet' in Italian, this graceful design has an enduring, timeless appeal thanks to its sculptural elemental quality.

Die *Foglio*-Wandleuchte veranschaulicht den Einfallsreichtum italienischer Designer in den 1960er Jahren, die mit minimalen Mitteln künstlerische, aber funktionale Entwürfe entwickelten. Im Prinzip ein Oval aus Metall, das an den Seiten gebogen wurde, um die Lichtquellen zu kaschieren, fungiert die *Foglio* als Reflektor, der ein sanftes diffuses Licht erzeugt. Dank seiner elementaren skulpturalen Qualität hat das anmutige Design der *Foglio*, was auf Italienisch „Blatt" bedeutet, etwas Beständiges und Zeitloses.

L'applique *Foglio* illustre la façon dont, dans les années 60, les designers italiens ont fait preuve d'inventivité pour créer des objets artistiques mais fonctionnels avec une économie de moyens. Ovale en métal dont les bords ont été repliés pour masquer les ampoules, la *Foglio* (« feuille » en italien) agit comme un réflecteur en produisant une douce lumière diffuse. Cet élégant design doit sa longévité et son charme intemporel à sa qualité sculpturale élémentaire.

Foglio wall light, 1966

Tobia Scarpa (Italy, 1935–)

www.flos.com
Enamelled or nickel–plated sheet metal
Lackiertes oder nickelbeschichtetes Metallblech
Feuille métallique émaillée ou nickelée
↕ 21 cm ↔ 37 cm
Flos, Bovezzo, Brescia, Italy

Goggle wall light, 2003

Ross Lovegrove (UK, 1958–)

www.luceplan.com
Polycarbonate with mirrored film
Polykarbonat mit irisierender Folie
Polycarbonate avec film irisé miroitant
↕ 32 cm ↔ 18 cm ⤢ 14 cm
Luceplan, Milan, Italy

Inspired by the shape and lens-treatment of Speedo swimming goggles, Ross Lovegrove's wall light incorporates an iridescent mirrored film that changes colour depending on the angle from which it is observed. Resembling the eye of some exotic fish, the design can be fixed to the wall straight or at a jaunty angle, and looks especially good when several are clustered together. Like Lovegrove's other designs, the *Goggle* wall light eloquently synthesizes state-of-the-art materials with a soft natural organic form.

Inspiriert von der Form und der Glasbearbeitung der Schwimmbrillen von Speedo, ist Ross Lovegroves Wandleuchte mit einer irsisierenden Folie ausgestattet, die je nach dem Blickwinkel des Betrachters die Farbe wechselt. Die *Goggle* ähnelt dem Auge eines exotischen Fisches, kann direkt an der Wand oder auch in einem verrückten Winkel angebracht werden und sieht besonders gut aus, wenn sie zu mehreren gruppiert wird. Wie die anderen Designs von Lovegrove synthetisiert auch die *Goggle*-Wandleuchte eloquent hochentwickelte Kunstmaterialien mit einer sanften, natürlich organischen Form.

Inspirée par la forme et le traitement des verres de lunettes de plongée Speedo, *Goggle* est équipée d'un film irisé miroitant qui change de couleur selon l'angle duquel on la regarde. Rappelant l'œil d'un poisson exotique, elle se plaque contre le mur ou se fixe de guingois. L'effet est encore plus saisissant quand plusieurs appliques sont regroupées sur le mur. Comme les autres créations de Lovegrove, *Goggle* conjugue avec éloquence des matériaux à la pointe de la technologie et une forme organique naturelle.

Metropoli wall light, 1992

Alberto Meda (Italy, 1945–), Riccardo Sarfatti (Italy, 1940–)
& Paolo Rizzatto (Italy, 1941–)

www.luceplan.com
Aluminium, glass or polycarbonate
Aluminium, Glass oder Polykarbonat
Aluminium, verre ou polycarbonate
⌀ 17, 27, 38, 56 cm
Luceplan, Milan, Italy

Winner of a Compasso d'Oro award in 1994, the *Metropoli* has an elemental quality that emphasizes its precise engineering. Like a ship's porthole, it has two main elements: a mounting section with a wide hole that allows easy electrical connection and subsequent inspection, and a hinged watch-case ring carrying the opalescent glass diffuser which facilitates bulb replacement and cleaning. The design accommodates various types of bulbs (incandescent, halogen or fluorescent) depending on the user's requirements.

Die elementare Qualität der 1994 mit einem Compasso d'Oro ausgezeichnete *Metropoli* unterstreicht ihre präzise Konstruktion. Wie das Bullauge eines Schiffes besteht auch sie aus zwei Elementen: einer Fassung mit breitem Loch zur einfachen Montage und Inspektion sowie einem aufklappbaren Schließring in Form eines Uhrengehäuses, der den Diffusor aus Opalglas enthält und sich leicht reinigen und warten lässt. Entsprechend den Bedürfnissen des Nutzers können verschiedene Lampen verwendet werden (Glühlampen, Halogenlampen oder Leuchtstofflampen).

Lauréat d'un Compasso d'Oro en 1994, *Metropoli* possède une qualité élémentaire qui met en valeur sa technique précise. Telle un hublot, elle comporte deux éléments principaux : une fixation avec une large ouverture facilitant le branchement puis l'inspection ; un boîtier portant le réflecteur en verre opalin équipé de charnières pour simplifier le changement d'ampoule et le nettoyage. L'applique peut accueillir différents types d'ampoule (incandescente, halogène ou fluorescente) selon les besoins.

Appearing to hover in the air, this visually stunning hanging light is made from a loop of translucent thermoplastic and comes in white, red or black. As its manufacturer notes, 'Lighting contributes to any space to the extent that it affects its appearance, its atmosphere and the feelings it creates,' and certainly the *Infinity 2021* does just this with elegance and beauty.

Diese optisch sehr wirkungsvolle Hängelampe besteht aus einem breiten, gewölbten Ring aus transluzentem Kunststoff und wird in Weiß, Rot oder Schwarz angeboten. Der Hersteller schreibt: „Leuchten beleben jeden Raum, weil sie sein Erscheinungsbild, seine Atmosphäre und die Gefühle, die er auslöst, bestimmen." Die *Infinity 2021* tut das mit Eleganz und formal ästhetischem Charme.

Infinity exprime la légèreté et l'élégance, comme suspendue dans les airs. Composée d'un abat-jour en thermoplastique translucide, elle diffuse sa lumière à travers toute la pièce, dégageant une atmosphère zen avec ses lignes pures et minimalistes. Une fois allumée, cette lampe met en scène tous vos intérieurs en assurant une esthétique peu ordinaire. Disponible en blanc, rouge ou noir, *Infinity* symbolise un raffinement d'une grande délicatesse.

Infinity 2021 hanging light, 2006
Robby Cantarutti (Italy, 1966–)

www.vibia.es
PMMA
PMMA
PMMA
⌀ 30, 45 cm
Vibia, Barcelona, Spain

Named after the Queen of the Fairies in William Shakespeare's *Midsummer's Night Dream*, the *Titania* light is suspended on invisible, height-adjustable nylon strands, which make it appear as though it is hovering in the air. Its interchangeable elliptical polycarbonate filters come in yellow, green, blue, violet and red, so that different visual effects can be created, ranging from a single band of colour to a rainbow-like spectrum.

Die nach der Königin der Elfen aus William Shakespeares *Sommernachtstraum* benannte *Titania* hängt an unsichtbaren, höhenverstellbaren Nylonfäden und sieht aus, als würde sie in der Luft schweben. Die austauschbaren elliptischen Filter aus Polykarbonat sind in Gelb, Grün, Blau, Violett und Rot erhältlich, so dass verschiedene visuelle Effekte erzeugt werden können, von einem einzelnen Farbstreifen bis zum Regenbogenspektrum.

Baptisée d'après la reine des fées du *Songe d'une nuit d'été* de Shakespeare, *Titania* est suspendue à des fils de nylon invisibles dont on peut régler la longueur et qui lui donnent l'air de flotter dans le vide. Elle s'accompagne de filtres elliptiques interchangeables en polycarbonate jaune, vert, bleu, violet et rouge, permettant de créer divers effets visuels, d'un simple faisceau d'une couleur à un spectre arc-en-ciel.

Titania suspension light, 1989

Alberto Meda (Italy, 1945–) & Paolo Rizzato (Italy, 1941–)

www.luceplan.com
Aluminium, polycarbonate, nylon
Aluminium, Polykarbonat, Nylon
Aluminium, polycarbonate, nylon
↕ 8 cm ↔ 70 cm ⤢ 27 cm
Luceplan, Milan, Italy

A much-loved Danish design from the 1960s, the *Norm 69* hanging light is made up of sixty-nine pieces of thin plastic sheet that are joined together like a puzzle without having to use any tools or glue. It is sold in flat-pack form and when constructed it forms a highly sculptural light, with the white or cream petal-like elements giving a pleasantly diffused light. Guaranteed to give any room a touch of affordable Scandinavian stylishness, the *Norm 69* comes in four different sizes.

Die *Norm 69*-Hängeleuchte, ein sehr beliebtes dänisches Design aus den 1960ern, besteht aus neunundsechzig dünnen Plastikteilen, die sich wie ein Puzzle ohne Werkzeug oder Klebstoff zusammensetzen lassen. Sie wird flach verpackt geliefert, und einmal zusammengebaut verbreitet diese sehr plastische Leuchte mit ihren weißen oder cremefarbenen „Blütenblattelementen" ein angenehm warmes Licht. In vier Größen erhältlich verleiht die *Norm 69* garantiert jedem Raum einen Hauch von erschwinglicher moderner skandinavischer Eleganz.

Conçue dans les années 60, la lampe *Norm 69* est devenue un collector du design scandinave. Surprenante le jour, elle devient fantastique une fois allumée. Visionnaire et futuriste, l'abat-jour est composé de soixante-neuf pièces qui ne nécessitent aucun outil ni colle pour l'assembler. Avec sa forme en bulbe, cette superbe lampe utilise pleinement les jeux de lumière, sans créer d'ombres indésirables. Disponible en quatre tailles, *Norm 69* s'inspire des formes naturelles, lui conférant une touche de légèreté. L'élégance scandinave à un prix raisonnable.

Norm 69 hanging light, 1969

Simon Karkov (Denmark, 1932–)

www.normann-copenhagen.com
Plastic
Plastik
Plastique
⌀ 42, 51, 60, 78 cm
Normann Copenhagen, Copenhagen, Denmark

PH Snowball hanging light, 1958

Poul Henningsen (Denmark, 1894–1967)

www.louispoulsen.com
Enamelled aluminium, chrome-plated aluminium
Emailliertes Aluminium, verchromtes Aluminium
Aluminium émaillé, aluminium chromé
↕ 39 cm ∅ 40 cm
Louis Poulsen Lighting, Copenhagen, Denmark

In 1957 the architect Charles Gjerrild asked Poul Henningsen to design an economical yet decorative light for his Adventist Church at Skodsborg Hydro. The resulting design comprised thirteen concentric metal shades set on a simple four-ribbed frame. Introduced a year later, the visually striking *Snowball* possessed a similar construction yet on a smaller scale, and incorporated only eight shades – making it more suitable for domestic spaces.

Der Architekt Charles Gjerrild bat 1957 Poul Henningsen, eine bezahlbare und dennoch dekorative Leuchte für seine Adventistenkirche in Skodsborg Hydro zu entwerfen. Henningsens Entwurf bestand aus dreizehn konzentrisch angeordneten Metallschirmen auf vier einfachen Rippen. Die Konstruktion der ein Jahr später auf dem Markt eingeführten *Snowball* basiert auf demselben Prinzip, aber ihr Durchmesser ist mit nur acht Schirmen kleiner. So eignet sich dieses optisch verblüffende Design auch für das häusliche Wohnumfeld.

En 1957, l'architecte Charles Gjerrild demande à Poul Henningsen de concevoir un éclairage design mais bon marché pour l'Église adventiste à Skodsborg Hydro. *PH Snowball* comprenait alors treize teintes métalliques sur une structure simple en ogive. Les formes de cette lampe sont alignées de sorte que chaque surface reçoit un rayon de lumière projeté exactement sous le même angle. Elle est diffusée dorénavant pour des espaces domestiques, en seulement huit teintes.

Taraxacum 88 hanging light, 1988

Achille Castiglioni (Italy, 1918-2002)

www.flos.it
Steel, steel suspension cable, polished
aluminum, light-bulbs
Stahl, Stahlkabel, Aluminium (glänzend
poliert), Glühbirnen
Acier, câble de suspension en acier,
aluminium poli, ampoules
Ø 80, 105 cm
Flos, Milan, Italy

Achille Castiglioni's *Taraxacum 88* hang-
ing light is made from a cluster of sixty
shimmering halogen bulbs that emit a
direct light as well as a softer reflected
light. Although based on a simple design
concept, like so many of Castiglioni's
designs, the resulting product is visually
sophisticated yet also engagingly play-
ful – it reminds one of children's bubble
blowing yet on a massive scale.

Die Hängelampe *Taraxacum 88* ist ein
kugeliges Gebilde aus zwanzig zusam-
mengeballten Glühbirnen auf glän-
zendem Aluminiumkörper, das sowohl
Licht abstrahlt als auch reflektiert. Das
Konzept ist zwar einfach, aber wie bei
so vielen Designs von Achille Castiglioni
ist auch hier das Endprodukt optisch
und formal anspruchsvoll gestaltet und
erinnert ein bisschen an Seifenblasen,
die Kinder entzücken und erstaunen.

Créée par Achille Castiglioni, la sus-
pension *Taraxacum 88* présente une
structure réalisée en aluminium poli,
enrichie de vingt ampoules halogènes,
diffusant une lumière directe ou douce
selon vos besoins. À l'instar des créa-
tions de Castiglioni, ce modèle propose
un design à la fois simple et sophistiqué,
voire ludique. *Taraxacum 88* s'apparente
aux bulles de chewing-gum réalisées
par les enfants, mais à une plus grande
échelle.

172 Sinus hanging light, 1972

Poul Christiansen (Denmark, 1947–)

www.leklint.com
PVC sheets
PVC-Folien
Feuilles de PVC
⌀ 33, 44, 60, 66 cm
Le Klint, Odense, Denmark

The Latin word 'sinus' means 'curve' or 'fold', an appropriate title for Poul Christiansen's light for Le Klint, which is made up of PVC sheets cut and folded into sculptural sine curves. This design is an icon of Danish Modernism that still looks as visually fresh as when it was launched in the early 1970s. It continues to work well in almost any interior setting, from the ultra-modern to the more traditional, thanks to its timeless sculptural quality.

Das lateinische Wort *sinus* bedeutet „Kurve" oder „Falte" – ein passender Name für Poul Christiansens Hängeleuchte für Le Klint. Sie besteht aus zurechtgeschnittenen PVC-Folienstreifen, die plastische Sinuskurven bilden. Diese Designikone der dänischen Moderne sieht immer noch genauso frisch aus wie bei ihrer Markteinführung in den 1970er Jahren. Egal ob ultramodern oder eher traditionell – dank ihrer zeitlos skulpturalen Qualität passt die *172 Sinus* in nahezu jede Umgebung.

Sinus illustre parfaitement l'étymologie de son nom issu du latin signifiant « pli de la toge ». Créée par Poul Christiansen, cette lampe est composée de feuilles de PVC découpées puis façonnées en courbes sinusoïdales, reflétant un extraordinaire aspect sculptural. Véritable icône du modernisme danois, Sinus a su garder sa fraîcheur visuelle d'antan. Conçue dans les années 70, cette lampe intemporelle reste très tendance, dans un intérieur ultra design aussi bien que dans une ambiance plus classique.

Model No. 2097 chandelier, 1958

Gino Sarfatti (Italy, 1912–1985)

www.flos.com
Gilded metal, brass
Vergoldetes Metall, Messing
Métal doré, laiton
↕ 72, 88 cm ⌀ 88, 100 cm
Flos, Bovezzo, Brescia, Italy

One of Gino Sarfatti's best-known designs, the *Model No. 2097*, with its branch-like arms, holds either thirty or fifty frosted light bulbs. This eye-catching, simple yet sophisticated design is a highly successful modern re-interpretation of the traditional chandelier. Thanks to its strong sculptural presence, Sarfatti's design looks fantastic in most interior schemes, and brings a touch of Italian style to virtually any environment.

Die an Äste erinnernden Arme von *Model No. 2097*, einem der bekanntesten Entwürfe von Gino Sarfatti, halten entweder dreißig oder fünfzig mattierte Glühlampen. Dieses auffällige und einfache, dennoch anspruchsvolle Design ist eine äußerst erfolgreiche moderne Neuinterpretation des traditionellen Kronleuchters. Dank seiner starken skulpturalen Präsenz sieht Sarfattis Design in fast jedem Ambiente fantastisch aus und verleiht praktisch allen Räumen einen Touch italienischen Stil.

Avec ses branches qui accueillent soit trente soit cinquante ampoules en verre dépoli, le *Model N° 2097* est l'une des créations les plus connues de Gino Sarfatti. Son design simple mais sophistiqué est une réinterprétation moderne très réussie du lustre classique. De par sa forte présence sculpturale, il s'accorde à merveille avec la plupart des styles décoratifs et apporte une touche d'élégance italienne à n'importe quel intérieur.

The Castiglioni brothers originally designed this attractive hanging light for the popular Splügen Bräu pub in their native Milan. With its rippled, mercury-like surface of spun aluminium, this ingenious design animates, reflects and diffuses any light falling on it. Although relatively simple in terms of construction, it has an inherently stylish yet essentialist sophistication. This design also has a futuristic Pop aesthetic that is an easily identifiable trademark of the Castiglionis' work.

Die Castiglioni-Brüder entwarfen diese attraktive Hängeleuchte für das beliebte Brauhaus Splügen Bräu in ihrer Heimatstadt Mailand. Mit der geriffelten, an Quecksilber erinnernden Oberfläche aus gedrehtem Aluminium animiert, reflektiert und streut dieses geniale Design jedes darauf fallende Licht. Auch wenn ihre Konstruktion relativ einfach ist, besitzt die *Splügen Bräu* eine inhärent stilvolle, dennoch essentialistische Perfektion. Ihre futuristische Pop-Ästhetik macht sie zu einem leicht identifizierbaren Markenzeichen der Castiglionis.

Les frères Castiglioni ont conçu cette belle suspension pour le Splügen Braü, un pub très prisé de leur Milan natal. Avec sa surface onduleuse en aluminium tourné qui rappelle du mercure, cette création ingénieuse anime, reflète et diffuse toute lumière qui la touche. Bien que d'une construction relativement simple, elle possède une sophistication élégante et essentialiste. Son esthétique futuriste Pop est également caractéristique du travail des Castiglioni.

Splügen Bräu hanging light, 1961

Achille Castiglioni (Italy, 1918–2002) & Pier Giacomo Castiglioni (Italy, 1913–1968)

www.flos.com
Polished and varnished spun aluminium
Gedrehtes Aluminium, aufpoliert und lackiert
Aluminium tourné, poli et verni
↕ 21 cm ⌀ 36 cm
Flos, Bovezzo, Brescia, Italy

Beat lights, 2007

Tom Dixon (UK, 1959–)

www.tomdixon.net
Brass
Messing
Laiton
↕ 16 cm ⌀ 36 cm (Beat Shade Wide)
↕ 30 cm ⌀ 24 cm (Beat Shade Fat)
↕ 36 cm ⌀ 19 cm (Beat Shade Tall)
Tom Dixon, London, UK

Like Tapio Wirkkala or Robert Welch before him, Tom Dixon skilfully manages to infuse his boldly sculptural designs with an engaging craft sensibility, which reflects a real understanding of materials and manufacturing processes. To this end, his stunning *Beat* lights express not only a formalistic confidence with their strong graphic silhouettes but also a high degree of manufacturing skill. Crucially, the *Beat* light range also demonstrates that contemporary design can be infused with a warm emotional appeal.

Genau wie vor ihm schon Tapio Wirkkala oder Robert Welch gelingt es auch Tom Dixon seine auffallend skulpturalen Designs gekonnt mit einer gewinnend handwerklichen Sensibilität zu durchdringen, in der sich ein tiefes Verständnis für Materialien und Herstellungsprozesse spiegelt. Deswegen drückt seine fantastische *Beat*-Leuchte nicht nur formale Geschlossenheit, sondern auch großes handwerkliches Können aus. Im Grunde verdeutlicht die Leuchtenserie *Beat*, dass auch zeitgenössisches Design emotionale Wärme ausstrahlen kann.

À l'instar de Tapio Wirkkala ou Robert Welch, Tom Dixon parvient habilement à insuffler au design une grande sensibilité ainsi qu'une beauté sculpturale. La collection *Beat* illustre un savoir-faire d'excellence et derrière chaque suspension on ressent la main de l'artisan. La forme de l'abat-jour nous interpelle par sa silhouette géométrique, nette et extrêmement graphique, diffusant la lumière directement ou en flux concentré. Cette collection démontre également que le design contemporain inspire une émotion chaleureuse.

Big Flower Pot hanging light, 1969

Verner Panton (Denmark, 1926–1998)

www.andtradition.com
Enamelled aluminium, stainless steel
Emailliertes Aluminium, Edelstahl
Aluminium émaillé, acier inoxydable
↕ 36 cm ⌀ 50 cm
&Tradition, Fredensborg, Denmark

Originally produced by Louis Poulsen of Copenhagen, this eye-catching hanging light reflects Verner Panton's wonderful ability to create forms that have a strong sculptural quality. Made up of two hemispheres of enamelled metal, the *Big Flower Pot* has a bold simplicity, which makes it work well in different interior settings. Named in tribute to the heady days of 1960s Flower Power, this design is an enduring Pop icon that looks as fresh today as when it was first launched.

Die ins Auge fallende, ursprünglich von der Kopenhagener Firma Louis Poulsen hergestellte Hängeleuchte *Big Flower Pot* spiegelt Verner Pantons außergewöhnliche Fähigkeit, Objekte von skulpturaler Präsenz zu schaffen. Die zwei halbkugelförmigen, emaillierten Schirme sind von schlichter Einfachheit, so dass die Leuchte in jeder Umgebung gut zur Geltung kommt. Der Name ist ein Tribut an die berauschende Zeit des Flower Powers der 1960er, das Design eine Ikone des Pops, die heute noch genauso frisch wirkt wie bei ihrer Markteinführung.

Initialement conçue par Louis Poulsen de Copenhague, cette lampe originale reflète l'extraordinaire capacité de Verner Panton à créer des formes qui dégagent une forte qualité sculpturale. Constituée de deux hémisphères en métal émaillé, *Big Flower Pot* est d'une simplicité audacieuse, s'adaptant à n'importe quel type d'intérieur. Cette lampe, qui doit son nom au frénétique mouvement des années 60, le « Flower power », est une véritable icône Pop. *Big Flower Pot* reste aujourd'hui encore d'un design très tendance.

Topan hanging light, 1960

Verner Panton (Denmark, 1926–1998)

www.andtradition.com
Enamelled aluminium
Emailliertes Aluminium
Aluminium émaillé
↕ 19 cm ⌀ 21 cm
&Tradition, Fredensborg, Denmark

Designed specifically for the Scandi-navian exhibition stand at the Cologne Furniture Fair, the *Topan* hanging light subsequently became Verner Panton's first lighting design to be put into mass production. With its simple spherical form the *Topan* is a highly versatile light, ideal for suspending either on its own over a table or as a cluster in a stairwell.

Nachdem sie speziell für den skandina-vischen Stand auf der Kölner Möbel-messe entworfen worden war, wurde die Hängeleuchte *Topan* das erste Design von Verner Panton, das in die Massenproduk-tion ging. Mit ihrer schlichten Kugel-form ist die *Topan* eine sehr vielseitige Leuchte: Sie kann allein über einem Tisch oder als Gruppe im Treppenhaus gehängt werden.

Conçue spécialement pour l'exposition scandinave au Salon du meuble de Cologne, *Topan* est l'une des premières lampes réalisées en production de masse. Grâce à sa forme sphérique simple, *Topan* offre une lumière très polyvalente. Une seule lampe de ce modèle peut s'avérer idéale pour éclairer une cuisine, plusieurs dans un escalier par exemple, pour un design simple mais élégant.

The *Mercury* suspension light is a truly remarkable design statement that has an otherworldly yet dynamic presence. Like huge blobs of floating mercury, the biomorphic elements reflect and scatter the light bouncing from and off them. At the same time, there is a sci-fi quality to the way these silvered pebbles catch reflections from the surrounding environment that's weirdly beautiful.

Die Hängelampe *Mercury* ist aufgrund ihrer irgendwie surrealen, dynamischen Präsenz ein wirklich bemerkenswertes Design-Statement. Wie riesige schwebende Quecksilberperlen reflektieren und streuen die biomorphen Lampenkugeln das Licht, das von ihnen ausgeht und abstrahlt. Gleichzeitig wirkt die Art, in der diese silbrigen Kiesel Spiegelungen aus der Umgebung auffangen, fantastisch schön – wie Magie aus der Science-Fiction-Welt.

Original et innovant, *Mercury* s'inspire de la nature pour un résultat aérien surprenant. Constitué de galets semblables à des gouttes de mercure, ce plafonnier semble flotter en apesanteur dans un jeu de lumières presque magique. Disposés sous un disque en aluminium, les galets se réfléchissent entre eux, faisant rebondir la lumière entre leurs surfaces biomorphiques lisses. Un effet velouté absolument envoûtant.

Mercury suspension light, 2007

Ross Lovegrove (UK, 1958–)

www.artemide.com
Die-cast aluminium, injection-moulded thermoplastic material
Druckgussaluminium, spritzgegossener thermoplastischer Kunststoff
Aluminium moulé sous pression, injection d'un matériau thermoplastique moulé
↕ 55 cm ⌀ 110 cm
Artemide, Pregnana Milanese, Italy

Carlotta de Bevilacqua has designed a number of interactive lights for Artemide's *Metamorfosi* range, which is based on the idea that coloured light can affect our mood, and thereby our psychological well-being. Like her other designs in the range, the *Tian Xia Halo* incorporates a coloured filter and comes with a remote control that allows the user to determine not only the intensity of the emitted light, but also its colour.

Für die *Metamorfosi*-Serie von Artemide hat Carlotta de Bevilacqua eine Reihe interaktiver Leuchten entworfen, die auf der Idee basieren, dass farbiges Licht unsere Stimmung und damit unsere psychische Gesundheit beeinflusst. Genau wie ihre anderen Designs dieser Serie hat auch die Hängeleuchte *Tian Xia* einen farbigen Filter und wird mit einer Fernbedienung geliefert, mit der man nicht nur das Licht dimmen, sondern auch noch die Farbe auszuwählen kann.

Carlotta de Bevilacqua a conçu plusieurs lumières interactives pour la collection *Metamorfosi* d'Artemide, selon l'idée que la lumière colorée affecte notre humeur et donc notre bien-être psychologique. À l'instar de ses autres créations, *Tian Xia Halo* comporte un filtre de couleur ainsi qu'une télécommande permettant à l'utilisateur de déterminer non seulement l'intensité de la lumière, mais aussi sa couleur. Une merveille technologique aux lignes pures et élégantes.

Tian Xia Halo hanging light, 2006

Carlotta de Bevilacqua (Italy, 1957–)

www.artemide.com
Polished aluminium, mirror-finished thermoplastic, coloured filters
Poliertes Aluminium, Thermokunststoff mit Spiegelfolie, farbige Filter
Aluminium poli, finition miroir thermoplastique, filtres colorés
↕ 45 cm ⌀ 80 cm
Artemide, Pregnana Milanese, Italy

With its space-age connotations, the *O-Space* hanging light is an eye-catching design that gives a pleasant ambient light as well as a direct downward light. Its continuous, single-piece shade has a strong sculptural presence and accentuates the poetic interplay of light on its curved surfaces. Made of expanded polyurethane – the same plastic used for televisions and computer monitors – the design is extremely lightweight, yet its unusual form gives it an aesthetic solidity.

Die futuristisch anmutende *O-Space* Pendelleuchte ist ein Blickfang und spendet angenehmes diffuses oder direktes Licht. Die durchgängige einteilige Form hat eine starke skulpturale Präsenz und betont das poetische Wechselspiel des Lichts auf ihrer geschwungenen Oberfläche. Das aufgeschäumte Polyurethan – der gleiche Kunststoff, der auch für Fernsehbildschirme und Computermonitore verwendet wird – macht die *O-Space* zu einem echten Leichtgewicht, die durch ihre außergewöhnliche Form jedoch eine ästhetische Kompaktheit erhält.

Avec son allure d'ovni, cette suspension attire le regard. Elle diffuse une agréable lumière d'ambiance ainsi qu'un faisceau direct vers le bas. Son corps d'une seule pièce a une forte présence sculpturale qu'accentue le jeu poétique de la lumière sur ses surfaces courbes. Réalisée en polyuréthane expansé (le même plastique que pour les télévisions et les moniteurs d'ordinateur), *O-Space* est extrêmement légère mais sa forme originale lui confère une solidité esthétique.

O–Space hanging light, 2003
Luca Nichetto (Italy, 1976–) & Gianpietro Gai (Italy, 1972–)

www.foscarini.com
Chromed metal, expanded polyurethane
Verchromtes Metall, aufgeschäumtes Polyurethan
Métal chromé, polyuréthane expansé
↕ 29 cm ↔ 56 cm ⤢ 43 cm
Foscarini, Marcon, Italy

Saucer hanging light, 1947

George Nelson (USA, 1908–1986)

www.modernica.net
Spray-on Cocoon polymer, steel, nickel
Aufgesprühte Kokon-Sprühhaut aus Polymer, Stahl, Nickel
Polymère Cocoon, acier, nickel
↕ 19.5 cm ⌀ 44.5 cm
Modernica, Los Angeles (CA), USA

George Nelson referred to his *Bubble* lighting range, which included the *Saucer* hanging light, as "one of those happy accidents which occur all too infrequently in the designer's experience." With his office needing some large light fixtures Nelson decided to design his own using a new spray-on plastic developed to mothball battleships. The resulting Mid-Century Modern designs were highly influential and are now being faithfully reissued.

George Nelson bezeichnete die *Bubble*-Leuchten, zu der auch die Hängeleuchte *Saucer* gehört, als „einen dieser glücklichen Zufälle, die sich nur allzu selten in der Praxis eines Designers ereignen". Da sein Büro einige große Beleuchtungskörper benötigte, beschloss Nelson, selbst welche zu entwerfen. Dabei verwendete er eine Kokonhaut aus aufgesprühtem, ursprünglich für das Einmotten von Kriegsschiffen verwendeten Kunststoffs. Die so entstandenen Designs sind Ikonen der 1950er Jahre und werden heute originalgetreu wieder aufgelegt.

Lorsque George Nelson se réfère à sa collection *Bubble*, dont *Saucer* fait partie, il évoque « l'un de ces heureux hasards qui se produisent trop rarement dans le travail d'un designer ». Son bureau nécessitait une grande lumière, aussi il décida de créer son propre éclairage selon un nouveau procédé de plastique côtelé mis au point pour les navires. Les créations design des années 50 restent très tendance et éternellement rééditées.

Sinus 550 hanging light, 1967

Piet Hein (Denmark, 1905–1996)

www.holmegaard.com
Glass
Glas
Verre
↕ 8 cm ∅ 55 cm
Holmegaard Glasværk, Holmegaard, Denmark

Originally Piet Hein intended this design to be made of plastic but he was displeased with the results, and it was only when it was executed in hand-blown opaque glass that he was satisfied. Inspired by sine curves, which Hein believed to be symbolic of shapes found in the natural world, the light has a mathematically harmonious form, which bends the emitted light so that it produces a soft and pleasing glow rather than a harsh glare. Its refined form also makes the Sinus 550 light appear to defy gravity, floating weightlessly in space.

Ursprünglich wollte Piet Hein sein Design in Kunststoff ausführen, war aber von dem Ergebnis enttäuscht und erst zufrieden, als er es in Mund geblasenem Opalglas sah. Inspiriert von einer Sinuskurve, die Hein als Symbol der Formen der Natur betrachtete, besitzt die Leuchte eine mathematisch harmonische Form und lenkt das Licht so, dass es einen sanften, angenehmen Schimmer statt eines grellen Scheins erzeugt. Diese raffinierte Form sorgt auch dafür, dass die Sinus 550 der Schwerkraft zu trotzen und im Raum zu schweben scheint.

Piet Hein a d'abord tenté de réaliser cette suspension en plastique mais, mécontent du résultat, a fini par la faire exécuter en verre soufflé bouche. Inspiré par les courbes sinusoïdales, symboliques pour Hein des formes que l'on trouve dans la nature, la Sinus 550 a une silhouette mathématiquement harmonieuse qui fléchit le faisceau lumineux émis de sorte à produire un agréable halo plutôt qu'un éclat cru. Avec son design raffiné, elle semble défier la gravité et flotter en apesanteur.

Yki Nummi's *Skyflyer* is a sculptural lighting design with a simple construction of two disc-like shades made of moulded opaque acrylic. Available in two sizes, it was also known as the *Lokki*, meaning 'seagull' in Finnish; and when a number of these lights are hung clustered together, they do indeed resemble a flock of sea birds riding a breeze. Although designed fifty years ago, this is a design that still has a remarkable visual freshness.

Bei Yki Nummis *Skyflyer* handelt es sich um ein skulpturales Leuchtendesign, bei dem in einer einfachen Konstruktion zwei scheibenähnliche Hälften aus gepresstem, opakem Acryl zusammengefügt wurden. Die in zwei Größen erhältliche Leuchte wurde unter dem Namen *Lokki* (Finnisch für „Möwe") bekannt – und tatsächlich wirken mehrere dieser Leuchten zusammen wie ein Schwarm Seevögel, die von einer Brise getragen werden. Obwohl schon fünfzig Jahre alt, strahlt dieses Design immer noch eine bemerkenswerte optische Frische aus.

Skyflyer d'Yki Nummi offre un véritable aspect sculptural malgré un design simple constitué de deux abat-jour inversés en acrylique opaque moulé. Disponible en deux tailles, cette lampe est également connue sous le nom de *Lokki*, signifiant « mouette » en finlandais. En effet, lorsque plusieurs lampes de ce modèle sont réunies dans un même espace, elles transmettent l'impression d'une volée d'oiseaux de mer dans la brise. Conçue il y a cinquante ans, *Skyflyer* a gardé sa fraîcheur visuelle première.

Skyflyer hanging light, 1960

Yki Nummi (Finland, 1925–1984)

www.adelta.de
PMMA, steel
PMMA, Stahl
PMMA, acier
↕ 32 cm ⌀ 50, 70 cm
Adelta, Dinslaken, Germany

Modern Art table light, 1956

Yki Nummi (Finland, 1925–1984)

www.adelta.de
PMMA
PMMA
PMMA
↕ 40 cm ⌀ 28.5 cm
Adelta, Dinkslaken, Germany

One of the most progressive lighting designers of his generation, Yki Nummi created arresting lighting designs notable for their use of acrylic plastics. His *Modern Art* table light incorporates a section of clear acrylic tubing, which functions as a transparent support for a translucent, milky-white plastic shade. Structurally simple yet aesthetically refined, this design was selected for the Museum of Modern Art's permanent collection, an honour celebrated in its name.

Yki Nummi zählte zu den führenden Leuchtendesignern seiner Generation. Seine faszinierenden Designs wurden bekannt durch die frühe Verwendung des Werkstoffs Acryl. Seine Tischleuchte *Modern Art* besteht aus einer klaren Acrylröhre, die als durchsichtige Stütze für den lichtdurchlässigen, milchig-weißem Plastikschirm dient. Die einfache und zugleich ästhetisch durchdachte Konstruktion hat der *Modern Art* einen Platz in der Dauerausstellung des New Yorker Museum of *Modern Art* gesichert – eine Auszeichnung an sich.

Designer de luminaires parmi les plus progressistes de sa génération, Yki Nummi est l'un des premiers à utiliser l'acrylique. *Modern Art* comporte une base en acrylique transparent alors que l'abat-jour diffuse une superbe lumière douce et veloutée. Classique du design finlandais, *Modern Art* s'avère structurellement simple et offre un design raffiné. Cette lampe fait partie de la collection permanente du musée d'Art moderne dont elle a emprunté le nom.

Poul Henningsen began developing a series of multi-shaded lights in 1924 that were intended to reduce the dazzling glare from electric light bulbs. The same year he began designing lights for Louis Poulsen and, a year later, his first PH light was awarded a gold medal at the 1925 Exposition Internationale des Arts Décoratifs et Industriels Modernes in Paris. The concentric arrangement of the lights' shades – made of either opaque glass or enamelled metal – was apparently inspired by a stacked cup, bowl and saucer.

Poul Henningsen begann 1924 mit der Entwicklung von Leuchten mit mehreren Schirmen, um das blendende Strahlen elektrischer Glühbirnen zu verringern. Im gleichen Jahr entwarf er Leuchten für Louis Poulsen, und schon ein Jahr später erhielt seine erste PH Leuchte die Goldmedaille auf der Exposition Internationale des Arts Décoratifs et Industriels Modernes in Paris. Das konzentrische Arrangement der Lampenschirme – aus opakem Glas oder gezogenem Aluminium – bezog seine Inspiration sicher von übereinandergestapelter Tasse, Untertasse und Schüssel.

En 1924, Poul Henningsen élabore une série d'éclairages à lumière tamisée, visant à réduire l'éblouissement provoqué par les ampoules électriques. La même année, il conçoit des lampes design pour Louis Poulsen et son premier modèle PH reçoit une médaille d'or à l'Exposition internationale des Arts décoratifs et industriels modernes à Paris, en 1925. Les lampes PH ⅓ disposent d'un système basé sur une spirale logarithmique, où le point focal de la source lumineuse se situe au centre de la spirale.

PH ⅔ table light & PH ⅔ hanging light, 1925–1926
Poul Henningsen (Denmark, 1894–1967)

www.louispoulsen.com
Enamelled aluminium, steel, Bakelite
Emailliertes Aluminium, Stahl, Bakelit
Aluminium émaillé, acier, Bakélite
↕ 54 cm ⌀ 45 cm
↕ 20 cm ⌀ 40 cm
Louis Poulsen Lighting, Copenhagen, Denmark

Although more restrained than some of Verner Panton's iconoclastic lighting designs, the *Panthella* floor light and table light are still extremely beautiful with their sculptural flowing lines, and in some ways they are perhaps more practical too. Essentially a hemispherical shade atop a flaring pedestal stem, the space-age *Panthella* looks as though it has been plucked from the film set of *2001: A Space Odyssey* or *Barbarella*.

Auch wenn sie zurückhaltender sind als die meisten anderen ikonoklastischen Designs von Verner Panton, so bestechen die *Panthella*-Boden- und Tischleuchte doch durch ihre skulptural fließenden Linien – in gewisser Hinsicht sind sie vielleicht sogar praktischer. Im Prinzip eine Halbkugel auf einem schimmernden Fuß wirkt die *Panthella* des Raumfahrtzeitalters als sei sie ein Filmrequisit aus *2001: Odyssee im Weltraum* oder *Barbarella*.

Plus modérée que les designs luminaires iconoclastes de Verner Panton, *Panthella* révèle une forme organique équilibrée, émettant une lumière diffuse et agréable. La source lumineuse se cache derrière un abat-jour hémisphérique, et un pied en forme de trompette contribue à une superbe distribution de la lumière ainsi qu'à une forme parfaitement équilibrée, sculpturale. Ces lampes « spatiales » semblent tout droit sorties de *2001: l'Odyssée de l'espace* ou de *Barbarella*.

Panthella table light & floor light, 1971
Verner Panton (Denmark, 1926–1998)

www.louispoulsen.com
Injection-moulded acrylic, ABS, steel
Spritzgegossenes Acryl, ABS, Stahl
Acrylique moulé par injection, ABS, acier
↕ 58 cm ⌀ 40 cm
↕ 130.5 cm ⌀ 50 cm
Louis Poulsen Lighting, Copenhagen, Denmark

Home office
Arbeitszimmer
Le bureau

Formosa perpetual wall calendar, 1963

Enzo Mari (Italy, 1932–)

www.danesemilano.com
Aluminium, lithographed PVC, anodized aluminium
Aluminium, lithographiertes PVC, eloxiertes Aluminium
Aluminium, PVC lithographié , aluminium anodisé
↕ 31.5 cm ↔ 31.5 cm
Danese, Milan, Italy

Available in Italian, English, French and German, the *Formosa* is probably the best-known perpetual wall calendar in the world, and without question the most stylish. Certainly this classic design is testament to Enzo Mari's impressive aptitude for finding the perfect balance between structural form and typography. It comes in four different colour combinations: black support with black lettering, black support with red lettering, aluminium support with black lettering and aluminium support with red lettering.

Der in Italienisch, Englisch, Französisch und Deutsch erhältliche *Formosa* ist vermutlich der bekannteste ewig gültige Wandkalender der Welt – und fraglos der eleganteste. Dieses klassische Design ist ein weiterer Beweis für Enzo Maris beeindruckende Begabung, das perfekte Gleichgewicht zwischen struktureller Form und Typographie herzustellen. Der Kalender ist in vier verschiedenen Farbkombinationen erhältlich: Schwarze Grundplatte mit schwarzer oder roter Beschriftung und Aluminium-Grundplatte mit schwarzer oder roter Beschriftung.

Disponible en italien, anglais, français et allemand, le *Formosa* est probablement le calendrier perpétuel mural le plus connu du monde et sans conteste le plus élégant. Son design classique témoigne de l'impressionnant talent d'Enzo Mari pour trouver l'équilibre parfait entre forme structurelle et la typographie. Il existe en quatre combinaisons de couleurs : support noir, lettres noires ; support noir, lettres rouges ; support aluminium, lettres noires ; support aluminium, lettres rouges.

Timor perpetual desk calendar, 1967

Enzo Mari (Italy, 1932–)

www.danesemilano.com
ABS, lithographed PVC
ABS, lithographiertes PVC
ABS, PVC lithographié.
↕ 16 cm ↔ 17 cm ⤢ 9 cm
Danese, Milan, Italy

This stylish and sophisticated desk calendar is an acknowledged icon of Italian design and is one of Enzo Mari's best-known designs. The inverted "J" form of the calendar is perfectly complimented by the bold font used for the lettering. This everlasting calendar is available in Italian, English, French and German and although it was designed over forty years ago it looks as fresh and innovative as the day it was designed.

Dieser stilvolle und ausgefeilte Tischkalender ist eine Ikone des italienischen Designs und einer der bekanntesten Entwürfe von Enzo Mari. Die Form des umgekehrten „J" wird perfekt durch die fetten Buchstaben der Beschriftung ergänzt. Dieser ewig gültige Kalender ist in den Sprachen Italienisch, Englisch, Französisch und Deutsch erhältlich und sieht über vierzig Jahre nach seinem Entwurf noch genauso frisch und innovativ aus.

Ce calendrier perpétuel de bureau élégant et sophistiqué est un objet emblématique du design italien et l'un des plus connus d'Enzo Mari. Sa forme en « J » inversé s'harmonise parfaitement avec les caractères gras de sa typographie. Il existe en italien, anglais, français et allemand et, bien qu'inventé il y a plus de quarante ans, paraît toujours aussi moderne et innovateur que le jour de sa conception.

Canarie desk set, 1958

Bruno Munari (Italy, 1907–1998)

www.danesemilano.com
Anodized aluminium, melamine
Eloxiertes Aluminium, Melamin
Aluminium anodisé, mélamine
↕ 6.5 cm ↔ 24.5 cm ⤢ 6.5 cm
Danese, Milan, Italy

Both structurally simple and aesthetically sophisticated, Bruno Munari's *Canarie* desk set incorporates a pencil holder, a pin tray and two ashtrays all made from either white or black melamine. These accessories reside in the two rectangular aluminium containers in a configuration of your choosing. Named after the Canary Islands, the set is a practical little desk-bound archipelago.

Bruno Munaris Schreibtisch-Set *Canarie* besteht aus einem Stift- und einem Büroklammerhalter sowie zwei Aschenbechern und überzeugt durch strukturelle Einfachheit und ästhetische Eleganz. Die rechteckigen Aluminiumbehälter mit weißer oder schwarzer Melaminbeschichtung sind unterschiedlich kombinierbar. Das nach den Kanarischen Inseln benannte Set ist eine praktische kleine Inselgruppe auf dem Schreibtisch.

À la fois structurellement simple et esthétiquement sophistiqué, *Canarie*, de Bruno Munari, inclut un porte-crayon, une boîte à trombones et deux cendriers en mélamine blanche ou noire qui se disposent dans deux plateaux rectangulaires en aluminium selon la configuration de votre choix. Baptisé d'après les îles Canaries, ce set forme un petit archipel de fonctionnalité sur le bureau.

Trina pencil holder, 2006

Hani Rashid (Egypt/Canada, 1958–)

www.alessi.com
Cast aluminium
Gussaluminium
Fonte d'aluminium
↕ 13 cm ↔ 15 cm ↗ 8 cm
Alessi, Crusinallo, Italy

This highly sculptural pencil holder has a mirror finish that enhances its architectural presence. The *Trina*, with its dynamic tri-form, reflects the spatially experimental qualities of Hani Rashid's buildings, powerfully demonstrating that functional desk accessories do not have to be aesthetically boring. Hani Rashid has described this type of functional yet artistic product as 'object architecture', and his grouped desk accessories can certainly form a diminutive cityscape.

Dieser äußerst skulpturale Stifthalter erhält durch das Hochglanz-Finish eine architektonische Präsenz. Die dynamische dreiteilige Form von *Trina* spiegelt die räumlich-experimentellen Qualitäten von Hani Rashids Gebäuden wieder und zeigt eindrucksvoll, dass funktionale Schreibtischutensilien ästhetisch nicht langweilig sein müssen. Hani Rashid beschreibt diese Art eines funktionellen, dennoch künstlerischen Produkts als „Objekt-Architektur", und so bilden seine gruppierten Schreibtischaccessoires eine Art Stadtlandschaft im Kleinen.

La finition réfléchissante de ce porte-crayon sculptural renforce sa présence architecturale. Avec ses trois branches dynamiques, *Trina* reflète l'expérimentation spatiale des édifices d'Hani Rashid, démontrant avec puissance qu'un objet fonctionnel peut être beau et artistique. Hani Rashid qualifie ce type de design « objet architecturé ». De fait, tous ses accessoires de bureau regroupés pourraient former un mini « paysage urbain ».

Electronic Calculator M, 2007

Naoto Fukasawa (Japan, 1956–)

www.plusminuszero.jp
Various materials
Verschiedene Materialien
Matériaux divers
↕ 16.5 cm ↔ 10.6 cm ⤢ 2.6 cm
Plus Minus Zero, Tokyo, Japan

Over the last decade Naoto Fukasawa has almost single-handedly pioneered a highly refined essentialist language of design, which is governed by a practical efficiency and an aesthetic purity. His many designs for both the home and office display a sense of 'rightness' and 'quietness'. Accordingly, his *Electronic Calculator M* harmoniously balances Western functionalism with Eastern formal simplicity to create a timeless solution.

Nahezu im Alleingang bereitete Naoto Fukasawa in den letzten zehn Jahren den Weg für eine überaus raffinierte essenzialistische Formensprache, die sich gleichermaßen durch hohe Praktikabilität und ästhetische Klarheit charakterisiert. Seine zahlreichen Designs für Heim und Büro spiegeln sein Gespür für ‚Schlichtheit' wider. Demgemäß verbindet sein *Electronic Calculator M* westliche Funktionalität mit fernöstlicher formaler Zurückhaltung zu einem zeitlosen Objekt.

Naoto Fukasawa ouvre la voie au langage essentialiste du design pour une vision à la fois extrêmement raffinée et pratique. Pureté esthétique et fonctionnalité se retrouvent dans toutes ses créations. Son œuvre insuffle un sentiment de justesse et de sérénité, dans un bureau comme dans un intérieur plus personnel. Intemporelle, la *calculatrice M* incarne une parfaite harmonie entre le fonctionnalisme occidental et la simplicité orientale.

LC 59 ELA calculator, 2003

Theo Williams (UK, 1967–)

www.lexon-design.com
Plastic
Plastik
Plastique
↕ 19.8 cm ↔ 9.8 cm ↗ 0.7 cm
Lexon, Boulogne, France

As the Design Director of Habitat since 2007, Theo Williams has helped shape the British domestic landscape in recent years. Prior to this, he designed a number of landmark products for the French manufacturer, Lexon, including the extra-thin desktop *ELA* calculator. This electronic device not only looks and feels great but also boasts a currency converter, a two-line display and a useful tax function.

Als Designdirektor von Habitat (seit 2007) hat Theo Williams in den vergangenen Jahren den Stil britischer Haushaltswaren und Wohnungseinrichtungen entscheidend mit geprägt. Zuvor hatte er etliche herausragende Produkte für das französische Unternehmen Lexon gestaltet, darunter diese extrem dünne elektronische Rechenmaschine. Dieses Gerät ist nicht nur äußerst elegant und formschön, sondern bietet zusätzlich eine Devisenwechselkursberechnung, ein zweizeiliges Display und eine nützliche Steuerberechnungsfunktion.

En 2007, Theo Williams reprend les rênes du département design d'Habitat et bouleverse quelque peu l'intérieur domestique britannique. Auteur de nombreuses références pour le fabricant français Lexon, il a conçu cette superbe calculatrice extra-mince, *ELA*. Esthétique, cet article électronique est non seulement agréable à manipuler, mais comporte également un convertisseur de devises, un affichage sur deux lignes et une fonction taxe bien utile.

Ameland paper knife, 1962

Enzo Mari (Italy, 1932–)

www.danesemilano.com
Satin-finished stainless steel
Satinierter Edelstahl
Acier inoxydable, finition satiné
↕ 2 cm ↔ 22 cm
Danese, Milan, Italy

Named after one of the West Frisian Islands located off the north coast of the Netherlands, the *Ameland* paper knife is an object of sculptural beauty. Its unusual twisted form not only allows it to sit comfortably in the hand, but also encourages a suitably flowing movement when it is used for its designated task. Highly effective in terms of function, the *Ameland* is sharp enough to open letters cleanly and quickly, but is sufficiently safe to handle without worry.

Der nach einer der Westfriesischen Inseln vor der Nordküste Hollands benannte Brieföffner ist ein Objekt von skulpturaler Schönheit. Dank der in sich gedrehten Form liegt *Ameland* nicht nur gut in der Hand, sondern ermöglicht bei der Anwendung auch eine einfache, fließende Bewegung. Funktional äußerst effektiv, ist er scharf genug, um Briefe schnell und sauber, aber gefahrlos zu öffnen.

Baptisé d'après une île de la Frise occidentale au large des Pays-bas, le coupe-papier *Ameland* est un objet d'une beauté sculpturale. Avec sa forme originale arquée, il tient bien dans la main tout en facilitant le geste pour lequel il a été conçu. Très fonctionnel, il est suffisamment tranchant pour ouvrir le courrier proprement et rapidement tout en pouvant être manipulé sans danger.

Simple yet sophisticated, the *Wave* note holder continues Georg Jensen's decades-long tradition of crafting useful and beautiful objects for the home. The *Wave* was designed by the Canadian-born industrial designer, Steve McGugan, who has also created products for Bang & Olufsen, Stelton and Novo Nordisk. His innovative and stylish work has won numerous awards, and this note holder is not only the perfect desk accessory, but also works well in the kitchen for writing messages or making lists.

Mit der schlichten, aber edlen Zettelbox Wave setzt Georg Jensen seine jahrzehntelange Tradition nützlicher und schöner Objekte für Zuhause fort. *Wave* ist ein Entwurf des aus Kanada stammenden Industrie-Designers Steve McGugan, der auch für Bang & Olufsen, Stelton und Novo Nordisk gearbeitet hat. Seine innovativen und stilvollen Arbeiten wurden mit zahlreichen Preisen ausgezeichnet, und diese Zettelbox ist nicht nur das perfekte Schreibtischaccessoire, sondern kann auch für Notizen und Einkaufslisten in der Küche genutzt werden.

Simple mais sophistiqué, *Wave* se situe dans la longue tradition des objets domestiques beaux et utiles édités par Georg Jensen. Il a été conçu par le designer industriel canadien Steve McGugan, dont le travail innovateur et élégant lui ont valu de nombreux prix (il a également créé des produits pour Bang & Olufsen, Stelton et Novo Nordisk). Parfait pour le bureau, son support pour bloc-notes trouve également sa place dans la cuisine pour laisser des messages ou dresser des listes.

Wave note holder, 1992

Steve McGugan (Canada, 1960–)

www.georgjensen.com
Stainless steel, plastic
Edelstahl, Plastik
Inox, plastique
↔ 15 cm ↗ 12.5 cm
Georg Jensen, Copenhagen, Denmark

Folle 24/6 stapler, 1976

Henning Andreasen (Denmark, 1923–)

www.brixdesign.com
Stainless steel, hardened steel
Edelstahl, gehärteter Stahl
Acier inoxydable, acier trempé
↔ 15.2 cm
Folle/Brix Design, Stege, Denmark

Simply the best stapler money can buy, the *Folle 24/6* is a sublime example of Danish design and engineering excellence. It was selected for the permanent collection of the Industrial Design Department at the Museum of Modern Art in New York, and for this reason is sometimes known as the 'MoMA stapler'. It was also awarded the Danish Design Council's ID prize. This classic stapler sits solidly on a desk but also fits comfortably in the hand, being perfectly weighted and balanced.

Folle 24/6, einfach die beste Heftmaschine, die man für Geld kaufen kann, ist ein großartiges Beispiel für Design und Ingenieurskunst aus Dänemark, wo sie mit dem *ID*-Preis ausgezeichnet wurde. Als Dauerexponat in der Industriedesignsammlung des Museum of Modern Art in New York kennt man *Folle 24/6* auch unter der Bezeichnung ,MoMA Tacker'. Dieser klassische Heftapparat ist perfekt gewichtet und ausbalanciert; steht fest auf dem Tisch und liegt zugleich bequem in der Hand.

L'agrafeuse *Folle 24/6* illustre l'élégance du design danois, avec sa ligne épurée et sa technologie de pointe. Sélectionnée pour la collection permanente du département « design industriel » du musée d'Art moderne de New York, cette création est un véritable petit bijou. Surnommée « l'agrafeuse MoMA », elle a reçu le prix du Danish Design Council pour son caractère à la fois fonctionnel et minimaliste. Ergonomique, cette agrafeuse est agréable à utiliser, parfaitement équilibrée. Une acquisition idéale pour votre bureau.

Folle clip cup & pencil cup, 1990

Henning Andreasen (Denmark, 1923–) & Folmer Christensen (Denmark, active 1970s–1990s)

www.brixdesign.com
Stainless steel
Edelstahl
Acier inoxydable
↕ 4.5 cm (clip cup)
↕ 11 cm (pencil cup)
Folle/Brix Design, Stege, Denmark

Combining design integrity with manufacturing excellence, Folle produces the ultimate desk accessories money can buy, such as this weighty clip cup and matching pencil holder. The clip cup can also be used to store other small items such as rubber bands, erasers etc, while the pencil holder is heavy enough – weighing in at nearly half a kilo – to accommodate scissors and paperknives without tipping over. Although expensive, Folle products will last generations due to their superb quality and the timelessness of their classic designs.

Folle vereint einwandfreies Design mit hervorragender Fertigungstechnik und produziert die besten Büroaccessoires, die für Geld zu haben sind, etwa diese schwere Büroklammerablage mit passendem Bleistifthalter. In der Ablage lassen sich auch andere Kleinigkeiten wie Gummibänder oder Radiergummis aufbewahren. Der fast fünfhundert Gramm schwere Bleistifthalter beherbergt mühelos auch Scheren oder Papiermesser. Die Produkte von Folle sind zwar kostspielig, halten aber dank ihrer Qualität und ihrem zeitlosen Design ein Leben lang.

La collection *Folle* fournit le *nec plus ultra* des accessoires de bureau. Cette coupelle à trombones et ce pot à crayons combinent parfaitement l'intégrité créative à l'excellence industrielle. La coupelle sert également à stocker de petits articles comme par exemple des élastiques ou des gommes. Ciseaux et coupe-papier se rangent aisément dans le pot à crayons dont le poids (un demi-kilo) assure une parfaite stabilité. Le prix élevé des produits *Folle* dernière génération se justifie par une incomparable qualité intemporelle.

Folle letter holder, c.1990

Folmer Christensen (Denmark, active 1970s–1990s)

www.brixdesign.com
Stainless steel
Edelstahl
Acier inoxydable
↕ 14.5 cm
Folle/Brix Design, Stege, Denmark

As with all products manufactured by Folle, the first thing that's striking about this envelope holder is how well made and heavy it is. Designed by Folmer Christensen, the founder of Folle, it is a modern reworking of a traditional letter holder and has a weighty double-thick base, making it extremely stable. As a Modern object for the home that is both useful and beautiful, it exemplifies the best attributes of classic Danish design.

Bei diesem Briefständer fallen, genau wie bei allen anderen Folle-Produkten, als erstes das Gewicht und die gelungene Verarbeitung auf. Bei diesem Design von Folmer Christensen, dem Gründer von Folle, handelt es sich um eine moderne Interpretation des traditionellen Briefhalters mit einem schweren doppelten Boden, der hohe Standfestigkeit garantiert. Gleichermaßen schön wie zweckmäßig vereint dieses moderne Accessoire für Zuhause die besten Eigenschaften klassischen dänischen Designs in sich.

À l'instar des autres créations Folle, ce porte-enveloppe démontre un incontestable savoir faire. Conçu par Folmer Christensen, ce modèle revisite le porte- courrier classique, avec une base composée d'une double épaisseur, assurant une parfaite stabilité. À la fois fonctionnels et esthétiques, ces créations modernes incarnent les plus beaux attraits du design danois classique. Ce porte-enveloppe dispose de lignes pures, voire minimalistes, indispensable sur un bureau design ou plus classique.

Like other office accessories designed by Enzo Mari, the *Sumatra* correspondence tray is notable for its elegant simplicity. It can easily be stacked to form a stylish yet practical filing system. As with his other desk equipment designed for Danese, the *Sumatra* is named after an island, and is available in a number of colour options.

Wie andere, von Enzo Mari entworfene Büroaccessoires besticht auch die Büroablage *Sumatra* durch ihre elegante Einfachheit. Stapelt man mehrere aufeinander, erhält man ein elegantes und dennoch praktisches Ablagesystem. Mari benannte all seine für Danese entwickelten Schreibtischutensilien nach einer Insel, so auch *Sumatra*, die in einer Vielzahl von Farben erhältlich ist.

Comme d'autres accessoires de bureau d'Enzo Mari, cette corbeille à correspondance se distingue par son élégante simplicité. Les *Sumatra* (qui portent le nom d'une île à l'instar de toutes ses créations pour bureau éditées par Danese) s'empilent pour former un système de classement pratique. Elles existent en différentes couleurs.

Sumatra correspondence tray, 1976
Enzo Mari (Italy, 1932–)

www.danesemilano.com
Injection-moulded technopolymer
Spritzguss-Technopolymer
Technopolymère moulé par injection
↕ 6.5 cm ↔ 26 cm ↗ 33 cm
Danese, Milan, Italy

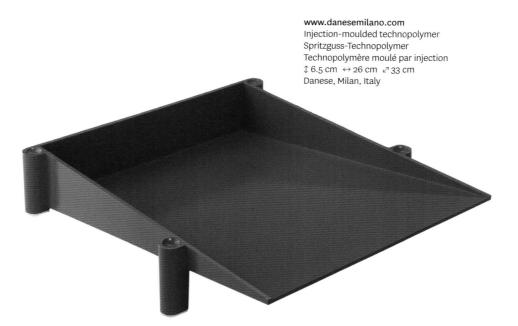

Parq document tray, 2006

Hani Rashid (Egypt/Canada, 1958–)

www.alessi.com
Thermoplastic resin
Thermoplastisches Harz
Résine thermoplastique
↕ 11 cm ↔ 25 cm ⤢ 35 cm
Alessi, Crusinallo, Italy

An eye-catching reworking of the traditional stacking document tray, Hani Rashid's *Parq* echoes the sweeping and dynamic forms of his architecture, which is conceived using state-of-the-art 3D modelling software. As he notes, 'form follows means, means follow tools, tools yield to desires, and desire is everything'. Looking like a model for one of his progressive buildings, the *Parq* is available in three colours: black, white and pale blue.

Hani Rashids *Parq* ist eine ins Auge fallende Neuauflage des traditionellen, stapelbaren Ablagekorbs und spiegelt die schwungvollen, dynamischen Formen seiner Architektur wider, die mit Hilfe modernster 3D-Software entstehen. „Form folgt Möglichkeit, Möglichkeit folgt Werkzeug, Werkzeug lässt Begehren entstehen, und Begehren ist alles", so Rashid. *Parq* sieht aus wie das Modell für eines seiner progressiven Gebäude und ist in Schwarz, Weiß und Blassblau erhältlich.

Séduisante réinterprétation de la corbeille à courrier, *Parq* évoque les lignes fluides et dynamiques de l'architecture de son concepteur, Hani Rashid. Travaillant avec des logiciels de numérisation 3D, ce dernier observe : « Le moyen dicte la forme, les outils dictent le moyen, les outils cèdent aux désirs et le désir est tout. » Ressemblant à la maquette de l'un de ses édifices avant-gardistes, *Parq* se décline en trois couleurs : noir, blanc et bleu pâle.

Rolling Frame task chair, 1994–2000

Alberto Meda (Italy, 1945–)

www.aliasdesign.it
Extruded aluminium, die-cast aluminium, PVC-covered polyester mesh or leather
Stranggepresstes Aluminium, spritzge-gossenes Aluminium, PVC-beschichtetes Polyestergewebe oder Leder
Aluminium extrudé, fonte d'aluminium, PVC recouvert de mailles de polyester ou de cuir
↕ 85 cm ↔ 73 cm ⤢ 73 cm
Alias, Bergamo, Italy

Part of Alberto Meda's award-winning *Frame Collection*, the *Rolling Frame* task chair incorporates a breathable yet durable PVC-covered polyester mesh to provide excellent support. Combining different technologies in a continuous form, Alberto Meda describes the chair as a "tribute to Eames and his light structures in die-cast aluminium." … He continues, "The pursuit of a certain visual lightness is connected with that of formal continuity and the 'organic' solution of the connections."

Der Bürodrehstuhl *Rolling Frame* gehört zu Alberto Medas preisgekrönter *Frame Collection*. Das atmungsaktive und zugleich stabile Polyestergewebe ist PVC-beschichtet und bietet exzellente Stützfunktion. Die Verbindung verschiedener Techniken und fließender Formgebung beschreibt Meda selbst als „Tribut an Eames und seine leichten Strukturen aus spritzgegossenem Aluminium" und ergänzt: „Das Streben nach visueller Leichtigkeit ist verbunden mit dem nach formaler Kontinuität und einer ‚organischen' Verbindung von beidem."

Élément de la célèbre collection *Frame* créée par Alberto Meda, le fauteuil *Rolling Frame* est réalisé en PVC, recouvert d'une maille de polyester garantissant un soutien absolu. Selon le créateur, la combinaison de différentes technologies fait de « ce fauteuil un hommage à Eames notamment par la légèreté de sa structure en aluminium moulé sous pression […] La continuité de la forme et la solution organique des raccords offrent une incontestable finesse visuelle ».

Designed over fifty years ago, the *EA 108 Aluminium Group* chair is still an excellent option for a home office as it does not look too corporate and offers a good level of support. The padded sling seat provides comfort without the need for bulky upholstery, while the aluminium frame gives the design stability and lightness, both physically and visually. The innovative combination of materials, together with the clarity of its revealed construction, make this chair one of the greatest of all time.

Der vor über fünfzig Jahren entworfene Bürostuhl *EA 108 Aluminium Group* ist immer noch eine hervorragende Wahl für das Home-Office, er bietet guten Sitzkomfort und wirkt nicht zu offiziell. Der gepolsterte Sitz ist auch ohne sperrige Polsterung bequem, das Aluminiumgestell ist stabil und lässt das Design optisch wie physisch leicht aussehen. Der innovative Materialeinsatz kombiniert mit dem Sichtbarmachen der Konstruktion hat diesen Stuhl zu einem der besten aller Zeiten werden lassen.

Aluminium Group est l'une des plus belles créations du 20ᵉ siècle. Caractérisé par un alliage intelligent de matériaux, ce modèle représente un magnifique fauteuil de bureau. Les profilés en aluminium confèrent au siège stabilité et légèreté. Le revêtement est tendu sans support dans deux cadres latéraux et représente un véritable élément porteur de la structure. Il épouse ainsi les formes du corps, et, bien que dépourvu de rembourrage épais, son assise offre un confort maximal. Conçu il y a plus de cinquante ans, *EA 108* est une pure merveille.

Aluminium Group chair (model no. EA 108), 1958

Charles Eames (USA, 1907–1978) & Ray Eames (USA, 1912–1988)

www.hermanmiller.com
www.vitra.com
Die-cast aluminium, high-frequency welded leather- or fabric-covered upholstery
Aluminiumspritzguss, hochfrequenzgeschweißtes Leder oder Stoffpolsterung
Aluminium moulé sous pression, cuir soudé à haute fréquence, ou recouvert de tissu d'ameublement
↕ 83 cm ↔ 58 cm ↗ 59 cm
Herman Miller, Zeeland, (MI), USA/Vitra, Weil am Rhein, Switzerland

Designed and engineered as an eco-effi-cient product, the *IS* task chair is a good home office option that uses 65% recy-cled materials and is 100% recyclable. According to its designers, it is: 'the first task chair to be designed, manufactured and marketed using techniques from the automotive industry. A chair with a personality, designed to be sustainable and environmentally responsible from the outset'. Available with or without arms, the *IS* chair has all the normal adjustment features you would expect from a high-end ergonomic task chair.

Der als umweltfreundliches Produkt entworfene und konstruierte *IS* Bürostuhl ist eine gute Option für das Home-Office. Er besteht zu 65% aus recyceltem Mate-rial, ist 100% recyclebar und, so seine Designer, „der erste Bürostuhl, der mit Hilfe von Techniken aus der Autoindustrie konstruiert, gefertigt und vermarktet wurde. Ein Stuhl mit Persönlichkeit, so gestaltet, dass er nachhaltig und von Anfang an umweltverträglich ist." Der mit oder ohne Armlehnen erhältliche *IS* bietet alle Einstellungen, die man von einem hochwertigen und ergonomischen Bürostuhl erwarten kann.

Constituant un excellent fauteuil de bureau pour la maison, *IS*, créé avec 65% de matériaux recyclés et 100% recy-clable, a été conçu comme un produit éco-efficient. Selon ses designers : « C'est le premier fauteuil dessiné, fabriqué et commercialisé avec des techniques de l'industrie automobile ; un fauteuil avec du caractère, conçu d'emblée pour être durable et écologiquement respon-sable. » Disponible avec ou sans accou-doirs, *IS* est équipé de tous les réglages qu'on peut attendre d'un siège de bureau ergonomique haut de gamme.

IS task chair, 2008

Connections Design Team with Webb Associates
(UK, est. 1989)

www.connection.uk.com
65% recycled materials
65% recycelte Materialien
Matériaux recyclés à 65%
↕ 100–120 cm ↔ 54.5 cm ↗ 40–47 cm
Connection, Huddersfield, UK

The ergonomic *Aeron* was completely groundbreaking when first introduced in 1992, completely redefining the design of work chairs. Coming in three sizes, this high-performance task chair has a comfortable suspension, a smooth tilt mechanism and excellent lower-back support, while its form-fitting, breathable Pellicle mesh seat and back conform to the user's shape giving continuous support and minimizing pressure. A healthy seating solution, the *Aeron* also has a distinctive high-tech aesthetic that works well in the home office, plus it is 94% recyclable and comes in three sizes.

Der ergonomische *Aeron* war bei seiner Einführung 1992 eine absolute Revolution, denn er definierte das Design von Bürostühlen völlig neu. Der in drei Größen erhältliche, äußerst vielseitige Arbeitsstuhl bietet eine bequeme Federung, einen sanften Kippmechanismus und hervorragende Abstützung des unteren Wirbelsäulenbereichs, während sich Sitz und Rückenlehne aus atmungsaktivem Pellicle-Polyestergewebe der Körperform optimal anpassen und so den Druck minimieren. Der *Aeron* ist nicht nur ein gesundes Sitzmöbel, sondern besitzt auch eine ausgeprägte Hightech-Ästhetik, die in einem Home-Office gut zur Geltung kommt.

Aeron révolutionna la conception des fauteuils de bureau lors de son lancement en 1992. Décliné en trois tailles, ce siège très performant est équipé d'une suspension confortable, d'une bascule pneumatique et d'un excellent soutien lombaire, son assise et son dossier étant recouvert d'un tissage Pellicle aéré qui épouse la forme du dos et du bassin tout en les soutenant et en limitant les pressions. Excellente solution ergonomique, l'esthétique high-tech caractéristique d'*Aeron* le rend bien adapté pour un bureau à la maison.

Aeron office chair, 1992

Don Chadwick (USA, 1936–)
& Bill Stumpf (USA, 1936–)

www.hermanmiller.com
Recycled aluminium, fibreglass-reinforced polyester, Pellicle polyester mesh
Recyceltes Aluminium, glasfaserverstärktes Polyester, Pellicle-Polyestergewebe
Aluminium recyclé, polyester renforcé par fibre de verre, tissage en « Pellicle » polyester
↕ 104, 107, 114 cm ↔ 59, 51, 55 cm ↗ 40, 43, 47 cm
Herman Miller Inc., Zeeland (MI), USA

Lotus high armchair, 2006

Jasper Morrison (UK, 1959–)

www.cappellini.it
Cast aluminium, beech plywood, fabric- or leather-covered polyurethane upholstery
Gegossenes Aluminium, Birkenschichtholz, mit Stoff oder Leder bezogene Polyurethanpolsterung
Fonte d'aluminium, contreplaqué de hêtre, recouvert de tissu ou cuir d'ameublement
↕ 122 cm ↔ 65 cm ↗ 65 cm
Cappellini, Milan, Italy

Jasper Morrison's *Lotus* range for Cappellini comprises five different chairs as well as a matching footstool. The collection's elegant high armchair has a moulded plywood seat shell that is upholstered with varying densities of polyurethane foam to ensure optimum comfort. The fabric or leather covering is then hot-pressed onto the foam upholstery to give the chair its distinctive integrated cushioning effect. The chair also has a removable magnetic headrest that can be height adjusted to suit the user, and its five-star base is available with or without castors.

Jasper Morrisons *Lotus*-Programm für Cappellini umfasst fünf verschiedene Stühle mit passendem Hocker. Der Sitz dieses eleganten hohen Armlehnstuhls aus der *Lotus*-Kollektion ist aus geformtem Schichtholz, dessen unterschiedlich starke Polyurethanpolsterung maximalen Komfort garantiert. Seine charakteristische Polsterung erhält der Sessel durch heißes Aufbügeln des Stoff- oder Lederbezugs auf die Polsterung. Die magnetische Kopfstütze ist höhenverstellbar, der fünfsternige Fuß mit oder ohne Rollen erhältlich.

La collection *Lotus* de Jasper Morrison pour Cappellini comprend cinq chaises différentes ainsi qu'un pouf. Ce fauteuil pivotant dispose d'un piètement en étoiles (cinq branches), avec ou sans roulettes. Disponible avec ou sans accoudoirs, ce fauteuil dispose d'une exceptionnelle assise entièrement recouverte d'un revêtement non déhoussable, proposant un confort optimal. Encore plus ductile, cette version est dotée d'un appuie-tête aimanté réalisé dans le même tissu, ou cuir, que l'assise. La hauteur du dossier est proposée en trois variantes, selon les attentes de l'utilisateur.

Soft Pad Group lounge chair (model no. EA 216), 1969

Charles Eames (USA, 1907–1978) & Ray Eames (USA, 1912–1988)

www.hermanmiller.com
www.vitra.com
Die-cast aluminium, high-frequency welded leather or fabric-covered upholstery
Aluminiumspritzguss, hochfrequenzgeschweißtes Leder oder Stoffpolsterung
Aluminium moulé sous pression, cuir soudé à haute fréquence ou recouvert de tissu d'ameublement
↕ 92 cm ↔ 62 cm ↗ 72 cm
Herman Miller, Zeeland, (MI), USA/Vitra, Weil am Rhein, Switzerland

In 1969, Charles and Ray Eames took the frames they had designed for their earlier *Aluminium Group* chairs and added sling seats with integrated deep cushions. The resulting *Soft Pad Group* was opulently comfortable and became a ubiquitous feature of American executive office interiors; in England, the high-backed version was used as the hot seat in the BBC television quiz, *Mastermind*, and came to epitomise the long-running show. Today the *Soft Pad Group* has an appealing retro look that makes it a stylish choice for home offices.

1969 schufen Charles und Ray Eames die *Soft Pad Group*, indem sie die Gestelle ihrer früheren *Aluminium Group* mit einer Sitzschale, die zwischen zwei Aluminiumprofilen gespannt und zusätzlich mit integrierten Postern versehen ist, versahen. Die opulenten Sessel der *Soft Pad Group* sind überaus bequem und wurden zur allgegenwärtigen Einrichtung von US-amerikanischen Vorstandsbüros. In Großbritannien ist das Model mit hohem Rücken aus der Fernsehshow *Mastermind* bekannt und wurde zum Inbegriff der über viele Jahre laufenden Fernsehshow. Heute hat die *Soft Pad Group* einen ansprechenden Retro-Look, der sie zur stilvollen Wahl für das Home-Office macht.

Créée en 1969 par Charles et Ray Eames, le fauteuil *Soft Pad* est identique à la chaise *Aluminium*, de par sa structure et sa forme. En revanche son rembourrage offre un contraste intéressant avec la sobriété du profilé d'aluminium. Il adoucit ses contours sans toutefois lui ôter sa transparence et sa clarté. Omniprésente dans les bureaux des cadres américains, la collection *Soft Pad* s'avère extrêmement confortable. Alliant élégance et ergonomie, cette collection révèle un look rétro original, idéal pour votre bureau personnel.

The *Sina*'s innovative design utilises two curved sections moulded in Bayfit® – a strong and hardwearing polyurethane hard-foam developed by the German plastic company, Bayer, for use in the automotive industry. The result is a small armchair with a big visual presence. This swivelling chair functions well and looks great in any domestic living area, but the option of castors and a height-adjustment mechanism make it perfect for use in a home office, too. The two-part seat shell is padded for extra comfort and can be upholstered in either fabric or leather.

Das innovative Design der Sitzschale des *Sinas* wird aus zwei gebogenen Halbschalen aus Bayfit® geformt – einem strapazierfähigen und haltbaren Polyurethanhartschaum, der von dem deutschen Unternehmen Bayer für die Automobilindustrie hergestellt wird. Das Material verleiht dem schmalen Armlehnstuhl eine starke visuelle Präsenz. Der Drehstuhl sieht in jedem häuslichen Wohnumfeld gut aus, aber die Möglichkeit, das Design durch Rollen und einen Mechanismus zur Höhenverstellung zu ergänzen, prädestinieren ihn geradezu für den Einsatz im Home-Office. Die Polsterung der zweiteiligen Sitzschale sorgt für besonderen Komfort und ist mit Stoff- oder Lederbezug erhältlich.

Deux formes arrondies se rejoignent et maintiennent leur autonomie pour donner naissance à un petit fauteuil à la forte personnalité. Moulé dans Bayfit®, un système de « mousses à mémoire » en polyuréthane qui reprennent lentement leur forme, ce fauteuil pivotant dispose d'une assise rembourrée incroyablement confortable. Ce système est développé par la société allemande Bayer. *Sina* dispose d'une base en aluminium, avec ou sans roulettes selon si vous le destinez à votre bureau ou votre intérieur. Réglable, ce siège peut être revêtu de tissu ou de cuir.

Sina chair (model nos. PS4 & PS5), 1999
Uwe Fischer (Germany, 1958–)

www.bebitalia.it
Cold-shaped polyurethane foam, tubular steel, aluminium, fabric or leather upholstery
Kaltgeformter Polyurethanschaum, Stahlrohr, Aluminium, Stoff- oder Lederpolsterung
Mousse de polyuréthane moulée à froid, acier tubulaire, aluminium, tissu ou cuir d'ameublement
↕ 75 cm ↔ 64 cm ⤢ 56 cm (*PS4*)
↕ 77–86 cm ↔ 71 cm ⤢ 71 cm (*PS5*)
B&B Italia, Novedrate, Italia

Worknest task chair, 2006

Ronan Bouroullec (France, 1971–) & Erwan Bouroullec (France, 1976–)

www.vitra.com
Aluminium, fibreglass-reinforced polyamide, upholstery-covered polyurethane foam
Aluminium, Fiberglas-verstärktes Polyamid, Poster aus bezogenem Polyurethanschaum
Aluminium, polyamide renforcé de fibre de verre, rembourrage de mousse de
polyuréthane
↕ 90–103 cm ↔ 67 cm ↗ 59 cm
Vitra, Weil am Rhein, Switzerland

For over a decade the Bouroullec brothers have worked together on a host of landmark designs. In 2002 they met Rolf Fehlbaum, the chairman of Vitra, and since then they have collaborated on a number of influential designs for the company. The *Worknest* was born of the desire to create a task chair that unlike other models did not employ, as the Bouroullecs put it, a visual language 'with obvious references to robots and technology' but was instead more humancentric with its soft accommodating curves and skin-like textile covering.

Seit mehr als einem Jahrzehnt haben die Brüder Bouroullec gemeinsam viele bahnbrechende Designs realisiert. 2002 trafen sie Rolf Fehlbaum, den späteren Präsidenten des Vitra-Verwaltungsrats. Seitdem haben sie an einer Reihe von wegweisenden Vitra-Designs mitgewirkt. *Worknest* entstand aus dem Wunsch, einen Bürostuhl zu entwerfen, dem nicht – so die Bouroullecs – eine visuelle Sprache zugrunde liegt, die „so offensichtlich auf Roboter und Technik Bezug nimmt". Vielmehr sollte sich das Design mit seinen sanften und anschmiegsamen Kurven und dem hautähnlichen Stoffbezug am Menschen orientieren.

Les frères Bouroullec rompent volontairement la monotonie grâce à des formes et des coloris librement combinables. En 2002, ils rencontrent Rolf Fehlbaum, président de Vitra, et multiplient les créations pour ce fabricant, dont la plupart sont devenues cultes. Ce fauteuil pivotant *Worknest* est le contrepoint à toute esthétique technique, soulignant délibérément un caractère confortable. Dissimulée sous un revêtement en tricot, sa technique ergonomique offre un confort optimal. Avec son esthétique apaisante et harmonieuse, *Worknest* illustre parfaitement la philosophie de ses créateurs qui consiste à réinventer les conventions.

ATM office series, 2002

Jasper Morrison (UK, 1959–)

www.vitra.com
Sheet steel, powder–coated sheet aluminium (pedestal)/powder–coated sheet aluminium, oak–veneered sheet aluminium (shelving)
Stahlblech, pulverbeschichtetes Aluminiumblech (Gestell)/pulverbeschichtetes Aluminiumblech, eichenfurniertes Aluminiumblech (Regale)
Tôle d'acier, tôle d'aluminium laqué (piètement)/tôle d'aluminium laqué, tôle d'aluminium plaqué chêne (tableau)
↕ 61 cm ↔ 42 cm ⤢ 61 cm (pedestal)
↕ 67, 103, 147 cm (shelving)
Vitra GmbH, Weil am Rhein, Germany

Because of the extreme functional purity of its design, the ATM series has a captivating timelessness, reminiscent of Dieter Rams's legendary 606 shelving system for Vitsoe. Specifically designed for home office use, the ATM series includes a desk and a mobile pedestal unit with two drawers, one for storing utensils and the other for filing. This design can be harmoniously integrated with other pieces from Jasper Morrison's ATM range, but also works just as well by itself. The matching mobile shelves come in three different heights and widths and can be used like a screen to delineate separate areas in a room.

Die extreme funktionelle Klarheit des Designs verleiht der ATM-Serie etwas überaus Zeitloses und erinnert an Dieter Rams legendäres Regalsystem 606 für Vitsoe. Der eigens für den Gebrauch im Home-Office entworfene ATM-Rollcontainer ist mit zwei Schubladen ausgestattet, eine für die Aufbewahrung von Utensilien, die andere für Dokumente. Er lässt sich harmonisch mit anderen Objekten aus Jasper Morrisons ATM-Serie kombinieren, lässt sich aber auch einzeln stellen. Das passende mobile Regalsystem ist in drei verschiedenen Höhen erhältlich und ermöglicht es, einen Teil des Raums wie mit einer Zwischenwand abzutrennen.

Caractérisée par des lignes sobres et une fonctionnalité clairement définie, la collection ATM dévoile une intemporalité captivante, véritable réminiscence des étagères 606, créées par le légendaire Dieter Rams pour Vitsoe. Spécialement conçue pour les bureaux privés, la gamme ATM inclut un meuble de rangement mobile comprenant deux tiroirs, le premier pour les petites fournitures et le second pour le classement des dossiers. Cette création s'intègre harmonieusement aux autres éléments de la gamme conçue par Jasper Morrison. Disponibles en trois hauteurs et largeurs différentes, les étagères mobiles se déplacent facilement afin de structurer l'espace de la pièce.

Airia desk, 2008

Kaiju Studios (USA, est. 2001)

www.hermanmiller.com
Walnut, laminate, aluminium, cork
Walnuss, Laminat, Aluminium, Kork
Noyer, stratifié, aluminium, liège
↕ 77.5 cm ↔ 142 cm ↗ 76 cm
Herman Miller, Zeeland, (MI), USA

As Ayako Takase of Kaiju Studios observes, "There are lots of beautiful desks out there, but they don't support work and home functionality." By combining natural materials with technology management, the dual-level *Airia* desk meets the goal of home-office functionality with its purposeful and intelligent layout. Working well in both traditional and contemporary interiors, the *Airia* and its matching media cabinet has a timeless quality, and was designed to "keep for the rest of your life – and give to your kids".

Wie Ayako Takase von den Kaiju Studios feststellt, gibt „es da draußen eine Menge schöner Schreibtische, aber sie werden den Ansprüchen eines häuslichen Arbeitsplatzes nicht gerecht." Das zweckmäßige und intelligente Layout des *Airias* kombiniert naturbelassene Materialien mit gelungenem Technikmanagement und erfüllt so die Ansprüche eines praktischen Home-Offices. Der *Airia* und der passende Aktenschrank passen in traditionelle wie moderne Interieurs. Das Design ist zeitlos, entworfen „um Sie ein Leben lang zu begleiten – und ihren Kindern zu vererben".

Airia offre un design simple et poétique, le reflet d'une élégance tant dans la fonction que dans la forme. En combinant l'organisation et la performance au raffinement esthétique, ce bureau offre un superbe espace de travail à votre intérieur. Un espace de gestion des câbles assure une incontestable fonctionnalité. Réalisé avec des matériaux nobles, *Airia* semble intemporel, conçu pour durer. Cette création ne sera en rien altérée par les aléas du temps et saura suivre toutes les générations.

Senior desking system, 2007

Studio Cappellini

www.cappellini.it
Lacquered or stained oak, santos or wenge veneered Macroter, chromed metal
Lackierte oder gebeizte Eiche; Santos- oder Wenge-Holz, Macroter furniert;
verchromtes Metall
Chêne laqué ou teinté, Macroter plaqué en bois santos ou wengé, métal chromé
↕ 72 cm ↔ 220 cm ↗ 90 cm
Cappellini/Cap Design, Mariano Comense, Italy

As the founder of one of the most progressive furniture companies in the world, Giulio Cappellini knows a lot about design and what the market desires. It is no surprise, therefore, that his in-house design studio has now come up with a great design of its own: the *Senior* desking system. With its clean lines and logical arrangement of various drawers and work surfaces, this desking system does not look too 'officey' and is therefore perfect for home use.

Als Gründer eines der weltweit progressivsten Unternehmen in der Möbelherstellung weiß Giulio Cappellini eine Menge über Design und die Wünsche des Marktes. So überrascht es nicht, dass das Design-Studio seines Unternehmens jetzt mit dem Schreibtischsystem *Senior* ein eigenes fantastisches Design entwickelt hat. Durch seine klaren Linien und die logische Anordnung verschiedener Schubladen und Arbeitsflächen sieht das Schreibtischsystem nicht zu sehr nach Büro aus und eignet sich daher auch perfekt für zu Hause.

Fondateur de l'une des maisons de mobilier les plus progressistes du monde, Giulio Cappellini s'y connaît en design et sait interpréter les désirs du marché. Il n'est donc pas surprenant que son propre studio ait conçu cet excellent bureau *Senior*. Avec ses lignes pures et la disposition logique de ses tiroirs et plans de travail, il ne fait pas trop « bureaucratique » et convient donc parfaitement pour la maison.

According to Herman Miller, 'With his *Swag Leg Group*, George Nelson didn't try to design an innovation; the innovation resulted from his criteria for the design. He began with the legs, insisting that they be made of metal, machine formed, and pre-finished. He also wanted them to be easy for the consumer to assemble, so the desk and tables could ship knocked down to save on costs'. Fifty years after this stylish desk was first launched, it still remains a viable option especially for a home office.

Herman Miller sagte: „Mit seiner *Swag Leg Group* versuchte George Nelson nicht, eine Innovation zu entwerfen; die Innovation resultierte aus seinen Design-Kriterien. Er begann mit den Beinen und bestand darauf, dass sie aus Metall gefertigt wurden, maschinengeformt und einbaufertig. Er wollte auch, dass sie für den Benutzer einfach zu montieren waren, damit der Schreibtisch und die Tische für den Transport zerlegt werden konnten, um Kosten zu sparen." Dieser elegante Schreibtisch ist auch fünfzig Jahre nach seiner Markteinführung besonders für ein Home-Office attraktiv.

Selon Herman Miller, « avec sa série *Swag Leg*, George Nelson n'a pas cherché à innover ; l'innovation a résulté de son critère de conception. Il a commencé par les pieds, les voulant en métal, formés à la machine et préfinis. Ils devaient être faciles à assembler par les clients, afin que les meubles puissent être livrés en pièces détachées et réduire les coûts ». Cinquante ans après sa création, cet élégant secrétaire convient toujours autant pour travailler chez soi.

Nelson Swag Leg Group desk, 1957

George Nelson (USA, 1907–1986)

www.hermanmiller.com
Laminate, chromed steel
Laminat, verchromtes Metall
Acier chromé, bois stratifié
↕ 87.5 cm ↔ 99 cm ↗ 72 cm
Herman Miller Inc., Zeeland (MI), USA

Enchord desk, 2008

Industrial Facility/Sam Hecht (UK, 1969–) & Kim Colin (USA, 1961–)

www.hermanmiller.com
Lacquered steel, laminate
Lackierter Stahl, Laminat
Acier laqué, bois stratifié
↕ 73 cm ↔ 152.5–157.5 cm ⤢ 75.5 cm
Herman Miller Inc., Zeeland (MI), USA

Perfect for home office use, the *Enchord* table/desk has a fixed top as well as a lower secondary work surface that can be configured to the left, right or centre depending on the user's requirements. The desk comes in two colour combinations, white and pesto green, or oak veneer and chalk white. Like other products designed by Sam Hecht and Kim Colin of Industrial Facility, the *Enchord* desk has a minimal aesthetic that makes it easy to introduce into any interior scheme.

Der perfekt für das Home-Office geeignete *Enchord* Tisch/Schreibtisch bietet eine feste Tischplatte sowie eine niedrigere zweite Arbeitsplatte, die entsprechend den Anforderungen des Benutzers links, rechts oder in der Mitte angebracht werden kann. Er ist in den Farbkombinationen Weiß und Pesto-Grün sowie Eichefurnier und Mattweiß erhältlich. Wie andere, von Sam Hecht und Kim Colin von Industrial Facility entworfene Produkte, passt auch der *Enchord*-Schreibtisch dank seiner minimalistischen Ästhetik in jede Einrichtung.

Le bureau *Enchord* comporte un plan de travail rigide, ainsi qu'une tablette inférieure pouvant être déplacée à droite, à gauche ou au centre, en fonction des besoins de l'utilisateur. Ce bureau existe en deux combinaisons de couleurs : blanc/vert pesto et blanc/placage en chêne. À l'instar d'autres créations conçues par Sam Hecht et Kim Colin d'Industrial Facility, le bureau *Enchord* propose une esthétique épurée et minimaliste qui s'intègre parfaitement à n'importe quel type d'intérieur.

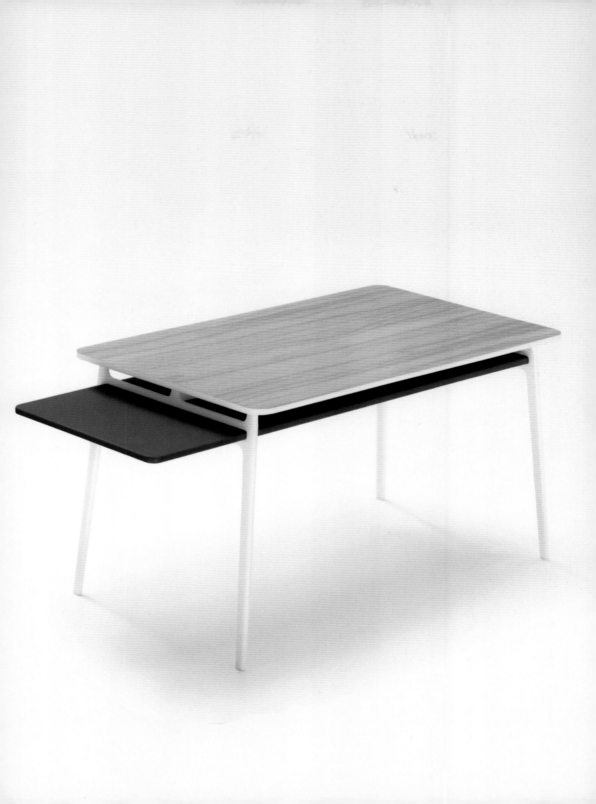

Progetto 1 desk, 2006

Monica Armani (Italy, 1964–)

www.bebitalia.it
Steel, wood, laminate
Stahl, Holz, Laminat
Acier, bois, bois stratifié
↕ 72.5 cm ↔ 133, 173, 207 cm ⤢ 67.5, 87.5, 104.5 cm
B&B Italia, Novedrate, Italia

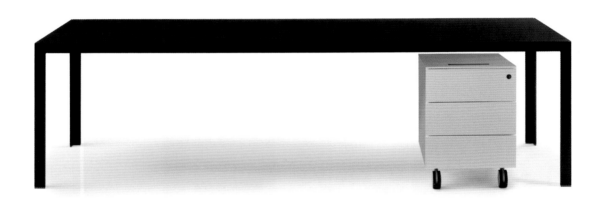

Stylishly minimalistic, the *Progetto 1* desk with its elegant steel frame was intended for executive offices or meeting rooms but works equally well within a home office environment. The simple frame comes in either a black, white or steel finish, while the desktop is available in glass, laminate or wood veneer. A matching filing pedestal and an under-table shelving attachment can also be specified, and the desk has a variety of cable management options so its clean lines can remain unencumbered from a mess of snaking cords.

Der minimalistisch gestaltete Schreibtisch *Progetto 1* mit seinem eleganten Stahlrahmen ist zwar für Büros und Konferenzräume konzipiert, eignet sich aber genauso gut für den häuslichen Arbeitsbereich. Der einfache Rahmen ist in Schwarz, Weiß oder glänzendem Chrom erhältlich, die Tischplatte ist aus Glas, Laminat oder Holzfurnier. Zusätzlich gibt es einen passenden Rollcontainer und Regalelemente, die unter der Tischplatte angebracht werden. *Progetto 1* bietet verschiedene Kabelführungen, damit herumliegende Kabel nicht die klare Linienführung unterbrechen.

Minimaliste et élégant à la fois, *Progetto 1* s'avère très extrêmement fonctionnel, idéal aussi bien dans un bureau que dans un intérieur plus personnel. Sa structure aux lignes droites existe en différentes finitions : noir, blanc ou acier. Son plateau est disponible en verre, laminé ou placage en bois. La designer, Monica Armani, propose d'y associer un caisson blanc pour accentuer les contrastes. *Progetto 1* s'avère très agréable à utiliser, proposant de nombreuses options telles qu'une gestion de câbles intégrés. Fini les fils entortillés derrière votre espace de travail !

BaObab desk, 2005

Philippe Starck (France, 1949–)

www.vitra.com
Polyethylene, polyurethane foam
Polyethylen, Polyurethanschaum
Polyéthylène, mousse de polyuréthane
↕ 72 cm ↔ 180 cm ⤢ 110 cm
Vitra, Weil am Rhein, Switzerland

The seed of the Baobab tree, which is found in the African savannah region, inspired the free-form shape of this desk. Highly sculptural, Philippe Starck's design was specifically created for the modern home office and has a refreshingly casual feel thanks to its lack of right angles. Constructed as a single piece it has integrated storage space and cable management. Aesthetically and structurally innovative with an embracing organic form, the *BaObab* desk is a delightfully unconventional design available in a variety of colours.

Der Samen des afrikanischen Affenbrotbaums (Baobab) inspirierte Philippe Starck zu der frei fließenden Form dieses Tischs. Sein skulpturales Design ist speziell für das häusliche Arbeitszimmer konzipiert. Da es keine rechten Winkel besitzt, wirkt es erfrischend unbeschwert. Der in einem Stück hergestellte Schreibtisch verfügt über integrierten Stauraum und Kabelführungen. Ästhetisch wie konzeptionell innovativ, wirkt der *BaObab* durch seine den Nutzer umschmeichelnde organische Form erfreulich unkonventionell und ist in verschiedenen Farben erhältlich.

Inspiré de la graine de baobab des savanes africaines, Philippe Starck repense la fonction d'un bureau à l'ère de la communication sans fil. Le *BaObab* offre l'essentiel : de nombreux espaces de rangement et une gestion de câbles intégrés. Ce bureau sculptural apporte un sentiment de bien-être et de confort par l'absence d'angles droits et son corps monobloc. *BaObab* définit un caractère clairement émotionnel, souligné par une importante palette de couleurs acidulées. Au monde coutumier des angles droits, ce modèle oppose un langage formel organique.

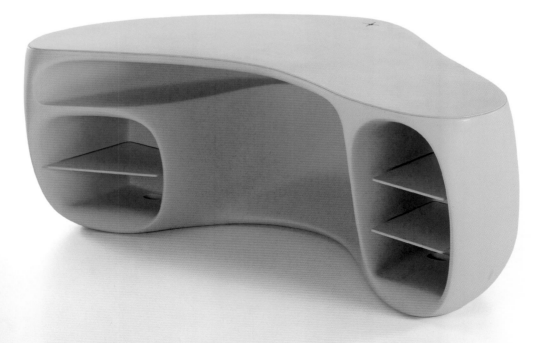

Bathroom
Badezimmer
La salle de bains

Selecta 791 bathroom scales, 1980s

Seca Design Team

www.seca-online.com
Powder-coated steel, chromed steel, glass, rubber
Pulverbeschichteter Stahl, verchromter Stahl, Glas, Gummi
Acier poudré, acier chromé, verre, caoutchouc
↕ 46 cm ↔ 10.5 cm ↗ 30 cm
Seca, Hamburg, Germany

These classic bathroom scales are veritable icons of German design and, with their sturdy construction, will quite literally last a lifetime of daily use. Seca scales are also renowned for their weighing accuracy, and are often found in doctors' surgeries and hospitals. Unlike electronic models, the mechanical *Selecta 791* scales can be relied on year after year, while their no-nonsense utilitarian styling is impervious to the vacillations of fashion.

Diese klassische Personenwaage ist eine echte Ikone des deutschen Designs, die dank ihrer robusten Konstruktion täglich benutzt werden kann und trotzdem ewig hält. Seca Waagen sind für ihre Genauigkeit bekannt, und man sieht sie häufig in Arztpraxen und Krankenhäusern. Im Gegensatz zu elektronischen Modellen ist die *Selecta 791* sehr zuverlässig und dank ihres geradlinigen Designs gegen die Schwankungen der Mode gefeit.

Véritable emblème du design allemand, cette balance Seca d'une robustesse à toute épreuve est conçue pour durer toute une vie. Elle est également réputée pour sa précision, ce qui explique qu'on la trouve souvent dans les cabinets de médecins et les hôpitaux. Contrairement aux modèles électroniques, la balance mécanique *Selecta 791* reste fiable au fil des ans tandis que son esthétique sobre et utilitaire reste impénétrable aux fluctuations de la mode.

SG75 bathroom scales, 2005

Stefano Giovannoni (Italy, 1954–)

www.alessi.com
Stainless steel, thermoplastic
Edelstahl, Thermoplastik
Inox, résine thermoplastique
↕ 3.5 cm ↔ 30 cm ⤢ 30 cm
Alessi, Crusinallo, Italy

These sleek electronic bathroom scales are made from mirror-polished stainless steel, and have an easy-to-read LED display. Measuring just 3.5 cm in height, they are an elegant and discreet solution, just like Giovannoni's earlier kitchen scales for Alessi. Giovannoni's designs fall into two categories: playful and expressive cartoon-like objects or essentialist, neo-minimal products. The SG75 scales, with their purist aesthetic and functional intelligence, fall into the latter category.

Diese schnittige Personenwaage besteht aus poliertem Edelstahl und einer gut lesbaren LED-Anzeige. Mit nur 3,5 cm Höhe ist sie eine ebenso elegante und diskrete Lösung wie Giovannonis frühere, für Alessi entworfene Küchenwaage. Die Designs von Giovannoni lassen sich in zwei Kategorien fassen: verspielte und expressive, comicartige Objekte oder essentialistische, neo-minimalistische Produkte. Wegen ihrer puristischen Ästhetik und funktionellen Intelligenz fällt die SG75 Personenwaage in letztere Kategorie.

Ce pèse-personne électronique en inox poli est équipé d'un affichage LED facilement lisible. Mesurant à peine 3,5 cm de hauteur, il est à la fois élégant et discret, à l'instar des balances de cuisine conçues par Giovannoni pour Alessi. Ce designer crée deux types de design : des objets ludiques et expressifs proches de la bande dessinée et des produits essentialistes néo-minimalistes. Avec son esthétique puriste et son intelligence fonctionnelle, SG75 appartient à cette seconde catégorie.

9208B medicine cabinet, 1992

Thomas Eriksson (Sweden, 1959–)

www.cappellini.it
Enamelled steel
Lackiertes Metall
Acier émaillé
↕ 43 cm ↔ 43 cm ⤢ 14.5 cm
Cappellini, Arosio, Italy

This eye-catching cruciform design is a stylish Post-Modern reinterpretation of a traditional medicine cabinet. The choice of this symbolic form both emphasizes and facilitates its intended function: when you see it on a wall you instantly know what it is for, a vital consideration in an emergency situation. This cabinet is part of Cappellini's *Progetto Oggetto* range of stylish home accessories, which includes other designs by Thomas Eriksson.

Das auffällige Design in Form eines Kreuzes ist eine stilvolle postmoderne Neuinterpretation des traditionellen Medizinschränkchens. Seine symbolische Form verdeutlicht und vereinfacht die Funktion: Sieht man es an einer Wand hängen, weiß man sofort, wozu es da ist – ein besonders in Notfällen entscheidender Aspekt. Dieses Medizinschränkchen ist Teil der Serie eleganter Wohnaccessoires *Progetto Oggetto* von Cappellini, die auch weitere Designs von Thomas Eriksson umfasst.

Cet attrayant design cruciforme est une belle réinterprétation post-moderne de l'armoire à pharmacie traditionnelle. Sa forme symbolique souligne et facilite à la fois sa fonction : il suffit de l'apercevoir sur le mur pour comprendre à quoi elle sert, un détail vital en cas d'urgence. Ce meuble fait partie de la ligne d'élégants accessoires de maison *Progetto Oggetto* de Cappellini, qui inclut d'autres créations de Thomas Eriksson.

No. 1024-00 nailbrush & No. 1036-00 Lovisa bath brush, 2002

Lovisa Wattman (Sweden, 1967–)

www.iris.se
Oil-treated oak, tampico fibre or horsehair
Eiche ölbehandelt, Tampico-Faser oder Pferdehaar
Chêne huilé, fibres de tampico ou crin
↔ 10 cm (nailbrush)
↔ 17 cm (bath brush)
Iris Hantverk, Enskede, Sweden

These beautiful designs are made by hand in Sweden by Iris Hantverk, which employs visually impaired craftsmen to make their wonderful range of brushes. These traditionally styled brushes are comfortable to hold and give a good grip while, thanks to their straightforward aesthetic, they also have an endearing honesty and simple beauty. The nailbrush, shown here, has bristles made of tampico fibre, which comes from a Mexican cactus-like plant; the bathbrush, though, uses natural horsehair.

Diese wundervollen Bürsten von Iris Hantverk werden in Schweden per Hand von sehbehinderten Menschen gefertigt. Die traditionellen Bürsten liegen gut und sicher in der Hand und besitzen eine geradlinige Ästhetik, die ihnen etwas ansprechend Aufrichtiges und Schönes verleiht. Die hier abgebildete Nagelbürste hat Borsten aus Tampico-Faser, die aus einer mexikanischen Agavenart gewonnen wird; die der Badebürste bestehen aus Pferdehaar.

Ces belles brosses artisanales font partie de la formidable ligne produite en Suède par Iris Hantverk qui emploie des artisans visuellement déficients. Leur design traditionnel assure une prise confortable tandis que leur esthétique dépouillée leur confère une authenticité attachante et une beauté simple. Les poils de la brosse à ongles, ci-dessus, sont en fibres de tampico, une plante rappelant le cactus provenant du Mexique ; la brosse pour le bain est en crin de cheval naturel.

Toilet brush & waste bin, 2007

Industrial Facility/Sam Hecht (UK, 1969–) & Kim Colin (USA, 1961–)

www.muji.com
ABS, polypropylene
ABS, Polypropylen
ABS, polypropylène
↕ 37 cm (brush)
↕ 18 cm (bin)
MUJI/Ryohin Keikaku Co. Ltd., Tokyo, Japan

Like other designs by Sam Hecht and Kim Colin of Industrial Facility, this toilet brush is thoughtfully and logically designed, while being aesthetically unobtrusive. Indeed, the studio takes enormous pleasure in creating anonymous mass-produced objects because they have a powerful universality. Created for the Japanese no-brand company, MUJI, this design and its matching bin have a quiet, simple and refined aesthetic.

Wie andere Designs von Sam Hecht und Kim Colin von Industrial Facility ist auch dieses durchdacht und logisch, aber dennoch ästhetisch unaufdringlich. Das Studio hat großen Spaß daran, anonyme, massenproduzierte Objekte zu kreieren, weil diese eine große Universalität besitzen. Dieses Design für das japanische Unternehmen MUJI, das markenlose Produkte vertreibt, überzeugt durch eine zurückhaltende, einfache und edle Ästhetik.

Sam Hecht et Kim Colin d'Industrial Facility prennent un immense plaisir à concevoir des objets anonymes produits en masse car ils aiment leur puissante universalité. Créée pour l'enseigne japonaise MUJI, spécialisée dans « la qualité sans marques », cette brosse pour w.-c., à la fois judicieuse et logique, possède une esthétique simple, discrète et raffinée.

Slim toilet brush, 2006

Simplehuman Design Team with Lum Design Associates
(USA, est. 1999)

www.simplehuman.com
Various materials
Verschiedene Materialien
Matériaux divers
↕ 44.5 cm
Simplehuman, Torrance (CA), USA

Simplehuman's motto is 'tools for efficient living', and all their products are designed first and foremost around the user. Their *Slim* toilet brush has a slender form that gives better cleaning performance and which also provides more space-efficient storage. In addition, the innovative pivoting door of the brush holder allows easy and quick single-handed removal and replacement.

Das Motto von Simplehuman lautet „Werkzeuge für ein effizientes Leben", und alle Produkte des Design-Teams zielen in erster Linie auf den Benutzer ab. Die schlanke Form der *Slim*-Toiletten-bürste ermöglicht nicht nur eine gründ-lichere Reinigung, sondern auch eine platzsparende Aufbewahrung. Darüber hinaus kann die Bürste dank der innova-tiven Schwenköffnung am Halter einfach und schnell entnommen werden.

Simplehuman a pour devise « des outils pour vivre efficacement » et tous leurs produits sont conçus avant tout autour de l'utilisateur. Leur brosse pour w.-c. *Slim* possède un manche élancé qui facilite le nettoyage et ne tient pas de place. En outre, la porte pivotante inno-vante de son socle permet de la sortir et de la ranger facilement et rapidement d'une seule main.

Part of the extensive *Duo* range, this soap dispenser has a clean modern form that epitomizes the superlative quality of German-made bathroom accessories. Available in either a matte or polished stainless steel finish, the design also comes as a standalone version. The essential purity of the cylindrical design echoes the 'form follows function' credo of the Bauhaus, while at the same time its reassuring weightiness implies manufacturing excellence.

Dieser Seifenspender gehört zur umfangreichen *Duo*-Serie und verkörpert in seiner sauberen, modernen Form die hervorragende Qualität von Badezimmeraccessoires Made in Germany. Das entweder in mattem oder poliertem Edelstahl erhältliche Design gibt es auch mit Wandhalter. Die schlichte Klarheit des zylindrischen Designs spiegelt das Bauhaus-Credo „Form folgt Funktion" wider, während sein solides Gewicht hervorragende Fertigung garantiert.

La ligne moderne et sobre de ce distributeur de savon, qui appartient à la vaste gamme *Duo*, illustre la qualité exceptionnelle des accessoires de salle de bains allemands. Disponible en inox mat ou poli, il existe également en version murale. La pureté de son design cylindrique rappelle la devise du Bauhaus, « la fonction dicte la forme », tandis que sa masse solide et rassurante reflète l'excellence de sa fabrication.

Duo bathroom soap dispenser, 2003
Flöz Industrie Design (Germany, est.1989)

www.blomus.com
Stainless steel
Edelstahl
Inox
↕ 19 cm ⌀ 5 cm
Blomus/Scheffer-Klute GmbH, Sundern, Germany

Bella Vista 17606 cosmetic mirror, 2005
Studio Moll Design (Germany, est. 1971)

www.keuco.de
Chromed metal, mirrored glass, LED illumination
Verchromtes Metall, Spiegelglas, LED-Beleuchtung
Métal chromé, miroir en verre, illumination LED
↕ 35.6 cm ⌀ 21.8 cm
Keuco GmbH & Co., Hemer, Germany

The *Bella Vista 17606* has a single con-cave mirror, providing a 3x magnification, which is surrounded by a long-lasting circular LED light providing an excel-lent level of illumination without glare. In addition, its flexible, spine-like stem permits easy positioning. This useful mirror was designed by Studio Moll Design, founded by Reiner Moll in 1971 and named 'Design Team of the Year' by the Design Zentrum Nordrhein Westfalen in 1991.

Der *Bella Vista 17606* ist ein einzelner, 3-fach vergrößernder konkaver Spiegel, umgeben von einer langlebigen LED-Beleuchtung, die hervorragende Hellig-keit bietet, ohne zu blenden. Dank des biegsamen Stiels lässt er sich einfach in die gewünschte Position bringen. Dieser nützliche Spiegel ist ein Design von Studio Moll Design, das 1971 von Reiner Moll gegründet und 1991 vom Design Zentrum Nordrhein Westfalen zum „Design-Team des Jahres" ernannt wurde.

Bella Vista 17606 est équipé d'un miroir concave grossissant trois fois l'image entouré d'une lumière LED circulaire longue durée qui assure un éclairage excellent sans être aveuglant. En outre, sa tige flexible permet de le positionner facilement. Ce miroir pratique a été conçu par le Studio Moll Design, fondé par Reiner Moll en 1971 et nommé « équipe de designers de l'année » par le Design Zentrum Nordrhein Westfalen en 1991.

Duemila toilet roll holder, 2000s

Lineabeta Design Team

www.lineabeta.com
Chromed metal
Verchromtes Metall
Métal chromé
↕ 20 cm ↔ 18 cm ↗ 5.5 cm
Lineabeta, Vicenza, Italy

It is often hard to find well-designed and high-quality manufactured bathroom fixtures and fittings, however, the Italian firm, Lineabeta, specialises in just this. The company produces over a million products a year, sold in sixty-five countries around the world. Importantly, Lineabeta is dedicated to design and innovation, and this is borne out by the sleek styling and practical function of its products – such as this toilet roll holder.

Armaturen und Zubehör fürs Bad in schönem Design und von guter Qualität sind oft schwer zu finden, aber die italienische Firma Lineabeta ist genau darauf spezialisiert. Das Unternehmen stellt jährlich über eine Million Produkte her, die in fünfundsechzig Ländern der Welt verkauft werden. Design und Innovation haben für Lineabeta oberste Priorität, und die Produkte überzeugen durch elegantes Styling und praktische Funktion – so auch dieser Toilettenpapierhalter.

Trouver des accessoires de salle de bains à la fois créatifs et de très bonne qualité s'avère souvent difficile. La société italienne Lineabeta se consacre à la création et à l'innovation, offrant élégance et fonctionnalité à ses objets, comme par exemple ce dérouleur de papier toilette. Lineabeta produit plus d'un million de créations par an vendues dans soixante-quinze pays.

Baketo towel holder, 2000s

Lineabeta Design Team

www.lineabeta.com
Chromed metal
Verchromtes Metall
Métal chromé
↕ 21 cm ↔ 20 cm ↗ 9 cm
Lineabeta, Vicenza, Italy

Lineabeta produces ten ranges of avant-garde bathroom fixtures, which include a dazzling array of towel rails and holders. In fact, its fittings are often specified for hotels as they not only look good, but are also very durable. The *Baketo* towel holder exemplifies the clarity of form and functional purpose that's characteristic of the company's high-quality bathroom products.

Lineabeta produziert zehn Kollektionen avantgardistischer Badezimmerarmaturen, darunter eine beachtliche Zahl an Handtuchhaltern und -stangen. Die Armaturen des Unternehmens finden sich häufig in Hotels, da sie nicht nur gut aussehen, sondern auch sehr langlebig sind. Der *Baketo*-Handtuchhalter ist ein schönes Beispiel für die klaren Formen und die hohe Funktionalität, durch die sich die qualitativ hochwertigen Badezimmerprodukte von Lineabeta auszeichnen.

Lineabeta produit dix collections d'accessoires de salle de bains avant-gardistes. Toutes offrent un éblouissant panel de porte-serviettes et supports. De fait, ces équipements se destinent le plus souvent au monde hôtelier, de par leur ligne sobre et la robustesse de leur matériau. Le porte-serviettes *Baketo* illustre à merveille l'ambition de cette société, pour des accessoires de salle de bains aux formes simples et fonctionnelles.

Axor Massaud toilet brush & holder, 2006

Jean-Marie Massaud (France, 1966–)

www.hansgrohe.com
Glazed ceramic, chromed metal
Mineralguss, verchromtes Metall
Céramique émaillée, métal chromé
↕ 47.1 cm
Hansgrohe Deutschland Vertriebs, Schiltach, Germany

Typically quirky yet elegant, Jean-Marie Massaud's toilet brush and holder for Hansgrohe is a household design that considerably raises the aesthetic bar for similar products. It looks like a small silver tree sprouting out of a plant pot and, as such, adds a touch of sculptural glamour and eccentric humour to a very mundane but necessary object.

Die ausgefallene und dennoch elegante Toilettenbürste mit Halter, die Jean-Marie Massaud für Hansgrohe entwickelt hat, ist ein Haushaltsdesign, das die ästhetische Messlatte für ähnliche Produkte sehr hoch legt. Sie sieht aus wie ein kleiner silberner Baum, der aus einem Topf heraus wächst und verleiht damit einem sehr profanen, aber notwendigen Objekt einen Hauch von skulpturalem Glanz und exzentrischem Humor.

Typiquement décalé mais toujours élégant, le porte-brosse de Jean-Marie Massaud pour Hansgrohe place haut la barre esthétique de ce type d'équipement ménager. Evoquant un petit arbre argenté poussant dans un pot blanc, il confère une touche de glamour sculptural et d'humour excentrique à un objet très banal mais nécessaire.

Axor Massaud basin, 2006

Jean-Marie Massaud (France, 1966–)

www.hansgrohe.com
Glazed ceramic
Mineralguss
Céramique émaillée
↔ 60, 80 cm
Hansgrohe Deutschland Vertriebs, Schiltach, Germany

One of the most interesting designers working within the industrial design field, Jean-Marie Massaud creates objects that are not only functionally innovative but also aesthetically surprising and visually pleasing. His extraordinary bathroom range for Hansgrohe is no exception, with the seductive, organic forms of its asymmetrical basin and bath the very antithesis of the tediously ubiquitous white bathroom suite.

Jean-Marie Massaud ist einer der interessantesten Designer auf dem Gebiet des Industriedesigns und schafft Objekte, die nicht nur funktional innovativ, sondern auch ästhetisch überraschend und visuell ansprechend sind. Seine außergewöhnliche Reihe von Badeinrichtungen für Hansgrohe ist da keine Ausnahme. Die verführerische organische Form des asymmetrischen Waschtisches und der Badewanne ist die Antithese des langweiligen weißen Badezimmers.

Jean-Marie Massaud, l'un des designers les plus intéressants travaillant dans le domaine du design industriel, crée des objets qui ne sont pas uniquement fonctionnellement innovants mais également esthétiquement surprenants et visuellement agréables. Son extraordinaire collection conçue pour Hansgrohe ne fait pas exception. Les formes organiques séduisantes de son lavabo et sa baignoire asymétriques sont l'antithèse de l'inévitable et monotone de équipement de salle de bains blanche.

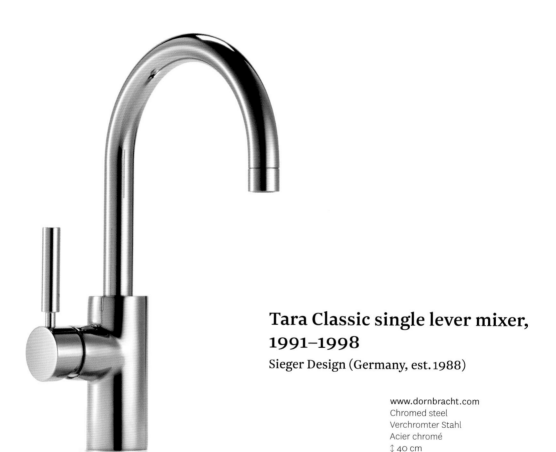

Tara Classic single lever mixer, 1991–1998

Sieger Design (Germany, est. 1988)

www.dornbracht.com
Chromed steel
Verchromter Stahl
Acier chromé
↕ 40 cm
Dornbracht, Iserlohn, Germany

Developed by Sieger Design in 1991, the *Tara* range of taps was further expanded in 1998 and, that same year, was shown at the Chicago Athenaeum's Good Design Exhibition. As an archetypal collection of bathroom and kitchen taps, in which the faucet has been pared down to its most essential form, it was awarded an iF Award in 2007. With its x-shaped mixer taps, or simple rod-like lever, and arching spout, the collection has a strong architectural presence.

Tara, die 1991 von Sieger Design entwickelte Serie von Wasserhähnen, wurde 1998 erweitert und im gleichen Jahr bei der Good Design Exhibition des Chicago Athenaeum Museum of Architecture and Design gezeigt. Als archetypische Kollektion von Badezimmer- und Küchenarmaturen, bei der der Wasserhahn auf seine essentiellste Form reduziert wurde, erhielt der Entwurf 2007 einen iF Award. Die kreuzförmige Mischbatterie und der gebogene Wasserhahn verleihen der Kollektion eine starke architektonische Qualität.

Développée par Sieger Design en 1991, la ligne de robinetterie *Tara* a été élargie en 1998 et présentée cette même année à l'Anthenaeum Good Design Exhibition de Chicago. Collection archétypale avec un robinet épuré à l'essentiel, elle a été récompensée d'un prix iF en 2007. Avec ses mélangeurs en x et son verseur en arc, la ligne possède une forte présence architecturale.

Axor Starck Classic basin mixer, 1994

Philippe Starck (France, 1949–)

www.hansgrohe.com
Chromed metal
Verchromtes Metall
Métal chromé
↕ 17 cm
Hansgrohe Deutschland Vertriebs, Schiltach, Germany

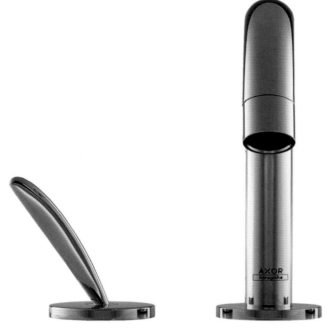

One of Hansgrohe's best-selling ranges, Philippe Starck's *Axor Starck* collection of bathroom fittings is marked by slender and uncompromisingly minimalistic forms. Like other designs by Starck, the range's elegant mixing tap, shown here, also has an engaging quirkiness thanks to its unusual control levers, which allows the water to be turned on and off using either the hand or the forearm.

Philippe Starcks Kollektion *Axor Starck* zeichnet sich durch schlanke, kompromisslos minimalistische Formen aus und gehört zu Hansgrohes meistverkauften Armaturen. Wie andere Designs von Starck besitzt auch die hier gezeigte elegante Mischbatterie dank ihres ungewöhnlichen Bedienhebels etwas sehr Eigenes, denn das Wasser kann entweder mit der Hand oder dem Unterarm auf- bzw. zugedreht werden.

Élancée et résolument minimaliste, la collection de robinetterie *Axor Starck*, signée par Philippe Starck, est l'une des gammes vedettes d'Hansgrohe. Comme d'autres designs de Starck, l'élégant mitigeur de la ligne, montré ici, témoigne également d'une charmante excentricité avec son levier de contrôle inhabituel. Il permet d'ouvrir ou de couper l'eau avec la main ou le coude.

Renesse™ mixing tap, 2006

EliumStudio (France, est. 2000)

www.toto.co.jp
Chromed brass
Verchromtes Messing
Laiton chromé
↔ 13.5 cm
Toto, Fukuoka, Japan

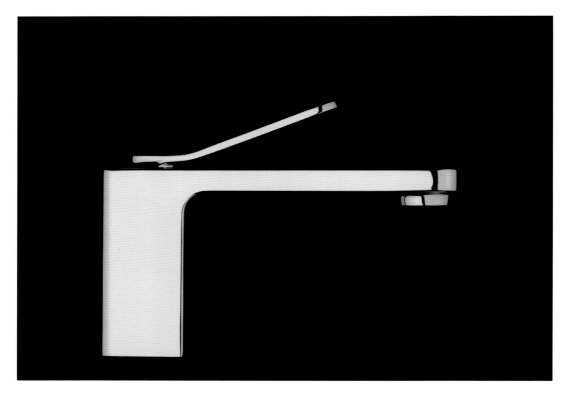

Manufactured by the renowned Japanese bathroom company, Toto, this elegant single-lever faucet was originally created to compliment other bathroom furnishings in its *Kiwami*™ and *Renesse*™ collections. The design's internal mechanism incorporates a washer-less ceramic disk valve, which not only allowed EliumStudio to create a highly refined and integrated form, but also ensures performance without drips.

Der von dem angesehenen japanischen Sanitärkonzern Toto hergestellte elegante Einhandmischer wurde ursprünglich als Ergänzung zu anderen Armaturen der Kollektionen *Kiwami*™ und *Renesse*™ entwickelt. Das dichtungsfreie Scheibenventil aus Keramik im Inneren sorgt dafür, dass er nicht tropft. Dieser Mechanismus hat ElimStudio die Herstellung einer äußerst raffinierten und integrierten Form ermöglicht.

Fabriqué par Toto, le célèbre spécialiste japonais des salles de bains, cet élégant robinet à levier unique fut initialement créé pour compléter les gammes *Kiwami*™ et *Renesse*™. Son mécanisme interne intègre une valve circulaire en céramique sans joint qui permet à EliumStudio de créer cette forme raffinée et compacte tout en évitant que l'appareil ne goutte.

Awarded a Best of the Best Red Dot Award in 2007, the *Grohe Ondus* faucet has an innovative form that is as functional as it is beautiful. Its design was based on the concept of 'sensual minimalism', which Paul Flowers (Grohe's senior vice-president of design) believes to be, 'the difference between great design and styling'. With its simplicity infused with emotion, this design is clearly inspired by nature.

Der 2007 mit dem Red Dot: Best of the Best für hohe Designqualität ausgezeichnete Wasserhahn *Grohe Ondus* besticht durch eine innovative Form, die ebenso funktional wie schön ist. Grundlage des Designs war das Konzept des „sinnlichen Minimalismus", in dem Paul Flowers (Designchef von Hansgrohe) „den Unterschied zwischen großem Design und Formgebung" sieht. Die von Emotion durchdrungene Schlichtheit des Designs ist zweifellos von der Natur inspiriert, soll aber nicht organisch aussehen.

Classé parmi les « best of the best » aux Red Dot Awards de 2007, le robinet *Grohe Ondus* a une forme innovante aussi fonctionnelle que belle. Son design est basé sur le concept du « minimalisme sensuel » que Paul Flowers (vice-président de la branche design de Hansgrohe) décrit comme « la différence entre une excellente conception et le design ». Avec sa simplicité non dénuée d'émotion, ce design s'inspire clairement de la nature sans chercher une forme organique.

Grohe Ondus mixing tap, 2007

Grohe Design Team

www.grohe.com
Chromed metal
Verchromtes Messing
Métal chromé
↕ 24 cm
Grohe, Düsseldorf, Germany

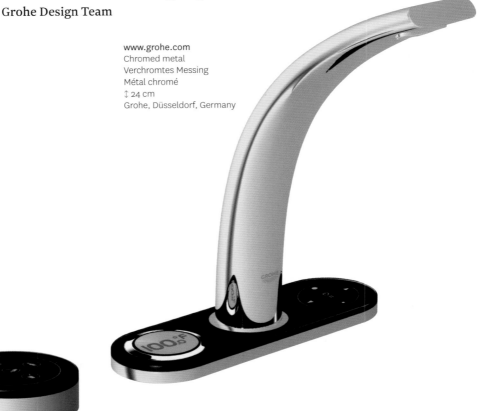

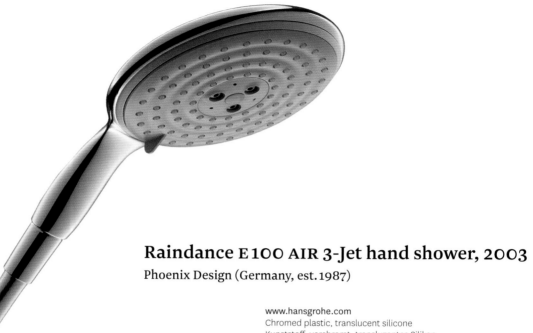

Raindance E 100 AIR 3-Jet hand shower, 2003

Phoenix Design (Germany, est. 1987)

www.hansgrohe.com
Chromed plastic, translucent silicone
Kunststoff, verchromt, transluzentes Silikon
Plastique chromé, silicium translucide
↔ 20 cm ⌀ 11 cm
Hansgrohe, Schiltach, Germany

Winner of a Red Dot award and a Design Plus award nominee, the *Raindance E 100* hand shower has been designed, as its name suggests, to recreate the experience of a shower of rain. It boasts five different spray modes that can be adjusted single-handedly, and is available in a chromed finish or with a translucent two-tone grey-green silicone head.

Wenn man unter dem mit dem Red Dot Award ausgezeichneten und für einen Design Plus nominierten Duschkopf *Raindance E 100* steht, erlebt man – wie der Name schon andeutet – so etwas wie einen Regenschauer im Badezimmer. Man kann mit einer Hand fünf verschiedene „Schauerstärken" einstellen, und der Duschkopf ist entweder verchromt oder mit transluzenter Silikonbeschichtung in zweierlei Grautönen erhältlich.

Comme son nom l'indique, *Raindance* s'inspire de l'eau de pluie naturelle et de ses gouttes d'eau perlées. Récompensé d'un Red Dot et nominé pour le Design Plus, ce pommeau de douche offre un véritable jet de pluie et propose cinq modes de pression différents. Ce modèle existe avec une pomme de douche en finition chromée ou en silicium translucide bicolore, gris vert.

Throughout his career, Christophe Pillet has consistently designed elegantly functional products with a Gallic visual twist, such as his zc1 tap system. This is a truly comprehensive programme that can be customised according to individual needs. Manufactured to the highest standards in Italy, this contemporary range of bathroom hardware is complemented by Pillet's zc2 collection of kitchen taps for the same company.

Christophe Pillet ist dafür bekannt, dass er konsequent elegante funktionale Produkte voller echt französischer Raffinesse kreiert, so auch die Badezimmerarmaturenserie zc1, die in verschiedenen Ausführungen lieferbar ist und je nach Kundenwünschen zusammengestellt und abgewandelt werden kann. Die Armaturen werden in hoher Qualität in Italien produziert, und zwar vom selben Hersteller wie die Küchenarmaturen von Pillets zc2-Kollektion.

Tout au long de sa carrière, Christophe Pillet a conçu des designs à la fois fonctionnels et raffinés, révélant une élégance très française. zc1 illustre parfaitement sa conception créative. Cet ensemble de robinets s'avère vraiment complet, personnalisable selon vos besoins. Réalisée suivant les normes les plus strictes en Italie, cette collection contemporaine d'accessoires de salle de bains est complétée par zc2, une gamme de robinets pour la cuisine, conçue pour la même société.

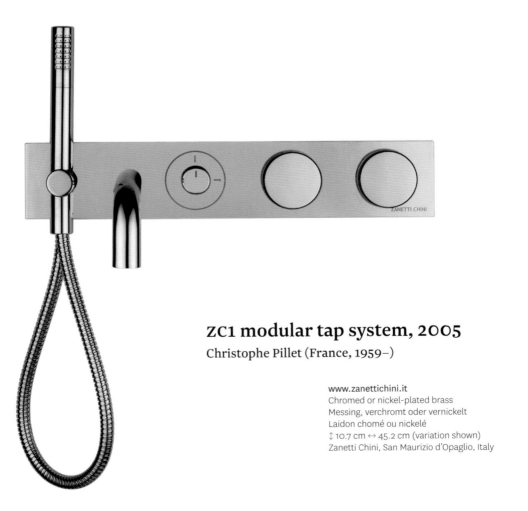

zc1 modular tap system, 2005

Christophe Pillet (France, 1959–)

www.zanettichini.it
Chromed or nickel-plated brass
Messing, verchromt oder vernickelt
Laidon chomé ou nickelé
↕ 10.7 cm ↔ 45.2 cm (variation shown)
Zanetti Chini, San Maurizio d'Opaglio, Italy

2m EauZone shower unit, 2006

Matki Design Team

www.matki.co.uk
Glass, chromed brass
Glas, verchromtes Messing
Verre, laiton chromé
↕ 204.4 cm
Matki, Bristol, UK

This minimalistic shower solution comes in two configurations: either as a large twin-entrance unit or as a smaller corner unit. The shower slab can either be exposed or recessed into the floor, while the glass panels are specially treated for easy cleaning. The shower itself features a large 'deluge' showerhead, as well as a handset and six body jets; and, importantly, the design also includes a fast-flow shower waste.

Diese minimalistische Dusch-Lösung ist in zwei Ausführungen erhältlich: entweder als große Kabine mit Doppeltür oder als kleinere Eckkabine. Die Duschwanne kann entweder frei stehen oder in den Boden eingelassen werden, während die Glaswände speziell behandelt sind, um leichte Reinigung zu gewährleisten. Die Dusche selbst bietet einen großen Wasserfall-Duschkopf sowie einen abnehmbaren Duschkopf und sechs Körperdüsen. Außerdem enthält das Design eine Vorrichtung für schnellen Wasserablauf.

Cette solution de douche minimaliste existe en deux configurations : une unité spacieuse avec double porte ou une version plus petite formant une encoignure. Le bac peut être soit exposé soit encastré tandis que les panneaux de verre sont traités spécialement pour un nettoyage facile. La colonne elle-même comporte une large pomme « déluge », une douchette à main et six jets corporels. Plus important encore, le système est équipé d'un système d'évacuation rapide des eaux.

Walk-in freestanding shower unit, 2006

Matki Design Team

www.matki.co.uk
Glass, chromed brass
Glas, verchromtes Messing
Verre, laiton chromé
↕ 214 cm (including shower tray)
Matki, Bristol, UK

This elegant walk-in shower unit is a freestanding design. It features an innovative mixer, with a two-way thermostatic control, set on an attractive column. It comes with a choice of teak or white acrylic decking, and has an unusual, square-shaped showerhead for easy cleaning, as well as a concealed outlet for rapidly removing waste water.

Diese elegante begehbare Dusche ist freistehend designt. Sie bietet eine innovative Mischbatterie mit zweistufigem Temperaturregler an einer attraktiven Säule und ist mit poliertem Teak- oder weißem Acrylboden und einer ungewöhnlichen rechteckigen Duschtasse erhältlich, die sich leicht reinigen lässt. Der verdeckte Abfluss nimmt das verbrauchte Wasser schnell auf.

Cette élégante cabine de douche est équipée d'une technologie novatrice avec un mitigeur thermostatique à double commande monté sur une colonne. Elle existe avec un revêtement en teck ou en acrylique blanc. Sa pomme de douche carrée inhabituelle permet un nettoyage facile et sa bonde dissimulée assure une évacuation rapide des eaux usées.

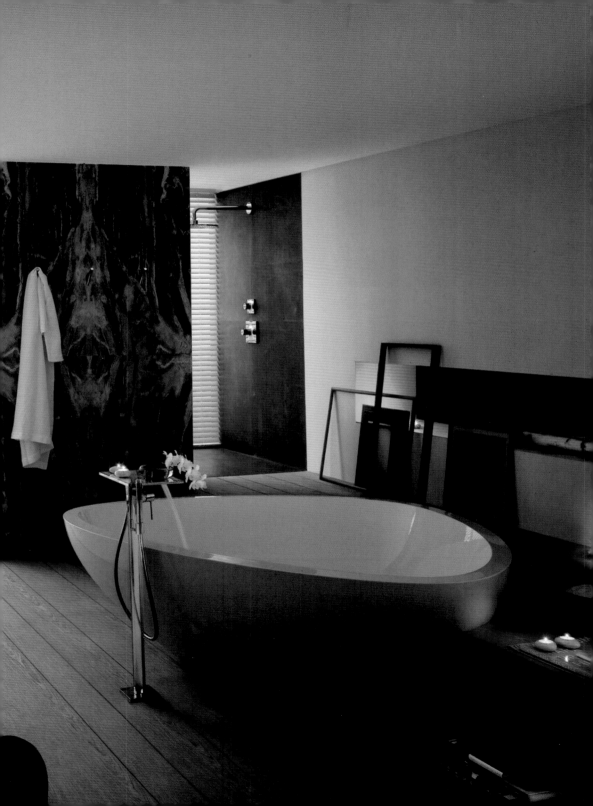

This unusual design is part of a new generation faucet system for baths, showers and washbasins, devised by the eminent French designer Jean-Marie Massaud for Hansgrohe. With its shelf-like form, the top of the faucet can be used like a tray to hold a glass of wine, candles, soap, a vase of flowers – in fact whatever you want – while, from underneath, water cascades into the bath or basin like a beautiful waterfall.

Das ungewöhnliche Design gehört zu einer neuen Generation von Armaturen für Bäder, Duschen und Waschbecken, die der bekannte französische Designer Jean-Marie Massaud für Hansgrohe entwickelt hat. Der wie eine Ablage gestaltete Einhandmischer kann genutzt werden, um ein Glas Wein, Kerzen, Seife, eine Vase mit Blumen oder was immer man möchte abzustellen, während darunter das Wasser wie aus einem natürlichen Wasserfall in die Wanne oder das Becken läuft.

Ce design inhabituel appartient à une nouvelle génération de robinetterie pour baignoires, douches et lavabos conçue pour Hansgrohe par l'éminent designer français Jean-Marie Massaud. Avec sa forme plate, la surface du robinet peut servir de plateau pour accueillir un verre à vin, des bougies, un savon, un vase... ou tout ce que vous voulez, tandis que, dessous, l'eau se déverse dans la baignoire ou le lavabo en une belle cascade.

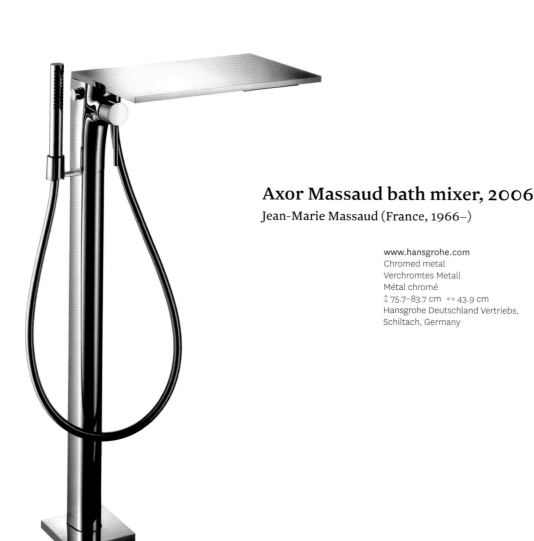

Axor Massaud bath mixer, 2006

Jean-Marie Massaud (France, 1966–)

www.hansgrohe.com
Chromed metal
Verchromtes Metall
Métal chromé
↕ 75.7–83.7 cm ↔ 43.9 cm
Hansgrohe Deutschland Vertriebs,
Schiltach, Germany

FS1 floor-mounted bath mixer, 2008

Vola Design Team

www.vola.dk
Brushed chrome-plated brass
Messing, verchromt und gebürstet
Laiton chromé brossé
↕ 108 cm ↔ 14.8 cm ↗ 30 cm
Vola, Horsens, Denmark

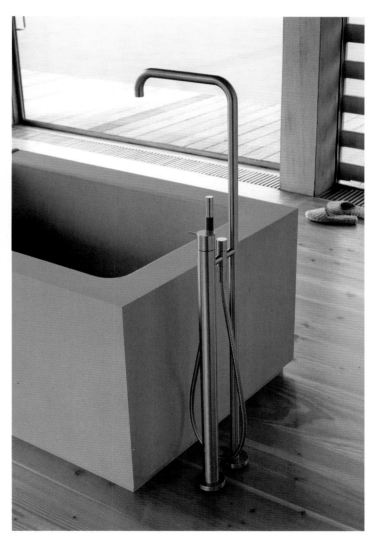

Much loved by architects, Vola's classic bathroom fixtures have a timeless classicism that is utterly impervious to the vagaries of fashion. This famous range was first designed by Arne Jacobsen in the early 1960s, but over the years Vola's design department has steadily added to it. New products include this floor-mounted bath mixer, which perpetuates the design excellence and functionality of Jacobsen's originals.

Volas klassische Badezimmerarmaturen sind aufgrund ihrer zeitlosen, keinen Moden unterworfenen Ästhetik bei Architekten sehr beliebt. Die ersten Designs schuf Arne Jacobsen schon Anfang der 1960er Jahre, aber Volas Designer haben sie über die Jahre immer wieder ergänzt. Zu den neuen Armaturen gehört diese Badewannen-Mischbatterie mit aus dem Boden aufsteigendem Rohr, die Jacobsens elegantes Originaldesign fortführt.

Très appréciés par les architectes, les accessoires de salle de bains Vola révèlent un classicisme intemporel, indifférent aux caprices de la mode. Cette célèbre collection a été initialement conçue par Arne Jacobsen au début des années 60. Au fil des ans, le département design de Vola poursuit l'œuvre de ce créateur en offrant de nouveaux produits. La robinetterie hors-sol FS1 offre un design raffiné et fonctionnel, perpétuant les originaux de Jacobsen.

Istanbul sanitary ware, 2008

Ross Lovegrove (UK, 1958–)

www.vitra.com.tr
Ceramic, chromed metal
Keramik, verchromtes Metall
Céramique, métal chromé
↕ 8 cm ↗ 13 cm (basin mixer)
↔ 100 cm (basin)
VitrA, Bilecik, Turkey

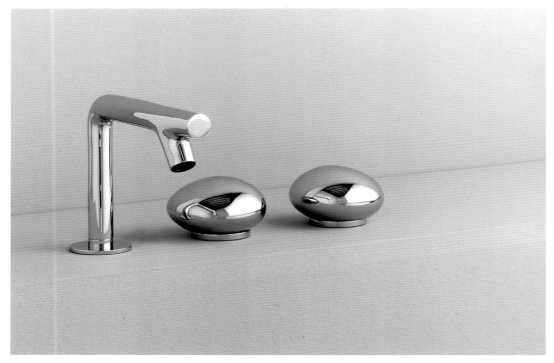

Over the last decade there has been a rise in the phenomenon of 'bathroom culture': a symptom, perhaps, of our need for relaxation in an increasing stressful world. Ross Lovegrove's *Istanbul* range of bathroom fixtures and fittings epitomizes this trend, and was itself inspired by age-old Turkish bathing traditions, Ottoman calligraphy and Islamic geometric patterns. With its branch-like taps and pebble-like controls, the *Istanbul* range also beautifully expresses Lovegrove's uniquely sensual approach to design.

Im Laufe der vergangenen zehn Jahre hat das Phänomen „Badezimmer-Kultur" stark zugenommen, vielleicht ein Symptom unseres Bedürfnisses nach Entspannung in einer immer stressigeren Welt. *Istanbul*, Ross Lovegroves Serie von Badezimmerarmaturen, verkörpert diesen Trend und wurde von uralten türkischen Badetraditionen, osmanischer Kalligraphie und islamischen geometrischen Mustern inspiriert. Der an eine Astgabel erinnernde Wasserhahn und die kieselsteinartigen Regler der *Istanbul*-Reihe bringen auch sehr schön Lovegroves einzigartigen sinnlichen Designansatz zum Ausdruck.

La dernière décennie a été marquée par l'avènement d'une « culture de la salle de bains », signe, sans doute, de notre besoin de relaxation dans un monde toujours plus stressant. La ligne de sanitaires et d'accessoires de bain *Istanbul* dessinée par Ross Lovegrove illustre cette tendance. Elle s'inspire de la tradition ancestrale des bains turcs, de la calligraphie ottomane et des motifs géométriques islamiques. Avec ses robinets en forme de branche et ses commandes évoquant des galets, elle reflète merveilleusement la démarche de design unique et sensuelle de Lovegrove.

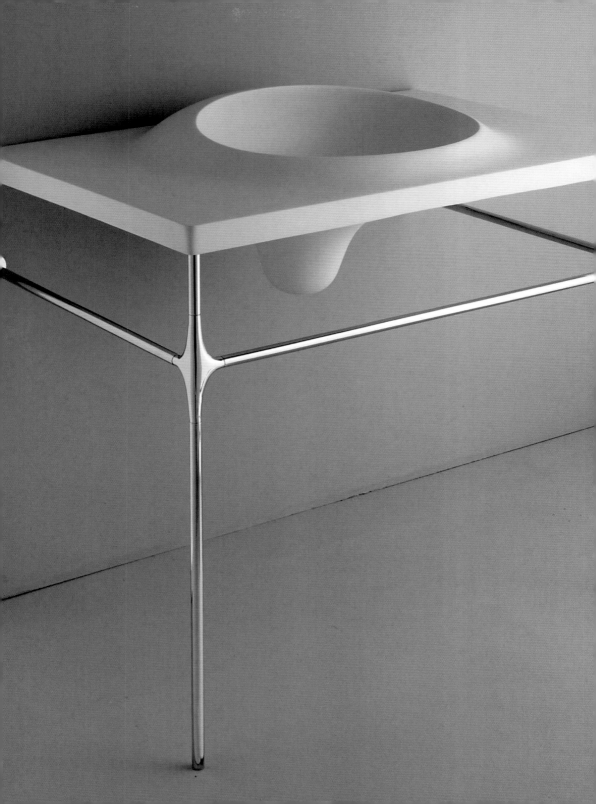

Istanbul towel ring, multiple towel hook & toilet brush holder, 2008

Ross Lovegrove (UK, 1958–)

www.vitra.com.tr
Chromed metal
Verchromtes Metall
Métal chromé
↔ 34.8 cm (ring)
↕ 9 cm ↔ 32 cm (hook)
↕ 42 cm (brush)
VitrA, Bilecik, Turkey

Ross Lovegrove skilfully combines organic forms and cutting-edge technology in order to produce objects of rare sculptural beauty, which also have a superlative functional logic. His *Istanbul* range of bathroom fixtures, fittings and accessories comprises over one hundred products that work holistically to create a visually complete and functionally unified environment.

Ross Lovegrove kombiniert geschickt organische Formen und hochmoderne Technologie zu Objekten von seltener skulpturaler Schönheit und unübertroffener funktionaler Logik. Die von ihm entworfene Badkollektion *Istanbul* umfasst über hundert Produkte, die in ihrer Gesamtheit für ein visuell vollständiges und funktional einheitliches Ambiente sorgen.

Ross Lovegrove sait comme personne marier les formes organiques et la technologie de pointe pour concevoir des objets d'une rare beauté sculpturale qui possèdent également une exceptionnelle logique fonctionnelle. Sa ligne de sanitaires, d'équipement et d'accessoires de salle de bains *Istanbul* compte une centaine de produits qui s'associent de manière holistique pour créer un environnement visuellement complet et fonctionnellement unifié.

Istanbul pedestal washbasin, 2008

Ross Lovegrove (UK, 1958–)

www.vitra.com.tr
Ceramic, chromed metal
Keramik, verchromtes Metall
Céramique, métal chromé
↕ 85 cm ↔ 60.5 cm
VitrA, Bilecik, Turkey

Throughout his career, Ross Lovegrove has created exquisitely refined objects that break both aesthetic and technical boundaries, and that are the result of his uniquely human-centric methodology, which he terms: 'organic essentialism'. His award-winning *Istanbul* bathroom range powerfully exemplifies this sensual approach to design, with its gracefully sculptural forms and sensitive, functional logic.

Ross Lovegroves überaus elegante Objekte überschreiten ästhetische und auch technische Grenzen. Sie sind das Ergebnis von Lovegroves einzigartigem, auf den Menschen ausgerichtetem Ansatz, den er „organischen Essentialismus" nennt. Seine preisgekrönte Badkollektion *Istanbul* mit ihren anmutigen plastischen Formen und funktionalen Logik veranschaulicht diesen sinnlichen Umgang mit Design.

Tout au long de sa carrière, Ross Lovegrove a créé des objets d'un raffinement exquis qui repoussent les limites esthétiques et techniques. Ils sont le fruit de sa méthodologie unique, centrée sur l'homme, qu'il qualifie « d'essentialisme organique ». Sa ligne primée d'équipement de salle de bains illustre à merveille son approche sensuelle avec ses formes sculpturales gracieuses et sa logique sensible et fonctionnelle.

Sabbia bathtub & washbasins, 2008

Naoto Fukasawa (Japan, 1956–)

www.boffi.com
Cast-moulded Cristalplant (aluminum trihydrate, polyester and acrylic resin)
Formgepresstes Cristalplant (Aluminiumtrihydrat, Polyester und Acrylharz)
Cristalplant moulé (hydrate d'aluminium, polyester et résine d'acrylique)
↕ 55 cm ↔ 171.9 cm ⤢ 151 cm
Boffi, Lentate sul Seveso, Italy

According to Boffi, the *Sabbia* is the first large mono-bloc moulded bathtub to be produced without any jointing points. Made from a single cast of white resin, the bathing section is completely integrated into its support resulting in a highly sculptural design, which has a very Japanese Zen-like aesthetic. The lateral water supply is also reminiscent of a waterfall, adding another sensory dimension to bathing.

Nach Angaben von Boffi ist *Sabbia* die erste große Blockbadewanne, die ohne jegliche Verbindungspunkte gefertigt wird. Die Acrylharz-Wanne aus einem Guss ist vollständig in den Trägerrahmen integriert, so dass ein sehr skulpturales Design von ausgesprochen japanischer, Zen-artiger Ästhetik entsteht. Der seitliche Wasserspender erinnert an einen Wasserfall und erweitert das Badeerlebnis um eine neue, sinnliche Dimension.

Selon Boffi, *Sabbia* est la première baignoire monobloc moulée, réalisée sans joints. Conçue à partir d'un seul moule de résine blanche, la partie du bain est directement intégrée dans le volume géométrique de la baignoire. Extrêmement sculpturale, *Sabbia* reflète à la perfection l'esthétique japonaise, zen et minimaliste à la fois. La robinetterie s'apparente à une chute d'eau, ajoutant une dimension sensorielle au bain.

Terra bathtub, 2006

Naoto Fukasawa (Japan, 1956–)

www.boffi.com
Cast-moulded Cristalplant (aluminium trihydrate, polyester and acrylic resin)
Gussgeformtes Cristalplant (Aluminiumtrihydrat, Polyester und Acrylharz)
Cristalplant moulé (hydrate d'aluminium, polyester et résine d'acrylique)
↕ 50 cm ↔ 170 cm ⤢ 151 cm
Boffi, Lentate sul Seveso, Italy

A master form-giver, Naoto Fukasawa creates objects that are at once functionally excellent and innately beautiful. His designs are possessed of an inner quietness, an almost reflective quality that is utterly compelling. Made from a pure white marble-like acrylic resin, the *Terra* bathtub demonstrates this perfectly, with a strong sculptural presence that belies its practicality.

Naoto Fukasawa ist ein meisterhafter Formgestalter. Seine Produkte sind ebenso zweckmäßig wie formschön und von einer Klarheit und ruhigen Schlichtheit, die absolut unwiderstehlich wirkt. Die aus einem speziellen, rein weißen, marmorähnlichen Acrylharz gefertigte Badewanne *Terra* demonstriert dies beispielhaft und ist trotz ihrer skulpturalen Form äußerst funktional.

Naoto Fukasawa maîtrise la forme et conçoit des objets à la fois fonctionnels et esthétiques. Ses créations reflètent une sérénité intérieure et une qualité réflexive des plus convaincantes. Réalisée en résine acrylique blanche s'apparentant au marbre, la baignoire *Terra* illustre parfaitement le savoir-faire de son créateur, alliant beauté sculpturale et fonctionnalité.

Tina bathtub, 2005

Lavernia Cienfuegos y Asociados (Spain, est. 1995)

www.sanico.es
Stonefeel mineral resin or marble
Mineralisches Kunstharz Stonefeel oder Marmor
Résine minérale Stonefeel ou marbre
↕ 65 cm ↔ 180 cm ↗ 86 cm
Sanico, Valencia, Spain

The *Tina* bath can be used as a freestanding unit or installed against a wall, with either floor- or wall-mounted faucets. This elegant design is normally made from a resin specially developed by Sanico to have convincing stone-like textural and aesthetic qualities, achieved by incorporating minerals into the formula. A special-order marble version is also available. Simple yet stylish, this design received a Design Plus Award from the Rat für Formgebung (German Design Council) in 2005.

Die *Tina*-Badewanne mit Armaturen für Boden- oder Wandmontage kann freistehen oder an der Wand eingebaut werden. Das elegante Design wird normalerweise aus einem speziellen, von Sanico entwickelten Kunstharz gefertigt, das durch Beimischung von Mineralien die Struktur und Ästhetik von Stein erhält. Es gibt auch eine Sonderanfertigung in Marmor. Die schlichte und dennoch stilvolle Badewanne wurde 2005 vom Rat für Formgebung mit einem Design Plus Award ausgezeichnet.

Tina s'installe parfaitement contre un mur avec sa robinetterie encastrée, ou dans n'importe quelle partie de la salle de bains, avec une robinetterie à même le sol. Élégante et minimaliste, elle a été réalisée à partir d'une résine spécialement développée par Sanico, comprenant des minéraux afin de créer une texture s'apparentant à la pierre. Une version existe également en marbre, uniquement sur commande. Récompensée par le Conseil du Design allemand, la baignoire *Tina* propose une ligne raffinée.

Bath 1 bathroom system, 2007

Jacob Jensen (Denmark, 1926–) & Timothy Jacob Jensen (Denmark, 1962–)

www.lifa-design.com
Aluminium, laminate
Aluminium, Laminat
Aluminium, stratifié
Lifa Design, Holstebro, Denmark

Available in either black or white, the *Bath 1* system incorporates basins and drawers within a distinctive and sleek exterior. The unusual angularity of the design gives the system a dynamic, faceted quality, which is strikingly different from most other bathroom units. The Jacob Jensen studio has also created another system entitled *Bath 2*, which is equally visually striking and exquisitely detailed.

Die Sanitärobjekte der Serie *Bath 1* sind in Schwarz oder Weiß lieferbar und umfassen einen eleganten Waschtisch mit seidig glänzender Schubladenfront. Aufgrund seiner kantig-vieleckigen Form wirkt dieses Modell dynamisch facettiert und hebt sich so von der Masse der üblichen Sanitärobjekte und Badmöbel ab. Jacob Jensens Designbüro hat auch die ebenso ausgefallene und raffiniert detaillierte Serie *Bath 2* gestaltet.

Disponible en noir et blanc, *Bath 1* comprend des lavabos et des tiroirs, révélant un design original et élégant. L'angularité inhabituelle de cette création lui confère une qualité dynamique, à facettes, différant de la plupart des meubles de salle de bains. Le studio de Jacob Jensen a également créé *Bath 2*, à angles droits, tout aussi impressionnant et extraordinairement détaillé.

Maintenance
Instandhaltung
Bricolage et entretien

DC25 All Floor vacuum cleaner, 2005

James Dyson (UK, 1947–)

www.dyson.com
ABS, polycarbonate
ABS, Polykarbonat
ABS, polycarbonate
↕ 107 cm ↔ 39.2 cm ⤢ 31 cm
Dyson, Malmesbury, UK

After literally years of painstaking research and development, James Dyson launched his *Dual Cyclone™* vacuum cleaner in 1993, which with its no-loss-of-suction bag-less technology quite literally revolutionized the vacuum cleaner industry. In a climate of perpetual innovation, Dyson's company has since honed this design for even better performance – its latest incarnation, the *Dyson DC25*, sits on top of a ball which houses the cleaner's motor. This unusual configuration allows excellent manoeuvrability thanks to its lower centre of gravity.

Nach Jahren sorgfältiger Recherche und Entwicklung brachte James Dyson 1993 seinen Staubsauger *Dual Cyclone™* auf den Markt, der ohne Saugkraftverlust und ohne Beutel arbeitet und damit die Staubsauger-Industrie regelrecht revolutionierte. In einem Klima ständiger Innovation hat Dyson's Unternehmen dieses Design noch weiter verbessert – seine letzte Reinkarnation ist der *Dyson DC25*. Bei diesem ungewöhnlichen Modell sitzt der Saugfilter auf einem Ball, in dem sich der Motor des Geräts befindet, das dank des niedrigeren Schwerpunkts hervorragend zu lenken ist.

Après des années de recherches et de développement, James Dyson lance son aspirateur sans sac *Dual Cyclone™* en 1993, utilisant la séparation cyclonique pour séparer la poussière de l'air. Une véritable révolution dans l'industrie de l'aspirateur ! En quête d'innovation perpétuelle, la société Dyson perfectionne ce modèle afin de le rendre plus performant. La dernière version, le *Dyson DC25* est posé sur une balle contenant le moteur de l'aspirateur. Ce système inhabituel autorise une plus grande manœuvrabilité grâce à son centre de gravité abaissé.

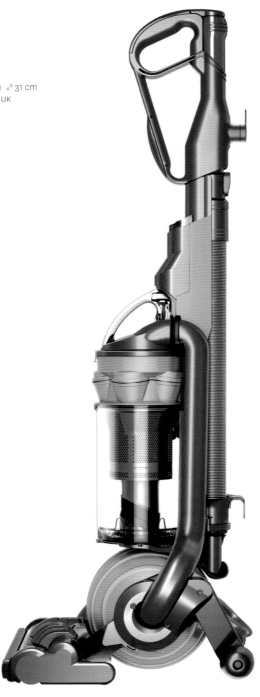

DC32 Animal vacuum cleaner, 2005

James Dyson (UK, 1947–)

www.dyson.com
ABS, polycarbonate
ABS, Polycarbonat
ABS, polycarbonate
↕ 35 cm ↔ 30 cm ⤢ 49 cm
Dyson, Malmesbury, UK

Very compact yet extremely powerful, the *DC32 Animal* vacuum cleaner is a remarkably robust no-nonsense design that incorporates Dyson's excellent bag-less *Dual Cyclone™* technology. This model has been created specifically to deal with stubborn-to-shift pet hair and comes with a range of useful tools to get into all sorts of nooks and crannies. Like other vacuums designed by Dyson the layout of the design is also highly intuitive, which means you don't have to spend a day reading a manual to learn how to operate it.

Der sehr kompakte, aber äußerst leistungsstarke *DC32 Animal*-Staubsauger ist ein bemerkenswert robustes, geradliniges Design, das die hervorragende *Dual Cyclone™* Technologie bietet und ebenfalls ohne Beutel auskommt. Dieses Modell wurde eigens für die Aufnahme schwer zu entfernender Tierhaare entwickelt und wird mit einer Reihe praktischer Zubehörteile geliefert, mit denen man in alle Ecken und Winkel kommt. Wie alle Staubsauger von Dyson besticht auch dieses Modell durch eine sehr intuitive Ausführung, so dass man nicht erst einen ganzen Tag die Gebrauchsanleitung lesen muss, um zu verstehen, wie es funktioniert.

Compact mais extrêmement puissant, l'aspirateur sans sac *DC32 Animal* présente un design incroyablement robuste. Doté de la technologie *Dual Cyclone™*, ce modèle a été spécialement conçu pour combattre les poils d'animaux. Il est livré avec une gamme d'accessoires utiles, permettant d'accéder à toutes sortes de coins et recoins. À l'instar des autres aspirateurs Dyson, ce modèle propose un design hautement intuitif, laissant transparaître clairement son mode de fonctionnement. Fini les interminables « modes d'emploi », d'un simple coup d'œil, vous comprendrez aisément les fonctionnalités de cet aspirateur.

Named by *Time* magazine as one of the 'coolest inventions' of 2002, the *Roomba* vacuum cleaning robot is manufactured by iRobot Corporation, a company that was founded by three roboticists from the renowned Massachusetts Institute of Technology in 1990. Their latest generation of cleaning robot, shown below, has numerous advanced features, including a self-charging facility and on-board scheduling that allows you to preset up to seven different cleaning times per week.

Der von *Time* als eine der „coolsten Erfindungen" des Jahres 2002 bezeichnete *Roomba* Staubsaugerroboter wird von der Firma iRobot hergestellt, ein Unternehmen, das 1990 von drei Roboteringenieuren des berühmten Massachusetts Institute of Technology gegründet wurde. Ihre letzte, hier gezeigte Generation von Reinigungsrobotern besitzt zahlreiche verbesserte Eigenschaften, beispielsweise eine Selbstladestation und einen Timer, um bis zu sieben Arbeitszeiten pro Woche festzulegen.

Surnommé par le magazine *Time* « l'invention la plus cool de 2002 », le robot aspirateur *Roomba* est fabriqué par iRobot Corporation, une société fondée en 1990 par trois roboticiens issus de la prestigieuse Massachusetts Institute of Technology. Leur dernière génération de robot nettoyeur, ci-dessous, possède de nombreuses fonctions avancées, dont un dispositif autochargeable et la possibilité de le programmer pour fonctionner à des heures différentes jusqu'à sept jours par semaine.

Roomba 560 vacuum cleaning robot, 2002

Helen Greiner (USA, 1967–) & Colin Angle (USA, 1967–)

www.irobot.com
Various materials
Verschiedene Materialien
Matériaux divers
↕ 8 cm ⌀ 33 cm
iRobot Corporation, Bedford (MA), USA

E-cloth mop set, 2000
E-Cloth Design Team

www.e-cloth.com
Microfibre, plastic
Mikrofaser, Kunststoff
Microfibre, plastique
↔ 45 cm ⟋ 13.5 cm (base)
↕ 100–180 cm (handle)
E-cloth/EnviroProducts, Lamberhurst, UK

A revolutionary cleaning tool, this mop incorporates an E-cloth head, which has fibres that measure $\frac{1}{100}$ of the width of a human hair. This extraordinarily absorbent dirt-busting textile collects and traps dust, grease and particles with its microfibres, and can be used to clean with just plain water – so no more household chemicals. This means it not only saves you money, but it is also a lot better for the environment.

Dieser Mopp ist wirklich ein revolutionäres Reinigungsinstrument. Die Fasern sind nur ein Hundertstel so breit wie ein menschliches Haar, ziehen Schmutz, Staub, Fett und kleinste Partikel an und halten sie fest. Zum Putzen wird nur noch klares Wasser und keine chemischen Haushaltsreiniger mehr benötigt. Damit lässt sich nicht nur Geld sparen, es ist auch wesentlich besser für die Umwelt.

Totalement révolutionnaire, cet outil de nettoyage comprend une tête E-cloth, dont les fibres représentent $\frac{1}{100}$e d'un cheveu humain. Ce textile extrêmement absorbant enlève la poussière, la graisse et les particules grâce à ses microfibres. Fini les produits d'entretien, cette matière se nettoie simplement avec de l'eau claire. De fait, non seulement vous économisez mais vous agissez positivement sur l'environnement.

Magò broom, 1998
Stefano Giovannoni (Italy, 1954–)

www.magisdesign.com
Air-moulded polyethylene reinforced with fibreglass, polyester
Spritzgegossenes Polypropylen mit Glasfaser verstärkt, Polyester
Polyéthylène moulé par soufflage et renforcé de fibres de verre, polyester
↕ 142 cm
Magis, Motta di Livenza, Italy

The *Magò* broom is a durable design intended to infuse the mundane job of sweeping with a touch of fun. It comes in seven different colour schemes (with the colours of the polyethylene handles playfully contrasting with those of the polyester bristles), and replacement heads and a handy wall hook are also available. Like other home wares designed by Stefano Giovannoni, the *Magò* has a charming Neo-Pop sensibility.

Der *Magó*-Besen ist ein haltbares Design, mit dem selbst eine so profane Tätigkeit wie Kehren Spaß macht. Er wird in sieben verschiedenen Farbkombinationen hergestellt (die Farben des Polyethylengriffs bilden einen spielerischen Kontrast zu denen der Polyesterborsten) und ist mit Ersatzborstenkopf sowie einem praktischen Wandhaken erhältlich. Wie andere, von Stefano Giovannoni entworfene Haushaltsartikel besitzt auch der *Magó* einen ansprechenden Neo-Pop-Charme.

Magò est un article résistant conçu pour rendre plus joyeuse la corvée du balayage. Il existe en sept combinaisons de couleurs (le manche en polyéthylène contrastant avec la brosse en polyester) et peut être fourni avec des brosses de rechange et un crochet mural. Comme d'autres articles ménagers créés par Stefano Giovannoni, le balai *Magò* possède un charmant aspect néo-Pop.

Part of the famous *Good Grips* range, the household scrub brush, the corners and edges brush, the bar brush and the grout brush – all shown here – have two types of bristles. There are stiff outer bristles for deep scrubbing, and soft inner bristles for polishing surfaces. Their comfortable, non-slip elastomer handles ensure a secure grip even when wet, while the raised position of the handles in relation to the brush section gives better leverage and helps to keep knuckles protected.

Die hier abgebildeten Scheuerbürsten für Rillen, Ecken, Kanten und Flächen gehören zu oxos *Good Grips*-Produktfamilie und sind alle mit zwei verschiedenen Borsten bestückt: am Rand mit harten Borsten für die Tiefenreinigung und in der Mitte mit weicheren zum Polieren. Selbst wenn sie nass sind, liegen die rutschfesten Griffe aus weichem Kunststoff gut und fest in der Hand, und da sie höher liegen als die Borsten verschonen die Bürsten beim Scheuern auch die Fingerknöchel.

Issues de la célèbre gamme *Good Grips*, ces brosses possèdent deux types de poils : des poils raides qui assurent un nettoyage en profondeur, et des poils doux pour faire briller les surfaces. Leur manche en élastomère antidérapant permet de les tenir fermement, même lorsqu'elles sont mouillés. De plus, la position surélevée des manches par rapport à la brosse offre un parfait effet de levier tout en protégeant vos mains.

Good Grips household brushes, 2004

Smart Design (USA, est. 1978)

www.oxo.com
Plastic, Santoprene, nylon
Plastik, Santopren, Nylon
Plastique, Santoprene, nylon
OXO International, New York (NY), USA

Good Grips dustpan and brush, 2004
Smart Design (USA, est. 1978)

www.oxo.com
Plastic, Santoprene, nylon
Plastik, Santopren, Nylon
Plastique, Santoprene, nylon
OXO International, New York (NY), USA

Smart Design began designing high-quality household tools for OXO in 1991, based on extensive research into the needs of people with different abilities, including arthritis patients and young children. The resulting designs were ergonomically revolutionary and epitomize the inclusive and democratic ideals of Good Design. The dustpan and brush, shown here, feature soft, egg-shaped handles, while the splayed form of the broom makes sweeping easier for everyone.

1991 entwarfen die Designer von Smart Design die ersten hochwertigen Haushaltsutensilien für oxo International, nachdem sie gründlich recherchiert hatten, welche Bedürfnisse Menschen mit Handicaps, wie z. B. Arthritis-Patienten, oder Kinder haben. Ihre Erkenntnisse flossen in damals revolutionäre Produktdesigns ein, welche die sozialen und demokratischen Ideale der „guten Form" beispielhaft verkörpern. Die hier abgebildete Kehrschaufel und der Handfeger haben weiche, eiförmige Handgriffe, und der schneebesenförmige Handfeger erleichtert jedem Benutzer das Aufkehren.

En 1991, Smart Design commence à concevoir pour oxo des ustensiles ménagers de grande qualité. D'importantes recherches concernant les réels besoins des personnes sont alors entreprises, notamment pour celles atteintes d'arthrite et les enfants. Le résultat fut ergonomiquement révolutionnaire, incarnant les idéaux inclusifs et démocratiques de Good Design. Cette pelle dotée de poignées ergonomiques en forme d'œuf et cette large balayette facilitant le nettoyage illustrent parfaitement l'ambition de ces créateurs.

Over the last decade, Normann Copenhagen has become known for its idiosyncratic housewares that innovatively reinterpret existing typologies. Its aim is to create objects that not only look better, but also function better too. Ole Jensen's *Dustpan & Broom* combination, for instance, possesses a higher degree of ergonomic comfort than most traditional models, as well as being a lot more stylish – with the pan available in either black, dark grey, light grey or purple.

Normann Copenhagen wurde in den letzten zehn Jahren bekannt durch seine eigenwilligen Neuinterpretationen existierender Typologien. Erklärtes Ziel des Unternehmens ist es, Objekte zu schaffen, die nicht nur besser aussehen, sondern auch besser funktionieren. Ole Jensens Kombination *Dustpan & Broom* ist beispielsweise viel ergonomischer als die meisten traditionellen Modelle und zugleich wesentlich stylischer – die Kehrschaufel ist in Schwarz, Dunkel- oder Hellgrau oder in Purpur erhältlich.

Synonymes d'élégance, la pelle et la balayette *Dustpan & Broom* ont été créées pour Normann Copenhagen, connu pour ses articles ménagers idiosyncrasiques visant à revisiter les objets de manière novatrice. Une façon de mettre un peu de style dans un article purement fonctionnel. *Dustpan & Broom* bénéficient d'un confort ergonomique, tout en étant très raffinées. La pelle est disponible en noir, gris foncé, gris clair, ou violet. Un design aux lignes pures qui donne envie de tout nettoyer.

Dustpan & Broom, 2009

Ole Jensen (Denmark, 1958–)

www.normann-copenhagen.com
Polypropylene, beech, natural bristles
Polypropylen, Buche, Naturborsten
Polypropylène, hêtre, poils naturels
Normann Copenhagen, Copenhagen, Denmark

This highly practical three-foot stepladder is lightweight yet strong and, thanks to its innovative closing mechanism, it is also easy to store. In addition, it has a slip-resistant finish and a handy carrying handle, which can also be used to mount it on a wall when not in use. Like other home products manufactured by Kartell, the *Tiramisù* not only looks good but is also functionally innovative.

Diese praktische dreistufige Klappleiter ist ein Leichtgewicht, aber dennoch stabil, und lässt sich dank ihres innovativen Verschlussmechanismus' einfach verstauen. Außerdem bietet sie eine rutschfeste Oberfläche und einen praktischen Tragegriff, an dem man sie auch an der Wand aufhängen kann. Wie andere Einrichtungsgegenstände von Kartell sieht *Tiramisù* nicht nur gut aus, sondern ist auch funktional innovativ.

Ultraléger mais robuste, cet escabeau à trois échelons très pratique possède un ingénieux mécanisme de fermeture qui le rend facile à ranger. En outre, il est équipé d'un vernis antidérapant ainsi que d'une poignée facilitant son transport et permettant de l'accrocher au mur une fois replié. Comme les autres articles pour la maison de Kartell, *Tiramisù* est à la fois beau et doté de fonctions innovantes.

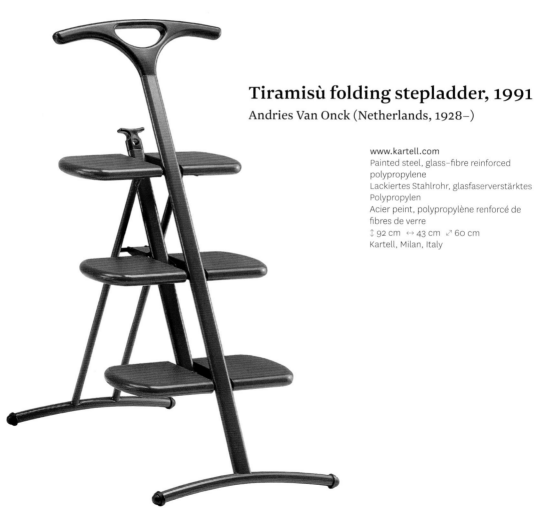

Tiramisù folding stepladder, 1991
Andries Van Onck (Netherlands, 1928–)

www.kartell.com
Painted steel, glass–fibre reinforced polypropylene
Lackiertes Stahlrohr, glasfaserverstärktes Polypropylen
Acier peint, polypropylène renforcé de fibres de verre
↕ 92 cm ↔ 43 cm ↗ 60 cm
Kartell, Milan, Italy

Good Grips hand tools, 2005

Smart Design (USA, est. 1978)

www.oxo.com
Various materials
Verschiedene Materialien
Matériaux divers
OXO International Ltd., New York City (NY), USA

This all-purpose hardware range comprises fourteen tools, including: long-nosed pliers, three different types of hammer, an adjustable wrench, screwdrivers, a level, measuring tapes and multi-purpose snips. Like other products in the *Good Grips* range, these tools were designed with inclusivity in mind. Everybody can use them, including older people with arthritis, thanks to their soft, sure-grip handles.

Dieses Allzweckset besteht aus vierzehn Werkzeugen: Flachzange, drei verschiedene Hämmer, ein verstellbarer Schraubenschlüssel, verschiedene Schraubenzieher, Wasserwaage, Maßband und Schere. Wie bei anderen Produkten der *Good Grips*-Serie stand auch bei diesem Werkzeug das Prinzip der Inklusivität im Vordergrund – dank der weichen, sicheren Griffe kann es jeder benutzen, auch ältere Menschen mit Arthritis.

Cet ensemble d'outils comprend quatorze pièces : tenailles, pinces, trois types de marteaux, clé à molette, tournevis, niveau, mètre à ruban, et ciseaux multi-usage. À l'instar d'autres produits de la gamme *Good Grips*, ces outils sont faciles à manipuler grâce à leur design ergonomique. Ils sont utilisables par tous, notamment par les personnes âgées souffrant d'arthrite, grâce à leurs poignées confortables et antidérapantes.

Amleto ironing board, 1992

Design Group Italia (Italy, est. 1968)

www.magisdesign.com
Anodized aluminium, sheet metal, polyester textile, silicone
Eloxiertes Aluminium, Metallblech, Polyester, Silikon
Aluminium anodisé, tôle, textile polyester, silicone
↕ 77–93 cm ↔ 132 cm ⤡ 51 cm
Magis, Motta di Livenza, Italy

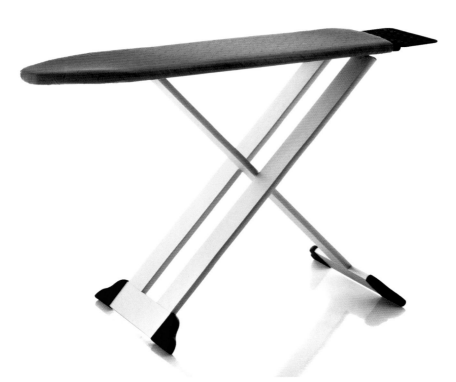

Perhaps the most stylish ironing board ever created, the *Amleto* folds completely flat, so that it measures just seven centimetres in depth. It can also be stored on a special customized wall hook to save space. Additionally, its height can be adjusted from seventy-seven up to ninety-three centimetres to provide the optimum height for all users. Its padded cover, available in either lilac or grey polyester, is also replaceable.

Amleto ist das vielleicht eleganteste Bügelbrett, das je entworfen wurde, und lässt sich so flach zusammenklappen, dass es nur sieben Zentimeter in der Tiefe misst. Um Platz zu sparen, kann es auch an einem speziell angefertigten Wandhaken aufbewahrt werden. Außerdem lässt es sich von siebenundsiebzig auf bis zu dreiundneunzig Zentimeter verstellen, so dass für jeden Benutzer die optimale Höhe gewährleistet ist. Der Polyesterbezug in lila oder grau ist ebenfalls auswechselbar.

À la fois robuste, esthétique et fonctionnelle, cette planche à repasser est certainement la plus élégante jamais créée. *Amleto* se plie à plat pour faciliter le rangement (seulement sept centimètres de profondeur). Elle est livrée avec un crochet en aluminium anodisé pour une fixation murale. Cette planche possède une taille ajustable de soixante-dix-sept à quatre-vingt-treize centimètres, idéale pour tous les utilisateurs. La housse en polyester est disponible en couleur lilas ou gris pâle.

Guaranteed for ten years, this sturdy ironing board is a true laundry room workhorse. Measuring forty-five centimetres in width, it is substantially wider than regular models making ironing easier and quicker. It also boasts a heat-resistant foldable holder for steam units and steam irons, and can be adjusted to four different worktop heights. It also has a child lock to prevent it accidentally collapsing.

Dieses robuste Bügelbrett mit zehn Jahren Garantie ist ein echtes Arbeitspferd im Wäschezimmer. Mit fünfundvierzig Zentimetern ist es wesentlich breiter als reguläre Modelle und macht das Bügeln einfacher und schneller. Außerdem bietet es eine hitzebeständige, aufklappbare Halterung für Dampfstationen und Dampfbügeleisen und kann auf vier verschiedene Arbeitshöhen eingestellt werden. Eine Kindersicherung verhindert, dass es versehentlich zusammenfällt.

Garantie dix ans, cette planche à repasser est indispensable dans une buanderie idéale. Son plateau dispose d'un repose fer en métal dit « stop vapeur », repliable. Mesurant quarante-cinq centimètres, il permet un repassage facile et rapide. Cette planche est réglable en quatre hauteurs de telle sorte que vous pourrez par exemple repasser en position assise. Équipée d'une sécurité enfant, elle se verrouille automatiquement dans la position choisie.

C ironing board, 2003

Brabantia Design Team

www.brabantia.com
Lacquered metal, plastic, cotton-covered foam or viscose
Lackiertes Metall, Plastik, Schaumstoff mit Bezug aus Baumwolle oder Viskose
Métal laqué, plastique, mousse recouverte de coton ou viscose
↕ 63–102 cm ↔ 135 cm ⤡ 45 cm
Brabantia Nederland BV, Waalre, The Netherlands

Washing-Up Bowl, 2002

Ole Jensen (Denmark, 1958–)

www.normann-copenhagen.com
Synthetic rubber, beech, natural bristles
Synthetisches Gummi, Buche, Naturborsten
Caoutchouc synthétique, hêtre, poils naturels
↕ 14 cm ↔ 28 cm ⤢ 28 cm
Normann Copenhagen, Copenhagen, Denmark

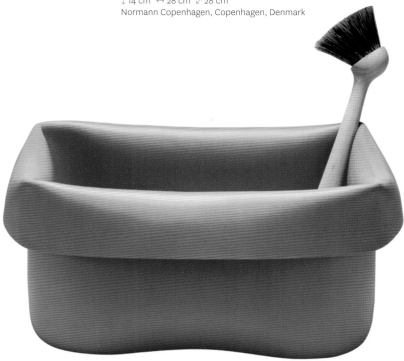

Normann Copenhagen specialises in the manufacture of contemporary housewares that often add a visual and functional twist to traditional typologies. Ole Jensen's *Washing-Up Bowl*, for example, utilises flexible synthetic rubber, so that its cuff-like rim can be turned up if extra depth is required. The winner of a Design Plus award in 2002, this bowl with its wooden brush also brings a touch of glamour to the chore of washing dishes, and is available in wide range of colours, including blue, green, yellow, pink, red, black and brown.

Normann Copenhagen ist auf die Herstellung moderner Haushaltsartikel spezialisiert, die eine eher traditionelle Typologie oft visuell und funktional aufwerten. Ole Jensens *Washing-Up Bowl* beispielsweise besteht aus flexiblem synthetischem Gummi und hat einen manschettenartigen Rand, der nach oben gebogen werden kann, wenn mehr Tiefe benötigt wird. Die Schüssel wurde 2002 mit einem Design Plus Award ausgezeichnet und verleiht der lästigen Pflicht des Geschirrspülens etwas Glamouröses. Sie ist in zahlreichen Farben erhältlich, darunter Blau, Grün, Gelb, Pink, Rot, Schwarz und Braun.

Normann Copenhagen se spécialise dans la fabrication d'articles ménagers contemporains offrant une perspective visuelle et fonctionnelle différente des modèles classiques. La bassine *Washing-Up* d'Ole Jensen est réalisée en caoutchouc synthétique flexible afin de pouvoir remonter les rebords en fonction de la profondeur requise. Récompensé d'un Design Plus en 2002, cette bassine apporte une touche glamour à la corvée de vaisselle. Disponible dans une vaste palette de couleurs, bleu, vert, jaune, rose, rouge, noir et marron. Même les produits les plus simples allient esthétique et fonction.

X-Frame laundry hamper, 2008

Simplehuman Design Team & Lum Design Associates (USA, est. 1999)

www.simplehuman.com
Chromed steel, rubber, cotton and polyester mesh
Edelstahl, Gummi, Baumwoll- und Polyestergewebe
Acier inoxydable, caoutchouc, coton et maille polyester
↕ 77 cm ↔ 46 cm ↗ 40 cm
Simplehuman, Torrance (CA), USA

Designed for storing and transporting dirty laundry, the *X-Frame* hamper is also collapsible so it can be stored or carried easily when not in use. The bag section is made from a breathable and machine-washable canvas-like mesh, and there are rubber grips on the bottom to prevent slippage. Another version of this innovative design has two bags, enabling laundry to be sorted more efficiently.

Der für die Aufbewahrung und den Transport von schmutziger Wäsche entworfene *X-Frame*-Wäschesack lässt sich nach Gebrauch platzsparend zusammenfalten. Der Sack besteht aus einem atmungsaktiven, maschinenwaschbaren Gewebe, und die Gummistopper unten am Gestell machen ihn rutschfest. Es gibt auch eine Version dieses innovativen Designs mit zwei Säcken, die das Sortieren von Wäsche effizienter macht.

Facilement transportable grâce à sa structure pliable, *X-Frame* a été conçu afin de stocker et de transporter le linge sale. Lavable en machine, le sac est conçu dans une toile semblable à de la maille, ce qui favorise l'aération de son contenu. Le piètement dispose de pièces en caoutchouc, qui induit une parfaite adhérence. Une version « deux sacs » de ce modèle améliore encore le tri du linge.

Peter Sägesser's fireplace tool set is precisely engineered and thoughtfully designed to be highly functional. The tools – a long-handled brush, a set of tongs, a poker, and an ash shovel – are also elegantly understated, and would be a stylish complement to any contemporary fireplace. These elegant products also exemplify the attributes of Swiss design: clean lines, high-quality manufacture and excellent functionality.

Peter Sägessers präzise konstruiertes Kaminbesteck ist ein durchdachtes Design von hoher Funktionalität. Die Besteckteile – eine Bürste mit langem Griff, zwei Zangen, ein Schürhaken und eine Ascheschaufel – überzeugen zudem durch elegantes Understatement und sind eine stilvolle Ergänzung eines jeden modernen Kamins. Diese geschmackvollen Produkte veranschaulichen perfekt die Attribute des Schweizer Designs: klare Linien, qualitativ hochwertige Fertigung und hervorragende Funktionalität.

Ce set d'outils de cheminée créé par Peter Sägesser a été conçu puis réalisé afin d'offrir une parfaite fonctionnalité. Composé d'une brosse à long manche, de pinces, d'un tisonnier et d'une pelle, ce set propose des outils à l'élégance discrète, idéal pour tout type de cheminées contemporaines. Ces produits illustrent les qualités du design suisse, lignes épurées, fabrication de grande qualité et une excellente fonctionnalité.

Model No. 1150 fireplace tool set, 2007

Peter Sägesser (Switzerland, 1952–)

www.saegiag.ch
Brushed stainless steel, iron, stainless steel, beech, ebonised wood or cherry
Gebürsteter Edelstahl, Eisen, Edelstahl, Buche, ebonisiertes Holz oder Kirschbaum
Acier inoxydable brossé, fer, acier inoxydable, hêtre, bois ébonisé ou merisier
↕ 65 cm ⌀ 8 cm
Sägi, Zurich, Switzerland

This simple cylindrical waste bin designed by Gino Colombini is not only a classic Kartell design from the mid-1960s, but a veritable icon of Italian design. It was initially only manufactured in opaque ABS. Today, however, it is also produced in injection-moulded PMMA in a wide range of translucent colours. The original option is, nonetheless, more durable and resilient to scratching. This design also works well as an indoor plant holder.

Dieser schlichte zylindrische Papierkorb von Gino Colombini ist nicht nur ein klassisches Kartell-Design der 1960er Jahre, sondern eine echte Ikone des italienischen Designs. Er wurde anfänglich nur aus undurchsichtigem ABS hergestellt, ist heute aber auch in vielen Farben aus transparentem PMMA erhältlich. Die Originalversion ist jedoch robuster und weniger anfällig für Kratzer. Das Design funktioniert auch gut als Behälter für Pflanzen im Haus.

Cette corbeille à papier cylindrique dessinée par Gino Colombini est un classique de la firme Kartell depuis le milieu des années 60 et un véritable objet emblématique du design italien. Initialement uniquement produite en ABS opaque, elle existe désormais en PMMA moulé par injection dans une vaste gamme de couleurs translucides. Toutefois, la version originale est plus robuste et résistante aux éraflures. La corbeille peut également être convertie en cache-pot.

4670 waste bin, 1966

Gino Colombini (Italy, 1915–)

www.kartell.com
Injection-moulded ABS or PMMA
Spritzgegossenes ABS oder PMMA
ABS ou PMMA moulé par injection
↕ 38 cm ∅ 25 cm
Kartell, Milan, Italy

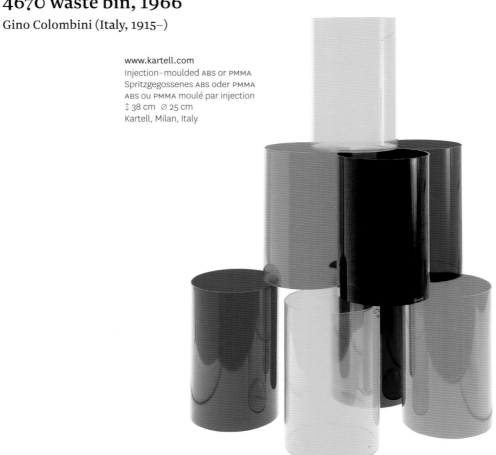

Trash waste bin, 2005

Jasper Morrison (UK, 1959–)

www.magisdesign.com
Injection-moulded polypropylene
Spritzgegossenes Polypropylen
Polypropylène moulé par injection
↕ 28 cm ↔ 24 cm ⤢ 24 cm
↕ 36 cm ↔ 30.5 cm ⤢ 30.5 cm
Magis, Motta di Livenza, Italy

Simple and functional, the durable plastic *Trash* waste bin comes in two sizes and five colours: orange, sky blue, beige, white and black. It is available with both a removable lid (that has a circular opening), and also an internal holder for bin liners, which ensures a stylish presence as well as a functional appeal. Ideal for use in the home or the office, the *Trash* is a typically well-designed Morrison solution that is functionally persuasive as well as visually restrained.

Dieser schlichte und funktionale Abfalleimer ist in zwei Größen und fünf verschiedenen Farben zu haben: Orange, Himmelblau, Beige, Weiß und Schwarz. Es gibt ihn sowohl mit abnehmbarem Deckel (mit einer runden Öffnung) als auch mit einem Ring zur Befestigung von Müllsäcken, so dass er nicht nur durch sein stilvolles Äußeres, sondern auch durch seine Funktionalität überzeugt. Der dezente *Trash*-Abfalleimer ist ideal für Heim und Büro, eine typische, gut durchdachte Lösung von Jasper Morrison, bei der Funktionalität im Vordergrund steht.

Simple et fonctionnelle, la robuste corbeille *Trash* existe en deux tailles et cinq couleurs : orange, bleu ciel, beige, blanc et noir. Disponible avec un couvercle amovible (percé d'une ouverture ronde) ainsi qu'une bague pour la fixation d'un sac-poubelle, elle est aussi élégante que fonctionnelle et convient autant pour la maison que le bureau. *Trash* est caractéristique du design toujours bien conçu de Morrison, mariant l'efficacité fonctionnelle et la maîtrise esthétique.

Garbino waste bin, 1995

Karim Rashid (Egypt/Canada, 1960–)

www.umbra.com
Polypropylene
Polypropylen
Polypropylène
↕ 33 cm ⌀ 25 cm
Umbra, Toronto, Canada

Available with either a matte or glossy surface, the *Garbino* – with its soft flowing curves and seductive biomorphic shape – adds a spark of glamour to the humble waste bin. Probably Karim Rashid's most commercially successful design, the award-winning *Garbino* incorporates two integral handles, and is extremely inexpensive to mass produce. As a result, it is a highly democratic, as well as really useful, 'designer' object for the home.

Der entweder mit matter oder glänzender Oberfläche erhältliche *Garbino* mit seinen weichen, fließenden Kurven und der verführerischen biomorphen Form verleiht dem einfachen Papierkorb etwas Glamouröses. Das wohl meistverkaufte und preisgekrönte Design von Karim Rashid hat zwei integrierte Griffe und lässt sich äußerst kostengünstig in großen Mengen produzieren. Damit ist der *Garbino* ein sehr demokratisches und wirklich nützliches „Designer"-Objekt für Zuhause.

Disponible avec une surface mate ou brillante, les courbes douces et la séduisante forme biomorphique de *Garbino* apporte une touche de glamour à l'humble corbeille à papier. Plus grand succès commercial de Karim Rashid, cette corbeille primée possède deux poignées intégrées et est extrêmement bon marché à produire. Elle est donc hautement démocratique en plus d'être très pratique, un objet de « créateur » pour la maison.

In 1950, Isamu Saitou established the Saito workshop in Kawane – a town located in the Haibara District of Shizuoka – and began manufacturing furniture and other household products using techniques for moulding plywood developed during the Second World War. Seven years later, the venture moved to Shizuoka City and began to manufacture, mainly for export, stylish mid-century designs including an ice bucket, trays and this elegant waste bin, which won a Japanese Good Design Award in 1966.

Isamu Saitou gründete 1950 die Saito-Werkstatt in Kawane, eine Stadt im Bezirk Haibara in der Präfektur Shizuoka, und begann mit der Herstellung von Möbeln und anderen Haushaltswaren, für die er Techniken zum Formen von Pressholz anwandte, die während des Zweiten Weltkriegs entwickelt wurden. Sieben Jahr später zog der Betrieb nach Shizuoka Stadt um und begann mit der, hauptsächlich für den Export bestimmten, Produktion von stilvollen Designs, darunter einem Eiskübel, Tabletts und diesem eleganten Papierkorb, der 1966 den japanischen Good Design Award gewann.

En 1950, Isamu Saito a fondé l'atelier Saito à Kawane, une ville située dans le district de Haibara (préfecture de Shizuoka) afin d'y créer des meubles et objets pour la maison en utilisant les techniques de moulage du contre-plaqué développées durant la Seconde Guerre mondiale. Sept ans plus tard, son entreprise a déménagé dans la ville de Shizuoka et s'est mise à produire, princi-palement pour l'exportation, d'élégants objets design pour la maison dont un seau à glace, des plateaux et cette belle corbeille à papier, lauréate d'un Good Design Award en 1966.

901 waste bin, 1957
Saito Design Team

www.saito-wood.com
Laminated abachi, kalopanax or walnut
Gepresstes Abachi-, Kalopanax- oder Walnussholz
Abachi, kalopanax ou noyer lamellé
↕ 30.5 cm ⌀ 25.5 cm
Saito Wood Company, Shizuoka City, Japan

Like other products produced by the Saito Wood Company, this stylish waste bin is exquisitely made and possesses a quietly refined oriental aesthetic. It comes in three different colours, according to which the following plywoods have been selected: abachi (a hard balsawood), kalopanax (a deciduous tree native to Japan) or walnut. Its unusual yet innovative flip–lid conceals the bin's contents, so it's perfect if you don't like looking at trash.

Wie andere Produkte der Saito Wood Company besitzt auch dieser stilvolle und erlesen verarbeitete Abfalleimer eine zurückhaltende fernöstliche Ästhetik. Er ist in drei verschiedenen Farbtönen erhältlich, für die folgende Presshölzer ausgewählt wurden: Abachi (ein hartes, leichtes Holz), Kalopanax (ein in Japan heimischer Laubbaum) oder Walnuss. Der ungewöhnliche, doch innovative Klappdeckel verbirgt den Inhalt des Eimers, ist also perfekt geeignet, für alle, die nicht gerne auf Abfälle schauen.

Comme d'autres produits réalisés par la Saito Wood Company, cette élégante corbeille d'une facture exquise possède une esthétique orientale raffinée et discrète. Elle existe en trois couleurs en fonction du type de contreplaqué utilisé : l'abachi (un bois léger africain), le kalopanax (un arbre à feuilles caduques qui pousse au Japon) ou le noyer. Son couvercle à bascule original et innovant permet de cacher son contenu.

952 waste bin, c. 1960s
Saito Design Team

www.saito-wood.com
Laminated abachi, kalopanax or walnut
Gepresstes Abachi-, Kalopanax- oder Walnussholz
Abachi, kalopanax ou noyer lamellé
↕ 28.5 cm ⌀ 20.5 cm
Saito Wood Company, Shizuoka City, Japan

Finger-Proof Butterfly Step Can waste bin, 2008

Simplehuman Design Team & Lum Design Associates (USA, est. 1993)

www.simplehuman.com
Brushed steel, plastic
Gebürsteter Stahl, Plastik
Acier brossé, plastique
↕ 66 cm ↔ 26.5 cm ⤢ 59 cm
Simplehuman, Torrance (CA), USA

This innovative garbage can has a slender form that allows it to be placed in narrow spaces that would not accommodate a normal-sized bin. Additionally, its unusual lid opens from the centre like a butterfly's wings in order to allow maximum clearance under low kitchen counter tops. Like other home wares by Simplehuman, this bin has been developed by going back to the first principle of design – how to make an existing product perform better.

Dieser innovative Abfalleimer lässt sich dank seiner schlanken Form auch dort unterbringen, wo ein normal großer Abfalleimer nicht hinpassen würde. Außerdem öffnet sich sein ungewöhnlicher Deckel in der Mitte wie die Flügel eines Schmetterlings, um maximalen Freiraum unter niedrigen Arbeitsflächen zu ermöglichen. Wie bei anderen Haushaltsartikeln von Simplehuman besann man sich auch bei der Entwicklung dieses Eimers des ersten Designprinzips – wie lässt sich Leistung eines bereits bestehenden Produkts verbessern?

La forme élancée de cette poubelle originale permet de la ranger dans un espace trop étroit pour accueillir un récipient de taille standard. En outre, son couvercle s'ouvre par le milieu comme des ailes de papillon afin de prendre moins de place sous un comptoir de cuisine bas. Comme d'autres articles de Simplehuman, cet objet a été développé en revenant au premier principe du design : comment rendre un produit existant plus performant.

This ingenious, award-winning waste bin has a rubber-coated lipped lid that looks like an inverted bowl, and allows it to be opened from any angle. This device also allows the lid to be balanced securely while its open, and only a small amount of pressure is needed to close it. When closed, the design has a sleek, minimalist aesthetic, which is unusual for a waste bin – usually one of the home's least glamorous objects yet something we all have to use every day.

Dieser raffinierte, preisgekrönte Abfall-eimer hat einen gummibeschichteten Metalldeckel, der aussieht wie eine umgedrehte Schüssel und sich von allen Seiten öffnen lässt. Durch diese Vorrich-tung balanciert der geöffnete Deckel auf der Kante und lässt sich mit einem Minimum an Druck wieder schließen. Geschlossen besitzt das Design eine schlanke, minimalistische Ästhetik – ungewöhnlich für einen Abfalleimer, der normalerweise zu den am wenigsten glamourösen Objekten im Haus gehört, aber trotzdem jeden Tag gebraucht wird.

Cette ingénieuse poubelle primée est équipée d'un couvercle caoutchouté qui ressemble à une coupe inversée et peut s'ouvrir de n'importe quel côté. Il tient seul bien en place une fois ouvert et se referme d'une simple pression légère. Fermée, la poubelle possède une esthétique épurée et minimaliste, ce qui est inhabituel pour ce type d'objet, l'un des moins distingués de la maison mais néanmoins d'usage quotidien.

Balance Act waste bin, 2006

Claus Jensen (Denmark, 1966–) & Henrik Holbæk (Denmark, 1960–)

www.evasolo.com
Stainless steel, rubber-coated metal
Edelstahl, gummibeschichtetes Metall
Acier inoxydable, métal caoutchouté
↕ 40 cm ⌀ 26.5 cm
Eva Solo, Maaloev, Denmark

In 1931, Holger Nielsen won a car in a raffle but, because he did not possess a licence, he decided to sell it to buy a lathe for turning metal instead. This marked the birth of his metalworking factory. A few years later, he began manufacturing this classic pedal bin, with its bold Art Deco styling and sturdy metal construction. Although designed some seventy years ago, it is still an excellent choice thanks its aesthetic and functional durability.

Holger Nielsen gewann 1931 bei einer Tombola ein Auto, aber da er keinen Führerschein hatte, verkaufte er es und kaufte sich von dem Geld eine Metall-drehbank. Dies war die Geburt seiner Metallwarenfabrik. Ein paar Jahre später begann er mit der Herstellung dieses klassischen Treteimers, der durch sein Art-Deco-Styling und seine robuste Metallkonstruktion überzeugt. Das Design ist zwar schon siebzig Jahre alt, aber dank seiner Ästhetik und zuverlässigen Funktionalität noch immer eine gute Wahl.

En 1931, Holger Nielsen remporta une automobile dans une tombola mais, n'ayant pas de permis, il la vendit pour s'acheter un tour pour travailler les métaux. C'est ainsi que naquit son atelier Vipp. Quelques années plus tard, il commença à fabriquer cette poubelle à pédale au style Art déco et à la construction robuste en métal. Bien que dessinée il y a soixante-dix ans, elle constitue toujours un excellent choix grâce à sa pérennité esthétique et fonctionnelle.

Vipp pedal bin, 1939
Holger Nielsen (Denmark, 1914–1992)

www.vipp.dk
Enamelled stainless steel
Emaillierter Edelstahl
Acier inoxydable émaillé
↕ 30, 52, 72 cm ⌀ 30 cm
Vipp, Copenhagen, Denmark

Pushboy waste bin, 1989

Egbert Neuhaus (Germany, 1953–)

www.wesco.de
Powder-coated sheet steel, stainless steel, plastic
Pulverbeschichtetes Stahlblech, Edelstahl, Plastik
Tôle d'acier poudrée, acier inoxydable, plastique
↕ 75.5 cm ⌀ 40 cm
M Westermann & Company, Arnsberg, Germany

For over 140 years, M Westermann & Company has produced metal homeware designs, including various innovative pedal bins. Launched in the late 1980s, however, the retro-styled *Pushboy* was essentially a re-design of an earlier American 'trash can' from the 1920s, and as such reflected the contemporary revival of interest in Americana. With its impressive fifty-litre capacity and its large input flap, the classic *Pushboy* is available in either stainless steel or fifteen different colours.

M Westermann & Company produziert seit über einhundertvierzig Jahren Haushaltswaren aus Metall, darunter verschiedene Treteimer. Der Ende der 1980er Jahre auf den Markt gebrachte *Pushboy* im Retro-Design ist jedoch eigentlich eine Neuauflage eines amerikanischen Abfalleimers aus den 1920er Jahren und spiegelte das damals neu erwachte Interesse an Americana wider. Der *Pushboy* hat ein beeindruckendes Fassungsvermögen von fünfzig Litern, eine große Einfüllklappe und ist entweder in Edelstahl oder in fünfzehn verschiedenen Farben erhältlich.

Depuis plus de cent quarante ans, M Westermann & Company produit des articles en métal pour la maison, dont différentes ingénieuses poubelles à pédale. Lancée à la fin des années 80, la *Pushboy* à l'allure rétro est en fait le re-design d'une *trash can* made in USA des années 20 et reflétait alors le regain d'intérêt pour le patrimoine esthétique américain. Avec son impressionnante capacité de cinquante litres et son grand clapet, ce classique du design existe en acier inoxydable ou en quinze couleurs différentes.

Other

Diverses

Accessoires de rangement

Tykho radio, 1997

Marc Berthier (France, 1935–)

www.lexon-design.com
Silicone rubber, various materials
Silikonbeschichtetes Gummi, verschiedenen Materialien
Gomme siliconée, matériaux divers
↕ 8 cm ↔ 14 cm ↗ 4 cm
Lexon, Boulogne, France

An instant success when first launched in the late 1990s, Marc Berthier's *Tykho* radio has an enchanting tactility thanks to being entirely encased in a silicone rubber shell. The synthetic housing also waterproofs this retro-Pop radio, so that you can use it in the shower or around a pool or even on the beach. Typical of Berthier's work, this radio is highly innovative in terms of function, with its rotating aerial also doubling up as a station tuner. The *Tykho* radio is available in red, blue, white, green and yellow.

Als es Ende der 1990er Jahre auf den Markt kam, war Marc Berthiers Radio *Tykho* sofort ein Erfolg. Das Gummigehäuse fühlt sich nicht nur gut an, sondern ist auch wasserdicht, so dass man dieses Retro-Pop-Radio auch unter der Dusche, am Schwimmbeckenrand oder am Strand einschalten kann. Wie alle Arbeiten von Berthier ist auch das *Tykho*-Radio funktional äußerst innovativ, denn über die drehbare Antenne lassen sich gleichzeitig die Sender einstellen. Das Design ist in Rot, Blau, Weiß, Grün und Gelb erhältlich.

Rencontrant un succès immédiat dès son lancement à la fin des années 90, la radio *Tykho* de Marc Berthier est très agréable au toucher grâce à son boîtier en gomme siliconée. Cet habillage la rend également étanche, si bien qu'on peut l'utiliser sous la douche, au bord de la piscine ou à la plage. Typique du travail de Berthier, cette radio « rétro Pop » possède des fonctions innovantes telle que son antenne qu'il suffit de tourner pour rechercher des fréquences. *Tykho* existe en rouge, bleu, blanc, vert et jaune.

Tykho table fan, 1998

Marc Berthier (France, 1935–)

www.lexon–design.com
ABS, PVC
ABS, PVC
ABS, PVC
⌀ 20 cm
Lexon, Boulogne, France

Throughout his long and productive design career, Marc Berthier has created highly innovative products whose playful, post-Pop sensibility lend them an engaging as well as distinctive character. His *Tykho* table fan, with its unusual design, is no exception and includes a two–speed motor operated from a control along its cable. The design is available with a choice of blue, purple, orange and green PVC blades.

In seiner langen und kreativen Laufbahn als Designer hat Marc Berthier stets innovative Produkte gestaltet, die durch ihr verspieltes, interessantes Post-Pop-Design etwas sehr Charakteristisches haben. Auch sein *Tykho*-Tischventilator besticht durch ein ungewöhnliches Design und ist mit einem zweistufigen Motor ausgestattet, der einfach am Bedienungsschalter eingestellt werden kann. Man bekommt ihn mit PVC-Flügeln in Blau, Violett, Orange oder Grün.

Tout au long de sa longue et productive carrière, le designer Marc Berthier a créé des objets très innovants possédant un côté ludique post-Pop qui leur confère une personnalité propre et attachante. Son ventilateur de table *Tykho*, avec son design original, ne fait pas exception. Il inclut un moteur à deux vitesses contrôlé par une commande située sur son fil d'alimentation. Il existe avec des pales en PVC bleues, violettes, orange et vertes.

Jasper Morrison likes to keep things simple; in fact, for him the simpler, the better. Throughout his prolific career, he has consistently designed 'ideal' products that are guided by function and stripped of any superfluous decoration. For instance, his classic *Bottle* wine rack, manufactured by Magis, is a highly practical and durable design. Easy and inexpensive to produce, it is an admirably efficient solution, with each stacking module holding six bottles.

Jasper Morrison mag es einfach – sein Grundsatz ist: je einfacher, desto besser. Während seiner ganzen, überaus produktiven Karriere hat er stets „ideale" Entwürfe ohne überflüssigen Schmuck kreiert, bei denen die Funktion im Vordergrund steht. So ist sein klassisches Weinregal *Bottle*, hergestellt von Magis, nicht nur praktisch sondern auch äußerst langlebig. Das Regalmodul fasst sechs Flaschen, ist einfach und kostengünstig zu produzieren und dabei bewundernswert effizient.

Jasper Morrison aime les choses simples. D'ailleurs selon lui, plus c'est simple, mieux c'est ! Durant son impressionnante carrière, il a conçu des produits proches de la perfection, guidés par la fonction et dépouillés de décorations superflues. Par exemple, son porte-bouteilles empilable fabriqué par Magis est une création fonctionnelle et durable. Facile et peu coûteux à produire, c'est une solution admirablement efficace. Chaque module empilable contient six bouteilles.

Bottle stacking wine rack, 1994

Jasper Morrison (UK, 1959–)

www.magisdesign.com
Injection-moulded polypropylene, aluminium
Spritzgegossenes Polypropylen, Aluminium
Polypropylène moulé par injection, aluminium
↕ 25 cm ↔ 36 cm ↗ 22 cm
Magis, Motta di Livenza, Italy

WR–101 wine rack, 1966

Saito Wood Design Team

www.saito-wood.com
Abachi, kalopanax or walnut laminate
Abachi-, Kalopanax- oder Walnusslaminat
Abachi, kalopanax ou noyer laminé
↕ 38 cm ↔ 33.5 cm ↗ 18 cm
Saito Wood, Shizuoka City, Japan

This beautiful wine rack is made from six identical, wave-like pieces of moulded plywood that are fixed together using only two metal rods. The simple yet aesthetically refined result is both highly practical and extremely pleasing to the eye. Like other plywood designs manufactured by Saito Wood, the *WR-101* wine rack also exemplifies the extraordinary level of craftsmanship that can still be found in Japan today.

Dieses elegante Weinregal ist aus sechs identisch gebogenen Schichtholzplatten gefertigt, die nur durch zwei Metallstäbe aneinander befestigt sind. Das einfache und zugleich ästhetisch anspruchsvolle Ergebnis ist nicht nur ziemlich praktisch, sondern sieht auch sehr geschmackvoll aus. Wie auch andere Kreationen aus dem Hause Saito Wood ist das Weinregal *WR-101* beispielhaft für das auch heute noch außergewöhnlich hohe Niveau japanischer Handwerkskunst.

Ce magnifique porte-bouteilles est constitué de six compartiments en contre-plaqué modelé, en forme de vague, reliés simplement par deux tiges métalliques. Le résultat, à la fois simple mais très raffiné, est aussi fonctionnel que beau. Comme d'autres créations en contreplaqué réalisées par Saito Wood, le porte-bouteilles *WR-101* illustre la qualité de l'artisanat que l'on trouve de nos jours au Japon.

Donkey 3 book storage unit, 2003

Shin Azumi (Japan, 1965–) & Tomoko Azumi (Japan, 1966–)

www.isokonplus.com
Birch
Birke
Bouleau
↕ 41 cm ↔ 60 cm ↗ 35 cm
Isokon Plus, London, UK

During the 1930s, the Isokon Furniture Company was at the forefront of British Modernism producing furniture by, among others, Marcel Breuer – including his *Penguin Donkey*, which was specifically designed to store the popular paperbacks. In 1963, Ernest Race redesigned this useful book storage unit and, more recently, Shin and Tomoko Azumi have created a 21st century version of this British classic.

Die Isokon Furniture Company, in den 1930er Jahren eine der Vorreiter der britischen Moderne, setzte unter anderem Entwürfen von Marcel Breuer um, darunter auch sein speziell für die damals beliebten Taschenbücher entworfenes Regal *Penguin Donkey*. Schon 1963 erlebte *Penguin Donkey* durch Ernest Race eine Reedition, und mit *Donkey 3* haben Shin und Tomoko Azumi kürzlich eine Version dieses britischen Designklassikers für das 21. Jahrhundert vorgelegt.

Durant les années 30, la société Isokon Furniture était à la pointe du modernisme britannique et s'est notamment spécialisée dans la production de meubles tels que le *Penguin Donkey* de Marcel Breuer, conçu pour ranger les livres de poche. En 1963, Ernest Race revisite cette petite bibliothèque, à l'instar de Shin et Tomoko Azumi qui offrent une nouvelle version très contemporaine de ce classique britannique.

Eric Pfeiffer likes to focus his efforts on 'the design of everyday objects in our lives'. He prefers simplicity to complexity and, as a result, his furniture designs have a strong reductive quality. This not only gives them a purist aesthetic, but also makes them easy to manufacture. His *W* magazine stand is no exception, and can be seen as an intelligent and stylish solution to the problem of storing magazines.

Eric Pfeiffer konzentriert sich auf „das Design von Alltagsobjekten in unserem Leben". Er bevorzugt Einfachheit statt Komplexität, und so besitzen seine Möbel etwas sehr Reduziertes, erhalten einerseits eine puristische Ästhetik und sind andererseits einfach anzufertigen. Sein *W*-Zeitungsständer ist da keine Ausnahme, eine intelligente und elegante Lösung des Problems der Aufbewahrung von Zeitungen und Zeitschriften.

Eric Pfeiffer concentre ses efforts sur « le design des objets de la vie quotidienne ». Préférant la simplicité à la complexité, ses meubles ont un style épuré, voire minimaliste, résultat d'une esthétique pure et facile à réaliser. Son porte-revues *W* vintage ne déroge pas à la règle, et peut être interprété comme une solution intelligente et chic pour entreposer des magazines.

W magazine stand, 2000
Eric Pfeiffer (USA, 1969–)

www.offi.com
Walnut, birch or oak veneer, moulded plywood
Formverleimtes Schichtholz mit Walnuss-, Birke- oder Eichefurnier
Contreplaqué moulé de noyer, bouleau ou chêne plaqué
↕ 41 cm ↔ 38 cm ↗ 33 cm
Offi & Company, Tiburon (CA), USA

DNA CD rack, 2003
Kaichiro Yamada (Japan, 1973–)

www.idea-in.com
ABS
ABS
ABS
↕ 30.8 cm ↔ 21 cm ⤢ 21 cm
IDEA International, Tokyo, Japan

Inspired by the DNA double helix, this eye-catching product by Kaichiro Yamada offers, quite literally, a new twist on the design of the CD holder. It comes in two different heights and a choice of four colours: white, red, yellow and blue. Interestingly, its spiralling structure breaks up the visual mass of a stack of CDs and gives a relatively mundane object an appealing sculptural form.

Die DNA-Doppelhelix lieferte die Anregung für dieses ausgefallene Design von Kaichiro Yamada, das buchstäblich eine überraschende Wendung in der Produktsparte CD-Regale darstellt. Es wird in zwei Höhen und vier Farben (Weiß, Rot, Gelb, Blau) angeboten. Die Spiralform bricht den CD-Stapel optisch auf und verleiht einem alltäglichen Funktionsmöbel die Anmutung einer interessanten Skulptur.

Inspiré par la double hélice de l'ADN et créé par Kaichiro Yamada, ce produit original offre littéralement une nouvelle tournure au design du porte-CD. Sa structure en spirale rompt la masse visuelle d'une pile de CD classique, révélant une forme sculpturale absolument irrésistible. DNA existe en deux hauteurs et en quatre couleurs : blanc, rouge, jaune et bleu. Un design inédit, à la fois esthétique et fonctionnel.

Data Base media holder, 2003

Claus Jensen (Denmark, 1966–) & Henrik Holbæk (Denmark, 1960–)

www.evasolo.com
Corrugated aluminium, sheet aluminium
Aluminiumwellblech, Aluminiumblech
Tôle d'aluminium ondulée
Eva Solo, Maaloev, Denmark

Winning a prestigious Red Dot award in 2003, the *Data Base* media holder is an innovative solution both in terms of material usage and function. Strong yet light, it is made from a piece of corrugated aluminium that provides a non-slip base, and two moveable sheet metal ends that support the DVDs or CDs being stored. Like all products that meet the criteria of 'Good Design', the *Data Base* is derived from a simple idea that is extremely effective.

Der *Data Base*-Ständer für DVDs oder CDS wurde 2003 mit dem renommierten Red Dot Award ausgezeichnet und stellt im Hinblick auf den Materialeinsatz wie auch auf die Funktion eine innovative Lösung dar. Er besteht aus einer Aluminiumwell-blechplatte mit rutschfester Unterseite und zwei verschiebbaren Blechstützen an beiden Enden. Wie alle Produkte, die den Kriterien des „guten Designs" entsprechen, ist der äußerst zweckmäßige *Data Base* das Ergebnis einer einfachen Entwurfsidee.

Ce classeur de DVD/CD, lauréat du prestigieux prix Red Dot en 2003, offre une solution innovante sur le plan de la fonction et de la manipulation. Robuste mais léger, il est constitué d'une tôle d'aluminium ondulée qui empêche les disques de glisser et de deux languettes métalliques amovibles qui les sou-tiennent. Comme tous les produits satis-faisant aux critères de « Bon design », *Data Base* découle d'une idée simple mais extrêmement efficace.

Convenient and portable, the *Candela Guardian* is a highly innovative nightlight that is not only ideal for making nocturnal trips to the kitchen, bathroom or baby's room, but also doubles up as a useful emergency light, automatically switching itself on if there is a power cut. Unlike other nightlights, its long-lasting LED bulbs and rechargeable lithium ion battery mean that it requires very little maintenance. It is also cool to the touch and, impressively, a full charge lasts up to eight hours.

Beim *Candela Guardian* handelt es sich um ein innovatives und praktisches Steckdosennachtlicht, das man mitnehmen kann, wenn man nachts die Küche, das Bad oder das Kinderzimmer aufsuchen möchte, ohne überall Licht zu machen. Außerdem macht es sich als Notfalllampe nützlich, die sich bei einem Stromausfall automatisch einschaltet. Anders als andere Nachtlichter ist *Candela Guardian* mit einem langlebigen LED-Leuchtmittel und einer wieder aufladbaren Lithiumbatterie ausgestattet und daher äußerst pflegeleicht. Außerdem fühlt es sich kühl an und eine Batterieladung reicht für bis zu acht Stunden Leuchtdauer.

Pratique et mobile, la veilleuse *Candela* reste des plus novatrices. Idéale pour se rendre la nuit dans la cuisine, la salle de bains ou dans la chambre des enfants, elle s'emploie comme lampe de secours et s'allume automatiquement lors d'une coupure de courant. Elle est équipée d'ampoules longue durée de type LED et d'une batterie au lithium rechargeable. Son entretien est réduit au minimum. Froide au toucher, cette veilleuse fonctionne huit heures d'affilée avant d'être rechargée.

Candela Guardian nightlight, 2004–2007

Duane Smith (Canada, 1972–) & Stéfane Barbeau (Canada, 1971–)

www.oxo.com
ABS, LEDS, lithium ion battery, other materials
ABS, LED-Leuchtdioden, Lithiumionenbatterie, andere Materialien
ABS, LED, batterie en lithium, matériaux divers
↕ 21.3 cm
OXO International, New York City (NY), USA/Vessel, Boston (MA), USA

Mandu clothes valet, 1932

Eckart Muthesius (Germany, 1904–1989)

www.classicon.com
Chromium-plated tubular steel
Verchromtes Stahlrohr
Acier tubulaire chromé
↕ 109 cm ↔ 41 cm ↗ 38 cm
Classicon, Cologne, Germany

The son of Hermann Muthesius, the great German design reformer who founded the Deutscher Werkbund, Eckart Muthesius synthesised the functionalism of Modernism with the sculptural geometry of the Art Deco style to create furnishings that were both stylish and practical. The *Mandu* clothes valet is made of chromed tubular steel, and was originally designed for the Maharajah of Indore.

Eckart Muthesius – Sohn des berühmten Architekten und Mitbegründers des Deutschen Werkbunds Hermann Muthesius – schuf stilvolle und zugleich zweckmäßige Einrichtungsgegenstände, in denen er die Neue Sachlichkeit der Architekturmoderne mit der skulpturalen Geometrie des Jugendstils verband. Den stummen Diener *Mandu* aus verchromtem Stahlrohr entwarf er für den Palast des Maharadschas von Indore.

Grand réformateur du design allemand, le fils d'Hermann Muthesius, Eckart Muthesius fonda la Deutscher Werkbund. Son ambition est de synthétiser le fonctionnalisme du Modernisme à travers la géométrie sculpturale du style Art déco, et de créer ainsi des meubles à la fois pratiques et élégants. Le chevalet vêtement *Mandu* en acier tubulaire chromé fut initialement conçu pour le Maharaja d'Indore.

The *Flux* is a simple, affordable, yet highly ingenious design solution with brilliant functional flexibility; it grips all types of flooring, and can be used to wedge open windows and stop doors from slamming shut. Suitable for both indoor and outdoor use, this comma-shaped device is made of weather-resistant durable rubber and fits snugly into gaps between 1 cm and 9 cm. It also comes in a range of different colours.

Der *Flux* ist eine einfache, erschwingliche und doch geniale Designlösung von überzeugender funktionaler Flexibilität. Er ist griffig auf allen Oberflächen, fixiert Fenster und verhindert, dass Türen zuschlagen. Der für den Innen- und Außenbereich geeignete Stopper aus wasserfestem Vollgummi sieht aus wie ein Komma und passt mühelos in Spalten von einem bis neun Zentimetern Breite. Zudem ist er in vielen verschiedenen Farben erhältlich.

Flux illustre un design simple, bon marché et pourtant très ingénieux. Idéal pour caler les fenêtres ou bloquer les portes afin d'éviter qu'elles claquent, cette création s'adapte à tous les revêtements de sol. À l'intérieur comme à l'extérieur, ce dispositif en caoutchouc s'apparente à une virgule et résiste aux intempéries. S'intègre parfaitement dans les écarts de un et neuf centimètres. Existe dans une importante gamme de couleurs.

Flux door/window stopper, 2002

Frank Meyer (Germany, 1971–)

www.fensterstopper.de
Rubber
Gummi
Caoutchouc
↕ 10 cm
Extrasign, Bad Dürkheim, Germany

Th 25i thermometer, 2006

Hauke Murken (Germany, 1963–) & Sven Hansen (Germany, 1969–)

www.mawa–design.de
Silver-anodized aluminium, glass
Silber-eloxiertes Aluminium, Glas
Aluminium anodisé et argenté, verre
↕ 6 cm
Mawa Design, Potsdam, Germany

Suitable for both indoor and outdoor use, this centigrade thermometer, with its sleekly engineered form and easy-to-read layout, exemplifies the rational methodology of its creators: the Berlin-based design duo, Hauke Murken and Sven Hansen. This quintessentially German design is also available in a bronzed finish.

Das für den Innen- und Außenbereich geeignete, schlanke und leicht abzulesende Thermometer veranschaulicht die rationale Methodik seiner Schöpfer: das in Berlin ansässige Designer-Duo Hauke Murken und Sven Hansen. Dieses typisch deutsche Design ist auch mit einem bronzierten Finish erhältlich.

Convenant à l'intérieur comme à l'extérieur, ce thermomètre centigrade à la forme dépouillée et à la lecture facile illustre la méthodologie rationnelle de ses créateurs : le duo basé à Berlin Hauke Murken et Sven Hansen. Ce design typiquement allemand existe également avec une finition bronze.

Danish industrial designer, Jacob Jensen came to prominence with his sleek designs for Bang & Olufsen during the 1960s and 1970s. In the early 1990s, he founded his own manufacturing company to produce his distinctive designs for the home, including his well-known modular *Weather Station* range, with its logical user interface. The *Combination 1*, shown here, comprises an alarm clock, a hygrometer as well as indoor and outdoor thermometers.

Der dänische Industriedesigner Jacob Jensen wurde in den 1960er und 1970er Jahren vor allem wegen seiner eleganten und schlanken Designs für Bang & Olufsen bekannt. Anfang der 1990er Jahre gründete er sein eigenes Unternehmen, um ausgefallene Designs für zu Hause herzustellen, darunter auch seine bekannten Wetterstationen mit ihrer logischen Benutzeroberfläche. Die hier abgebildete *Combination 1* besteht aus Wecker, Hygrometer sowie Innen- und Außenthermometern.

Designer industriel suédois, Jacob Jensen s'est fait connaître avec ses créations épurées pour Bang & Olufsen dans les années 60 et 70. Au début des années 90, il a créé sa propre société afin de produire ses objets caractéristiques pour la maison, dont sa célèbre gamme modulaire *Weather Station* à l'interface utilisateur logique. *Combination 1* (montrée ici), comprend un réveil, un hygromètre et des thermomètres intérieurs et extérieurs.

Combination 1 Weather Station alarm clock, hygrometer, indoor & outdoor thermometers, 1994–1999

Jacob Jensen (Denmark, 1926–)

www.jacobjensen.com
Plastic, metal
Kunststoff, Metall
Plastique, métal
↕ 16 cm ↔ 14 cm
Jacob Jensen, Brædstrup, Denmark

Radio-controlled alarm clock, 2007

Jacob Jensen (Denmark 1926–)

www.jacobjensen.com
Thermoplastic, various materials
Thermoplastik, verschiedene Materialien
Thermoplastique, matériaux divers
↕ 6 cm ↔ 14 cm
Jacob Jensen, Brædstrup, Denmark

Part of Jacob Jensen's stylish *Weather Station* range, this radio-controlled alarm clock is a real winner, and the authors' design of choice for wake-up calls. Easy to programme, and with good readability, this twenty-four-hour clock has an excellent alarm, a built-in light and a snooze option. It is a robust yet elegant design and, most importantly, it possesses an alarm that just cannot be ignored.

Dieser Funkwecker gehört zu Jacob Jensens eleganter *Weather Station* und ist eine echte Bereicherung. Er ist mit Jensens bevorzugtem Signalton ausgestattet und zeigt die Zeit im 24-Stunden-Format an. Leicht zu programmieren und abzulesen, bietet der Wecker neben einer Displaybeleuchtung auch eine Schlummertaste. Das robuste und dennoch elegante Design verfügt über einen ansteigenden Signalton, der einfach nicht überhört werden kann.

Ce réveil au design chic et épuré fait partie de la gamme *Weather Station* créée par Jacob Jensen. Facile à programmer et offrant une bonne lisibilité, ce réveil possède une alarme performante, une lumière intégrée et une fonction « snooze ». Il s'agit d'une conception à la fois robuste et élégante. Petit plus, ce réveil dispose d'un régulateur progressif du volume de l'alarme.

From the mid-1950s to the mid-1990s, the Braun design team, under the legendary guidance of its director Dieter Rams, articulated a highly distinctive formal language resulting in a range of electronic products with striking visual clarity. Although technological obsolescence has meant that most of these seminal designs have fallen out of production, the *AB 5* quartz alarm clock is still in manufacture, and is a classic and affordable example of the aesthetic and functional excellence of Braun design.

Mitte der 1950er bis Mitte der 1990er Jahre entwickelte das Designteam von Braun unter der Leitung des legendären Chefdesigner Dieter Rams eine unverwechselbare Formensprache, die zu einer Reihe von Elektrogeräten von verblüffender visueller Klarheit führte. Die meisten dieser wegweisenden Designs sind technisch überholt und werden nicht mehr produziert, aber dies trifft nicht auf den *AB 5* Quarz-Wecker zu. Er gilt noch immer als klassisches und bezahlbares Beispiel für die Ästhetik und funktionale Vollendung des Designs von Braun.

Des années 50 aux années 90, le célèbre directeur de l'équipe de design de Braun, Dieter Rams prône un design novateur, esthétique, fonctionnel, durable et fidèle à l'ère électronique. Selon Rams, la finalité du design ne doit pas privilégier la forme, mais bien la fonction de l'objet. Malgré l'obsolescence technologique qui a entraîné le retrait de plusieurs créations, le réveil *AB 5* continue d'être fabriqué, exemple classique de l'excellence du design de Braun.

AB5 alarm clock, 1993
Dietrich Lubs (Germany, 1938–)

www.braun.com
Thermoplastic, quartz movement
Thermoplastik, Quarz-Uhrwerk
Thermoplastique, mouvement à quartz
∅ 6.7 cm
Braun, Kronberg, Germany

Static table clock, 1959
Richard Sapper (Germany, 1932–)

www.lorenz.it
Steel, acrylic
Stahl, Acryl
Acier, acrylique
↕ 7.5 cm ↔ 6.3 cm ⤢ 10 cm
Lorenz, Novegro di Segrate, Italy

Still in production fifty years after it was first designed, Richard Sapper's *Static* table clock is a design classic that is as cool as it is useful. The design was Sapper's first independent project, and it subsequently launched his career as one of the world's foremost industrial designers. When it was introduced, the *Static* clock with its protruding dial was considered absolutely revolutionary, and as such won a prestigious Compasso d'Oro award in 1960.

Richard Sappers *Static* Tischuhr ist ein ebenso cooler wie nützlicher Design-Klassiker, der inzwischen schon seit fünfzig Jahren produziert wird. *Static* war Sappers erstes unabhängiges Projekt und der Beginn seiner Karriere als einer der weltweit führenden Industriedesigner. Bei ihrer ersten Präsentation galt die Tischuhr mit ihrem vorstehenden Zifferblatt als revolutionär und wurde 1960 mit dem angesehenen Compasso d'Oro ausgezeichnet.

Fabriquée depuis plus de cinquante ans, l'horloge de table *Static* offre un design classique à la fois décontracté et efficace. Récompensée par le célèbre Compasso d'Oro en 1960, *Static* n'a jamais été égalée. Fonctionnelle et originale, cette horloge a fait sensation lors de son lancement. Elle représente le premier projet de Richard Sapper, devenu depuis l'un des plus grands designers industriels.

Spindle wall clock, 1957 & Asterisk wall clock, 1950

George Nelson (USA, 1907–1986)

www.vitra.com
Walnut, aluminium, quartz mechanism/lacquered wood, metal, quartz mechanism
Walnuss, Aluminium, Quarz-Uhrwerk/lackiertes Holz, Metall, Quarz-Uhrwerk
Noyer, aluminium, mouvement à quartz/bois laqué, métal
∅ 57.7, 25 cm
Vitra, Weil am Rhein, Germany

Sculptural and playful, George Nelson's wall clocks reflect the optimistic *zeitgeist* of 1950s America. With their strong graphic outlines, the *Asterisk* and *Spindle* have also become much-loved and iconic symbols of Mid-Century Modernism, while nonetheless winning admiration for their quirky charm. Initially manufactured by the Howard Miller Clock Company, these striking timepieces are now faithfully reissued under licence by Vitra Collections.

George Nelsons skulpturale und verspiele Wanduhren verkörpern den optimistischen Zeitgeist des Amerika der 1950er Jahre. Wegen ihrer ausgeprägten grafischen Form sind *Asterisk* und *Spindle* zu überaus beliebten und ikonischen Symbolen der Moderne dieser Zeit geworden und werden wegen ihres eigenwilligen Charmes bewundert. Ursprünglich von der Howard Miller Clock Company hergestellt, werden diese markanten Zeitmesser heute von Vitra Collections in Lizenz originalgetreu neu aufgelegt.

Sculpturales et originales, les horloges de George Nelson incarnent l'esprit américain des années 50. Véritables icônes du modernisme de cette époque, les formes de l'*Asterisk* et du *Spindle* offrent une alternative originale aux traditionnels objets de mesure du temps. Initialement fabriqués par la société Howard Miller Clock, elles sont désormais rééditées sous licence par Vitra Collections.

Sunflower wall clock, 1958
& Ball wall clock, 1950

George Nelson (USA, 1907–1986)

www.vitra.com
Birch, lacquered wood, metal, quartz
mechanism/lacquered wood, metal,
quartz mechanism
Birke, lackiertes Holz, Metall, Quarz-
Uhrwerk/lackiertes Holz, Metall, Quarz-
Uhrwerk
Bouleau, bois laqué, métal, mouvement
à quartz/bois laqué, métal
⌀ 75, 33 cm
Vitra, Weil am Rhein, Germany

With its atomic-like structure, the *Ball* clock was an overnight bestseller. As Nelson himself remembered, it was rapidly selected by 'Mrs America...[as] *the* clock to put in your kitchen', and its space-age connotations certainly suggested a new and more optimistic future. The eye-catching *Sunflower*, however, has a strong sense of visual freshness and sunny charm that remains as endearing today as when it was first launched over sixty years ago.

Die *Ball*-Uhr, deren Struktur an Atome denken lässt, wurde über Nacht zum Bestseller. Nelson selbst erinnerte sich, dass sie schon bald von „der amerikanischen Hausfrau... [als] *die* Uhr für die Küche" ausgesucht wurde, und mit ihren Anklängen an das Weltraumzeitalter suggerierte sie damals sicherlich eine optimistischere Zukunft. Die auffällige *Sunflower* hingegen überzeugt durch visuelle Frische und einen sonnigen Charme, der heute noch so ansprechend ist wie vor über sechzig Jahren.

L'horloge *Ball* connut un succès immédiat grâce à sa structure « atomique ». Nelson lui-même se souvient que cette création a été rapidement élue par « Mme Amérique [...] comme étant l'horloge idéale pour la cuisine ». Ses connotations futuristes suggèrent une pointe d'optimisme. *Sunflower* offre un design raffiné à l'esthétique attrayante. Créée il y a plus de soixante ans, cette superbe horloge a gardé tout son charme et demeure un grand classique.

Night desk clock, 1948

George Nelson (USA, 1907–1986)

www.vitra.com
Lacquered wood, metal, brass, acrylic
Lackiertes Holz, Metall, Messing, Acryl
Bois laqué, métal, laiton, acrylique
↕ 14.8 cm ↔ 10.7 cm ↗ 10 cm
Vitra, Weil am Rhein, Germany

Looking as though it has escaped from 'The Jetsons', George Nelson's sculptural *Night* desk clock encapsulates the now endearingly retro sci-fi spirit of the postwar period. Originally produced by the Howard Miller Clock Company, this classic timekeeper has now been scrupulously reproduced by Vitra, so you too can own a piece of space-race Modernism.

George Nelsons skulpturale *Night*-Tisch-uhr sieht aus, als stamme sie aus der Zeichentrickserie *Die Jetsons* und verkör-pert auf gewinnende Art den Science-Fiction-Geist der Nachkriegszeit. Dieser klassische, ursprünglich von der Howard Miller Clock Company produzierte Zeit-messer wird jetzt originalgetreu von Vitra neu aufgelegt, und so ist wieder ein Stück der Moderne aus der Zeit des Wettlaufs ins All erhältlich.

L'horloge *Night* de George Nelson illustre parfaitement l'esprit rétro futuriste d'après-guerre : un design simple et efficace. Conçu initialement par la société Howard Miller Clock, ce classique est de nouveau fabriqué par Vitra. Pourquoi donc se priver d'autant de moderniste inspiré par la conquête de l'espace…

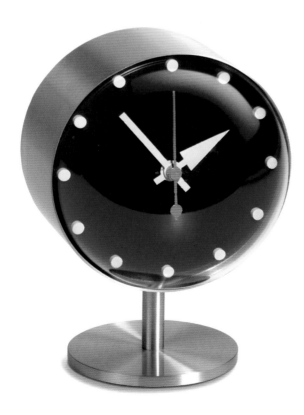

Diamond desk clock, 1947

George Nelson (USA, 1907–1986)

www.vitra.com
Lacquered wood, metal
Lackiertes Holz, Metall
Bois laqué, métal
↕ 17 cm ↔ 25.5 cm ⤢ 14 cm
Vitra, Weil am Rhein, Germany

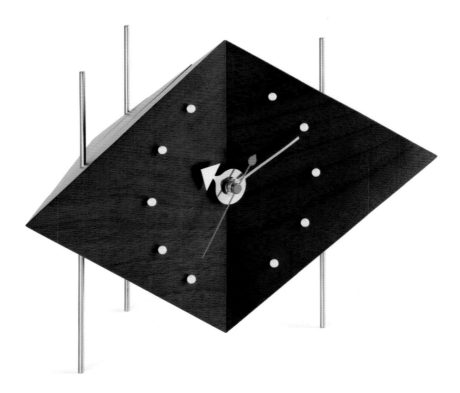

Even today, the *Diamond* desk clock seems fresh and iconoclastic when compared with more contemporary models on the market. George Nelson's work had a strong graphic quality that gave it a highly distinctive look, and which profoundly influenced the subsequent generation of designers in the 1960s. Significantly, he demonstrated that it was possible to design 'outside the box' while creating functional products with a stylish and characterful presence.

Verglichen mit zeitgenössischen Modellen wirkt die *Diamond*-Tischuhr auch heute noch sehr modern und ikonoklastisch. George Nelsons Arbeiten besitzen eine ausgeprägte grafische Qualität, die ihnen ein unverkennbares Äußeres verlieh und in den 1960er Jahren großen Einfluss auf nachfolgende Generationen von Designern hatte. Vor allem zeigte Nelson, dass es möglich war, unkonventionelle, aber trotzdem funktionale Produkte mit einer stilvollen und ausdrucksstarken Präsenz zu entwerfen.

Aujourd'hui encore, l'horloge *Diamond* reste iconoclaste comparée aux modèles contemporains que l'on trouve sur le marché. L'œuvre de George Nelson propose une indéniable qualité graphique, révélant ainsi un design original et distinctif. Son travail innovant influença d+ailleurs la génération de designers des années 60. Cette création illustre à la perfection l'ambition de Nelson : créer des produits à la fois fonctionnels, stylés et de caractère.

Two-Timer wall clock, 2008

Industrial Facility/Sam Hecht (UK, 1969–) & Kim Colin (USA, 1961–)

www.establishedandsons.com
Lacquered steel, glass, two quartz movements
Lackierter Stahl, Glas, zwei Quarz-Uhrwerke
Acier laqué, verre, deux mouvements à quartz
Ø 30, 60 cm
Established & Sons, London, UK

One of the defining characteristics of modern life is mass mobility, with huge numbers of people visiting, travelling and working around the globe. As Sam Hecht observes, 'It's as if everyone these days has come from or is going to somewhere else…*Two-Timer* is a useful expression to this modern phenomenon merging two different time zones into one clock'. By incorporating two dials into one clock face, the design symbolizes the idea of a united world.

Eines der charakteristischen Merkmale des modernen Lebens ist Mobilität, Massen von Menschen rund um den Globus, die sich irgendwohin fortbewegen. Sam Hecht bemerkt dazu: „Als ob heutzutage jeder von irgendwoher kommt oder irgendwohin geht… *Two-Timer* ist ein zweckmäßiger Ausdruck dieses modernen Phänomens und vereint zwei verschiedene Zeitzonen in einer Uhr." Durch die beiden Ziffernblätter symbolisiert das Design die Idee einer vereinten Welt.

L'une des principales caractéristiques de la vie contemporaine est la mobilité de masse. Surprenante par ses formes « liquides », *Two-Timer* vous permet de savoir en un coup d'œil l'heure qu'il est dans un autre pays. Cette horloge murale est munie de deux cadrans qui affichent simultanément deux fuseaux horaires, le principal sur le grand et le second sur le petit. Le concept de ce modèle symbolise l'image d'un monde moderne et uni.

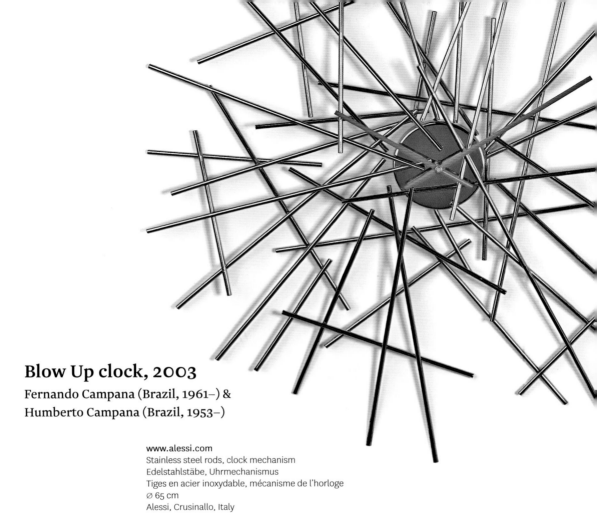

Blow Up clock, 2003

Fernando Campana (Brazil, 1961–) &
Humberto Campana (Brazil, 1953–)

www.alessi.com
Stainless steel rods, clock mechanism
Edelstahlstäbe, Uhrmechanismus
Tiges en acier inoxydable, mécanisme de l'horloge
⌀ 65 cm
Alessi, Crusinallo, Italy

Designed by the engaging Campana brothers from Brazil, whose playful work has redefined the parameters of contemporary design in recent years, this clock is part of their well-known *Blow Up* series. This includes a variety of furniture executed from seemingly randomly welded stainless steel rods. Inspired by the criss-crossing of urban pylons, and informed by their observation of artisans working with bamboo, this clock (like so many of their designs) fuses industrial processes with traditional craft skills in order to create something poetic and beautiful.

Die sympathischen, aus Brasilien stammenden Campana-Brüder, deren verspielte Arbeiten die Parameter des zeitgenössischen Designs der letzten Jahre neu definiert haben, entwarfen diese Wanduhr als Teil ihrer bekannten *Blow Up*-Serie. Dazu gehört eine Vielzahl von Möbeln, die aus scheinbar willkürlich zusammengeschweißten Edelstahlstäben gefertigt sind. Inspiriert von den sich kreuzenden Masten und Pfeilern im urbanen Raum sowie von Kunsthandwerkern, die mit Bambus arbeiten, verschmelzen bei dieser Wanduhr (wie bei so vielen ihrer Designs) industrielle Prozesse mit traditionellen handwerklichen Fertigkeiten und es entsteht etwas Poetisches und Schönes.

La famille *Blow Up* s'agrandit avec cette magnifique horloge murale conçue par les frères Campana. Ces deux créateurs brésiliens ont su insuffler avec succès un vent de fraîcheur au design de l'art ménager. Leur modalité de conception fait allusion aux formes de recyclage en alliant la poésie aux données fonctionnelles. La collection *Blow Up* émerge de l'idée d'assembler d'hypothétiques bouts de fils d'acier en les soudant entre eux. Il s'agit également d'une interprétation technologique de l'ancienne technique de tressage des Indiens brésiliens. Cette horloge design rappelle également le jeu du mikado.

City Hall clock, 1956

Arne Jacobsen (Denmark, 1902–1971)

www.rosendahl.com
Aluminium, glass
Aluminium, Glas
Aluminium, verre
⌀ 16, 21, 29, 48 cm
Rosendahl, Hørsholm, Denmark

ARNE JACOBSEN

Arne Jacobsen initially designed the *City Hall* clock for Rødovre Town Hall, a veritable architectural masterpiece of International Modernism. Echoing the characteristics of the building, the clock tends towards abstraction and schematic regularity with its use of strips and dots rather than numerals. Originally produced by Louis Poulsen, this well-designed clock is very easy to read, even from a long distance, and encapsulates the aesthetic and functional refinement of Danish Modernism.

City Hall wurde 1956 für das Rathaus von Rødrove entworfen, das als echtes architektonisches Meisterwerk der internationalen Moderne gilt. Die Uhr greift die Merkmale des Gebäudes auf und besitzt durch die Verwendung von Streifen und Punkten statt Ziffern etwas Abstraktes und eine schematisch Regelmäßigkeit. Die zu Anfang von Louis Poulsen hergestellte Uhr ist auch aus großer Entfernung sehr einfach abzulesen und steht für die ästhetische und funktionale Vollendung der dänischen Moderne.

Arne Jacobsen conçut initialement l'horloge *City Hall* pour la mairie de Rødovre, véritable chef-d'œuvre architectural du modernisme international. Faisant écho aux caractéristiques de l'édifice, cette création se fond dans son environnement. Abstrait et régulier, ce cadran, devenu presque institutionnel avec ses bandes et ses petits cercles, facilite la lecture de l'heure, même à distance. Cette horloge illustre parfaitement le modernisme danois, à la fois esthétique et fonctionnel.

Banker's Clock, 1971

Arne Jacobsen (Denmark, 1902–1971)

www.rosendahl.com
Aluminium, glass
Aluminium, Glas
Aluminium, verre
⌀ 16, 21, 29, 48 cm
Rosendahl, Hørsholm, Denmark

Arne Jacobsen originally designed this striking and Minimalist wall clock in the early 1970s for the starkly Modernist, cuboid headquarters building of the National Bank of Denmark in Copenhagen – hence its name. The elegant spiral of dots on its dial that mark the hours helps to emphasize the passage of time while simultaneously giving the design a very distinctive graphic quality.

Arne Jacobsen entwarf diese auffällige, minimalistische Wanduhr zu Beginn der 1970er Jahre ursprünglich für das ausgeprägt moderne, quaderförmige Gebäude der Dänischen Nationalbank in Kopenhagen – daher der Name. Die elegante Spirale aus Punkten auf dem Ziffernblatt, die die Stunden anzeigen, veranschaulicht das Verstreichen der Zeit und verleiht dem Design gleichzeitig eine ausgesprochen grafische Qualität.

Créée par Arne Jacobsen au début des années 70 pour le siège social de la Banque nationale du Danemark à Copenhague (d'où son nom), cette horloge murale offre un design épuré, voire minimaliste. L'élégante spirale à points de son cadran souligne l'écoulement du temps tout en offrant un design d'une grande qualité graphique.

Model No. 367/6046 wall clock & Model No. 367/6047 wall clock, 1956–1957

Max Bill (Germany, 1908–1994)

www.junghans.de
Ground and polished aluminium, mineral glass, quartz or radio-controlled movement
Geschliffenes und poliertes Aluminium, Mineralglas, Quarz- oder Funkuhrwerk
Aluminium poli, verre minéral, quartz ou radiopiloté
Ø 20, 30 cm
Ø 20, 30 cm
Junghans, Schramberg, Germany

Having studied at the Bauhaus in Dessau, Max Bill became in the early 1950s the first director of the Hochschule für Gestaltung in Ulm, Germany, an influential teaching institution that is remembered for its systematic and functionalist approach to design. Max Bill's wall clocks for Junghans not only beautifully exemplify the tenets promoted by the school with their perfect mathematical proportions and exquisitely engineered casings, but also reflect Bill's fascination with the subject of time.

Nach seinem Studium am Bauhaus in Dessau war Max Bill Anfang der 1950er Jahre der erste Rektor der einflussreichen Hochschule für Gestaltung in Ulm, die für ihren systematischen und funktionalistischen Designansatz bekannt war. Die perfekten mathematischen Proportionen und die hervorragend konstruierten Gehäuse seiner Wanduhren für Junghans veranschaulichen nicht nur sehr schön die Grundsätze der Schule, sie spiegeln auch die Faszination wider, die das Phänomen Zeit auf Bill ausübte.

Ancien étudiant du Bauhaus, Max Bill devient au début des années 50 le premier directeur de la Hochschule für Gestaltung en Allemagne, une école supérieure spécialisée dans la forme et la fonctionnalité. Les horloges murales de Max Bill pour Junghans illustrent les principes promus par cette école, le rapport entre la petite et la grande aiguille privilégiant de parfaites proportions. Ces créations reflètent la fascination que Bill vouait au temps.

3587124 clock, 3587126 barometer, 3587128 thermometer & 3587130 hygrometer, 1978

Henning Koppel (Denmark, 1918–1981)

www.georgjensen.com
Coated steel, glass
Beschichteter Stahl, Glas
Acier chromé, bois
∅ 10 cm
Georg Jensen, Copenhagen, Denmark

Henning Koppel's thoroughly modern reworking of the traditional barometer comes with a matching thermometer and hygrometer so that you can create your very own weather-predicting station. A matching wall clock is also available from Georg Jensen. This elegant timekeeping design also comes in two larger sizes (15 or 22 centimeters in diameter). Its simple graphic layout expresses the refinement of Koppel's work, and his goal of creating everyday products marked by beauty and practicality.

Henning Koppels äußerst moderne Reedition des traditionellen Barometers wird durch ein passendes Thermometer und ein Hygrometer ergänzt, so dass man sich seine eigene Wetterstation zusammenstellen kann. Dazu gibt es außerdem noch eine passende Wanduhr von Georg Jensen. Dieses elegante Chronometer-Design ist in zwei Größen erhältlich (15 oder 22 Zentimeter Durchmesser). Das schlichte grafische Layout bringt die Raffinesse von Koppels Arbeit sowie sein Bestreben zum Ausdruck, zugleich schöne und praktische Alltagsgegenstände zu schaffen.

Ces instruments de mesure conçus par Henning Koppel conservent un raffinement intemporel. Modernes et pratiques, ce thermomètre et cet hygromètre vous permettront de composer votre propre station météorologique. Vous serez également séduit par cette pendule murale, simple et élégante, disponible chez Georg Jensen. Existe en deux tailles, quinze ou vingt-deux centimètres de diamètre. Toutes ces créations illustrent le souci de Koppel de créer des objets du quotidien à la fois esthétiques et fonctionnels.

Usha umbrella stand, 1932

Eckart Muthesius (Germany, 1904–1989)

www.classicon.com
Chromium-plated steel, wood
Verchromter Stahl, Holz
Acier chromé, bois
↕ 50 cm ∅ 28 cm
Classicon, Cologne, Germany

Putting cutting-edge design theory into practice, Eckart Muthesius created furnishings using modern industrial materials, yet at the same time his work had a sculptural dynamism that set it apart from the pared-down utilitarian aesthetic of the Bauhaus. His *Usha* umbrella stand, which was originally designed for the Maharajah of Indore's fairytale palace, is made from a spiral of chromed steel that coils upwards like a charmed snake.

Eckart Muthesius setzte die reformerischen Designtheorien seiner Zeit um, indem er aus Industriematerialien Möbel und Einrichtungsgegenstände schuf, deren plastische Dynamik sie jedoch von der Neuen Sachlichkeit des Bauhauses abhob. Dieser ebenfalls für den Märchenpalast des Maharadschas von Indore entworfene Schirmständer besteht aus einer verchromten Stahlrohrspirale, die sich wie eine von Flötentönen hervorgelockte Kobra in die Höhe schlängelt.

Eckart Muthesius conçoit un mobilier moderne en utilisant des matériaux industriels. Empruntes d'un dynamisme sculptural, ses créations se distinguent de l'esthétique utilitariste abrégée de l'école Bauhaus. Conçu initialement pour le palais du Maharaja d'Indore, son porte-parapluie *Usha* s'apparente à une spirale, en acier chromé, s'enroulant vers le haut tel un serpent charmé par la musique. Cette création très contemporaine concrétise joliment la théorie du design d'avant-garde.

This classic umbrella stand designed by Gino Colombini was originally produced only in opaque glossy ABS, but is now also available in translucent PMMA, and in a variety of eye-catching colours. Easy to clean and highly durable, its form is a perfect cylinder with two cutouts making it easily transformable into a waste bin, especially when used in conjunction with the optional stainless steel ashtray that fits over the upper rim.

Dieser klassische, von Gino Colombini entworfene Schirmständer wurde ursprünglich aus nicht durchsichtigem, glänzendem ABS hergestellt, ist aber inzwischen auch in durchsichtigem PMMA und einer Vielzahl auffälliger Farben erhältlich. Der zylindrische Behälter ist einfach zu reinigen, sehr robust und mit zwei Seitenöffnungen versehen, so dass er sich leicht in einen Papierkorb verwandeln lässt, besonders in Verbindung mit der optionalen Aufsatzschale aus Edelstahl, die als Aschenbecher dient.

Ce porte-parapluie classique dessiné par Gino Colombini était autrefois réalisé en ABS opaque et brillant mais est désormais également disponible en PPMA translucide dans toute une gamme de couleurs vives. Facile à nettoyer et très résistant, son cylindre parfait est percé de deux fenêtres latérales qui permettent de le transformer facilement en corbeille à papier. Une cuvette en acier inoxydable, vendue à part, vient s'encastrer sur le bord supérieur et fait cendrier.

7610 umbrella stand, 1965
Gino Colombini (Italy, 1915–)

www.kartell.com
Injection-moulded ABS or PMMA
Spritzgegossenes ABS oder PMMA
ABS ou PMMA moulé par injection
Kartell, Milan, Italy

Tree coat stand, 2005

Michael Young (UK, 1966–) & Katrin Petursdóttir (Iceland, 1967–)

www.swedese.se
Lacquered or oak-veneered MDF
MDF, lackiert oder Eiche furniert
MDF laqué ou plaqué en chêne
↕ 134, 194 cm
Swedese, Vaggeryd, Sweden

The British industrial designer, Michael Young, and the Icelandic illustrator, Kathrin Petursdóttir have designed a number of quirky yet functional objects together. Their best-known design is the *Tree* coat stand for Swedese, which comes in two sizes and can be used either freestanding or wall-mounted. Its form – a cartoon-like silhouette of a leafless tree – has a poetic quality that makes the design immediately emotionally engaging, while its many branches are ideal for hanging coats, bags and hats.

Der britische Industriedesigner Michael Young und die isländische Illustratorin Kathrin Petursdóttir, haben zusammen eine Reihe verrückter und dennoch funktionaler Objekte entworfen. Ihr bekanntestes Design ist der Kleiderständer *Tree* für Swedese, der in zwei Größen erhältlich ist und entweder frei stehen oder an der Wand befestigt werden kann. Seine Form – eine cartoonartige Silhouette eines kahlen Baums – besitzt eine poetische Qualität, die das Design sehr stimmungsvoll macht. Die vielen Äste sind ideal zum Aufhängen von Mänteln, Taschen und Hüten.

Le designer industriel britannique Michael Young et l'illustratrice islandaise Kathrin Petursdóttir, ont conçu ensemble un certain nombre d'objets excentriques mais fonctionnels. Leur création la plus connue est le portemanteau *Tree* qu'ils ont dessiné pour Swedese. Disponible en deux tailles, il peut être monté sur pied ou accroché au mur. Sa forme, la silhouette d'un arbre nu semblant sorti d'une bande dessinée, le rend immédiatement sympathique tandis que ses nombreuses branches peuvent accueillir chapeaux, sacs et manteaux.

Hut ab coat stand, 1997

Konstantin Grcic (Germany, 1965–)

www.moormann.de
Ash or walnut
Esche oder Walnuss
Frêne ou noyer
↕ 200 cm
Nils Holger Moormann, Aschau im
Chiemgau, Germany

Konstanin Grcic's *Hut ab* coat stand is
made of jointed wooden poles that make
it easy to collapse and transport. In Eng-
lish, its title means 'hats off', and there
is certainly enough room for hats, as
well as jackets and bags to be hung from
its six hook–like projections. Winning a
Blueprint 100% Design Award in 1998,
this flexible design is also tall enough
to accommodate long coats. But, when
folded up, it needs a minimum of space,
making it perfect for a nomadic lifestyle.

Konstantin Grcics Garderobe *Hut ab*
besteht aus miteinander verbundenen
Holzstäben und lässt sich mühelos
zusammenklappen und transportieren.
Die einfachen Haken bieten ausreichend
Platz für Hüte, Jacken und Taschen. Das
1998 mit dem Blueprint 100% Design
Award ausgezeichnete, flexible Design
ist auch hoch genug für lange Mäntel
und lässt sich platzsparend zusammen-
falten – perfekt für einen nomadischen
Lebensstil.

Composé de deux éléments en bois,
le portemanteau *Hut ab* de Konstantin
Grcic est facile à plier et à transporter.
Son nom signifie « chapeau bas » et ses
six branches permettent effectivement
d'accrocher ses couvre-chefs aussi bien
que des vestes et des sacs. Lauréat
d'un Blueprint 100% Design en 1998, ce
design flexible est également assez grand
pour y suspendre un long manteau. En
revanche, une fois replié, il requiert un
minimum d'espace, le rendant idéal pour
un style de vie nomade.

In 1999, Hauke Murken and Sven Hansen established their own design studio in Berlin, and have since designed a number of award-winning accessories for the home. Their products have a very German sensibility – simple, functional, innovative – and possess a cool minimalist style, which is encapsulated in the highly rational design of their *gh2* coat hook, with its glass disk that protects the wall from fingerprints.

Hauke Murken und Sven Hansen gründeten 1999 ihr eigenes Design-Studio in Berlin und haben seitdem eine Reihe von preisgekrönten Einrichtungsaccessoires entworfen. Ihre Produkte sind einfach, funktional und innovativ und zeichnen sich durch einen kühlen, minimalistischen Stil aus, der in dem äußerst rationalen Design des Kleiderhakens *gh2* auf den Punkt gebracht wird. Die Glasscheibe schützt die Wand vor Fingerabdrücken.

En 1999, Hauke Murken et Sven Hansen ont établi leur atelier de design à Berlin et ont depuis souvent été primés pour leurs accessoires pour la maison. Leurs produits ont une sensibilité bien allemande – simple fonctionnelle et innovante. Leur style frais et minimaliste est parfaitement illustré par le design hautement rationnel de leur portemanteau *gh2*, avec son disque en verre qui protège le mur des traces de doigts.

gh2 coat hook, 2007

Hauke Murken (Germany, 1963–) & Sven Hansen (Germany, 1969–)

www.mawa-design.de
Toughened glass, stainless steel
Hartglas, Edelstahl
Verre renforcé, acier inoxydable
⤢ 6 cm ⌀ 9 cm
Mawa Design, Potsdam, Germany

gl4 wardrobe hook, 2007

Hauke Murken (Germany, 1963–) & Sven Hansen (Germany, 1969–)

www.mawa–design.de
Stainless steel, powder-coated steel
Edelstahl, pulverbeschichteter Stahl
Acier inoxydable, acier revêtu
↕ 13 cm ↔ 6 cm ↗ 14 cm
Mawa Design, Potsdam, Germany

Perfect for hanging a few clothes while using the minimum amount of space, Hauke Murken and Sven Hansen's *gl4* wardrobe hook is an innovative solution that has an appealingly minimalist aesthetic. Beautifully engineered, it is a three-dimensional realization of the Modernist credo – 'form follows function' – and, as such, reflects the rational roots of German design. It is also available in a white finish.

Der Garderobenhaken *gl4* von Hauke Murken und Sven Hansen eignet sich perfekt, um auf kleinstem Raum ein paar Kleider aufzuhängen, eine innovative Lösung von ansprechend minimalistischer Ästhetik. Die dreidimensionale Umsetzung des modernistischen Credos „Form folgt Funktion" ist sehr schön ausgeführt und reflektiert die rationalen Wurzeln des deutschen Designs. Der Haken ist auch mit weißem Finish erhältlich.

Idéal pour suspendre quelques vêtements en utilisant le minimum d'espace, le crochet de penderie *gl4* de Hauke Murken et Sven Hansen est une solution innovante à l'esthétique minimaliste plaisante. Superbement conçu, c'est la concrétisation tridimensionnelle du credo moderniste « la forme suit la fonction ». À ce titre, il reflète les racines rationnelles du design allemand. Il existe également avec une finition blanche.

Doorbell, 2005
Jacob Jensen (Denmark, 1926–)

www.jacobjensen.com
Plastic, metal
Kunststoff, Metall
Plastique, métal
↕ 17.5 cm ↔ 12 cm ⤢ 6 cm
Jacob Jensen, Brædstrup, Denmark

This cordless doorbell not only looks good, it also sounds great with its five different, specially composed, high-quality polyphonic ring tones. There is a classic bell sound, an oriental-style tune, a lounge-style vibe, a hard-of-hearing beat and, lastly, the sound of the designer, Jacob Jensen, knocking on a wooden door. As Jensen notes: 'New ideas emerge on the functional side…new functions always bring new forms'.

Diese schnurlose Türklingel sieht nicht nur gut aus, sondern hört sich mit ihren fünf verschiedenen, speziell komponierten polyphonen Klingeltönen auch gut an. Man kann wählen zwischen einem klassischen Glockenton, einer orientalischen Melodie, einer Lounge-Melodie, einem Klingelton für Schwerhörige sowie dem Klopfen des Designers Jacob Jensen. „Neue Ideen entstehen auf der funktionalen Seite … neue Funktionen bringen immer neue Formen mit sich", wie Jensen sagt.

Non contente d'être belle, cette sonnette sans fil a un son superbe avec cinq sonneries polyphoniques de haute qualité composées spécialement : du carillon classique à un air oriental en passant par quelques vibrations *lounge* et un roulement particulier pour les malentendants sans oublier le son propre au designer Jacob Jensen : un *toc, toc* sur une porte en bois. Comme l'observe Jensen : « De nouvelles idées émergent sur le plan fonctionnel… Les nouvelles fonctions entraînent toujours de nouvelles formes. »

The humble doorknocker has been around for centuries, yet today all too often an electric buzzer is used instead. Pascal Charmolu's doorknocker is, however, an excellent choice for those who still like to hear an old-fashioned rap on the door. It is a very contemporary and stylish reinterpretation of the traditional knocker, and with its rubber-ball mounted on the sturdy stainless steel arm, it has a charming, no-nonsense industrial aesthetic.

Den einfachen Türklopfer kennt man schon seit Jahrhunderten, aber heutzutage werden fast nur noch elektrische Türklingeln benutzt. Pascal Charmolus Türklopfer ist jedoch eine hervorragende Wahl für alle, die noch immer gerne ein altmodisches Klopfen an der Tür hören. Er ist eine sehr moderne und stilvolle Neuinterpretation des traditionellen Klopfers und erhält durch den Gummiball, der an einem schweren Arm aus Edelstahl befestigt ist, eine nüchterne industrielle Ästhetik.

Incontournable durant des siècles, le heurtoir finit par tomber en désuétude, remplacé par la sonnette d'entrée électrique. Pascal Charmolu remet au goût du jour cet objet insolite, un marteau de porte version design et contemporaine. Cette création se compose d'un bras en acier inoxydable extrêmement résistant surmonté d'une boule en caoutchouc. Dénuée de toute fioriture, cette nouvelle version s'avère très actuelle, absolument charmante avec son style épuré.

Doorknocker, 2008

Pascal Charmolu (France, 1958–)

www.borninsweden.se
Brushed steel, synthetic rubber
Edelstahl gebürstet, synthetisches Gummi
Acier brossé, caoutchouc synthétique
↕ 17.5 cm ⌀ 4.5 cm
Born in Sweden, Borås, Sweden

FSB 1025 door handle, 1995

Hartmut Weise (Germany, 1953–)

www.fsb.de
Stainless steel
Edelstahl
Acier inoxydable
↔ 13.3 cm
Franz Schneider Brakel, Brakel, Germany

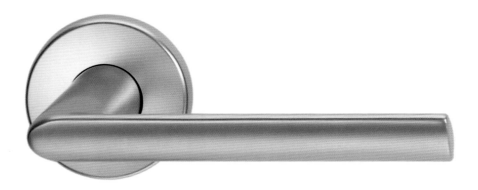

Simple and refined, the *FSB 1025* door handle is a slender model that possesses a striking visual lightness. Working as an in-house designer at Franz Schneider Brakel, Harmut Weise has even gone as far as describing the design's straight handle as, 'a vividly condensed ridge of luminosity'. Certainly, this eye-catching element does give the design a distinctive look, and one that is eminently suitable for uncluttered and minimalist interiors.

Der schlichte Türdrücker *FSB 1025* ist ein schlankes Modell von verblüffender visueller Leichtigkeit. Hartmut Weise, Hausdesigner bei Franz Schneider Brakel, geht sogar soweit, den geraden Griff des Designs als „eine lebhaft verdichtete Lichtkante" zu beschreiben. Dieses auffällige Element verleiht dem Design ein unverwechselbares Aussehen, das sich hervorragend für klare und minimalistische Einrichtungen eignet.

Simple et raffinée, la *FSB 1025* est une poignée élancée d'une surprenante légèreté visuelle. Designer maison chez Franz Schneider Brakel, Hartmut Weise a même décrit sa manette droite comme « une crête de luminosité fortement condensée ». De fait, ce détail séduisant confère à l'ensemble un caractère bien à lui et en fait un design convenant parfaitement dans les intérieurs dépouillés et minimalistes.

In the spring of 2000, the architectural hardware company Franz Schneider Brakel tasked their in-house designer, Hartmut Weise, to: 'design us some treats for the hand and the eye, or tools for the hand and treats for the eye, both in stainless steel'. The resulting series of designs, including the *FSB 1194*, shared a common theme, described by the company as, 'the inherent formal tension of parts punched out of flat metal and then joined together'.

Im Frühjahr 2000 bat der Hersteller von Baubeschlägen, Franz Schneider Brakel, seinen Hausdesigner Hartmut Weise, er solle „Schmeichler für Hand und Auge oder Werkzeuge für die Hand und Schmeichler für das Auge entwerfen. Beides aus Edelstahl." Die entstandene Reihe von Designs, zu der auch der *FSB 1194* gehört, hatte ein gemeinsames Thema, das vom Unternehmen als „formale innere Spannung der aus flachem Material geprägten und dann zusammengefügten Teile" beschrieben wurde.

Au printemps 2000, la compagnie de ferrures de bâtiment Franz Schneider Brakel a confié à son designer maison, Hartmut Weise, la mission de « développer des lignes agréables pour la main et l'œil ou des outils pour la main et flatteurs pour les yeux ». Ses créations, dont la *FSB 1194*, ont toutes un point commun, que la compagnie décrit comme « la tension interne et formelle du matériau plat, estampé et assemblé en suite ».

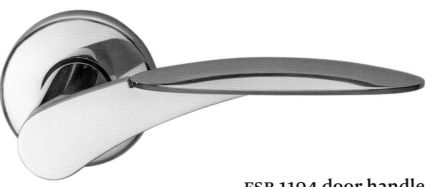

FSB 1194 door handle, 2000
Hartmut Weise (Germany, 1953–)

www.fsb.de
Stainless steel
Edelstahl
Acier inoxydable
↔ 13.4 cm
Franz Schneider Brakel, Brakel, Germany

FKD 25 door handle, 1925

Ferdinand Kramer (Germany, 1898–1985)

www.tecnoline.de
Polished and nickel-plated brass
Poliertes und vernickeltes Messing
Laiton nickelé et poli
↔ 11 cm
Tecnoline, Bremen, Germany

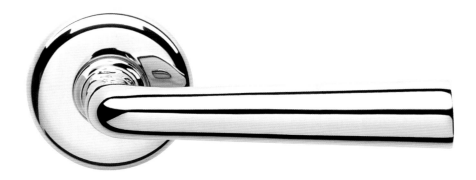

Ferdinand Kramer briefly studied at the Weimar Bauhaus, before training under the Munich-based architect, Theodor Fischer. He subsequently headed the Department of Standardization in Frankfurt during the 1920s – a unit of the city's influential Department of Urban Planning. As an important design reformer who utterly rejected historicism, Kramer also designed functionalist furniture for Thonet and a variety of household items and fittings, including this elegant door handle with its distinctive, conical lever.

Ferdinand Kramer studierte kurz am Bauhaus in Weimar, bevor er sein Architekturstudium bei Theodor Fischer in München begann. In den 1920er Jahren leitete er die Abteilung für Typisierung des einflussreichen Städtischen Hochbauamts in Frankfurt. Als bedeutender Designreformer, der jeglichen Historizismus strikt ablehnte, entwarf Kramer auch funktionalistische Möbel für Thonet sowie eine Vielzahl von Ausstattungs- und Einrichtungsgegenständen, darunter diesen eleganten Türdrücker mit dem markanten, konisch zulaufenden Griff.

Ferdinand Kramer a brièvement étudié au Bauhaus de Weimar avant de suivre une formation à Munich avec l'architecte Theodor Fischer. Il a ensuite dirigé le bureau de standardisation de Francfort dans les années 20, une branche de l'influent département d'urbanisation de la ville. Important réformateur qui rejetait catégoriquement l'historicisme, Kramer a également conçu des meubles fonctionnalistes pour Thonet ainsi qu'une variété d'équipement et d'accessoires pour la maison dont cette élégante poignée avec sa manette conique caractéristique.

Gro D 23 door handle, c. 1923

Walter Gropius (Germany, 1883–1969) & Adolf Meyer
(Germany, 1881–1929)

www.tecnoline.de
Polished and nickel-plated brass or stainless steel
Poliertes, vernickeltes Messing oder Edelstahl
Laiton nickelé et poli ou acier inoxydable
↔ 11 cm
Tecnoline, Bremen, Germany

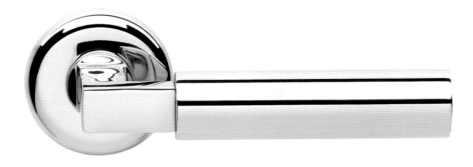

Walter Gropius and Adolf Meyer originally designed this Modernist door handle for a Berlin-based manufacturer, SA Loevy, in around 1923. It is generally regarded as the quintessential Bauhaus handle design, and was actually used in Gropius's own director's residence on the school's Dessau campus. The design comes with a variety of differently shaped doorplates and, like buildings by Gropius himself, it is completely stripped of ornamentation so as to reveal its pure functionalism.

Walter Gropius und Adolf Meyer entwarfen diesen modernistischen Türdrücker um 1923 ursprünglich für die Berliner Firma S.A. Loevy. Er gilt allgemein als die Quintessenz des Bauhaus-Griffdesigns und wurde auch in Gropius' Direktorenzimmer auf dem Campus in Dessau eingesetzt. Das Design ist mit zahlreichen verschiedenen Abdeckungen erhältlich. Wie bei den von Gropius selbst entworfenen Gebäuden wurde auch hier auf jegliche Verzierung verzichtet, um die reine Funktion freizulegen.

Walter Gropius et Adolf Meyer dessinèrent initialement cette poignée de porte moderniste pour un fabriquant berlinois, SA Loevy, vers 1923. Considérée aujourd'hui comme la quintessence de la poignée Bauhaus, Gropius l'utilisa également dans sa résidence de directeur sur le campus de Dessau. Ce design existe avec des plaques de formes différentes et, à l'instar des bâtiments conçus par Gropius, est dépouillé de tout ornement afin de mettre en valeur son fonctionnalisme pur.

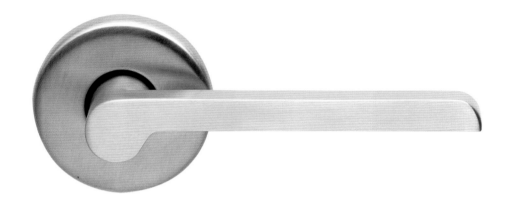

WD 28 door handle, 1928

Wilhelm Wagenfeld (Germany, 1900–1990)

www.tecnoline.de
Polished and nickel-plated brass or stainless steel
Poliertes, vernickeltes Messing oder Edelstahl
Laiton nickelé et poli ou acier inoxydable
↔ 11.5 cm
Tecnoline, Bremen, Germany

Originally designed for the famous architectural hardware company of SA Loevy in Berlin, the WD 28 door handle was initially sold in limited quantities – perhaps being a little too progressive for popular taste. As a quintessential Bauhaus–era design, however, it was used for Erich Mendelsohn's ultra-modern Columbus Haus in Potsdamer Platz, Berlin (1931–1932). Simple yet sophisticated, Wagenfeld's timeless design has an appealing, soft–edged Modernist aesthetic.

Der ursprünglich für die berühmte Bronzegießerei S.A. Loevy entworfene Türdrücker WD 28 wurde zunächst in geringer Stückzahl hergestellt, weil er für den Geschmack der damaligen Zeit vielleicht ein wenig zu progressiv war. Als exemplarisches Design der Bauhaus-Ära wurde er jedoch für alle Türen in Erich Mendelsohns ultramodernem Columbushaus am Potsdamer Platz (1931–1932) verwendet. Dieses einfache, aber elegante Wagenfeld-Design besitzt eine ansprechende, gemäßigte modernistische Ästhetik.

Conçue pour le célèbre fabriquant de matériel architectural berlinois SA Loevy, la poignée WD 28 fut initialement vendue en quantités limitées, étant sans doute un peu trop progressiste pour l'époque. Toutefois, caractéristique du design de style Bahaus, elle fut utilisée dans l'ultramoderne résidence Columbus Haus d'Erich Mendelsohn sur la Potsdamer Platz de Berlin (1931–1932). Simple et sophistiqué à la fois, cet objet intemporel possède une séduisante et discrète esthétique moderniste.

Described by Hugh Pearman as, 'a Mercedes-Benz of a handle, a trademark Morrison piece – thought through from first principles to be enduring rather than modish', the *FSB 1144* door handle is an exquisite piece of design engineering that fits beautifully in the hand. Like other designs by Jasper Morrison, it possesses an ideal archetypal form that transcends time and fashion – it is, as Vico Magistretti would have put it, 'a design without adjectives'.

Hugh Pearman beschrieb den *FSB 1144* als „Mercedes-Benz unter den Türgriffen, ein typisches Morrison-Stück – vom Grundsatz her durchdacht und beständig, statt modisch". Dieses erlesene Design ist so konstruiert, dass es sich wie von selbst in die Hand schmiegt. Wie andere Entwürfe von Jasper Morrison besitzt dieser Türdrücker eine ideale archetypische Form, die Zeit und Mode transzendiert, und ist, wie Vico Magistretti es formuliert hätte, „ein Design ohne Adjektive".

Décrite par Hugh Pearman comme « la Mercedes de la poignée de porte, un objet typiquement Morrison conçu d'emblée pour durer plutôt qu'en fonction des tendances du jour », la *FSB 1144* est un superbe exemple de conception technique qui tient merveilleusement dans la main. Comme d'autres designs de Jasper Morrison, elle possède une forme archétypale idéale qui transcende le temps et la mode. C'est, pour reprendre les termes de Vico Magistretti, « un design sans adjectif ».

FSB 1144 door handle, 1990

Jasper Morrison (UK, 1959–)

www.fsb.de
Anodized aluminium or stainless steel
Eloxiertes Aluminium oder Edelstahl
Aluminium anodisé ou acier inoxydable
↔ 13.1 cm
Franz Schneider Brakel, Brakel, Germany

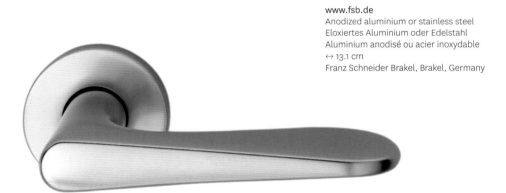

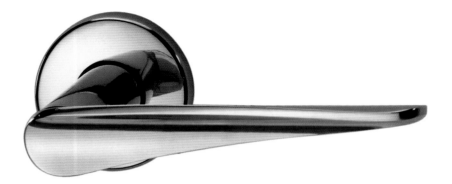

FSB 1197 door handle, 2000
Hartmut Weise (Germany, 1953–)

www.fsb.de
Stainless steel
Edelstahl
Acier inoxydable
↔ 13.8 cm
Franz Schneider Brakel, Brakel, Germany

After experimenting with various production techniques, Hartmut Weise developed an innovative series of architectural hardware designs in 2000, which included the FSB 1197 handle. Described by Franz Schneider Brakel as, 'very much in the spirit of "new flatness"', the range that includes the FSB 1197 is manufactured from flat, punched stainless steel. As such, the design's expressive and dynamic forms echo the sculptural confidence found in contemporary architecture as it looked to a new millennium.

Nachdem er mit verschiedenen Produktionstechniken experimentiert hatte, entwickelte Hartmut Weise 2000, eine innovative Reihe von Baubeschlägen, zu der auch der FSB 1197 Türdrücker gehört. Diese Reihe, die laute Franz Schneider Brakel „ganz im Geiste der neuen Flachheit'" steht, wird aus flachem, geprägtem Edelstahl gefertigt. So spiegeln die expressiven dynamischen Formen des Designs das Vertrauen in das Plastische wieder, das die zeitgenössische Architektur an der Schwelle eines neuen Jahrtausends besaß.

Après avoir expérimenté plusieurs techniques de production, Hartmut Weise a développé une innovante série de ferrures de bâtiment en 2000, dont la gamme à laquelle appartient la poignée FSB 1197. Décrite par Franz Schneider Brakel comme « très dans l'esprit de la "new flatness" », cette ligne est fabriquée en acier inoxydable plat et estampé. Les formes expressives et dynamiques de ce design reflètent l'assurance sculpturale de l'architecture contemporaine à l'aube d'un nouveau millénaire.

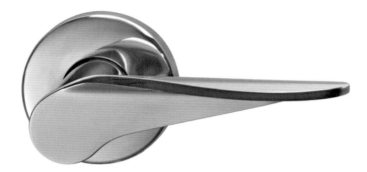

FSB 1128 door handle, 1994

Erik Magnussen (Denmark, 1940–)

www.fsb.de
Stainless steel
Edelstahl
Acier inoxydable
↔ 11.3 cm
Franz Schneider Brakel, Brakel, Germany

The development of this handle design took over a year, from Erik Magnussen's first pencil sketch to the final working prototype. Understanding the material's intrinsic qualities, Magnussen decided to innovatively 'fold' the stainless steel, rather than using the traditional methods of bending, welding and flattening. The outcome was a timeless and beautifully engineered design, which is part of a complete product family.

Von Erik Magnussens erster Kohleskizze bis zum Prototyp dauerte die Entwicklung dieses Griff-Designs über ein Jahr. Nachdem Magnussen sich mit den spezifischen Eigenschaften von Edelstahl beschäftigt hatte, beschloss er, ihn zu „falten" statt traditionelle Verfahren wie Biegen, Schweißen oder Aufweiten anzuwenden. Das Ergebnis war ein zeitloses und sehr schön konstruiertes Design, das Teil einer kompletten Produktfamilie ist.

Le développement de cette poignée de porte a pris plus d'un an, de la première ébauche au crayon d'Erik Magnussen au prototype final. Comprenant les qualités intrinsèques du matériau, le designer a décidé de « replier » l'acier inoxydable plutôt que de le mandriner, de le souder et de l'aplatir. Le résultat est un objet intemporel magnifiquement conçu, appartenant à une famille de produits complète.

Meta door handle, 2004

Konstantin Grcic (Germany, 1965–)

www.colombodesign.com
Chrome-plated brass
Messing (verchromt)
Laiton chromé
↔ 14.3 cm
Colombo Design, Terno d'Isola, Italy

Available with either a matt or shiny chrome-plated finish, there is a no-nonsense, robust masculinity to the *Meta* door handle. At the same time, it possesses a compelling formal refinement that is so characteristic of Konstantin Grcic's work. He conceives of his objects interacting in the world. "No object ever exists purely on its own," Grcic states. "It would be strange to speak of a door handle without talking about the door… And of course… we can never speak about objects without imagining people using them."

Der Hersteller bietet den *Meta*-Türgriff entweder matt oder glänzend verchromt an. Trotz seiner gewissermaßen maskulin wirkenden Robustheit ist er – typisch für Konstantin Grcic – formal äußerst raffiniert. Grcic will, dass seine Produkte mit der Welt „interagieren", weil er meint, dass kein Objekt jemals losgelöst von allen anderen existiert. Grcic zufolge wäre es seltsam, von einem Türgriff zu sprechen, ohne über die Tür zu reden, und unmöglich, über Gebrauchsgegenstände zu reden ohne sich die Menschen vorzustellen, die sie gebrauchen werden.

Cette poignée de porte *Meta* reflète une indéniable robustesse masculine ainsi qu'une évidente fonctionnalité. Elle présente un élégant raffinement formel, si caractéristique du travail de Konstantin Grcic. Selon lui, « aucun objet n'existe vraiment par lui-même », et il ajoute « Il serait malvenu de parler d'une poignée de porte sans évoquer la porte elle-même […] Et bien sûr, nous ne pouvons jamais parler d'objets sans imaginer les personnes qui les utilisent. » Disponible en chromé mat ou brillant, *Meta* reflète un design fonctionnel raffiné.

DRD 99 door handle, 1999

Dieter Rams (Germany, 1932–)

www.tecnoline.de
Nickel-plated Zamak (zinc alloy)
Vernickeltes Zamak (Zinklegierung)
Zamak (alliage de zinc) nickelé.
↔ 13.5 cm
Tecnoline, Bremen, Germany

For many years the influential design director of Braun, Dieter Rams almost single-handedly pioneered the functionalist vocabulary that became synonymous with German design excellence. For Rams, good design means as little design as possible, and his work has always been guided by the belief that, 'simple is better than complicated'. This door handle reflects his credo with its sparse yet refined form dictated by functional and ergonomic requirements.

Viele Jahre hat Dieter Rams, der einflussreiche Chefdesigner von Braun, fast selbstständig den Weg für das funktionalistische Vokabular bereitet, das zum Synonym für hervorragendes deutsches Design werden sollte. Für Rams bedeutet gutes Design so wenig Design wie möglich, und seine Arbeit war stets von der Überzeugung „einfach ist besser als kompliziert" geleitet. Dieser Türdrücker mit seiner sparsamen, doch eleganten und von funktionalen und ergonomischen Anforderungen bestimmten Form reflektiert dieses Credo.

Pendant de nombreuses années, l'influent directeur du design de Braun, Dieter Rams, a défini presque à lui seul le vocabulaire fonctionnaliste devenu synonyme de l'excellence du design allemand. Pour Rams, un bon design signifie le moins de design possible. Son travail a toujours été guidé par le principe : « pourquoi faire compliqué quand on peut faire simple ». Cette poignée de porte l'illustre parfaitement avec sa forme épurée et raffinée dictée par des besoins fonctionnels et ergonomiques.

Amisa door handle, 2006

Satyendra Pakhalé (India, 1967–)

www.colombodesign.com
Chrome-plated brass
Messing Verchromtes
Laiton chromé
↔ 13.8 cm
Colombo Design, Terno d'Isola, Italy

The *Amisa* door handle is sculpted to fit ergonomically in the hand with its rounded lever and its thumb-accommodating depression. Available with either a shiny or matt finish, the swelling organic form of Pakhalé's elegant sculptural design is the epitome of contemporary soft-edged Modernism.

Der Türgriff *Amisa* ist ergonomisch geformt, so dass er mit seiner Rundung und einer Vertiefung für den Daumen einen festen Griff ermöglicht. Er wird in einer matten oder glänzenden Ausführung angeboten und verkörpert mit seiner schwellenden, geschwungenen Form den Inbegriff des heutigen modernen Produktdesigns.

Amisa offre une totale ergonomie avec sa béquille à bout arrondi et la partie plate à l'avant permettant de faire levier sur le pouce pour l'ouverture de la porte. Disponible en brillant ou en mat, cette création de Pakhalé possède une forme organique révélant une élégance sculpturale. Véritable incarnation contemporaine du design moderniste.

Zelda door handle, 2004

Jean-Marie Massaud (France, 1966–)

www.colombodesign.it
Chrome-plated brass
Verchromtes Messing
Laiton chromé
↔ 14 cm
Colombo Design, Terno d'Isola, Italy

The French architect-designer, Jean-Marie Massaud is an accomplished form-giver whose work has a highly distinctive look that is both dynamic and futuristic. His sleek *Zelda* lever handle, for example, has a hard-edged geometry that power-fully distinguishes it from other models on the market. This attractive and sophisticated contemporary-style design comes in either a polished or matt finish, while a matching square-shaped escutcheon is also available.

Der französische Architekt und Designer Jean-Marie Massaud ist ein versierter Formgeber, dessen unverwechselbare Arbeiten gleichermaßen dynamisch und futuristisch anmuten. Sein geschmeidiger Türdrücker *Zelda* beispielsweise besitzt eine weichkonturierte Geometrie, die ihn deutlich von anderen Modellen auf dem Markt unterscheidet. Dieses attraktive und elegante moderne Design ist entweder mit poliertem oder mattem Finish und einer passenden quadratischen Schlüsselrosette erhältlich.

L'architecte designer français Jean-Marie Massaud travaille inlassablement la forme, proposant des designs originaux, à la fois dynamiques et futuristes. Son élégante poignée de porte *Zelda* reflète une géométrie douce et épurée, différente des autres modèles disponibles sur le marché. Ce design simple mais sophistiqué, de style contemporain, existe en finition polie ou mat. Un cache-entrée carré, assorti au modèle, est également disponible.

Gira door handle, 1998

Jasper Morrison (UK, 1959–)

www.colombodesign.com
Chrome-plated brass, or zirconium stainless steel-coated brass
Messing ,verchromt oder mit Zirkonium-Edelstahl beschichtet
Laiton chromé ou zirconium en acier inoxydable enduit de laiton
↔ 14.3 cm
Colombo Design, Terno d'Isola, Italy

Jasper Morrison is a master at skillfully updating existing typologies in order to create "ideal" solutions. His objects have both an inherent logic and sparse beauty that derives from his rational form-follows-function approach to design. At first glance the *Gira* may look like other door handles, yet on reflection it is actually a highly refined and understated design.

Jasper Morrison versteht es meisterhaft, bestehende Typologien zu aktualisieren und daraus „Ideallösungen" zu entwickeln. Seine schlüssigen, schlichten und formschönen Produktdesigns entwickelt er nach der Maxime „die Form folgt der Funktion". Auf den ersten Blick sieht der *Gira* vielleicht wie andere Türgriffe aus, bei näherer Betrachtung erweist er sich aber als raffiniertes Design-Understatement.

Jasper Morrison est passé maître dans l'art de « moderniser » et de « sublimer » des objets déjà existants. Ses créations observent à la fois une logique interne et une beauté rare résultant de son approche selon laquelle « la fonction influence la forme ». *Gira* ressemble à une poignée quelconque, mais lorsqu'on l'observe attentivement elle s'avère extrêmement raffinée, pour un design discret.

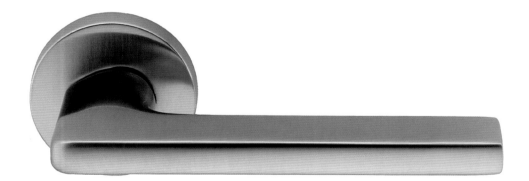

LWD 27 door handle, 1927

Ludwig Wittgenstein (Germany, 1889–1951)

www.tecnoline.de
Polished and nickel-plated brass
Poliertes, vernickeltes Messing
Laiton nickelé et poli
↔ 14 cm
Tecnoline, Bremen, Germany

Between 1926 and 1928, the Austrian philosopher Ludwig Wittgenstein designed and built – with the assistance of the architect Paul Engelmann – a Modernist villa for his sister, Margarethe Stonborough-Wittgenstein, in Kundmanngasse, Vienna. To complement the stark unadorned exterior, which was inspired by the work of Adolf Loos, Wittgenstein also designed suitably Modernist fixtures and fittings for the house, including this door handle, which incorporates a distinctive rounded metal rod for its lever.

Der österreichische Philosoph Ludwig Wittgenstein baute zwischen 1926 und 1928 mit Unterstützung des Architekten Paul Engelmann für seine Schwester Margarethe Stonborough-Wittgenstein eine modernistische Villa in der Kundmanngasse in Wien. Als Ergänzung zu dem nüchternen Äußeren des von Adolf Loos inspirierten Hauses entwarf Wittgenstein auch entsprechend modernistische Einbauten und Zubehör für die Innenräume, darunter diesen Türdrücker mit dem charakteristischen Griff aus einer Rundstange.

Entre 1926 et 1928, le philosophe autrichien Ludwig Wittgenstein a dessiné et construit, avec l'aide de l'architecte Paul Engelmann, une villa moderniste pour sa sœur Margarethe Stonborough-Wittgenstein à Kundmanngasse, à Vienne. Afin de compenser l'austérité de la façade inspirée par l'œuvre d'Adolf Loos, il conçut également les équipements intérieurs, dont cette poignée de porte à la manette ronde et épurée.

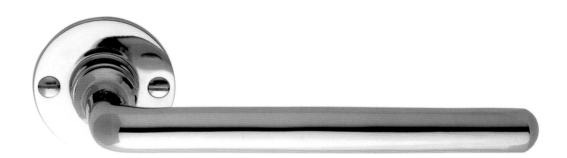

Children
Für Kinder
Pour les enfants

Rebel child's set, 2005

Johan Verde (Norway, 1964–)

www.stelton.com
Porcelain, stainless steel, rubber
Porzellan, Edelstahl, Gummi
Porcelaine, acier inoxydable, caoutchouc
Stelton, Copenhagen, Denmark

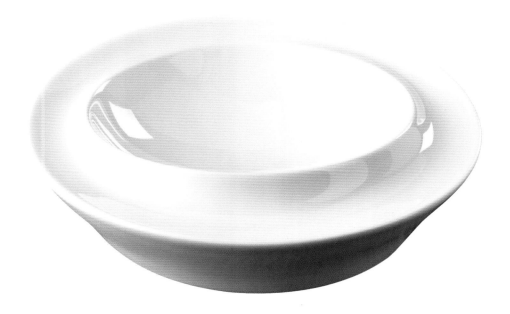

The beautiful and refined form of this revolutionary child's set was based on analysis of how children actually move, thereby making it easier for young children to handle than traditional equivalents. The concave edge of the plate helps catch spilled food, while the mug and spoon are ergonomically resolved to provide optimum comfort, ease of handling and stability. The bowl also has a rubber bottom preventing it from sliding. The *Rebel* won an iF Product Design Award in 2006.

Die schöne und edle Form dieses revolutionären Kindergeschirrs geht auf die Analyse der tatsächlichen Bewegungen von Kindern zurück, so dass es für die Kleinen einfacher zu handhaben ist als traditionelle Pendants. Der konkav geformte Rand des Tellers fängt übergeschwapptes Essen auf, während der Becher und der Löffel ergonomisch so geformt sind, dass sie nicht nur bequem in der Handhabung, sondern auch stabil sind. Dank der Gummiunterlage kann der Teller nicht verrutschten. *Rebel* wurde 2006 mit dem iF Product Design Award ausgezeichnet.

Beau et raffiné, ce service révolutionnaire repose sur une analyse de la gestualité enfantine, le rendant plus facile à manipuler par de jeunes enfants. Le bord concave de l'assiette retient les aliments renversés tandis que la forme ergonomique de la tasse et de la cuillère assure un plus grand confort, un usage facile et plus de stabilité. Le dessous du bol est en caoutchouc afin de ne pas glisser. *Rebel* a été récompensé d'un prix iF Product Design en 2006.

Animal Friends children's cutlery, 2008

Karin Mannerstål (Sweden, 1963–)

www.gense.se
Stainless steel
Edelstahl
Acier inoxydable
Gense, Eskilstuna, Sweden

Children's cutlery is often conceived as scaled-down versions of adult-sized flatware, however, Karin Mannerstål's *Animal Friends* range is a charming exception to this rule. Featuring a rabbit, a teddy bear, a cat and a monkey, each 'tool' has child-friendly rounded corners and edges, and is designed to comfortably fit in a toddler's hand. Suitable for children between the ages of one and four, this delightful range should certainly help make mealtimes more fun!

Kinderbesteck wird meist als verkleinerte Version des Bestecks für Erwachsene konzipiert, aber Karin Mannerståls *Animal Friends* ist eine reizende Ausnahme von dieser Regel. Hase, Teddybär, Katze und Affe zieren diese „Esswerkzeuge" mit kinderfreundlich abgerundeten Ecken und Kanten, die von kleinen Händen mühelos gehalten werden können. Das lustige, für Kinder zwischen einem und vier Jahren geeignete Besteck sorgt mit Sicherheit dafür, dass Essen mehr Spaß macht.

Les couverts pour enfants s'apparentent souvent à ceux des adultes, en taille réduite. La collection *Animal Friends* de Karin Mannerstål fait office d'exception. Chaque couvert présente la tête d'un animal : un lapin, un chat, un ours, et un singe. Ergonomiques, ces couverts aux extrémités arrondies ont été spécialement conçus pour les enfants. Idéale pour les bambins âgés de un à quatre ans, cette délicieuse collection rend les repas plus amusants !

Puppy child's stool, 2005

Eero Aarnio (Finland, 1932–)

www.magismetoo.com
Moulded polyethylene
Geformtes Polyethylen
Polyéthylène moulé
↕ 34.5, 45, 55.5, 80.5 cm
Magis, Motta di Livenza, Italy

Best remembered for his iconoclastic seating designs of the 1960s, Eero Aarnio has continued to design unusual furniture pieces that possess a strong emotional pull. His *Puppy* child's stool is no exception, and as its name suggests it takes the form of an abstracted pet, instantly appealing to children of all ages. This amalgam of seat and toy is produced in four sizes and three colours (white, orange and green), and is suitable for outdoor use.

Der vor allem für die ikonoklastischen Designs von Sitzmöbeln der 1960er Jahre bekannte Eero Aarnio hat auch danach ungewöhnliche Möbel von starker emotionaler Anziehungskraft entworfen. Sein Kinderhocker *Puppy* ist da keine Ausnahme: Der abstrakte Hund spricht Kinder jeden Alters sofort an. Die Mischung aus Sitzmöbel und Spielzeug wird in vier Größen und drei Farben hergestellt (Weiß, Orange und Grün) und eignet sich auch für den Außenbereich.

Surtout connu pour ses sièges iconoclastes des années 60, Eero Aarnio n'a cessé de créer des meubles originaux au puissant attrait émotionnel. Son tabouret d'enfant *Puppy* ne fait pas exception. Sa silhouette abstraite de chiot séduit immédiatement les enfants de tous âges. Cette union du siège et du jouet, produite en quatre tailles et trois couleurs (blanc, orange et vert), convient aussi pour l'extérieur.

Renowned for his ability to create innovative yet functional designs, Eero Aarnio's *Trioli* child's chair has two seat heights depending on how it is oriented (either 27 cm or 37 cm). The design can also be placed on its side as a fun ride-upon rocker. Available in red, blue, yellow and white polyethylene, the playful *Trioli* is also suitable for outdoor use and is sufficiently robust to cope with the destructive tendencies of young children.

Eero Aarnio ist berühmt für seine innovativen und gleichzeitig funktionalen Designs. Sein Kinderstuhl *Trioli* bietet zwei Sitzhöhen, je nach Ausrichtung (entweder 27 cm oder 37 cm). Legt man ihn auf die Seite, wird er zu einer Wippe. Der lustige *Trioli* ist in rotem, blauem, gelbem und weißem Polyethylen erhältlich und auch für den Außenbereich geeignet, robust genug für herumtollende kleine Kinder.

Eero Aarnio est connu pour ses créations inventives mais fonctionnelles. Sa chaise *Trioli* permet de s'asseoir à deux hauteurs différentes selon le sens dans laquelle elle est posée (vingt-sept ou trente-sept centimètres). Couchée sur le flanc, elle devient également un cheval à bascule. Disponible en polyéthylène rouge, bleu, jaune et blanc, elle est suffisamment robuste pour résister aux mauvais traitements d'un jeune enfant.

Trioli child's chair, 2005

Eero Aarnio (Finland, 1932–)

www.magismetoo.com
Rotationally moulded polyethylene
Rotationsgeformtes Polyethylen
Polyéthylène moulé par rotation
↕ 58 cm ↔ 49.6 cm ↗ 45 cm
Magis, Motta di Livenza, Italy

Piedras low chair, bench & table, 2006

Javier Mariscal (Spain, 1950–)

www.magismetoo.com
Rotational-moulded polyethylene
Rotationsgeformtes Polyethylen
Polyéthylène moulé par rotation
↕ 47 cm ↔ 117.5 cm ⤢ 60 cm
↕ 47 cm ↔ 73 cm ⤢ 60 cm
↕ 25 cm ↔ 62 cm ⤢ 60 cm
Magis, Motta di Livenza, Italy

As the name suggests, the *Piedras* low chair, bench and low table are stone-like designs, which almost look as though they've come straight out of a *Flintstones* cartoon. Even better, they are suitable for outdoor use and, apart from providing children with a nice place to sit, with a little imagination can also provide hours of make-believe creative fun, as secret caves or granite forts.

Der Name *Piedras* (Steine) verweist schon darauf, dass diese niedrigen Möbel wie Steine aussehen, die direkt aus dem Wohnzimmer der Cartoon-Familie Feuerstein zu stammen scheinen. Sie können auch im Garten aufgestellt werden und bieten Kindern nicht nur bequeme Sitzgelegenheiten und einen Spieltisch, sondern eignen sich auch bestens für Steinzeit- und Höhlenspiele.

Comme son nom l'indique, le salon *Piedras* s'apparente au mobilier de la famille Pierrafeu, avec le fauteuil, le sofa et la table basse semblables à des rochers sculptés. Conçu pour l'extérieur, *Piedras* permet aux enfants de s'évader en créant un monde imaginaire ou des grottes secrètes. Durant des heures, les enfants ne se lassent pas d'imaginer toutes sortes de situations, dans un mobilier de « dessin animé ».

Ladrillos shelving system, 2005

Javier Mariscal (Spain, 1950–)

www.magismetoo.com
Rotational-moulded polyethylene, zinc-plated steel, HPL laminate
Rotationsgeformtes Polyethylen, verzinkter Stahl, HPL-Schichtstoffplatten
Polyéthylène moulé par rotation, acier zingué, stratifié HPL
↕ 25, 35, 40 cm ↔ 200 cm ⤢ 36.8 cm
Magis, Motta di Livenza, Italy

Since the 1980s, the Spanish designer Javier Mariscal has gained a considerable reputation for his playful work, which ranges from visual identities and communication design to interiors and landscaping. Designed specifically for children, his *Ladrillos* shelving system incorporates eight differently coloured cartoon-like supports made of rotational-moulded polyethylene. The result is absolutely charming, as well as being a practical place to store all those knick-knacks, toys and books children seem to accumulate.

Seit den 1980er Jahren hat sich der spanische Designer Javier Mariscal mit witzigen, verspielten Arbeiten einen Namen gemacht, die von Firmenlogos und Webdesigns zu Inneneinrichtungen und Landschaftsplanungen reichen. Sein *Ladrillos*-Regalsystem für Kinderzimmer umfasst acht verschiedenfarbige, cartoonartige Gestellteile aus rotationsgeformtem Polyethylen. Abgesehen von seiner Funktion als Aufbewahrungsort für alles, was das Kinderherz erfreut – Bücher, Legos, etc. –, ist das Regal ganz entzückend.

Depuis les années 80, Javier Mariscal est connu pour son travail ludique, allant de l'identité visuelle et du design de communication aux intérieurs et aménagements paysagers. Conçue spécialement pour les enfants, son étagère *Ladrillos* comporte de petits personnages réalisés en polyéthylène moulé par rotation, en huit couleurs acidulées. Idéale pour ranger des bibelots, jouets ou livres, *Ladrillos* reflète fantaisie et fonctionnalité. Cette création offre une pointe d'humour au design.

Soon after the *Panton* chair was launched in the late 1960s, Verner Panton began thinking about a child-sized version of his seminal design but it was deemed financially unviable. Nearly fifty years later, however, Vitra decided to make a child–sized edition available. Approximately 25% smaller than the original, it is otherwise absolutely identical in every detail. With its bright colours, smooth curves and scrubbable surface, the *Panton Junior* is ideal for pre-school and primary school-aged children.

Kaum war der *Panton*-Stuhl auf dem Markt, begann Verner Panton, über eine Kinderversion seines bahnbrechenden Designs nachzudenken. Dieses Vorhaben scheiterte jedoch aus finanziellen Erwägungen. Fast fünfzig Jahre später hat sich Vitra nun entschlossen, eine für Kinder geeignete Edition in Hellblau, Hellrosa, Orange, Rot, Schwarz und Weiß zu produzieren. Der Stuhl ist im Vergleich zur Erwachsenenversion etwa ein Viertel kleiner, ansonsten aber in allen Details gleich. Mit seinen leuchtenden Farben, den sanften Rundungen und der abwaschbaren Oberfläche ist der *Panton Junior* ideal für Kinder im Kindergarten- und Grundschulalter.

Peu après le lancement de sa célèbre chaise *Panton*, Verner Panton envisagea d'en créer une version miniature pour enfant. Toutefois, l'idée s'avéra financièrement peu rentable. Près de cinquante ans plus tard, Vitra l'a enfin réalisée, l'éditant en citron vert, bleu clair, rose pâle, orange, rouge, noir et blanc. Hormis le fait qu'elle soit environ un quart plus petite que la version adulte, elle lui est en tout point identique. Avec ses belles couleurs, ses courbes douces et sa surface facile à nettoyer, la *Panton Junior* est idéale pour les enfants de maternelle et de primaire.

Panton Junior chair, 1959/2006

Verner Panton (Denmark, 1926–1998)

www.vitra.com
Polypropylene
Polypropylen
Polypropylène
↕ 62.8 cm ↔ 37.6 cm ↗ 44.6 cm
Vitra, Weil am Rhein, Switzerland

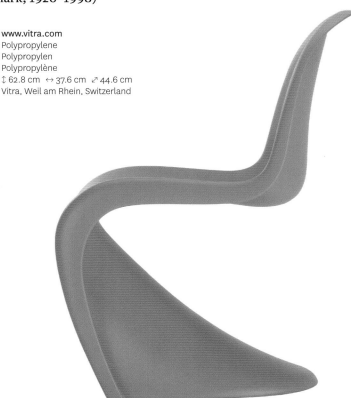

Hang-It-All coat rack, 1953

Charles Eames (USA, 1907–1978) & Ray Eames (USA, 1912–1988)

www.hermanmiller.com
Powder-coated steel, painted maple
Pulverbeschichteter Stahl, lackiertes Ahorn
Acier revêtu, érable peint
↕ 37 cm ↔ 50 cm ⤢ 17 cm
Herman Miller, Zeeland (MI), USA

The *Hang-It-All* is an iconic mid-century Modern design, which playfully subverted the humble coat rack into a colourful and sculptural object. Throughout their careers, Charles and Ray Eames were fascinated by the idea of childhood, and made various whimsical furniture pieces and toys designed specifically for children. Their *Hang-It-All*, though originally intended for this market, actual appeals to anyone young at heart, and provides a useful place to hang hats, jackets, bags and backpacks.

Hang-It-All ist eine Designikone der 1950er Jahre und verwandelt die einfache Garderobe in ein buntes, skulpturales Objekt verwandelt. In ihrer gesamten Laufbahn waren Charles und Ray Eames von der Vorstellung der Kindheit fasziniert und schufen skurrile Möbelstücke und Spielzeuge eigens für Kinder. *Hang-It-All* war zwar ursprünglich auch für diesen Markt bestimmt, spricht aber im Grunde jeden an, der sich im Herzen jung fühlt, und ist eine praktische Lösung zum Aufhängen von Hüten, Jacken, Taschen und Rucksäcken.

Objet emblématique du design moderniste des années 50, *Hang-It-All* détourne avec humour l'humble portemanteau pour en faire un accessoire coloré et sculptural. Fascinés par l'enfance, Charles et Ray Eames ont créé des meubles et jouets amusants spécialement pour les enfants tout au long de leur carrière. Bien qu'initialement destiné à ce marché, *Hang-It-All* séduit tous ceux qui ont l'esprit jeune et offre une solution pratique pour accrocher chapeaux, manteaux, sacs et sacs à dos.

Linus children's table, 2006

Javier Mariscal (Spain, 1950–)

www.magismetoo.com
Injection-moulded polypropylene, fiberglass, polymeric coated MDF
Spritzguss-Polypropylen, Glasfaser, MDF mit Polymerbeschichtung
Polypropylène moulé par injection, fibre de verre, médium, revêtement polymère
↕ 50 cm ↔ 75 cm ⤢ 75 cm (variation shown)
Magis, Motta di Livenza, Italy

Part of Magis' *Me Too* collection, the *Linus* table was originally designed to be used with Javier Mariscal's stacking *Alma* children's chairs. However, it also works well with other children's seating too. The table's legs are made from resilient polypropylene, while the top (available in three different sizes) is made from wipe-clean plastic coated MDF. Named after the loveable character from Charles M. Schulz's comic strip *Peanuts*, the design also incorporates safety features such as rounded corners and edges.

Als Teil der Kinderkollektion *Me Too* von Magis wurde *Linus* ursprünglich entworfen, um in Verbindung mit Javier Mariscals stapelbarem Kinderstuhl *Alma* benutzt zu werden, funktioniert aber auch sehr gut mit anderen Kinderstühlen. Die Tischbeine bestehen aus strapazierfähigem Polypropylen, während die Platte (in drei verschiedenen Größen erhältlich) aus pflegeleichtem, beschichteten MDF gefertigt ist. Das nach der liebenswerten Figur aus der Comicserie *The Peanuts* von Charles M. Schulz benannte Design weist zudem Sicherheitsmerkmale wie abgerundete Ecken und Kanten auf.

Faisant partie de la ligne *Me Too* de Magis, *Linus* fut conçue pour accompagner la chaise d'enfant empilable du même designer, *Alma*. Toutefois, elle fonctionne très bien avec d'autres sièges. Ses pieds sont en polypropylène résistant et le plateau (disponible en trois tailles) en médium enduit facile à nettoyer d'un coup d'éponge. Baptisée d'après l'attachant personnage des *Peanuts* de Charles M. Schulz, son design prend également en compte la sécurité avec des bords et des coins arrondis.

Children's furniture is often made of brightly coloured plastics to appeal to their love of shiny and garish things. With her *Porcupine Desk* Hella Jongerius has instead opted for solid wood. She did, however, enliven this charming design with a faux-naïve decorative illustration and angled holes to keep crayons in, which look a bit like the spines on a porcupine's back. The table also has an open shelf for books or toys as well as a handy drawer.

Möbel für Kinderzimmer werden vielfach aus farbigem Plastik hergestellt, weil Kinder glänzende und bunte Dinge lieben. Für ihren „Stachelschwein-Schreibtisch" wählte Hella Jongerius stattdessen massives Hainbuchenholz. Allerdings belebte sie den entzückenden Tisch mit naiven Dekorationen und schräg eingeschnittenen Löchern für Stifte. Damit bestückt, lässt der Tisch dann ein wenig an ein borstiges Stachelschwein denken. Der Tisch ist mit einem Regal für Bücher oder Spielzeug und einer Schublade ausgestattet.

Le mobilier pour enfants est souvent réalisé en plastique, avec des couleurs vives. Fabriqué en bois massif, *Porcupine* se différencie par ses pieds asymétriques, son dessin de chaîne du bonheur décorée de motifs d'animaux et ses trous parsemés où l'on enfonce les crayons. Le bureau apparaît alors tel un porc-épic, d'où son nom. Le plateau dispose également d'un espace ouvert pour les livres ainsi que d'un tiroir. Ludique et poétique à la fois, *Porcupine* est une pure merveille.

Porcupine Desk, 2007

Hella Jongerius (Netherlands, 1963–)

www.vitra.com
Hornbeam, lacquer
Hainbuche, Lackbeschichtung
Charme, laqué
↕ 54 cm ↔ 57 cm ⤢ 72 cm
Vitra, Weil am Rhein, Switzerland

Zoo Timers wall clocks, 1965

George Nelson (USA, 1908–1986)

www.vitra.com
Lacquered and silkscreened wood, metal, quartz mechanism
Lackiertes, mehrfarbig bedrucktes Holz, Metall, Quarzuhrwerk
Bois laqué et sérigraphie, métal, mécanisme à quartz
↕ 25.5, 26, 32 cm
Vitra, Birsfelden, Switzerland

As an exceptionally talented designer running a multi-disciplined design consultancy, George Nelson had a breadth of talent to design everything from furniture and lighting to product architecture, exhibitions and signage. Fusing product design with graphic design, his *Zoo Timers* are characterful clocks for children that explore the diversity of the animal kingdom, with *Omar the Owl*, *Fernando the Fish*, *Talulah the Toucan* and *Elihu the Elephant*.

Der außergewöhnliche Designer George Nelson war ein echtes Multitalent. Er betrieb ein Büro für Industriedesign und gestaltete nicht nur Möbel und Leuchten, sondern auch Produkte, Ausstellungen und Beschilderungen. Seine *Zoo Timer* verbinden Produktdesign und Grafikdesign, ausdrucksvolle Uhren für Kinder, die mit der Eule *Omar*, dem Fisch *Fernando*, dem Tukan *Talulah* und dem Elefanten *Elihu* die Vielfalt des Tierreichs erkunden.

Designer de génie, George Nelson ne manque pas d'imagination. Le langage graphique de ses horloges murales Zoo, des figures du monde animal dessinées en couleurs vives, diffère sensiblement de la structure des horloges murales classiques. Ludique et pédagogique à la fois, *Zoo* permet aux enfants d'apprendre l'heure en s'amusant. Existe en différents modèles : *Omar* le hibou, *Fernando* le poisson, *Talulah* le toucan et *Elihu* l'éléphant.

Uffizi bunk bed, 2006

Jenny Argie (USA, 1970–) & Andrew Thornton (USA, 1974–)

www.argington.com
Hard wood, birch plywood
Massivholz, Birkenschichtholz
Bois dur, contreplaqué de bouleau
↕ 196 cm ↔ 229 cm ⤢ 119 cm
Argington, Brooklyn (NY), USA

The American artist, Jennie Argie, and the architect and mathematician, Andrew Thornton, founded Argington Inc. in 2003 in order to manufacture modern-style children's furniture to their own design using sustainable methods of production. Their innovative *Uffizi* bunk bed can be used in the traditional way to accommodate two children, but then as a child gets older it can be converted into a stylish loft bed with a desk underneath.

Die amerikanische Künstlerin Jennie Argie und der Architekt und Mathematiker Andrew Thornton gründeten 2003 das Unternehmen Argington Inc., um selbst entworfene moderne Möbel für Kinder unter Verwendung nachhaltiger Produktionsmethoden herzustellen. Ihr innovatives *Uffizi*-Etagenbett kann traditionell für zwei Kinder genutzt werden, lässt sich aber auch zu einem schicken Hochbett mit einem Schreibtisch darunter umfunktionieren, wenn ein Kind größer wird.

L'artiste américaine Jennie Argie et l'architecte mathématicien Andrew Thornton fondent Argington Inc. en 2003. Leur ambition est de fabriquer des meubles pour enfants originaux, dans un style moderne tout en utilisant des méthodes durables de production. Innovant, leur lit superposé *Uffizi* s'utilise non seulement de manière classique, mais propose également une nouvelle configuration. Lorsque l'enfant grandit le lit inférieur se transforme en bureau, conférant à *Uffizi* un style loft.

Garden
Für den Garten
Jardinage

The original concept for this unusual bird feeder dates from 1991, but the updated design was only put into production a full decade later. Like other designs by Jasper Morrison, it is a simple and functional product with an essential logic: the upper disk of plastic provides shelter from the rain, while the lower one supplies ample space for our little feathered friends and their birdseed. The hanger-like hook also allows for easy placement, either from a branch or outside a window.

Das ursprüngliche Konzept für diese ausgefallene Futterkrippe für Vögel stammt aus dem Jahr 1991, aber mit der Produktion des überarbeiteten Designs wurde erst zehn Jahre später begonnen. Wie andere Designs von Jasper Morrison ist auch der *Bird Table* eine schlichtes, funktionales Produkt mit einer essentiellen Logik: Die obere Plastikscheibe schützt vor Regen, während die untere reichlich Platz für unsere kleinen gefiederten Freunde und ihr Futter bietet. Das Ganze lässt sich mühelos an einem Ast oder vor einem Fenster aufhängen.

Le concept original derrière cette singulière mangeoire à oiseaux date de 1991 mais elle n'a été mise en fabrication sous une version remise à jour qu'une bonne décennie plus tard. Comme d'autres créations de Jasper Morrison, c'est un produit simple et fonctionnel répondant à une logique essentielle : le disque supérieur en plastique protège de la pluie tandis que celui du dessous accueille nos petits amis à plumes et les graines. Le grand crochet permet de la suspendre facilement à une branche ou devant une fenêtre.

Bird Table bird feeder, 1991

Jasper Morrison (UK, 1959–)

www.magisdesign.com
Stainless steel, injection-moulded polypropylene
Edelstahl, spritzgegossenes Polypropylen
Acier inoxydable, polypropylène moulé par injection
↕ 98.5 cm ⌀ 42 cm
Magis, Motta di Livenza, Italy

A dog is supposedly a man's best friend, so it is only fitting that faithful Fido should get his own designer kennel. Michael Young's *Dog House* is perfect for smaller dogs, and comes with a brass plate inscribed in Latin with the words: *amicus fidelis protectio fortis* ('faithful friend, strong protector'); or which can equally be personalized with a dog's name. Unlike most kennels on the market, this design is stylishly chic and would suit the most aesthetically discerning canine-lover.

Der Hund ist angeblich der beste Freund des Menschen, und daher soll der treue Bello auch seine eigene Designer-Hütte haben. Michael Youngs *Dog House* eignet sich perfekt für kleinere Hunde und ist mit einem Messingschild mit der lateinischen Aufschrift *amicus fidelis protectio fortis* (treuer Freund und starker Beschützer) versehen. Das Schild kann jedoch auch mit dem Namen des Hundes beschriftet werden. Anders als die meisten Hundehütten auf dem Markt, gefällt dieses schicke Design sicherlich auch dem ästhetisch anspruchsvollsten Hundeliebhaber.

Le chien étant censé être le meilleur ami de l'homme, il est normal que notre fidèle Médor ait sa propre niche de créateur. *Dog House* de Michael Young convient aux petits chiens et est ornée d'une plaque en laiton portant l'inscription en latin : *amicus fidelis protectio fortis* (« ami fidèle protection forte »). Elle peut aussi être personnalisée avec le nom du toutou. Contrairement à la plupart des niches sur le marché, celle-ci est d'un chic qui satisferait les amateurs de chiens les plus esthètes.

Dog House kennel, 2001

Michael Young (UK, 1966–)

www.magisdesign.com
Rotation-moulded polyethylene, stainless steel, brass
Im Rotationsgussverfahren hergestelltes Polyethylen, Edelstahl, Messing
Polyéthylène moulé par rotation, acier inoxydable, laiton
↕ 75.5 cm ↔ 48.5 cm ↗ 89 cm
Magis, Motta di Livenza, Italy

Like many of the household products manufactured by oxo International, the *Good Grips Outdoor Pour & Store* watering cans have numerous innovative features and user benefits – from their non-slip, easy-to-hold handles to their ingenious rotating spouts that make it easier to both fill the cans and store them. Available in three sizes, the designs also come with rose attachments that provide a fine spray when required, but which fit conveniently into the filling hole when not in use.

Wie viele Haushaltsartikel von oxo International besitzt auch die Gießkanne *Good Grips Outdoor Pour & Store* zahlreiche innovative Merkmale und Vorteile für den Benutzer – von dem rutschfesten, leicht zu handhabenden Griff bis zu dem raffinierten, beweglichen Ausgießer, durch den sich die Kanne leicht füllen und verstauen lässt. Zu dem Design gehört auch ein Ausgießeraufsatz für feinen Sprühnebel, der sich oben auf der Kanne einstecken lässt, wenn er nicht gebraucht wird.

Comme bon nombre des articles pour la maison fabriqués par oxo International, l'arrosoir *Good Grips Outdoors Pour & Store* présente de nombreux avantages et détails innovants, de son manche antidérapant et ergonomique à son ingénieux bec rotatif qui facilite à la fois le remplissage et le rangement. Il s'accompagne d'une pomme supplémentaire qui assure une délicate vaporisation et se range à l'intérieur de l'arrosoir quand elle ne sert pas.

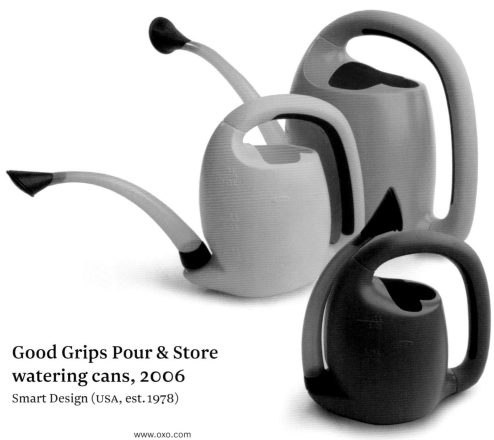

Good Grips Pour & Store watering cans, 2006

Smart Design (USA, est. 1978)

www.oxo.com
Thermoplastic, Santoprene
Thermoplastik, Santopren
Thermoplastique, Santoprene.
1, 3, 8 l
oxo International, New York City (NY), USA

Stelton Classic watering can, 1978

Peter Holmblad (Denmark, 1934–)

www.stelton.com
Stainless steel
Edelstahl
Acier inoxydable
1.5 l
Stelton, Copenhagen, Denmark

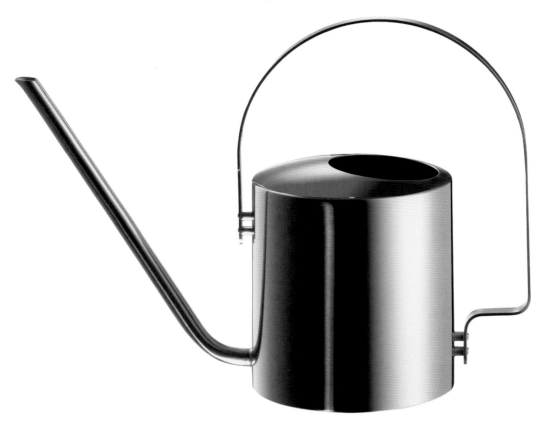

The managing director and owner of Stelton until 2004, Peter Holmblad is also a highly accomplished designer who has designed numerous homewares for the company. His satin-polished, stainless-steel watering can has a 1.5-litre capacity and is a beautiful example of high-quality Danish craftsmanship. Perfectly balanced, both functionally and aesthetically, this is a watering can that deserves to be seen.

Peter Holmblad war bis 2004 Direktor und Eigentümer von Stelton, ist aber auch ein sehr fähiger Designer, der zahlreiche Produkte für das Unternehmen entworfen hat. Seine Blumengießkanne aus matt poliertem Edelstahl fasst 1,5 Liter und ist ein schönes Beispiel für hochwertige dänische Handwerkskunst. Die sowohl funktional als auch ästhetisch perfekt ausgewogene Gießkanne ist ein echter Hingucker.

Directeur et propriétaire de Stelton jusqu'en 2004, Peter Holmblad est également un éminent designer qui a conçu de nombreux objets pour la maison pour sa société. En acier inoxydable poli et satiné, son arrosoir d'une capacité de 1,5 litre est un superbe exemple du design danois de grande qualité. Parfaitement équilibré, tant sur plan esthétique que fonctionnel, c'est un objet qui mérite d'être vu.

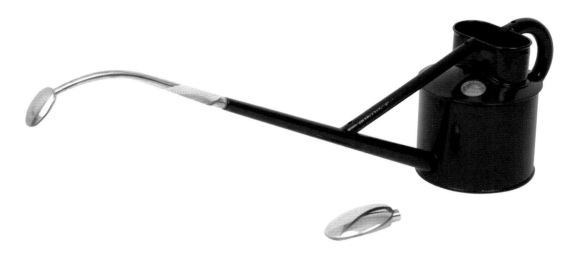

Professional Long Reach Watering Can, c. 1886

John Haws (UK, active 1880s–1890s)

www.haws.co.uk
Heavy gauged steel, galvanised steel, brass
Stahlprofile, verzinktes Stahlblech, Messing
Acier calibré, acier galvanisé, laiton
3.5 l, 4.5 l, 8.8 l
Haws Watering Cans, West Midlands, UK

Haws has been manufacturing watering cans since 1886, including its classic long-reach models that come with an oval-shaped brass rose to provide a gentle spray for delicate seedlings. Available in a range of colours and three different capacities, this watering can not only reflects Britain's industrial manufacturing heritage, but also demonstrates the way a design that's honed over decades can be unsurpassed.

Die Firma Haws produziert seit 1886 Gießkannen, darunter die klassischen Modelle mit langem Ausgussrohr und ovalem Brausekopf aus Messing, mit dem zarte Sämlinge sanft beregnet werden können. Die Kanne ist in drei Größen und in verschiedenen Farben lieferbar. Sie ist nicht nur ein Beispiel für Großbritanniens industrielles Erbe, sondern auch dafür, dass ein über Jahrzehnte immer wieder in Details verbessertes Design unübertroffen bleibt.

Haws fabrique des arrosoirs depuis 1886, notamment ce modèle à longue portée de forme ovale. La pomme en laiton inversée vers le haut génère une pluie douce pour tous les végétaux, même les plus fragiles. Disponible en plusieurs couleurs et en trois capacités, cet arrosoir reflète non seulement l'héritage industriel britannique, mais démontre également la volonté du design d'évoluer sans jamais renier les valeurs sûres des objets bien conçus.

With a royal warrant, the Hill Brush Company specialises in the design and manufacture of high-quality brushes and buckets. Certainly the 10-litre *MBK4* is definitely not your average pail – it is quite a bit more expensive and extraordinarily well made, too. As a utilitarian object, it powerfully demonstrates that working tools can have an inherent beauty when their design is derived from their pure function.

Die Hill Brush Company – Hoflieferant der britischen Krone – hat sich auf die Gestaltung und Herstellung hochwertiger Bürsten und Eimer spezialisiert. Der 10-Liter-Eimer *MBK4* aus Edelstahl ist definitiv nicht „Null-Acht-Fünfzehn". Er ist ein bisschen teurer als andere, außerordentlich gediegen verarbeitet und beweist eindrucksvoll, dass auch Gebrauchsgegenstände schön sein können, wenn ihre Formgebung sich harmonisch aus der Funktion ergibt.

Honorée par un mandat royal, la société Hill Brush est spécialisée dans la conception et la fabrication de brosses et de seaux de grande qualité. Certes un peu plus coûteux qu'un seau ordinaire, le modèle *MBK4* de 10 litres demeure un objet utilitaire d'une conception parfaite. Ce seau confirme que les outils de travail possèdent également une beauté intrinsèque lorsque leur design découle de leur fonction pure.

MBK4 Stainless Steel Bucket, 2001
Hillbrush Design Team

www.hillbrush.com
Stainless steel
Edelstahl
Acier inoxydable
10 l
The Hill Brush Company Ltd, Wiltshire, UK

Portobello planters, 1979

Jonathan De Pas (Italy, 1932–1991), Donato D'Urbino (Italy, 1935–)
& Paolo Lomazzi (Italy, 1936–)

www.zanotta.it
Anodised aluminium alloy, moulded ABS
Eloxierte Aluminiumverbindung, geformtes ABS
Alliage d'aluminium anodisé, ABS moulé
↕ 33 cm ↔ 82 cm ↗ 41 cm
↕ 38 cm ↔ 41 cm ↗ 41 cm
Zanotta, Nova Milanese, Italy

In the late 1970s an industrial aesthetic became very fashionable in product and furniture design, and De Pas, D'Urbino and Lomazzi's *Portobello* planter epitomised this new if short-lived macho style. Still in production, the no-nonsense *Portobello* window box and matching flowerpots look fantastic when planted up, as their unrelenting industrial aesthetic offers an engaging visual tension between man-made and natural worlds.

Ende der 1970er Jahre wurden Produkte und Möbel im „Industrie-Look" modern und die *Portobello*-Pflanzkübel von De Pas, D'Urbino und Lomazzi entsprachen ganz diesem neuen, wenn auch kurzlebigen maskulinen Stil. Die schlichten Balkonkästen und Übertöpfe dieser Serie werden heute noch produziert und sehen bepflanzt fantastisch aus, da ihre Industrieästhetik eine ansprechende visuelle Spannung zwischen dem Produkt von Menschenhand und den Produkten der Natur erzeugt.

Très à la mode à la fin des années 70, l'esthétique industrielle se rencontre partout dans les produits comme dans le mobilier. Le pot *Portobello* de De Pas, D'Urbino et Lomazzi incarne cet éphémère engouement au style macho. Ce pot de fleurs *Portobello* est fantastique lorsqu'il est placé en hauteur. Son esthétique industrielle insuffle un agréable rapprochement entre l'homme et la nature.

Good Grips Container Garden Set gardening tools, 2005

Smart Design (USA, est. 1978)

www.oxo.com
Thermoplastics (including Santoprene), stainless steel
Kunststoff (einschließlich Santopren), Edelstahl
Plastiques (dont Santoprene), acier inoxydable
OXO International, New York City (NY), USA

This compact set of tools was designed specifically for container gardening and features soft, non-slip grips so that even people with arthritic hands can tend to their plants in comfort. The tools have other 'inclusive design' features too, including the trowel's easy-to-read measurement markings, and the floral snips' finger loop that provides extra stability. Furthermore, the tools can also be stored conveniently in their matching and easily transportable caddy.

Dieses kompakte Werkzeugset wurde eigens für Blumenkästen entworfen und hat weiche, rutschfeste Griffe, so dass selbst Menschen mit Arthritis bequem ihre Pflanzen versorgen können. Die Werkzeuge besitzen auch andere „inklusive" Designmerkmale, beispielsweise die einfach abzulesenden Maßeinteilungen auf der Pflanzkelle oder der Fingerring an der Blumenschere, der für zusätzliche Stabilität beim Schneiden sorgt. Außerdem können die Werkzeuge bequem in der passenden und leicht zu transportierenden Tasche verstaut werden.

Ce jeu d'outils compact, conçu spécifiquement pour l'entretien des bacs et des pots de fleurs, présente des poignées souples et antidérapantes afin que même les jardiniers arthritiques puissent travailler confortablement. Les outils présentent d'autres caractéristiques de « conception inclusive » telles que les graduations facilement lisibles sur la truelle ou la boucle pour le pouce sur les cisailles qui assure une stabilité supplémentaire. Enfin, le jeu se range dans un panier assorti facilement transportable.

Having made fine hand-forged tools for almost one hundred years, the third generation of the Sneeboer family continues this tradition by producing more than 200 different models. In fact, the company manufactures an unbelievable range of trowels and other tools designed for specific tasks, such as dandelion digging, potting or transplanting. The choice of true plantsmen, Sneeboer tools combine age-old craftsmanship with design innovation – the FSC-certified wood handles make them a greener choice, too.

Seit fast hundert Jahren stellt die Firma Sneeboer handgeschmiedete Gartenwerkzeuge her und produziert heute 200 verschiedene Modelle, unter anderem eine unglaubliche Vielzahl von Schaufeln und Schäufelchen sowie Wurzelstechern für verschiedene gärtnerische Zwecke. Sneeboer-Geräte verbinden bewährte handwerkliche Fertigung mit innovativem Design. Sie sind deshalb vielfach für erfahrene Gärtner die erste Wahl – und aufgrund ihrer FSC-zertifizierten Griffe aus dem nachwachsenden Rohstoff Kirschbaum auch eine umweltbewusste Wahl.

Depuis près d'un siècle Sneeboer fabrique des outils forgés à la main, perpétrant cette tradition à travers plus de deux cents modèles. De fait, cette entreprise produit une collection impressionnante de truelles et autres outils conçus pour des tâches spécifiques, telles que bêcher le pissenlit, mettre en pot ou transplanter. Indispensables à tous les jardiniers, les outils Sneeboer combinent un savoir-faire artisanal à un design innovant. Les manches en bois certifié FSC assure un choix écologique non négligeable.

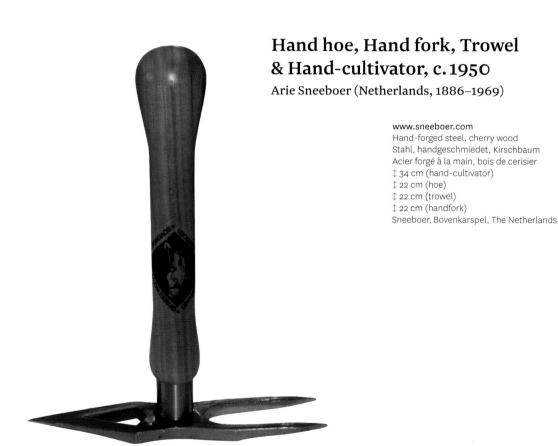

Hand hoe, Hand fork, Trowel & Hand-cultivator, c. 1950

Arie Sneeboer (Netherlands, 1886–1969)

www.sneeboer.com
Hand-forged steel, cherry wood
Stahl, handgeschmiedet, Kirschbaum
Acier forgé à la main, bois de cerisier
↕ 34 cm (hand-cultivator)
↕ 22 cm (hoe)
↕ 22 cm (trowel)
↕ 22 cm (handfork)
Sneeboer, Bovenkarspel, The Netherlands

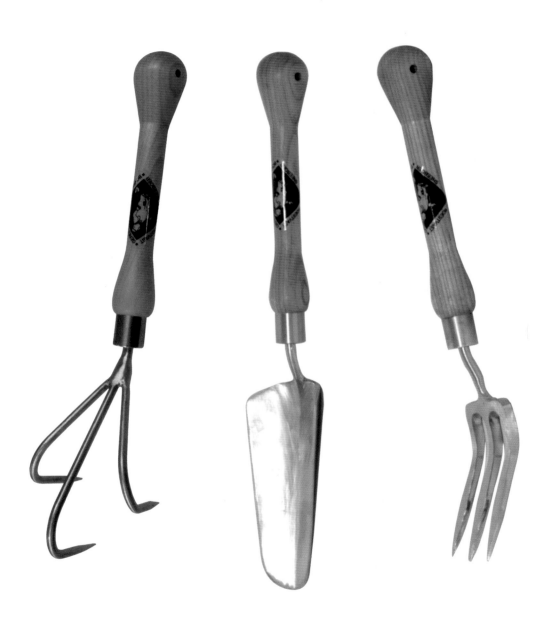

Felco 22 Classic two-hand pruning shears, c. 1970 & Felco 7 Classic secateurs, c. 1970

Felco Design Team

www.felco.com
Forged aluminium alloy, hardened steel, plastic
Geschmiedete Aluminiumlegierung, gehärteter Stahl, Kunststoff
Alliage d'aluminium forgé, acier trempé, plastique
↕ 84 cm
↕ 21 cm
Felco, les Geneveys-sur-Coffrane, Switzerland

The words 'Swiss made' are a good indicator of design excellence and high-quality manufacturing, and this is certainly the case for Felco garden tools. Reliable, efficient and ergonomic, Felco shears and secateurs have handles forged from aluminium and blades made of high-quality steel, which ensures they cut cleanly and precisely. These high-performance products are also incredibly durable and come with a lifetime guarantee.

Das Warenzeichen „Swiss made" ist ein verlässlicher Indikator für hochwertiges Design und hervorragende Verarbeitung. Das gilt auch für die Gartengeräte von Felco. Die Garten- und Astscheren der Firma sind solide, effizient und ergonomisch gestaltet, haben geschmiedete Aluminiumgriffe und Klingen aus hochwertigem Stahl, so dass man mit ihnen saubere Schnitte ausführen kann. Es sind Hochleistungsgeräte, deren Verschleißteile austauschbar sind und die daher extrem lange halten.

La mention « fabriqué en Suisse » certifie un design d'excellence et une fabrication de grande qualité, à l'instar des outils de jardin Felco. Performants, fiables et ergonomiques, l'élagueur et le sécateur Felco possèdent des poignées en aluminium forgé et des lames en acier trempé d'excellente qualité, pour une coupe nette et précise. Ces outils s'avèrent extrêmement résistants et sont garantis à vie.

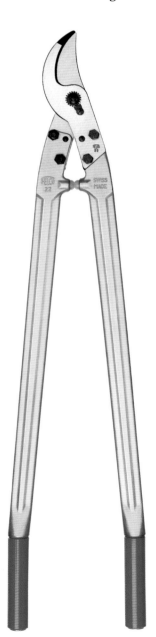

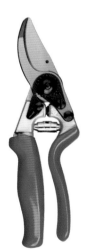

Bahco 23-inch hedge shears (model no. P51), 1960s

Bahco Design Team

www.bahco.com
Hardened steel, rubber
Gehärteter Stahl, Gummi
Acier trempé, caoutchouc
↕ 58.4 cm
Bahco, Enköping, Sweden

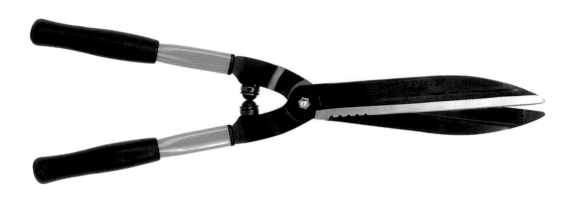

In the harsh climate of Sweden, tools have historically been incredibly important for survival, so it is not surprising that one of the best tool manufacturers is a Swedish company, Bahco. For over 150 years it has produced superior-quality products, from saws to screwdrivers. Its 23-inch hedge shears, for instance, are functionally precise and directly informed by ergonomic considerations for better user safety.

Im rauen Klima Schwedens sind agrar- und forstwirtschaftliche Geräte seit jeher überlebenswichtig. Deshalb ist es nicht verwunderlich, dass die schwedische Firma Bahco zu den weltweit besten Werkzeugherstellern zählt. Seit über 150 Jahren produziert sie von Sägen bis Schraubenziehern alles, was man für Arbeiten in Haus und Garten an Gerätschaften braucht – und das in Spitzenqualität. Die abgebildete Heckenschere arbeitet präzise und ist mit dem Ziel der höheren Arbeitssicherheit ergonomisch geformt.

En Suède, les outils se révèlent extrêmement importants pour la survie, de par les conditions climatiques très rudes. Ainsi, n'est-il pas surprenant que l'un des meilleurs fabricants d'outils soit suédois. Depuis cent cinquante ans, Bahco réalise des produits de très grande qualité, des scies aux tournevis. Conçue de manière ergonomique, cette cisaille à haie de cinquante-sept centimètres démontre une fonctionnalité précise et assure une parfaite sécurité pour les utilisateurs.

The British love of gardening is legendary, and some of the best gardening tools in the world are produced by the British company, Bulldog. Established in 1780, the company has a long history, and its current *Premier* range of tools includes a plethora of different forks and spades for different soil conditions and functions – borders, potato digging, shrubberies, spiking, planting and more.

Dass die Briten begeisterte Gärtner sind, ist allseits bekannt. Die traditionsreiche, 1780 gegründete britische Firma Bulldog produziert noch heute einige der weltweit besten Gartengeräte. Ihre aktuelle *Premier*-Serie umfasst viele verschiedene Grabgabeln und Spaten für unterschiedliche Böden und Arbeitsgänge, als da sind: Blumenbeete umgraben, Kartoffeln ernten, Wurzelwerk roden, Unkraut jäten, Pflanzlöcher graben, etc..

La passion des Anglais pour le jardinage est légendaire. De fait, la société britannique Bulldog Tools produit le *nec plus ultra* des outils de jardin fabriqués dans le monde entier. Fondée en 1780, cette entreprise crée la collection *Premier* comprenant une pléthore de fourches et de pelles, adaptées au sol et à leur fonction pour travailler les plate-bandes, les massifs d'arbustes, bêcher le sol à pommes de terre, et réaliser tous types de plantations.

Premier Garden Spade, c. 1900
& Premier Border Fork, c. 1900
Bulldog Design Team

www.bulldogtools.co.uk
Solid forged steel, ash
Stahl, geschmiedet, Esche
Acier forgé, frêne
↕ 100, 110 cm
↕ 100 cm
Bulldog Tools, Wigan, England

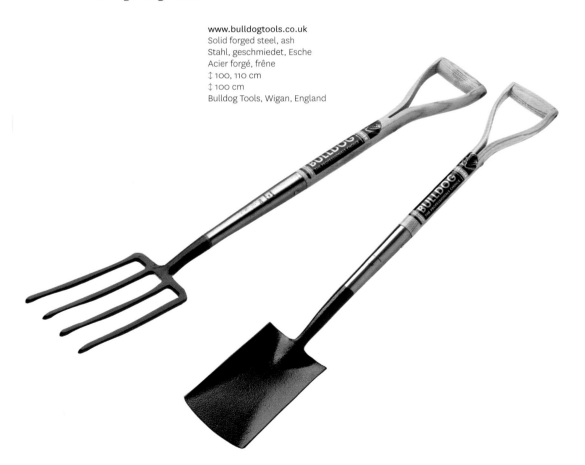

Springbok Lawn Rake 54", c. 1900 (original design) & Nail Tooth Garden Rake, c. 1900

Bulldog Design Team

www.bulldogtools.co.uk
Fibreglass, steel
Glasfaser, Stahl
Fibre de verre, acier
↕ 165 cm
↕ 122 cm
Bulldog Tools, Wigan, England

The Bulldog Tools' factory has the only working forge still making garden tools in the United Kingdom. Using a unique specification of steel, the tools, such as the *Nail Tooth Garden Rake*, have an inherent flexibility that allows them to absorb shock and pressure without distorting. The company produces thirty-four different rakes for a host of gardening tasks including many with fiberglass handles, such as the *Springbok Lawn Rake*, for added strength and reduced weight.

Das Bulldog-Werk ist die einzige industrielle Schmiede in Großbritannien, die heute noch aus einem speziellen Stahl Gartengeräte herstellt, zum Beispiel diesen „Klauen-Zahn-Gartenrechen". Alle Geräte sind so biegsam, dass sie Stöße und Druck aushalten, ohne sich zu verformen. Bulldog produziert verschiedene Rechen und Harken, viele mit Glasfasergriffen wie etwa den besonders starken, dabei aber sehr leichten Laubrechen *Springbok Lawn Rake*.

Bulldog Tools possède la seule forge fabriquant aujourd'hui encore des outils de jardinage au Royaume-Uni. Utilisant une spécification unique de l'acier, ses outils tels que le râteau à feuilles *Nail Tooth* illustrent une souplesse inhérente permettant d'amortir la pression et les chocs, sans distorsion. Cette société fabrique trente-quatre râteaux différents afin de réaliser une multitude de travaux de jardin. La plupart sont équipés de manches en fibre de verre, notamment le râteau *Springbok*, pour une plus grande résistance et un poids réduit.

Serralunga was one of the first companies to manufacture avant-garde designs using rotational moulding, a plastics moulding process that had previously been used solely for the production of large, hollow, industrial casings. For his design of the *New Wave* planter, Ross Lovegrove has pushed the formal boundaries of this technique, and created a sculptural organic form that poetically expresses the oozing nature of heated plastic.

Serralunga war eines der ersten Unternehmen, das avantgardistische Designs im Rotationsgussverfahren herstellte. Dieses Verfahren wurde vorher nur bei der Produktion von großen, hohlen Industriebehältern aus Kunststoff angewandt. Für sein Design des *New Wave*-Blumentopfs hat Ross Lovegrove die formalen Grenzen dieser Technik ausgereizt und eine sklupturale organische Form geschaffen, die auf poetische Weise das Fließende von erhitztem Kunststoff zum Ausdruck bringt.

Serralunga est l'une des premières entreprises à fabriquer des créations avant-gardistes utilisant le moulage par rotation. Ce processus consiste à mouler des matières plastiques selon le même procédé employé pour la production des grands revêtements industriels. Pour concevoir le vase *New Wave*, Ross Lovegrove a repoussé les limites formelles de cette technique, créant une forme sculpturale organique qui exprime poétiquement la nature « transpirante » du plastique chauffé.

New Wave planter, 2007

Ross Lovegrove (UK, 1958–)

www.serralunga.com
Polyethylene
Polyethylen
Polyéthylène
↕ 92 cm ⌀ 77 cm
Serralunga, Biella, Italy

For the design of the *Flow* planter, sophisticated CAD software was used to create its dynamic, flowing lines that seamlessly meld into one another. The result is the very antithesis of the traditional flowerpot and, at up to two metres high, is instead a sculptural *tour de force* that would liven up any garden, terrace or patio. Remarkably, it is made using rotational moulding, the same technology used to create municipal refuse bins, so that as well as looking beautiful, it is also extremely durable.

Für das Design des *Flow*-Blumentopfs wurde hochentwickelte CAD-Software eingesetzt, so dass dynamische, fließende Linien entstehen, die nahtlos miteinander verschmelzen. Das Ergebnis ist die absolute Antithese des traditionellen Blumentopfes und mit bis zu zwei Metern Höhe eher eine skulpturale *Tour-de-force*, die jeden Garten, jede Terrasse und jeden Innenhof bereichert. *Flow* wird im Rotationsgussverfahren hergestellt, die gleiche Technologie, die auch bei der Herstellung von städtischen Mülleimern angewendet wird – ein Design, das nicht nur schön aussieht, sondern auch äußerst langlebig ist.

Flow a été réalisé grâce à un logiciel très sophistiqué de CAD, afin de créer des lignes sinueuses fluides et dynamiques, changeant d'apparence selon l'angle de vue. Cette création s'avère l'antithèse du pot de fleurs classique, allant jusqu'à deux mètres de hauteur. Un véritable tour de force sculptural, idéal dans un jardin, sur une terrasse ou dans un patio. Fabriquée suivant la même technologie utilisée pour les poubelles municipales, le moulage par rotation, cette création offre une esthétique sublime tout en étant extrêmement résistante.

Flow planter, 2007
Zaha Hadid (Iraq/UK, 1950–) & Patrik Schumacher (Germany, 1961–)

www.serralunga.com
Polyethylene
Polyethylen
Polyéthylène
↕ 120 cm ↔ 117 cm (medium)
↕ 200 cm ↔ 146 cm (large)
Serralunga, Biella, Italy

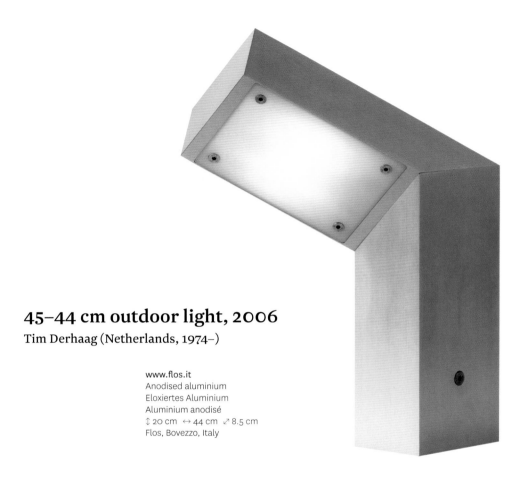

45–44 cm outdoor light, 2006

Tim Derhaag (Netherlands, 1974–)

www.flos.it
Anodised aluminium
Eloxiertes Aluminium
Aluminium anodisé
↕ 20 cm ↔ 44 cm ↗ 8.5 cm
Flos, Bovezzo, Italy

Young designer Tim Derhaag goes back to his Dutch roots with his pared-down *45–44 cm* outdoor light, which harks back to the unrelenting geometric formalism of the De Stijl movement. This articulated light has a strong sculptural quality and can be floor, wall or ceiling mounted. It can also be used indoors or outdoors thanks to its sturdy die-cast aluminium construction.

Mit seiner schlichten Leuchte *45–44 cm* für den Innen- oder Außenbereich kehrt der Designer Tim Derhaag zu seinen niederländischen Wurzeln zurück, das heißt zum strengen Formalismus der De-Stijl-Bewegung. Das gegliederte Modell von starker skulpturaler Qualität ist als Stand-, Wand- oder Deckenleuchte erhältlich. Mit ihrem robusten Aluminiumkörper eignet sie sich aber besonders für den Außenbereich.

Jeune designer, Tim Derhaag s'inspire de ses origines néerlandaises pour créer cet éclairage extérieur, *45–44 cm*, fortement inspiré par le formalisme géométrique implacable du mouvement De Stijl. Cette lampe articulée possède une qualité sculpturale non négligeable, s'installant sur un plancher, au mur ou au plafond. Cette création s'utilise à l'intérieur ou en extérieur, grâce à sa fabrication en aluminium coulé.

Like his architect father Carlo, the Italian designer Tobia Scarpa has an innate sense of mass and proportion, which gives his work a distinctive presence. Originally designed in the early 1970s, the *Tamburo* outdoor light has a triangular-sectioned stem and screened glass diffusers, giving it a strong architectural quality. Coated in polyurethane paint, the design is weather-resistant and, with its tilted head, provides both direct and indirect light – making it an ideal choice for lighting pathways.

Wie schon sein Vater, der Architekt Carlo Scarpa, besitzt auch der italienische Designer Tobia Scarpa ein angeborenes Gespür für Masse und Proportion, das seinen Arbeiten eine unverkennbare Präsenz verleiht. Die bereits in den frühen 1970er Jahren entworfene *Tamburo*-Pollerleuchte hat einen dreikantigen, untergliederten „Stamm" und verglaste Leuchtkörper, was ihr eine starke architektonische Qualität verleiht. Die Beschichtung mit Polyurethan macht das Design wetterfest, der geneigte Leuchtenkopf bietet direktes und indirektes Licht – einfach eine ideale Wahl, um Fußwege auszuleuchten.

Le designer italien Tobia Scarpa a un sens inné de la masse et de la proportion, donnant à son travail une présence distinctive. Conçu au début des années 70, l'éclairage extérieur *Tamburo* comporte une tige à section triangulaire qui renferme l'appareillage. Une tête inclinée abrite les sources lumineuses, offrant une lumière directe ou indirecte. Enduit de peinture polyuréthane, ce design intemporel révèle une forte qualité sculpturale et résiste aux intempéries. Idéal sur une terrasse ou dans une allée.

Tamburo Pole outdoor light, 2006

Tobia Scarpa (Italy, 1935–)

www.flos.it
Polyurethane-coated die-cast aluminium, glass
Aluminiumspritzguss mit Polyurethanbeschichtung, Glas
Enduit de polyuréthane, fonte d'aluminium, verre
↕ 40 cm ⌀ 35 cm
Flos, Bovezzo, Italy

Lighthouse oil lamp, 2007

Christian Bjørn (Denmark, 1944–)

www.menu.as
Porcelain, stainless steel, glass
Porzellan, Edelstahl, Glas
Porcelaine, acier inoxydable, verre
↕ 22, 35, 50, 65 cm
Menu, Fredensborg, Denmark

As the designer, Christian Bjørn observes: 'This oil lamp doesn't burn with just a little flame, it burns like a fantastic bonfire!' Winner of a Red Dot Award and an iF Industrial Design Award, this lamp has a form reminiscent of a lighthouse and produces a similarly reassuring glow at night. Its unique filling system allows it to be easily replenished from the top, and it is also available in four different sizes, which look great when grouped together.

„Diese Öllampe brennt nicht nur mit einer kleinen Flamme, sie brennt wie ein fantastisches Feuer", so der Designer Christian Bjørn. Die Form der Lampe, die mit einem Red Dot Award und einem iF Industrial Design Award ausgezeichnet wurde, erinnert an einen Leuchtturm und verbreitet am Abend einen beruhigenden Lichtschein. Durch das einzigartige Auffüllsystem kann das Öl von oben eingefüllt werden. Die Lampe ist in vier verschiedenen Größen erhältlich und sieht besonders gut aus, wenn sie zu mehreren aufgestellt wird.

Comme l'observe le designer Christian Bjørn : « Cette lampe à huile ne brûle pas d'une simple petite flamme mais tel un formidable feu de joie ! » Lauréate d'un prix Red Dot et d'un iF Industrial Design award, *Lighthouse* évoque un phare dont elle produit le halo rassurant la nuit. Son système de remplissage permet de verser l'huile par le haut. Il en existe quatre tailles différentes qui sont du plus bel effet quand elles sont regroupées.

Yin Yang loungers, 2006

Nicolas Thomkins (Switzerland, 1953–)

www.dedon.de
Woven synthetic fibre
Geflochtene Synthetik-Fasern
Tissés en fibres synthétiques
↕ 83 cm ⌀ 194 cm
Dedon, Lüneberg, Germany

Former Bayern Munich goalkeeper Bobby Dekeyser retired from football in 1990, and went on to develop a new synthetic fibre using traditional weaving techniques found on the Philippine island of Cebu. Ideal for outdoor furniture, Dedon is a durable fibre that is weatherproof and colourfast, as well as 100% recyclable. Various designers have since created visually stunning furnishings for the Dedon company, including Nicholas Thomkins' interlocking *Yin Yang* and Frank Ligthart's stacking *Obelisk* set from 2004 (shown overleaf).

Nachdem Bobby Dekeyser, Ex-Torwart von Bayern München, 1990 seine Karriere als Profifußballer beendet hatte, entwickelte er eine neue synthetische Faser unter Verwendung traditioneller Flechttechniken der philippinischen Insel Cebu. Die widerstandsfähige, wetter- und farbbeständige, zu 100% recycelbare Faser Dedon ist ideal für Outdoor-Möbel. Verschiedene Designer haben seitdem visuell verblüffende Möbel für Dedon entworfen. Dazu gehören auch Nicholas Thomkins' Sessel *Yin Yang* und Frank Ligtharts stapelbares Set *Obelisk* von 2004 (siehe die folgende Doppelseite).

L'ancien gardien de but du Bayern de Munich, Bobby Dekeyser développe à partir de 1990 une nouvelle fibre synthétique en utilisant les techniques traditionnelles de tissage de l'île philippine Cebu. Idéale pour les meubles de jardin, Dedon est une fibre durable, résistante aux intempéries et recyclable à 100 %. De nombreux designers ont créé des meubles à la fois originaux et élégants pour la société Dedon, notamment Nicholas Thomkins avec ses chauffeuses *Yin Yang* et Frank Ligthart, avec ses fauteuils empilables *Obelisk* en 2004 (voir double page suivante).

One of the best outdoor chairs to be launched in the last decade, Jerszy Seymour's *Easy Chair* is not only comfortable but also looks really good sitting on a terrace in the sun. Available in a choice of nine colours, including bright purple, fuchsia and yellow, the *Easy chair* stacks well, so it can be efficiently stored when not in use. Moreover, thanks to its thoughtful design, any rainwater is effectively funnelled down its fluted legs.

Jerszy Seymours *Easy Chair* ist einer der besten Stühle für Haus und Garten, die in den letzten zehn Jahren auf den Markt gekommen sind. Er ist nicht nur bequem, sondern sieht auch sehr gut aus, wenn er auf einer Terrasse in der Sonne steht. Der *Easy Chair* ist in neun verschiedenen Farben zu haben, darunter Violett, Fuchsia und Gelb, und lässt sich gut stapeln und verstauen, wenn er nicht gebraucht wird. Das durchdachte Design sorgt auch dafür, dass Regenwasser an den konkav geformten Beinen abläuft.

L'une des meilleures chaises d'extérieur lancée durant la décennie écoulé, l'*Easy Chair* de Jerszy Seymour n'est pas seulement confortable mais a également belle allure au soleil sur la terrasse. Disponible dans un choix de neuf couleurs, dont le violet vif, le fuchsia et le jaune vif, l'*Easy Chair* s'empile facilement. En outre, grâce à une ingénieuse conception, l'eau de pluie s'écoule facilement le long des pieds cannelés.

Easy Chair, 2004
Jerszy Seymour (UK, 1968–)

www.magisdesign.com
Injection-moulded, glass-fibre reinforced polypropylene
Spritzgegossenes, glasfaserverstärktes Polypropylen
Polypropylène renforcé de fibre de verre et moulé par injection
↕ 75 cm ↔ 59 cm ↗ 61 cm
Magis, Motta di Livenza, Italy

PIP-e chair, 2007

Philippe Starck (France, 1949)

www.driade.it
Polypropylene
Polypropylen
Polypropylène
↕ 83 cm ↔ 54.5 cm ⤢ 52.5 cm
Driade, Fossadello di Caorso, Italy

The small stackable *PIP-e* chair is made from tough polypropylene, which makes it ideal for the garden or patio. A modern reworking of a traditional metal chair, the *PIP-e* has a one-piece mono-bloc plastic construction and is available in four colours: white, anthracite grey, bright orange and lemon yellow. Although intended for outdoor use, this stylish yet well-priced design can also be used indoors.

Der kleine, stapelbare Sessels *PIP-e* aus robustem Polypropylen ist ideal für Hof und Garten. Der in den Farben Weiß, Anthrazit, Leuchtendorange und Limonengelb erhältliche *PIP-e* ist eine moderne Neuinterpretation des klassischen Metallstuhls. Auch wenn er für den Außenbereich konzipiert wurde, ist er auch für den Innenbereich geeignet.

Véritable prouesse technique, ce petit fauteuil monobloc en polypropylène repense la traditionnelle chaise de jardin en métal. Les lames qui le structurent apportent une grande légèreté. *PIP-e* reflète une élégance simple et efficace. Disponible en quatre couleurs : blanc, gris anthracite, orange vif et jaune citron. Inspiré des modèles des jardins publics, ce fauteuil s'utilise à l'intérieur comme à l'extérieur.

Tokyo-Pop chaise longue, 2003

Tokujin Yoshioka (Japan, 1967–)

www.driade.com
Polyethylene
Polyethylen
Polyéthylène
↕ 78.5 cm ↔ 157 cm ⤢ 74 cm
Driade, Milan, Italy

Tokujin Yoshioka is an extraordinarily talented designer, whose work effortlessly spans the cultural sensibilities of the East and the West. His mono-bloc *Tokyo-Pop* chaise is a sculptural masterpiece made from rotationally moulded plastic that can be used indoors or outdoors, and comes in black, white, anthracite or terracotta. Perfect for striking a pose, even in a wet bathing suit.

Tokujin Yoshioka ist ein außergewöhnlich talentierter Designer, dessen Arbeit mühelos das kulturelle Empfinden des Ostens und des Westens überspannt. Seine Monobloc-Liege *Tokyo-Pop* ist ein skulpturales Meisterwerk aus Rotationskunststoff, das sich sowohl für den Innen- als auch für den Außenbereich eignet und in Schwarz, Weiß, Anthrazit oder Terracotta zu haben ist. Perfekt, um sich in Pose zu werfen, selbst in einem nassen Badeanzug.

Designer extrêmement talentueux, Tokujin Yoshioka s'inspire naturellement des sensibilités culturelles de l'Orient et de l'Occident. Sa chaise longue monobloc *Tokyo-Pop* est un véritable chef-d'œuvre sculptural, en plastique moulé par rotation. Idéale aussi bien à l'extérieur qu'à l'intérieur, *Tokyo-Pop* existe en noir, blanc, anthracite ou terracotta. Une création invitant à la détente, même en maillot de bain mouillé.

Heaven outdoor chair, 2007

Jean-Marie Massaud (France, 1966–)

www.emu.it
Painted, pre-galvanized steel netting, painted tubular steel
Lackiertes, vorverzinktes Metallgeflecht, lackierte Stahlstangen
Grillage de fil d'acier prégalvanisé et peint, tubes d'acier peints
↕ 68 cm ↔ 92 cm ⤢ 78 cm
Emu, Marsciano, Italy

The *Heaven* chair is a very attractive design that almost hugs the sitter with its contoured seating section made of pre-galvanized wire netting. Available in white, grey, blue and green, it has a quiet elegance that is perfect in any outdoor setting. Two further versions of this chair are also available: both dining height yet with different seat widths. This lower armchair model, however, is perfect for relaxing.

Der Stuhl *Heaven* ist ein sehr attraktives Design, das den Benutzer durch die konturierte Sitzschale aus vorverzinktem Metallgeflecht buchstäblich umhüllt. Der in Weiß, Grau, Blau und Grün erhältliche Stuhl besitzt eine zurückhaltende Eleganz, die ihn in jedem Außenraum zur Geltung kommen lässt. Es gibt ihn auch mit einer etwas breiteren Sitzschale und als noch breiteres, niedrigeres Modell mit Armlehnen, das sich hervorragend zum Relaxen eignet.

La très séduisante chaise *Heaven* étreint presque celui qui s'assied dedans avec sa coque en grillage d'acier prégalvanisé. Disponible en blanc, gris, bleu et vert, son élégance discrète convient parfaitement à tous les décors extérieurs. Il en existe deux autres versions, une chaise avec une coque légèrement plus grande et un fauteuil encore plus ample et plus bas, idéal pour s'y détendre.

Swell outdoor furniture, 2007

Richard Schultz (USA, 1926–)

www.bebitalia.it
Cast, extruded and powder-coated aluminium, PVC, butyrate, Gore Tenara, stainless steel
Stranggepresster und pulverbeschichteter Aluminiumguss, PVC, Butyrate, Gore Tenara, Edelstahl
Fonte Aluminium revêtu et extrudé, PVC, butyrate, Gore Tenara, acier inoxydable
↕ 72 cm ↔ 76 cm ↗ 80 cm
B&B Italia, Novedrate, Italy

Inspired by his earlier *1966* collection of outdoor furniture, Richard Schultz recently designed the *Swell* range, which is more luxurious thanks to its generously ample proportions. In fact, according to B&B Italia, it is the only large-scale modular sling seating available on the market. Certainly, with the recent vogue for gardens and terraces being used as outdoor living rooms, the *Swell* seating collection would appear to be a perfect solution.

Inspiriert von seiner früheren *1966 Collection* von Möbeln für den Außenbereich, entwarf Richard Schultz vor kurzem die Kollektion *Swell*, die dank ihrer großzügigen Abmessungen noch luxiöser ist. Laut B&B Italia sind es die einzigen, auf dem Markt erhältlichen Drahtgitter-Sitzmöbel in Elementbauweise in dieser Größe. Da Gärten und Terrassen in jüngster Zeit immer mehr als Wohnzimmer im Freien genutzt werden, bietet sich die *Swell*-Sitzkollektion als perfekte Einrichtungslösung an.

Inspiré par sa première collection de mobilier de jardin *1966*, Richard Schultz a récemment conçu la ligne *Swell*, plus luxueuse grâce à ses proportions plus généreuses. Selon B&B Italia, c'est le plus grand ensemble de meubles d'extérieur modulaires en toile synthétique disponible sur le marché. Le fait est qu'avec la nouvelle mode des jardins et terrasses reconverties en salons en plein air, la ligne *Swell* semble offrir la meilleure solution.

Leaf outdoor furniture collection, 2005

Lievore Altherr Molina (Spain, est. 1991)

www.arper.com
Painted steel
Lackierter Stahl
Acier peint
↕ 82 cm ↔ 60 cm ↗ 48.5 cm (side chair)
↕ 79 cm ↔ 151.5 cm ↗ 56 cm (chaise longue)
↕ 73 cm ↔ 60 cm ↗ 56 cm (lounge chair)
Arper, Monastier di Treviso, Italy

Comprising a chaise longue, a lounge chair and two side chairs, the *Leaf* collection offers, according to its manufacturer, 'contemporary comfort inspired by nature'. With their structure echoing the veining of leaves, the natural habitat for these chairs is outdoors in a garden, and in the right light they throw evocative leaf-like shadows. These spectacular designs are available in white, mocha or green, and also come with optional cushions to provide greater comfort.

Die *Leaf*-Kollektion umfasst eine Liege, einen Armlehnsessel und zwei Stühle und bietet laut Hersteller zeitgenössischen, von der Natur inspirierten Komfort. Aufgrund ihrer Strukturen, die an Blattadern erinnern, ist ihr natürlicher Platz draußen im Garten. Im richtigen Licht werfen sie blattartige Schatten. Diese ausdrucksstarken Sitzmöbel sind in Weiß, Mokka oder Grün lieferbar; dazu gibt es passende Kissenauflagen.

Comprenant une chaise longue, un fauteuil lounge, et deux chaises, la collection *Leaf* offre « un confort contemporain inspiré par la nature ». Leur design en forme de feuille, les multiples nervures de la structure transportent inexorablement l'utilisateur au cœur du monde végétal. Lorsque la lumière se pose sur ces chaises de jardin, les « ombres de la nature » apparaissent. De petits coussins optionnels sont également disponibles. Ce mobilier existe en blanc, moka ou vert.

Woven cane furniture always looks wonderful in a conservatory or garden room, and can give a room an almost tropical colonial elegance. The Spanish architect-designer Oscar Tusquets Blanca's *Fina Filipina* armchair for Driade is no exception; its arching arms swoop down to form the design's front legs, giving the chair an almost animal-like poise. Intended for indoor use only, this design is available in blue or green cane and can be stacked four units at a time.

Korbmöbel passen wunderbar in jeden Wintergarten oder Garten und erzeugen je nach Designstil eine „koloniale" oder fernöstliche Atmosphäre. Der stapelbare *Fina Filipina*-Korbsessel, den der spanische Architekt und Möbeldesigner Ocar Tusquets Blanca für Driade entwarf, bildet da keine Ausnahme. Der Gestellrahmen der Rückenlehne setzt sich im großen Schwung über die Armlehnen fort und bildet so die Vorderbeine. Der Korbstuhl ist nur für den Innenbereich bestimmt und in Blau oder Grün erhältlich. Vier bis fünf Stück lassen sich aufeinander stapeln.

Les meubles en canne de rotin s'avèrent fantastiques dans un jardin d'hiver ou sur une terrasse, conférant une élégance coloniale. *Fina Filipina* de l'architecte designer espagnol Oscar Tusquets Blanca pour Driade ne déroge pas à la règle. Ses accoudoirs arqués descendent lentement et constituent les pieds avant du fauteuil, insufflant légèreté et équilibre. Empilable, *Fina Filipina* s'utilise uniquement en extérieur. Disponible en canne bleue ou verte. Un design à la fois simple, élégant et très confortable.

Fina Filipina stackable chair, 1993

Oscar Tusquets Blanca (Spain, 1941–)

www.driade.it
Steel, woven cane
Stahl, Rattangeflecht
Acier, canne de rotin
↕ 83.5 cm ↔ 65 cm ⤢ 62 cm
Driade, Fossadello di Caorso, Italy

Charlotte chair, 1994

Mario Botta (Italy, 1943–)

www.horm.it
Steel, woven rattan
Stahl, Rattangeflecht
Acier, canne de rotin
↕ 70 cm ↔ 90 cm ↗ 72 cm
Horm, Pordenone, Italy

A truly great architect, Mario Botta has also designed a number of landmark chairs. Made of natural woven rattan, the *Charlotte* chair is perhaps not as well known as some of his other seating designs, but is nevertheless worthy of note. Like his buildings, this armchair has a strong elemental quality that derives from Botta's use of bold geometric forms. Perfect for a garden room, this woven rattan chair is an interesting contemporary style option.

Mario Botta ist nicht nur ein wirklich großer Architekt, sondern hat auch Möbel entworfen, darunter eine Reihe außergewöhnlicher Stühle. Der Rattansessel *Charlotte* ist zwar nicht so bekannt wie seine anderen Sitzmöbel, aber dennoch bemerkenswert. Wie Bottas Bauten ist auch dieser Armlehnstuhl modular aus kraftvoll wirkenden geometrischen Formen aufgebaut. Dieser geflochtene Rattansessel ist als zeitgenössisches Designmöbel eine gute Wahl für den Wintergarten.

Grand architecte, Mario Botta a conçu plusieurs chaises, devenues des incontournables du design. Réalisé en rotin canné, le fauteuil *Charlotte* est certainement la moins connue de ses créations de sièges. Pourtant, il s'agit d'une pièce élégante et confortable. À l'instar de ses constructions, *Charlotte* dispose d'une qualité élémentaire simple due à sa forme géométrique audacieuse. Sobre et attirant, ce fauteuil mérite attention.

The *Kama Dyvan* outdoor seating system combines high-quality French craftsmanship with Gallic design chic. Available in a broad palette of colours and finishes, the *Kama Dyvan* can also be ordered with a wide variety of cushions. These can be combined in different ways, enabling the design to be customised according to the user's specific needs.

Die Gartenmöbel der Kollektion *Kama Dyvan* verbinden handwerklich qualitätvolle Verarbeitung mit französischer Eleganz. Die Möbel sind in verschiedenen Farben, mit unterschiedlichen Oberflächen und einer breiten Auswahl an Kissen lieferbar. Sie lassen sich individuell zusammenstellen – je nach Bedürfnissen und Geschmack des Bestellers.

Le canapé *Kama Dyvan* allie merveilleusement le savoir-faire français au design chic. Suivant la disposition des coussins, cette création modulable se transforme au gré de vos attentes. *Kama Dyvan* propose un design conceptuel novateur à l'élégance formelle. Disponible dans une importante palette de couleurs et de finitions, ce modèle dispose également d'une grande variété de coussins.

Kama Dyvan outdoor seating system, 2008
Benjamin Ferriol (France, 1981–)

www.egoparis.com
Aluminium, vinyl or outdoor upholstery
Aluminium, Vinyl oder wetterfeste Polsterung
Aluminium, vinyle ou ameublement extérieur
↕ 75 cm ↔ 210 cm ⤢ 88 cm
Ego Paris, Paris, France

1966 Collection outdoor lounger, 1966

Richard Schultz (USA, 1926–)

www.bebitalia.it
Powder-coated, cast and extruded aluminium, PVC, polyester, stainless steel
Stranggepresster und pulverbeschichteter Aluminiumguss, PVC, Polyester, Edelstahl
Fonte Aluminium revêtu et extrudé, PVC, polyester, acier inoxydable
↕ 90 cm ↔ 65 cm ⤢ 193 cm
B&B Italia, Novedrate, Italy

As Richard Schultz recalls: 'I designed the collection in 1966 at the request of Florence Knoll, who wanted well-designed outdoor furnishings that would withstand the corrosive salt air at her home in Florida. Through the years, the *1966 Collection* has earned a special place in the world of outdoor furniture'. Now manufactured by B&B Italia, this iconic outdoor furniture range still looks as stylishly fresh today as when it was first launched over forty years ago.

Richard Schultz entwarf die Kollektion 1966 auf Wunsch von Florence Knoll, die – so erinnert sich der Designer – „gut gestaltete Gartenmöbel haben wollte, die der zersetzenden Salzluft an ihrem Wohnsitz in Florida widerstehen würden. Über die Jahre hat sich die *1966 Collection* einen besonderen Platz in der Welt der Gartenmöbel erobert." Heute wird sie in einer Neuedition von B&B Italia produziert und sieht immer noch genauso modern und stilvoll aus wie bei ihrer Markteinführung vor über vierzig Jahren.

Richard Schultz se souvient : « J'ai conçu la *Collection 1966* à la demande de Florence Knoll, qui souhaitait un mobilier de jardin résistant aux intempéries, pour sa maison de Floride. Au fil des années, cette collection acquit une place privilégiée dans le monde du mobilier de jardin. » Fabriquée actuellement par B&B Italia, cette célèbre gamme créée pour le jardin a su garder son élégance et sa fraîcheur depuis son lancement il y a maintenant plus de quarante ans.

Summa tray table, 1993

Jesús Gasca (Spain, 1939–)

www.stua.com
Wenge, cherry or lacquered ash, aluminium, cotton
Wenge, Kirsche oder lackierte Esche, Aluminium, Baumwolle
Wengé, cerisier ou frêne laqué, aluminium, coton
↕ 42 cm ⌀ 54 cm
Stua, Astigarraga, Spain

Although not specifically intended for outdoor use, the *Summa* tray table is the perfect piece to use when dining *al fresco* in the summer. It folds flat for easy storage, and the removable tray can be used to ferry food, plates and cutlery between the kitchen and a covered terrace or outside eating area. The *Summa* is also a useful occasional table to use indoors too, and comes in three different finishes.

Zwar ist dieser kleine Tisch mit abnehmbarem Tablett nicht ausdrücklich als Gartentisch gedacht, eignet sich aber aufgrund seiner Doppelfunktion perfekt als Transportmittel und zugleich Beistelltisch für eine Mahlzeit auf der Gartenterrasse. Er lässt sich zusammenklappen und so Platz sparend verstauen, kann sich aber genauso im Wohnzimmer als kleines Beistelltischchen nützlich machen. Es gibt ihn in drei Ausführungen.

La table d'appoint *Summa* s'utilise aussi bien à l'intérieur qu'à l'extérieur. Extrêmement fonctionnelle, cette table comporte un plateau amovible très pratique pour transporter la nourriture, les couverts et les assiettes entre la cuisine et la terrasse. Pliable, cette table se range très facilement, permettant ainsi un gain de place important. Disponible en trois finitions différentes, *Summa* arbore une simplicité désarmante, alliant à merveille esthétique et fonctionnalité.

The profoundly talented Jean-Marie Massaud designed this elegant outdoor table to compliment his exquisite *Heaven* outdoor chairs. Cleverly made from interwoven pre-galvanized steel tubes, it possesses a strong Op-Art quality, as well as an arresting visual lightness. It comes in four sizes, ranging from a large dining table to a small occasional table. The table top is made from eight-millimetre-thick toughened glass, so is robust enough for years of outdoor use.

Der äußerst begabte Jean-Marie Massaud entwarf diesen eleganten Outdoor-Tisch als Ergänzung zu seinen edlen *Heaven* Stühlen. Der aus vorverzinkten Stahlstangen kunstvoll geflochtene Tisch erinnert an Arbeiten der Op-Art und besitzt eine faszinierende visuelle Leichtigkeit. Er ist in vier Größen erhältlich, vom großen Esstisch bis zum kleinen Beistelltisch. Die Platte besteht aus acht mm dickem gehärtetem Glas und ist so robust, dass sie viele Jahre im Freien übersteht.

Le très talentueux Jean-Marie Massaud a dessiné cette élégante table d'extérieur pour accompagner ses exquises chaises *Heaven*. Ingénieusement conçue avec un tressage de tubes d'acier prégalvanisés, elle possède une forte qualité Op-Art ainsi qu'une surprenante légèreté visuelle. Elle existe en quatre tailles, de la grande table de salle à manger au guéridon. Son plateau en verre renforcé de huit millimètres d'épaisseur est assez robuste pour résister à des années d'utilisation en plein air.

Heaven outdoor table, 2007
Jean-Marie Massaud (France, 1966–)

www.emu.it
Painted, pre-galvanized tubular steel, toughened glass
Lackierte, vorverzinkte Stahlstangen, gehärtetes Glas
Tubes d'acier prégalvanisé et peint, verre renforcé
↕ 75 cm ⌀ 80 cm (variation shown)
Emu, Marsciano, Italy

A recent addition to Gufram's famous *I Multipli* collection, Ross Lovegrove's *Softcrete* modular sofa is made of moulded self-skinning polyurethane foam, which surreally looks like hard concrete but is actually comfortably squishy. The individual units can be joined together using steel couplings, and a matching side table is also available.

Ross Lovegroves aus Sitzelementen zusammenstellbares Sofa *Softcrete* ergänzt die berühmte *I Multipli*-Kollektion des Möbelherstellers Gufram. Geformt aus Polyurethanschaum, der seine eigene Haut bildet, wirkt es wie aus hartem Beton gegossen, ist aber unglaublich bequem. Die einzelnen Elemente lassen sich mit Stahlflanschen verbinden. Dazu ist ein passender Beistelltisch erhältlich.

Récemment ajouté à la célèbre collection *I Multipli*, le canapé modulable *Softcrete* de Ross Lovegrove est réalisé en mousse de polyuréthane moulée, révélant une forme minimaliste. Inspiré des blocs de béton, ce sofa s'avère pourtant extrêmement confortable. Les modules sont reliés par des tiges en acier, permettant toute sorte de configurations. Une table d'appoint assortie est également disponible.

Softcrete sofa, 2006

Ross Lovegrove (UK, 1958–)

www.gufram.it
Expanded polyurethane, Guflac, steel
Polyurethanschaum, Guflac-Beschichtung, Stahl
Polyuréthane expansé, Guflac, acier
↕ 70 cm ↔ 70 cm ↗ 70 cm (sofa unit)
Gufram, Balangero, Italy

This simple yet eye-catching collection of furniture came about because the celebrated American designers, Lella and Massimo Vignelli, needed some casual furnishings for their new home near Sorrento in southern Italy. In the end, they decided to design it themselves. The resulting multi-purpose cube, bench and table are rotation moulded from weather-resistant polypropylene, making these striking and elemental pieces suitable for both indoor and outdoor use.

Diese einfache und dennoch auffällige Möbelkollektion entstand, weil die bekannten amerikanischen Designer Lella und Massimo Vignelli ein paar Alltags-möbel für ihr neues Heim in der Nähe von Sorrento in Süditalien suchten und schließlich beschlossen, sie selbst zu entwerfen. Die wirkungsvolle Gruppe aus Mehrzweckwürfel, Bank und Tisch ist im Rotationsgussverfahren aus wetterfestem Polypropylen gefertigt und ist sowohl drinnen als auch draußen verwendbar.

Cette ligne de mobilier belle et simple a vu le jour car les célèbres designers américains Lella et Massimo Vignelli cherchaient des meubles décontractés pour leur nouvelle maison près de Sorrento en Italie. N'en trouvant pas, ils décidèrent de les dessiner eux-mêmes, créant ce cube polyvalent, ce banc et cette table dans du polypropylène moulé par rotation et résistant aux intempéries, des pièces étonnantes et élémentaires convenant aussi bien à l'intérieur qu'à l'extérieur.

The Vignelli Collection indoor/outdoor furniture, 2005

Lella Vignelli (Italy/USA, 1934–) & Massimo Vignelli (Italy/USA, 1931–)

www.helleronline.com
Rotation-moulded polypropylene
Im Rotationsgussverfahren hergestelltes Polypropylen
Polypropylène moulé par rotation
↕ 46 cm ↔ 46 cm ⤢ 46 cm (cube)
↕ 46 cm ↔ 182 cm ⤢ 46 cm (big bench)
↕ 46 cm ↔ 120 cm ⤢ 120 cm (low table)
Heller, New York (NY), USA

Deneb Outdoor table & bench, 2004

Jesús Gasca (Spain, 1939–)

www.stua.com
Anodised aluminium, teak
Eloxiertes Aluminium, Teak
Aluminium anodisé, teck
↕ 73 cm ↔ 120, 160, 180 cm ⤢ 80, 90 cm (table)
↕ 44 cm ↔ 100, 140, 160 cm ⤢ 40 cm (bench)
Stua, Astigarraga, Spain

In 1987 Jesús Gasca designed his glass-topped *Deneb* table for the home or office environment. He subsequently revisited this elegant design and adapted it into a range suitable for use outside. With their slatted teak tops, the resulting *Deneb Outdoor* table, bench and stool combine high-tech manufacturing with simple, ideal forms, thereby providing a graceful functionalism as well as a durable solution to open-air dining.

1987 schuf Jesús Gasca den Glastisch *Deneb* für Wohnbereiche oder Büros. Später griff er das elegante Design noch einmal auf, und zwar für seine Gartenmö-bel-Kollektion *Deneb Outdoor*. Mit ihren Teaklattenflächen kombinieren diese Modelle schlichte „Idealformen" mit High-Tech-Konstruktionen und sind damit elegant sachliche und zudem äußerst wetterbeständige Gartenmöbel.

Inspiré par sa table vitrée *Deneb* (pour la maison ou le bureau), Jesús Gasca conçut cet ensemble pour le jardin. Le plateau de la table et l'assise du banc sont réalisés en lattes de teck posées sur une structure en aluminium. Cet ensemble révèle un look contemporain et un fonctionnalisme gracieux. Parfaite combinaison de haute technologie et de formes simples qui invite à des repas conviviaux en plein air.

San Marco outdoor table & bench, 2008

Gae Aulenti (Italy, 1927–)

www.zanotta.it
Steel, laminate
Stahl, Laminat
Acier, stratifié
↕ 73 cm ↔ 60–180 cm ⤢ 60, 80 cm (table)
↕ 45 cm ↔ 100, 130, 160 cm ⤢ 30 cm (bench)
Zanotta, Nova Milanese, Italy

Throughout her career Gae Aulenti has created designs that have a strong graphic aspect, such as her stylishly minimal *San Marco* table and bench, which are intended for both indoor and outdoor use. Their demountable steel frames come in a white or graphite painted finish, while the weather-resistant laminate tabletop is available in either white or brown. For added comfort an upholstered seat cushion is also an option.

Im Laufe ihrer gesamten Karriere hat Gae Aulenti Designs von stark grafischem Charakter geschaffen, so auch den elegant-minimalistischen *San Marco*-Tisch mit passender Bank, die beide sowohl im Wohnzimmer als auch auf der Gartenterrasse einsetzbar sind. Die zerlegbaren Stahlgestelle sind weiß oder graphitgrau beschichtet und die Schichtholz-Tischplatte entweder in Weiß oder Braun lieferbar, mit oder ohne Polsterauflagen.

Tout au long de sa carrière Gae Aulenti a doté ses créations d'un fort aspect graphique. *San Marco* illustre un design pur et des finitions exceptionnelles. La structure en acier verni blanc ou en graphite est démontable. Le plateau de la table et l'assise du banc en laminé stratifié (blanc ou marron) associent élégance et résistance aux intempéries. Pour plus de confort, un coussin optionnel est également disponible.

Summit® S-450 Gas Grill, 2007

Weber-Stephen design team

www.weber.com
Cast aluminium, stainless steel
Aluguss, Edelstahl
Aluminium coulé, acier inoxydable
↕ 150 cm (with lid open) ↔ 170 cm ⤢ 77 cm
Weber-Stephen, Chicago (IL), USA

Outdoor cooking has always been enjoyed in America, with its roots going back to the pioneers. In the 1950s barbecuing became especially popular, and it was during this consumer boom-time that George Stephen invented his famous kettle-shaped Weber barbecue. Weber-Stephen continues to design and produce superior grills today, such as the *Summit® S-450* with its four burners and rotisserie function.

In Amerika ist das Kochen im Freien seit der Wild-West-Pionierzeit populär. In den 1950er Jahren wurde besonders das Grillen unter freiem Himmel beliebt und George Stephen entwickelte damals – in der ersten Blütezeit der Konsumgesell-schaft – seinen berühmten kesselför-migen Gartengrill. Heute produziert die Nachfolgefirma Weber-Stephen hochwer-tige Grills, darunter den *Summit® S-450* mit vier Flammen und Spießbraten-Funktion.

Depuis l'époque des pionniers, cuisiner dehors est devenu une véritable insti-tution en Amérique. Dans les années 50, le barbecue attire de plus en plus d'adeptes. Profitant de cet engouement, George Stephen invente le premier barbecue à couvercle, en forme de boule. Weber-Stephen continue de concevoir et de produire des barbecues d'une qualité supérieure, tels que *Summit® S-450*, doté de quatre brûleurs et d'une fonction rôtissoire.

Luxius No. 1 outdoor kitchen, 2008

Luxius Design Team

www.luxius.nl
Stainless steel, oak
Edelstahl, Eiche
Acier inoxydable, chêne
↕ 65 cm ↔ 185 cm
Luxius, Mierlo, Netherlands

For those living in sunnier climes, outdoor eating is an important way of life and it is not surprising that 'outdoor kitchens' are becoming increasingly popular. The *Luxius No. 1* is perhaps the ultimate model with its robust double-layered stainless steel stove and ample storage space. Additional cupboards and a sink unit can also be added to the configuration. And for those who are feeling adventurous, it even has a stone grill, a baking plate and a roasting spit.

Für alle, die in wärmeren Gefilden leben, ist es fast selbstverständlich, draußen zu essen, und so überrascht es nicht, dass „Gartenküchen" immer beliebter werden. Vielleicht ist die *Luxius Nr. 1* mit dem robusten, doppelschichtigen Edelstahlherd und reichlich Stauraum das ultimative Modell. Das Ganze kann noch durch zusätzliche Schränke und eine Spüle erweitert werden. Und für alle, die es abenteuerlich mögen, gibt es sogar noch einen Steingrill, eine Grillplatte und einen Drehspieß.

Prendre les repas en plein air fait partie du mode de vie de ceux qui vivent sous le soleil. Aussi il n'est pas surprenant que les cuisines extérieures deviennent de plus en plus populaires. *Luxius No. 1* s'avère parfaite, avec son fourneau en acier inoxydable double couche et un important espace de rangement. Des placards et un évier optionnels sont également disponibles afin d'agrandir la configuration initiale. Pour les plus ambitieux, il existe un barbecue en pierre, une plaque de cuisson et un tournebroche.

Index

Picture credits

Acknowledgements

This book has been a monumental undertaking and its realisation would not have been possible without the help and assistance of many people. Heartfelt thanks must firstly go to Jennifer Tilston for her excellent picture sourcing and good-natured perseverance. Special thanks must also go to Rob Payne and Mark Thomson for their first rate graphic design and tireless implementation, Paul Chave for his exquisite new photography, Quintin Colville for his superlative copy-editing and Rosanna Negrotti for her careful and precise proofreading. We would also like to acknowledge the tireless efforts of Yvonne Havertz, who did a wonderful job coordinating the translations, and of course, the translators themselves, Birgit Herbst, Cara Kanter, Jessika Komina, Sandra Knuffinke, Annette Wiethüchter, Philippe Safavi and Stéphanie Jaunet. We would also like to give a very big thank you to the many designers and manufacturers who supplied images and information (you made this book happen!), including:

All-Clad – Chloe Faidy; Alessi – Pete Collard; Alias Design – Francesca Noseda; Arflex – Elisabette Bartesaghi; Artelano Paris – Raphaël Milan; Artemide – Dean Sahar; Artifort – Margiret van Sonsbeek; Arzberg – Ian Bailey; Asplund – Nina Brisius; Atelier du Vin – Simon Gilboy; Avarte – Noora Raitisto; B-Line – Fabio Bordin; B&B Italia – Laura Quickfall; Boffi – Ciara Philips; Cappellini/Poltrona Frau – Giuliana Reggio; Casala – Wilma Koning; Case Furniture – Duncan Bull; Cassina – Enrica Porro; Classicon – Alexandra Boeninger; Cuisipro – Elizabeth Burns; Danese – Laura Salviati; De La Espada – Phoebe Montoya; Dedon – Catherine Frinier; Driade – Francesco Farabola; Edra – Roberta Ugo; Emmemobili – Maurizio Rainoldi; Emu – Letizia Guardelli; Established & Sons – Juliet Scott; Erik Jorgensen – Charlotte Riis Røikjaer; Eva Solo – Majken Holmsteen; Flos – Clara Buoncristiani; Georg Jensen – Katrine Schrøder; Hans Grohe – Kayleigh; Herman Miller – Mike Stuk; Horm – Monica de Riz; Iittala – Sophie Linne; Isokon Plus – Cat; Jacob Jensen – Christopher Howie; Jasper Morrison – Laurence Maulderi; Kartell – Keren Avni; Knoll – Mabel Peralta; LaPalma – Maurizio Baiardo; Le Klint – Karin Frederiksen; Lifa Design – Merete Steenberg Thomsen; Louis Poulsen – Ida Praestgaard; Luxo – Romana Berzolla; Manufactum – Franziska Baumgaertner; Materia – Annica Gunnarsson; Matki – Helen Marsh; MDF Italia – Lucia Legè; Mobles 114 – Marta Termoleda; Modernica – Frank Novak; Moroso – Veronica Villa; Muji – James Lawless; Nendo – Akihiro Ito; OXO International – Charlotte Pinelli; Plank – Andreas Mangeng; Poliform – Sam Young; ProFeelDesign – Maarit Miettinen; Rosenthal – Silke Jahn; Royal Copenhagen – Karin Skipper-Ulstrup; RSVP – Cheryl Walczyk; Sagaform – Eva Fridén; Sanico – Estrella Sanz; SCP – Danka Nisevic; Serien – Helga Wiegel; Serralunga – Federica Moglia; Simplehuman – Rose Pater; Smart Design – Thomas Isaacson; SpHaus – Pamela Dell'Orto; Stelton – Nina Sylvest; String – Pär Josefsson; Stua – Jon Gasca; Swedese – Lina Fors; Theo Williams; Tobias Grau – Katherin Schmidtke; Vibia – James Mansfield; Vipp – Allan Sørensen; Vitra – Rahel Ueding; VitrA – Rebecca Wallace; Ycami – Silvia Marinoni & Nicoletta Galimberti; Zanotta – Daniela De Ponti; Zwilling – Brian Lane